The Humanities

Culture, Continuity & Change

SECOND EDITION

Henry M. Sayre

OREGON STATE UNIVERSITY

BOOK 1
THE ANCIENT WORLD
AND THE CLASSICAL PAST:
PREHISTORY TO 200 CE

Prentice Hall

Boston Columbus Indianapolis New York San Francisco Upper Saddle River Amsterdam Cape Town Dubai London Madrid Milan Munich Paris Montréal Toronto Delhi Mexico City São Paulo Sydney Hong Kong Seoul Singapore Taipei Tokyo

For Bud Therien, art publisher and editor par excellence, and a good friend.

Editorial Director: Craig Campanella Editor in Chief: Sarah Touborg Acquisitions Editor: Billy Grieco Assistant Editor: David Nitti

Editor-in-Chief, Development: Rochelle Diogenes

Development Editor: Margaret Manos

Media Director: Brian Hyland Senior Media Editor: David Alick Media Project Manager: Rich Barnes

Vice President of Marketing: Brandy Dawson

Executive Marketing Manager: Kate Stewart Mitchell Senior Managing Editor: Ann Marie McCarthy Associate Managing Editor: Melissa Feimer

Senior Project Manager: Barbara Marttine Cappuccio

Project Manager: Marlene Gassler

Senior Manufacturing Manager: Mary Fisher Senior Operations Specialist: Brian Mackey

Senior Art Director: Pat Smythe Interior Design: PreMedia Global Cover Designer: Pat Smythe

Manager, Visual Research: Beth Brenzel

Photo Research: Francelle Carapetyan / Image Research

Editorial Services

Pearson Imaging Center: Corin Skidds, Robert Uibelhoer Full-Service Project Management: PreMediaGlobal

Composition: PreMediaGlobal

Printer/Binder: Courier / Kendallville Cover Printer: Phoenix Color, Corp. Cover Image: Scala / Art Resource, NY

Credits and acknowledgments borrowed from other sources and reproduced, with permission, in this textbook appear on appropriate page within text and beginning on page Credits-1.

Copyright © 2012, 2008 Pearson Education, Inc., publishing as Prentice Hall, 1 Lake St., Upper Saddle River, NJ 07458. All rights reserved. Manufactured in the United States of America. This publication is protected by Copyright, and permission should be obtained from the publisher prior to any prohibited reproduction, storage in a retrieval system, or transmission in any form or by any means, electronic, mechanical, photocopying, recording, or likewise. To obtain permission(s) to use material from this work, please submit a written request to Pearson Education, Inc., Permissions Department, 1 Lake St., Upper Saddle River, NJ 07458.

Library of Congress Cataloging-in-Publication Data Sayre, Henry M.

The humanities: culture, continuity & change / Henry M. Sayre. -- 2nd ed.

p. cm.

Includes bibliographical references and index. ISBN-13: 978-0-205-78215-4 (alk. paper) ISBN-10: 0-205-78215-9 (alk. paper)

1. Civilization--History--Textbooks. 2. Humanities--History--Textbooks. I. Title.

CB69.S29 2010 909--dc22

2010043097

10 9 8 7 6 5 4 3 2

Prentice Hall is an imprint of

ISBN 10: 0-205-01330-9 ISBN 13: 978-0-205-01330-2

SERIES CONTENTS

BOOK ONE

THE ANCIENT WORLD AND THE CLASSICAL PAST:

- PREHISTORY TO 200 CE
- 1 The Rise of Culture: From Forest to Farm
- 2 Mesopotamia: Power and Social Order in the Early Middle East
- 3 The Stability of Ancient Egypt: Flood and Sun
- 4 The Aegean World and the Rise of Greece: Trade, War, and Victory
- 5 Golden Age Athens and the Hellenic World: The School of Hellas
- 6 Rome: Urban Life and Imperial Majesty
- 7 Other Empires: Urban Life and Imperial Majesty in China and India

BOOK TWO

THE MEDIEVAL WORLD AND THE SHAPING OF CULTURE 200 CE TO 1400

- 8 The Flowering of Christianity: Faith and the Power of Belief in the Early First Millennium
- 9 The Rise and Spread of Islam: A New Religion
- 10 The Fiefdom and Monastery, Pilgrimage and Crusade: The Early Medieval World in Europe
- 11 Centers of Culture: Court and City in the Larger World
- 12 The Gothic Style: Faith and Knowledge in an Age of Inquiry
- 13 Siena and Florence in the Fourteenth Century: Toward a New Humanism

BOOK THREE

THE RENAISSANCE AND THE AGE OF ENCOUNTER:

- 1400 TU 1600
- 14 Florence and the Early Renaissance: Humanism in Italy
- 15 The High Renaissance in Rome and Venice: Papal Patronage
- 16 The Renaissance in the North: Between Wealth and Want
- 17 The Reformation: A New Church and the Arts
- 18 Encounter and Confrontation: The Impact of Increasing Global Interaction
- 19 England in the Tudor Age: "This Other Eden"
- 20 The Early Counter-Reformation and Mannerism:Restraint and Invention

BOOK FOUR

EXCESS, INQUIRY, AND RESTRAINT: 1600 TO 1800

- 21 The Baroque in Italy: The Church and Its Appeal
- 22 The Secular Baroque in the North: The Art of Observation
- 23 The Baroque Court: Absolute Power and Royal Patronage
- 24 The Rise of the Enlightenment in England: The Claims of Reason
- 25 The Rococo and the Enlightenment on the Continent: Privilege and Reason
- 26 The Rights of Man: Revolution and the Neoclassical Style

BOOK FIVE

ROMANTICISM, REALISM, AND EMPIRE: 1800 TO 1900

- 27 The Romantic World View: The Self in Nature and the Nature of Self
- 28 Industry and the Working Class: A New Realism
- 29 Global Confrontation and Civil War: Challenges to Cultural Identity
- 30 In Pursuit of Modernity Paris in the 1850s and 1860s
- 31 The Promise of Renewal: Hope and Possibility in Late Nineteenth-Century Europe
- 32 The Course of Empire: Expansion and Conflict in America
- 33 The Fin de Siècle: Toward the Modern

BOOK SIX

MODERNISM AND THE GLOBALIZATION OF CULTURES: 1900 TO THE PRESENT

- 34 The Era of Invention: Paris and the Modern World
- 35 The Great War and Its Impact: A Lost Generation and a New Imagination
- 36 New York, Skyscraper Culture, and the Jazz Age: Making It New
- 37 The Age of Anxiety: Fascism and Depression, Holocaust and Bomb
- **38** After the War: Existential Doubt, Artistic Triumph, and the Culture of Consumption
- 39 Multiplicity and Diversity: Cultures of Liberation and Identity in the 1960s and 1970s
- **40** Without Boundaries: Multiple Meanings in a Postmodern World

Preface vi

The Rise of Culture

FROM FOREST TO FARM 3

The Beginnings of Culture in the Paleolithic Era 4

Agency and Ritual: Cave Art 4 Paleolithic Culture and Its Artifacts 5

The Rise of Agriculture in the Neolithic Era 8

Neolithic Jericho and Skara Brae 9 Neolithic Pottery Across Cultures 11

Neolithic Ceramic Figures 12

The Neolithic Megaliths of Northern Europe 13

The Role of Myth in Cultural Life 18

Native American Cultural Traditions 18

Japan and the Role of Myth in the Shinto Religion 22

Sacred Sites: The Example of the Americas 24

The Olmec 24

The Mound Builders 24

READINGS

1.1 Zuni Emergence Tale, Talk Concerning the First Beginning 21

1.2 The Japanese Creation Myth: The Kojiki 29

FEATURES

MATERIALS & TECHNIQUES

Methods of Carving 7

Post-and-Lintel and Corbel Construction 18

CLOSER LOOK The Design and Making of Stonehenge 17

CONTINUITY & CHANGE Representing the Power of the Animal World 27

Mesopotamia

POWER AND SOCIAL ORDER IN THE EARLY MIDDLE EAST 31

Sumerian Ur 33

Religion in Ancient Mesopotamia 34

Royal Tombs of Ur 35

Akkad 37

Akkadian Sculpture 37

Babylon 40

The Law Code of Hammurabi 41

The Assyrian Empire 43

Mesopotamian Literature 44

The Blessing of Inanna 44

The Epic of Gilgamesh 45

The Hebrews 50

Moses and the Ten Commandments 50

Kings David and Solomon, and Hebrew Society 52

The Prophets and the Diaspora 53

Neo-Babylonia 54

The Persian Empire 56

READINGS

2.1 from the Law Code of Hammurabi (ca. 1792–1750 BCE) 42

2.2 The Blessing of Inanna (ca. 2300 BCE) 45

2.3 from the Epic of Gilgamesh, Tablet I (ca. 1200 BCE) (translated by Maureen Gallery Kovacs) 61

2.3a-e from the Epic of Gilgamesh, Tablet I, I, VI, X, XI (ca. 1200 BCE) 46–48

2.4 from the Hebrew Bible, Genesis (Chapters 2-3, 6-7) 61

2.4a from the Hebrew Bible (Deuteronomy 6:6-9) 51

2.4b from the Hebrew Bible (Song of Solomon 4:1-6, 7:13-14) 52

2.5 from the Hymn to Marduk (1000-700 BCE) 54

2.6 from the Zend-Avesta (ca. 600 BCE) 58

FEATURES

CONTEXT Mesopotamian Gods and Goddesses CLOSER LOOK Cuneiform Writing in Sumer 39 MATERIALS & TECHNIQUES Lost-Wax Casting 40 CONTINUITY & CHANGE The Stability of Egyptian Culture 59

The Stability of Ancient Egypt

FLOOD AND SUN 65

The Nile and Its Culture 66

Egyptian Religion: Cyclical Harmony 68 Pictorial Formulas in Egyptian Art 69

The Old Kingdom 72

The Stepped Pyramid at Saqqara 73

Three Pyramids at Giza 73

Monumental Royal Sculpture: Perfection and Eternity 76

The Sculpture of the Everyday 78

The Middle Kingdom at Thebes 79

Middle Kingdom Literature 79

Middle Kingdom Sculpture 79

The New Kingdom 81

Temple and Tomb Architecture and Their Rituals 81

Akhenaten and the Politics of Religion 85 The Return to Thebes and to Tradition 87

The Late Period, the Kushites, and the Fall of Egypt 89

The Kushites 90

Egypt Loses Its Independence 90

READINGS

3.1 from Memphis, "This It Is Said of Ptah" (ca. 2300 BCE) 69

3.2 The Teachings of Khety (ca. 2040–1648 BCE) 93

3.3 from Akhenaten's Hymn to the Sun (14th century BCE) 86

3.4 from The Book of Going Forth by Day 88

FEATURES

CONTEXT Major Periods of Ancient Egyptian History 68 **CONTEXT** Some of the Principal Egyptian Gods 69 **CLOSER LOOK** Reading the *Palette of Narmer* 71 CONTEXT The Rosetta Stone 75 MATERIALS & TECHNIQUES Mummification 84 CONTINUITY & CHANGE Mutual Influence through Trade 91

The Aegean World and the Rise of Greece

TRADE, WAR, AND VICTORY 95

The Cyclades 96

Minoan Culture in Crete 96

Minoan Painting 96

Minoan Religion 97

The Palace of Minos 98

Mycenaean Culture on the Mainland 100

The Homeric Epics 103

The Iliad 105

The Odyssey 106

The Rise of the Greek City-States 108

Behavior of the Gods 110

The Polis 110

Life in Sparta 111

The Sacred Sanctuaries 112

Male Sculpture and the Cult of the Body 116

The Athens of Peisistratus 118

Toward Democracy 118

Female Sculpture and the Worship of Athena 119

Athenian Pottery 120 The Poetry of Sappho 123

The First Athenian Democracy 124

READINGS

4.1 from Homer, Iliad, Book 16 (ca. 750 BCE) 128

4.1a from Homer, Iliad, Book 24 (ca. 750 BCE) 106

4.2 from Homer, Odyssey, Book 9 (ca 725 BCE) 130

4.2a from Homer, Odyssey, Book 4 (ca. 725 BCE) 106

4.2b from Homer, Odyssey, Book 1 (ca. 725 BCE) 107

4.3 from Hesiod, Works and Days, (ca. 700 BCE) 110

4.4 from Hesiod, Theogony, (ca. 700 BCE) 110

4.5 Thucydides, History of the Peloponnesian Wars 111

4.6 from Aristotle's Athenian Constitution 118

4.7a-b Sappho, lyric poetry 124

FEATURES

CONTEXT The Greek Gods 112

CLOSER LOOK The Classical Orders 115

CONTINUITY & CHANGE Egyptian and Greek Sculpture 125

Golden Age Athens and the Hellenic World

THE SCHOOL OF HELLAS 135

The Good Life and the Politics of Athens 136

Slaves and Metics 137

The Women of Athens 137

Pericles and the School of Hellas 138

Beautiful Mind, Beautiful Body 139

Rebuilding the Acropolis 140

The Architectural Program at the Acropolis 141 The Sculpture Program at the Parthenon 146

Philosophy and the Polis 148

The Philosophical Context 148

Plato's Republic and Idealism 149

Plato's Symposium 150

The Theater of the People 151

Comedy 152

Tragedy 152

The Performance Space 155

The Hellenistic World 156

The Empire of Alexander the Great 156

Toward Hellenistic Art: Sculpture in the Late Classical Period 158

Aristotle: Observing the Natural World 159

Pergamon: Hellenist Capital 160

Alexandria 163

READINGS

5.1 from Euripides, Medea (431 BCE) 137

5.2a Thucydides, History of the Peloponnesian Wars, Pericles's Funeral Speech (ca. 410 BCE) 138

5.2b-c Pericles's Funeral Speech 139

5.3 Plutarch, Life of Pericles (75 cE) 141

5.4 from Plato, Crito 168

5.5 Plato, "Allegory of the Cave," from The Republic 169

5.6 Plato, from The Symposium 171

5.6a Plato, The Symposium 151

5.7a-b Sophocles, Antigone 153-154

5.8 Aristotle, from Poetics 172

FEATURES

CLOSER LOOK The Parthenon 143

CONTINUITY & CHANGE Rome and Its Hellenistic Heritage 165

URBAN LIFE AND IMPERIAL MAJESTY 175

Origins of Roman Culture 177

The Etruscan Roots 177

The Greek Roots 180

Republican Rome 181

Roman Rule 182

Cicero and the Politics of Rhetoric 183

Portrait Busts, Pietas, and Politics 184

Imperial Rome 185

Family Life 186

Education of the Sexes 187

The Philosophy of the City: Chance and Reason 188

Literary Rome: Catullus, Virgil, Horace, and Ovid 189

Augustus and the City of Marble 191

Pompeii 202

The Late Roman Empire: Moral Decline 204

READINGS

6.1a Virgil, Aeneid, Book II 180

6.1b Homer, Odyssey, Book VIII 181

6.1c Virgil, Aeneid, Book VI 181

6.2 Cicero, On Duty 183

6.3 Cicero, Letters to Atticus 184

6.4 Juvenal, Satires 188

6.5 Seneca, Tranquility of Mind 189

6.6 Catullus, Poems 5 and 43 209

6.7 from Virgil, Georgics 189

6.8 Virgil, from the Aeneid, Book IV 209

6.9 Horace, Ode 13 from the Odes 211

6.10 from Letters of Pliny the Younger 202

6.11 Seneca, Moral Epistles, Epistle 86 205

FEATURES

CLOSER LOOK The Forum Romanum and Imperial Forums 195 MATERIALS & TECHNIQUES Arches and Vaults 196 CONTINUITY & CHANGE Christian Rome 206

Other Empires

URBAN LIFE AND IMPERIAL MAJESTY IN CHINA AND INDIA 213

Early Chinese Culture 214

Chinese Calligraphy 214

The Shang Dynasty (ca. 1700-105 BCE) 215

The Zhou Dynasty (1027-256 BCE) 217

Imperial China 220

The Qin Dynasty (221–206 BCE): Organization and Control 220 The Han Dynasty (206 BCE-220 CE): The Flowering of Culture 221

Ancient India 226

Hinduism and the Vedic Tradition 228 Buddhism: "The Path of Truth" 231

READINGS

7.1 from the Book of Songs 237

7.1a from the Book of Songs 217

7.2 from the Dao de jing 218

7.3 Confucius, from the Analects 237

7.4 from Emperor Wu's "Heavenly Horses" 221 7.5 Liu Xijun, "Lament" 224

7.6 Fu Xuan, "To Be a Woman" 224

7.7 from "The Second Teaching" in the Bhagavad Gita: Krishna's Counsel in Time of War 238

7.8 from the Dhammapada 240

FEATURES

CLOSER LOOK The Tomb of Qin Shihuangdi 223 CONTINUITY & CHANGE The Silk Road 235

Index Index-1

Photo and Text Credits Credits-1

SEE CONTEXT AND MAKE CONNECTIONS . . .

DEAR READER,

You might be asking yourself, why should I be interested in the Humanities? Why do I care about ancient Egypt, medieval France, or the Qing Dynasty of China?

I asked myself the same question when I was a sophomore in college. I was required to take a year long survey of the Humanities, and I soon realized that I was beginning an extraordinary journey. That course taught me where it was that I stood in the world, and why and how I had come to find myself there. My goal in this book is to help you take the same journey of discovery. Exploring the humanities will help you develop your abilities to look, listen, and read closely; and to analyze, connect, and question. In the end, this will help you navigate your world and come to a better understanding of your place in it.

What we see reflected in different cultures is something of ourselves, the objects of beauty and delight, the weapons and wars, the melodies and harmonies, the sometimes troubling but always penetrating thought from which we spring. To explore the humanities is to explore ourselves, to understand how and why we have changed over time, even as we have, in so many ways, remained the same.

I've come to think of this second edition in something of the same terms. What I've tried to do is explore new paths of inquiry even as I've tried to keep the book recognizably the same. My model, I think, has been Bob Dylan. Over the years, I've heard the man perform more times than I can really recall, and I just saw him again in concert this past summer. He has

been performing "Highway 61" and "Just Like a Woman" for nearly fifty years, but here they were again, in new arrangements that were totally fresh—recognizably the same, but reenergized and new. That should be the goal of any new edition of a book, I think, and I hope I've succeeded in that here.

ABOUT THE

AUTHOR

Hey My

Henry M. Sayre is Distinguished Professor of Art History at Oregon State University—Cascades Campus in Bend, Oregon. He earned his Ph.D. in American Lit-

erature from the University of Washington. He is producer and creator of the 10-part television series, A World of Art: Works in Progress, aired on PBS in the Fall of 1997; and author of seven books, including A World of Art, The Visual Text of William Carlos Williams, The Object of Performance: The American Avant-Garde since 1970; and an art history book for children, Cave Paintings to Picasso.

The Humanities: Culture, Continuity & Change helps students see context and make connections across the humanities by tying together the entire cultural experience through a narrative storytelling approach. Written around Henry Sayre's belief that students learn best by remembering stories rather than memorizing facts, it captures the voices that have shaped and influenced human thinking and creativity throughout our history.

With a stronger focus on engaging students in the critical thinking process, this new edition encourages students to deepen their understanding of how cultures influence one another, how ideas are exchanged and evolve over time, and how this collective process has led us to where we stand today. With several new features, this second edition helps students to understand context and make connections across time, place, and culture.

To prepare the second edition, we partnered with our current users to hear what was successful and what needed to be improved. The feedback we received through focus groups, online surveys, and reviews helped shape and inform

this new edition. For instance, to help students make stronger global connections, the organization of the text and the Table of Contents have been modified. As an example, reflections of this key goal can be seen in Chapters 6 and 7, which are now aligned to show parallels more easily in the developments of urban culture and imperial authority between Rome, China, and India.

Through this dialogue, we also learned how humanities courses are constantly evolving. We learned that more courses are being taught online and that instructors are exploring new ways to help their students engage with course material. We developed MyArtsLab with these needs in mind. With powerful online learning tools integrated into the book, the online and textbook experience is more seamless than ever before. In addition, there are wonderful interactive resources that you, as the instructor, can bring directly into your classroom.

All of these changes can be seen through the new, expanded, or improved features shown here.

THE HUMANITIES: CULTURE, CONTINUITY & CHANGE

is the result of an extensive development process involving the contributions of over one hundred instructors and their students. We are grateful to all who participated in shaping the content, clarity, and design of this text. Manuscript reviewers and focus group participants include:

ALABAMA

Cynthia Kristan-Graham, Auburn University

CALIFORNIA

Collette Chattopadhyay, Saddleback College Laurel Corona, San Diego City College Cynthia D. Gobatie, Riverside Community College John Hoskins, San Diego Mesa College Gwenyth Mapes, Grossmont College Bradley Nystrom, California State University-Sacramento

Joseph Pak, Saddleback College John Provost, Monterey Peninsula College Chad Redwing, Modesto Junior College Stephanie Robinson, San Diego City College Alice Taylor, West Los Angeles College Denise Waszkowski, San Diego Mesa College

COLORADO

Renee Bragg, Arapahoe Community College Marilyn Smith, Red Rocks Community College

CONNECTICUT

Abdellatif Hissouf, Central Connecticut State University

FLORIDA

Wesley Borucki, Palm Beach Atlantic University Amber Brock, Tallahassee Community College Connie Dearmin, Brevard Community College Kimberly Felos, St. Petersburg College Katherine Harrell, South Florida Community

Ira Holmes, College of Central Florida
Dale Hoover, Edison State College
Theresa James, South Florida Community College
Jane Jones, State College of Florida, ManateeSarasota

Jennifer Keefe, Valencia Community College Mansoor Khan, Brevard Community College Connie LaMarca-Frankel, Pasco-Hernando Community College

Sandi Landis, St. Johns River Community College-Orange Park

Joe Loccisano, State College of Florida David Luther, Edison College James Meier, Central Florida Community College Brandon Montgomery, State College of Florida Pamela Wood Payne, Palm Beach Atlantic University

Gary Poe, Palm Beach Atlantic University Frederick Smith, Florida Gateway College Kate Myers de Vega, Palm Beach Atlantic University

Bill Waters, Pensacola State College

GEORGIA

Leslie Harrelson, Dalton State College Lawrence Hetrick, Georgia Perimeter College Priscilla Hollingsworth, Augusta State University Kelley Mahoney, Dalton State College Andrea Scott Morgan, Georgia Perimeter College

IDAHO

Jennifer Black, Boise State University Rick Davis, Brigham Young University-Idaho Derek Jensen, Brigham Young University-Idaho

ILLINOIS

Thomas Christensen, University of Chicago Timothy J. Clifford, College of DuPage Leslie Huntress Hopkins, College of Lake County Judy Kaplow, Harper College Terry McIntyre, Harper College Victoria Neubeck O'Connor, Moraine Valley Community College

Sharon Quarcini, Moraine Valley Community

Paul Van Heuklom, Lincoln Land Community College

INDIANA

Josephina Kiteou, University of Southern Indiana

KENTUCKY

Jonathan Austad, Eastern Kentucky University Beth Cahaney, Elizabethtown Community and Technical College Jeremy Killian, University of Louisville Lynda Mercer, University of Louisville Sara Northerner, University of Louisville

MASSACHUSETTS

Peter R. Kalb, Brandeis University

MICHIGAN

Martha Petry, Jackson Community College Robert Quist, Ferris State University

Elijah Pritchett, University of Louisville

MINNESOTA

Mary Johnston, Minnesota State University

NEBRASKA Michael Hoff.

Michael Hoff, University of Nebraska

NEVADA

Chris Bauer, Sierra College

NEW JERSEY

Jay Braverman, Montclair State University Sara E. Gil-Ramos, New Jersey City University

NEW MEXICO

Sarah Egelman, Central New Mexico Community College

NEW YORK

Eva Diaz, Pratt Institute Mary Guzzy, Corning Community College Thelma Ithier Sterling, Hostos Community College Elizabeth C. Mansfield, New York University Clemente Marconi, New York University

NORTH CAROLINA

Melodie Galloway, University of North Carolina at Asheville

Jeanne McGlinn, University of North Carolina at Asheville

Sophie Mills, University of North Carolina at Asheville

Constance Schrader, University of North Carolina at Asheville

Ronald Sousa, University of North Carolina at Asheville

Samer Traboulsi, University of North Carolina at Asheville

NORTH DAKOTA

Robert Kibler, Minot State University

OHIC

Darlene Alberts, Columbus State Community College

Tim Davis, Columbus State Community College Michael Mangus, The Ohio State University at Newark

Keith Pepperell, Columbus State Community College

Patrice Ross, Columbus State Community College

OKLAHOMA

Amanda H. Blackman, Tulsa Community College-Northeast Campus
Diane Boze, Northeastern State University
Jacklan J. Renee Cox, Rogers State University
Jim Ford, Rogers State University
Diana Lurz, Rogers State University
James W. Mock, University of Central Oklahoma

Gregory Thompson, Rogers State University

PENNSYLVANIA

Elizabeth Pilliod, Rutgers University-Camden Douglas B. Rosentrater, Bucks County Community College

Debra Thomas, Harrisburg Area Community College

RHODE ISLAND

Mallica Kumbera Landrus, Rhode Island School of Design

TEXAS

Mindi Bailey, Collin County Community College

Peggy Brown, Collin County Community College

Marsha Lindsay, Lone Star College-North Harris Aditi Samarth, Richland College Lee Ann Westman, University of Texas at El Paso

UTAH

Matthew Ancell, Brigham Young University Terre Burton, Dixie College Nate Kramer, Brigham Young University Joseph D. Parry, Brigham Young University

VIRGINIA

Margaret Browning, Hampton University Carey Freeman, Hampton University John Long, Roanoke College Anne Pierce, Hampton University Jennifer Rosti, Roanoke College

SEE CONTEXT AND MAKE CONNECTIONS . . .

NEW THINKING AHEAD

These questions open each chapter and represent its major sections, leading students to think critically and focus on important issues.

NEW THINKING BACK

These end-of-chapter reviews follow up on the **Thinking Ahead** questions, helping students further engage with the material they've just read and stimulate thought and discussion.

NEW CLOSER LOOK

Previously called "Focus" in the first edition, these highly visual features offer an in-depth look at a particular work from one of the disciplines of the humanities. The annotated discussions give students a personal tour of the work—with

informative captions and labels—to help students understand its meaning. A new critical thinking question, *Something to Think About*, prompts students to make connections and further apply this detailed knowledge of the work.

THINKING BACK What features characterize the beginnings of human

The widespread use of stone tools and weapons by Homos appiers, the hominal species that evolved around 120,000 to 100,000 years ago, gives rise to the name of the earliest are of human development. The Fallesthite care Carvers fashioned stone figures, both in the round and in releft. In care painting, such as those discovered at Chairwise Clove, the artistic great skill in creadering annuals helps with naturalistic fielder in an imberned human skill, unsersaid the state of the strength of

What characteristics distinguish the Neolithic

nom the Passachter.

As the ice that covered the Northern Hemisphere slowly melred, people began cultivating edible grasses and domericating animals. Gradually, farming supplinted hunting as the primary means of sustaining life, especially in the great river valleys where water was expecially in the great river valleys where water was required. The proposed of the

RACTICE MORE Get flashcards for images and terms and review chapter material with quizzes at www.myartslab.co

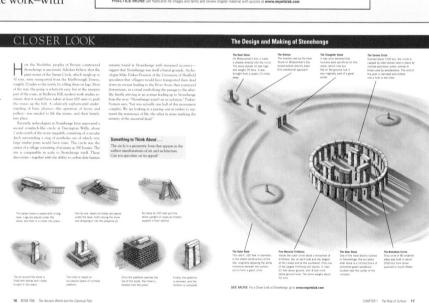

CONTINUITY **C**CHANGE

Representing the Power of the Animal World

he two images shown here in some sense bracket the six volumes of The Humanities. Then fit [Fig. 12-49, of the Humanities Then fit [Fig. 12-49, drawings of a shore. The second (Fig. 12-52), a drawing by contemporary American painter Susain Rothensberg (b. 1945), also represents a bruse, though in many ways less realized light than the cave drawing. The body of Bothensberg shore seems to have disappeared and, eyeless, as if blinded, it learns forward, its mouth open, choking or gagging or gogging for air.

In his catalog essay for a 1993 retrospective exhibition of othenberg's painting, Michael Auping, chief curator at

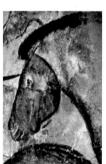

Fig. 1.24 Horse. Detail from Chauvet Cave, Vallon-Pont-d'Arc, Ardéche porge, France (Fig. 1.1), ca. 30,000 act. Note the resistor banking that delines the volume of the horse's head. It is a realism that artists throughout history have sometimes sought to achieve, and sometimes

the Albright-Knox, Museum in Buffalo, New York, described Barbenbergk kind of drawing: "Redutively spontanous, the drawing are Rothenbergh, peoples energy made imminent..., (They) unscover realins of the psych ethat are perhaps not yor fully explicable." The same could be said of the cave drawing executed by a numeless hunterguebere more than 20,000 years ago. That artistic wast, must have seemed just as strange as Rothenberg's, lit by flickering fivelight in the dash reseases of the cave, its bely

It seems certain that in some measure both drawings were the expression of a psychic need on the part of the artist—whether derived from the energy of the hout or of manute inside—to know as soften as image of the power and valuesability of the animal world. That drew, which we will see in the risk of the Boston, & of the Middle East will see the set of the Boston, & of the Middle East a Jung loss in the pulsec complex of an Austrian King as Nineesh—remains constant from the Septiming of art to the present slay. It is the compalison to express the increpossible, to visualise the midd as well as the world. It

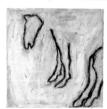

Fig. 1.25 Susan Rothenberg, Untitled, 1978, Acrylic, flashe, and percil or paper; 20" × 20" Collection Walker Art Center Minnagolis. Art Center Acquisition Fund, 1978. © 2008 Susan Rothenberg/Artist's Rights Society (ARS), NY Part of the entiries of this image comes from Rothenberg's use of Italiesh, e. Princh's roll-based color fairs i clear and so create a mistry.

CHAPTER 1 The Rise of Culture 2

CONTINUITY & CHANGE ESSAYS

These full-page essays at the end of each chapter illustrate the influence of one cultural period upon another and show cultural changes over time.

CONTINUITY & CHANGE ICONS

These in-text references provide a window into the past. The eye-catching icons enable students to refer to material in other chapters that is relevant to the topic at hand.

WITH THE FOLLOWING KEY FEATURES

CONTEXT

These boxes summarize important background information in an easy-to-read format.

MATERIALS AND TECHNIQUES

These features explain and illustrate the methods artists and architects use to produce their work.

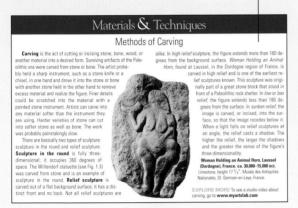

PRIMARY SOURCES

Each chapter of The Humanities includes Primary Source Readings in two formats. Brief readings from important works are included within the body of the text. Longer readings located at the end of each chapter allow for a more indepth study of particular works. The organization offers great flexibility in teaching the course.

MORE CONNECTIONS TO MyArtsLab

The text is keyed to the dynamic resources on MyArtsLab, allowing instructors and students online access to additional information, music, videos, and interactive features.

The 'SEE MORE' icon correlates to the Closer Look features in the text, directing students to MyArtsLab to view interactive Closer Look tours online. These features enable students to zoom in to see detail they could not otherwise see on the printed page or even in person. 'SEE MORE' icons also indicate when students can view works of architecture in full 360-degree panoramas.

The 'LEARN MORE' icons lead students online for additional primary source readings or to watch architectural simulations.

The 'HEAR MORE' icons indicate where musical performances can be listened to in streaming audio on www.myartslab.com. Online audio also includes 'Voices'vivid first-person accounts of the experiences of ordinary people during the period covered in the chapter.

The 'EXPLORE MORE' icons direct students to videos of artists at work in their studios, allowing them to see and understand a wide variety of materials and techniques used by artists throughout time.

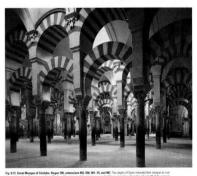

SEE CONTEXT AND MAKE CONNECTIONS . . .

Designed to save instructors time and to improve students' results, MyArtsLab, is keyed specifically to the chapters of Sayre's *The Humanities*, second edition. In addition, MyArtsLab's many features will encourage students to experience and interact with works of art. Here are some of those key features:

- A complete **Pearson eText** of the book, enriched with multimedia, including: a unique human-scale figure by all works of fine art, an audio version of the text, primary source documents, video demonstrations, and much more. Students can highlight, make notes, and bookmark pages.
- 360-degree Architectural Panoramas for major monuments in the book help students understand buildings from the inside and out.
- Closer Look Tours These interactive walk-throughs offer an in-depth look at key works of art, enabling students to zoom in to see detail they could not otherwise see on the printed page or even in person. Enhanced with expert audio, they help students understand the meaning and message behind the work of art.

- Robust **Quizzing** and **Grading Functionality** is included in MyArtsLab. Students receive immediate feedback from the assessment questions that populate the instructor's gradebook. The gradebook reports give an in-depth look at the progress of individual students or the class as a whole.
- MyArtsLab is your one stop for instructor material. Instructors can access the Instructor's Manual, Test Item File, PowerPoint images, and the Pearson MyTest assessment-generation program.

MyArtsLab with eText is available for no additional cost when packaged with *The Humanities*, second edition. The program may also be used as a stand-alone item, which costs less than a used text.

To register for your MyArtsLab account, contact your local Pearson representative or visit the instructor registration page located on the homepage of www.myartslab.com.

WITH MyArtsLab AND ADDITIONAL RESOURCES

FLEXIBLE FORMATS

CourseSmart eTextbooks offer the same content as the printed text in a convenient online format—with high-lighting, online search, and printing capabilities. With a CourseSmart eText, student can search the text, make notes online, print out reading assignments that incorporate lecture notes, and bookmark important passages for later review. Students save 60% over the list price of the traditional book. www.coursesmart.com.

Books à la Carte editions feature the exact same text in a convenient, three-hole-punched, loose-leaf version at a discounted price—allowing students to take only what they need to class. Books à la Carte editions are available both with and without access to MyArtsLab.

Students save 35% over the net price of the traditional book.

Custom Publishing Opportunities

The Humanities is available in a custom version specifically tailored to meet your needs. You may select the content that you would like to include or add your own original material. See you local publisher's representative for further information. www.pearsoncustom.com

INSTRUCTOR RESOURCES

Classroom Response System (CRS) In-Class Questions

Get instant, class-wide responses to beautifully illustrated chapter-specific questions during a lecture to gauge students' comprehension—and keep them engaged. Available for download under the "For Instructors" tab within your MyArtsLab account—www.myartslab.com.

Instructor's Manual and Test Item File

This is an invaluable professional resource and reference for new and experienced faculty. Each chapter contains the following sections: Chapter Overview, Chapter Objectives, Key Terms, Lecture and Discussion Topics, Resources, and Writing Assignments and Projects. The test bank includes multiple-choice, true/false, short-answer, and essay questions. Available for download from the instructor support section at www.myartslab.com.

MyTest

This flexible, online test-generating software includes all questions found in the printed Test Item File. Instructors can quickly and easily create customized tests with MyTest. www.pearsonmytest.com

ClassPrep

Instructors who adopt Sayre's *The Humanities* will receive access to ClassPrep, an online site designed to make lecture preparation simpler and less time-consuming. The site includes the images from the text in both high-resolution JPGs, and ready-made PowerPoint slides for your lectures. ClassPrep can be accessed through your MyArtsLab instructor account.

The Ancient World and the Classical Past

PREHISTORY TO 200 CE

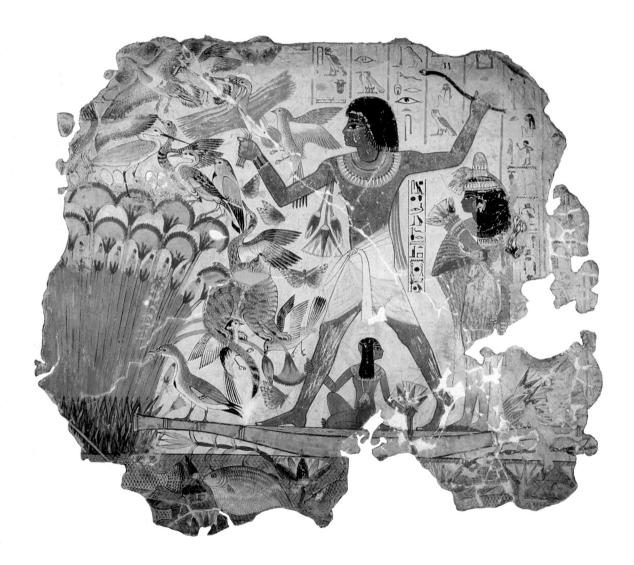

Detail from Nebamun Hunting Birds, from the tomb of Nebamun, Thebes. ca. 1400 BCE (see Fig 3.2).

he history of human beings on this planet is, geologically speaking, very short. The history of their coming together in groups for their common good is even shorter, covering a span of perhaps 25,000 to 50,000 years on a planet that scientists estimate to be between 4 and 5 billion years old. We call these groups, as they become more and more sophisticated, civilizations. A civilization is a

social, economic, and political entity distinguished by the ability to express itself through images and written language. Civilizations develop when the environment of a region can support a large and productive population. It is no accident that the first civilizations arose in fertile river valleys, where agriculture could take hold: the Tigris and the Euphrates in Mesopotamia, the Nile in Egypt, the Indus on the Indian

subcontinent, and the Yellow in China. Civilizations require technologies capable of supporting the principal economy. In the ancient world, agriculture was supported by the technologies related to irrigation.

With the rise of agriculture, and with irrigation, human nature began to assert itself over and against nature as a whole. People increasingly thought of themselves as masters of their own destiny. At the same time, different and dispersed populations began to come into contact with one another as trade developed from the need for raw materials not native to a particular region. Organizing this level of trade and production also required an administrative elite to form and establish cultural priorities. The existence of such an elite is another characteristic of civilization. Finally, as the history of cultures around the world makes abundantly clear, one of the major ways in which societies have acquired the goods they want and simultaneously organized themselves is by means of war.

If a civilization is a system of organization, a culture is the set of common values—religious, social, and/or political that govern that system. Out of such cultures arise scientific and artistic achievements by which we characterize different cultures. Before the invention of writing sometime around the fourth millennium BCE, these cultures created myths and legends that explained their origins and relation to the world. As we do today, ancient peoples experienced the great uncontrollable, and sometimes violent forces of nature—floods, droughts, earthquakes, and hurricanes. Prehistoric cultures understood these forces as the work of the invisible gods, who could not be approached directly but only through the mediating agency of shamans and priests, or kings and heroes. As cultures became increasingly self-assertive, in the islands between mainland Greece and Asia Minor, in Egypt, in China, on the Indian subcontinent, and on the Greek mainland, these gods seemed increasingly knowable. The gods could still intervene in human affairs, but now they did so in ways that were recognizable. It was suddenly possible to believe that if people could come to understand themselves, they might also understand the gods. The study of the natural world might well shed light on the unknown, on the truth of things.

It is to this moment—it was a long "moment," extending for centuries—that the beginnings of scientific inquiry can be traced. Humanism, the study of the human mind and its moral and ethical dimensions, was born. In China, the formalities of social interaction—moderation, personal integrity, selfcontrol, loyalty, altruism, and justice—were codified in the writings of Confucius. In Mesopotamia and Greece, the presentation of a human character working things out (or not) in the face of adversity was the subject of epic and dramatic literature. In Greece, it was also the subject of philosophy literally, "love of wisdom"—the practice of reasoning that followed from the Greek philosopher Socrates's famous dictum, "Know thyself." Visual artists strove to discover the perfections of human form and thought. By the time of the rise of the Roman Empire, at the end of the first millennium BCE, these traditions were carried on in more practical ways, as the Romans attempted to engineer a society embodying the values they had inherited from the Greeks.

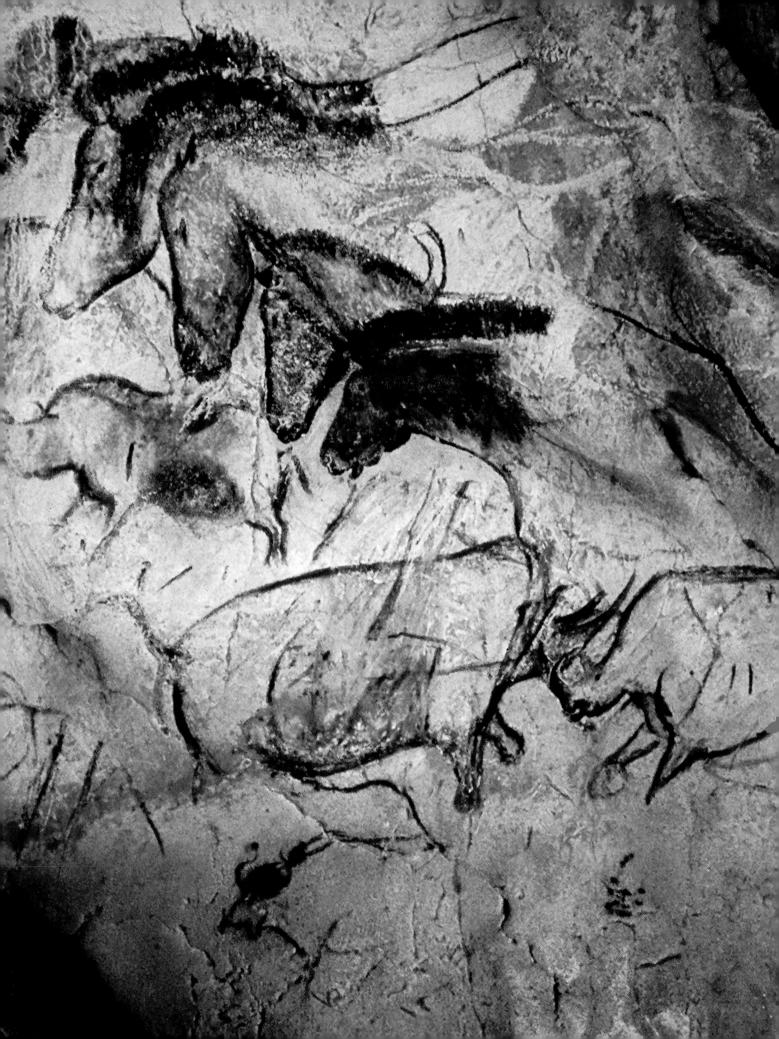

1

The Rise of Culture

From Forest to Farm

THINKING AHEAD

What features characterize the beginnings of human culture?

What characteristics distinguish the Neolithic from the Paleolithic?

What is a megalith?

How can we understand the role of myth in prehistoric culture?

n a cold December afternoon in 1994, Jean-Marie Chauvet and two friends were exploring the caves in the steep cliffs along the Ardèche River gorge in southern France. After descending into a series of narrow passages, they entered a large chamber. There, beams from their headlamps lit up a group of drawings that would astonish the three explorers—and the world (Fig. 1.1).

Since the late nineteenth century, we have known that prehistoric peoples, peoples who lived before the time of writing and so of recorded history, drew on the walls of caves. Twenty-seven such caves had already been discovered in the cliffs along the 17 miles of the Ardèche gorge (Map 1.1). But the cave found by Chauvet [shoh-veh] and his friends transformed our thinking about prehistoric peoples. Where previously discovered cave paintings had appeared to modern eyes as childlike, this cave contained drawings comparable to those a contemporary artist might have done. We can only speculate that other comparable artworks were produced in prehistoric times but have not survived, perhaps because they were made of wood or other perishable materials. It is even possible that art may have been made earlier than 30,000 years ago, perhaps as people began to inhabit the Near East, between 90,000 and 100,000 years ago.

At first, during the Paleolithic [PAY-lee-uh-LITH-ik] era, or "Old Stone Age," from the Greek *palaios*, "old," and *lithos*, "stone," the cultures of the world sustained themselves on game and wild plants. The cultures themselves were small, scattered, and nomadic, though evidence suggests some interaction among the various groups. We begin

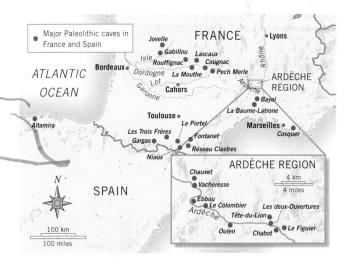

Map 1.1 Major Paleolithic caves in France and Spain.

▼ Fig. 1.1 Wall painting with horses, Chauvet Cave, Vallon-Pont-d'Arc, Ardèche gorge, France. ca. 30,000 BCE. Ministère de la Culture et de la Communication. Direction Regionale des Affaires Culturelles de Rhone-Alpes. Service Regional de l'Archeologie. Paint on limestone, approx. height 6'. In the center of this wall are four horses, each behind the other in a startlingly realistic space. Below them, two rhinoceroses fight.

HEAR MORE Listen to an audio file of your chapter at www.myartslab.com

this book, then, with the cultures of prehistoric times, evidence of which survives in wall paintings in caves and small sculptures dating back more than 25,000 years.

THE BEGINNINGS OF CULTURE IN THE PALEOLITHIC ERA

A culture encompasses the values and behaviors shared by a group of people, developed over time, and passed down from one generation to the next. Culture manifests itself in the laws, customs, ritual behavior, and artistic production common to the group. The cave paintings at Chauvet suggest that, as early as 30,000 years ago, the Ardèche gorge was a center of culture, a focal point of group living in which the values of a community find expression. There were others like it. In northern Spain, the first decorated cave was discovered in 1879 at Altamira [al-tuh-MIR-uh]. In the Dordogne [dor-DOHN] region of southern France to the west of the Ardèche, schoolchildren discovered the famous Lascaux Cave in 1940 when their dog disappeared down a hole. And in 1991, along the French Mediterranean coast, a diver discovered the entrance to the beautifully decorated Cosquer [kos-KAIR] Cave below the waterline near Marseille [mar-SAY].

Agency and Ritual: Cave Art

Ever since cave paintings were first discovered, scholars have been marveling at the skill of the people who produced them, but we have been equally fascinated by their very existence. Why were these paintings made? Most scholars believe that they possessed some sort of agency—that is, they were created to exert some power or authority

over the world of those who came into contact with them. Until recently, it was generally accepted that such works were associated with the hunt. Perhaps the hunter, seeking game in times of scarcity, hoped to conjure it up by depicting it on cave walls. Or perhaps such drawings were magic charms meant to ensure a successful hunt. But at Chauvet, fully 60 percent of the animals painted on its walls were never, or rarely, hunted—such animals as lions, rhinoceroses, bears, panthers, and woolly mammoths. One drawing depicts two rhinoceroses fighting horn-to-horn beneath four horses that appear to be looking on (see Fig. 1.1).

What role, then, did these drawings play in the daily lives of the people who created them? The caves may have served as some sort of ritual space. A ritual is a rite or ceremony habitually practiced by a group, often in religious or quasireligious context. The caves, for instance, might be understood as gateways to the underworld and death, as symbols of the womb and birth, or as pathways to the world of dreams experienced in the dark of night, and rites connected with such passage might have been conducted in them. The general arrangement of the animals in the paintings by species or gender, often in distinct chambers of the caves, suggests to some that the paintings may have served as lunar calendars for predicting the seasonal migration of the animals. Whatever the case, surviving human footprints indicate that these caves were ritual gathering places and in some way were intended to serve the common good.

At Chauvet, the use of color suggests that the paintings served some sacred or symbolic function. For instance, almost all of the paintings near the entrance to the cave are painted with natural red pigments derived from ores rich in iron oxide. Deeper in the cave, in areas more difficult to reach, the vast majority of the animals are painted in black

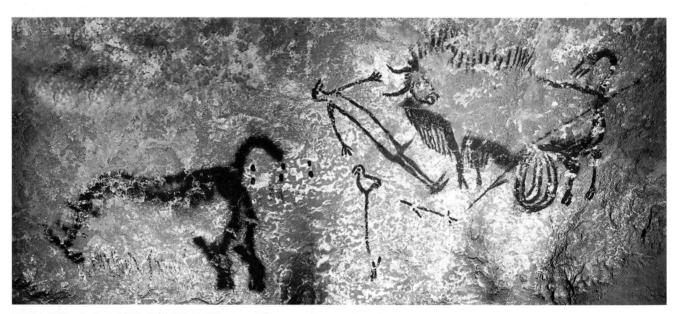

Fig. 1.2 Wall painting with bird-headed man, bison, and rhinoceros, Lascaux Cave, Dordogne, France. ca. 15,000–13,000 BCE. Paint on limestone, length approx. 9'. In 1963, Lascaux was closed to the public so that conservators could fight a fungus attacking the paintings. Most likely, the fungus was caused by carbon dioxide exhaled by visitors. An exact replica called Lascaux II was built and can be visited.

pigments derived from ores rich in manganese dioxide. This shift in color appears to be intentional, but we can only guess at its meaning.

The skillfully drawn images at Chauvet raise even more important questions. The artists seem to have understood and practiced a kind of perspectival drawing—that is, they were able to convey a sense of three-dimensional space on a two-dimensional surface. In the painting reproduced on the opening page of this chapter, several horses appear to stand one behind the other (see Fig. 1.1). The head of the top horse overlaps a black line, as if peering over a branch or the back of another animal. In no other cave yet discovered do drawings show the use of shading, or modeling, so that the horses' heads seem to have volume and dimension. And yet these cave paintings, rendered over 30,000 years ago, predate other cave paintings by at least 10,000 years, and in some cases by as much as 20,000 years.

One of the few cave paintings that depicts a human figure is found at Lascaux, in the Dordogne region of southwestern France. What appears to be a male wearing a bird's-head mask lies in front of a disemboweled bison (Fig. 1.2). Below him is a bird-headed spear thrower, a device that enabled hunters to throw a spear farther and with greater force. (Several examples of spear throwers have survived.) In the Lascaux painting, the hunter's spear has pierced the bison's hindquarters, and a rhinoceros charges off to the left. We have no way of knowing whether this was an actual event or an imagined scene. One of the painting's most interesting and inexplicable features is the discrepancy between the relatively naturalistic representation of the animals and the highly stylized, almost abstract realization of the human figure. Was the sticklike man added later by a different, less talented artist? Or does this image suggest that man and beast are different orders of being?

Before the discovery of Chauvet, historians divided the history of cave painting into a series of successive styles, each progressively more realistic. But Chauvet's paintings, by far the oldest known, are also the most advanced in their realism, suggesting the artists' conscious quest for visual naturalism, that is, for representations that imitate the actual appearance of the animals. Not only were both red and black animals outlined, their shapes were also modeled by spreading paint, either with the hand or a tool, in gradual gradations of color. Such modeling is extremely rare or unknown elsewhere. In addition, the artists further defined many of the animals' contours by scraping the wall behind so that the beasts seem to stand out against a deeper white ground. Three handprints in the cave were evidently made by spitting paint at a hand placed on the cave wall, resulting in a stenciled image.

Art, the Chauvet drawings suggest, does not necessarily evolve in a linear progression from awkward beginnings to more sophisticated representations. On the contrary, already in the earliest artworks, people obtained a very high

degree of sophistication. Apparently, even from the earliest times, human beings could choose to represent the world naturalistically or not, and the choice not to represent the world in naturalistic terms should not necessarily be attributed to lack of skill or sophistication but to other, more culturally driven factors.

Paleolithic Culture and Its Artifacts

Footprints discovered in South Africa in 2000 and fossilized remains uncovered in the forest of Ethiopia in 2001 suggest that, about 5.7 million years ago, the earliest upright humans, or hominins (as distinct from the larger classification of hominids, which includes great apes and chimpanzees as well as humans), roamed the continent of Africa. Ethiopian excavations further indicate that sometime around 2.5 or 2.6 million years ago, hominid populations began to make rudimentary stone tools, though long before, between 14 million and 19 million years ago, the Kenyapithecus [ken-yuh-PITH-i-kus] ("Kenyan ape"), a hominin, made stone tools in east central Africa. Nevertheless, the earliest evidence of a culture coming into being are the stone artifacts of Homo sapiens [ho-moh SAY-pee-uhnz] (Latin for "one who knows"). Homo sapiens evolved about 100,000-120,000 years ago and can be distinguished from earlier hominids by the lighter build of their skeletal structure and larger brain. A 2009 study of genetic diversity among Africans found the San people of Zimbabwe to be the most diverse, suggesting that they are the most likely origin of modern humans from which others gradually spread out of Africa, across Asia, into Europe, and finally to Australia and the Americas.

Homo sapiens were hunter-gatherers, whose survival depended on the animals they could kill and the foods they could gather, primarily nuts, berries, roots, and other edible plants. The tools they developed were far more sophisticated than those of their ancestors. They included cleavers, chisels, grinders, hand axes, and arrow- and spearheads made of flint, a material that also provided the spark to create an equally important tool—fire. In 2004, Israeli archeologists working at a site on the banks of the Jordan River reported the earliest evidence yet found of controlled fire created by hominids—cracked and blackened flint chips, presumably used to light a fire, and bits of charcoal dating from 790,000 years ago. Also at the campsite were the bones of elephants, rhinoceroses, hippopotamuses, and small species, demonstrating that these early hominids cut their meat with flint tools and ate steaks and marrow. Homo sapiens cooked with fire, wore animal skins as clothing, and used tools as a matter of course. They buried their dead in ritual ceremonies, often laying them to rest accompanied by stone tools and weapons.

The Paleolithic era is the period of *Homo sapiens*' ascendancy. These Upper Paleolithic people carved stone tools and weapons that helped them survive in an inhospitable

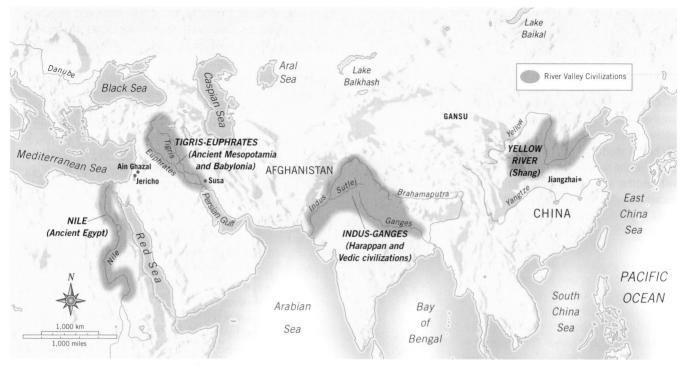

Map 1.2 The great river valley civilizations. ca. 2000 BCE. Agriculture thrived in the great river valleys throughout the Neolithic era, but by the end of the period, urban life had developed there as well, and civilization as we know it had emerged

THE RISE OF AGRICULTURE IN THE NEOLITHIC ERA

As the ice covering the Northern Hemisphere began to recede around 10,000 BCE, the seas rose, covering, for instance, the cave entrance at Cosquer in southern France (see Map 1.1), filling what is now the North Sea and English Channel with water, and inundating the land bridge that had connected Asia and North America. Agriculture began to replace hunting and gathering, and with it, a nomadic lifestyle gave way to a more sedentary way of life. The consequences of this shift were enormous, and ushered in the Neolithic [nee-uh-LITH-ik] era, or "New Stone Age."

For 2,000 years, from 10,000 to 8000 BCE, the ice covering the Northern Hemisphere receded farther and farther northward. As temperatures warmed, life gradually changed. During this period of transition, areas once covered by vast regions of ice and snow developed into grassy plains and abundant forests. Hunters developed the bow and arrow, which were easier to use at longer range on the open plains. They fashioned dugout boats out of logs to facilitate fishing, which became a major food source. They domesticated dogs to help with the hunt as early as 11,000 BCE, and soon other animals as well—goats and cattle particularly. Perhaps most important, people began to cultivate the more edible grasses. Along the eastern shore of the Mediterranean, they harvested wheat; in Asia, they cultivated millet and rice; and in the Americas, they grew squash, beans, and corn. Gradually, farming replaced hunting as the primary means of sustaining life. A culture of the fields developed—an agri-culture, from the Latin ager, "farm," "field," or "productive land."

Agricultural production seems to have originated about 10,000 BCE in the Fertile Crescent, an area arching from southwest Iran, across the foothills of the Taurus Mountains in southeastern Turkey, then southward into Lebanon. By about 8000 BCE. Neolithic agricultural societies began to concentrate in the great river valleys of the Middle East and Asia (Map 1.2). Here, distinct centers of people involved in a common pursuit began to form. A civilization is a social, economic, and political entity distinguished by the ability to express itself through images and written language. Civilizations develop when the environment of a region can support a large and productive population. An increasing population requires increased production of food and other goods, not only to support itself, but to trade for other commodities. Organizing this level of trade and production also requires an administrative elite to form and to establish priorities. The existence of such an elite is another characteristic of civilization. Finally, as the history of cultures around the world makes abundantly clear, one of the major ways that societies have acquired the goods they want and simultaneously organized themselves is by means of war.

Gradually, as the climate warmed, Neolithic culture spread across Europe. By about 5000 BCE, the valleys of Spain and southern France supported agriculture, but not until about 4000 BCE is there evidence of farming in the northern reaches of the European continent and England. The Neolithic era does not end in these colder climates until about 2000 BCE,

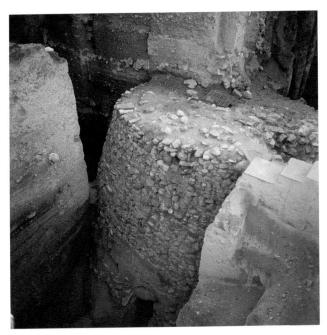

Fig. 1.5 Early Neolithic wall and tower, Jericho, Jordan. ca. 7500 BCE. The smooth walls and sand brick at Jericho construction are architectural innovations that go far beyond the rudimentary construction techniques of the hunter-gatherers (compare Fig. 1.4, for instance).

and continues on more remote regions, such as Africa and the Americas, well into the first millennium.

Meanwhile, the great rivers of the Middle East and Asia provided a consistent and predictable source of water, and people soon developed irrigation techniques that fostered organized agriculture and animal husbandry. As production outgrew necessity, members of the community were freed to occupy themselves in other endeavors—complex food preparation (bread, cheese, and so on), construction, religion, even military affairs. Soon, permanent villages began to appear, and villages began to look more and more like cities.

Neolithic Jericho and Skara Brae

Jericho is one of the oldest known settlements of the Neolithic era. It is located in the Middle East some 15 miles east of modern Jerusalem, on the west bank of the Jordan River. Although not in one of the great river valleys, Jericho was the site of a large oasis, and by 7500 BCE, a city had developed around the water source. The homes were made of mud brick on stone foundations and had plaster floors and walls. Mud bricks were a construction material found particularly in hot, arid regions of the Neolithic Middle East, where stone and wood were in scarce supply. The city was strongly fortified (Fig. 1.5), indicating that all was not peaceful even in the earliest Neolithic times. It was surrounded by a ditch, probably not filled with water, but dug out in order to increase the height of the walls behind. The walls themselves were between 5 and 12 feet thick, and the towers rose to a height of 30 feet. What particular troubles necessitated these fortifications is debatable, but Jericho's most precious resource was without doubt its water, and others probably coveted the site.

The most startling discovery at Jericho is the burial of ten headless corpses under the floors of the city's houses. The skulls of the dead were preserved and buried separately, the features rebuilt in plaster and painted to look like the living ancestor (Fig. 1.6). Each is unique and highly realistic, possessing the distinct characteristics of the ancestor. The purpose of the skull portraits is unknown to us. Perhaps the people of Jericho believed that the spirit of the dead lived on in the likeness. Whatever the case, the existence of the skulls indicates the growing stability of the culture, its sense of permanence and continuity.

Preserved in the cold northern climate of the Orkney Islands off the northeast coast of Scotland is Skara Brae [SKAR-uh brey]. Some 4,000 years younger than Jericho, Skara Brae is a Neolithic village dating from between 3100 and 2600 BCE. The seaside village was apparently buried long ago beneath a layer of sand during a massive storm, and then, in 1850, uncovered when another storm swept the sand away.

The houses of Skara Brae are made entirely of stone—virtually the only buildings on the treeless Orkney Islands. The walls are made by **corbeling**, a construction technique (see *Materials & Techniques*, page 18), in which layers of flat stones are piled one upon the other, with each layer projecting slightly inward as the wall rises. As the walls curve inward, they are buttressed, or supported, on the outside by earth. Nothing of the roofs has survived, suggesting that they were constructed of organic matter such as straw thatch or seaweed (seaweed remained a common roofing material in the Orkney Islands into the twentieth century). Furniture

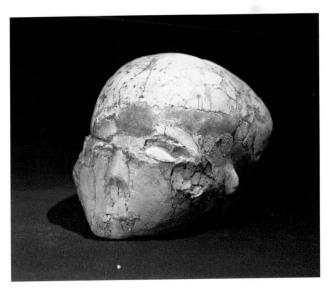

Fig. 1.6 Plastered skull from Jericho. Pre-pottery Neolithic B period. ca. 7000–6000 BCE. Life-size. Nicholson Museum, University of Sydney, Sydney, Australia. NM Inv. 57.03: presented by Dame Kathleen Kenyon, British School of Archaeology in Jerusalem. Hair was originally painted onto the head, and the eye sockets were filled with cowrie shell to give the "portrait" realism.

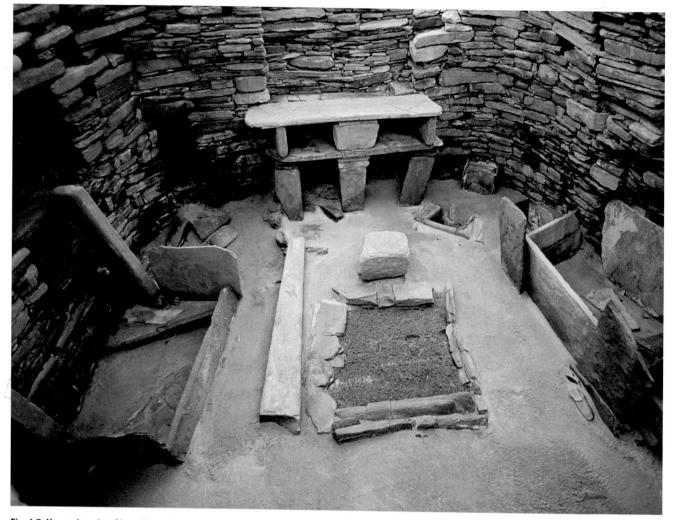

Fig. 1.7 House interior, Skara Brae, Orkney Islands, Scotland. ca. 3100–2600 BCE. This is a view of the interior of house 7 in Fig. 1.8. In this and other houses, archeologists have found stone cooking pots; mortars for grinding grains, including barley and wheat; carved stone balls; bone tools used for fishing and sewing; and pottery. In this view, the walls are just beginning to curve inward in corbeling.

was built into the walls—in the house shown here, rectangular stone beds at either side of a central hearth, and a stone bench along the back wall (Fig. 1.7). The bed frames would have been filled with organic materials such as heather or straw, and covered with furs. Storage spaces have been fashioned into the walls above the beds and in the back left corner. The only light in the house would have come from the smoke hole above the hearth.

The houses in the village were connected by a series of narrow walkways that were probably covered (Fig. 1.8). Each of the houses is more or less square, with rounded corners. They are relatively spacious, ranging in size from 12 by 14 feet to 20 by 21 feet. That Skara Brae was continually inhabited for five hundred years suggests that life in the village was relatively comfortable despite the harsh climate.

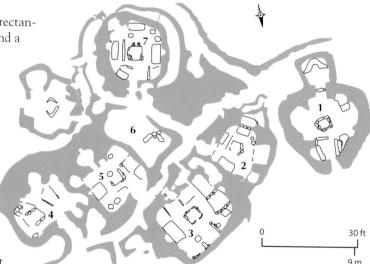

Fig. 1.8 Plan, Village of Skara Brae, Orkney Islands, Scotland. ca. 3100–2600 BCE. The numbers refer to individual houses.

Neolithic Pottery Across Cultures

The transition from cultures based on hunting and fishing to cultures based on agriculture led to the increased use of pottery vessels. Ceramic vessels are fragile, so huntergatherers would not have found them practical for carrying food, but people living in the more permanent Neolithic settlements could have used them to carry and store water, and to prepare and store certain types of food.

There is no evidence of pottery at the Jericho site. But, as early as 10,000 BCE, Japanese artisans were making clay pots capable of storing, transporting, and cooking food and water. Over the course of the Neolithic era, called the Jomon Joe-monl period in Japan (12,000–300 BCE), their work became increasingly decorative. *Jomon* means "cord markings" and refers to the fact that potters decorated many of their wares by pressing cord into the damp clay. As in most Neolithic societies, women made Jomon pottery; their connection to fertility and the life cycle may have become even more important to Neolithic cultures in the transition from

Deep Bowl with sculptural rim, late middle Joman period ca. 2000 BCE, Japan. Ca. 2000 BCE.

- Call Terra Cotta.

- Freedom of expression.

- Anything but practical.

Fig. 1.9 Deep bowl with sculptural rim, late Middle Jomon period (ca. 2500–1600 BCE), Japan. ca. 2000 BCE. Terracotta, 14 $\frac{1}{2}$ " \times 12 $\frac{1}{3}$ ". Musée des Arts Asiatiques-Guimet, Paris, France. The motifs incised on this pot may have had some meaning, but most interesting is the potter's freedom of expression. The design of the pot's flamelike rim is anything but practical.

hunting and gathering to agricultural food production. Jomon women built their pots up from the bottom with coil upon coil of soft clay. They mixed the clay with a variety of adhesive materials, including mica, lead, fibers, and crushed shells. After forming the vessel, they employed tools to smooth both the outer and interior surfaces. Finally, they decorated the outside with cord markings and fired the pot in an outdoor bonfire at a temperature of about 1650 degrees Fahrenheit (900 degrees centigrade). By the middle Jomon period, potters had begun to decorate the normal flat-bottomed, straight-sided jars with elaborately ornate and flamelike rims (Fig. 1.9), distinguished by their asymmetry and their unique characteristics. These rims suggest animal forms, but their significance remains a mystery.

The Neolithic cultures that flourished along the banks of the Yellow River in China beginning in about 5000 BCE also produced pottery. These cultures were based on growing rice and millet (grains from the Near East would not be introduced for another 3,000 years), and this agricultural emphasis spawned towns and villages, such as Jiangzhai, the largest Neolithic site that has been excavated in China. The Jiangzhai community, near modern Xi'an [she-an], in Shaanxi [shahn-shee] province, dates to about 4000 BCE and consisted of about 100 dwellings. At its center was a communal gathering place, a cemetery, and, most important, a kiln, an oven specifically designed to achieve the high temperatures necessary for firing clay. Indeed, the site yielded many pottery fragments. Farther to the east, in Gansu [gan-soo] province, Neolithic potters began to add painted decoration to their work (Fig. 1.10). The flowing, curvilinear forms painted on the shallow basin illustrated here include "hand" motifs on the outside and round, almost eyelike forms that flow into each other on the inside.

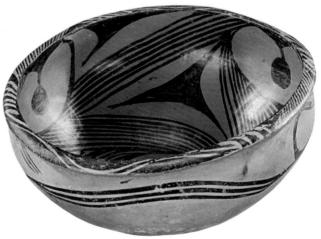

Fig. 1.10 Basin (*pen*), Majiayao culture, Majiayao phase, Gansu Province, China. ca. 3200–2700 BCE. Earthenware with painted decoration, diameter 11". The Metropolitan Museum of Art, New York. Anonymous Loan (L.1996.55.6). The designs on this bowl are examples of the kind of markings that would eventually develop into writing.

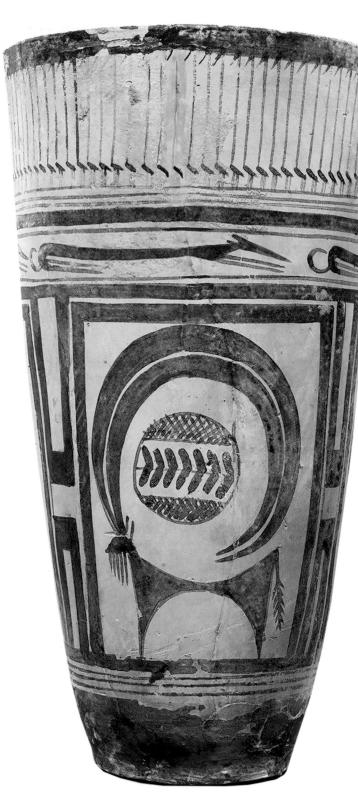

Fig. 1.11 Beaker with ibex, dogs, and long-necked birds, from Susa, southwest Iran. ca. 5000-4000 BCE. Baked clay with painted decoration, height 11 1/4" Musée du Louvre, Paris. The ibex was the most widely hunted game in the ancient Middle East, which probably accounts for its centrality in this design.

Some of the most remarkable Neolithic painted pottery comes from Susa [soo-suh], on the Iranian plateau. The patterns on one particular beaker (Fig. 1.11) from around 5000 to 4000 BCE are highly stylized animals. The largest of these is an ibex, a popular decorative feature of prehistoric ceramics from Iran. Associated with the hunt, the ibex may have been a symbol of plenty. The front and hind legs of the ibex are rendered by two triangles, the tail hangs behind it like a feather, the head is oddly disconnected from the body, and the horns rise in a large, exaggerated arc to encircle a decorative circular form. Hounds race around the band above the ibex, and wading birds form a decorative band across the beaker's top.

In Europe, the production of pottery apparently developed some time later, around 3000 BCE. Early pots were made either by molding clay over a round stone or by coiling long ropes of clay on top of one another and then smoothing the seams between them. Then the pots were fired at temperatures high enough to make them watertight—above 700 degrees Fahrenheit (370 degrees centigrade).

By this time, however, artisans in Egypt had begun using the potter's wheel, a revolving platter for forming vessels from clay with the fingers. It allowed artisans to produce a uniformly shaped vessel in a very short time. By 3000 BCE, the potter's wheel was in use in the Middle East as well as China. Because it is a machine created expressly to produce goods, it is in many ways the first mechanical and technological breakthrough in history. As skilled individuals specialized in making and decorating pottery, and traded their wares for other goods and services, the first elemental forms of manufacturing began to take shape.

Neolithic Ceramic Figures

It is a simple step from forming clay pots and firing them to modeling clay sculptural figures and submitting them to the same firing process. Examples of clay modeling can be found in some of the earliest Paleolithic cave sites where, at Altamira, for instance, in Spain, an artist added clay to an existing rock outcropping in order to underscore the rock's natural resemblance to an animal form. At Le Tuc d'Audoubert, south of Lascaux, an artist shaped two, two-feetlong clay bison as if they were leaning against a rock ridge.

But these Paleolithic sculptures were never fired. One of the most interesting examples of Neolithic fired clay figurines were the work of the so-called Nok peoples who lived in modern Nigeria. We do not know what they called themselves—they are identified instead by the name of the place where their artifacts were discovered. In fact, we know almost nothing about the Nok. We do not know how their culture was organized, what their lives were like, or

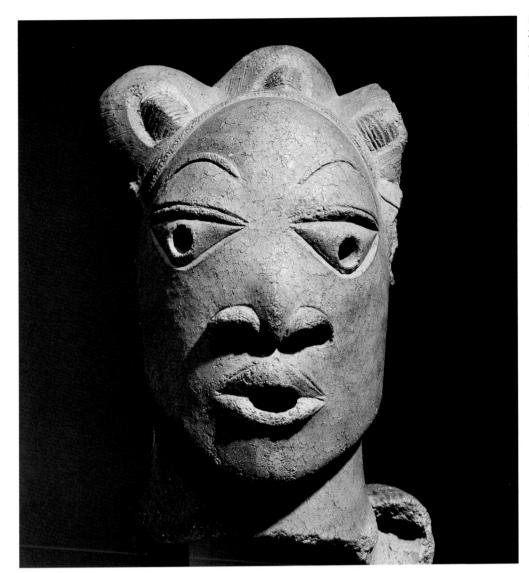

Fig. 1.12 Head, Nok. ca. 500 BCE—200 cE. Terracotta, height 14 $^3/_{16}$ ". © Werner Forman/Art Resource, NY. This slightly-larger-than-life-size head was probably part of a complete body, and shows the Nok people's interest in abstract geometrical representations of facial features and head shape. Holes in the eyes and nose were probably used to control temperature during firing.

what they believed. But while most Neolithic peoples in Africa worked in materials that were not permanent, the Nok fired clay figures of animals and humans that were approximately life-size.

These figures were first unearthed early in the twentieth century by miners over an area of about 100 square kilometers. Carbon-14 and other forms of dating revealed that some of these objects had been made as early as 800 BCE and others as late as 600 CE. Little more than the hollow heads have survived intact, revealing an artistry based on abstract geometrical shapes (Fig. 1.12). In some cases, the heads are represented as ovals, and in others, as cones, cylinders, or spheres. Facial features are combinations of ovals, triangles, graceful arches, and straight lines. These heads were probably shaped with wet clay and then, after firing, finished by carving details into the hardened clay. Some scholars have argued that the technical and artistic

sophistication of works by the Nok and other roughly contemporaneous groups suggests that it is likely there are older artistic traditions in West Africa that have not as yet been discovered. Certainly, farther to the east, in the sub-Saharan regions of the Sudan, Egyptian culture had exerted considerable influence for centuries, and it may well be that Egyptian technological sophistication had worked its way westward.

The Neolithic Megaliths of Northern Europe

A distinctive kind of monumental stone architecture appears late in the Neolithic period, particularly in what is now Britain and France. Known as **megaliths** [MEG-uh-liths], or "big stones," these works were constructed without the use of mortar and represent the most basic form of architectural construction. Sometimes, they consisted merely of posts—upright

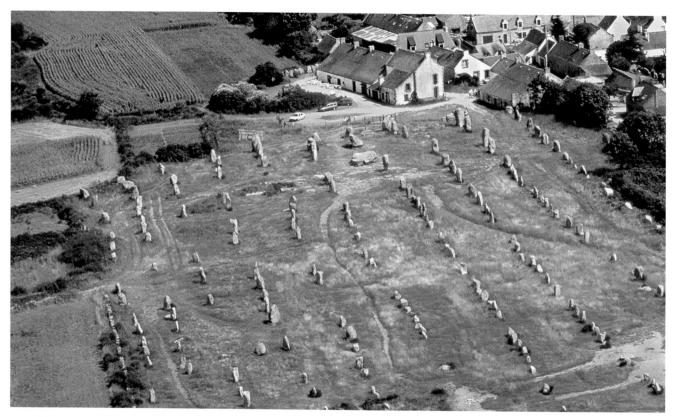

Fig. 1.13 Neolithic menhir alignments at Ménec, Carnac, Brittany, France. ca. 4250–3750 BCE. According to an ancient legend, the Carnac menhirs came into being when a retreating army was driven to the sea. Finding no ships to aid their escape, they turned to face their enemy and were transformed into stone.

stones stuck into the ground—called menhirs [MEN-hir], from the Celtic words men, "stone," and hir, "long." These single stones occur in isolation or in groups. The largest of the groups is at Carnac [kahr-nak], in Brittany (Fig. 1.13), where some 3,000 menhirs arranged east to west in 13 straight rows, called alignments, cover a 2-mile stretch of plain. At the east end, the stones stand about 3 feet tall and gradually get larger and larger until, at the west end, they attain a height of 13 feet. This east-west alignment suggests a connection to the rising and setting of the sun and to fertility rites. Scholars disagree about their significance; some speculate that the stones may have marked out a ritual procession route; others think they symbolized the body and the process of growth and maturation. But there can be no doubt that megaliths were designed to be permanent structures, where domestic architecture was not. Quite possibly the megaliths stood in tribute to the strength of the leaders responsible for assembling and maintaining the considerable labor force required to construct them.

Another megalithic structure, the dolmen [DOLE-muhn], consists of two posts roofed with a capstone, or lintel. Because it is composed of three stones, the dolmen is a trilithon [try-LITH-un], from Greek *tri*, "three," and *lithos*, "rock," and it formed the basic unit of architectural structure for thous ands of years. Today, we call this kind of construction post-and-lintel (see *Materials & Techniques*, page 18). Megaliths such

as the dolmen, in County Clare, Ireland (Fig. 1.14), were probably once covered with earth to form a fully enclosed burial chamber, or cairn [karn].

A third type of megalithic structure is the cromlech [krahm-lek], from the Celtic *crom*, "circle," and *lech*, "place." Without doubt, the most famous megalithic structure in the world is the cromlech known as Stonehenge (Fig. 1.15), on Salisbury Plain, about 100 miles west of modern London. A henge is a special type of cromlech, a circle surrounded by a ditch with built-up embankments, presumably for fortification.

The site at Stonehenge reflects four major building periods, extending from about 2750 to 1500 BCE. By about 2100 BCE, most of the elements visible today were in place. In the middle was a U-shaped arrangement of five post-and-lintel trilithons. The one at the bottom of the U stands taller than the rest, rising to a height of 24 feet, with a 15-foot lintel 3 feet thick. A continuous circle of sandstone posts, each weighing up to 50 tons and all standing 20 feet high, surrounded the five trilithons. Across their top was a continuous lintel 106 feet in diameter. This is the Sarsen Circle. Just inside the Sarsen Circle was once another circle, made of bluestone—a bluish dolerite—found only in the mountains of southern Wales, some 120 miles away. (See Closer Look, pages 16–17.)

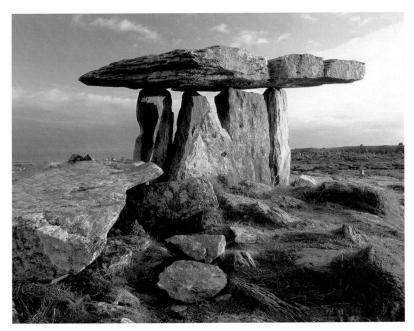

Fig. 1.14 Neolithic dolmen. Poulnabrone Dolmen, on the Burren limestone plateau, County Clare, Ireland. ca. 2500 BCE. A mound of earth once covered this structure, an ancient burial chamber

Why Stonehenge was constructed remains a mystery, although it seems clear that orientation toward the rising sun at the summer solstice connects it to planting and the harvest. Stonehenge embodies, in fact, the growing importance of agricultural production in the northern reaches of Europe. Perhaps great rituals celebrating the earth's plenty took place here. Together with other megalithic structures of the era, it suggests that the late Neolithic peoples who built it were extremely social beings, capable of great cooperation. They worked together not only to find the giant stones that rise at the site, but also to quarry, transport, and raise them. In other words, theirs was a culture of some magnitude and no small skill. It was a culture capable of both solving great problems and organizing itself in the name of creating a great social center. For Stonehenge is, above all, a center of culture. Its fascination for us today lies in the fact that we know so little of the culture that left it behind.

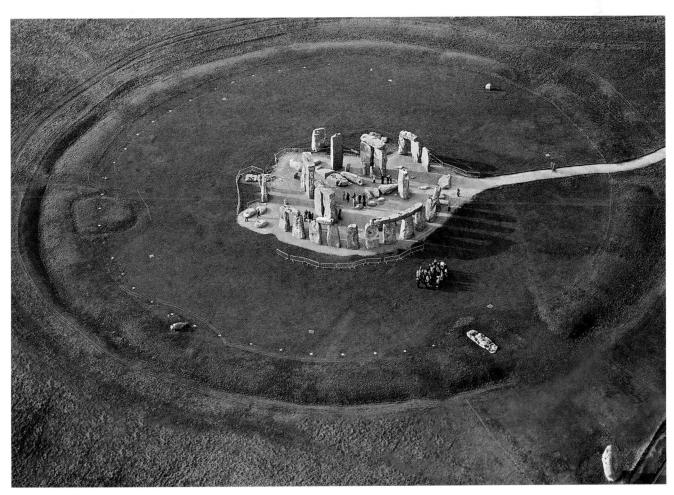

Fig. 1.15 Stonehenge, Salisbury Plain, Wiltshire, England. ca. 2750–1500 BCE. Like most Neolithic sites, Stonehenge invites speculation about its significance. Of this, however, we are certain: At the summer solstice, the longest day of the year, the sun rises directly over the Heel Stone. This suggests that the site was intimately connected to the movement of the sun.

CLOSER LOOK

ow the Neolithic peoples of Britain constructed Stonehenge is uncertain. Scholars believe that the giant stones of the Sarsen Circle, which weigh up to 50 tons, were transported from the Marlborough Downs, roughly 20 miles to the north, by rolling them on logs. Most of the way, the going is relatively easy, but at the steepest part of the route, at Redhorn Hill, modern work studies estimate that it would have taken at least 600 men to push the stones up the hill. A relatively sophisticated understanding of basic physics—the operation of levers and pulleys—was needed to lift the stones, and their lintels, into place.

Recently, archeologists at Stonehenge have uncovered a second cromlech-like circle at Durrington Wells, about 2 miles north of the stone megalith, consisting of a circular ditch surrounding a ring of postholes out of which very large timber posts would have risen. The circle was the center of a village consisting of as many as 300 houses. The site is comparable in scale to Stonehenge itself. These discoveries—together with the ability to carbon-date human

remains found at Stonehenge with increased accuracy—suggest that Stonehenge was itself a burial grounds. Archeologist Mike Parker-Pearson of the University of Sheffield speculates that villagers would have transported their dead down an avenue leading to the River Avon, then journeyed downstream, in a ritual symbolizing the passage to the afterlife, finally arriving at an avenue leading up to Stonehenge from the river. "Stonehenge wasn't set in isolation," Parker-Pearson says, "but was actually one half of this monument complex. We are looking at a pairing—one in timber to represent the transience of life, the other in stone marking the eternity of the ancestral dead."

Something to Think About . . .

The circle is a geometric form that appears in the earliest manifestations of art and architecture. Can you speculate on its appeal?

The sarsen stone is raised with a long lever. Logs are placed under the stone, and then it is rolled into place.

One by one, layers of timber are placed under the lever, both raising the stone and dropping it into the prepared pit.

As many as 200 men pull the stone upright on ropes as timbers support it from behind.

The pit around the stone is filled with stones and chalks to pack it into place.

The lintel is raised on successive layers of a timber platform.

Once the platform reaches the top of the posts, the lintel is levered onto the posts.

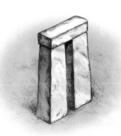

Finally, the platform is removed, and the trilithon is complete.

The Design and Making of Stonehenge

The Slaughter Stone The Avenue The Sarsen Circle The Heel Stone The shadow cast by the Heel It was once believed that Erected about 1500 BCE, the circle is On Midsummer's Eve, it casts Stone on Midsummer's Eve humans were sacrificed on this capped by lintel stones held in place by a shadow directly into the circle. would extend directly down stone, which now lies mortise-and-tenon joints, similar to The stone stands 16 feet high flat on the ground, but it those used by woodworkers. The end of this ceremonial approach. and weighs 35 tons. It was was originally part of a great the post is narrowed and slotted brought from a quarry 23 miles portal. into a hole in the lintel. away.

SEE MORE For a Closer Look at Stonehenge, go to www.myartslab.com

50 tons.

The Outer Bank

This ditch, 330 feet in diameter.

is the oldest construction at the

limestone beneath the surface

soil to form a giant circle.

site, originally exposing the white

Five Massive Trilithons

Inside the outer circle stood a horseshoe of

trilithons, two on each side and the largest

of the largest trilithons still stands. It rises

below ground level. The stone weighs about

22 feet above ground, with 8 feet more

at the closed end at the southwest. Only one

The Altar Stone

complex.

One of the most distinct stones

altar stone is a 16-foot block of

in Stonehenge, the so-called

smoothed green sandstone

located near the center of the

The Bluestone Circle

This circle of 80 smallish

slabs was built in about

quarried in South Wales.

2000 BCE from stone

Materials & Techniques

Post-and-Lintel and Corbel Construction

Post-and-lintel is the most basic technique for spanning space. In this form of construction two **posts**, or pieces fixed firmly in an upright position, support a lintel, or horizontal span. Two posts and a single lintel, as seen at Carnac and Stonehenge (see Figs. 1.14, 1.15), constitute a trilithon (from the Greek *tri*, "three," and *lithos*, "rock"). The corbel construction of the houses at Skara Brae (see Fig. 1.8). In corbeling, layers of rock are laid with the edge of each row projecting inward beyond the row below it until the walls almost meet at the top. The rows are buttressed, or supported, by earth piled on the outside. A roof of organic material can cover the top, or a stone can be set over the top to completely enclose the space (to create a tomb, for instance).

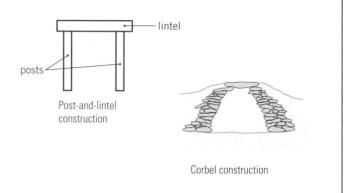

LEARN MORE View an architectural simulation about post-and-lintel construction at **www.myartslab.com**

THE ROLE OF MYTH IN CULTURAL LIFE

A myth is a story that a culture assumes is true. It also embodies the culture's views and beliefs about its world, often serving to explain otherwise mysterious natural phenomena. Myths stand apart from scientific explanations of the nature of reality, but as a mode of understanding and explanation, myth has been one of the most important forces driving the development of culture. Although myths are speculative, they are not pure fantasy. They are grounded in observed experience. They serve to rationalize the unknown and to explain to people the nature of the universe and their place within it.

Much of our understanding of the role of myth in prehistoric cultures comes from stories that have survived in cultures around the world that developed without writing—that is, **oral cultures**—such as San cultures of Zimbabwe and the Oceanic peoples of Tahiti in the South Pacific. These cultures have passed down their myths and histories over the centuries, from generation to generation, by word of mouth. Although, chronologically speaking, many of these cultures are contemporaneous with the medieval, Renaissance, and even modern cultures of the West, they are actually closer to the Neolithic cultures in terms of social practice and organization, and, especially in terms of agency, myth, and ritual, they can help us to understand the outlook of actual Neolithic peoples.

Both nineteenth-century and more recent anthropological work among the San people suggests that their belief systems can be traced back for thousands of years. As a result, the meaning of their rock art that survives in open-air caves below the overhanging stone cliffs atop the hills of what is now Matobo National Park in Zimbabwe (Fig. 1.16), some

of which dates back as far as 5,000 to 10,000 years ago, is not entirely lost. A giraffe stands above a group of smaller giraffes crossing a series of large, white, lozenge-shaped forms with brown rectangular centers, many of them overlapping one another. To the right, six humanlike figures are joined hand in hand, probably in a trance dance. For the San people, prolonged dancing activates num, a concept of personal energy or potency that the entire community can acquire. Led by a shaman, a person thought to have special ability to communicate with the spirit world, the dance encourages the num to heat up until it boils over and rises up through the spine to explode, causing the dancers to enter into a trance. Sweating and trembling, the dancers variously convulse or become rigid. They might run, jump, or fall. The San believe that in many instances, the dancer's spirit leaves the body, traveling far away, where it might enter into battle with supernatural forces. At any event, the trance imbues the dancer with almost supernatural agency. The dancers' num is capable of curing illnesses, managing game, or controlling the weather.

Native American Cultural Traditions

Seventeen thousand years ago, about the time that the hunter-gatherers at Lascaux painted its caves, the Atlantic and Pacific oceans were more than 300 feet below modern levels, exposing a low-lying continental shelf that extended from northeastern Asia to North America. It was a land-scape of grasslands and marshes, home to the woolly mammoth, the steppe bison, wild horses, caribou, and antelope. Although recent research has found evidence of migration into North America as early as 25,000 years ago, at some

point around 15,000 BCE, large numbers of hunter-gatherers in northeastern Asia followed these animals across the grasslands land bridge into the Americas. By 12,000 BCE, prehistoric hunters had settled across North America and begun to move farther south, through Mesoamerica (the region extending from central Mexico to northern Central America), and on into South America, reaching the southern end of Chile no later than 11,000 BCE.

Around 9000 BCE, for reasons that are still hotly debated—perhaps a combination of overhunting and climatic change—the peoples of the Americas developed agricultural societies. They domesticated animals—turkeys, guinea pigs, dogs, and llamas, though never a beast of burden, as in the rest of the world—and they cultivated a whole new range of plants, including maize and corn (domesticated in the Valley of Mexico by 8000 BCE), beans, squash, tomatoes, avocados, potatoes, tobacco, and cacao, the source of chocolate. The wheel remained unknown to them, though they learned to adapt to almost every conceivable climate

and landscape. A creation myth, or story of a people's origin, told by the Maidu [MY-doo] tribe of California, characterizes this early time: "For a long time everyone spoke the same language, but suddenly people began to speak in different tongues. Kulsu (the Creator), however, could speak all languages, so he called his people together and told them the names of the animals in their own language, taught them to get food, and gave them their laws and rituals. Then he sent each tribe to a different place to live."

The Anasazi and the Role of Myth The Anasazi [ahnuh-SAH-zeel people thrived in the American Southwest from about 900 to 1300 CE, a time roughly contemporaneous with the late Middle Ages in Europe. They left us no written record of their culture, only ruins and artifacts. As William M. Ferguson and Arthur H. Rohn, two prominent scholars of the Anasazi, have described them: "They were a Neolithic people without a beast of burden, the wheel, metal, or a written language, yet they constructed magnificent masonry

Fig. 1.16 Wall painting with giraffes, zebra, eland, and abstract shapes, San people, Inanke, Matobo National Park, Zimbabwe. Before 1000 cr. Photo: Christopher and Sally Gable © Dorling Kindersley. The animals across the bottom are elands, the largest of antelope, resembling cattle.

Fig. 1.17 Spruce Tree House, Mesa Verde, Anasazi culture. ca. 1200–1300 cs. The courtyard was formed by the restoration of the roofs over two underground kivas.

housing and ceremonial structures, irrigation works, and water impoundments." At Mesa Verde [MAY-suh VURD-ee], in what is today southwestern Colorado, their cliff dwellings (Fig. 1.17) resemble many of the Neolithic cities of the Middle East, such as Ain Ghazal [ine gah-zahl] ("spring of the gazelles"), just outside what is now Amman, Jordan. Though Ain Ghazal flourished from about 7200 to 5000 BCE, thousands of years before the Mesa Verde community, both

complexes were constructed with stone walls sealed with a layer of mud plaster. Their roofs were made of wooden beams cross-layered with smaller twigs and branches and sealed with mud. Like other Neolithic cultures, the Anasazi were accomplished in pottery-making, decorating their creations with elaborately abstract, largely geometric shapes and patterns.

The Anasazi abandoned their communities in the late thirteenth century, perhaps because of a great drought that lasted from about 1276 to 1299. Their descendants may be the Pueblo [PWEB-loh] peoples of the American Southwest today. (Anasazi is in fact a Navajo word meaning "enemy

Fig. 1.18 Cribbed roof construction of a kiva. After a National Park Service pamphlet.

ancestors"—we do not know what the Anasazi called themselves.) What is remarkable about the Pueblo peoples, who despite the fact that they speak several different languages share a remarkably common culture, is that many aspects of their culture have survived and are practiced today much as they were in ancient times. For all Pueblo peoples, the village is not just the center of culture but the very center of the world. And the cultural center of village life is the **kiva**

[KEE-vuh] (Fig. 1.18), two of which have been restored at Spruce Tree House to form the plaza visible in Fig. 1.17. They are constructed of horizontally laid logs built up to form a dome with an access hole. The roof area thus created is used as a common area. Down below, in the enclosed kiva floor, was a *sipapu* [see-paw-pool, a small, round hole symbolic of the Anasazi creation myth, which told of the emergence of the Anasazi's ancestors from the depths of the Earth. In the parched Southwestern desert country, it is equally true that water, like life itself, also seeps out of small fissures in the Earth. Thus, it is as if the Anasazi community, and everything necessary to its survival, were to emerge from Mother Earth.

Zuni Pueblo Emergence Tales The Pueblos have maintained the active practice of their ancient religious rites and ceremonies, which they have chosen not to share with outsiders. Most do not allow their ceremonial dances to be photographed. These dance performances tell stories that relate to the experiences of the Pueblo peoples, from planting, hunting, and fishing in daily life to the larger experiences of birth, puberty, maturity, and death. Still other stories explain the origin of the world, the emergence of a particular Pueblo people into the world, and their history. Most Pueblo people believe that they originated in the womb of Mother Earth and, like seeds sprouting from the soil in the springtime, were called out into the daylight by their Sun Father. This belief about origins is embodied in a type of narrative known as an emergence tale, a form of creation myth (Reading 1.1).

READING 1.1

Zuni Emergence Tale, Talk Concerning the First Beginning

Yes, indeed. In this world there was no one at all. Always the sun came up; always he went in. No one in the morning gave him sacred meal; no one gave him prayer sticks; it was very lonely. He said to his two children: "You will go into the fourth womb. Your fathers, your mothers, kä-eto·we, tcu-eto·we, mu-eto·we, le-eto·we, all the society priests, society pekwins, society bow priests, you will bring out yonder into the light of your sun father."

So begins this emergence tale, which embodies the fundamental principles of Zuni religious society. The Zuni, or "Sun People," are organized into groups, each responsible for a particular aspect of the community's well-being, and each group is represented by a particular -eto·we, or fetish, connecting it to its spiritual foundation in Earth's womb. The pekwins mentioned here are sun priests, who control the ritual calendar. Bow priests oversee warfare and social behavior. In return for corn and breath given them by the Sun Father, the Zuni offer him cornmeal and downy feathers attached to painted prayer sticks symbolizing both

clouds—the source of rain—and breath itself. Later in the tale, the two children of the Sun Father bring everyone out into the daylight for the first time:

Into the daylight of their sun father they came forth standing. Just as early dawn they came forth. After they came forth there they set down their sacred possessions in a row. The two said, "Now after a little while when your sun father comes forth standing to his sacred place you will see him face to face. Do not close your eyes." Thus he said to them. After a little while the sun came out. When he came out they looked at him. From their eyes the tears rolled down. After they had looked at him, in a little while their eyes became strong. "Alas!" Thus they said. They were covered all over with slime. With slimy tails and slimy horns, with webbed fingers, they saw one another. "Oh dear! is this what we look like?" Thus they said.

Then they could not tell which was which of their sacred possessions.

From this point on in the tale, the people and priests, led by the two children, seek to find the sacred "middle place," where things are balanced and orderly. Halona-Itiwana [ha-LOH-nah it-ee-WAH-nah] it is called, the sacred name of the Zuni Pueblo, "the Middle Ant Hill of the World." In the process, they are transformed from indeterminate, salamander-like creatures into their ultimate human form, and their world is transformed from chaos to order.

At the heart of the Zuni emergence tale is a moment when, to the dismay of their parents, many children are transformed into water-creatures—turtles, frogs, and the like—and the Hero Twins instruct the parents to throw these children back into the river. Here they become *kachinas* [kuh-CHEE-nuhs] or *katcinas*, deified spirits, who explain:

May you go happily. You will tell our parents, "Do not worry." We have not perished. In order to remain thus forever we stay here. To Itiwana but one day's travel remains. Therefore we stay nearby. . . . Whenever the waters are exhausted and the seeds are exhausted you will send us prayer sticks. Yonder at the place of our first beginning with them we shall bend over to speak to them. Thus there will not fail to be waters. Therefore we shall stay quietly nearby.

The Pueblo believe that kachina spirits, not unlike the *num* of the San people of Africa, manifest themselves in performance and dance. Masked male dancers impersonate the kachinas, taking on their likeness as well as their supernatural character. Through these dance visits the kachinas, although always "nearby," can exercise their powers for the good of the people. The nearly 250 kachina personalities embody clouds, rain, crops, animals, and even ideas such as

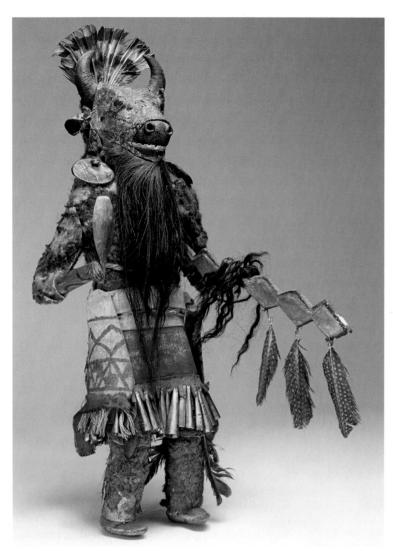

Fig. 1.19 Buffalo Kachina, Zuni culture. ca. 1875. Wood, cloth, hide, fur, shell, feathers, horse hair, tin cones. © Millicent Rogers Museum. The Buffalo Kachina is designed to increase the population of furbearing animals in the arid environment of the Southwest. Derived from a Plains Indian ritual dance, it was first danced by the Zuni near the end of the last century as the region's wildlife was becoming increasingly threatened.

Japan and the Role of Myth in the Shinto Religion

A culture's religion—that is, its understanding of the divine—is thus closely tied to and penetrated by mythical elements. Its beliefs, as embodied in its religion, stories, and myths, have always been closely tied to seasonal celebrations and agricultural production—planting and harvest in particular, as well as rain—the success of which was understood to be inextricably linked to the well-being of the community. In a fundamental sense, myths reflect the community's ideals, its history (hence, the preponderance of creation myths in both ancient societies and contemporary religions), and its aspirations. Myths also tend to mirror the culture's moral and political systems, its social organization, and its most fundamental beliefs.

A profound example is the indigenous Japanese religion of Shinto. Before 200 CE, Japan was fragmented; its various regions were separated by sea and mountain, and ruled by numerous competing and often warring states. The *Records of Three Kingdoms*, a classic Chinese text dating from about 297 CE, states that in the first half of the third century CE, many or

most of these states were unified under the rule of Queen Himiko. According to the Records: "The country formerly had a man as ruler. For some seventy or eighty years after that there were disturbances and warfare. Thereupon the people agreed upon a woman for their ruler. Her name was Himiko." After her rule, Japan was more or less united under the Yamato emperors, who modeled their rule after the Chinese, and whose imperial court ruled from modern-day Nara Prefecture, then known as Yamato Province. Its peoples shared a mythology that was finally collected near the end of the Yamato period, in about 700 CE, called the Kojiki [koh-JEEkee or "Chronicles of Japan." (See Reading 1.2, page 29.) According to the Kojiki, the islands that constitute Japan were formed by two kami [KAH-mee], or gods—Izanagi [izah-NAH-gee] and his consort Izanami [izah-NAH-mee]. Among their offspring was the sun goddess, Amaterasu Omikami [AH-mah-teh-rah-soo OH-mee-kah-mee], from whom the Japanese Imperial line later claimed to have descended. In other words, Japanese emperors could claim not merely to have been put in position by the gods; they could claim to be direct descendants of the gods, and hence divine.

Amaterasu is the principal goddess of the early indigenous religious practices that came to be known as Shinto. She

growth and fertility. Although kachina figurines (Fig. 1.19) are made for sale as art objects, particularly by the Hopi, the actual masks worn in ceremonies are not considered art objects by the Pueblo people. Rather, they are thought of as active agents in the transfer of power and knowledge between the gods and the men who wear them in dance, just like the African Baule mask. In fact, kachina dolls made for sale are considered empty of any ritual power or significance.

Pueblo emergence tales, and the ritual practices that accompany them, reflect the general beliefs of most Neolithic peoples. These include the following:

- belief that the forces of nature are inhabited by living spirits, which we call animism
- belief that nature's behavior can be compared to human behavior (we call the practice of investing plants, animals, and natural phenomena with human form or attributes anthropomorphism), thus explaining what otherwise would remain inexplicable
- belief that humans can communicate with the spirits of nature, and that, in return for a sacrificial offering or a prayer, the gods might intercede on their behalf

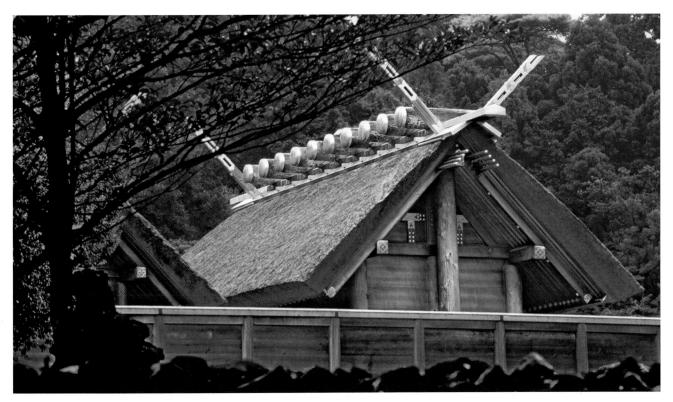

Fig. 1.20 Naiku (Inner) Shrine housing Amaterasu, Ise, Japan. Late fifth—early sixth century ce. Although the site has been sacred to Shinto since prehistoric times, beginning in the reign of the emperor Temmu (r. 673–86 cE), the Shinto shrine at Ise has been rebuilt by the Japanese ruling family, with some inevitable lapses, every 20 years. The most recent reconstruction occurred in 1993 and will occur again in 2013.

is housed in a shrine complex at Ise, a sacred site from prehistoric times. In many respects, Shinto shares much with Pueblo religions. In Shinto, trees, rocks, water, and mountains—especially Mount Fuji, the volcano just outside Tokyo which is said to look over the country as its protector—are all manifestations of the kami, which, like kachinas, are the spirits that are embodied in the natural world. Even the natural materials with which artists work, such as clay, wood, and stone, are imbued with the kami and are to be treated with the respect and reverence due to a god. The kami are revered in matsuri, festivals that usually occur on an annual basis in which, it is believed, past and present merge into one, everyday reality fades away, and people come face-to-face with their gods. The matsuri serve to purify the territory and community associated with the kami, restoring them from the degradation inevitably worked upon them by the passing of time. During the festival, people partake of the original energies of the cosmos, which they will need to restore order to their world. Offerings such as fish, rice, and vegetables, as well as music and dancing, are presented to the kami, and the offerings of food are later eaten.

The main sanctuary at Ise, or shoden [SHOH-dehn], consists of undecorated wooden beams and a thatched roof (Fig. 1.20). Ise is exceptional in its use of these plain and simple materials, which not only embody the basic tenet of Shinto—reverence for the natural world—but also the

continuity and renewal of a tradition where wood, rather than stone, has always been the principal building material. The most prominent festival at Ise is the *shikinen-sengu* ceremony, which involves the installation of the deity in a new shrine in a celebration of ritual renewal held every 20 years. The shrine buildings are rebuilt on empty ground adjacent to the older shrine, the deity is transferred to the new shrine, and the older shrine is razed, creating empty ground where the next shrine will be erected. The empty site is strewn with large white stones and is left totally bare except for a small wooden hut containing a sacred wooden pole, a practice that scholars believe dates back to very ancient times. This cycle of destruction and renewal connects the past to the present, the human community to its gods and their original energies.

The three sacred treasures of Shinto—a sword, a mirror, and a jewel necklace—were said to be given by Amaterasu to the first emperor, and they are traditionally handed down from emperor to emperor in the enthronement ceremony. The mirror is housed at Ise, the sword at the Atsuta Shrine in Nagoya, and the jewel necklace at the Imperial Palace in Tokyo. These Imperial regalia are not considered mere symbols of the divine but "deity-bodies" in which the powers of the gods reside, specifically wisdom in the mirror, valor in the sword, and benevolence in the jewel necklace. To this day, millions of Japanese continue to practice Shinto, and they undertake pilgrimages to Ise each year.

SACRED SITES: THE EXAMPLE OF THE AMERICAS

In some prehistoric cultures, priests or priestesses were principally responsible for mediating between the human and the divine. In others, as in Shinto, the ruler was the representative of the divine world on Earth. But in almost all prehistoric cultures, communication with the spiritual world was conducted in special precincts or places such as Ise. Many scholars believe that caves served this purpose in Paleolithic times. In Neolithic culture, sites such as Stonehenge and the Anasazi kiva served this function.

The Olmec

As early as 1300 BCE, a preliterate group known as the Olmec [OHL-mek] came to inhabit the area between Veracruz and Tabasco on the southern coast of the Gulf of Mexico (see Map 1.3), where they built huge ceremonial precincts in the middle of their communities. Many of the characteristic features of later Mesoamerican culture, such as pyramids, ball courts, mirror-making, and the calendar system, originated in the lowland agricultural zones that the Olmec inhabited.

The Olmec built their cities on great earthen platforms, probably designed to protect their ceremonial centers from rain and flood. On these platforms, they erected giant pyramidal mounds, where an elite group of ruler-priests lived, supported by the general population that farmed the rich, sometimes swampy land that surrounded them. These pyramids

may have been an architectural reference to the volcanoes that dominate Mexico, or they may have been tombs. Excavations may eventually tell us. At La Venta [luh VEN-tuh], very near the present-day city of Villahermosa [vee-yuh-er-MOH-suhl, three colossal stone heads stood guard over the ceremonial center on the south end of the platform (Fig. 1.21), and a fourth guarded the north end by itself. Each head weighs between 11 and 24 tons, and each bears a unique emblem on its headgear, which is similar to old-style American leather football helmets. At other Olmec sites-San Lorenzo, for instance—as many as eight of these heads have been found, some up to 12 feet high. They are carved of basalt, although the nearest basalt quarry is 50 miles to the south in the Tuxtla [toost-luh] Mountains. They were evidently at least partially carved at the quarry, then loaded onto rafts and floated downriver to the Gulf of Mexico before going back upriver to their final resting places. The stone heads are generally believed to be portraits of Olmec rulers, and they all share the same facial features, including wide, flat noses and thick lips. They suggest that the ruler was the culture's principal mediator with the gods, literally larger than life.

The Mound Builders

Sometime between 1800 and 500 BCE, at about the same time that the Olmec were building the La Venta mound cluster in Mexico, Neolithic hunter-gatherers in eastern North America began building huge ceremonial centers of their own, consisting of large-scale embankments and burial mounds

Map 1.3 Olmec civilization sites. The Olmec inhabited most of the area that we now refer to as Mesoamerica from 1300 to 400 BCE.

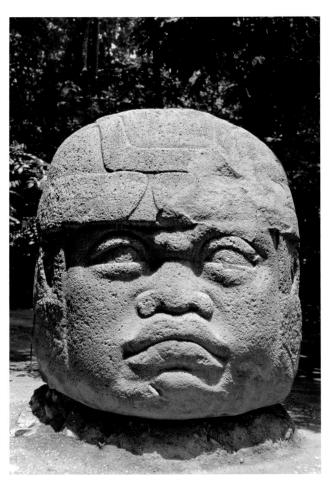

Fig. 1.21 Colossal head, La Venta, Mexico, Olmec culture. ca. 900–500 BCE. Basalt, height 7'50". La Venta Park, Villahermosa, Tabasco, Mexico. Giant heads such as this one faced out from the ceremonial center and evidently served to guard it.

(Map 1.4). These people, who probably had arrived in North America sometime between 14,000 and 10,000 BCE, are known as the Woodlands peoples because the area where they lived, from the Mississippi River basin in the West to the Atlantic Ocean in the East, was originally forested.

One of these Woodlands peoples, the Hopewell culture in southern Ohio, enveloped the corpses of what we presume were their highest-ranking leaders from head to toe in freshwater pearls, weighted them down with plates of beaten copper, and then surrounded them with jewelry, sculpture, and pottery. These burials give us a fair idea of the extent of Woodlands trade. Their copper came from the Great Lakes, decorative shell from the Gulf Coast, alligator and shark teeth from Florida, and mica from the Appalachian Mountains. There are even examples of obsidian that can be traced to what is now Yellowstone National Park, and grizzly bear teeth from the Rocky Mountains.

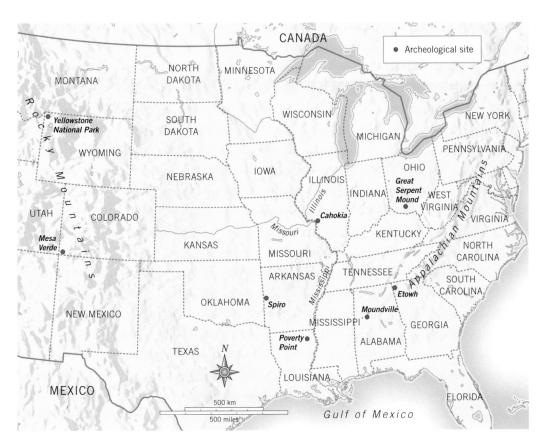

Map 1.4 Archeological sites of the Anasazi and the mound builders' archeological sites in North America.

Fig. 1.22 Great Serpent Mound, Adams County, Ohio, Hopewell culture. ca. 600 BCE-200 ce. Length approx. 1,254'. Recently, archeologists have carbon-dated an artifact found at the Great Serpent Mound as late as 1070 CE. As a result, some now think that the mound may be related to Halley's comet, which passed by the Earth in 1066.

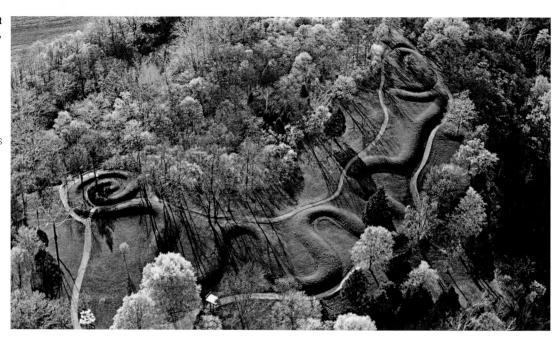

The most intriguing of the Hopewell mounds is the Great Serpent Mound, near Locust Grove, Ohio (Fig. 1.22). Nearly a quarter of a mile long, it contains no burial sites. Its "head" consists of an oval enclosure that may have served some ceremonial purpose, and its tail is a spiral. The spiral would, in fact, become a favorite decorative form of the Mississippian culture, which developed out of the Woodlands-era cultures and raised ritual mound building to a new level of achievement. The great mound at Cahokia [kuh-HO-kee-uh] (Fig. 1.23), near the juncture of the Illinois, Missouri, and Mississippi rivers at modern East St. Louis, Illinois, required the moving of over 22 million cubic feet of earth and probably three centuries to construct, beginning about 900 CE. It was the focal point of a ritual center that contained as many as 120 mounds, some of

which were aligned with the position of the sun at the equinoxes, as well as nearly 400 other platforms, wooden enclosures, and houses. Evidence suggests that the Mississippians worshipped the sun: The Natchez people, one of the Mississippian peoples who survived contact with European culture, called their chief the Great Sun, and their highest social class the Suns.

The Mississippian culture sustained itself primarily by the cultivation of corn, suggesting close connections to Mexico, where cultivation of corn was originally perfected. As many as 4 million people may have lived in the Mississippi Valley. Cahokia itself thrived, with a population of 20,000 people within its six-square-mile area, until just before 1500, when the site was mysteriously abandoned.

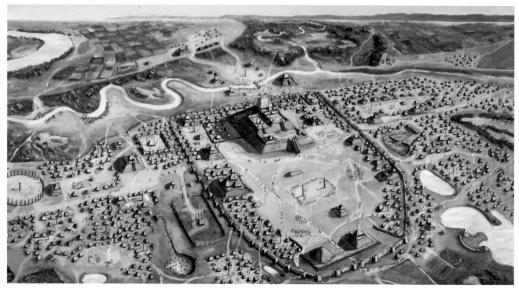

Fig. 1.23 Reconstruction of central Cahokia, East St. Louis, Illinois, Mississippian culture. ca. 1150 ce. East-west length approx. 3 mi.; north-south length approx. 2 1/4 mi.; base of great mound, $1,037' \times 790'$; height approx. 100'. William Iseminger, "Reconstruction of Central Cahokia Mounds". c. 1150 ce. Courtesy of Cahokia Mounds State Historic Site. The stockade, or fence, surrounding the central area. indicates that warfare probably played an important role in Mississippian life.

Representing the Power of the Animal World

he two images shown here in some sense bracket the six volumes of *The Humanities*. The first (Fig. 1.24), from the Chauvet Cave, is one of the earliest known drawings of a horse. The second (Fig. 1.25), a drawing by contemporary American painter Susan Rothenberg (b. 1945), also represents a horse, though in many ways less realistically than the cave drawing. The body of Rothenberg's horse seems to have disappeared and, eyeless, as if blinded, it leans forward, its mouth open, choking or gagging or gasping for air.

In his catalog essay for a 1993 retrospective exhibition of Rothenberg's painting, Michael Auping, chief curator at

Fig. 1.24 Horse. Detail from Chauvet Cave, Vallon-Pont-d'Arc, Ardèche gorge, France (Fig. 1.1). ca. 30,000 BCE. Note the realistic shading that defines the volume of the horse's head. It is a realism that artists throughout history have sometimes sought to achieve, and sometimes ignored, in their efforts to express for the forces that drive them.

the Albright-Knox Museum in Buffalo, New York, described Rothenberg's kind of drawing: "Relatively spontaneous, the drawings are Rothenberg's psychic energy made imminent [They] uncover realms of the psyche that are perhaps not yet fully explicable." The same could be said of the cave drawing executed by a nameless huntergatherer more than 20,000 years ago. That artist's work must have seemed just as strange as Rothenberg's, lit by flickering firelight in the dark recesses of the cave, its body disappearing, too, into the darkness that surrounded it.

It seems certain that in some measure both drawings were the expression of a psychic need on the part of the artist—whether derived from the energy of the hunt or of nature itself—to fix upon a surface an image of the power and vulnerability of the animal world. That drive, which we will see in the art of the Bronze Age of the Middle East in the next chapter—for instance, in the haunting image of a dying lion in the palace complex of an Assyrian king at Nineveh—remains constant from the beginnings of art to the present day. It is the compulsion to express the inexpressible, to visualize the mind as well as the world.

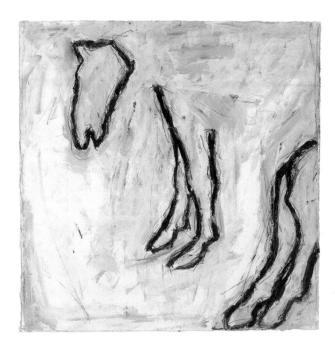

Fig. 1.25 Susan Rothenberg. Untitled. 1978. Acrylic, flashe, and pencil on paper, 20" × 20". Collection Walker Art Center, Minneapolis. Art Center Acquisition Fund, 1979. © 2008 Susan Rothenberg/Artist's Rights Society (ARS), NY. Part of the eeriness of this image comes from Rothenberg's use of flashe, a French vinyl-based color that is clear and so creates a misty, qhostlike surface.

What features characterize the beginnings of human culture?

The widespread use of stone tools and weapons by Homo sapiens, the hominid species that evolved around 120,000 to 100,000 years ago, gives rise to the name of the earliest era of human development, the Paleolithic era. Carvers fashioned stone figures, both in the round and in relief. In cave paintings, such as those discovered at Chauvet Cave, the artists' great skill in rendering animals helps us to understand that the ability to represent the world with naturalistic fidelity is an inherent human skill, unrelated to cultural sophistication. Culture can be defined as a way of living—religious, social, and/or political—formed by a group of people and passed on from one generation to the next. What can the earliest art tell us about the first human cultures? What questions remain a mystery?

What characteristics distinguish the Neolithic from the Paleolithic?

As the ice that covered the Northern Hemisphere slowly melted, people began cultivating edible grasses and domesticating animals. Gradually, farming supplanted hunting as the primary means of sustaining life, especially in the great river valleys where water was abundant. The rise of agriculture is the chief characteristic of the Neolithic age. Along with agriculture, permanent villages such as Skara Brae begin to appear. What does the appearance of fire-baked pottery tell us about life in Neolithic culture?

What is a megalith?

During the fifth millennium BCE, Neolithic peoples began constructing monumental stone architecture, or megaliths, in France and England. Upright, single stone posts called menhirs were placed in the ground, either individually or in groups, as at Carnac in Brittany. Elementary post-and-lintel construction was employed to create dolmens, two posts roofed with a capstone. The most famous of the third type of monumental construction, the circular cromlech, is Stonehenge, in England. What does the enormous amount of human labor required for the construction of these megaliths suggest about the societies that built them?

How can we understand the role of myth in prehistoric culture?

Neolithic culture in the Americas lasted well into the second millennium CE. Much of our understanding of the role of myth in prehistoric cultures derives from the traditions of contemporary Native American tribes that still survive in tribes such as the Hopi and Zuni, who are the direct descendents of the Anasazi. Their legends, such as the Zuni emergence tale, encapsulate the fundamental religious principles of the culture. Such stories, and the ritual practices that accompany them, reflect the general beliefs of most Neolithic peoples. Can you describe some of these beliefs? What role do sacred sites, such as those at Ise in Japan, or Cahokia in the Mississippi Valley, play?

PRACTICE MORE Get flashcards for images and terms and review chapter material with quizzes at www.myartslab.com

GLOSSARY

agency The idea that an object possesses qualities that help to effect change.

animism The belief that the forces of nature are inhabited by living spirits.

anthropomorphism The practice of investing plants, animals, and natural phenomena with human form or attributes.

cairn A fully enclosed burial chamber covered with earth.

carving The act of cutting or incising stone, bone, wood, or other material into a desired form.

civilization A culture that possesses the ability to organize itself thoroughly and communicates through written language.

corbeling A method for creating walls and roofs by layering stones so that they project inward over the layer beneath.

creation myth A story of a people's origin.

cromlech A circle of megaliths, usually surrounding a dolmen or mound.

culture The set of values, beliefs, and behaviors that governs or determines a common way of living formed by a group of people and passed on from one generation to the next.

dolmen A type of prehistoric megalithic structure made of two posts supporting a horizontal capstone.

emergence tale A type of narrative that explains beliefs about a people's origins.

hominids The earliest upright mammals, including humans, apes, and other related forms.

hunter-gatherer One whose primary method of subsistence depends on hunting animals and gathering edible plants and other foodstuffs from nature.

kiva A Pueblo ceremonial enclosure that is usually partly underground and serves as the center of village life.

lintel A horizontal architectural element.

megalith Literally, "big stone"; large, usually rough, stones used in a monument or structure.

menhir A large, single, upright stone.

modeling The use of shading in a two-dimensional representation to give a sense of roundness and volume.

myth A story that a culture assumes is true. A myth also embodies the culture's views and beliefs about its world,

often serving to explain otherwise mysterious natural phenomena.

naturalism In art, representations that imitate the reality in appearance of natural objects.

oral culture A culture that develops without writing and passes down stories, beliefs, values, and systems by word of mouth.

perspectival drawing The use of techniques to show the relation of objects as they appear to the eye and to convey a sense of three-dimensional space on a two-dimensional surface.

post A piece fixed firmly in an upright position.

post-and-lintel A form of construction consisting of two posts (upright members) that support a lintel (horizontal member).

prehistoric Existing in or relating to the times before writing and recorded history.

relief sculpture A three-dimensional work of art carved out of a flat background surface.

ritual A rite or ceremony habitually practiced by a group, often in religious or quasi-religious context.

sculpture in the round A fully three-dimensional work of art.

shaman A person thought to have special ability to communicate with the spirit world.

trilithon A type of megalithic structure composed of three stones: two posts and a lintel; served in prehistory as the basic architectural unit.

READINGS

READING 1.2

The Japanese Creation Myth: The Kojiki

The following is a beginning of a modern retelling of the Kojiki or Records of Ancient Matters the oldest surviving account of ancient Japanese history. This creation myth details the origins of Japan and the sacred spirits, or kami, which are objects of worship for the indigenous religion of Japan, Shintoism.

Before the heavens and the earth came into existence, all was a chaos, unimaginably limitless and without definite shape or form. Eon followed eon: then, lo! out of this boundless, shapeless mass something light and transparent rose up and formed the heaven. This was the Plain of High Heaven, in which materialized a deity called Ame-no-Minaka-Nushi-no-Mikoto (the Deity-of-the-August-Center-of-Heaven). Next the heavens gave birth to a deity named Takami-Musubi-no-Mikoto (the High-August-Producing-Wondrous-Deity), followed by a third called Kammi-Musubi-no-Mikoto (the Divine-Producing-Wondrous-Deity). These three divine beings are called the Three Creating Deities.

In the meantime what was heavy and opaque in the void gradually precipitated and became the earth, but it had taken an immeasurably long time before it condensed sufficiently to form solid ground. In its earliest stages, for millions and millions of years, the earth may be said to have resembled oil floating, medusa-like, upon the face of the waters. Suddenly like the sprouting up of a reed, a pair of immortals were born from its bosom. . . . Many gods were thus born in succession, and so they increased in number, but as long as the world remained in a chaotic state, there was nothing for them to do. Whereupon, all the Heavenly deities summoned the two divine beings, Izanagi and Izanami, and bade them descend to the nebulous place, and by helping each other, to consolidate it into terra firma. [The heavenly deities] handed them a spear called Ama-no-Nuboko, embellished with costly gems. The divine couple received respectfully and ceremoniously the sacred weapon and then withdrew from the presence of the deities, ready to perform their august commission. Proceeding forthwith to the Floating Bridge

of Heaven, which lay between the heaven and the earth, they stood awhile to gaze on that which lay below. What they beheld was a world not yet condensed, but looking like a sea of filmy fog floating to and fro in the air, exhaling the while an inexpressibly fragrant odor. They were, at first, perplexed just how and where to start, but at length Izanagi suggested to his companion that they should try the effect of stirring up the brine with their spear. So saying he pushed down the jeweled shaft and found that it touched something. Then drawing it up, he examined it and observed that the great drops which fell from it almost immediately coagulated into an island, which is, to this day, the Island of Onokoro. Delighted at the result, the two deities descended forthwith from the Floating Bridge to reach the miraculously created island. In this island they thenceforth dwelt and made it the basis of their subsequent task of creating a country First, the island of Awaji was born, next, Shikoku, then, the island of Oki, followed by Kyushu; after that, the island Tsushima came into being, and lastly, Honshu, the main island of Japan. The name of Oyashi-ma-kuni (the Country of the Eight Great Islands) was given to these eight islands

READING CRITICALLY

One of the key moments in this creation myth is when the heavenly deities order Izanagi and Izanami to "descend to the nebulous place, and by helping each other, to consolidate it into terra firma." What does this tell us about Japanese culture?

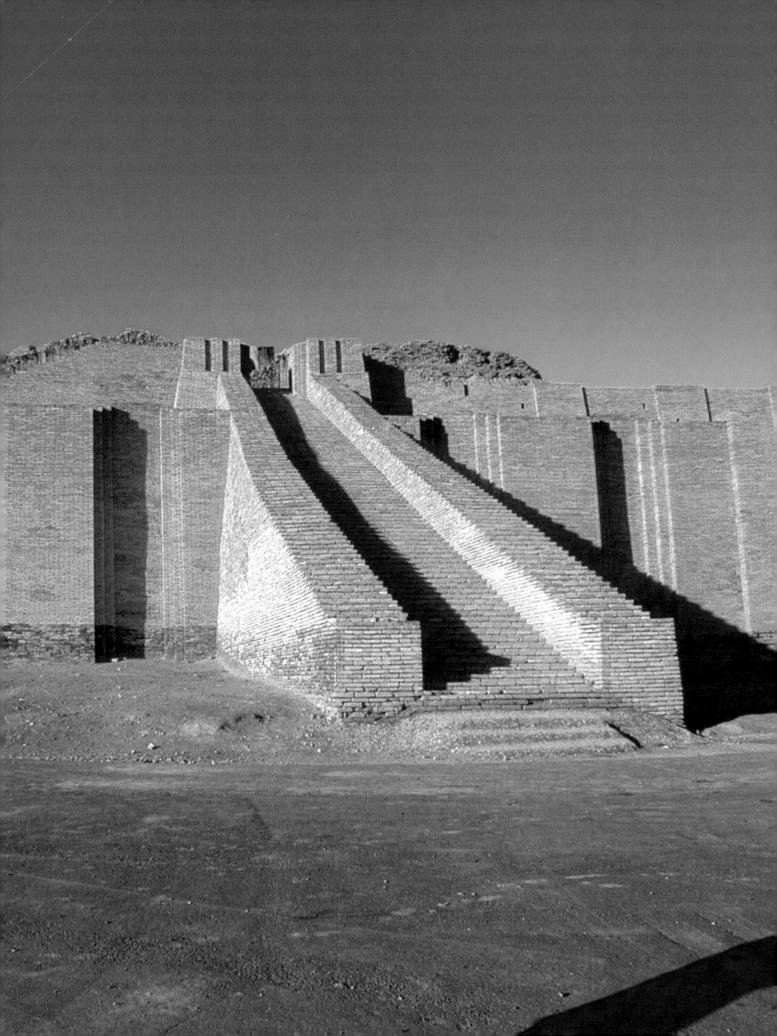

Mesopotamia

Power and Social Order in the Early Middle East

THINKING AHEAD

What characteristics distinguish the ancient civilizations of Sumer, Akkad, Babylon, and Assyria?

How does the Epic of Gilgamesh embody the relationship between the Mesopotamian ruler and the gods?

What distinguished the Hebrews from other cultures of the Ancient Near East?

What characteristics did the Persian religion share with Judaism?

n September 1922, British Archeologist C. Leonard Woolley boarded a steamer, beginning a journey that would take him to southern Iraq. There, Woolley and his team would discover one of the richest treasure troves in the history of archeology in the ruins of the ancient city of Ur. Woolley concentrated his energies on the burial grounds surrounding the city's central ziggurat [ZIG-uh-rat], a pyramidal temple structure consisting of successive platforms with outside staircases and a shrine at the top. (Fig. 2.1). Digging there in the winter of 1927, he unearthed a series of tombs with several rooms, many bodies, and masses of golden objects (Fig. 2.2) vessels, crowns, necklaces, statues, and weapons—as well as jewelry and lyres made of electrum and the deep-blue stone lapis lazuli. With the same sense of excitement that was felt by Jean-Marie Chauvet and his companions when they first saw the paintings on the wall of Chauvet cave, Woolley was careful to keep what he called the "royal tombs" secret. On January 4, 1928, Woolley telegrammed his colleagues in Latin. Translated to English, it read:

I found the intact tomb, stone built, and vaulted over with bricks of queen Shubad [later known as Puabi] adorned with a dress in which gems, flower crowns and animal figures are woven. Tomb magnificent with jewels and golden cups.

-Woolley

Fig. 2.2 Vessel in the shape of an ostrich egg, from the Royal Cemetery of Ur. ca. 2550 BCE. Gold, lapis lazuli, red limestone, shell, and bitumen, hammered from a single sheet of gold and with geometric mosaics at the top and bottom of the egg. Height 5 $\frac{3}{4}$ "; Diameter 5 $\frac{1}{8}$ " University of Pennsylvania Museum of Archaeology and Anthropology. The array of materials came from trade with neighbors in Afghanistan, Iran, Anatolia, and perhaps Egypt and Nubia.

■ Fig. 2.1 The ziggurat at Ur (modern Muqaiyir, Iraq). ca. 2100 BCE. The best preserved and most fully restored of the ancient Sumerian temples, this ziggurat was the center of the city of Ur, in the lower plain between the Tigris and Euphrates rivers.

HEAR MORE Listen to an audio file of your chapter at www.myartslab.com

When Woolley's discovery was made public, it was worldwide news for years.

Archeologists and historians were especially excited by Woolley's discoveries, because they opened a window onto the larger region we call Mesopotamia [mes-uh-po-TAY-mee-uh], the land between the Tigris [TIE-gris] and Euphrates [you-FRAY-teez] rivers. Ur was one of 30 or 40 cities that arose in Sumer, the southern portion of Mesopotamia (Map 2.1). Its people abandoned Ur more than 2,000 years ago, when the Euphrates changed its course away from the city.

The peoples of the region were, in fact, almost totally dependent on the two rivers for their livelihoods. By irrigating the lands just outside the marshes on the riverbanks, the conditions necessary for extensive and elaborate communities such as Ur began to arise: People dug canals and ditches and cooperated in regulating the flow of water in them, which eventually resulted in crops that exceeded the needs of the population. These could be transformed into foodstuffs of a more elaborate kind, including beer. Evidence indicates that over half of each grain harvest went into producing beer. Excess crops were also traded by boat with nearby communities or up the great rivers to the north, where stone, wood, and metals were available in exchange. As people congregated in central locations to exchange goods, cities began to form. Cities such as Ur became hubs of great trading networks. With trade came ideas, which were incorporated into local custom and spawned newer and greater ideas in turn. Out of the exchange of goods and ideas, then, the conditions were in place for great cultures to arise.

This chapter outlines the cultural forces that came to define Mesopotamia. After agriculture, first among these was

metallurgy, the science of separating metals from their ores and then working or treating them to create objects. The technology probably originated in the Fertile Crescent to the north about 4000 BCE, but as it spread southward, the peoples of Mesopotamia adopted it as well.

This new technology would change the region's social organization, inaugurating what we have come to call the Bronze Age. Metallurgy required the mining of ores, specialized technological training, and skilled artisans. Although the metallurgical properties of copper were widely understood, technicians discovered that by alloying it with tin they could create bronze, a material of enormous strength and durability. Bronze weapons would transform the military and the nature of warfare. Power consolidated around the control and mastery of weaponry, and thus bronze created a new military elite of soldiers dedicated to protecting the Sumerian city-states from one another for control of produce and trade. The city-states, in turn, spawned governments ruled by priest-kings, who exercised power as intermediaries between the gods and the people. In their secular role, the priest-kings established laws that contributed to the social order necessary for maintaining successful agricultural societies. The arts developed largely as celebrations of the priest-kings' powers. In order to keep track of the production and distribution of goods, the costs of equipping the military, and records relating to enforcing laws and regulations, writing, perhaps the greatest innovation of the Bronze Age, developed. If agricultural production served to stimulate the creation of urban centers, metallurgy made possible the new military cultures of the city-states. The arts served to celebrate these new centers of

> power, and writing, which arose out of the necessity of tracking the workings of the state, would come to celebrate the state in a literature of its own.

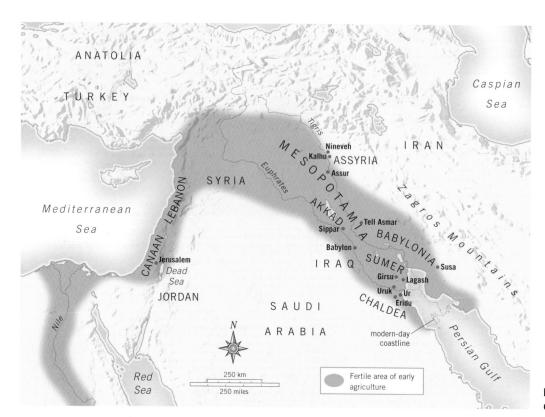

Map 2.1 Major Mesopotamian capitals. ca. 2600–500 BCE.

SUMERIAN UR

Ur is not the oldest city to occupy the southern plains of Mesopotamia, the region known as Sumer [SOO-mur]. That distinction belongs to Uruk [oo-RUK], just to the north. But the temple structure at Ur is of particular note because it is the most fully preserved and restored. It was most likely designed to evoke the mountains surrounding the river valley, which were the source of the water that flowed through the two rivers and, so, the source of life. Topped by a sanctuary, the ziggurat might also have symbolized a bridge between heaven and earth. Woolley, who supervised the reconstruction of the first platform and stairway of the ziggurat at Ur (Fig. 2.3), speculated that the platforms of the temple were originally not paved but covered with soil and planted with trees, an idea that modern archeologists no longer accept.

Visitors—almost certainly limited to members of the priesthood—would climb up the stairs to the temple on top. They might bring an offering of food or an animal to be sacrificed to the resident god—at Ur, it was Nanna or Sin, god of the moon. Visitors often placed in the temple a statue that represented themselves in an attitude of perpetual prayer. We know this from the inscriptions on many of the statues. One, dedicated to the goddess Tarsirsir, protector of Girsu, a city-state across the Tigris and not far upstream from Ur, reads:

To Bau, gracious lady, daughter of An, queen of the holy city, her mistress, for the life of Nammahani . . . has dedicated as an offering this statue of the protective goddess of Tarsirsir which she has introduced to the courtyard of Bau. May the statue, to which let my mistress turn her ear, speak my prayers.

A group of such statues, found in 1934 in the shrine room of a temple at Tell Asmar, near modern Baghdad, includes seven men and two women (Fig. 2.4). The men wear belted,

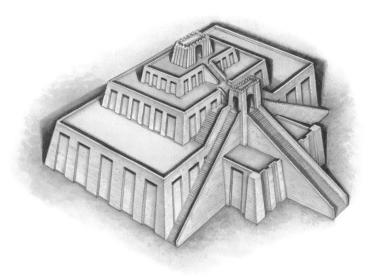

Fig. 2.3 Reconstruction drawing of the ziggurat at Ur (modern Muqaiyir, Iraq). ca. 2100 BCE. British archeologist Sir Leonard Woolley undertook reconstruction of the ziggurat in the 1930s (see Fig. 2.1). In his reconstruction, a temple on top, which was the home of the patron deity of the city, crowning the three-tiered platform, the base of which measures 140 by 200 feet. The entire structure rose to a height of 85 feet. Woolley's reconstruction was halted before the second and third platforms were completed.

fringed skirts. They have huge eyes, inlaid with lapis lazuli (a blue semiprecious stone) or shell set in bitumen. The single arching eyebrow and crimped beard (only the figure in the at the right is beardless) are typical of Sumerian sculpture. The two women wear robes. All figures clasp their hands in front of them, suggestive of prayer when empty and of making an offering when holding a cup. Some scholars believe that the tallest man represents Abu, god of vegetation, due to his especially large eyes, but all of the figures are probably worshippers.

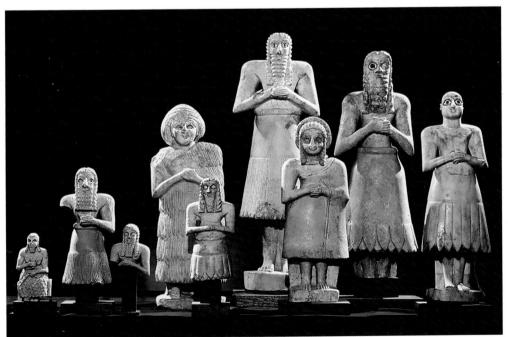

Fig. 2.4 Dedicatory statues, from the Abu Temple, Tell Asmar, Iraq. ca. 2900–2700 BCE. Marble, alabaster, and gypsum, height of tallest figure, approx. 30". Excavated by the Iraq Expedition of the Oriental Institute of the University of Chicago, February 13, 1934. Courtesy of the Oriental Institute of the University of Chicago. The wide-eyed appearance of these figures is probably meant to suggest they are gazing in perpetual awe at the deity.

Religion in Ancient Mesopotamia

Although power struggles among the various city-states dominate Mesopotamian history, with one civilization succeeding another, and with each city-state or empire claiming its own particular divinity as chief among the Mesopotamian gods, the nature of Mesopotamian religion remained relatively constant across the centuries. With the exception of the Hebrews, the religion of the Mesopotamian peoples was polytheistic, consisting of multiple gods and goddesses connected to the forces of nature—sun and sky, water and storm, earth and its fertility (see Context, this page). We know many of them by two names, one in Sumerian and the other in the Semitic language of the later, more powerful Akkadians. A famous Akkadian cylinder seal (Fig. 2.5), an engraved cylinder used as a signature by rolling it into a wet clay tablet in order to confirm receipt of goods or to identify ownership, represents many of the gods. The figures are recognizably gods because they wear pointed headdresses with multiple horns, though the figure on the left, beside the lion and holding a bow, has not been definitively identified. The figure with two wings standing atop the scaly mountain is Ishtar [ISH-tar], goddess of love and war. Weapons rise from her shoulders, and she holds a bunch of dates in her hand, a symbol of fertility. Beneath her, cutting his way through the mountain so that he can rise at dawn, is the sun god, Shamash [SHAH-mash]. Standing with his foot on the mountain at the right, streams of water with fish in them flowing from his shoulders, is Ea [EE-ah], god of water, wisdom, magic, and art. Behind him is his vizier [vih-ZEER], or "burden-carrier."

To the Mesopotamians, human society was merely part of the larger society of the universe governed by these gods and a reflection of it. Anu, father of the gods, represents the authority, which the ruler emulates as lawmaker and -giver. Enlil [EN-lil], god of the air—the calming breeze as well as the violent storm—is equally powerful, but he represents force, which the ruler emulates in his role as military leader. The active principles of fertility, birth, and agricultural plenty are those of the goddess Belitili [bell-eh-TEE-lee], while water, the life force itself, the creative element, is embodied in the god Ea, or Enki [EN-kee], who is also god of the arts. Both Belitili and Ea are subject to the authority of

Mesopotamian Gods and Goddesses		
Name	Symbol	Role
An/Anu	horned cap	Father of the gods, god of the sky
Enlil	horned cap	God of the air and storm; later replaces Anu as father of the gods
Utu/Shamash	solar disc	Sun-god, lord of truth and justice
Inanna/Ishtar	solar disc	Goddess of love and war
	star	
Ninhursag /Belitili		Mother Earth
	ʻomega' symbol	
Enki/Ea		God of water, lord of wisdom, magic, art
	goat-fish	
Marduk		Chief god of Babylon
	spade	

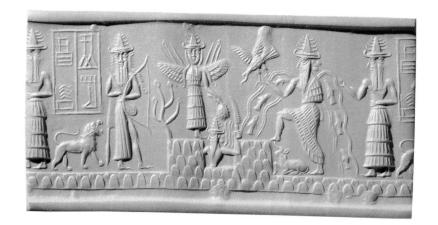

Fig. 2.5 Cylinder seal impression and the Seal of Adda. Akkadian. ca. 2200–2159 BCE. Greenstone, height 1 ½". The two-line inscription at the left identifies the seal's owner as Adda, a scribe.

Anu. Ishtar is subject to Enlil, ruled by his breezes (in the case of love) and by his storm (in the case of war). A host of lesser gods represented natural phenomena, or, in some cases, abstract ideas, such as truth and justice.

The Mesopotamian ruler, often represented as a "priest-king," and often believed to possess divine attributes, acts as the intermediary between the gods and humankind. His ultimate responsibility is the behavior of the gods—whether Ea blesses the crop with rains, Ishtar his armies with victory, and so on.

Royal Tombs of Ur

Religion was central to the people of Ur, and the cemetery at Ur, discovered by Sir Leonard Woolley in 1928, tells us a great deal about the nature of their beliefs. Woolley unearthed some 1,840 graves, most dating from between 2600 and 2000 BCE. The greatest number of graves were individual burials of rich and poor alike. However, some included a built burial chamber rather than just a coffin and contained more than one body, in some cases as many as 80. These multiple burials, and the evidence of elaborate burial rituals, suggest that members of a king or queen's court accompanied the ruler to the grave. The two richest burial sites, built one behind the other, are now identified as royal tombs, one belonging to Queen Puabi [poo-AH-bee], the other to an unknown king (but it is not that of her husband, King Meskalamdug [mes-kah-LAM-doog], who is buried in a different grave).

Fig. 2.6 Soundbox panel front of the lyre from Tomb 789 (alternatively identified as the unknown king's or Puabi's tomb), from the cemetery at Ur (modern Muqaiyir, Iraq). ca. 2600 BCE.

Wood with inlaid gold, lapis lazuli, and shell, height approx. 12 1/4". University of Pennsylvania Museum of Archaeology and Anthropology, Philadelphia. Museum object #B17694, (image #150848). The meaning of the scenes on the front of this lyre has always puzzled scholars. On the bottom, a goat holding two cups attends a man with a scorpion's body. Above that, a donkey plays a bull-headed lyre held by a bear, while a seated jackal plays a small percussion instrument. On the third level, animals walking on their hind legs carry food and drink for a feast. In the top panel, a man with long hair and beard, naked but for his belt, holds two humanheaded bulls by the shoulders.

The Golden Lyres In the grave of either the unknown king or Oueen Puabi (records are confusing on this point) were two lyres, one of which today is housed in Philadelphia (Fig. 2.6), the other in London (Fig. 2.7). Both are decorated with bull's heads and are fronted by a panel of narrative scenes—that is, scenes representing a story or event. Although originally made of wood, which rots over time, these objects were able to be saved in their original form due to an innovation of Woolley's during the excavation. He ordered his workers to tell him whenever they came upon an area that sounded hollow. He would fill such hollows (where the original wood had long since rotted away) with wax or plaster, thus preserving, in place, the decorative effects on the object's outside. It seems likely that the mix of animal and human forms that decorate these lyres represents a funerary banquet in the realm of the dead. They are related, at least thematically, to events in the Sumerian Epic of Gilgamesh, which we will discuss later in the chapter. This suggests that virtually

Fig. 2.7 Lyre from Tomb 789 (alternatively identified as the unknown king's or Puabi's tomb), from the cemetery at Ur (modern Muqaiyir, Iraq). ca. 2600 BCE. Gold leaf and lapis lazuli over a wood core, height $44 \frac{1}{2}$ " restored 1971–1972. © The Trustees of the British Museum.

every element of the culture—from its music and literature to its religion and politics—was tied in some way to every other. The women whose bodies were found under the two lyres may have been singers and musicians, and the placement of the lyres over them would indicate that the lyres were put there after the celebrants died.

Such magnificent musical instruments indicate that music was important in Mesopotamian society. Surviving documents tell us that music and song were part of the funeral ritual, and music played a role in worship at the temple, as well as in banquets and festivals. Indeed, a fragment of a

poem from the middle of the third millennium BCE found at Lagash [LAY-gash] indicates that Sumerian music was anything but funereal. It is music's duty, the poet says,

To fill with joy the Temple court And chase the city's gloom away The heart to still, the passions calm, Of weeping eyes the tears to stay.

The Royal Standard of Ur One of Woolley's most important discoveries in the Royal Cemetery was the so-called *Royal Standard of Ur* (Fig. 2.8). Music plays a large part here, too.

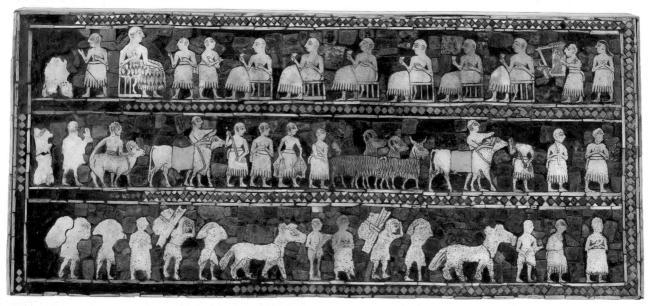

Fig. 2.8 Royal Standard of Ur, front ("War") and back ("Peace") sides, from tomb 779, cemetery at Ur (modern Muqaiyir, Iraq). ca. 2600 BCE. Shell, lapis lazuli, and red limestone, originally on a wooden framework, height 8", length 19". © The Trustees of The British Museum/Art Resource, NY. For all its complexity of design, this object is not much bigger than a sheet of legal paper. Its function remains a mystery, though it may have served as a pillow or headrest. Sir Woolley's designation of it as a standard was purely conjectural.

SEE MORE To view a Closer Look feature about the Royal Standard of Ur, go to www.myartslab.com

The main panels of this rectangular box of unknown function are called "War" and "Peace," because they illustrate, on one side, a military victory and, on the other, the subsequent banquet celebrating the event, or perhaps a cult ritual. Each panel is composed of three **registers**, or self-contained horizontal bands within which the figures stand on a **ground-line**, or baseline.

At the right side of the top register of the "Peace" panel (the lower half of Fig. 2.8), a musician plays a lyre, and behind him another, apparently female, sings. The king, at the

left end, is recognizable because he is taller than the others and wears a tufted skirt, his head breaking the register line on top. In this convention, known as social perspective, or hieratic scale, the most important figures are represented as larger than the others. In other registers on the "Peace" side of the Standard, servants bring cattle, goats, sheep, and fish to the celebration. These represent the bounty of the land and perhaps even delicacies from lands to the north. (Notice that the costumes and hairstyles of the figures carrying sacks in the lowest register are different from those in the other two.) This display of consumption and the distribution of food may have been intended to dramatize the power of the king by showing his ability to control trade routes.

On the "War" side of the Standard, the king stands in the middle of the top register. War chariots trample the enemy on the bottom register. (Note that the chariots have solid wheels; spoked wheels were not invented until approximately 1800 BCE.) In the middle register, soldiers wearing leather cloaks and bronze helmets lead naked, bound prisoners to the king in the top register, who will presumably decide their fate. Many of the bodies found in the royal tombs were wearing similar military gar-

ments. The importance of the *Royal Standard of Ur* is not simply as documentary evidence of Sumerian life but as one of the earliest examples we have of historical narrative.

AKKAD

At the height of the Sumerians' power in southern Mesopotamia, a people known as the Akkadians arrived from the north and settled in the area around modern Baghdad. Their capital city, Akkad [AK-ad], has never been discovered and in all likelihood lies under Baghdad itself. Under Sargon [SAR-gun] I (r. ca. 2332–2279 BCE), the Akkadians conquered virtually all other cities in Mesopotamia, including

those in Sumer, to become the region's most powerful city-state. Sargon named himself "King of the Four Quarters of the World" and equated himself with the gods, a status bestowed upon Akkadian rulers from Sargon's time forward. Legends about Sargon's might and power survived in the region for thousands of years. Indeed, the legend of his birth gave rise to what amounts to a **narrative genre** (a class or category of story with a universal theme) that survives to the present day: the boy from humble origins who rises to a position of might and power, the so-called "rags-to-riches" story.

As depicted on surviving clay tablets, Sargon was an illegitimate child whose mother deposited him in the Euphrates River in a basket. There, a man named Akki [AK-kee] (after whom Akkad itself is named) found him while drawing water from the river and raised him as his own son. Such stories of abandonment, orphanhood, and being a foundling raised by foster parents will become a standard feature in the narratives of mythic heroes.

Although the Akkadian language was very different from Sumerian, through most of the third millennium BCE—that is, until Sargon's dynastic ambitions altered the balance of power in the region—the two cultures coexisted peacefully. The Akkadians adopted Sumerian culture and customs (see Fig. 2.5) and their style of cuneiform writing, a script made of wedge-shaped characters (see Closer Look, pages 38-39), although not their language. In fact, many bilingual dictionaries and Sumerian texts with Akkadian translations survive. The Akkadian language was Semitic in origin, having more in common with other languages of the region, particularly Hebrew, Phoenician, and Arabic. It quickly became the common language of Mesopotamia, and peoples of the region spoke Akkadian, or dialects of it, throughout the second millennium BCE and well into the first.

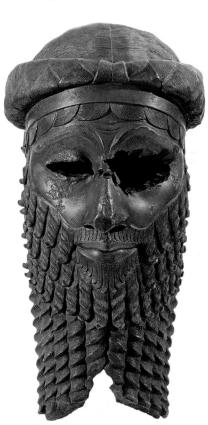

Fig. 2.9 Head of an Akkadian Man, from Nineveh (modern Kuyunjik, Iraq). ca. 2300–2200 BCE. Copper alloy, height 14 1/8" Iraq Museum, Baghdad.

Akkadian Sculpture

Although Akkad was arguably the most influential of the Mesopotamian cultures, few Akkadian artifacts survive, perhaps because Akkad and other nearby Akkadian cities have disappeared under Baghdad and the alluvial soils of the Euphrates plain. Two impressive sculptural works do remain, however. The first is the bronze head of an Akkadian man (Fig. 2.9), found at Nineveh [NIN-eh-vuh]. Once believed to be Sargon the Great himself, many modern scholars now think it was part of a statue of Sargon's grandson, Naramsin [nuh-RAHM-sin] (ca. 2254–2218 BCE). It may be neither, but it is certainly the bust of a king. Highly realistic, it

HEAR MORE Listen to the advice of a father to his son, written down over 4,000 years ago at www.myartslab.com

CLOSER LOOK

riting first appeared in the middle of the fourth millennium BCE in agricultural records as pictograms—pictures that represent things or concepts—etched into clay tablets. For instance, the sign for "woman" is a pubic triangle, and the more complicated idea of "slave" is the sign for "woman" plus the sign for "mountains"—literally, a "woman from over the mountains":

Pictograms could also represent concepts. For instance, the signs for "hatred" and "friendship" are, respectively, an "X" and a set of parallel lines:

Beginning about 2900 BCE, most writing began to look more linear, for it was difficult to draw curves in wet clay. So scribes adopted a straight-line script made with a triangle-tipped **stylus** [STY-lus], or writing tool, cut from reeds. The resulting impressions looked like wedges. Cuneiform writing was named from the Latin *cuneus*, "wedge."

By 2000 BCE, another significant development in the progress of writing had appeared: Signs began to represent not things but sounds. This **phonetic writing** liberated the sign from its picture. Previously, they had been linked, as if, in English, we represented the word *belief* with pictograms for "bee" and "leaf."

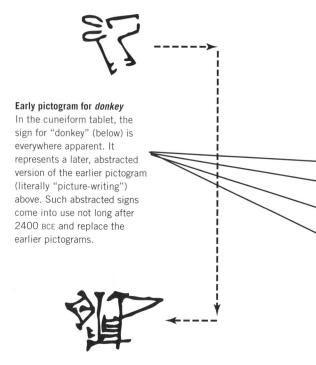

Later cuneiform pictogram of donkey

Cuneiform Writing in Sumer

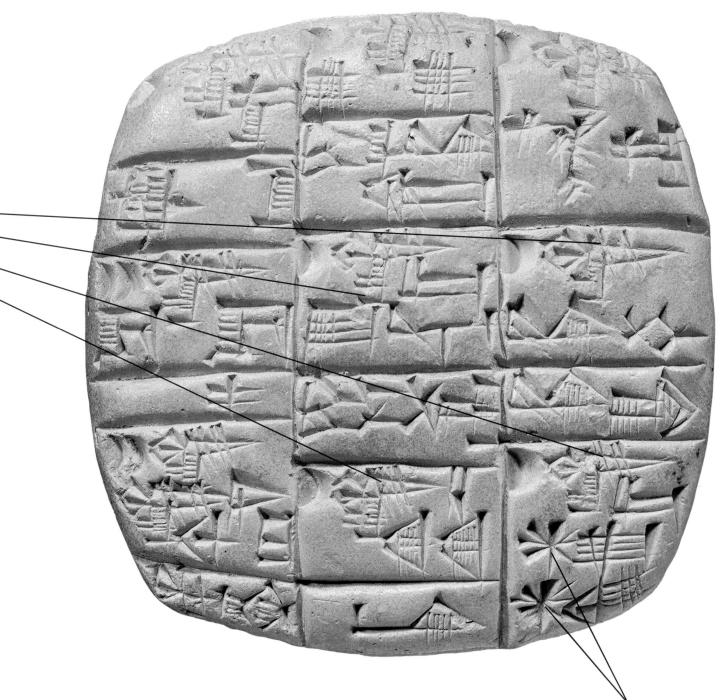

Something to Think About . . .

What is it about this "document" that underscores the necessity of writing in the development of a civilization?

Sumerian tablet from Lagash, modern Tello, Iraq. ca. 2360 BCE. Clay. Musée du Louvre, Paris. This tablet is an economic document detailing the loan of donkeys to, among others, a farmer, a smith, and a courier.

These stars are the Sumerian sign for "god." They sometimes have many more points than the eight seen here.

Materials & Techniques

Lost-Wax Casting

At about the same time that cuneiform script was adopted, Mesopotamian culture also began to practice metallurgy, the process of mining and smelting ores. At first, copper was used almost exclusively; later, an alloy of copper and tin was melted and combined to make bronze. The resulting material was much stronger and more durable than anything previously known.

Because sources of copper and tin were mined in very different regions of the Middle East, the development of trade routes was a

necessary prerequisite to the technology. While solid bronze pieces were made in simple molds as early as 4000 BCE, hollow bronze casts could produce larger pieces and were both more economical and lightweight. The technology for making hollow bronze casts was developed by the time of the Akkadians, in the second millennium BCE. Called **lost-wax casting**, the technique is illustrated below.

A positive model (1), often created with clay, is used to make a negative mold (2). The mold is coated with wax, the wax shell is filled with a cool fireclay, and the mold is removed (3). Metal rods, to hold the shell in place, and wax rods, to vent the mold, are then added (4). The whole is placed in sand, and the wax is burned out. Molten bronze is poured in where the wax used to be (5). When the bronze has hardened, the whole is removed from the sand and the rods and vents are removed (6).

EXPLORE MORE To see a studio video on lost-wax casting, go to www.myartslab.com

depicts a man who appears both powerful and majestic. In its damaged condition, the head is all that survives of a life-size statue that was destroyed in antiquity. Its original gemstone eyes were removed, perhaps by plundering soldiers, or possibly by a political enemy who recognized the sculpture as an emblem of absolute majesty. In the fine detail surrounding the face—in the beard and elaborate coiffure, with its braid circling the head—it testifies to the Akkadian mastery of the lost-wax casting technique, which originated in Mesopotamia as early as the third millennium BCE (see Materials & Techniques, above). It is the earliest monumental work made by that technique that we have.

The second Akkadian sculpture we will look at is the Stele of Naramsin (Fig. 2.10). A stele [STEE-lee] is an upright stone slab carved with a commemorative design or inscription. (The word is derived from the Greek for "standing block.") This particular stele celebrates the victory of Sargon's grandson over the Lullubi [lool-LOO-bee] in the Zagros Mountains of eastern Mesopotamia sometime between 2252 and 2218 BCE. The king, as usual, is larger than anyone else (another example of social perspective or hierarchy of scale). The Akkadians, in fact, believed that Naramsin became divine during the course of his reign. In the stele, his divinity is represented by his horned helmet and by the physical perfection of his body. Bow and arrow in hand, he stands atop a mountain pass, dead and wounded Lullubians beneath his feet. Another Lullubian falls before

him, a spear in his neck. Yet another seems to plead for mercy as he flees to the right. Behind Naramsin, his soldiers climb the wooded slopes of the mountain—here represented by actual trees native to the region.

The sculptor abandoned the traditional register system that we saw in the *Royal Standard of Ur* and set the battle scene on a unified landscape. The lack of registers and the use of trees underscore the reality of the scene—and by implication, the reality of Naramsin's divinity. The divine and human worlds are, in fact, united here, for above Naramsin three stars (cuneiform symbols for the gods) look on, protecting both Naramsin, their representative on Earth, and his troops. Both the copper bust of the Akkadian king and *Stele of Naramsin* testify to the role of the king in Mesopotamian culture, in general, as both hero and divinity. If the king is not exactly the supreme god Marduk of the *Hymn*, he behaves very much like him, wielding the same awe-inspiring power.

BABYLON

The Akkadians dominated Mesopotamia for just 150 years, their rule collapsing not long after 2200 BCE. For the next 400 years, various city-states thrived locally. No one in Mesopotamia matched the Akkadians' power until the first decades of the eighteenth century BCE, when Hammurabi [ham-uh-RAH-bee] of Babylon [BAB-uh-lon] (r. 1792–1750 BCE) gained control of most of the region.

The Law Code of Hammurabi

Hammurabi imposed order on Babylon where laxness and disorder, if not chaos, reigned. A giant stele, the so-called Law Code of Hammurabi, survives (Fig. 2.11). By no means the first of its kind, though by far the most complete, the stele is a record of decisions and decrees made by Hammurabi over the course of some 40 years of his reign. Its purpose was to celebrate his sense of justice and the wisdom of his rule. Atop the stele, in sculptural relief, Hammurabi receives the blessing of Shamash, the sun god; notice the rays of light coming from his shoulders. The god is much

same time, the phallic design of the stele, like such other Mesopotamian steles as the Stele of Naramsin, asserts the masculine prowess of the king. Below the relief, 282 separate "articles" cover both sides of the basalt monument. One of the great debates of legal history is the question of whether these articles actually constitute a code of law. If by code we mean a comprehensive, systematic, and methodical compilation of all aspects of Fig. 2.11 Stele of Hammurabi, from Susa

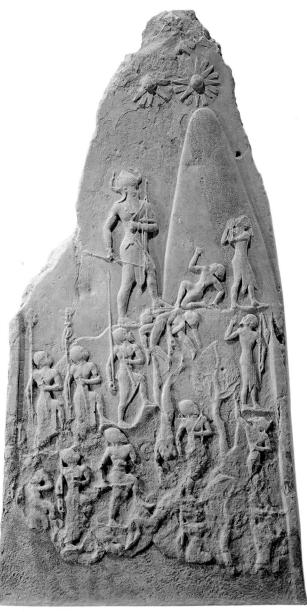

Fig. 2.10 Stele of Naramsin, from Susa (modern Shush, Iran). ca. 2254–2218 BCE. Pink sandstone, height approx. 6' 6". Chuzeville/Musée du Louvre, Paris, France. This work, which was stolen by invading Elamites around 1157 BCE, as an inscription on the mountain indicates, was for centuries one of the most influential of all artworks, copied by many rulers to celebrate their own military feats.

SEE MORE To view a Closer Look feature about the Stele of Naramsin, go to www.myartslab.com

(modern Shush, Iran). ca. 1760 BCE. Diorite, height of stele, approx. 7', height of relief, 28". Musée du Louvre, Paris. Like the Stele of Naramsin, this stele was stolen by invading Elamites and removed to Susa, where, together with the Stele of Naramsin, it was excavated by the French in 1898.

larger than Hammurabi; in fact, he is to Hammurabi as Hammurabi, the patriarch, is to his people. If Hammurabi

is divine, he is still subservient to the greater gods. At the

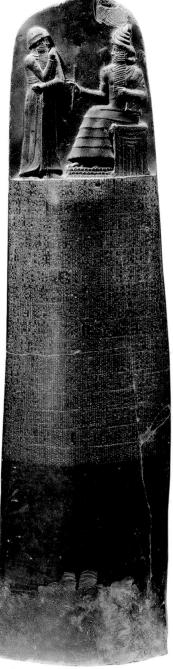

Mesopotamian law, then it is not. It is instead selective, even eccentric, in the issues it addresses. Many of its articles seem to be "reforms" of already existing law, and as such they define new principles of justice.

Principles and Social Inequalities Chief among these is the principle of *talion* [TAL-ee-un]—an eye for an eye, a tooth for a tooth—which Hammurabi introduced to Mesopotamian law. (Sections of earlier codes from Ur compensate victims of crimes with money.) This principle punished the violence or injustice perpetuated by one free person upon another, but violence by an upper-class person on a lower-class person was penalized much less severely. Slaves (who might be either war captives or debtors) enjoyed no legal protection at all—only the protection of their owner.

The code tells us much about the daily lives of Mesopotamian peoples, including conflicts great and small. In rules governing family relations and class divisions in Mesopotamian society, inequalities are sharply drawn. Women are inferior to men, and wives, like slaves, are the personal property of their husbands (although protected from the abuse of neglectful or unjust husbands). Incest is strictly forbidden. Fathers cannot arbitrarily disinherit their sons—a son must have committed some "heavy crime" to justify such treatment. The code's strongest concern is the maintenance and protection of the family, though trade practices and property rights are also of major importance.

The following excerpts from the code, beginning with Hammurabi's assertion of his descent from the gods and his status as their favorite (Reading 2.1), give a sense of the code's scope. But the code is, finally, and perhaps above all, the gift of a king to his people, as Hammurabi's epilogue, at the end of the excerpt, makes clear:

READING 2.1

from the Law Code of Hammurabi

(ca. 1792-1750 BCE)

When the august god Anu, king of the Anunnaku deities, and the god Enlil, lord of heaven and earth, who determines the destinies of the land, allotted supreme power over all peoples to the god Marduk, the firstborn son of the god Ea, exalted him among the Igigu deities, named the city of Babylon with its august name and made it supreme exalted within the regions of the world, and established for him within it eternal kingship whose foundations are as fixed as heaven and earth, at that time, the gods Anu and Bel, for the enhancement of the well-being of the people, named me by my name, Hammurabi, the pious prince, who venerates the gods, to make justice prevail in the land, to abolish the wicked and the evil, to prevent the strong from oppressing the weak, to rise like the Sun-god Shamash over all humankind, to illuminate the land. . . .

1. If a man accuses another man and charges him with homicide but cannot bring proof against him, his accuser shall be killed. . . .

- **8.** If a man steals an ox, a sheep, a donkey, a pig, or a boat—if it belongs either to the god or to the palace, he shall give thirtyfold; if it belongs to a commoner, he shall replace it tenfold; if the thief does not have anything to give, he shall be killed. . . .
- **32.** If there is either a soldier or a fisherman who is taken captive while on a royal campaign, a merchant redeems him, and helps him get back to his city—if there are sufficient in his own estate for the redeeming, he himself shall redeem himself: if there are not sufficient means in his estate to redeem him he shall be redeemed by his city's temple; if there are not sufficient means in his city's temple to redeem him, the palace shall redeem him; but his field, orchard, or house shall not be given for his redemption. . . .
- **143.** If [a woman] is not circumspect, but is wayward, squanders her household possessions, and disparages her husband, they shall cast that woman into the water. . . .
- **195.** If a child should strike his father, they shall cut off his hand.
- **196.** If an *awilu* [in general, a person subject to law] should blind the eye of another *awilu*, they shall blind his eye.
- **197.** If he should break the bone of another *awilu*, they shall break his bone. . . .
- **229.** If a builder constructs a house for a man but does not make his work sound, and the house he constructs collapses and causes the death of the householder, that builder shall be killed. . . .
- **282.** If a slave should declare to his master, "You are not my master," he (the master) shall bring charge and proof against him that he is indeed his slave, and his master shall cut off his ear. . . .

These are the decisions which Hammurabi, the able king, has established, and thereby has directed the land along the course of truth and the correct way of life.

I am Hammurabi, noble king. . .

May any king who will appear in the land in the future, at any time, observe the pronouncements of justice that I have inscribed upon my stele. May he not alter the judgments that I rendered and verdicts that I gave, nor remove my engraved image. If that man has discernment, and is capable of providing just ways for his land may he heed the pronouncements I have inscribed upon my stele, may the stele reveal for him the traditions, the proper conduct, the judgements of the land that I rendered, the verdicts of the land that I gave and may he, too, provide just ways for all humankind in his care. . . .

I am Hammurabi, king of justice. . . .

Consequences of the Code Even if Hammurabi meant only to assert the idea of justice as the basis for his own divine rule, the stele established what amounts to a uniform code throughout Mesopotamia. It was repeatedly copied for over a thousand years, long after it was removed to Susa in 1157 BCE with the Naramsin stele, and it established the rule of law in

Mesopotamia for a millennium. From this point on, the authority and power of the ruler could no longer be capricious, subject to the whim, fancy, and subjective interpretation of his singular personality. The law was now, at least ostensibly, more objective and impartial. The ruler was required to follow certain prescribed procedures. But the law, so prescribed in writing, was now also much less flexible, hard to change, and much more impersonal. Exceptions to the rule were few and difficult to justify. Eventually, written law would remove justice from the discretion of the ruler and replace it by a legal establishment of learned judges charged with enacting the king's statutes.

THE ASSYRIAN EMPIRE

With the fall of Babylon in 1595 BCE to a sudden invasion of Hittites from Turkey, the entire Middle East appears to have undergone a period of disruption and instability. Only the Assyrians, who lived around the city of Assur in the north, managed to maintain a continuing cultural identity. Over the centuries, they became increasingly powerful until, beginning with the reign of Ashurnasirpal II (r. 883–859 BCE), they dominated the entire region.

Ashurnasirpal [ah-SHOOR-na-zir-pahl] II built a magnificent capital at Kalhu (modern Nimrud), on the Tigris River, surrounded by nearly 5 miles of walls, 120 feet thick and 42 feet high. A surviving inscription tells us that Ashurnasirpal invited 69,574 people to celebrate the city's dedication. The entire population of the region, of all classes, probably did not exceed 100,000, and thus many guests from throughout Mesopotamia and farther away must have been invited.

Assyrian Art Alabaster reliefs decorated many of the walls of Ashurnasirpal's palace complex, including a depiction of Ashurnasirpal II Killing Lions (Fig. 2.12). The scene uses many of the conventions of Assyrian pictorial representation. For instance, to create a sense of deep space, the sculptor used the device of overlapping, which we first encountered in prehistoric cave paintings (see Fig. 1.2). This is done convincingly where the king stands in his chariot in front of its driver, but less so in the case of the horses drawing the chariot. For instance, there are three horse heads but only six visible legs—three in front and three in back. Furthermore, Assyrian artists never hid the face of an archer (in this case, the king himself) by realistically having him aim down the shaft of the arrow, which would have the effect of covering his eye with his hand. Instead, they drop the arrow to shoulder level and completely omit the bowstring so that it appears to pass (impossibly) behind the archer's head and back.

The scene is also a **synoptic** view, that is, it depicts several consecutive actions at once: As soldiers drive the lion toward the king from the left, he shoots it; to the right, the same lion lies dying beneath the horses' hooves. If Assyrian artists seem unconcerned about accurately portraying the animals, that is because the focus of the work is on the king himself, whose prowess in combating the lion, traditional symbol of power, underscores his own invincibility. And it is in the artists' careful balance of forms—the relationship between the positive shapes of the relief figures and the negative space between them—that we sense the importance placed on an orderly arrangement of parts. This orderliness reflects, in all probability, their sense of the orderly character of their society.

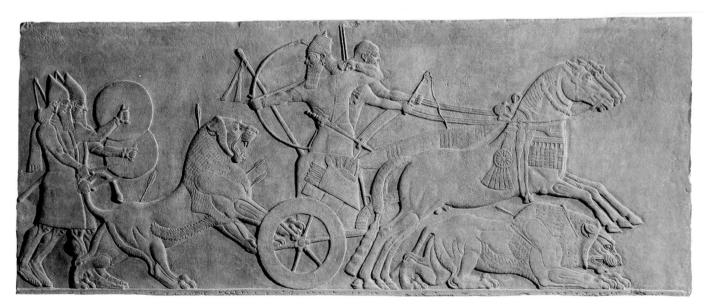

Fig. 2.12 Ashurnasirpal II Killing Lions, from the palace complex of Ashurnasirpal II, Kalhu (modern Nimrud, Iraq). ca. 850 BCE. Alabaster, height approx. 39". The British Museum, London. The repetition of forms throughout this relief helps create a stunning design. Notice especially how the two shields carried by the soldiers are echoed by the chariot wheel and the king's arched bow.

Cultural Propaganda Rulers in every culture and age have used the visual arts to broadcast their power. These reliefs were designed to celebrate and underscore for all visitors to Ashurnasirpal's palace the military prowess of the Assyrian army and their king. They are thus a form of cultural propaganda, celebrating the kingdom's achievements even as they intimidate its potential adversaries. In fact, the Assyrians were probably the most militant civilization of ancient Mesopotamia, benefactors of the invention of iron weaponry. By 721 BCE, the Assyrians had used their iron weapons to conquer Israel, and by the middle of the seventh century BCE, they controlled most of Asia Minor from the Nile Valley to the Persian Gulf.

The Assyrians also used their power to preserve Mesopotamian culture. Two hundred years after the reign of Ashurnasirpal, Ashurbanipal (r. 668–627 BCE) created the great library where, centuries later, the clay tablets containing the Sumerian *Epic of Gilgamesh*, discussed in the following pages, were stored. Its still partially intact

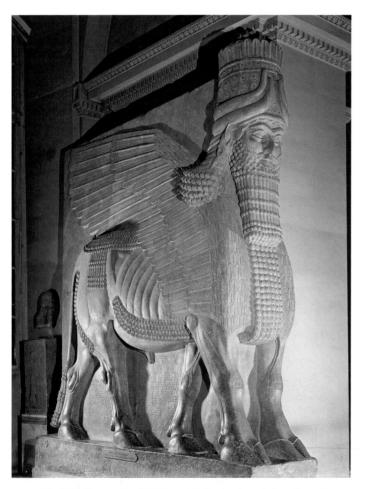

Fig. 2.13 Human-Headed Winged Bull, one of a pair from the entrance to the palace of Sargon II, Khorsabad, Iraq. ca. 720 BCE. Limestone, height approx. 13' 10". Musée du Louvre, France. Seen from a three-quarter view, as here, this hybrid beast that guarded the palace entrance has five legs. He stands firmly before you when seen from the front, and seems to stride by you when seen from the side.

collection today consists of 20,000 to 30,000 cuneiform tablets containing approximately 1,200 distinct texts, including a nearly complete list of ancient Mesopotamian rulers. Each of its many rooms was dedicated to individual subjects—history and government, religion and magic, geography, science, poetry, and important government materials.

As late as Ashurbanipal's reign, reliefs of the lion hunt were still a favored form of palace decoration, but those depicted from his palace at Nineveh, in what is now northern Iraq, reveal that the lions were caged and released for the king's hunt, which was now more ritual than real, taking place in an enclosed arena. The lions were sacrificed as an offering to the gods. In one section of the relief, Ashurbanipal, surrounded by musicians, pours a libation, a liquid offering to the gods, over the dead animals as servants bring more bodies to the offering table. This ritual was implicit in all kingly hunts, even Ashurnasirpal's 200 years earlier, for in his pursuit and defeat of the wild beast, the ruler masters the most elemental force of nature—the cycle of life and death itself.

The Assyrian kings represented their might and power not only through the immense size of their palaces and the decorative programs within, but also through massive gateways that greeted the visitor. Especially impressive are the gateways with giant stone monuments, such as those in Iraq at the Khorsabad [KOR-suh-bahd] palace of Sargon II (r. 721-705 BCE), who named himself after Sargon of Akkad. These monuments (Fig. 2.13) are composites, part man, part bull, and part eagle, the bull signifying the king's strength and the eagle his vigilance. The king himself wears the traditional horned crown of Akkad and the beard of Sumer, thus containing within himself all Mesopotamian history. Such composites, especially in monumental size, were probably intended to amaze and terrify the visitor and to underscore the ruler's embodiment of all the forces of nature, which is to say, his embodiment of the very gods.

MESOPOTAMIAN LITERATURE

Sumerian literature survives on nearly 100,000 clay tablets and fragments. Many deal with religious themes in the form of poems, blessings, and incantations to the gods.

The Blessing of Inanna

One particularly interesting Sumerian religious work is *The Blessing of Inanna* (Reading 2.2). It recounts the myth of the goddess Inanna, here depicted as a young girl from Uruk who decides to visit Enki, the god of wisdom. Inanna travels south to Eridu, the chief seaport of Sumer, where Enki lives. Apparently taken with Inanna, Enki offers a series of toasts, each time bestowing upon her one of his special powers, including the highest powers of all:

READING 2.2

The Blessing of Inanna (ca. 2300 BCE)

Enki and Inanna drank beer together.
They drank more beer together.
They drank more and more beer together.
With their bronze vessels filled to overflowing,
With the vessels of Urash, Mother of the Earth
They toasted each other; they challenged each other.
Enki, swaying with drink,
toasted Inanna: "In the name of my power!
In the name of my holy shrine!
To my daughter Inanna I shall give
The high priesthood! Godship!
The noble, enduring crown! The throne of kingship!"
Inanna replied: "I take them!"

Having gathered all 80 of Enki's mighty powers, Inanna piles them all into her boat and sails back up river. The drunken Enki realizes what he has done and tries to recover his blessings, but Inanna fends him off. She returns to Uruk, blessed as a god, and enters the city triumphantly, bestowing now her own gifts on her people, who subsequently worship her. Enki and the people of Eridu are forced to acknowledge the glory of Inanna and her city of Uruk, assuring peace and harmony between the two competing city-states.

The Sumerians worshipped Inanna as the goddess of fertility and heaven. In this tale, she and Enki probably represent the spirits of their respective cities and the victory of Uruk over Eridu. That Inanna appears in the work first as a mere mortal is a classic example of anthropomorphism, endowing the gods and the forces of nature that they represent with humanlike traits. The story has some basis in fact, since Uruk and Eridu are the two oldest Mesopotamian cities, and surviving literary fragments suggest that the two cities were at war sometime after 3400 BCE.

The Epic of Gilgamesh

One of the great surviving manuscripts of Mesopotamian culture and the oldest story ever recorded is the *Epic of Gilgamesh*. It consists of some 2,900 lines written in Akkadian cuneiform script on eleven clay tablets, none of them completely whole (Fig. 2.14). It was composed sometime before Ashurbanipal's reign, possibly as early as 1200 BCE, by Sinleqqiunninni [sin-lek-KEE-un-nin-nee] a scholar-priest of Uruk. This would make Sinleqqiunninni the oldest known author. We know that Gilgamesh was the fourth king of Uruk, ruling sometime between 2700 and 2500 BCE. (The dates of his rule were recorded on a clay tablet, the *Sumerian King List.*) Recovered fragments of his story date back nearly to his actual reign, and the story we have, known as the Standard Version, is a compilation of these earlier versions.

The work is the first example we have of an **epic**, a long, narrative poem in elevated language that follows characters of a high position through a series of adventures, often including a visit to the world of the dead. For many literary scholars, the epic is the most exalted poetic form. The central figure is a legendary or historical figure of heroic proportion, in this case the Sumerian king Gilgamesh. Homer's *lliad* and *Odyssey* (see Chapter 4) had been considered the earliest epic, until late in the nineteenth century, when *Gilgamesh* was discovered in the library of King Ashurbanipal at

Fig. 2.14 Fragment of Tablet 11 of the *Epic of Gilgamesh*, containing the Flood Story. From the Library of Ashurbanipal, Nineveh (modern Kuyunjik, Iraq). Second millennium BCE. © The Trustees of the British Museum/Art Resource, NY. This example, which is relatively complete, shows how difficult it is to reconstruct the *Gilgamesh* epic in its entirety.

Nineveh, believed to be the first library of texts in history systematically collected and organized.

The scope of an epic is large. The supernatural world of gods and goddesses usually plays a role in the story, as do battles in which the hero demonstrates his strength and courage. The poem's language is suitably dignified, often consisting of many long, formal speeches. Lists of various heroes or catalogs of their achievements are frequent.

Epics are often compilations of preexisting myths and tales handed down generation to generation, often orally, and finally unified into a whole by the epic poet. Indeed, the main outline of the story is usually known to its audience. The poet's contribution is the artistry brought to the subject, demonstrated through the use of epithets, metaphors, and similes. Epithets are words or phrases that characterize a person (for example, "Enkidu, the protector of herdsmen," or "Enkidu, the son of the mountain"). Metaphors are words or phrases used in place of another to suggest a similarity between the two, as when Gilgamesh is described as a "raging flood-wave who destroys even walls of stone." Similes compare two unlike things by the use of the word "like" or "as" (for example, "the land shattered like a pot").

Perhaps most important, the epic illuminates the development of a nation or race. It is a national poem, describing a people's common heritage and celebrating its cultural identity. It is hardly surprising, then, that Ashurbanipal preserved the *Epic of Gilgamesh*. Just as Sargon II depicted himself at the gates of Khorsabad in the traditional horned crown of Akkad and the beard of Sumer, containing within himself all Mesopotamian history, the *Epic of Gilgamesh* preserves the historical lineage of all Mesopotamian kings—Sumerian, Akkadian, Assyrian, and Babylonian. The tale embodies their own heroic grandeur, and thus the grandeur of their peoples.

The poem opens with a narrator guiding a visitor (the reader) around Uruk. The narrator explains that the epic was written by Gilgamesh himself and was deposited in the city's walls, where visitors can read it for themselves. Then the narrator introduces Gilgamesh as an epic hero, two parts god and one part human. The style of the following list of his deeds is the same as in hymns to the gods (**Reading 2.3a**):

READING 2.3a

from the Epic of Gilgamesh, Tablet I

(ca. 1200 BCE)

Supreme over other kings, lordly in appearance, he is the hero, born of Uruk, the goring wild bull. He walks out in front, the leader, and walks at the rear, trusted by his companions. Mighty net, protector of his people, raging flood-wave who destroys even walls of stone! . . . It was he who opened the mountain passes, who dug wells on the flank of the mountain.

It was he who crossed ocean, the vast seas, to the rising sun,

who explored the world regions, seeking life.

It was he who reached by his own sheer strength the Utanapishtim, the Faraway,

who restored the cities that the Flood had destroyed! . . .

Who can compare to him in kingliness? Who can say like Gilgamesh: "I am King!"?

After a short break in the text, Gilgamesh is described as having originally oppressed his people. Hearing the pleas of the people for relief, the gods create a rival, Enkidu [EN-kee-doo], to challenge Gilgamesh (Reading 2.3b):

READING 2.3b

from the Epic of Gilgamesh, Tablet I

(ca. 1200 BCE)

Enkidu

born of Silence, endowed with the strength of Ninurta. His whole body was shaggy with hair, he had a full head of hair like a woman. . . . He knew neither people nor settled living. . . . He ate grasses with the gazelles, and jostled at the watering hole with the animals.

Enkidu is, in short, Gilgamesh's opposite, and their confrontation is an example of the classic struggle between nature, represented by Enkidu, and civilization, by Gilgamesh. Seduced by a harlot (see **Reading 2.3c**, page 47), Enkidu loses his ability to commune with the animals (i.e., he literally loses his innocence), and when he finally wrestles Gilgamesh, the contest ends in a draw. The two become best friends.

Gilgamesh proposes that he and Enkidu undertake a great adventure, a journey to the Cedar Forest (either in present-day southern Iran or Lebanon), where they will kill its guardian, Humbaba [hum-BAH-buh] the Terrible, and cut down all the forest's trees. Each night on the six-day journey to the forest, Gilgamesh has a terrible dream, which Enkidu manages to interpret in a positive light. As the friends approach the forest, the god Shamash informs Gilgamesh that Humbaba is wearing only one of his seven coats of armor and is thus extremely vulnerable. When Gilgamesh and Enkidu enter the forest and begin cutting down trees, Humbaba comes roaring up to warn them off. An epic battle ensues, and Shamash intervenes to help the two heroes defeat the great guardian. Just before Gilgamesh cuts off Humbaba's head, Humbaba curses Enkidu, promising that he will find no peace in the world and will die before his friend Gilgamesh. In a gesture that clearly evokes the triumph of civilization over nature, Gilgamesh and Enkidu cut down the tallest of the cedar trees to make a great cedar gate for the city of Uruk.

At the center of the poem, in Tablet VI, Ishtar, goddess of both love and war, offers to marry Gilgamesh. Gilgamesh refuses, which unleashes Ishtar's wrath. She sends the Bull of Heaven to destroy them, but Gilgamesh and Enkidu slay it instead (see Reading 2.3c)

READING 2.3c

from the *Epic of Gilgamesh*, Tablet VI (ca. 1200 BCE)

A Woman Scorned

. . .When Gilgamesh placed his crown on his head Princess, Ishtar raised her eyes to the beauty of Gilgamesh.

"Come along, Gilgamesh, be you my husband, to me grant your lusciousness.1"

Be you my husband, and I will be your wife.

I will have harnessed for you a chariot of lapis lazuli and gold,

with wheels of gold . . .

Bowed down beneath you will be kings, lords, and princes.

The Lullubu people² will bring you the produce of the mountains and countryside as tribute.

Your she-goats will bear triplets, your ewes twins, your donkey under burden will overtake the mule, your steed at the chariot will be bristling to gallop, your ox at the yoke will have no match."

Gilgamesh addressed Princess Ishtar saying:
Do you need oil or garments for your body?
Do you lack anything for food or drink?
I would gladly feed you food fit for a god,
I would gladly give you wine fit for a king . . .
a half-door that keeps out neither breeze nor blast,
a palace that crushes down valiant warriors,
an elephant who devours its own covering,
pitch that blackens the hands of its bearer,
a waterskin that soaks its bearer through,
limestone that buckles out the stone wall,
a battering ram that attracts the enemy land,
a shoe that bites its owner's feet!
Where are your bridegrooms that you keep

forever? . . .
You loved the supremely mighty lion,
yet you dug for him seven and again seven pits.
You loved the stallion, famed in battle,
yet you ordained for him the whip, the goad,
and the lash,

ordained for him to gallop for seven and seven hours,

ordained for him drinking from muddied waters,3

¹Literally "fruit."

you ordained for his mother Silili to wail continually.

You loved the Shepherd, the Master Herder, who continually presented you with bread baked in embers,

and who daily slaughtered for you a kid.
Yet you struck him, and turned him into a wolf, so his own shepherds now chase him and his own dogs snap at his shins.
You loved Isbullant, your father's date gardener.

You loved Ishullanu, your father's date gardener, who continually brought you baskets of dates, and brightened your table daily.

You raised your eyes to him, and you went to him: 'Oh my Ishullanu, let us taste of your strength, stretch out your hand to me, and touch our "vulva."'4

Ishullanu said to you:

'Me? What is it you want from me?...'
As you listened to these his words
you struck him, turning him into a dwarf(?),⁵...
And now me! It is me you love, and you will ordain
for me as for them!"

Her Fury

When Ishtar heard this in a fury she went up to the heavens, going to Anu, her father, and crying, going to Antum, her mother, and weeping:

"Father, Gilgamesh has insulted me over and over,

"Father, Gilgamesh has insulted me over and over, Gilgamesh has recounted despicable deeds about me,

despicable deeds and curses!"

Anu addressed Princess Ishtar, saying:

"What is the matter? Was it not you who provoked King Gilgamesh?

So Gilgamesh recounted despicable deeds about you,

despicable deeds and curses!"

Ishtar spoke to her father, Anu, saying:

"Father, give me the Bull of Heaven,
so he can kill Gilgamesh in his dwelling.
If you do not give me the Bull of Heaven,
I will knock down the Gates of the Netherworld,
I will smash the door posts, and leave the doors
flat down,

and will let the dead go up to eat the living! And the dead will outnumber the living!"

Anu addressed Princess Ishtar, saying:

"If you demand the Bull of Heaven from me, there will be seven years of empty husks for the land of Uruk.

Have you collected grain for the people? Have you made grasses grow for the animals?" Ishtar addressed Anu, her father, saying:

"I have heaped grain in the granaries for the people,

⁴This line probably contains a word play on *hurdatu* as "vulva" and "date palm," the latter being said (in another unrelated text) to be "like the vulva."

5Or "frog"?

²The Lullubu were a wild mountain people living in the area of modern-day western Iran. The meaning is that even the wildest, least controllable of peoples will recognize Gilgamesh's rule and bring tribute.

³Horses put their front feet in the water when drinking, churning up mud.

I made grasses grow for the animals, in order that they might eat in the seven years of empty husks.

I have collected grain for the people,

I have made grasses grow for the animals. . . . "

When Anu heard her words,

he placed the nose-rope of the Bull of Heaven in her hand.

Ishtar led the Bull of Heaven down to the earth. When it reached Uruk. . .

It climbed down to the Euphrates . . .

At the snort of the Bull of Heaven a huge pit opened

and 100 Young Men of Uruk fell in.

At his second snort a huge pit opened up,

and 200 Young Men of Uruk fell in.

At his third snort a huge pit opened up,

and Enkidu fell in up to his waist.

Then Enkidu jumped out and seized the Bull of Heaven by its horns.

The Bull spewed his spittle in front of him, with his thick tail he flung his dung behind him (?). Enkidu addressed Gilgamesh, saying:

"My friend, we can be bold(?) . . .

Between the nape, the horns, and . . . thrust your sword."

Enkidu stalked and hunted down the Bull of Heaven. He grasped it by the thick of its tail and held onto it with both his hands (?), while Gilgamesh, like an expert butcher, boldly and surely approached the Bull of Heaven. Between the nape, the horns, and . . . he thrust his sword. . . .

Ishtar went up onto the top of the Wall of Uruk-Haven,

cast herself into the pose of mourning, and hurled her woeful curse:

"Woe unto Gilgamesh who slandered me and killed the Bull of Heaven!"

When Enkidu heard this pronouncement of Ishtar, he wrenched off the Bull's hindquarter and flung it in her face:

"If I could only get at you I would do the same to you!

I would drape his innards over your arms!". . .

Gilgamesh said to the palace retainers:

"Who is the bravest of the men?

Who is the boldest of the males?

-Gilgamesh is the bravest of the men,

the boldest of the males!

She at whom we flung the hindquarter of the Bull of Heaven in anger,

Ishtar has no one that pleases her . . ."

But Gilgamesh and Enkidu cannot avoid the wrath of the gods altogether. One of them, the gods decide, must die, and so Enkidu suffers a long, painful death, attended by his friend, Gilgamesh, who is terrified (Reading 2.3d):

READING 2.3d

from the Epic of Gilgamesh, Tablet X

(ca. 1200 BCE)

My friend . . . Enkidu, whom I love deeply, who went through every hardship with me, the fate of mankind has overtaken him.

Six days and seven nights I mourned over him and would not allow him to be buried until a maggot fell out of his nose.

I was terrified by his appearance,
I began to fear death, and so roam the wilderness.

The issue of Enkidu, my friend, oppresses me, so I have been roaming long trails through the wilderness.

How can I stay silent, how can I be still? My friend whom I love has turned to clay. And I not like him? Will I lie down, never to get up again?

Dismayed at the prospect of his own mortality, Gilgamesh embarks on a journey to find the secret of eternal life from the only mortal known to have attained it. Utnapishtim lutna-PISH-timl, who tells him the story of the Great Flood. Several elements of Utnapishtim's story deserve explanation. First of all, this is the earliest known version of the flood story that occurs also in the Hebrew Bible, with Utnapishtim in the role of the biblical Noah. The motif of a single man and wife surviving a worldwide flood brought about by the gods occurs in several Middle Eastern cultures, suggesting a single origin or shared tradition. In the Sumerian version, Ea (Enki) warns Utnapishtim of the flood by speaking to the wall, thereby technically keeping the agreement among the gods not to warn mortals of their upcoming disaster. The passage in which Ea tells Utnapishtim how to explain his actions to his people without revealing the secret of the gods is one of extraordinary complexity and wit (Reading 2.3e). The word for "bread" is kukku, a pun on the word for "darkness," kukkû. Similarly, the word for "wheat," kibtu, also means "misfortune." Thus, when Ea says, "He will let loaves of bread shower down, / and in the evening a rain of wheat," he is also telling the truth: "He will let loaves of darkness shower down, and in the evening a rain of misfortune."

READING 2.3e

from the Epic of Gilgamesh, Tablet XI

(ca. 1200 BCE)

Utanapishtim spoke to Gilgamesh, saying:
"I will reveal to you, Gilgamesh, a thing that is hidden, a secret of the gods I will tell you!
Shuruppak, a city that you surely know, situated on the banks of the Euphrates, that city was very old, and there were gods inside it.
The hearts of the Great Gods moved them to inflict the Flood

Ea, the Clever Prince, was under oath with them so he repeated their talk to the reed house: 'Reed house, reed house! Wall, wall! Hear, O reed house! Understand, O wall! O man of Shuruppak, son of Ubartutu: Tear down the house and build a boat! Abandon wealth and seek living beings! Spurn possessions and keep alive human beings! Make all living beings go up into the boat. The boat which you are to build, its dimensions must measure equal to each other: its length must correspond to its width, Roof it over like the Apsu.' I understood and spoke to my lord, Ea: 'My lord, thus is your command. I will heed and will do it. But what shall I answer the city, the populace, and the Elders?'

Ea spoke, commanding me, his servant:
'... this is what you must say to them:
"It appears that Enlil is rejecting me
so I cannot reside in your city,
nor set foot on Enlil's earth.
I will go . . . to live with my lord, Ea,
and upon you he will rain down abundance,
a profusion of fowls, myriad fishes.
He will bring you a harvest of wealth,
in the morning he will let loaves of bread shower down,
and in the evening a rain of wheat."' . . .

I butchered oxen for the meat(?), and day upon day I slaughtered sheep. I gave the workmen(?) ale, beer, oil, and wine, as if it were river water,

so they could make a party like the New Year's Festival. . . .

The boat was finished. . . . Whatever I had I loaded on it: whatever silver I had I loaded on it, whatever gold I had I loaded on it.
Al the living beings that I had I loaded on it, I had all my kith and kin go up into the boat, all the beasts and animals of the field and the craftsmen I had go up. . . .

I watched the appearance of the weather the weather was frightful to behold! I went into the boat and sealed the entry. . . . Just as dawn began to glow there arose on the horizon a black cloud. Adad rumbled inside it. . . . Stunned shock over Adad's deeds overtook the heavens, and turned to blackness all that had been light. The . . . land shattered like a . . . pot. All day long the South Wind blew . . . , blowing fast, submerging the mountain in water, overwhelming the people like an attack. No one could see his fellow, they could not recognize each other in the torrent. The gods were frightened by the Flood, and retreated, ascending to the heaven of Anu.

The gods were cowering like dogs, crouching by the outer wall. Ishtar shrieked like a woman in childbirth. . . . Six days and seven nights came the wind and flood, the storm flattening the land. When the seventh day arrived, the storm was pounding, the flood was a war-struggling with itself like a woman writhing (in labor). The sea calmed, fell still, the whirlwind (and) flood stooped up. I looked around all day long—quiet had set in and all the human beings had turned to clay! The terrain was flat as a roof. I opened a vent and fresh air (daylight?) fell upon the side of my nose. I fell to my knees and sat weeping, tears streaming down the side of my nose. I looked around for coastlines in the expanse of the sea, and at twelve leagues there emerged a region (of land). On Mt. Nimush the boat lodged firm,

Mt. Nimush held the boat, allowing no sway.

When the gods discover Utnapishtim alive, smelling his incense offering, they are outraged. They did not want a single living being to escape. But since he has, they grant him immortality and allow him to live forever in the Faraway. As a reward for Gilgamesh's own efforts, Utnapishtim tells Gilgamesh of a secret plant that will give him perpetual youth. "I will eat it," he tells the boatman who is returning him home, "and I will return to what I was in my youth." But when they stop for the night, Gilgamesh decides to bathe in a cool pool, where the scent of the plant attracts a snake who steals it away, an echo of the biblical story of Adam and Eve, whose own immortality is stolen away by the wiles of a serpent—and their own carelessness. Broken-hearted, Gilgamesh returns home empty-handed.

The Epic of Gilgamesh is the first known literary work to confront the idea of death, which is, in many ways, the very embodiment of the unknown. Although the hero goes to the very ends of the earth in his quest, he ultimately leaves with nothing to show for his efforts except an understanding of his own, very human, limitations. He is the first hero in Western literature to yearn for what he can never attain, to seek to understand what must always remain a mystery. And, of course, until the death of his friend Enkidu, Gilgamesh had seemed, in his self-confident confrontation with Ishtar and in the defeat of the Bull of Heaven, as near to a god as a mortal might be. In short, he embodied the Mesopotamian hero-king. Even as the poem asserts the hero-king's divinity—Gilgamesh is, remember, two parts god—it emphasizes his humanity and the mortality that accompanies it. By making literal the first words of the Sumerian King List—"After the kingship had descended from heaven"—the Epic of Gilgamesh acknowledges what many Mesopotamian kings were unwilling to admit, at least publicly: their own, very human, limitations, their own powerlessness in the face of the ultimate unknown—death.

THE HEBREWS

The Hebrews (from Habiru, "outcast" or "nomad") were a people forced out of their homeland in the Mesopotamian basin in about 2000 BCE. According to their tradition, it was in the delta of the Tigris and Euphrates rivers that God created Adam and Eve in the Garden of Eden. It was there that Noah survived the same great flood that Utnapishtim survived in the Epic of Gilgamesh. And it was out of there that Abraham of Ur led his people into Canaan [KAY-nun], in order to escape the warlike Akkadians and the increasingly powerful Babylonians. There is no actual historical evidence to support these stories. We know them only from the Hebrew Bible—a word that derives from the Greek, biblia, "books"—a compilation of hymns, prophecies, and laws transcribed by its authors between 800 and 400 BCE, some 1,000 years after the events the Hebrew Bible describes. Although the archeological record in the Near East confirms some of what these scribes and priests wrote, especially about more contemporaneous events, the stories themselves were edited and collated into the stories we know today. They recount the Assyrian conquest of Israel, the Jews' later exile to Babylon after the destruction of Jerusalem by the Babylonian king Nebuchadnezzar [nebuh-kud-NEZ-ur] in 587 BCE, and their eventual return to Jerusalem after the Persians conquered the Babylonians in 538 BCE. The stories represent the Hebrews' attempt to maintain their sense of their own history and destiny. But it would be a mistake to succumb to the temptation to read the Hebrew Bible as an accurate account of the historical record. Like all ancient histories, passed down orally through generation upon generation, it contains its fair share of mythologizing.

The Hebrews differed from other Near Eastern cultures in that their religion was monotheistic—they worshipped a single god, whereas others in the region tended to have gods for their clans and cities, among other things. According to Hebrew tradition, God made an agreement with the Hebrews, first with Noah after the flood, later renewed with Abraham and each of the subsequent patriarchs (scriptural fathers of the Hebrew people): "I am God Almighty; be fruitful and multiply; a nation and a company of nations shall come from you. The land which I gave to Abraham and Isaac I will give to you, and I will give the land to your descendants after you" (Genesis 35: 11–12). In return for this promise, the Hebrews, the "chosen people," agreed to obey God's will. "Chosen people" means that the Jews were chosen to set an example of a higher moral standard (a light unto the nations), not chosen in the sense of favored, which is a common misunderstanding of the term.

Genesis, the first book of the Hebrew Bible, tells the story of the creation of the world out of a "formless void." It describes God's creation of the world and all its creatures, and his continuing interest in the workings of the world, an interest that would lead, in the story of Noah, to God's near-destruction of all things. It also posits humankind as easily tempted by evil. It documents the moment of the introduction of sin (and shame) into the cosmos, associating these with the single characteristic separating humans from animals—knowledge. And it shows, in the example of Noah, the reward for having "walked with God," the basis of the covenant. (See Reading 2.4, pages 61–63, for two selections from Genesis, the story of Adam and Eve and the story of Noah.)

Moses and the Ten Commandments

The biblical story of Moses and the Ten Commandments embodies the centrality of the written word to Jewish culture. The Hebrew Bible claims that in about 1600 BCE, drought forced the Hebrew people to leave Canaan for Egypt, where they prospered until the Egyptians enslaved them in about 1300 BCE. Defying the rule of the pharaohs, the Jewish patriarch Moses led his people out of Egypt. According to tradition, Moses led the Jews across the Red Sea (which miraculously parted to facilitate the escape) and into the desert of the Sinai [SYE-nye] peninsula. (The story became the basis for the book of Exodus.) Most likely, they crossed a large tidal flat, called the Sea of Reeds; subsequently, that body of water was misidentified as the Red Sea. Unable to return to Canaan, which was now occupied by local tribes of considerable military strength, the lews settled in an arid region of the Sinai desert near the Dead Sea for a period of 40 years, which archeologists date to sometime between 1300 and 1150 BCE.

In the Sinai desert, the Hebrews forged the principal tenets of a new religion that would eventually be based on the worship of a single god. There, too, the Hebrew god supposedly revealed a new name for himself-YHWH, a name so sacred that it could neither be spoken nor written. The name is not known and YHWH is a cipher for it. There are, however, many other names for God in the Hebrew Bible, among them Elohim [eh-loe-HEEM], which is plural in Hebrew, meaning "gods, deities"; Adonai [ah-dun-EYE] ("Lord"); and El Shaddai [shah-die], literally "God of the fields" but usually translated "God Almighty." Some scholars believe that this demonstrates the multiple authorship of the Bible. Others argue that the Hebrews originally worshipped many gods, like other Near Eastern peoples. Still other scholars suggest that God has been given different names to reflect different aspects of his divinity, or the different roles that he might assume—the guardian of the flocks in the fields, or the powerful master of all. Translated into Latin as "Jehovah" [ji-HOH-vuh] in the Middle Ages, the name is now rendered in English as "Yahweh." This God

Fig. 2.15 The Ark of the Covenant and sanctuary implements, mosaic floor decorations from Hammath near Tiberias, Israel. Fourth century ce. Z. Radovan/ www.BibleLandPictures.com, Israel Antiquities Authority, Jerusalem. Two menorahs (seven-branched candelabras) flank each side of the Ark. The menorah is considered a symbol of the nation of Israel and its mission to be "a light unto the nations" (Isaiah 42:6). Instructions for making it are outlined in Exodus 25:31-40. Relatively little ancient Jewish art remains. Most of it was destroyed as the Jewish people were conquered. persecuted, and exiled.

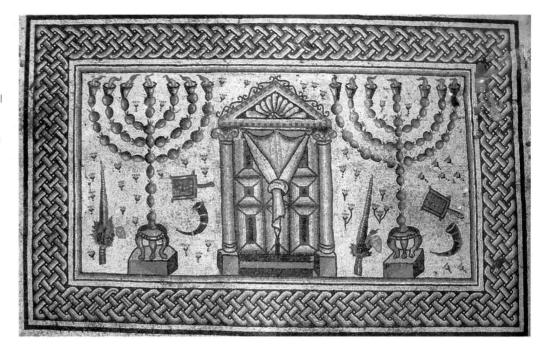

also gave Moses the Ten Commandments, carved onto stone tablets, as recorded in Deuteronomy 5:6–21. Subsequently, the Hebrews carried the commandments in a sacred chest, called the Ark of the Covenant (Fig. 2.15), which was lit by seven-branched candelabras known as *menorahs* [men-OR-uhz]. The centrality to Hebrew culture of these written words is even more apparent in the words of God that follow the commandments (Reading 2.4a):

READING 2.4a

from the Hebrew Bible (Deuteronomy 6:6-9)

- **6** Keep these words that I am commanding you today in your heart.
- **7** Recite them to your children and talk about them when you are at home and when you are away, when you lie down and when you rise.
- **8** Bind them as a sign on your hand, fix them as an emblem on your forehead,
- **9** and write them on the doorposts of your house and on your gates.

Whenever the Hebrews talked, wherever they looked, wherever they went, they focused on the commandments of their God. Their monotheistic religion was thus also an ethical and moral system derived from an omnipotent God. The Ten Commandments were the centerpiece of the Torah [tor-AH], or Law (literally "instructions"), consisting of the books of Genesis, Exodus, Leviticus, Numbers, and Deuteronomy. (Christians would later incorporate these books into their Bible as the first five books of the Old

Testament.) The Hebrews considered these five books divinely inspired and attributed their original authorship to Moses himself, although, as we have noted, the texts as we know them were written much later.

The body of laws outlined in the Torah is quite different from the code of Hammurabi. The code was essentially a list of punishments for offenses; it is not an *ethical* code (see Fig. 2.11 and Reading 2.1). Hebraic and Mesopotamian laws are distinctly different. Perhaps because the Hebrews were once themselves aliens and slaves, their law treats the lowest members of society as human beings. As Yahweh declares in Exodus 23:6: "You will not cheat the poor among you of their rights at law." At least under the law, class distinctions, with the exceptions of slaves, did not exist in Hebrew society, and punishment was levied equally. Above all else, rich and poor alike were united for the common good in a common enterprise, to follow the instructions for living as God provided.

After 40 years in the Sinai had passed, it is believed that the patriarch Joshua led the Jews back to Canaan, the Promised Land, as Yahweh had pledged in the covenant. Over the next 200 years, they gradually gained control of the region through a protracted series of wars described in the books of Joshua, Judges, and Samuel in the Bible. They named themselves the Israelites [IZ-ree-uh-lites], after Israel, the name that was given by God to Jacob. The nation consisted of 12 tribes, each descending from one of Jacob's 12 sons. By about 1000 BCE, Saul had established himself as king of Israel, followed by David, who as a boy rescued the Israelites from the Philistines [FIL-uh-steenz] by killing the giant Goliath with a stone thrown from a sling, as described in First Samuel, and later united Israel and Judah into a single state.

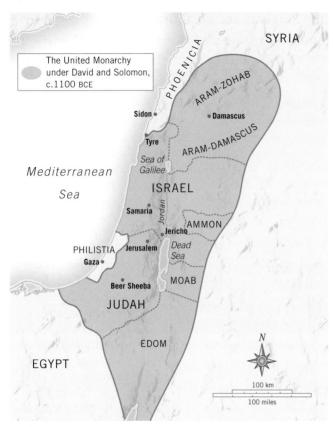

Map 2.2 The United Monarchy of Israel under David and Solomon. ca. 1100 BCF.

Kings David and Solomon, and Hebrew Society

King David reigned until 961 BCE. It was he who captured Jerusalem from the Canaanites and made it the capital of Israel (Map 2.2). As represented in the books of Samuel, David is one of the most complex and interesting individuals in ancient literature. A poet and musician, he is author of some of the Psalms. Although he was capable of the most deceitful treachery—sending one of his soldiers, Uriah [you-RYE-uh], to certain death in battle so that he could marry his widow, Bathsheba [bath-SHE-buh]—he also suffered the greatest sorrow, being forced to endure the betrayal and death of his son Absalom. David was succeeded by his other son, Solomon, famous for his fairness in meting out justice, who ruled until 933 BCE.

Solomon undertook to complete the building campaign begun by his father, and by the end of his reign, Jerusalem was, by all reports, one of the most beautiful cities in the Near East. A magnificent palace and, most especially, a splendid temple dominated the city. First Kings claims that Yahweh himself saw the temple and approved of it.

The rule of the Hebrew kings was based on the model of the scriptural covenant between God and the Hebrews. This covenant was the model for the relationship between the king and his people. Each provided protection in return for obedience and fidelity. The same relationship existed between the family patriarch and his household. His wife and children were his possessions, whom he protected in return for their unerring faith in him.

Although women were their husbands' possessions, the Hebrew Scriptures provide evidence that women may have had greater influence in Hebrew society than this patriarchal structure would suggest. In one of the many texts later incorporated into the Hebrew Bible and written during Solomon's reign, the "The Song of Songs, which is Solomon's" (as Chapter 1, Verse 1 of this short book reads), the woman's voice is particularly strong. It is now agreed that the book is not the work of Solomon himself, but rather a work of secular poetry, probably written during his reign. It is a love poem, a dialogue between a man (whose words are reproduced here in regular type) and a younger female lover, a Shulamite [SHOO-luh-mite], or "daughter of Jerusalem" (whose voice is in italics) (Reading 2.4b). This poem of sexual awakening takes place in a garden atmosphere reminiscent of Eden, but there is no Original Sin here, only fulfillment:

READING 2.4b

from the Hebrew Bible

(Song of Solomon 4:1-6, 7:13-14)

The Song of Songs (translated by Ariel and Chana Bloch)

How beautiful you are, my love, My friend! The doves of your eyes looking out from the thicket of your hair.

Your hair like a flock of goats bounding down Mount Gilead. . .

Your breasts are two fauns twins of a gazelle, grazing in a field of lilies.

An enclosed garden is my sister, my bride, A hidden well, a sealed spring. . . .

Awake, north wind! O south wind, come, breathe upon my garden, let its spices stream out.
Let my lover come into his garden and taste its delicious fruit. . . .

Let us go early to the vineyards to see if the vine has budded, if the blossoms have opened and the pomegranate is in flower.

There I will give you my love . . . rare fruit of every kind, my love, I have stored away for you.

So vivid are the poem's sexual metaphors that many people have wondered how the poem found its way into the Scriptures. But the Bible is frank enough about the attractions of sex. Consider Psalms 30:18–19: "Three things I marvel at, four I cannot fathom: the way of an eagle in the sky, the way of a snake on a rock, the way of a ship in the heart of the sea, the way of a man with a woman." The Song of Songs is full of double entendres [on-TAHN-druh], expressions that can be understood in two ways, one of them often sexual or risqué. Although the implications of such language are almost unavoidable, embarrassed Christian interpreters of the Bible for centuries worked hard to avoid the obvious and assert a higher purpose for the poem, reading it, especially, as a description of the relation between Christ and his "Bride," the Church.

Generations of translators also sought to obscure the powerful voice of the female protagonist in the poem by presenting the young woman as chaste and submissive, but of the two voices, hers is the more active and authoritative. In a world in which history is traced through the patriarchs, and genealogies are generally written in the form of the father "begetting" his sons, the young woman asserts herself here in a way that suggests that if in Hebrew society the records of lineage was in the hands of its men, the traditions of love-making—and by extension, the ability to propagate the lineage itself—were controlled by its women. It is even possible that a woman composed all or large parts of the poem, since women traditionally sang songs of victory and mourning in the Bible, and the daughters of Jerusalem actually function as a chorus in the poem, asking questions of the Shulamite.

The Prophets and the Diaspora

After Solomon's death, the United Monarchy of Israel split into two separate states. To the north was Israel, with its capital in Samaria [suh-MAR-ee-uh], and to the south, Judah, with its capital in Jerusalem. In this era of the two kingdoms, Hebrew culture was dominated by prophets, men who were prophetic not in the sense of foretelling the future, but rather in the sense of serving as mouthpieces and interpreters of Yahweh's purposes, which they claimed to understand through visions. The prophets instructed the people in the ways of living according to the laws of the Torah, and they more or less freely confronted anyone guilty of wrongful actions, even the Hebrew kings. They attacked, particularly, the wealthy Hebrews whose commercial ventures had brought them unprecedented material comfort and who were inclined to stray from monotheism and worship Canaanite [KAY-nuh-nite] fertility gods and goddesses. The moral laxity of these wealthy Hebrews troubled the prophets, who urged the Hebrew nation to reform spiritually.

In 722 BCE, Assyrians attacked the northern kingdom of Israel and scattered its people, who were thereafter known as the Lost Tribes of Israel. The southern kingdom of Judah survived another 140 years, until Nebuchadnezzar and the Babylonians overwhelmed it in 587 BCE, destroying the Temple of Solomon in Jerusalem and deporting the Hebrews to Babylon (Fig. 2.16). Not only had the Hebrews lost their homeland and their temple,

Fig. 2.16 Exile of the Israelites, from the palace of Sennacherib, Nineveh, Assyria. Late eighth century BCE.

Limestone. This relief shows a family of Israelites, their cattle yoked to a cart carrying their household into exile after being defeated by the Assyrians in 722 BCE. The relief seems to depict three generations of a family: the father in front with the cattle, the son behind carrying baggage, the wife of the father seated on the front of the cart, the son's wife and children seated behind her.

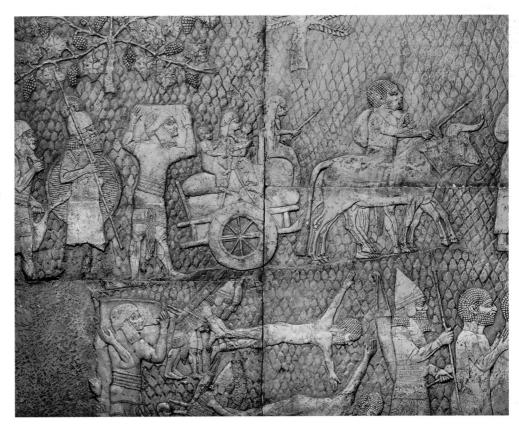

but the Ark of the Covenant itself disappeared. For nearly 60 years, the Hebrews endured what is known as the Babylonian Captivity. As recorded in Psalm 137: "By the rivers of Babylon, there we sat down, yea we wept, when we remembered Zion."

Finally, invading Persians, whom they believed had been sent by Yahweh, freed them from the Babylonians in 520 BCE. They returned to Judah, known now, for the first time, as the Jews (after the name of their homeland). They rebuilt a Second Temple of Jerusalem, with an empty chamber at its center, meant for the Ark of the Covenant should it ever return. And they welcomed back other Jews from around the Mediterranean, including many whose families had left the northern kingdom almost 200 years earlier. Many others, however, were by now permanently settled elsewhere, and they became known as the Jews of the Diaspora [die-AS-puh-ruh], or the "dispersion."

Hebrew culture would have a profound impact on Western civilization. The Jews provided the essential ethical and moral foundation for religion in the West, including Christianity and Islam, both of which incorporate Jewish teachings into their own thought and practice. In the Torah, we find the basis of the law as we understand and practice it today. So moving and universal are the stories recorded in the Torah that over the centuries they have inspired—and continue to inspire—countless works of art, music, and literature. Most important, the Hebrews introduced to the world the concept of ethical monotheism, the idea that there is only one God, and that God demands that humans behave in a certain way, and rewards and punishes accordingly. Few, if any, concepts have had a more far-reaching effect on history and culture.

NEO-BABYLONIA

From the eighth through the seventh century BCE, Babylon fell in and out of Assyrian rule, until Nabopolassar (r. 626–604 BCE), the first king of Babylonia, defeated the Assyrians, sacking Nineveh in 612 BCE. The Assyrian Empire collapsed completely in 609 BCE. Nabopolassar was followed by his son and heir, Nebuchadnezzar (r. 604–562 BCE), who continued on with his father's plan to restore Babylon's palace as the center of Mesopotamian civilization. It was here that the Hebrews lived in exile for nearly 50 years (586–538 BCE) after Nebuchadnezzar captured the people of Jerusalem.

Nebuchadnezzar wished to remake Babylon as the most remarkable and beautiful city in the world. It was laid out on both sides of the Euphrates River, joined together by a single bridge. Through the middle of the older, eastern sector, ran the Processional Way, an avenue also called "May the Enemy Not Have Victory" (Fig. 2.17). It ran from the Euphrates bridge eastward through the temple district, past the Marduk ziggurat. (Many believe this ziggurat was the legendary Tower of Babel [BAB-ul], described in Genesis 11 as the place where God, confronted with the prospect of "one people. . . one language," chose instead to "confuse the language of all the earth," and scatter people "abroad"

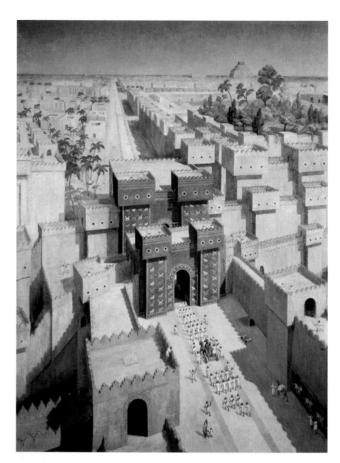

Fig. 2.17 Reconstruction drawing of Babylon with the Processional Way and the Ishtar Gate as it might have appeared in the sixth century BCE. Courtesy of the Oriental Institute of the University of Chicago. In the distance is the Marduk Ziggurat, and between the ziggurat and the Ishtar Gate are the famous Hanging Gardens in the palace of Nebuchadnezzar II.

over the face of the earth.") Then it turned north, ending at the Ishtar Gate, the northern entrance to the city. Processions honoring Marduk, the god celebrated above all others in Babylonian lore and considered the founder of Babylon itself, regularly filled the street, which was as much as 65 feet wide at some points and paved with large stone slabs. Marduk's might is celebrated in the *Hymn to Marduk* (Reading 2.5), found in Ashurbanipal's library:

READING 2.5

from the Hymn to Marduk (1000-700 BCE)

Lord Marduk, Supreme god, with unsurpassed wisdom. . . .

When you leave for battle the Heavens shake, when you raise your voice, the Sea is wild! When you brandish your sword, the gods turn back.

There is none who can resist your furious blow! Terrifying lord, in the Assembly of the gods no one equals you! . . .

Your weapons flare in the tempest!
Your flame annihilates the steepest mountain.

No trace of the city's famous Hanging Gardens survives, once considered among the Seven Wonders of the World, and only the base and parts of the lower stairs of the Marduk ziggurat still remain. But in the fifth century BCE, the Greek historian Herodotus [he-ROD-uh-tus] (ca. 484–430/420 BCE) described the ziggurat as follows:

There was a tower of solid masonry, a furlong in length and breadth, on which was raised a second tower, and on that a third, and so on up to eight. The ascent to the top is on the outside, by a path which winds round all the towers.... On the topmost tower, there is a spacious temple, and inside the temple stands a couch of unusual size, richly adorned with a golden table by its side.... They also declare that the god comes down in person into this chamber, and sleeps on the couch, but I do not believe it.

Although the ziggurat has disappeared, we can glean some sense of the city's magnificence from the Ishtar Gate (Fig. 2.18), named after the Babylonian goddess of fertility.

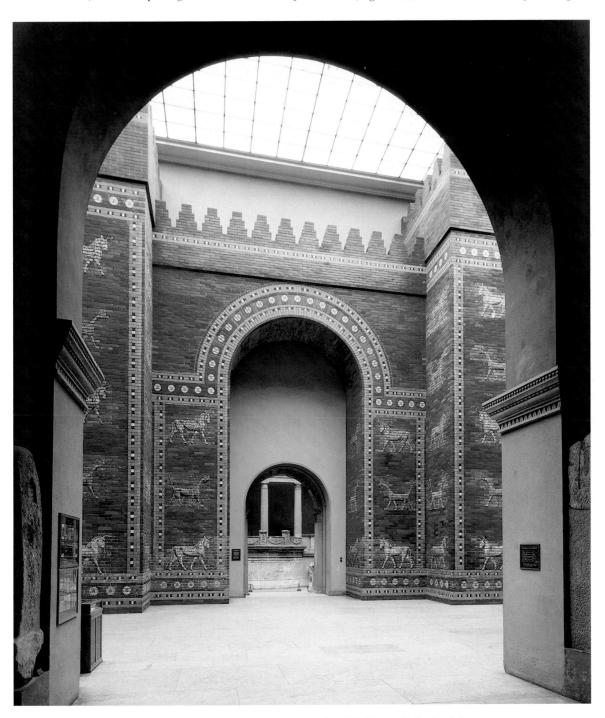

Fig. 2.18 Ishtar Gate (restored), from Babylon. ca. 575 BCE. Glazed brick. Staatliche Museen, Berlin. The dark blue bricks are glazed—that is, covered with a film of glass—and they would have shown brilliantly in the sun.

SEE MORE To view a Closer Look feature about the Ishtar Gate, go to www.myartslab.com

Today, the gate is restored and reconstructed inside one of the Berlin State Museums. It was made of glazed and unglazed bricks, and decorated with animal forms. The entire length of the Processional Way was similarly decorated on both sides, so the ensemble must have been a wondrous sight. The gate's striding lions are particularly interesting. They are traditional symbols of Ishtar herself. Alternating with rows of bulls with blue horns and tails, associated with deities such as Adad [AD-dad], god of the weather, are fantastic dragons with long necks, the forelegs of a lion, and the rear legs of a bird of prey, an animal form sacred to the god Marduk. Like so much other Mesopotamian art, it is at once a monument to the power of Nebuchadnezzar, an affirmation of his close relation to the gods, and a testament to his kingdom's wealth and well-being.

THE PERSIAN EMPIRE

In 520 BCE, the Persians, formerly a minor nomadic tribe that occupied the plateau of Iran, defeated the Babylonians and freed the Jews. Their imperial adventuring had begun in 559 BCE with the ascension of Cyrus II (called the Great, r. 559–530 BCE), the first ruler of the Achaemenid dynasty, named after Achaemenes [eck-KEE-min-ees], a warrior-king whom Persian legend says ruled on the Iranian plateau around 700 BCE. By the time of Cyrus's death, the Persians had taken control of the Greek cities in Ionia on the west coast of Anatolia. Under King Darius [duh-RY-us] (r. 522–486 BCE), they soon ruled a vast empire that stretched from Egypt in the south, around Asia Minor, to the Ukraine [you-KRAIN] in the north. The capital of the empire was Parsa, which the Greeks called Persepolis

[per-SEP-uh-lis], or city of the Persians, located in the Zagros [ZAG-rus] highlands of present-day Iran (Fig. **2.19**). Built by artisans and workers from all over the Persian Empire, including Greeks from Ionia, it reflected Darius's multicultural ambitions. If he was, as he said, "King of King, King of countries, King of the earth," his palace should reflect the diversity of his peoples.

The columns reflect Egyptian influence, and, especially in their fluting, the vertical channels that exaggerate their height and lend them a feeling of lightness, they reflect, as we will later see, in Chapter 4, the influence of the Greeks. Rulers are depicted in relief sculptures with Assyrian beards and headdresses (Fig. 2.20). In typical Mesopotamian fashion, they are larger than other people in the works. These decorations further reflect the Persians' sense that all the peoples of the region owed them allegiance. This relief, from stairway to the audience hall where Darius and his son Xerxes received visitors, is covered with images of their subjects bringing gifts to the palace—23 subject nations in all—Ionian, Babylonian, Syrian, Susian, and so on—each culture recognizable by its beards and costumes. Darius can be seen receiving tribute as Xerxes stands behind him as if waiting to take his place as the Persian ruler. Huge winged bulls with the heads of bearded kings, reminiscent of the human-headed winged bulls that guard the Khorsabad palace of Assyrian king Sargon II (see Fig. 2.13), dominated the approach to the south gateway. Thus, Mesopotamian, Assyrian, Egyptian, and Greek styles all intermingle in the palace's architecture and decoration.

The Persians also perfected the art of metalwork. The rhyton, or ritual cup, illustrated here (Fig. 2.21), is related to the many mythological creatures that can be

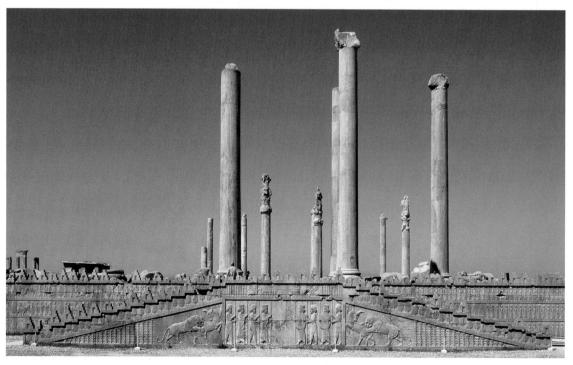

Fig. 2.19 Palace of Darius and Xerxes, Persepolis, Iran. 518—ca. 460 BCE. The palace stands on a rock terrace 545 yards deep and 330 yards wide. Approached by a broad staircase decorated with men carrying gifts, its centerpiece was the Hall of One Hundred Columns, a forest of stone comprised of ten rows of ten columns, each rising to a height of 40 feet.

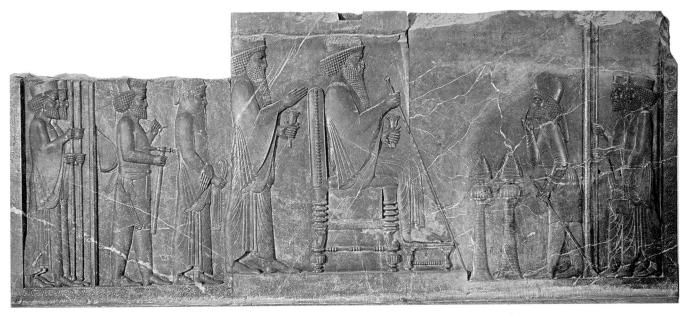

Fig. 2.20 Darius and Xerxes Receiving Tribute, detail of a relief from a stairway leading to the Apadana, ceremonial complex, Persepolis, Iran. 491–486 BCE. Limestone, height 8' 4". Iranbastan Museum, Teheran. This panel was originally painted in blue, scarlet, green, purple, and turquoise. Objects such as Darius's necklace and crown were covered in gold.

Fig. 2.21 Rhyton. Achaemenid, fifth—third centuries BCE. Gold.
Archaeological Museum, Teheran, Iran. This elaborate gold vessel would have probably served as both a drinking cup and a wine decanter.

found throughout Mesopotamian art—the hybrid human and bull creature that guarded the palace gate at Parsa, for instance, or the dragon with lion's feet decorating the Ishtar Gate in Babylon. This gold rhyton has been fashioned into a simurgh, a mythical creature with the body of a lion, the head of a dog, the wings of a griffin, and a peacock's tail.

The rhyton would have been used in rituals connected to the Zoroastrian religion practiced by the Persians. Zoroaster (the Greek name for the Iranian Zarathustra) was a Persian prophet who according to tradition lived in the sixth century BCE. However, linguistic analysis of the writings that are attributed to him places him ca. 1000 BCE. Whatever the case, his writings and other ritual hymns, prayers, and laws associated with the religion were collected in the sixth century into the Zend-Avesta [zen-dah-VEStah], or Book of Knowledge, the holy book of the Zoroastrian faith. Ahura Mazda, "the Wise Lord," is its supreme deity, creator of heaven and earth, and in almost all inscriptions, the one and only god. But Zoroastrianism is only semi-monotheistic: there are lesser gods—many of them remnants of earlier religious practices—but all of them created by Ahura Mazda himself. The Zend-Avesta sets up a dualistic universe in which asha (literally, "truth") is opposed to druj ("lie" or "deceit"). The physical order of the universe is the chief manifestation of asha and is wholly the work of Ahura Mazda. Druj manifests itself as anything that is opposed to this physical order—chaos, natural decay, evil deeds. Perhaps Zoroaster's greatest contribution to religious thought is his emphasis on free will. As the Zend-Avesta says, Ahura Mazda "has left it to men's wills" to choose for themselves whether to lead a life of "good thoughts, good words, good deeds." Those who do-thus helping Ahura Mazda to maintain the order of the universe-will be admitted to heaven. Those who choose to follow the path of evil will be condemned to hell.

In Zoroastrian tradition, the simurgh whose image is invoked on the rhyton lives on Mount Alburz, the highest mountain in the world, around which circled the sun, moon, and stars. From the summit of the mountain, the legendary Chinwad bridge, the "bridge of judgment," extended to heaven. There, the souls of the good men and women are greeted by a beautiful maiden and led across an ever-widening pathway to pairidaeza, from which the English word "paradise" derives, and the souls of the bad are greeted by an ugly old hag and led across an ever-narrowing bridge until they fall into hell. The bridge is described at some length in the Zend-Avesta (Reading 2.6):

READING 2.6

from the Zend-Avesta (ca. 600 BCE)

- 27. O Maker of the material world, thou Holy One! Where are the rewards given? Where does the rewarding take place? Where is the rewarding fulfilled? Whereto do men come to take the reward that, during their life in the material world, they have won for their souls?
- 28. Ahura Mazda answered: "When the man is dead. when his time is over, then the wicked, evil-doing Daevas1 cut off his eyesight. On the third night, when the dawn appears and brightens up, when Mithra, the god with beautiful weapons, reaches the all-happy mountains, and the sun is rising
- 29. 'Then the fiend, named Vizaresha², O Spitama³ Zoroaster, carries off in bonds the souls of the wicked Daeva-worshippers who live in sin. The soul enters the way made by Time, and open both to the wicked and to the righteous. At the head of the Chinwad bridge, the holy bridge made by Mazda, they ask for their spirits and souls the reward for the worldly goods which they gave away here below.
- 30. "Then comes the beautiful, well-shapen, strong and well-formed maid, with the dogs at her sides, one who can distinguish, who has many children, happy, and of high understanding. She makes the soul of the righteous one go up above . . . the Chinwad bridge; she places it in the presence of the heavenly gods themselves."

Daevas: supernatural entities with variously disagreeable characteristics; in the oldest Zoroastrian works they are "wrong" or "false" gods that are to be rejected in favor of the worship of the one God, Ahura-Mazda

²Vizaresh: a demon who, during that struggle of three days and three nights with the souls of the departed, wages terror on them and beats them. He sits at the gate of hell.

3Spitama: the original name of Zoroaster, who as a prince gave up his royal duties to meditate, spending fifteen years searching for enlightenment before a vision of Ahura-Mazda gave him the answers to his many questions.

In this context, it is worth recalling that the Zend-Avesta was compiled at about the same time as the Hebrew Bible. Its teachings would, in fact, influence all three of the great religions of the Western world—Judaism, Christianity, and Islam.

The Stability of Egyptian Culture

ivilization in Mesopotamia developed across the last three millennia BCE almost simultaneously with civilization in Egypt, a region on the northeastern corner of the African continent in close proxim-

ity to Mesopotamian and Mediterranean cultures. The civilizations of Egypt and Mesopotamia have much in common. Both formed around river systems—the Tigris and Euphrates in Mesopotamia; the Nile in Egypt. Both were agrarian societies that depended on irrigation, and their economies were hostage to the sometimes fickle, sometimes violent flow of their respective river systems. As in Mesopotamia, Egyptians learned to control the river's flow by constructing dams and irrigation canals, and it was probably the need to cooperate with one another in such endeavors that helped Mesopotamia and Egypt to create the civilization that would eventually arise in the Nile Valley.

The Mesopotamians and the Egyptians built massive architectural structures dedicated to their gods—the ziggurat in Mesopotamia and the pyramid in Egypt (see Figs. 2.1 and 3.6). Both unite the Earth and the heavens in a single architectural form, although the Mesopotamian ziggurat is topped by a temple and is considered the house of the city-state's god, and the Egyptian pyramid is funerary in nature with a royal burial

in the bottom. Both cultures developed forms of writing, although the cuneiform style of Mesopotamian culture and the hieroglyph style of Egyptian society were very different. There is ample evidence that the two civilizations traded with one another, and to a certain degree influenced one another.

What most distinguishes Mesopotamian from Egyptian culture, however, is the relative stability of the latter. Mesopotamia was rarely, if ever, united as a single entity. Whenever it was united, it was through force, the power of an

army, not the free will of a people striving for the common good. In contrast, political transition in Egypt was dynastic—that is, rule was inherited by members of the same family, sometimes for generations. As in Mesopotamia, however, the ruler's authority was cemented by his association with divine authority. He was, indeed, the manifestation of the gods on Earth. As a result, the dynastic rulers of Egypt sought to immortalize themselves through art and architecture. In fact, there is clear reason to believe that the sculptural image of a ruler was believed to be, in some sense, the ruler himself.

Embodying the ruler's sense of his own permanence is an obeliska four-sided stone shaft topped by a pyramidshaped block—which once marked the entrance to the Amon temple at Luxor during the reigns of the pharaohs Ramses II and Ramses III (Fig. 2.22). Some 3,300 years old, it stands today at the center of the Place de la Concorde in Paris, a gift to the French from the Egyptian government in the nineteenth century. The in-

scription, carved in hieroglyphics, says it all: "Son of Ra [the sun god]: Ramses-Meryamum ["Beloved of Amun"]. As long as the skies exist, your monuments shall exist, your name shall exist, firm as the skies."

Fig. 2.22 Obelisk of Luxor in the Place de la Concorde, Paris. Dynasty 19, ca. 1279–1213 BCE. Height 75'. The obelisk was a gift of the Egyptian government to the French, presented to them in 1829 by the Egyptian viceroy, Mehemet Ali. Gilded images on the pedestal portray the monumental task of transporting the monolith to Paris and erecting it in the city's most central square, the Place de la Concorde.

What characteristics distinguish the ancient civilizations of Sumer, Akkad, Babylon, and Assyria?

The royal tombs at the Sumerian city of Ur reveal a highly developed Bronze Age culture, based on the social order of the city-state, which was ruled by a priest-king acting as the intermediary between the gods and the people. The rulers also established laws and encouraged record-keeping, which in turn required the development of a system of writing—cuneiform script. In Sumer and subsequent Mesopotamian cultures, monumental architecture such as ziggurats were dedicated to the gods, and in each city-state, one of the gods rose to prominence as the city's protector. Under the rule of Hammurabi of Babylon, Mesopotamian law was codified, specifically in the stele that records the *Law Code of Hammurabi*. How would you characterize the general relationship between Mesopotamian rulers and the gods?

How does the Epic of Gilgamesh embody the relationship between the Mesopotamian ruler and the gods?

Preserved in the library of the Assyrian king Ashurbanipal, the *Epic of Gilgamesh* remains one of the greatest expressions of world literature. The sense of cultural continuity in Mesopotamia is underscored by the fact that the *Epic of Gilgamesh* preserves the historical lineage of all Mesopotamian kings—Sumerian, Akkadian, Babylonian,

and Assyrian. While asserting the king's divinity, the story also admits the king's human mortality. What are the characteristics of its epic form? What are its principal themes?

What distinguished the Hebrews from other cultures of the Ancient Near East?

The Hebrews practiced a monotheistic religion. They considered themselves the "chosen people" of God, whom they called Yahweh. The written word is central to their culture, and it is embodied in a body of law, the Torah, and more specifically in the Ten Commandments. What does the Torah have in common with the Law Code of Hammurabi? How does it differ? How do the stories in Genesis, the first book of the Hebrew Bible, compare to the *Epic of Gilgamesh*?

What characteristics did the Persian religion share with Judaism?

The last of the great Mesopotamian empires arose on the Iranian plateau. The Persian kings practiced the Zoroastrian religion. Like the Jews, the Persians' beliefs were collected in a single holy book, compiled at about the same time as the Hebrew Bible. However, the Persian religion was only semi-monotheistic. Their supreme deity, Ahura Mazda, was the creator of many lesser gods. In what way was Zoroastrian religion dualistic?

PRACTICE MORE Get flashcards for images and terms and review chapter material with quizzes at www.myartslab.com

GLOSSARY

city-states Governments based in urban centers of the Mesopotamian basin that controlled neighboring regions; also an independent self-governing city.

composite Made up of distinct parts.

cuneiform writing A writing system composed of wedge-shaped characters.

cylinder seal An engraved piece of stone or other material used as a signature, confirmation of receipt, or identification of ownership.

double entendre A word or expression that can be understood two ways, with one often having a sexual or risqué connotation.

epic A long narrative poem in elevated language that follows characters of a high position through a series of adventures, often including a visit to the world of the dead.

epithet A word or phrase that characterizes a person.

fluting The vertical channels in a column shaft.

ground-line A baseline.

hieratic scale A pictorial convention in which the most important figures are represented in a larger size than the others; see also *social perspective*.

lost-wax casting A sculptural process in which a figure is modeled in wax and covered in plaster or clay; firing melts away the wax and hardens the plaster or clay, which then becomes a mold for molten metal.

metallurgy The science of separating metals from their ores.

metaphor A word or phrase used in place of another to suggest a likeness.

 $\boldsymbol{\mathsf{narrative}}$ genre $\ A$ class or category of story with a universal theme.

narrative scene A scene that represents a story or event.patriarch A scriptural father of the Hebrew people.phonetic writing A writing system in which signs represent sounds.

pictogram A picture that represents a thing or concept. **priest-king** In ancient Mesopotamia, a government leader who acted as an intermediary between gods and people and established laws.

prophet One who serves as a mouthpiece for and interpreter of Yahweh's purposes, which is understood through visions. **register** A self-contained horizontal band.

 $\textbf{simile} \ \ A \ comparison \ of \ two \ unlike \ things \ using \ the \ word \ \textit{like}$

social perspective A pictorial convention in which the most important figures are represented in a larger size than the others; see also *hierarchy of scale*.

stele An upright stone slab carved with a commemorative design or inscription.

stylus A writing tool.

synoptic A view that depicts several consecutive actions at once. **ziggurat** A pyramidal temple structure consisting of successive platforms with outside staircases and a shrine at the top.

READING 2.3

from the Epic of Gilgamesh, Tablet I (ca. 1200 BCE) (translated by Maureen Gallery Kovacs)

The Epic of Gilgamesh describes the exploits of the Sumerian ruler Gilgamesh and his friend Enkidu. The following passage, from the first of the epic's 12 tablets, recounts how Enkidu, the primal man raised beyond the reach of civilization and fully at home with wild animals, loses his animal powers, and with them his innocence, when a trapper, tired of Enkidu freeing animals from his traps, arranges for a harlot from Uruk to seduce him. The story resonates in interesting ways with the biblical tale of Adam and Eve and their loss of innocence in the Garden of Eden.

10

20

TABLET I

THE HARLOT

The trapper went, bringing the harlot, Shamhat, with him, they set off on the journey, making direct way.

On the third day they arrived at the appointed place, and the trapper and the harlot sat down at their posts(?).

A first day and a second they sat opposite the watering hole. The animals arrived and drank at the watering hole, the wild beasts arrived and slaked their thirst with water. Then he, Enkidu, offspring of the mountains, who eats grasses with the gazelles, came to drink at the watering hole with the animals, with the wild beasts he slaked his thirst with water. Then Shamhat saw him—a primitive, a savage fellow from the depths of the wilderness!

"That is he, Shamhat! Release your clenched arms, expose your sex so he can take in your voluptuousness. Do not be restrained—take his energy! When he sees you he will draw near to you. Spread out your robe so he can lie upon you, and perform for this primitive the task of womanhood! His animals, who grew up in his wilderness, will become alien to him, and his lust will groan over you."

Shamhat unclutched her bosom, exposed her sex, and he took in her voluptuousness.

She was not restrained, but took his energy. She spread out her robe and he lay upon her, she performed for the primitive the task of womankind. His lust groaned over her; for six days and seven nights Enkidu stayed aroused, and had intercourse with the harlot 30 until he was sated with her charms. But when he turned his attention to his animals, the gazelles saw Enkidu and darted off, the wild animals distanced themselves from his body. Enkidu . . . his utterly depleted (?) body, his knees that wanted to go off with his animals went rigid; Enkidu was diminished, his running was not as before. But then he drew himself up, for his understanding had broadened.

READING CRITICALLY

In giving in to the temptation of the harlot Shamhat, Enkidu loses much here, but he also gains something. What is it that he comes to understand? How does it differ from the physical prowess that he has evidently lost?

READING 2.4

from the Hebrew Bible, Genesis (Chapters 2-3, 6-7)

The following excerpts from the first book of both the Hebrew Torah and the Christian Old Testament describe the story of Adam and Eve and the story of Noah. Together they demonstrate some of the characteristics of Hebrew monotheism—belief in the direct agency of their God in the workings of the world and his creation of a universe that is systematically planned and imbued with a moral order that derives from him. The passages also demonstrate the power and authority the Hebrews invested in their God.

CHAPTER 2

- 1 Thus the heavens and the earth were finished, and all their multitude.
- **2** And on the seventh day God finished the work that he had done, and he rested on the seventh day from all the work that he had done.
- **3** So God blessed the seventh day and hallowed it, because on it God rested from all the work that he had done in creation . . .
- 7 then the LORD God formed man from the dust of the ground, and breathed into his nostrils the breath of life; and the man became a living being.

- **8** And the LORD God planted a garden in Eden, in the east; and there he put the man whom he had formed.
- **9** Out of the ground the LORD God made to grow every tree that is pleasant to the sight and good for food, the tree of life also in the midst of the garden, and the tree of the knowledge of good and evil.
- **10** A river flows out of Eden to water the garden, and from there it divides and becomes four branches.
- **11** The name of the first is Pishon; it is the one that flows around the whole land of Havilah, where there is gold;
- **12** and the gold of that land is good; odellium and onyx stone are there.

- **13** The name of the second river is Gihon; it is the one that flows around the whole land of Cush.
- **14** The name of the third river is Tigris, which flows east of Assyria. And the fourth river is the Euphrates.
- **15** The LORD God took the man and put him in the garden of Eden to till it and keep it.
- **16** And the LORD God commanded the man, "You may freely eat of every tree of the garden;
- 17 but of the tree of the knowledge of good and evil you shall not eat, for in the day that you eat of it you shall die."
- **18** Then the LORD God said, "It is not good that the man should be alone; I will make him a helper as his partner."
- **19** So out of the ground the LORD God formed every animal of the field and every bird of the air, and brought them to the man to see what he would call them; and whatever the man called every living creature, that was its name.
- **20** The man gave names to all cattle, and to the birds of the air, and to every animal of the field; but for the man there was not found a helper as his partner.
- **21** So the LORD God caused a deep sleep to fall upon the man, and he slept; then he took one of his ribs and closed up its place with flesh.
- **22** And the rib that the LORD God had taken from the man he made into a woman and brought her to the man.
- 23 Then the man said, "This at last is bone of my bones and flesh of my flesh; this one shall be called Woman, for out of Man this one was taken."
- **24** Therefore a man leaves his father and his mother and clings to his wife, and they become one flesh.
- 25 And the man and his wife were both naked, and were not ashamed.

THE TEMPTATION AND EXPULSION

CHAPTER 3

- 1 Now the serpent was more crafty than any other wild animal that the LORD God had made. He said to the woman, "Did God say, 'You shall not eat from any tree in the garden'?"
- 2 The woman said to the serpent, "We may eat of the fruit of the trees in the garden;
- **3** but God said, 'You shall not eat of the fruit of the tree that is in the middle of the garden, nor shall you touch it, or you shall die."'
- 4 But the serpent said to the woman, "You will not die;
- **5** for God knows that when you eat of it your eyes will be opened, and you will be like God, knowing good and evil."
- **6** So when the woman saw that the tree was good for food, and that it was a delight to the eyes, and that the tree was to be desired to make one wise, she took of its fruit and ate; and she also gave some to her husband, who was with her, and he ate.
- **7** Then the eyes of both were opened, and they knew that they were naked; and they sewed fig leaves together and made loincloths for themselves.
- **8** They heard the sound of the LORD God walking in the garden at the time of the evening breeze, and the man and his wife hid themselves from the presence of the LORD God among the trees of the garden.

- **9** But the LORD God called to the man, and said to him, "Where are you?"
- 10 He said, "I heard the sound of you in the garden, and I was afraid, because I was naked; and I hid myself."
- 11 He said, "Who told you that you were naked? Have you eaten from the tree of which I commanded you not to eat?"
- 12 The man said, "The woman whom you gave to be with me, she gave me fruit from the tree, and I ate."

30

- 13 Then the LORD God said to the woman, "What is this that you have done?" The woman said, "The serpent tricked me, and I ate."
- **14** The LORD God said to the serpent, "Because you have done this, cursed are you among all animals and among all wild creatures; upon your belly you shall go, and dust you shall eat all the days of your life.
- **15** I will put enmity between you and the woman, and between your offspring and hers; he will strike your head, and you will strike his heel."
- **16** To the woman he said, "I will greatly increase your pangs in childbearing; in pain you shall bring forth children, yet your desire shall be for your husband, and he shall rule over you."
- 17 And to the man he said, "Because you have listened to the voice of your wife, and have eaten of the tree about which I commanded you, 'You shall not eat of it,' cursed is the ground because of you; in toil you shall eat of it all the days of your life;
- **18** thorns and thistles it shall bring forth for you; and you shall eat the plants of the field.
- **19** By the sweat of your face you shall eat bread until you return to the ground, for out of it you were taken; you are dust, and to dust you shall return."
- **20** The man named his wife Eve, because she was the mother of all living.
- **21** And the LORD God made garments of skins for the man and for his wife, and clothed them.

110

130

- 22 Then the LORD God said, "See, the man has become like one of us, knowing good and evil; and now, he might reach out his hand and take also from the tree of life, and eat, and live forever"—
- **23** therefore the LORD God sent him forth from the garden of Eden, to till the ground from which he was taken.
- **24** He drove out the man; and at the east of the garden of Eden he placed the cherubim, and a sword flaming and turning to guard the way to the tree of life.

THE STORY OF NOAH

CHAPTER 6

- **5** The LORD saw that the wickedness of humankind was great in the earth, and that every inclination of the thoughts of their hearts was only evil continually.
- **6** And the LORD was sorry that he had made humankind on the earth, and it grieved him to his heart.
- 7 So the LORD said, "I will blot out from the earth the human beings I have created—people together with animals and creeping things and birds of the air, for I am sorry that I have made them."

- 8 But Noah found favor in the sight of the LORD. . . .
- **13** And God said to Noah, "I have determined to make an end of all flesh, for the earth is filled with violence because of them; now I am going to destroy them along with the earth.
- **14** Make yourself an ark of cypress wood; make rooms in the ark, and cover it inside and out with pitch. . . .
- 17 For my part, I am going to bring a flood of waters on the earth, to destroy from under heaven all flesh in which is the breath of life; everything that is on the earth shall die.
- **18** But I will establish my covenant with you; and you shall come into the ark, you, your sons, your wife, and your sons' wives with you.
- **19** And of every living thing, of all flesh, you shall bring two of every kind into the ark, to keep them alive with you; they shall be male and female.
- **20** Of the birds according to their kinds, and of the animals according to their kinds, of every creeping thing of the ground according to its kind, two of every kind shall come in to you, to keep them alive.
- **21** Also take with you every kind of food that is eaten, and store it up; and it shall serve as food for you and for them."
- 22 Noah did this; he did all that God commanded him.

CHAPTER 7

- **6** Noah was six hundred years old when the flood of waters came on the earth.
- **7** And Noah with his sons and his wife and his sons' wives went into the ark to escape the waters of the flood.

8 Of clean animals, and of animals that are not clean, and of birds, and of everything that creeps on the ground,

160

170

180

- **9** two and two, male and female, went into the ark with Noah, as God had commanded Noah.
- **10** And after seven days the waters of the flood came on the earth. . . .
- **11** . . . on that day all the fountains of the great deep burst forth, and the windows of the heavens were opened.
- 12 The rain fell on the earth forty days and forty nights. . . .
- **18** The waters swelled and increased greatly on the earth; and the ark floated on the face of the waters.
- **19** The waters swelled so mightily on the earth that all the high mountains under the whole heaven were covered; . . .
- 21 And all flesh died that moved on the earth, birds, domestic animals, wild animals, all swarming creatures that swarm on the earth, and all human beings;
- 22 everything on dry land in whose nostrils was the breath of life died.
- 23 He blotted out every living thing that was on the face of the ground, human beings and animals and creeping things and birds of the air; they were blotted out from the earth. Only Noah was left, and those that were with him in the ark. . . .

READING CRITICALLY

The story of Noah is, in some sense, a parable of the value of choosing to "walk with God." How does it reflect, then, the idea of the covenant, God's agreement with the Hebrews?

63

central eastern Africa, one tributary in the mountains of Ethiopia and another at Lake Victoria in Uganda, from which it flows north for nearly 4,000 miles. Egyptian civilization developed along the last 750 miles of the river's banks, extending from the granite cliffs at Aswan, north to the Mediterranean Sea (see Map 3.1).

Nearly every year, torrential rains caused the river to rise dramatically. Most years, from July to November, the Egyptians could count on the Nile flooding their land. When the river receded, deep deposits of fertile silt covered the valley floor. Fields would then be tilled, and crops planted and tended. If the flooding was either too great or too minor, especially over a period of years, famine could result. The cycle of flood and sun made Egypt one of the most productive cultures in the ancient world and one of the most stable. For 3,000 years, from 3100 BCE until the defeat of Mark Antony and Cleopatra by the Roman general Octavian in 31 BCE, Egypt's institutions and

culture remained remarkably unchanged. Its stability contrasted sharply with the conflicts and shifts in power that occurred in Mesopotamia. The constancy and achievements of Egypt's culture are the subject of this chapter.

THE NILE AND ITS CULTURE

As a result of the Nile's annual floods, Egypt called itself Kemet, meaning "Black Land." In Upper Egypt, from Aswan to the Delta, the black, fertile deposits of the river covered an extremely narrow strip of land. Surrounding the river's alluvial plain was the "Red Land," the desert environment that could not support life, but where rich deposits of minerals and stone could be mined and quarried. Lower Egypt consists of the Delta itself, which today begins some 13 miles north of Giza [GHEE-zuh], the site of the largest pyramids, across the river from what is now

Map 3.1 Nile River Basin with archeological sites in relation to modern Cairo.

The broad expanse of the Lower Nile Delta was crisscrossed by canals, allowing for easy transport of produce and supplies.

Nebamun, Thebes. Dynasty 18, conventional representation of the spearing fish or hunting fowl, almost obligatory for the decoration of a tomb. The pigments were applied directly to a dry wall, a technique that has come to be known as fresco secco [FRES-coh SEK-koh], dry fresco. Such paintings are extremely fragile and susceptible to moisture damage, but Egypt's

modern Cairo. But in ancient times, it began 18 miles south of Giza, near the city of Memphis.

Fig. 3.2 Nebamun Hunting Birds. from the tomb of

ca. 1400 BCE. Fresco on dry plaster, approx. 2' 8" high. The British Museum, London. The fish and the birds, and the cat, are completely realistic, but this is not a realistic scene. It is a

deceased, in this case Nebamun,

arid climate has preserved them.

In this land of plenty, great farms flourished, and wildlife abounded in the marshes. In fact, the Egyptians linked the marsh to the creation of the world and represented it that way in the famous hunting scene that decorates the tomb of Nebamun [NEB-ah-mun] at Thebes [theebz] (Fig. 3.2). Nebamun is about to hurl a snake-shaped throwing stick into a flock of birds as his wife and daughter look on. The painting is a sort of visual pun, referring directly to sexual procreation. The verb "to launch a throwing stick" also means "to ejaculate," and the word for "throwing stick" itself, to "create." The hieroglyphs written between Nebamun and his wife translate as "enjoying oneself, viewing the beautiful, . . . at the place of constant renewal of life."

Scholars divide Egyptian history into three main periods of achievement. Almost all of the conventions of Egyptian art were established during the first period, the Old Kingdom. During the Middle Kingdom, the "classical" literary language that would survive through the remainder of Egyptian history was first produced. The New Kingdom was a period of prosperity that saw a renewed interest in art and architecture. During each of these periods, successive dynasties—or royal houses—brought peace and stability to the country. Between them were "Intermediate Periods" of relative instability (see Context, page 68).

Egypt's continuous cultural tradition—lasting over 3,000 years—is history's clearest example of how peace and prosperity go hand in hand with cultural stability. As opposed to the warring cultures of Mesopotamia, where city-state vied with city-state and empire with successive empire, Egyptian culture was predicated on unity. It was a theocracy, a state ruled by a god or by the god's representative—in this case a king (and very occasionally a queen), who ruled as the living representative of the sun god, Re [reh]. Egypt's government was indistinguishable from its religion, and its religion manifested itself in nature, in the flow of the Nile, the heat of the sun, and in the journey of the sun through the day and night and through the seasons. In the last judgment of the soul after death, Egyptians believed that the heart was weighed to determine whether it was "found true by trial of the Great Balance." Balance in all things—in nature, in social life, in art, and in rule—this was the constant aim of the individual, the state, and, Egyptians believed, the gods.

Whereas in Mesopotamia the flood was largely a destructive force (recall the flood in the Epic of Gilgamesh), in Egypt it had a more complex meaning. It could, indeed, be destructive, sometimes rising so high that great devastation resulted. But without it, the Egyptians knew, their culture could not endure. So, in Egyptian art and culture, a more complex way of thinking about nature, and about life itself, developed. Every aspect of Egyptian life is countered by an

CONTEXT

Major Periods of Ancient Egyptian History

The dates of the periods of Egyptian history, as well as the kingships within them, should be regarded as approximate. Each king numbered his own regal years, and insufficient information about the reign of each king results in dates that sometimes

vary, especially in the earlier periods, by as much as 100 years. Although there is general consensus on the duration of most individual reigns and dynasties, there is none concerning starting and ending points.

5500-2972 BCE	Predynastic Period No formal dynasties	Reign of Narmer and unification of Upper and Lower Egypt
2972-2647 все	Early Dynastic Period Dynasties 1–2	A unified Egypt ruled from Memphis
2647-2124 BCE	Old Kingdom Dynasties 3–8	The stepped pyramids at Saqqara in Dynasty 3; Pyramids at Giza in Dynasty 4
2123—2040 все	First Intermediate Period Dynasties 9–10	Egypt divided between a Northern power center at Hierakon- polis and a Southern one at Thebes
2040-1648 все	Middle Kingdom Dynasties 11–16	Reunification of Upper and Lower Egypt
1648—1540 все	Second Intermediate Period Dynasty 17	Syro-Palestinian invaders, the Hyksos, hold Lower Egypt and much of Upper Egypt until the Thebans defeat them
1540—1069 все	New Kingdom Dynasties 18–20	Reunification of Egypt; an extended period of prosperity and artistic excellence
1069-715 все	Third Intermediate Period Dynasties 21–24	More political volatility
715—332 все	Late Period Dynasties 25–31	Foreign invasions, beginning with the Kushites from the south and ending with Alexander the Great from the north

opposite and equal force, which contradicts and negates it, and every act of negation gives rise to its opposite again. As a result, events are cyclical, as abundance is born of devastation and devastation closely follows abundance. Likewise, just as the floods brought the Nile Valley back to life each year, the Egyptians believed that rebirth necessarily followed death. So their religion, which played a large part in their lives, reflected the cycle of the river itself.

Egyptian Religion: Cyclical Harmony

The religion of ancient Egypt, like that of Mesopotamia, was *polytheistic*, consisting of many gods and goddesses who were associated with natural forces and realms (see *Context*, page 69). When represented, gods and goddesses have human bodies and human or animal heads, and wear crowns or other headgear that identifies them by their attributes. The religion reflected an ordered universe in which the stars and planets, the various gods, and basic human activities were thought to be part of a grand and harmonious design. A person who did not disrupt this harmony did not fear death because his or her spirit would live on forever.

At the heart of this religion were creation stories that explained how the gods and the world came into being. Chief among the Egyptian gods was Re, god of the sun. According to these stories, at the beginning of time, the Nile created a great mound of silt, out of which Re was born. It was understood that Re had a close personal relationship with the king, who was considered the son of Re. But the king could also identify closely with other gods. The king was simultaneously believed to be the personification of the sky god, Horus [HOR-us], and was identified with deities associated with places like Thebes or Memphis when his power resided in those cities. Though not a full-fledged god, the king was netjer nefer [net-jer nef-er], literally, a "junior god." That made him the representative of the people to the gods, whom he contacted through statues of divine beings placed in all temples. Through these statues, Egyptians believed, the gods manifested themselves on earth. Not only did the orderly functioning of social and political events depend upon the king's successful communication with the gods, but so did events of nature—the ebb and flow of the river chief among them.

Like the king, all the other Egyptian gods descend from Re, as if part of a family. As we have said, many can be traced back to local deities of predynastic times who later assumed greater significance at a given place—at Thebes, for instance, the trinity of Osiris, Horus, and Isis gained a special significance. Osiris [oh-SY-ris], ruler of the underworld and god of the dead, was at first a local deity in the eastern Delta. According to myth, he was murdered by his

wicked brother Seth, god of storms and violence, who chopped his brother into pieces and threw them into the Nile. But Osiris's wife and sister, Isis [EYE-zis], the goddess of fertility, collected all these parts, put the god back together, and restored him to life. Osiris was therefore identified with the Nile itself, with its annual flood and renewal. The child of Osiris and Isis was Horus, who defeated Seth and became the mythical first king of Egypt. The actual, living king was considered the earthly manifestation of Horus (as well as the son of Re). When the living king died, he became Osiris, and his son took the throne as Horus. Thus, even the kingship was cyclical.

At Memphis, the triad of Ptah, Sakhmet, and Nefertum held sway. A stone inscription at Memphis describes Ptah as the supreme artisan and creator of all things (Reading 3.1):

READING 3.1

from Memphis, "This It Is Said of Ptah" (ca. 2300 BCE)

This it is said of Ptah: "He who made all and created the gods." And he is Ta-tenen, who gave birth to the gods, and from whom every thing came forth, foods, provisions, divine offerings, all good things. This it is recognized and understood that he is the mightiest of the gods. Thus Ptah was satisfied after he had made all things and all divine words.

He gave birth to the gods, He made the towns, He established the nomes [provinces], He placed the gods in their shrines, He settled their offerings, He established their shrines, He made their bodies according to their wishes, Thus the gods entered into their bodies, Of every wood, every stone, every clay, Every thing that grows upon him In which they came to be.

Sekhmet is Ptah's female companion. Depicted as a lioness, she served as protector of the king in peace and war. She is also the mother of Nefertum, a beautiful young man whose name means "perfection," small statues of whom were often carried by Egyptians for good luck.

The cyclical movement through opposing forces, embodied in stories such as that of Osiris and Isis, is one of the earliest instances of a system of religious and philosophic thought that survives even in contemporary thought. Life and death, flood and sun, even desert and oasis were part of a larger harmony of nature, one that was predictable in both the diurnal cycle of day and night but also in its seasonal patterns of repetition. A good deity like Osiris was necessarily balanced by a bad deity like Seth. The fertile Nile Valley was balanced by the harsh desert surrounding it. The narrow reaches of the upper Nile were balanced by the broad marshes of the Delta. All things were predicated upon the return of their opposite, which negates them, but

CONTEXT

Some of the Principal Egyptian Gods

- A Horus, son of Osiris, a sky god closely linked with the king; pictured as a hawk, or hawk-headed man.
- B Seth, enemy of Horus and Osiris, god of storms; pictured as an unidentifiable creature (some believe a wild donkey), or a man with this animal's head.
- C Thoth, a moon deity and god of writing, counting, and wisdom; pictured as an ibis, or ibis-headed man, often with a crescent moon on his head.
- D Khnum, originally the god of the source of the Nile, pictured as a bull who shaped men out of clay on his potter's wheel; later, god of pottery.
- E Hathor, goddess of love, birth, and death; pictured as a woman with cow horns and a sun disk on her head.
- F Sobek, the crocodile god, associated both with the fertility of the Nile, and, because of the ferocity of the crocodile, with the army's power and strength.
- G Re, the sun god in his many forms; pictured as a hawkheaded man with a sun disk on his head.

which in the process completes the whole and regenerates the cycle of being and becoming once again.

Pictorial Formulas in Egyptian Art

This sense of duality, of opposites, informs even the earliest Egyptian artifacts, such as the Palette of Narmer, found at Hierakonpolis [hy-ruh-KAHN-puh-liss], in Upper Egypt (see Closer Look, pages 70–71). A palette is technically an everyday object used for grinding pigments and making body- or eye paint. The scenes on the Palette of Narmer are in low relief. Like the Royal Standard of Ur (see Fig. 2.8), they are arranged in registers that provide a ground-line upon which the figures stand (the two liontamers are an exception). The figures typically face to the right, though often, as is the case here, the design is symmetrical, balanced left and right. The artist represents the various parts of the human figure in what the Egyptians thought was their most characteristic view. So, the face, arms, legs, and feet are in profile, with the left foot advanced in front of the right. The eye and shoulders are in front view. The mouth, navel and hips, and knees are

CLOSER LOOK

he Egyptians created a style of writing very different from that of their northern neighbors in Mesopotamia. It consists of hieroglyphs, "writing of the gods," from the Greek hieros, meaning "holy," and gluphein, "to engrave." Although the number of signs increased over the centuries from about 700 to nearly 5,000, the system of symbolic communication underwent almost no major changes from its advent in the fourth millennium BCE until 395 CE, when Egypt was conquered by the Byzantine Empire. It consists of three kinds of signs: pictograms, or stylized drawings that represent objects or beings, which can be combined to express ideas; phonograms, which are pictograms used to represent sounds; and determinatives, signs used to indicate which category of objects or beings is in question. The Palette of

Narmer is an early example of the then-developing hieroglyphic style. It consists largely of pictograms, though in the top center of each side, Narmer's name is represented as a phonogram.

The round circle formed by the two elongated lions' heads intertwined on the *recto*, or front, of the palette is a bowl for mixing pigments. The palette celebrates the defeat by Narmer (r. ca. 3000 BCE) of his enemies and his unification of both Upper and Lower Egypt, which before this time had been at odds. So on the recto side, Narmer wears the red cobra crown of Lower Egypt, and on the *verso*, or back, he wears the white crown of Upper Egypt—representing his ability (and duty) to harmonize antagonistic elements.

Flanking the top of each side of the palette is a goddess wearing cow's horns; such headdresses represent the divine attributes of the figure. Later, **Hathor**, the sky mother, a goddess embodying all female qualities, would possess these attributes, but this early image probably represents the cowgoddess, **Bat**.

The **mace** was the chief weapon used by the king to strike down enemies, and the scene here is emblematic of his power.

As on the other side of the palette, the king is here accompanied by his sandal-bearer, who stands on his own ground-line. He carries the king's sandals to indicate that the king, who is barefoot, stands on **sacred ground**, and that his acts are themselves sacred.

Narmer, wearing the white crown of Upper Egypt, strikes down his enemy, probably the embodiment of **Lower Egypt** itself, especially since he is, in size, comparable to Narmer himself, suggesting he is likewise a leader.

Two more figures represent the defeated enemy. Behind the one on the left is a small aerial view of a **fortified city**; behind the one on the right, a **gazelle trap**. Perhaps together they represent Narmer's victory over both city and countryside.

The hawk is a a representation. The king was rearthly embodi Horus has a hu which he holds symbolic representation to the representation of the representa

The hawk is a symbolic representation of the god **Horus**. The king was regarded as the earthly embodiment of Horus. Here, Horus has a human hand with which he holds a rope tied to a symbolic representation of a conquered land and people.

A human head grows from the same ground as six **papyrus** blossoms, possibly the symbol of Lower Føypt.

This hieroglyph identifies the man that Narmer is about to kill, a name otherwise unknown.

Palette of Narmer, verso side, from Hierakonpolis. Dynasty 1, ca. 3000 BCE. Schist, height $25\,{}^1\!\!/_4{}''$ Egyptian Museum, Cairo.

SEE MORE For a Closer Look at the *Palette of Narmer*, go to www.myartslab.com

Reading the Palette of Narmer

Narmer's Palette was not meant for actual use. Rather, it is a **votive**, or ritual object, a gift to a god or goddess that was placed in a temple to ensure that the king, or perhaps some temple official, would have access to a palette throughout eternity. It may or may not register actual historical events, although, in fact, Egypt marks its beginnings with the unification of its Upper and Lower territories. Subsequent kings, at any rate, presented themselves in almost

identical terms, as triumphing over their enemies, mace in hand, even though they had no role in a similar military campaign. It is even possible that by the time of Narmer such conventions were already in place, although our system of numbering Egyptian dynasties begins with him. Whether the scene depicted is symbolic, the **pictorial formulas**, or conventions of representation, that Egyptian culture used for the rest of its history are fully developed in this piece.

Something to Think About . . .

Do you see any connection between the Egyptian hieroglyphs, as seen on the *Palette of Narmer*, and Sumerian cuneiform writing?

These are two instances of the hieroglyphic sign for **Narmer**, consisting of a catfish above a chisel. Each individual hieroglyph is a pictogram but is utilized here for its phonetic sound. The word for "catfish" is *nar*, and the word for "chisel" is *mer* (or, perhaps, "sickly")—hence "Narmer." In the lower instance, the hieroglyph

identifies the king. In the instance at the top, the king's name is inside a depiction of his palace seen simultaneously from above, as a ground plan, and from the front, as a facade. This device, called a *serekh*, is traditionally used to hold the king's name.

We are able to identify **Narmer** not only from his hieroglyphic name, next to him, but by his relative size. As befits the king, he is larger than anyone else.

Similarly positioned on the other side of the palette and identified by the accompanying hieroglyph, this is the king's **sandal-bearer**.

The **bull** here strikes down his victim and is another representation of the king's might and power. Note that in the depictions of Narmer striking down his victim and in procession, a bull's tail hangs from his waistband.

Palette of Narmer, recto side, from Hierakonpolis. Dynasty 1, ca. 3000 BCE. Schist, height $25 \frac{1}{4}$ ". Egyptian Museum, Cairo.

Konpolis.

The defeated **dead** lie in two rows, their decapitated heads between their feet. Narmer in sacred procession reviews them, while above them, a tiny Horus (the hawk) looks on.

This is the **mixing bowl** of the palette. The lions may represent competing forces brought under control by the king. Each is held in check by one of the king's **lion-tamers**, figures that in some sense represent state authority.

This is a representation of a fortified city as seen both from above, as a floor plan, and from the front, as a facade. It is meant to represent the actual site of Narmer's victory.

in three-quarter view. As a result, the viewer sees each person in a **composite view**, the integration of multiple perspectives into a single unified image.

In Egyptian art, not only the figures but the scenes themselves unite two contradictory points of view into a single image. In the *Palette of Narmer*, the king approaches his dead enemies from the side, but they lie beheaded on the ground before him as seen from above. Egyptian art often represents

architecture in the same terms. At the top middle of the *Palette of Narmer*, the external facade of the palace is depicted simultaneously from above, in a kind of ground plan, with its niched facade at the bottom. The design contains Narmer's Horus-name, consisting of a catfish and a chisel. The hieroglyphic signs for Narmer could not be interpreted until the Rosetta Stone was discovered (see *Context*, page 75), but we are still not sure whether it is to be read "Narmer," which are

the later phonetic values of the signs. In fact, later meanings of these signs suggest that it might be read "sick catfish," which seems rather unlikely.

THE OLD KINGDOM

Although the Palette of Narmer probably commemorates an event in life, as a votive object it is devoted, like most surviving Egyptian art and architecture, to burial and the afterlife. The Egyptians buried their dead on the west side of the Nile, where the sun sets, a symbolic reference to death and rebirth, since the sun always rises again. The pyramid was the first monumental royal tomb. A massive physical manifestation of the reality of the king's death, it was also the symbolic embodiment of his eternal life. It would endure for generations as, Egyptians believed, would the king's ka [kah]. This idea is comparable to an enduring "soul" or "life force," a concept found in many other religions. The ka, which all persons possessed, was created at the same time as the physical body, itself essential for the person's existence since it provided

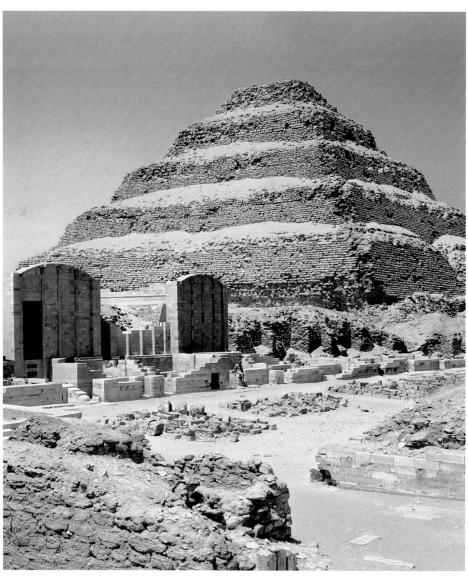

Fig. 3.3 Possibly the work of Imhotep. Stepped pyramid and funerary complex of Djoser, Saqqara. Dynasty 3, 2610 BCE. Limestone, height of pyramid 197'. The base of this enormous structure measures 460 feet east to west, and 388 feet north to south. It is the earliest known use of cut stone for architecture. The architect, Imhotep, was Djoser's prime minister. He is the first architect in history known to us by name.

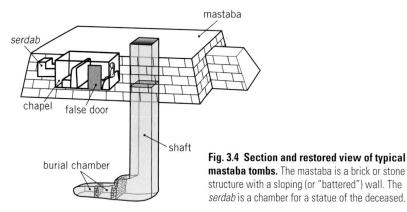

the ka with an individual identity in which its personality, or ba [bah], might also manifest itself. This meant that it was necessary to preserve the body after death so that the ba and ka might still recognize it for eternity. All the necessities of the afterlife, from food to furniture to entertainment, were placed in the pyramid's burial chamber with the king's body.

Funerary temples and grounds surrounded the temple so that priests could continuously replenish these offerings in order to guarantee the king's continued existence after death. Pyramids are the massive architectural product of what is known as the Old Kingdom, which dates from 2647 to 2124 BCE, a period of unprecedented achievement that solidified the accomplishments of the Early Dynastic Period initiated by Narmer.

The Stepped Pyramid at Saqqara

The first great pyramid was the Stepped Pyramid of Djoser [DJOH-zer] (r. ca. 2628–2609 BCE), who ruled at Saqqara [suh-KAHR-uh], just south of modern Cairo (Figs. 3.3, 3.4). It predates the Ziggurat at Ur by nearly 500 years and is therefore the first great monumental architecture in human history to have survived. It consists of a series of stepped platforms rising to a height of 197 feet, but since it sits on an elevated piece of ground, it appears even taller to the approaching visitor.

Above ground level, the pyramid of Djoser contains no rooms or cavities. The king's body rested below the first level of the pyramid, in a chamber some 90 feet beneath the original mastaba [MAS-tuh-buh]—a trapezoidal tomb structure that derives its name from the Arabic word for "bench." Such mastabas predate Djoser's pyramid but continued to be used for the burial of figures of lesser importance

for centuries. The pyramid is situated in a much larger, ritual area than this earlier form of tomb. The total enclosure of this enormous complex originally measured 1,800 by 900 feet—or six football fields by three.

The idea of stacking six increasingly smaller mastabas on top of one another to create a monumental symbol of the everlasting spirit of the king was apparently the brainchild of Imhotep [im-HO-tep], Djoser's chief architect. He is the first artist or architect whose name survives, and his reputation continued to grow for centuries after his death. Graffiti written on the side of the pyramid a thousand years after Djoser's death praises Imhotep for a building that seems "as if heaven were within it" and as though "heaven rained myrrh and dripped incense upon it."

Three Pyramids at Giza

From Djoser's time forward, the tomb of the king was dramatically distinguished from those of other members of the royal family. But within 50 years, the stepped form of Djoser's pyramid was abandoned and replaced with a smooth-sided, starkly geometric monument consisting of four triangular sides slanting upward from a square base to an apex directly over the center of the square. The most magnificent examples of this form are found at Giza, just north of Djoser's tomb at Saqqara.

Khufu's Pyramid Of the three pyramids at Giza, Khufu's (r. 2549–2526 BCE) is both the earliest and the grandest one (Fig. 3.5), measuring 479 feet high on a base measuring 755 feet square, built from an estimated 2.3 million stone blocks, weighing between 2 and 5 tons each. Historians

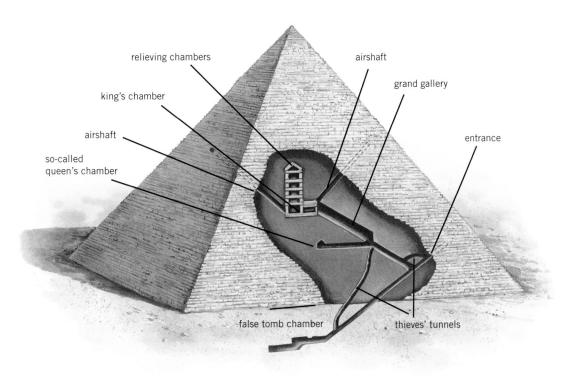

Fig. 3.5 Cutaway elevation of the pyramid of Khufu.

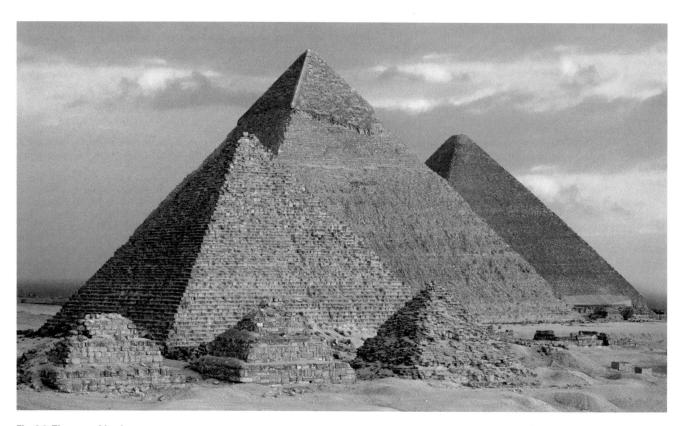

Fig. 3.6 The pyramids of Menkaure (ca. 2470 BCE), Khafre (ca. 2500 BCE), and Khufu (ca. 2530 BCE). Giza was an elaborate complex of ritual temples, shrines, and ceremonial causeways, all leading to one or another of the three giant pyramids.

Pyramid of boat pits western 04 Khufu to the NIIe mastaba field 9900000 0000000 eastern oopun. mastaba field boat pits Pyramid of Khafre Pyramids of Queens Mortuary Temple Great Sphinx Sphinx $\Box \triangleleft$ causeway Temple Valley Temple pyramid 90 enclosure walls Pyramid of Menkaura causeway Valley Mortuary Temple Temple $\boxtimes\boxtimes$ Pyramids of Queens 300 m 1000 ft

N

Fig. 3.7 Plan of the pyramids at

Giza. Surrounding the northernmost pyramid of Khufu were mastaba fields, a royal cemetery in which were buried various officials, priests, and nobility of the king's court. When a king died in the royal palaces on the east bank of the Nile, his body was transported across the river to a valley temple on the west bank. After a ritual ceremony, it was carried up the causeway to the temple in front of the pyramid where another ritual was performed—the "opening of the mouth," in which priests "fed" the deceased's ka a special meal. The body was then sealed in a relatively small tomb deep in the heart of the pyramid (see Fig. 3.5).

CONTEXT

The Rosetta Stone

Until the nineteenth century, Egyptian hieroglyphs remained untranslated. The key to finally deciphering them was the Rosetta Stone, a discovery made by Napoleon's army in 1799 and named for the town in the Egyptian Delta near where it was found. On the stone was a decree issued in 196 BCE by the priests of Memphis honoring the ruler Ptolemy V, recorded in three separate languages—Greek, demotic Egyptian (an informal and stylized form of writing used by the people—the "demos"), which first came into use in the eighth century BCE, and finally hieroglyphs, the high formal communication used exclusively by priests and scribes.

The stone was almost immediately understood to be a key to deciphering hieroglyphs, but its significance was not fully realized until years later. French linguist Jean-François Champollion began an intensive study of the stone in 1808 and concluded that the pictures and symbols in hieroglyphic writing stood for specific phonetic sounds, or, as he described it, constituted a "phonetic alphabet." A key to unlocking the code was a cartouche, an ornamental and symbolic frame reserved for the names of rulers. Champollion noticed that the cartouche surrounded a name, and deciphered the phonetic symbols for P, O, L, and T—four of the letters in the name Ptolemy. In another cartouche, he found the symbols for Cleopatra's name. By 1822, he had worked out enough of the writing system and the language to translate two texts, but Egyptologists have continued to improve and refine our understanding of the language to this day.

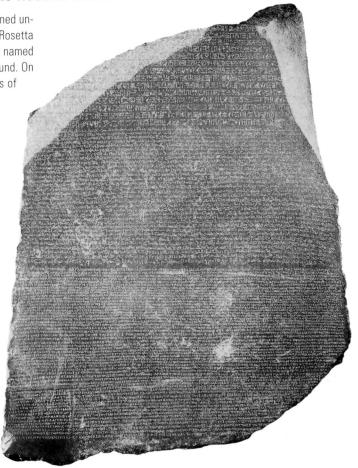

The Rosetta Stone. 196 BCE. Basalt, $46 \frac{1}{2}$ " $\times 30 \frac{1}{8}$ ". © The Trustees of the British Museum/Art Museum, NY. The top, parts of which have been lost, contains the formal hieroglyphs; the middle, demotic Egyptian; and the bottom, the Greek text of the decree.

speculate that the stones were dragged up inclined ramps made of compacted rubble bonded and made slippery with a kind of lime-clay, called *tafl*, although they may well have been raised from tier to tier up the side of the pyramid by means of levers not unlike those used by the workers at Stonehenge (see *Closer Look*, pages 16–17 Chapter 1). Whatever feats of engineering accomplished the transport of so much stone into such an enormous configuration, what still dazzles us is this pyramid's astronomical and mathematical precision. It is perfectly oriented to the four cardinal points of the compass (as are the other two pyramids, which were positioned later, probably using Khufu's alignment as a reference point).

The two airshafts that run from the two top chambers seem oriented to specific stars, including Sirius, the brightest star in the night sky. The relationship between the various sides of the structure suggests that the Egyptians understood and made use of the mathematical value π (pi). All of this has led to considerable theorizing about "the secret of the pyramids," the other two of which are Khafre's (r. 2518-2493 BCE), and Menkaure's (r. 2488-2460 BCE) (Figs. 3.6 and 3.7). Most convincing is the theory that the pyramid's sides represented the descending rays of the sun god Re, whose cult was particularly powerful at the time the pyramids were built. Because they were covered in a polished limestone sheath (the only remnant survives atop Khafre's pyramid), the sun must have glistened off them. And one convincing text survives: "I have trodden these rays as ramps under my feet where I mount up to my mother Uraeus on the brow of Re." Whatever their symbolic significance, they are above all extraordinary feats of human construction.

Fig. 3.8 The Great Sphinx (with the pyramid of Khafre in the background), Giza. Dynasty 4, ca. 2500 BCE. Limestone, height approx. 65'. Over the years, legend has had it that the artillery forces of Napoleon's invading army shot off the Sphinx's nose and ears. In truth, a fanatical Muslim cleric from Cairo severely damaged the statue in an attack in 1378.

The Great Sphinx In front of the pyramid dedicated to Khufu's son Khafre, and near the head of the causeway leading from the valley temple to the mortuary temple (see Fig. 3.6), is the largest statue ever made in the ancient world, the Great Sphinx [sfinks], carved out of an existing limestone knoll (Fig. 3.8). As in Egyptian depictions of the gods, the Sphinx is half man and half animal. But where the gods are normally depicted with an animal's head and a human body, the Sphinx is just the opposite: a lion's body supports the head of a king wearing the royal headcloth. The sculpture probably represents Khafre himself protecting the approach to his own funerary complex, and thus it requires Khafre's physical likeness, but its combination of animal and human forms also suggests the king's connection to the gods.

Monumental Royal Sculpture: Perfection and Eternity

The Sphinx's monumentality indicates the growing importance of sculpture to the Egyptian funerary tradition. The word for sculpture in Egyptian is, in fact, the same as for giving birth, and funerary sculpture served the same purpose as the pyramids themselves—to preserve and guarantee the king's existence after death, thereby providing a kind of rebirth. Although there are thousands of limestone and not a few sandstone funerary monuments, the materials of choice were diorite, schist, and granite, stones as durable

Fig. 3.9 Seated statue of Khafre, from valley temple of Khafre, Giza. Dynasty 4, ca. 2500 Bcs. Diorite, height 66". Egyptian Museum, Cairo. On the side of Khafre's throne, intertwining lotus and papyrus blossoms signify his rule of both Upper and Lower Egypt.

and enduring as the ka itself. These stones can also take on a high polish and, because they are not prone to fracture, can be finely detailed when carved. These stones were carved into three main types of male statue: (1) a seated figure, looking directly ahead, his feet side by side, one hand resting flat on the knee, the other clenched in a fist; (2) a standing figure, his gaze fixed into the distance, left foot forward, both hands alongside the body with fists clenched; and (3) a figure seated on the ground with legs crossed. The first two types were used for kings as well as important officials. The third was used for royal scribes. Also popular were statue pairs of husband and wife, either seated or standing.

The statue of Khafre from his valley temple at Giza (see Fig. 3.5) is an example of the first type (Fig. 3.9). The king sits rigidly upright and frontal, wearing a simple kilt and the same royal headdress as the Great Sphinx outside the valley temple. His throne is formed of the bodies of two stylized lions. Behind him, as if caressing his head, is a hawk, a manifestation of the god Horus, extending its wings in a protective gesture. In Egyptian society, the strong care for and protect the weak; so too Horus watches over Khafre as Khafre watches over his people. Because Khafre is a king and a divinity, he is shown with a perfectly smooth, proportioned face and a flawless, wellmuscled body. This idealized anatomy was used in Egyptian sculpture regardless of the actual age and body of the king portrayed, its perfection mirroring the perfection of the gods themselves. Most Egyptian statues were monolithic, or carved out of a single piece of stone, even those depicting more than a single figure.

The same effect is apparent in the statue of Menkaure with a woman—perhaps his queen, his mother, or even a goddess—that was also found at his valley temple at Giza (Fig. 3.10). Here, the deep space created by carving away the side of the stone to expose fully the king's right side seems to free him from the stone. He stands with one foot ahead of the other in the second traditional pose, the conventional depiction of a standing figure. He is not walking. Both feet are planted firmly on the ground (and so his left leg is, of necessity, slightly longer than his right). His back is firmly implanted in the stone panel behind him, but he seems to have emerged farther from it than the female figure who accompanies him, as if to underscore his power and might. Although the woman is almost the same size as the man, her stride is markedly shorter than his. She embraces him, her arm reaching round his back, in a gesture that reminds us of Horus's protective embrace of Khafre, but suggests also the simple marital affection of husband and wife. The ultimate effect of both of these sculptures—their solidity and unity, their sense of resolute purpose—testifies finally to their purpose, which is to endure for eternity.

Fig. 3.10 Menkaure with a Queen, probably Khamerernebty, from valley temple of Menkaure, Giza. Dynasty 4, ca. 2460 BCE. Schist, height 54 1/4". Museum of Fine Arts, Boston. Harvard University-Boston Museum of Fine Arts. 11.1738. Photograph © 2008 Museum of Fine Arts, Boston. Note that the woman's close-fitting attire is nearly transparent, indicating a very fine weave of linen.

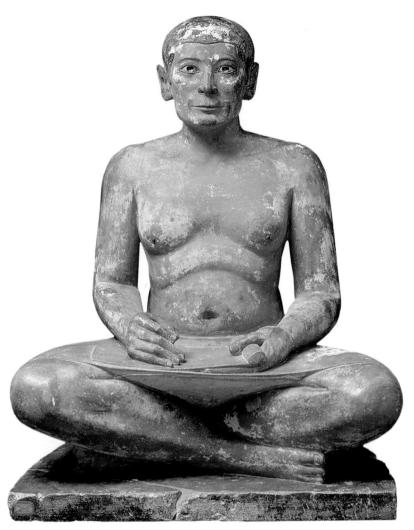

Fig. 3.11 Seated Scribe, from his mastaba, Saqqara. Dynasty 5, ca. 2400 BCE. Painted limestone, height 21". Musée du Louvre, Paris, France. Scribes were the most educated of Egyptians—not only able to read and write but accomplished in arithmetic, algebra, religion, and law. Their ka statues necessarily accompanied those of their kings into the afterlife.

The Sculpture of the Everyday

Idealized athletic physiques, austere dignity, and grand scale were for royalty and officials only. Lesser figures were depicted more naturally, with flabby physiques or rounded shoulders, and on a more human scale. The third traditional type of male figure in Egyptian sculpture was the royal scribe, and in Figure 3.11, we can see that a soft, flabby body replaces the hardened chest of a king. But the scribe's pose, seated cross-legged on the floor, marks him as literate and a valuable official of the king. The stone was carved out around his arms and head so that, instead of the monumental space of the king's sculpture, which derives from its compactness and its attachment to the slab of stone behind it, the scribe seems to occupy real space. The scribe's task was important: His statue would serve the king through eternity as he had served the king in life.

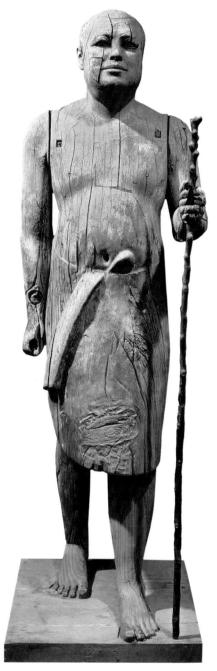

Fig. 3.12 Lector Priest Ka-aper (also known as the "Sheikh el-Beled"), from mastaba of Ka-aper, Saqqara. Dynasty 5, ca. 2450 BCE. Plaster and painted wood, height 3'7". Egyptian Museum, Cairo. This paunchy priest lacks the idealized physique reserved for more eminent nobility.

Statues of lesser persons were often made of less permanent materials, such as wood. Carved from separate pieces, with the arms attached to the body at the shoulders, such statues as that of the priest Ka-aper, found in his own tomb at Saqqara, could assume a more natural pose (Fig. 3.12). The eyes, made of rock crystal, seem vital and lively. Originally, the statue was covered with plaster and painted (men were usually red-brown, like the seated

scribe, and women yellow). Small statues of servants, especially those who made food, have also been found in the tombs of officials.

THE MIDDLE KINGDOM AT THEBES

The Old Kingdom collapsed for a variety of reasons—drought, a weakened kingship, greater autonomy of local administrators—all of which led to an Egypt divided between competing power centers in the North and South. After over 150 years of tension, Nebhepetre Mentuhotep II (2040–1999 BCE) assumed the rule of the Southern capital at Thebes, defeated the Northern kings, and reunited the country. The Middle Kingdom begins with his reign.

Thebes, on the west bank of the Nile, was the primary capital of the Middle Kingdom and included within its outer limits Karnak, Luxor, and other sites on the east bank (see Map 3.1). Although certain traditions remained in place from the Old Kingdom, change was beginning to occur.

Middle Kingdom Literature

One of the greatest changes took place in literature. Earlier, most writing and literature served a sacred purpose. But, during the Middle Kingdom, writers produced stories, instructive literature, satires, poems, biography, history, and scientific writings. Much of the surviving writing is highly imaginative, including tales of encounters with the supernatural. Among the most interesting texts is *The Teachings of Khety* [KEH-tee], a satiric example of instructive literature in which a scribe tries to convince his son to follow him into the profession. He begins by extolling the virtues of the scribe's life: "I shall make you love books more than your mother, and I shall place their excellence before you. It is greater than any office. There is nothing like it on earth." But he goes on to defend his own work by detailing all that is wrong with every other profession available to him:

I have seen a coppersmith at his work at the door of his furnace. His fingers were like the claws of the crocodile, and he stank more than fish excrement. . . .

I shall also describe to you the bricklayer. His kidneys are painful. When he must be outside in the wind, he lays bricks without a garment. His belt is a cord for his back, a string for his buttocks. His strength has vanished through fatigue and stiffness. . . .

The sandal maker is utterly wretched carrying his tubs of oil. His stores are provided with carcasses, and what he bites is hides.

The work provides us with a broad survey of daily life in the Middle Kingdom. It ends in a series of admonitions about how a young scribe must behave—advice that parents have been giving children for millennia (see **Reading 3.2**, page 93 for more of the text).

Middle Kingdom Sculpture

Although a new brand of literature began to appear in the Middle Kingdom, sculpture remained firmly rooted in tradition. The only innovation in the traditional seated king funerary statue of Nebhepetre Mentuhotep II is that the pose has been slightly modified (Fig. 3.13). Most noticeably, the king crosses his arms tightly across his chest. The pose is reminiscent of a mummy, an embalmed body wrapped for burial (see *Materials & Techniques*, page 84). The king's mummy-like pose probably refers to the growing cult of the god Osiris, discussed earlier. As early as the late Fifth Dynasty, the dead king was called "Osiris [King's Name]." By the time of the Middle Kingdom, ordinary, nonroyal people

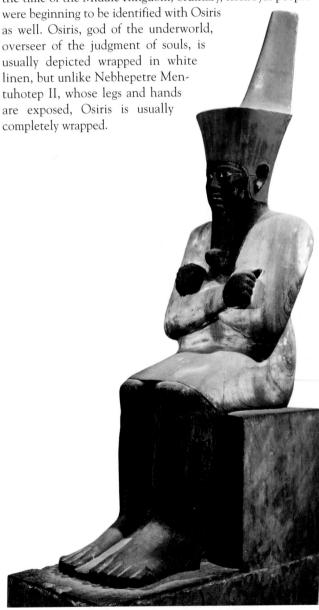

Fig. 3.13 Nebhepetre Mentuhotep II, from his funerary temple at Deir el-Bahri, Western Thebes. Dynasty 11, ca. 2000 BCE. Painted sandstone, height 72". Egyptian Museum, Cairo. The king's dark color here may refer to the "black land" of the Nile Valley, another symbol of the cycle of death and resurrection that is embodied in the Osiris myth.

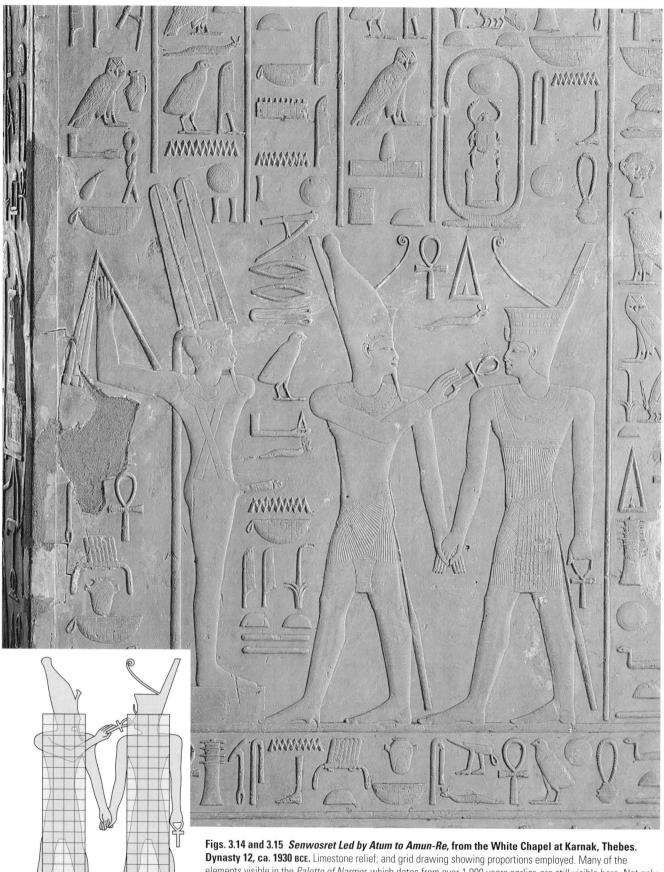

Dynasty 12, ca. 1930 BCE. Limestone relief; and grid drawing showing proportions employed. Many of the elements visible in the *Palette of Narmer*, which dates from over 1,000 years earlier, are still visible here. Not only are the bodies depicted in the conventional poses, but note the two figures on the right: King Senwosret wears the crown of Upper Egypt, and the god Atum wears the double crown of both Upper and Lower Egypt. Note also that just like Narmer, Senwosret and Atum each wears a bull's tail draped from his waist.

In relief carvings found in the temples of the Middle Kingdom, the traditional pose of the figure, which dates back to Narmer's time, still survives. The figures in a Twelfth Dynasty relief from the White Chapel at Karnak are depicted with right foot forward, feet and face in profile, and the shoulders and hips frontal (Fig. 3.14). But we have learned that figures were now conceived according to a grid. Much like a piece of graph paper, a grid is a system of regularly spaced horizontally and vertically crossed lines. Used in the initial design process, it enables the artist to transfer a design or enlarge it easily (Fig. 3.15). In the Egyptian system, the height of the figure from the top of the forehead (where it disappears beneath the headdress) to the soles of the feet is 18 squares. The top of the knee is 6 squares high, the waist, 11. The elbows are at the twelfth square, the armpits at the fourteenth, and the shoulders at the sixteenth. Each square also relates to the human body as a measure, representing the equivalent of one clenched fist.

This particular relief depicts the rise of yet another god in the Middle Kingdom-Amun, or, to associate him more closely with the sun, Amun-Re. Originally the chief god of Thebes, as the city became more prominent, Amun became the chief deity of all of Egypt. His name would appear (sometimes as "Amen") in many subsequent royal names—such as Amenhotep [ah-men-HO-tep] ("Amun is Satisfied") or, most famously, Tutankhamun [too-tahnk-AH-mun] ("The Living Image of Amun"). In the relief from the White Chapel, Atum, the god of the city of Heliopolis, just north of Memphis, that Nebhepetre Mentuhotep II had defeated four generations earlier, leads King Senwosret [sen-WAHZ-ret] I (1960–1916 BCE) to Amun, who stands at the left on a pedestal with an erect penis, signifying fertility. Atum turns to Senwosret and holds the hieroglyph ankh [ahnk], signifying life, to his nose. The king is depicted as having received the gift, since he holds it in his left hand.

The continuity and stability implied by this relief ended abruptly in 1648 BCE, when a Hyksos [HIK-sohs] king declared himself king of Egypt. The Hyksos were foreigners who had apparently lived in Egypt for some time. They made local alliances, introduced the horse-drawn chariot (which may well have helped them achieve their military dominance), and led Egypt into another "intermediate" period of disunity and disarray. Dissatisfaction with Hyksos rule originated, once again, in Thebes, and finally, in 1540 BCE, the Theban king Ahmose [AH-moh-seh] defeated the last Hyksos ruler and inaugurated the New Kingdom.

THE NEW KINGDOM

The worship of Amun that developed in the Twelfth Dynasty continued though the Middle Kingdom and into the Eighteenth Dynasty of the New Kingdom, 500 years later. In fact, there is clear evidence that the rulers of the Eighteenth Dynasty sought to align themselves closely with the

aims and aspirations of the Middle Kingdom. The funerary temple of Hatshepsut [hat-SHEP-sut] in western Thebes is an interesting case in point.

Temple and Tomb Architecture and Their Rituals

Hatshepsut (r. ca. 1479–1457 BCE) was the daughter of Thutmose [TOOT-mo-zeh] I (r. ca. 1504–1492 BCE) and married her half-brother Thutmose II. When her husband died, she became regent for their young son, Thutmose III, and ruled for 20 years as king (priests of Amun, in fact, declared her king). As her reign continued, sculptures of Hatshepsut increasingly lost many of their female characteristics until she is barely distinguishable, given family resemblances, from later sculptures of her son, Thutmose III (Fig. 3.16). Her breasts are barely visible, and she wears the false beard of the

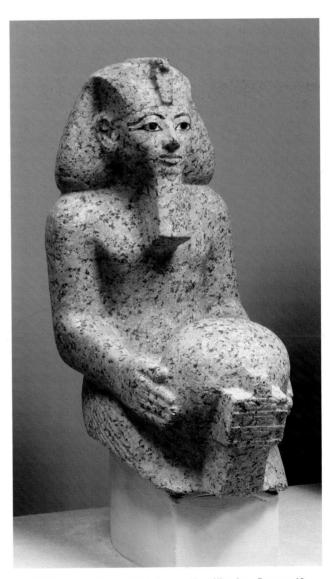

Fig. 3.16 Kneeling statue of Hatshepsut. New Kingdom, Dynasty 18, Joint reign of Hatshepsut and Thutmose III. ca. 1473–1458 BCE. Granite, paint, Height 34 ½"; width 12 ½", diameter 20 ½". © The Metropolitan Museum of Art/Art Resource, NY. This is one of at least eight, perhaps twelve, small kneeling statues of Hatshepsut believed to have lined the processional way of her temple at Deir el-Bahri.

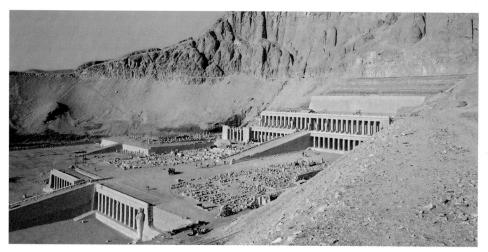

Fig. 3.17 Senenmut. Funerary temple of Hatshepsut, Deir el-Bahri, Western Thebes. Dynasty 18, ca. 1460 BCE. At the far left is the ramp and funerary temple of Nebhepetre Mentuhotep II. Dynasty 11 (Middle Kingdom). ca. 2000 BCE. Senenmut's name is associated with the tomb because he has titles that suggest he oversaw the project, and he had little images of himself carved behind doors, where they would not be seen. But he may or may not have been the actual

SEE MORE For a Closer Look at the Temple of Queen Hatshepsut, go to www.myartslab.com

Egyptian kings, the traditional symbol of the king's power and majesty.

Hatshepsut's temple, built on three levels, is modeled precisely on the two-level funerary temple of Nebhepetre Mentuhotep II, next to which it stands. Hatshepsut's temple is partly freestanding and partly cut into the rock cliffs of the hill (Fig. 3.17). The first level consisted of a large open plaza backed by a long colonnade, a sequence or row of columns supporting a lintel and roof. A long ramp led up to a second court that housed shrines to Anubis (god of embalming and agent of Osiris) and Hathor (the sky mother, probably a reference to Hatshepsut's gender). Another ramp led to another colonnade fronted with colossal royal statues, two more colonnades, a series of chapels, and behind them, cut into the cliff, a central shrine to Amun-Re.

The Great Temple of Amun at Karnak Directly across the valley from Hatshepsut's temple, and parallel to it, is the Great Temple of Amun at Karnak. It is a product of the age in which the Egyptian king came to be known as pharaoh [FAY-roh], from Egyptian per-aa, "great house," meaning the palace of the king. In the same way that we refer to the presidency as "the White House," or the government of England as "10 Downing Street," so the Egyptians, beginning in the Eighteenth Dynasty, came to speak of their rulers by invoking their place of residence. (The modern practice of referring to all Egyptian kings as "pharaoh," incidentally, can probably be attributed to its use in the Hebrew Bible to refer to both earlier and later Egyptian kings.)

The pharaohs engaged in massive building programs during the New Kingdom, lavishing as much attention on their temples as their tombs. Not only was Amun a focus of worship, but so was his wife, Mut, and their son Khonsu. Although each temple is unique, all of the New Kingdom temples share a number of common architectural premises. They were fronted by a **pylon**, or massive gateway with sloping walls, which served to separate the disorderly world of everyday existence from the orderly world of the temple.

Behind the pylon was one or more open courtyards leading to a roofed **hypostyle hall**, a vast space filled with

the many massive columns required to hold up the stone slabs forming the roof. The columns in the hypostyle hall of the Great Temple of Amun at Karnak have flower and bud capitals (Figs. 3.18, 3.19). Behind the hypostyle hall was the **sanctuary**, in which the statue of the deity was placed. To proceed into the temple was to proceed out of the light of the outside world and into a darker and more spiritual space. The temple was therefore a metaphor for birth and creation.

architect

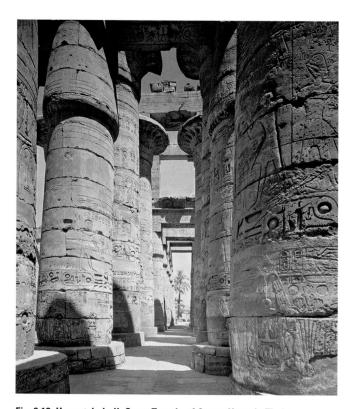

Fig. 3.18 Hypostyle hall, Great Temple of Amun, Karnak, Thebes.

Dynasty 19. ca. 1294–1212 BCE. It is difficult to sense the massive scale of these columns from a photo. Dozens of people could easily stand on the top of one of them, and it takes at least eight people, holding hands, to span the circumference of a given column near its base. An average person is no taller than the base and first drum, or circular disk of stone, forming the column.

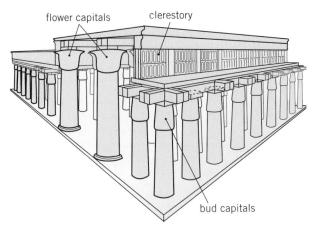

Fig. 3.19 Reconstruction drawing of the hypostyle hall, Great Temple of Amun, Karnak. Dynasty 19, ca. 1294–1212 BCE. The foreground columns have bud capitals, and the hall's central columns are taller with flower

capitals. The center columns are taller than the outer columns in order to admit light into the hall through windows along the upper walls. (Note that in this drawing the first five rows of columns in the front have been omitted for clarity. There are seven rows of columns on each side of the center rows.)

Each day, priests washed the deity statue, clothed it with a clean garment, and offered it two meals of delicious food. It was the "spirit" of the food that the gods enjoyed, and after the offering, the priests themselves ate the meals. Only kings and priests were admitted to the sanctuary, but at festival times, the cult statue of the deity was removed to lead processions—perhaps across the Nile to the funerary temples of the kings or to visit other deities in their temples (Mut regularly "visited" Amun, for instance).

The Great Temple of Amun at Karnak was the largest temple in Egypt. Although the temple was begun in the Middle Kingdom period, throughout the New Kingdom period pharaohs strove to contribute to its majesty and glory by adding to it or rebuilding its parts. The pharaohs built other temples to Amun as well. Each year, in an elaborate festival, the image of Amun from Karnak would travel south to visit his temple at Luxor. The most monumental aspects of both temples were the work of the Nineteenth Dynasty pharaoh Ramses [RAM-zeez] II (1279-1213 BCE), whose 66-year rule was longer than that of all but one other Egyptian king. It was he who, with his father, was responsible for decorating the enormous hypostyle hall at Karnak, and it was he who built the massive pylon gate at Luxor (Fig. 3.20).

Ramses's Pylon Gate at Luxor In front of the pylon stand two enormous statues of the king and, originally, a pair of obelisks—square, tapered stone columns topped by a pyramid shape—although only the eastern one remains in place; the other is in the Place de la Concorde in Paris (see Fig. 2.22). The outside of the pylon was decorated with reliefs and texts describing the king's victory over the Hittites, at a battle fought on the river separating modern Syria and Lebanon. The battle was not the unqualified military success depicted by the reliefs, so these may be an

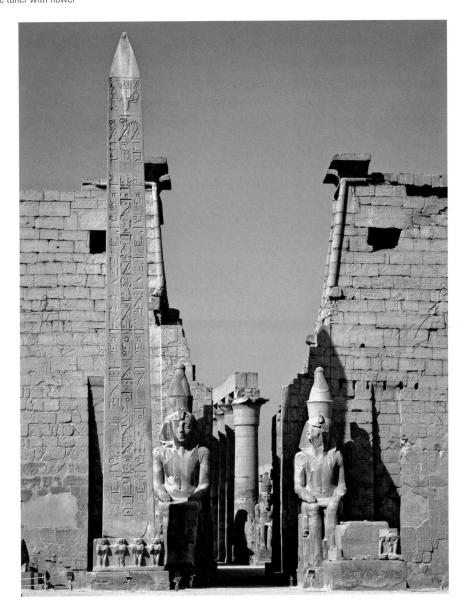

Fig. 3.20 Pylon gate of Ramses II with obelisk in the foreground, at Luxor, Thebes. Dynasty 19, ca. 1279–1212 BCE. The inscriptions on the pylon celebrate Ramses II's victory at the Battle of Qadesh over the Hittites as the two empires fought for control of Syria.

Materials & Techniques

Mummification

In the belief that the physical body was essential to the ka's survival in the afterlife, the Egyptians developed a sophisticated process to preserve the body, **mummification**. This was a multistaged, highly ritualized process.

The oldest evidence of mummification was recently found near Saggara and dates from 3100 to 2890 BCE. Mummification methods changed over time, and the techniques used between 1085 and 945 BCE were the most elaborate. Upon death, the body was carried across to the west bank of the Nile, symbolically "going into the west" like the setting sun. There it was taken to "the place of purification," where it was washed with natron. (Natron is a hydrated form of sodium carbonate used to absorb the body's fluids; it also turned the body black.) After this first step in its symbolic rebirth, the body was transferred to the House of Beauty, where it was properly embalmed, its inner organs removed, dried, coated in resin, and either preserved in their own special containers, called canopic jars, or wrapped in linen and put back inside the body. The body itself was stuffed with linen and other materials in order to maintain its shape and was surrounded by bags of natron for 40 days. The entire process was overseen by an Overseer of Mysteries, God's Seal-Bearer, who served as chief surgeon, and a lector priest who recited the required texts and incantations.

After 40 days, the body was cleaned with spices and perfumes, rubbed with oils to restore some of its suppleness, and then coated with resin to waterproof it. Its nails were sewn back on and artificial eyes put into its eye sockets. Cosmetics were applied to the face and a wig put on its head. Dressed and decked out in jewels, the body was, finally, wrapped in a shroud of bandages from head to foot, along with small figurines and amulets as protection on the journey through the underworld. Finally, a mask was placed on the head and shoulders. The wrapping process involved several stages: First the head and neck were wrapped, then fingers and toes individually, and the same for the arms and legs, which were then tied together. The embalmers also placed a papyrus scroll with spells from the Book of the Dead between the wrapped hands (a). After several more layers of wrapping impregnated with liquid

resin to glue the bandages together, the embalmers painted a picture of the god Osiris on the wrapping surface, did a final bandaging of the entire mummy with a large cloth attached by strips of linen (**b**), and then placed a board of painted wood on top. The mummy was now ready for its final ritual burial. The entire process took 70 days!

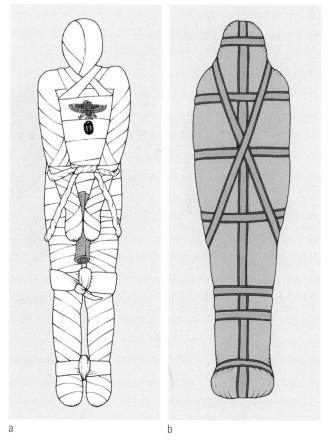

Two stages in the wrapping of a mummy. © The Trustees of the British Museum

early example of art used as propaganda, a theme that continues up to the present. It may be better to think of these reliefs as symbolic rather than historical, as images of the king restoring order to the land. Inside the pylon, around the walls of the courtyard, were complex reliefs depicting the king, in the company of deities, together with his chief wife, 17 of his sons, and some of the nearly 100 other royal children whom he fathered with 8 other official wives.

Such complexity typifies New Kingdom decoration. We see it clearly in the many surviving wall paintings in the rock-cut tombs across the river from Thebes. Earlier, we discussed the variety of fish and bird life in the painting of

Nebamun Hunting Birds (see Fig. 3.2). In a feast scene from the same tomb, the guests receive food from a servant in the top register, while below them, musicians and dancers entertain the group (Fig. 3.21). Very little is known about how Egyptian music actually sounded. Evidently, hymns were chanted at religious festivals, and song was a popular part of daily life. As in Mesopotamia, musical instruments—flutes, harps, lyres, trumpets, and metal rattles called *sistrums*—were often found in Egyptian tombs. In this wall painting, the two nude dancers are posed in a complex intertwining of limbs. Furthermore, of the four seated figures on the left—one of whom plays a double flute while the others appear to be clapping and, perhaps, chanting—two are depicted

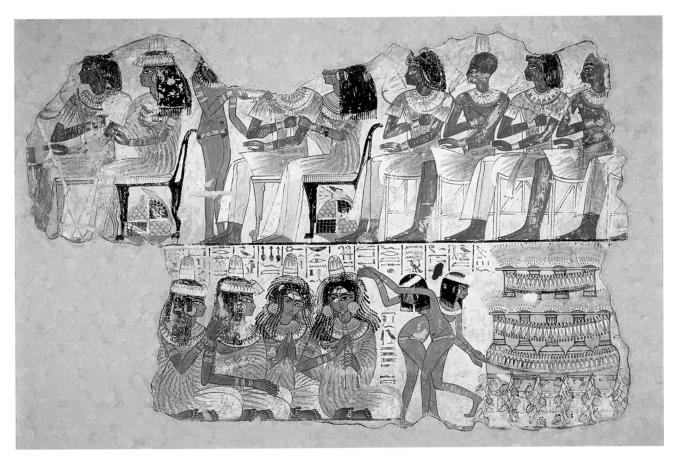

Fig. 3.21 Female Musicians and Dancers Entertaining Guests at a Meal, detail of a fresco from the tomb of Nebamun, Western Thebes. Dynasty 18, ca. 1360 BCE. Paint on plaster, height of fragment 24". The British Museum, London. © The Trustees of The British Museum/Art Resource, NY. The inclusion of such a scene in a tomb suggests that, in the New Kingdom, the dead demanded not only that they be accompanied by the usual necessities into the afterlife, but that they be entertained there as well.

frontally, a rarity in Egyptian art. The women wear cones of a scented fatty substance on their heads (as the cones melted, the women were bathed in its perfume), and the soles of their feet are turned toward us. In this luxurious atmosphere, a new informality seems to have introduced itself into Egyptian art.

Akhenaten and the Politics of Religion

Toward the end of the Eighteenth Dynasty, Egypt experienced one of the few real crises of its entire history when, in 1353 BCE, Amenhotep IV (r. 1353–1337 BCE) assumed the throne of his father Amenhotep III (r. 1391–1353 BCE). It was the father who had originally begun construction of the greater (southern) part of the Temple of Amun-Mut-Khonsu at Luxor and who built the third and tenth pylons at the Temple of Amun at Karnak. The great additions to these temples undertaken by Ramses II some 70 years later may have been a conscious return to the style—and traditions—of Amenhotep III. Certainly, they represent a massive, even overstated rejection of the ways of the son,

for Amenhotep IV had forsaken not only the traditional conventions of Egyptian representation but the very gods themselves.

Although previous Egyptian kings may have associated themselves with a single god whom they represented in human form, Egyptian religion supported a large number of gods. Even the Nile was worshipped as a god. Amenhotep IV abolished the pantheon of Egyptian gods and established a religion in which the sun disk Aten was worshipped exclusively. Other gods were still acknowledged, but they were considered to be too inferior to Aten to be worth worshipping. Whether Amenhotep's religion was henotheism—as we have seen before, in the Zoroastrian worship of Athura Mazda in Persia (see Chapter 2)—or truly monotheistic is a matter of some debate.

Amenhotep IV believed the sun was the creator of all life, and he may have composed *The Hymn to the Sun*, inscribed on the west wall of the tomb of Ay (r. 1327–1323 BCE) at el-Amarna [uh-MAHR-nuh] and in many other tombs as well (Reading 3.3):

READING 3.3

from Akhenaten's Hymn to the Sun

(14th century BCE)

Let your holy Light shine from the height of heaven, O living Aton, source of all life! From eastern horizon risen and streaming, you have flooded the world with your beauty. You are majestic, awesome, bedazzling, exalted, overlord over all earth, yet your rays, they touch lightly, compass the lands to the limits of all your creation. There in the Sun, you reach to the farthest of those you would gather in for your Son, whom you love; Though you are far, your light is wide upon earth; and you shine in the faces of all who turn to follow your journeying. When you sink to rest below western horizon earth lies in darkness like death, Sleepers are still in bedchambers, heads veiled, eye cannot spy a companion; All their goods could be stolen away,

heads heavy there, and they never knowing! Lions come out from the deeps of their caves, snakes bite and sting; Darkness muffles, and earth is silent:

he who created all things lies low in his tomb. Earth-dawning mounts the horizon, glows in the sun-disk as day:

You drive away darkness, offer your arrows of shining, and the Two Lands are lively with morningsong. Sun's children awaken and stand,

for you, golden light, have upraised the sleepers; Bathed are their bodies, who dress in clean linen, their arms held high to praise your Return.

Across the face of the earth they go to their crafts and professions. The herds are at peace in their pastures,

trees and the vegetation grow green; Birds start from their nests,

wings wide spread to worship your Person; Small beasts frisk and gambol, and all who mount into flight or settle to rest

live, once you have shone upon them; Ships float downstream or sail for the south, each path lies open because of your rising:

Fish in the River leap in your sight, and your rays strike deep in the Great Green Sea.

It is you create the new creature in Woman, shape the life-giving drops into Man.

Foster the son in the womb of his mother, soothe him, ending his tears

Re is clearly the life force and source of all good, the very origin of creation itself.

Amenhotep IV was so dedicated to Aten that he changed his own name to Akhenaten [ah-ken-AH-ten] ("The Shining Spirit of Aten") and moved the capital of Egypt from Thebes to a site many miles north that he also named Akhetaten (modern Tell el-Amarna). This move transformed Egypt's political and cultural as well as religious life. At this new capital he presided over the worship of Aten as a divine priest and his queen as a divine priestess. Temples to Aten were open courtyards, where the altar received the sun's direct rays.

Why would Amenhotep IV/Akhenaten have substituted monotheism for Egypt's traditional polytheistic religion? Many Egyptologists argue that the switch had to do with enhancing the power of the pharaoh. With the pharaoh representing the one god who mattered, all religious justification for the power held by a priesthood dedicated to the traditional gods was gone. As we have seen, the pharaoh was traditionally associated with the sun god Re. Now in the form of the sun disk Aten, Re was the supreme deity, embodying the characteristics of all the other gods, therefore rendering them superfluous. By analogy, Amenhotep IV/Akhenaten was now supreme priest, rendering all other priests superfluous as well. Simultaneously, the temples dedicated to the other gods lost prestige and influence. These changes also converted the priests into dissidents.

A New Art: The Amarna Style Such significant changes had a powerful effect on the visual arts as well. Previously, Egyptian art had been remarkably stable because its principles were considered a gift of the gods—thus perfect and eternal. But now, the perfection of the gods was in question, and the principles of art were open to reexamination as well. A new art replaced the traditional canon of proportion—the familiar poses of king and queen—with realism, and a sense of immediacy, even intimacy. So Akhenaten allowed himself and his family to be portrayed with startling realism, in what has become known, from the modern name for the new capital, as the Amarna style.

An example is a small relief from Akhenaten's new capital: The king is depicted with a skinny, weak upper body, his belly protruding over his skirt; his skull is elongated behind an extremely long, narrow facial structure; and he sits in a slumped, almost casual position (Fig. 3.22). (One theory holds that Akhenaten had Marfan syndrome, a genetic disorder that leads to skeletal abnormalities.) This depiction contrasts sharply with the idealized depictions of the pharaohs in earlier periods. Akhenaten holds one of his children in his arms and seems to have just kissed her. His two other children sit with the queen across from him, one turning to speak with her mother, the other touching the queen's cheek. The queen herself, Nefertiti [nef-er-TEEtee], sits only slightly below her husband and appears to share his position and authority. In fact, one of the most striking features of the Amarna style is Nefertiti's prominence in the decoration of the king's temples. In one, for example, she is shown slaughtering prisoners, an image traditionally reserved for the king himself. It is likely that her prominence was part of Akhenaten's attempt to substitute the veneration of his own family (who, after all, represent Aten on earth) for the traditional Amun-Mut-Khonsu family group.

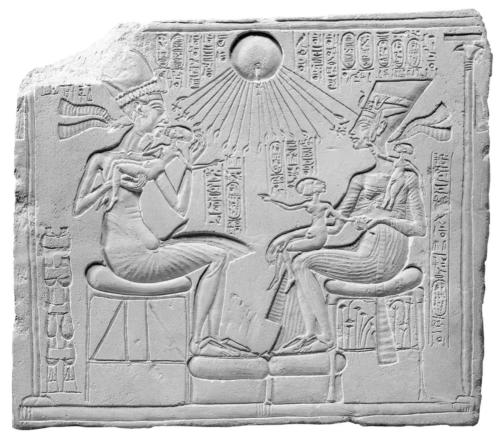

Fig. 3.22 Akhenaten and His Family, from Akhetaten (modern Tell el-Amarna). Dynasty 18, ca. 1345 BCE. Painted limestone relief, 12 ³/₄" × 14 ⁷/₈". Staatliche Museen zu Berlin, Preussischer Kulturbesitz, Ägyptisches Museum. Between Akhenaten and his queen Nefertiti, the sun disk Aten shines down beneficently. Its rays end in small hands, which hold the ankh symbol for life before both the king and queen.

SEE MORE For a Closer Look at *Akhenaten and His Family,* go to **www.myartslab.com**

In a house in the southern part of Akhenaten's new city at Amarna, the famous bust of Queen Nefertiti was discovered along with drawings and sculptures of the royal family (Fig. 3.23). This was the workshop of Thutmose, one of the king's royal artists. It seems likely that many other sculptures and reliefs were modeled on the bust of Nefertiti. At any rate, the queen's beauty cannot be denied, and this image of her has become famous worldwide. Even in her own time, she was known by such epitaphs as "Fair of Face" and "Great in Love."

The Return to Thebes and to Tradition

Akhenaten's revolution was short-lived. Upon his death, Tutankhaten (r. 1336–1327 BCE), probably Akhenaten's son, assumed the throne and changed his name to Tutankhamun (indicating a return to the more traditional gods, in this case Amun). The new king abandoned el-Amarna, moved the royal family to Memphis in the north, and reaffirmed Thebes as the nation's religious center. He died shortly after and was buried in the west bank of the Nile at Thebes, near the tomb of Hatshepsut.

The Tomb of Tutankhamun Tutankhamun's is the only royal tomb in Egypt to have escaped the discovery of looters. In addition to the royal sarcophagus discovered by Carter (see Fig. 3.1), there were also vast quantities of beautiful furniture in the tomb, including a golden throne that dates from early in the king's rule and still bears the indelible stamp of

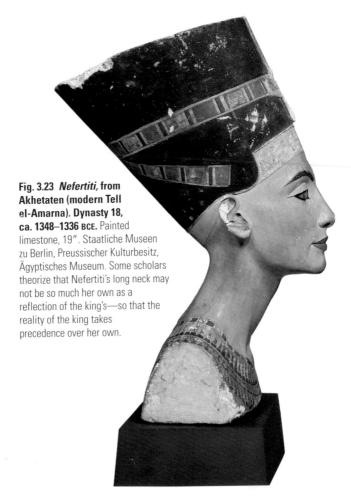

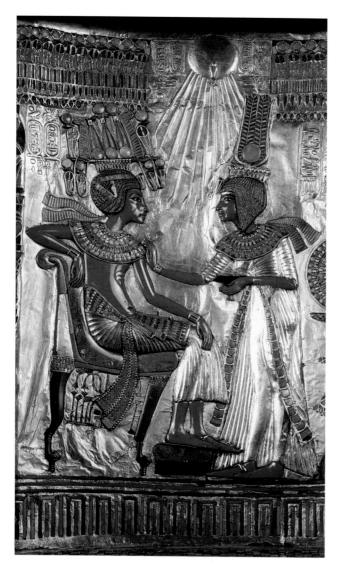

Fig. 3.24 Back of Tutankamun's "Golden Throne," from his tomb, Valley of the Kings, Western Thebes. Dynasty 18, ca. 1335 BCE. Wood, gold, faience, and semiprecious stones, height of entire throne 41", height of detail approx. 12 1/4". Egyptian Museum, Cairo. This throne shows that early in his life, at least, Tutankamun was still portrayed in the Armana style.

the Armana style, with Aten shining down on both the king and queen (Fig. 3.24). Jewelry of exquisite quality abounded, as did textiles—rarest of all archeological finds because they deteriorate over time. Carter and his team also found a golden *canopic* [kuh-NOPE-ik] chest—which held the king's embalmed internal organs—a shrine-shaped box of alabaster, carved with four compartments, each of which had a carved and gilded stopper depicting the king. It had an alabaster lid that covered the stoppers, and it was set in a larger shrine of gilded wood, protected by three gilded statues of goddesses, and covered by a shroud covered with gold rosettes.

The Final Judgment The elaborate burial process was not meant solely to guarantee survival of the king's *ka* and *ba*. It also prepared him for a "last judgment," a belief system that

would find expression in the Hebrew faith as well. In this two-part ritual, deities first questioned the deceased about their behavior in life. Then their hearts, the seat of the ka, were weighed against an ostrich feather, symbol of Maat [mah-aht], the goddess of truth, justice, and order. Egyptians believed the heart contained all the emotions, intellect, and character of the individual, and so represented both the good and bad aspects of a person's life. If the heart did not balance with the feather, then the dead person was condemned to nonexistence, to be eaten by a creature called Ammit [AH-mit], the vile "Eater of the Dead," part crocodile, part lion, and part hippopotamus. Osiris, wrapped in his mummy robes, oversaw this moment of judgment. Tut himself, depicted on his sarcophagus with his crossed arms holding crook and flail, was clearly identified with Osiris.

Books of Going Forth by Day At the time of Tut's death, the last judgment was routinely illustrated in Books of Going Forth by Day (also known as Books of the Dead), collections of magical texts or spells buried with the deceased to help them survive the ritual of judgment. One such magical text was the "Negative Confession" (**Reading 3.4**), which the deceased would utter upon entering the judgment hall:

READING 3.4

from The Book of Going Forth by Day

I have come unto you; I have committed no faults; I have not sinned; I have done no evil; I have accused no man falsely; therefore let nothing be done against me. I live in right and truth, and I feed my heart upon right and truth. That which men have bidden I have done, and the gods are satisfied thereat. I have pacified the god, for I have done his will. I have given bread unto the hungry and water unto those who thirst, clothing unto the naked, and a boat unto the shipwrecked mariner. I have made holy offerings unto the gods; and I have given meals of the tomb to the sainted dead. O, then, deliver ye me, and protect me; accuse me not before the great god. I am pure of mouth, and I am pure of hands . . .

I offer up prayers in the presence of the gods, knowing that which concerneth them. I have come forward to make a declaration of right and truth, and to place the balance upon its supports within the groves of amaranth. Hail, thou who art exalted upon thy resting place, thou lord of the *atef* crown, who declarest thy name as the lord of the winds, deliver thou me from thine angels of destruction, who make dire deeds to happen and calamities to arise, and who have no covering upon their faces, because I have done right and truth, O thou Lord of right and truth. I am pure, in my fore-parts have I been made clean, and in my hinder parts have I been purified; my reins have been bathed in the Pool of right and truth, and no member of my body was wanting. I have been purified in the pool of the south . . .

¹A conical headdress decorated with two ostrich feathers, joined with ram's horns and a sun disk, and associated particularly with Osiris.

LEARN MORE Gain insight about Books of the Dead from a primary source document at www.myartslab.com

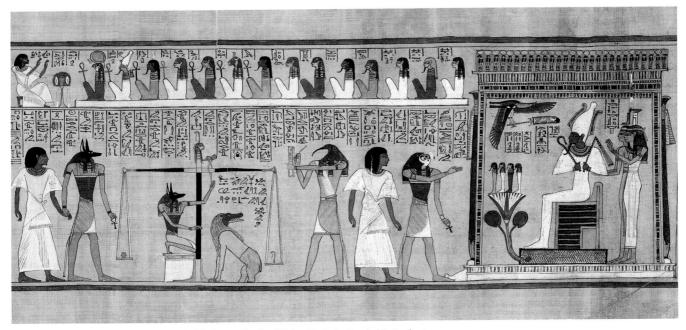

Fig. 3.25 Last Judgment of Hunefer by Osiris, from a Book of Going Forth by Day in his tomb at Thebes. Dynasty 19, ca. 1285 BCE. Painted papyrus scroll, height $15\,^{5}/_{8}$ ". The British Museum, London. At the top, Hunefer, having passed into eternity, is shown adoring a row of deities.

The following moment of judgment is depicted in one such Book of Going Forth by Day, a papyrus scroll created for an otherwise anonymous man known as Hunefer [HOO-nef-er] (Fig. 3.25). The scene reads from left to right in a continuous pictorial narrative. To the left, Anubis [uh-NOO-bis], overseer of funerals and cemeteries, brings Hunefer into the judgment area. Hunefer's heart, represented as a pot, is being weighed against the ostrich feather. In this image, Hunefer passes the test—not surprising, given that the work is dedicated to ensuring that Hunefer's ka survive in the afterlife. Horus brings Hunefer to Osiris, seated under a canopy, with his sisters at the right.

THE LATE PERIOD, THE KUSHITES, AND THE FALL OF EGYPT

From Tutankhamun's time through the Late Period (715–332 BCE) and until the fall of Egypt to the Romans in 30 BCE, the conventions of traditional representation remained in place. For example, the pose we saw in Menkaure's funeral sculpture of 2460 BCE (see Fig. 3.10) is repeated in the seventh-century BCE statue of Mentuemhet, the Governor (Fig. 3.26). Mentuemhet [men-too-EM-het] strides forward into eternal life, nearly 2,000 years after that Old Kingdom pharaoh, a strong visual signal of the stability of Egyptian culture.

Mentuemhet was probably the most influential official of the Twenty-fifth Dynasty (ca. 715–656 BCE). He was appointed governor of Thebes by the Kushites [KOOSH-ites] (from Kush, the Egyptian name for the southern region of Nubia, in today's Sudan). Nubia had long been an important neighbor, appearing in Egyptian records as far back as

Fig. 3.26 *Mentuemhet,* from Karnak, Thebes. Dynasty 25, ca. 660 BCE. Granite, height 54". Egyptian Museum, Cairo. The only concession to naturalistic representation in this sculpture is in the governor's facial features.

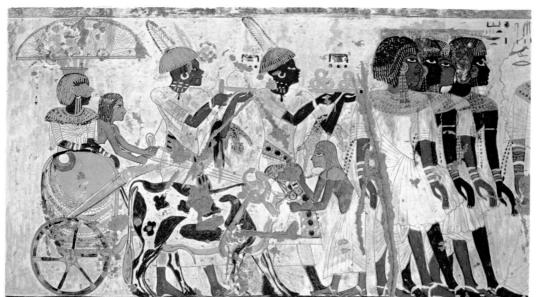

Fig. 3.27 Nubians Bringing Tribute, from the tomb of Amenhotep Huy, the Nubian viceroy under Tutankhamen, Qurnet Murai, Western Thebes. Dynasty 18, ca. 1330 BCE. Painting on plaster. Editions Gallimard, Paris. This painting represents the kind of trade relations that Egypt enjoyed with Nubia and Kush.

the Old Kingdom. Nubia served as a corridor for trade between Egypt and sub-Saharan Africa and was the main means by which Egypt procured gold and incense, as well as ivory, ebony, and other valuable items (Fig. 3.27). Because of its links with tropical Africa, over time, the population of Nubia became a diverse mixture of ethnicities.

Nubia had been the location of several wealthy urban centers, including Kerma, whose walls, mud-brick buildings, and lavish tombs were financed and built by indigenous Nubian rulers around 1650 BCE. Napata was built during an Egyptian annexation of the area in approximately 1500 BCE, during the reign of Thutmose I. Napata became the provincial capital of southern Nubia, an area the Egyptians knew as Kush.

The Kushites

The Kushites had an immense appetite for assimilating Egyptian culture. They adopted Egyptian religion and practices, worshipping Egyptian gods, particularly Amun, the Egyptian state god. The main religious center of Kush was at Jebel Barkal [JEB-uh bar-kahl], a mountain near the fourth cataract of the Nile where the Kushites believed Amun dwelled. Their adoption of Egyptian ways nevertheless retained their distinctly Nubian identity. The Kushites developed hieroglyphs to express their own language, continued to worship many of their own gods, and though they also began to erect pyramids over their royal tombs, theirs started from smaller bases and were distinctly steeper and more needle-like than their Egyptian counterparts. There are nearly 300 of these pyramids in modern Sudan, more than in Egypt itself. Although annexed to Egypt, Kush was essentially an independent state toward the end of the New Kingdom. Egypt relied upon Kush to supply gold and other resources (including Nubian soldiers, among the most feared warriors in the region), but as Egypt struggled with its own enemies to the east, the rulers of Kush eventually found themselves in a position to take control of Egypt

themselves. In the eighth century BCE, the Egyptians turned to Kush for the leadership they needed to help hold off the mounting threat of an Assyrian invasion, and the Egyptianized African rulers of Kush became the Twenty-fifth Dynasty of pharaohs. As pharaohs, the Kushite kings ruled an empire that stretched from the borders of Palestine possibly as far upstream as the Blue and White Niles, uniting the Nile Valley from Khartoum [KAR-toom] to the Mediterranean. They were expelled from Egypt by the Assyrians after a rule of close to 100 years.

Egypt Loses Its Independence

The Assyrians left rule of Egypt to a family of local princes at Saïs [SAY-is], in the western portion of the Nile Delta, inaugurating the Twenty-sixth, or Saite [SAY-eet] Dynasty (664–525 BCE). With Memphis as their administrative center, they emphasized Mediterranean trade, which in turn produced over 100 years of economic prosperity. But Egypt was anything but secure in power struggles that dominated the larger political climate of the region. In 525 BCE, the Persians invaded from the north and made the country a mere province in its empire. For the next 200 years, Egypt enjoyed brief periods of independence, until the Persians invaded again in 343 BCE. They had ruled for not much more than a decade when the Macedonian [mass-uh-DOH-nee-un] conqueror Alexander the Great drove them out and asserted his own authority. According to legend, the god Amun spoke to Alexander through an oracle, acknowledging him as his son and therefore legitimate ruler of Egypt. Its independence as a state had come to an end. When Alexander died, the country fell to the rule of one of his generals, Ptolemy [TAHL-uhmee], and beginning in 304 BCE, the final Ptolemaic [tahl-MAY-ik] Dynasty was under way. A kingdom in the Greek constellation, Egypt would finally fall to an invading Roman army in 30 BCE. But remarkably, until this moment, its artistic and religious traditions, as well as its daily customs, remained largely in place, practiced as they had been for 3,000 years.

Mutual Influence through Trade

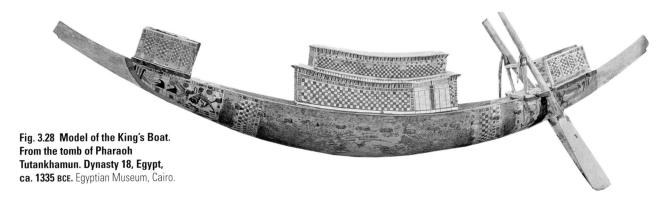

Ithough Egyptian art and culture remained extraordinarily stable for over 3,000 years, it would be a mistake to assume that this was because the region was isolated. In fact, Egypt was a center of trade for the entire Mediterranean basin. Spiral and geometric designs on Egyptian pottery from as early as the Twelfth Dynasty (1980–1801 BCE) suggest the influence of Aegean civilizations, and during the reign of Hatshepsut's young son, Thutmose III, connections with Aegean cultures appear to have been extremely close. Evidence from surviving images of both cultures' ship designs—ships that would have facilitated Aegean trade—suggests a mutual influence. A small-scale model of the king's boat from the tomb of King Tut shows a stern cabin, decorated with images of the king,

where the steersmen would have guided the boat (Fig. 3.28). Ships such as this were equipped with a mast that could be raised and fitted with a sail to catch the Nile winds from astern.

Egypt's influence in the Mediterranean was farflung, although it is unlikely that its ships set out to sea. Rather, their boats would have generally hugged the coast. But Egypt was a port of call, and traders from around the Mediterranean visited there. Archeologists excavating at Mycenae [my-SEE-neel, a center of culture that was firmly established on the Greek Peloponnesus [pel-uhpuh-NEE-sus by 1500 BCE, have discovered Egyptian scarabs at the site, including one bearing the name of Queen Tiy [tee], mother of Akhenaten. Scarabs are amulets in the shape of a beetle, and since the Egyptian word for beetle, kheprer, is derived from the word kheper, "to come into being," scarabs were associated with rebirth in the afterlife. Those displaying names were generally used as official seals. A shipwreck discovered off the coast of southern Turkey in 1982 gives us some sense of the extent of Mediterranean trade. Carbon dating of firewood found on board suggests the ship sank in about 1316 BCE. Its cargo included gold from Egypt, weapons from Greece, a scarab bearing Nefertiti's name (Fig. 3.29), amber from northern Europe, hippopotamus and elephant ivory, and tin from Afghanistan. Such trade resulted not only in the transfer of goods between various regions, but in a broader cultural diffusion as well, for ideas, styles, religions, and technologies spread from one culture to another throughout the region. Much work remains to be done on the interconnections and lines of continuity and change among the peoples of the Aegean, the broader Mediterranean, Mesopotamia, and Egypt, but it is clear that they knew of one another, traded with one another, and were stimulated by one another's presence.

Fig. 3.29 Scarab of Queen Nefertiti, wreck of the *Uluburun*.
ca. 1330 BCE. The Bodrum Museum of Underwater Archaeology, Bodrum, Turkey.

How did the idea of cycles shape Egyptian civilization?

The annual cycle of flood and sun, the inundation of the Nile River Valley that annually deposited deep layers of silt followed by months of sun in which crops could grow in the fertile soil, helped to define Egyptian culture. This predictable cycle helped to create a cultural belief in the stability and balance of all things that lasted for over 3,000 years. Can you describe this belief in terms of cyclical harmony? How does the Egyptian religion reflect this belief system?

Originally, what purposes did Egyptian sculpture and architecture serve?

Most surviving Egyptian art and architecture was devoted to burial and the afterlife, the cycle of life, death, and rebirth. The pyramids at Saqqara and Giza and the statuary of kings and queens were especially dedicated to this cycle. How do sculptures of lesser figures serve the same ends?

What important change distinguishes the Middle Kingdom?

Whereas in the Old Kingdom, writing had been used almost exclusively in a religious context, in the Middle Kingdom a vast secular literature developed. What does this secular literature tell us about Egyptian society?

Who was Amenhotep IV? Why did he change his name to Akhenaten?

The New Kingdom kings, now called "pharaoh," undertook massive, elaborately decorated building projects

at Karnak and Thebes. Toward the end of the Eighteenth Dynasty, Amenhotep IV forsook traditional conventions of Egyptian representation, abolished the pantheon of Egyptian gods, established a monotheistic religion in which the sun disk Aten was worshiped exclusively, and changed his own name to Akhenaten. How does Amenhotep IV's religion differ from Egyptian religion in general? What other changes to Egyptian tradition occurred during his reign?

Funeral practices soon included the incantation of texts and spells collected in Books of Going Forth by Day, which accompanied the deceased as they underwent a last judgment. What significance do you attach to the title of these books?

How did Egypt decline and fall?

After the end of the New Kingdom, traditional representational practices remained in place, even when Kushite kings from the south in modern Sudan ruled the country. How did the Nubians and Kushites contribute to Egyptian culture? Egypt became susceptible to invasion, and after it fell to Alexander the Great in 332 BCE, its independence as a state came to an end, even though the new Greek Ptolemaic Dynasty continued traditional Egyptian ways until Rome conquered the country in 30 BCE.

PRACTICE MORE Get flashcards for images and terms and review chapter material with quizzes at www.myartslab.com

GLOSSARY

ankh A hieroglyph of a cross topped with a loop; a symbol of life in ancient Egypt.

ba In ancient Egypt, an idea comparable to a person's personality.

cartouche In ancient Egyptian art, an ornamental and symbolic frame reserved for the names of rulers and their wives. **colonnade** A sequence or row of columns supporting a lintel and a roof.

 ${\color{red} \textbf{composite view}}$ A view that integrates multiple perspectives into a single unified representation.

determinative A sign used in Egyptian hieroglyphs to indicate the category of an object or being.

fresco secco "Dry fresco"; the technique of painting on dry plaster.

hieroglyph A sign used in hieroglyphic writing, a writing system consisting mainly of pictorial characters.

 $\begin{tabular}{ll} \textbf{hypostyle hall} & A \ vast \ space \ filled \ with \ columns \ supporting \ a \\ roof. \end{tabular}$

ka In ancient Egypt, an idea comparable to a "soul" or "life force."

mastaba A trapezoidal tomb structure.

mummification The process of embalming, drying, and preserving a body.

mummy An embalmed body wrapped for burial.

 $\mbox{\it obelisk } A$ square, tapered stone column topped by a pyramid shape.

pharaoh A ruler of ancient Egypt.

phonogram A pictogram used to represent a sound.

pictogram A drawing that represents an object or being; often combined in hieroglyphic writing to express ideas.

pictorial formula A convention of representation in art.

pylon A massive gateway with sloping walls.

sanctuary The most sacred place of a religious building. **sarcophagus** A rectangular stone coffin.

serekh A hieroglyphic device representing a pharaoh's palace seen simultaneously from above and the front, usually with a falcon on top of it (though not on *Narmer's Palette*; used to hold the pharaoh's name.

symmetrical Balanced on the left and right sides.

theocracy A state ruled by a god or by the god's representative. **votive** A ritual object.

READING 3.2

The Teachings of Khety (ca. 2040-1648 BCE)

In the following example of instructive literature, dating from the Middle Kingdom, a royal scribe tries to convince his son to follow him into the profession by debunking virtually every other career path the young man might choose to follow. The work is as instructive as it is amusing, since it presents a wonderfully complete picture of daily life in the Middle Kingdom.

The beginning of the teaching which the man of Tjel named Khety made for his son named Pepy, while he sailed southwards to the Residence to place him in the school of writings among the children of the magistrates, the most eminent men of the Residence.

So he spoke to him: Since I have seen those who have been beaten, it is to writings that you must set your mind. Observe the man who has been carried off to a work force. Behold, there is nothing that surpasses writings! They are a boat upon the water. Read then at the end of the Book of Kemyet this statement in it saying:

As for a scribe in any office in the Residence, he will not suffer want in it. When he fulfills the bidding of another, he does not come forth satisfied. I do not see an office to be compared with it, to which this maxim could relate. I shall make you love books more than your mother, and I shall place their excellence before you. It is greater than any office. There is nothing like it on earth. When he began to become sturdy but was still a child, he was greeted (respectfully). When he was sent to carry out a task, before he returned he was dressed in adult garments.

I do not see a stoneworker on an important errand or a goldsmith in a place to which he has been sent, but I have seen a coppersmith at his work at the door of his furnace. His fingers were like the claws of the crocodile, and he stank more than fish excrement.

Every carpenter who bears the adze is wearier than a field-hand. His field is his wood, his hoe is the axe. There is no end to his work, and he must labor excessively in his activity. At nighttime he still must light his lamp

The barber shaves until the end of the evening. But he must 30 be up early, crying out, his bowl upon his arm. He takes himself from street to street to seek out someone to shave. He wears out his arms to fill his belly, like bees who eat (only) according to their work.

The reed-cutter goes downstream to the Delta to fetch himself arrows. He must work excessively in his activity. When the gnats sting him and the sand fleas bite him as well, then he is judged.

The potter is covered with earth, although his lifetime is still among the living. He burrows in the field more than swine to bake his cooking vessels. His clothes being stiff with mud, his 40 head cloth consists only of rags, so that the air which comes forth from his burning furnace enters his nose. He operates a

pestle with his feet with which he himself is pounded, penetrating the courtyard of every house and driving earth into every open place.

I shall also describe to you the bricklayer. His kidneys are painful. When he must be outside in the wind, he lays bricks without a garment. His belt is a cord for his back, a string for his buttocks. His strength has vanished through fatigue and stiffness, kneading all his excrement. He eats bread with his fingers, although he washes himself but once a day

The weaver inside the weaving house is more wretched than a woman. His knees are drawn up against his belly. He cannot breathe the air. If he wastes a single day without weaving, he is beaten with 50 whip lashes. He has to give food to the doorkeeper to allow him to come out to the daylight

See, there is no office free from supervisors, except the scribe's. He is the supervisor!

But if you understand writings, then it will be better for you than the professions which I have set before you What I 60 have done in journeying southward to the Residence is what I have done through love of you. A day at school is advantageous to you

Be serious, and great as to your worth. Do not speak secret matters. For he who hides his innermost thoughts is one who makes a shield for himself. Do not utter thoughtless words when you sit down with an angry man.

When you come forth from school after midday recess has been announced to you, go into the courtyard and discuss the last part of your lesson book.

When an official sends you as a messenger, then say what he said. Neither take away nor add to it \dots

See, I have placed you on the path of God See, there is no scribe lacking sustenance, (or) the provisions of the royal house Honour your father and mother who have placed you on the path of the living.

READING CRITICALLY

Although the scribe Dua-Khety spends much time describing the shortcomings of other lines of work, he also reminds his son how he should behave at school. What do the father's words of advice tell us about the values of Egyptian society?

4

The Aegean World and the Rise of Greece

Trade, War, and Victory

THINKING AHEAD

What were the Cycladic, Minoan, and Mycenaean cultures?

Who was Homer and what did he write?

What is a polis and how did poleis shape Greek culture?

What does kouros mean?

Who or what inspired the rise of democracy in Athens?

he Aegean Sea, in the eastern Mediterranean, is filled with islands. Here, beginning in about 3000 BCE, seafaring cultures took hold. So many were the islands, and so close to one another, that navigators were always within sight of land. In the natural harbors where seafarers came ashore, port communities developed and trade began to flourish. A house from approximately 1650 BCE was excavated at Akrotiri on Thera, one of these islands. The Miniature Ship Fresco, a frieze that extended across the top of least three walls in a second-story room, suggests a prosperous, seafaring community engaged in a celebration of the sea (Fig. 4.1). People lounge on terraces and rooftops as boats glide by, accompanied by leaping dolphins.

The later Greeks thought of the Bronze Age Aegean peoples as their ancestors—particularly those who inhabited the islands of the Cyclades, the island of Crete, and Mycenae, on the Peloponnese [pel-uh-poh-NEEZ]—and considered their activities and culture part of their own prehistory. They even had a word for the way they knew them—archaiologia [ar-kaee-oh-LOH-ghee-uh], "knowing the past." They did not practice archeology as we do today, excavating ancient sites and scientifically analyzing the artifacts discovered there. Rather, they learned of their past through legends passed down, at first orally and then in writing, from generation to generation. Interestingly, the modern practice of archeology has confirmed much of what was legendary to the Greeks.

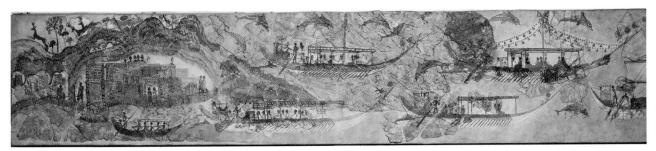

▼ Fig. 4.1 (left and above) Miniature Ship Fresco (detail and larger view from the left section), from Room 5, West House, Akrotiri, Thera. Before 1623 BCE. Height 15 ³/₄ ". National Archaeological Museum, Athens. The total length of this fresco is over 24 feet. Harbors such as this one provided shelter to traders who sailed between the islands of the Aegean Sea as early as 3000 BCE.

HEAR MORE Listen to an audio file of your chapter at www.myartslab.com

THE CYCLADES

The Cyclades are a group of more than 100 islands in the Aegean Sea between mainland Greece and the island of Crete (Map 4.1). They form a roughly circular shape, giving them their name, from the Greek word kyklos [kihklos], "circle" (also the origin of our word "cycle"). No written records of the early Cycladic [sih-KLAD-ik] people remain, although archeologists have found a good deal of art in and around hillside burial chambers. The most famous of these artifacts are marble figurines in a highly simplified and abstract style that appeals to the modern eye (Fig. 4.2). In fact, Cycladic figurines have deeply influenced modern sculptors. The Cycladic figures originally looked quite different because they were painted. Most of the figurines depict females, but male figures, including seated harpists and acrobats, also exist. The figurines range in height from a few inches to life-size, but anatomical detail in all of them is reduced to essentials. With their toes pointed down, their heads tilted back, and their arms crossed across their chests, the fully extended figures are corpselike. Their function remains unknown, but since most of these figures

were created for a mortuary purpose. By about 2200 BCE, trade with the larger island of Crete to the south brought the Cyclades into Crete's political orbit and radically altered Cycladic life. Evidence of this influence survives in the form of wall paintings discovered in 1967 on the island of Thera (today known as Santorini [san-tor-EE-nee]), at Akrotiri, a community that had been buried beneath one of the largest volcanic eruptions in the last 10,000 years. About 7 cubic miles of magma spewed forth, and the ash cloud that resulted during the first phase of the eruption was about 23 miles high. The enormity of the eruption caused the volcano at the center of Thera to collapse, producing a caldera, a large basin or depression that filled with seawater. The present island of Thera is actually the eastern rim of the original volcano (small volcanoes are still active in the center of Thera's crescent sea).

were found in graves, it seems likely that they

The eruption was so great that it left evidence worldwide—in the stunted growth of tree rings as far away as Ireland and California, and in ash taken from ice core samples in Greenland. With this evidence, scientists have dated the eruption to 1623 BCE. In burying the city, it also preserved the city of Akrotiri. Not only were their homes elaborately decorated—with mural paintings such as the *Miniature Ship Fresco*, made with water-based pigments on wet plaster—but they also enjoyed a level of personal hygiene unknown in Western culture until Roman times. Clay pipes led from interior toilets and baths to sewers built under

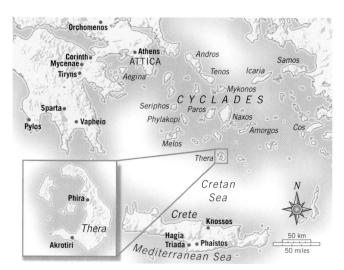

Map 4.1 Crete, the Cyclades, and the island of Thera (modern Santorini). Thera lies just north of Crete. Evidence suggests Cretan influence here by about 2000 BCE.

winding, paved streets. Straw reinforced the walls of their homes, protecting them against earthquakes and insulating them from the heat of the Mediterranean sun.

MINOAN CULTURE IN CRETE

Just to the south of the Cyclades lies Crete, the largest of the Aegean islands. Bronze Age civilization developed there as early as 3000 BCE. Trade routes from Crete established communication with such diverse areas as Turkey, Cyprus [SY-prus], Egypt, Afghanistan, and Scandinavia, from which the island imported copper, ivory, amethyst, lapis lazuli, carnelian, gold, and amber. From Britain, Crete imported the tin necessary to produce bronze. A distinctive culture called Minoan [mih-NO-un] flourished on Crete from about 1900 to 1375 BCE. The name comes from the legendary king Minos [MY-nos], who was said to have ruled the island's ancient capital of Knossos [NOSS-us].

Minoan Painting

Many of the motifs in the frescoes at Akrotiri, in the Cyclades, also appear in the art decorating Minoan palaces on Crete, including the palace at Knossos. This suggests the mutual influence of Cycladic and Minoan cultures by the start of the

Fig. 4.2 Figurine of a woman from the Cyclades. ca. 2500 BCE. Marble, height $15\sqrt[3]{4}$. Nicholas P. Goulandris Foundation. Museum of Cycladic Arts, Athens. N. P. Goulandris Collection, No. 206. Larger examples of such figurines may have been objects of worship.

second millennium BCE. Unique to Crete, however, is emphasis on the bull, the central element of one of the best-preserved frescoes at Knossos, the *Toreador Fresco* (Fig. 4.3). Three almost-nude figures appear to toy with a charging bull. (As in Egyptian art, women are traditionally depicted with light skin, men with a darker complexion.) The woman on the left holds the bull by the horns, the man vaults over its back, and the woman on the right seems to have either just finished a vault or to have positioned herself to catch the man. It is unclear whether this is a ritual activity, perhaps part of a rite of passage. What we do know is that the Minoans regularly sacrificed bulls, as well as other animals, and that the bull was at least symbolically associated with male virility and strength.

Minoan frescoes, as well as those on Thera, differ from ancient Egyptian frescoes in several ways. The most obvious is that they were painted not in tombs but on the walls of homes and palaces, where they could be enjoyed by the living. The two kinds of frescoes were made differently as well. Rather than applying pigment to a dry wall in the fresco secco [FRESS-koh SEK-koh] technique of the Egyptians, Minoan artists employed a buon fresco [bwon FRESS-koh] technique similar to that used by Renaissance artists nearly 3,000 years later (see Chapter 17). In buon fresco, pigment is mixed with water and then applied to a wall that has been coated with wet lime plaster. As the wall dries, the painting literally becomes part of it. Buon fresco is

far more durable than fresco secco, for the paint will not flake off as easily (though all walls will eventually crumble).

Minoan Religion

The people of Thera and Crete seem to have shared the same religion as well as similar artistic motifs. Ample archeological evidence tells us that the Minoans in Crete worshipped female deities. We do not know much more than that, but some students of ancient religions have proposed that the Minoan worship of one or more female deities is evidence that in very early cultures the principal deity was a goddess rather than a god.

One Goddess or Many? It has long been believed that one of the Minoan female deities was a snake goddess, but recently, scholars have questioned the authenticity of most of the existing snake goddess figurines. Sir Arthur Evans (1851–1941), who first excavated at the Palace of Minos on Crete, identified images of the Cretan goddess as "Mountain Goddess," "Snake Goddess," "Dove Goddess," "Goddess of the Caves," "Goddess of the Double Axes," "Goddess of the Sports," and "Mother Goddess." Evans saw all of these as different aspects of a single deity, or Great Goddess. Arthur Evans was the archeologist responsible for the first major excavation on Crete in the early twentieth century. A century after he introduced the Snake Goddess (Fig. 4.4) to the world, scholars are still debating its authenticity. In his book

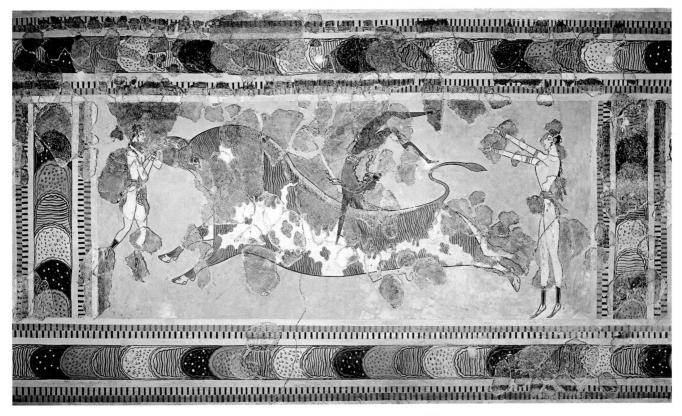

Fig. 4.3 Bull Leaping (Toreador Fresco), from the palace complex at Knossos, Crete. ca. 1450–1375 BCE. Fresco, height approx. $24^{-1}/2^{"}$. Archaeological Museum, Iráklion, Crete. The darker patches of the fresco are original fragments. The lighter areas are modern restorations.

Mysteries of the Snake Goddess (2002), Kenneth Lapatin makes a convincing case that craftspeople employed by Evans manufactured artifacts for the antiquities market. He believes that the body of the statue is an authentic antiquity, but the form in which we see it is largely the imaginative fabrication of Evans's restorers. Many parts were missing when the figure was unearthed, and so an artist working for Evans fashioned new parts and attached them to the figure. The snake in the goddess's right hand lacked a head, leaving its identity as a snake open to question. Most of the goddess's left arm, including the snake in her hand, were absent and later fabricated. When the figure was discovered, it lacked a head, and this one is completely fabricated. The cat on the goddess's head is original, although it was not found with the statue. Lapatin believes that Evans, eager to advance his own theory that Minoan religion was dedicated to the worship of a Great Goddess, never questioned the manner in which the figures were restored. As interesting as the figure is, its

identity as a snake goddess is at best questionable. We cannot even say with certainty that the principal deity of the Minoan culture was female, let alone that she was a snake goddess. There are no images of snake goddesses in surviving Minoan wall frescoes, engraved gems, or seals, and almost all of the statues depicting her are fakes or imaginative reconstructions.

It is likely, though, that Minoan female goddesses were closely associated with a cult of vegetation and fertility, and the snake is an almost universal symbol of rebirth and fertility. We do know that the Minoans worshipped on mountaintops, closely associated with lifegiving rains, and deep in caves, another nearly universal symbol of the womb in particular and origin in general. And in early cultures, the undulations of the earth itself—its hills and ravines, caves and riverbeds—were (and often still are) associated with the curves of the female body and genitalia. But until early Minoan writing is deciphered, the exact nature of Minoan religion will remain a mystery.

Fig. 4.4 Snake Goddess or Priestess, from the palace at Knossos, Crete. ca. 1500 BCE. Faience, height $11.5^{1}/8$ ". Archaeological Museum, Iráklion, Crete. Faience is a kind of earthenware ceramic decorated with glazes. Modern faience is easily distinguishable from ancient because it is markedly lighter in tone.

SEE MORE For a Closer Look at *Snake Goddess or Priestess*, go to **www.myartslab.com**

The Palace of Minos

The Snake Goddess was discovered along with other ritual objects in a storage pit in the Palace of Minos at Knossos. The palace as Evans found it is enormous, covering over six acres. There were originally two palaces at the site—an "old palace," dating from 1900 BCE, and a "new palace," built over the old one after an enormous earthquake in 1750 BCE. This "new palace" was the focus of Evans's attention.

It was one of three principal palace sites on Crete (see Map 4.1), and although Knossos is the largest, they are laid out along similar lines, with a central court surrounded by a labyrinth of rooms. They served as administrative, commercial, and religious centers ruled by a king, similar to the way palaces functioned in the civilizations of Mesopotamia and Egypt. The complexity of these unfortified palaces and the richness of the artifacts uncovered there testify to the power and prosperity of Minoan culture.

As its floor plan and reconstruction drawing make clear, the palace at Knossos was only loosely organized around a central, open courtyard (Fig. 4.5). Leading from the courtyard were corridors, staircases, and passageways that connected living quarters, ritual spaces, baths, and administrative offices, in no discernable order or design.

Workshops surrounded the complex, and vast store-

vide for the needs of both the palace population and the population of the surrounding countryside. In just one storeroom, excavators

rooms could easily pro-

discovered enough ceramic jars to hold 20,000 gallons of olive oil.

Hundreds of wooden columns decorated the palace. Only fragments have survived, but we know from paintings and ceramic house models how they must have looked. Evans created concrete replicas displayed today at the West Portico and the Grand Staircase (Fig. 4.6). The originals were made of huge timbers cut on Crete and then turned upside down so that the top of each is broader than the base. The columns were painted bright red with black capitals, the sculpted blocks that top them. The capitals are shaped liked pillows or cushions. (In fact, they are very close to the shape of an evergreen's root ball, as if the original design were suggested by trees felled in a storm.) Over time, as the columns rotted or were destroyed by earthquakes or possibly burned by invaders, they must have become increasingly difficult to replace, for

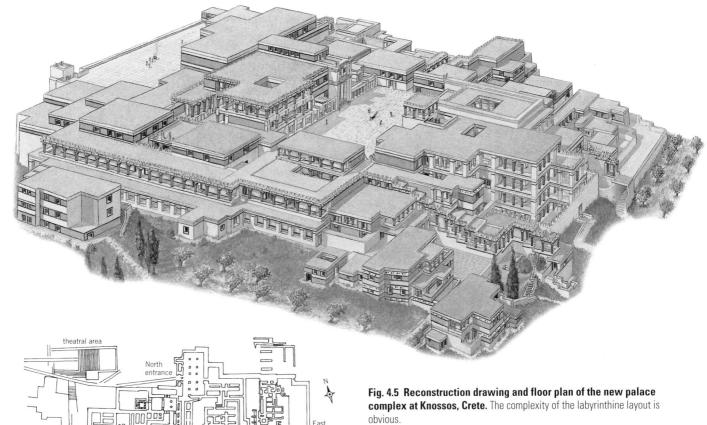

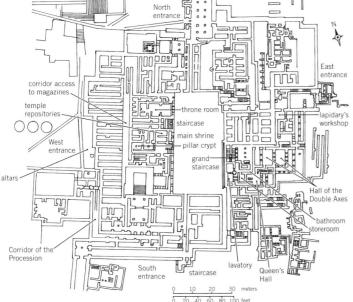

Minoan builders gradually deforested the island. This may be one reason why the palace complex was abandoned sometime around 1450 BCE.

Representations of double axes decorated the palace at every turn, and indeed the palace of Minos was known in Greek times as the House of the Double Axes. In fact, the Greek word for the palace was labyrinth, from labrys, "double ax." Over time, the Greeks came to associate the House of the Double Axes with its inordinately complex layout, and labyrinth came to mean "maze."

Fig. 4.6 Grand Staircase, east wing, palace complex at Knossos, Crete, as reconstructed by Sir Arthur Evans. ca. 1500 BCE. The staircase served as a light well and linked all five stories of the palace.

The Legend of Minos and the Minotaur The Greeks solidified the meaning of the labyrinth in a powerful legend. King Minos boasted that the gods would grant him anything he wished, so he prayed that a bull might emerge from the sea that he might sacrifice to the god of the sea, Poseidon [puh-SY-dun]. A white bull did emerge from the sea, one so beautiful that Minos decided to keep it for himself and sacrifice a different one from his herd instead. This angered Poseidon, who took revenge by causing Minos's queen, Pasiphae [pah-sif-eye], to fall in love with the bull. To consummate her passion, she convinced Minos's chief craftsperson, Daedalus [DEE-duh-lus], to construct a hollow wooden cow into which she might place herself and attract the bull. The result of this union was a horrid creature, half man, half bull: the Minotaur.

To appease the monster's appetite for human flesh, Minos ordered the city of Athens, which he also ruled, to send him 14 young men and women each year as sacrificial victims. Theseus, son of King Aegeus of Athens, vowed to kill the Minotaur. As he set sail for Crete with 13 others, he promised his father that he would return under white sails (instead of the black sails of the sacrificial ship) to announce his victory. At Crete, he seduced Ariadne [a-ree-AD-nee], daughter of Minos. Wishing to help Theseus, she gave him a sword with which to kill the Minotaur and a spindle of thread to lead himself out of the maze in which the Minotaur lived. Victorious, Theseus sailed home with Ariadne but abandoned her on the island of Naxos, where she was discovered by the god of wine, Dionysus, who married her and made her his queen. Theseus, sailing into the harbor at Athens, neglected to raise the white sails, perhaps intentionally. When his father, King Aegeus, saw the ship still sailing under black sails, he threw himself into the sea, which from then on took his name, the Aegean. Theseus, of course, then became king.

The story is a creation or origin myth, like the Zuni emergence tale (see Reading 1.1, page 21) or the Hebrew story of Adam and Eve in Genesis. But it differs from them on one important point: Rather than narrating the origin of humankind in general, it tells the story of the birth

of one culture out of another. It is the Athenian Greeks' way of knowing their past, their archaiologia. The tale of the labyrinth explained to the later Greeks where and how their culture came to be. It correctly suggests a close link to Crete, but it also emphasizes Greek independence from that powerful island. It tells us, furthermore, much about the emerging Greek character, for Theseus would, by the fifth century BCE, achieve the status of a national hero. The great tragedies of Greek theater represent Theseus as wily, ambitious, and strong. He stops at nothing to achieve what he thinks he must. If he is not altogether admirable, he mirrors behavior the Greeks attributed to their gods.

Nevertheless, he is anything but idealized or godlike. He is, almost to a fault, completely human.

It was precisely this search for the origins of Greek culture that led Sir Arthur Evans to the discovery of the Palace of Minos in Crete. He confirmed "the truth" in the legend of the Minotaur. If there was no actual monster, there was indeed a labyrinth. And that labyrinth was the palace itself.

MYCENAEAN CULTURE ON THE MAINLAND

When the Minoans abandoned the palace at Knossos in about 1450 BCE, warriors from the mainland culture of Mycenae, on the Greek mainland, quickly occupied Crete (see Map 4.1). One reason for the abandonment of Knossos was suggested earlier—the deforestation of the island. Another might be that Minoan culture was severely weakened in the aftermath of the volcanic eruption on Thera, and therefore susceptible to invasion or internal revolution. A third might be that the Mycenaean army simply overwhelmed the island. The Mycenaeans were certainly acquainted with the Minoan culture some 92 miles to their south, across the Aegean.

Minoan metalwork was prized on the mainland. Its fine quality is very evident in the *Vaphio Cup*, one of two golden cups found in the nineteenth century in a tomb at Vaphio [VAH-fee-oh], just south of Sparta, on the Peloponnese (Fig. 4.7). This cup was executed in **repoussé** [ruh-poo-SAY], a technique in which the artist hammers out the design from the inside. It depicts a man in an olive grove capturing a bull by tethering its hind legs. The bull motif is classically Minoan. The Mycenaeans, however, could not have been more different from the Minoans. Whereas Minoan towns were unfortified, and battle scenes

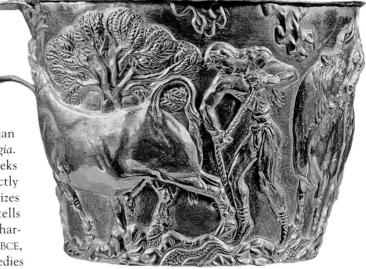

Fig. 4.7 Vaphio Cup, from a tomb at Vaphio, south of Sparta, Greece. ca. 1650–1450 BCE. Gold, height $3 \frac{1}{2}$ ". National Archaeological Museum, Iráklion, Crete. Mycenaean invaders used Crete as a base for operations for several centuries, and probably acquired the cup there.

Fig. 4.8 Lion Gate, Mycenae, Greece. ca. 1300 BCE. Limestone relief, panel approx. 9' 6" high. The lionesses are carved on a triangle of stone that relieves the weight of the massive doorway from the lintel. The original heads, which have never been found, were attached to the bodies with dowels.

were virtually nonexistent in their art, the Mycenaeans lived in communities surrounding fortified hilltops, and battle and hunting scenes dominate their art. Minoan culture appears to have been peaceful, while the warlike Mycenaeans lived and died by the sword.

The ancient city of Mycenae, which gave its name to the larger Mycenaean culture, was discovered by German archeologist Heinrich Schliemann (1822-1890) in the late nineteenth century, before Sir Arthur Evans discovered Knossos. Its citadel looks down across a broad plain to the sea. Its walls—20 feet thick and 50 feet high—were built from huge blocks of rough-hewn stone, in a technique called cyclopean [sy-KLOPE-ee-un] masonry because it was believed by later Greeks that only a race of monsters known as the Cyclopes [sy-KLOH-peez] could have managed them. Visitors to the city entered through a massive Lion Gate at the top of a steep path that led from the valley below (Fig. 4.8). The lionesses that stood above the gate's lintel were themselves 9 feet high. It is likely that their missing heads originally turned in the direction of approaching visitors, as if to ward off evil or, perhaps, humble them in their tracks, like Sargon's human-headed bull gates at Khorsabad (see Fig. 2.13). They were probably made of a different stone than the bodies and may have been plundered at a later time. From the gate, a long, stone street wound up the hill to the citadel itself. Here, overseeing all, was the king's palace.

Mycenae was only one of several fortified cities on mainland Greece that were flourishing by 1500 BCE and that have come to be called Mycenaean. Mycenaean culture was the forerunner of ancient Greek culture and was essentially feudal in nature—that is, a system of political organization held together by ties of allegiance between a lord and those who relied on him for protection. Kings controlled not only their own cities but also the surrounding countryside. Merchants, farmers, and artisans owed their own prosperity to the king and paid high taxes for the privilege of living under his protection. More powerful kings, such as those at Mycenae itself, also expected the loyalty (and financial support) of other cities and nobles over whom they exercised authority. A large bureaucracy of tax collectors, civil servants, and military personnel ensured the state's continued prosperity. Like the Minoans, they engaged in trade, especially for the copper and tin required to make bronze.

The feudal system allowed Mycenae's kings to amass enor-

mous wealth, as Schliemann's excavations confirmed. He discovered gold and silver death masks of fallen heroes (Fig. 4.9), as well as swords and daggers inlaid with imagery of events such as a royal lion hunt. He also found delicately carved ivory, from the tusks of hippopotamuses and elephants, suggesting if not the breadth of Mycenae's power, then the extent of its trade, which clearly included Africa. It seems likely, in fact, that the Mycenaean taste for war, and certainly their occupation of Crete, was moti-

vated by the desire to control trade routes

throughout the region. Schliemann discovered most of this wealth in shaft graves, vertical pits some 20 or 25 feet deep enclosed in a circle of stone slabs. These all date from the early years of Mycenaean civilization, about 1500 BCE. Beginning in about 1300 BCE, the Mycenaeans used a new architectural form, the tholos [THOH-lohs], to bury their kings. A tholos is a round building often called a beehive because of its shape. The most famous of these tombs is the Treasury of Atreus [AY-tree-us], the name Schliemann attributed to it (Figs. 4.10, 4.11). Atreus was the father of Fig. 4.9 Funerary mask (Mask of Agamemnon), from Grave Circle A, Mycenae, Greece, ca. 1600-1550 BCE, Gold, height approx. 12"

National Archaeological Museum, Athens. When Schliemann

discovered this mask, he believed it was the death mask of King Agamemnon, but it predates the Trojan War by some 300 years. Recent scholarship suggests that Schliemann may have added the handlebar mustache and large ears, perhaps to make the mask appear more "heroic."

Agamemnon, an early king of Mycenae known to us from the literature of later Greeks. However, no evidence supports Schliemann's attribution except the structure's extraordinary size, which was befitting of a legendary king, and the fact that it dates from approximately the time of the Trojan War.

(Agamemnon led the Greeks in the 10-year war against Trojans that would form the background for Homer's epic poems, the *Iliad* and the Odyssey, discussed next.) The approach to the Treasury of Atreus is by way of a long, openair passage nearly 115 feet long and 20 feet wide leading to a 16-foot-high door. Over the door is a relieving triangle, a triangular opening above the lintel designed to relieve some of the weight the lintel has to bear. (See the discussions of

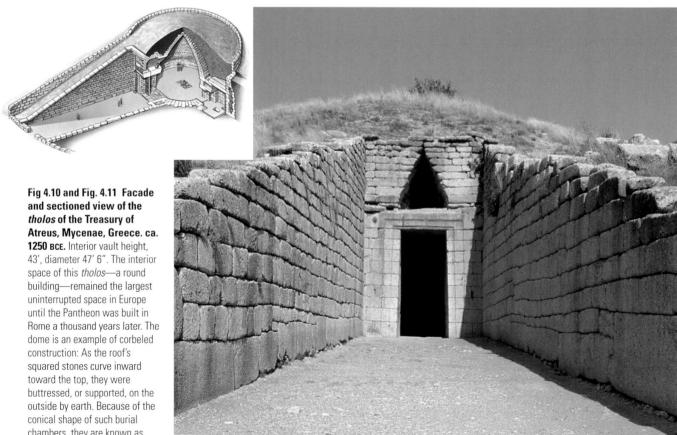

chambers, they are known as beehive tombs.

lintels in Chapter 1.) Surviving fragments reveal that a pair of green marble columns topped by two red marble columns originally adorned the facade of the Treasury of Atreus. The columns were engaged—that is, they were half-columns that projected from the wall but served no structural purpose. Behind the door lay the burial chamber, a giant domed space, in which the dead would have been laid out together with gold and silver artifacts, ceremonial weapons, helmets, armor, and other items that would indicate power, wealth, and prestige.

THE HOMERIC EPICS

One of the most fascinating aspects of the eastern Mediterranean in the Bronze Age is the development of written language. First, around the middle of the second millennium BCE, as trade increasingly flourished between and among the Greek islands and the mainland, a linear Minoan script began to appear on tablets and objects across the region. Then, 600 to 700 years later, the Phoenicians, the great traders of the area, began to spread a distinctly new writing system, based on an alphabet (apparently of their own invention), across the entire Mediterranean basin.

But if the Greeks plundered Phoenician traders, they also were quick to take advantage of their writing system. Their alphabet allowed the Phoenicians to keep records more easily and succinctly than their competitors. It could be quickly taught to others, which facilitated communication in the far-flung regions where their ships sailed, and, written on papyrus, it was much more portable than the clay tablets used in Mesopotamia.

Once the ancient Greeks adopted the Phoenician alphabet in about 800 BCE, they began to write down the stories from about their past—their archaiologia—that had been passed down, generation to generation, by word of mouth. The most important of these stories were composed by an author whom history calls Homer. Homer was most likely a bard, a singer of songs about the deeds of heroes and the ways of the gods. His stories were part of a long-standing oral tradition that dated back to the time of the Trojan War, which we believe occurred sometime between 1800 and 1300 BCE. Out of the oral materials he inherited, Homer composed two great epic poems, the Iliad and the Odyssey. The first narrates an episode in the 10-year Trojan War, which, according to Homer, began when the Greeks launched a large fleet of ships under King Agamemnon of Mycenae to bring back Helen, the wife of his brother King Menelaus of Sparta, who had eloped with Paris, son of King Priam [PRY-um] of Troy. The Odyssey narrates the adventures of one of the principal Greek leaders, Odysseus (also known as Ulysses), on his return home from the fighting.

Most scholars believed that these Homeric epics were pure fiction until the discovery by Heinrich Schliemann in the 1870s of the actual site of Troy, a multilayered site near modern-day Hissarlik [hih-sur-LIK], in northwestern Turkey. The Troy of Homer's epic was discovered at the sixth layer. (Schliemann also believed that the shaft graves at Mycenae, where he found so much treasure, were those of Agamemnon and his royal family, but modern dating techniques have ruled that out.) Suddenly, the Iliad assumed, if not the authority, then the aura of historical fact. Scholars studying both the poem and a Mycenaean vase known as the Warrior Vase have been struck by the similarity of many passages in the *Iliad* and scenes depicted on the vase. Those similarities testify to the accuracy of many of the poem's descriptions of Bronze Age Greece (Fig. 4.12).

How Homer came to compose two works as long as the *Iliad* and the *Odyssey* has been the subject of much debate. Did he improvise each oral performance from memory, or did he rely on written texts? There is clear evidence that **formulaic epithets**—descriptive phrases applied to a person or thing—helped him, suggesting that improvisation played an important part in the poem's composition. Common epithets in the *Iliad* include such phrases as "fleet-footed Achilles" and "bronze-armed Achaeans." (Achaean [uh-KEE-un] is the term Homer uses to designate the Greeks whom we associate with the Mycenaens.) These epithets appear to have been chosen to allow the performing poet to fit a given name easily into the

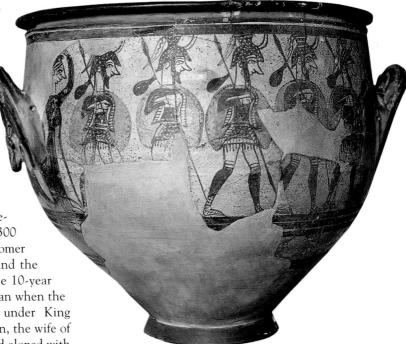

Fig. 4.12 Warrior Vase, from Mycenae, Greece. ca. 1300–1100 BCE. Ceramic, height 16". National Archaeological Museum, Athens. Dating from the time of the Trojan War, the vase depicts a woman, on the left, waving good-bye to departing troops.

hexameter structure of the verse line—what we today call "epic" meter. Each hexameter line of Homer's verse is composed of six metrical units, which can be made up of either dactyls (a long syllable plus two short ones) or spondees (two long syllables). "Fleet-footed" is a dactyl; "bronze-armed" a spondee. The first four units of the line can be either dactyls or spondees; the last two must be dactyl and spondee, in that order. This regular meter, and the insertion of stock phrases into it, undoubtedly helped the poet to memorize and repeat the poem.

In order to perform the 15,693 lines of the *Iliad*, it became increasingly necessary to write the poem down. By the sixth century BCE, it was recited every four years in

Athens (without omission, according to law), and many copies of it circulated around Greece in the fifth and fourth centuries BCE. Finally, in Alexandria, Egypt, in the late fourth century BCE, scribes wrote the poem on papyrus scrolls, perhaps dividing it into the 24 manageable units we refer to today as the poem's books.

The poem was so influential that it established certain epic conventions, standard ways of composing an epic that were followed for centuries to come. Examples include starting the poem *in medias res* [in MEH-dee-us rays], Latin for "in the middle of things," that is, in the middle of the story; invoking the muse at the poem's outset; and stating the poem's subject at the outset.

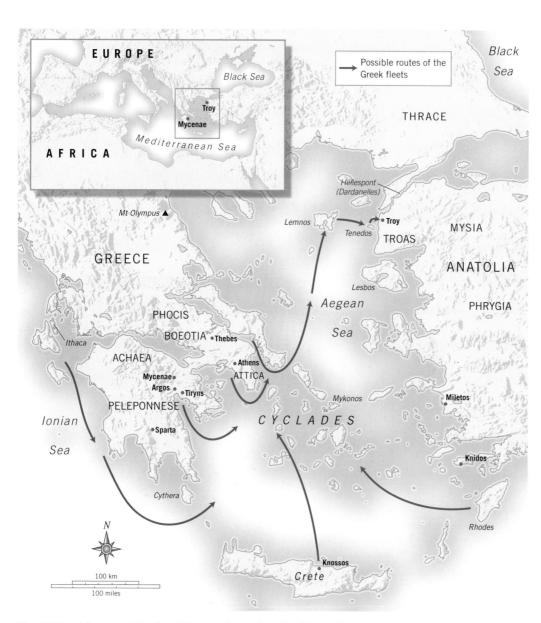

Map 4.2 Possible routes of the Greek fleets as they gathered and then sailed to Troy. At the end of Book 2 of the *Iliad*, Homer catalogs the participating parties in the Trojan War. He lists kings and their followers from more than 150 places. It seems doubtful that the conflict was truly precipitated by the abduction of Helen from Sparta. More likely, the Greeks wanted to wrest control of the Hellespont (today known as the Dardenelles) from the Trojans, in order to gain access to trading opportunities in the Black Sea and Asia.

The Iliad

The *Iliad* tells but a small fraction of the story of the Trojan War, which was launched by Agamemnon of Mycenae and his allies to attack Troy around 1200 BCE (Map 4.2). The tale begins after the war is under way and narrates what is commonly called "the rage of Achilles" [uh-KILleez], a phrase drawn from the first line of the poem. Already encamped on the Trojan plain, Agamemnon has been forced to give up a girl that he has taken in one of his raids, but he takes the beautiful Briseis [bree-SAY-us] from Achilles as compensation. Achilles, by far the greatest of the Greek warriors, is outraged, suppresses his urge to kill Agamemnon, but withdraws from the war. He knows that the Greeks cannot succeed without him, and in his rage he believes they deserve their fate. Indeed, Hector, the great Trojan prince, soon drives the Greeks back to their ships, and Agamemnon sends ambassadors to Achilles to offer him gifts and beg him to return to the battle. Achilles refuses: "His gifts, I loathe his gifts I wouldn't give you a splinter for that man! Not if he gave me ten times as much, twenty times over." When the battle resumes, things become desperate for the Greeks. Achilles partially relents, permitting Patroclus [puh-TROH-klus], his close friend and perhaps his lover, to wear his armor in order to put fear into the Trojans. Led by Patroclus, the Achaeans, as Homer calls the Greeks, drive the Trojans back.

An excerpt from Book 16 of the *Iliad* narrates the fall of

the Trojan warrior Sarpedon [sahr-PAY-dun] at the hands of Patroclus (see Reading 4.1, page 128). The passage opens with one of the scene's many Homeric similes: the charging Trojan forces described as "an onrush dark as autumn days / when the whole earth flattens black beneath a gale." Most notable, however, is the unflinching verbal picture Homer paints of the realities of war, not only its cowardice, panic, and brutality, but its compelling attraction as well. In this arena, the Greek soldier is able to demonstrate one of the most important values in Greek culture, his areté [ah-ray-TAY], often translated as "virtue," but actually meaning something closer to "being the best you can be" or "reaching your highest human potential." Homer uses the term to describe both Greek and Trojan heroes, and it refers not only to their bravery but to their effectiveness in battle.

The sixth-century BCE painting on the side of the Botkin Class Amphora—an amphora [am-FOR-uh] is a Greek jar with an egg-shaped body and two curved handles used for storing oil or wine—embodies the concept of

Fig. 4.13 Botkin Class Amphora, Greek. ca. 540–530 BCE. Black-figure decoration on ceramic, height $11^9/_{16}"$, diameter $9^1/_2"$. Museum of Fine Arts, Boston: Henry Lillie Pierce Fund 98.923. Photograph © 2008 Museum of Fine Arts, Boston. On the other side of this vase are two heavily armed warriors, one pursuing the other.

areté (Fig. 4.13). Here, two warriors, one armed with a sword, the other with a spear, confront each other with unwavering determination and purpose. At one point in the *Iliad*, Homer describes two such warriors, holding their own against one another, as "rejoicing in the joy of battle." They rejoice because they find themselves in a place where they can demonstrate their *areté*.

The following passage, from Book 24, the final section of the *Iliad*, shows the other side of war and the other side of the poem, the compassion and humanity that distinguish Homer's narration (Reading 4.1a). Soon after Patroclus kills Sarpedon, Hector, son of the king of Troy, strikes down Patroclus with the aid of the god Apollo. On hearing the news, Achilles is devastated and finally enters the fray. Until now, fuming over Agamemnon's insult, he has sat out the battle, refusing, in effect, to demonstrate his own areté. But now, he redirects his rage from Agamemnon to the Troian warrior Hector, whom he meets and kills. He then ties Hector's body to his chariot and drags it to his tent. The act is pure sacrilege, a violation of the dignity due the great Trojan warrior and an insult to his memory. Late that night, Priam, the king of Troy, steals across enemy lines to Achilles's tent and begs for the body of his son:

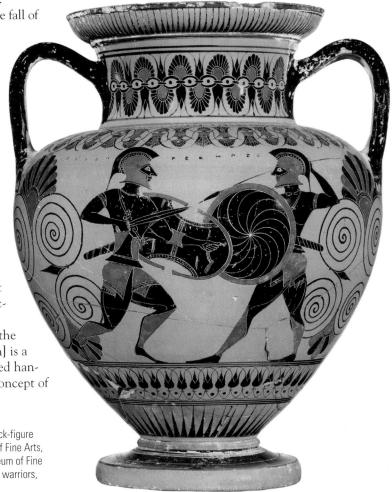

READING 4.1a

from Homer, Iliad, Book 24 (ca. 750 BCE)

"Remember your own father, great godlike Achillesas old as I am, past the threshold of deadly old age! No doubt the countrymen round about him plague him now, with no one there to defend him, beat away disaster. No one—but at least he hears you're still alive and his old heart rejoices, hopes rising, day by day, to see his beloved son come sailing home from Troy. But I-dear god, my life so cursed by fate . . . I fathered hero sons in the wide realm of Troy and now not a single one is left, I tell you. Fifty sons I had when the sons of Achaea came, nineteen born to me from a single mother's womb and the rest by other women in the palace. Many, most of them violent Ares cut the knees from under. But one, one was left me, to guard my wall, my peoplethe one you killed the other day, defending his fatherland, my Hector! It's all for him I've come to the ships now. to win him back from you—I bring a priceless ransom. Revere the gods, Achilles! Pity me in my own right, remember your own father! I deserve more pity . . . I have endured what no one on earth has ever done

I put to my lips the hands of the man who killed my son."

Those words stirred within Achilles a deep desire to grieve for his own father. Taking the old man's hand he gently moved him back. And overpowered by memory both men gave way to grief. Priam wept freely for man-killing Hector, throbbing, crouching before Achilles' feet as Achilles wept himself, now for his father, now for Patroclus once again, and their sobbing rose and fell throughout the house. Then Achilles called the serving-women out: "Bathe and anoint the bodybear it aside first. Priam must not see his son." He feared that, overwhelmed by the sight of Hector, wild with grief, Priam might let his anger flare and Achilles might fly into fresh rage himself. cut the old man down and break the laws of Zeus. So when the maids had bathed and anointed the body sleek with olive oil and wrapped it round and round in a braided battle-shirt and handsome battle-cape. then Achilles lifted Hector up in his own arms and laid him down on a bier, and comrades helped him raise the bier and body onto a sturdy wagon . . . Then with a groan he called his dear friend by name: "Feel no anger at me, Patroclus, if you learnever there in the House of Death-I let his father have Prince Hector back. He gave me worthy ransom and you shall have your share from me, as always. your fitting, lordly share."

Homer clearly recognizes the ability of these warriors to exceed their mere humanity, to raise themselves not only to a level of great military achievement, but to a state of compassion, nobility, and honor. It is this exploration of the "doubleness" of the human spirit, its cruelty and its human-

ity, its blindness and its insight, that perhaps best defines the power and vision of the Homeric epic.

The Odyssey

The fall of Troy to the Greek army after the famous ruse of the Trojan Horse (Fig. 4.14) is actually described in Book 4 of the Odyssey, the Iliad's 24-book sequel. In Reading 4.2a, Menelaus [me-nuh-LAY-us], now returned home with Helen, addresses her, while Telemachus [tel-uh-MOCK-us] son of the Greek commander Odysseus, listens:

READING 4.2a

from Homer, Odyssey, Book 4 (ca. 725 BCE)

. . . never have I seen one like Odysseus for steadiness and stout heart. Here, for instance, is what he did-had the cold nerve to doinside the hollow horse, where we were waiting. picked men all of us, for the Trojan slaughter, when all of a sudden, you [Helen] came by-I dare say drawn by some superhuman power that planned an exploit for the Trojans; and Deiphobos, that handsome man, came with you. Three times you walked around it, patting it everywhere, and called by name the flower of our fighters, making your voice sound like their wives, calling. Diomêdês and I crouched in the center Along with Odysseus; we could hear you plainly; and listening, we two were swept by waves of longing-to reply, or go. Odysseus fought us down, despite our craving, and all the Akhaians kept their lips shut tight, all but Antiklos. Desire moved his throat to hail you, but Odysseus' great hands clamped over his jaws, and held. So he saved us all, till Pallas Athena led you away at last.

Many of the themes of Homer's second epic are embedded in this short reminiscence. For although the poem narrates the adventures of Odysseus on his 10-year journey home from the war in Troy—his encounters with monsters, giants, and a seductive enchantress, and a sojourn on a floating island and in the underworld—its subject is, above all, Odysseus's passionate desire to once more see his wife, Penelope, and Penelope's fidelity to him. Where anger and lust drive the *Iliad*—remember Achilles's angry sulk and Helen's fickleness—love and familial affection drive the *Odyssey*. Penelope is gifted with areté in her own right, since for the 20 years of her husband's absence, she uses all the cunning in her power to ward off the suitors who flock to marry her, convinced that Odysseus is never coming home.

A second important theme taken up by Menelaus is the role of the gods in determining the outcome of human events. Helen, he says, must have been drawn to the Trojan Horse "by some superhuman / power that planned an exploit for the Trojans"—some god, in other words, on the Trojans'

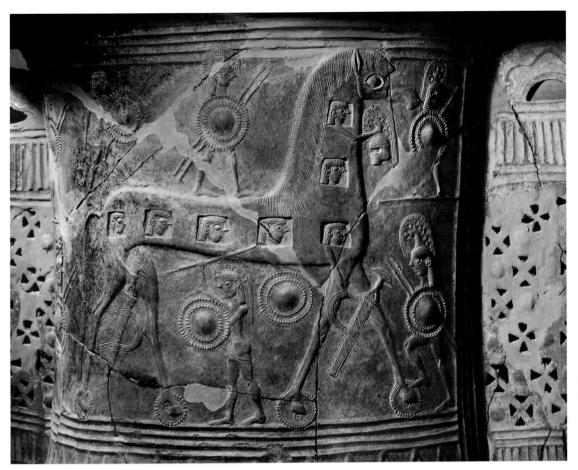

Fig. 4.14 *The Trojan Horse*, **detail from a storage jar from Chora, Mykonos. ca. 650** BCE. Total height of jar 5", detail as shown approx. 1". Archaeological Museum, Mykonos. This is the earliest known depiction of the Trojan Horse, the hollow "gift" that the supposedly departing Greeks left to King Priam and his followers. The artist has opened little windows in its side, showing the Greeks hiding within, ready to attack.

side. And, indeed, Pallas Athena, goddess of war and wisdom and protectress of the Achaeans, leads Helen away from the horse. But in both the *Iliad* and the *Odyssey*, Homer is careful to distinguish between how people *believe* the gods exercise control over events (**Reading 4.2b**) and what control they actually exercise. In fact, early on in Book 1 of the *Odyssey*, Zeus, king of the gods, exclaims:

READING 4.2b

from Homer, Odyssey, Book 1 (ca. 725 BCE)

My word, how mortals take the gods to task! All their afflictions come from us, we hear. And what of their own failings? Greed and folly double the suffering in the lot of man.

The Greek view of the universe contrasts dramatically with that of the Hebrews. If the Greek gods exercise some authority over the lives of human beings—they do control their ultimate fate—human beings are in complete control of how they live. By exercising selflessness and wis-

dom, as opposed to greed and folly, they could at least halve their suffering, Zeus implies. In the *Iliad*, the crimes that Paris and Achilles commit do not violate a divine code of ethics like the Ten Commandments but, rather, a code of behavior defined by their fellow Greeks. In the Greek world, humans are ultimately responsible for their own actions.

This is the real point of the fantastic episode of Odysseus's cunning trickery of the Cyclops Polyphemus [pol-ih-FEEmus] in Book 9 of the Odyssey, related by Odysseus himself to Alkinoös [ahl-ki-NOH-us], king of Phaeacia [fee-AY-shuh] (see Reading 4.2, pages 130–133 for the full tale). It is Odysseus's craftiness—his wit and his intelligence—not the intervention of the gods, that saves him and his men. Compared to the stories that have come down to us from other Bronze Age cultures such as Egypt or Mesopotamia, Homer is less concerned with what happened than how it happened. We encounter Odysseus's trickery, his skill at making weapons, and his wordplay (Odysseus calling himself "Nobody" in anticipation of Polyphemus being asked by the other Cyclopes who has blinded him and Polyphemus replying, "Nobody").

ally. First, across Greece, communities began to organize themselves and exercise authority over their own limited geographical regions, which were defined by natural boundaries—mountains, rivers, and plains. The population of even the largest communities was largely dedicated to agriculture, and agricultural values—a life of hard, honest work and self-reliance—predominated. The great pastoral poem of the poet Hesiod [HE-see-ud] (flourished ca. 700 BCE), Works and Days, testifies to this. Works and Days was written at about the same time as the Homeric epics in Boeotia [be-OH-she-uh], the region of Greece dominated by the city-state of Thebes. Particularly interesting is Hesiod's narration of the duties of the farmer as the seasons progress. Here are his words regarding the farmer's obligation to plow his fields (Reading 4.3):

READING 4.3

from Hesiod, Works and Days, (ca. 700 BCE)

Autumn

Mind now, when you hear the call of the crane Coming from the clouds, as it does year by year: That's the sign for plowing, and the onset of winter And the rainy season. That cry bites the heart Of the man with no ox.

Time then to feed your oxen
In their stall. You know it's easy to say,
"Loan me a wagon and a team of oxen."
And it's easy to answer, "Got work for my oxen."
It takes a good imagination for a man to think
He'll just peg together a wagon. Damn fool,
Doesn't realize there's a hundred timbers make up a
wagon

And you have to have 'em laid up beforehand at home. Soon as you get the first signs for plowing Get a move on, yourself and your workers, And plow straight through wet weather and dry, Getting a good start at dawn, so your fields Will full up. Work the land in spring, too, But fallow turned in summer won't let you down. Sow your fallow land while the soil's still light. Fallow's the charm that keeps wee-uns well-fed. Pray to Zeus-in-the-ground and to Demeter sacred For Demeter's holy grain to grow thick and full. Pray when you first start plowing, when you Take hold of the handle and come down with your stick. On the backs of the oxen straining at the yoke-pins. A little behind, have a slave follow with a hoe To make trouble for the birds by covering the seeds. Doing things right is the best thing in the world, Just like doing 'em wrong is the absolute worst. This way you'll have ears of grain bending Clear to the ground . . .

In this extract, Hesiod gives us a clear insight not only into many of the details of Greek agricultural production, but into social conditions as well. He mentions slaves twice in this short passage, and, indeed, all landowners possessed slaves (taken in warfare), who comprised over

half the population. He also mentions the Greek gods Zeus [zoos], king of the gods and master of the sky, and Demeter, goddess of agriculture and grain (see Context, page 112). In fact, it was Hesiod, in his Theogony [the-OG-uh-nee] (The Birth of the Gods), who first detailed the Greek pantheon (literally, "all the gods"). The story of the creation of the world that he tells in this work (Reading 4.4) resembles the origin myths from the Zuni emergence tale (see Reading 1.1) and the Japanese Shinto Kojiki (see Reading 1.2):

READING 4.4

from Hesiod, Theogony, (ca. 700 BCE)

First of all the Void¹ came into being, next broadbosomed Earth, the solid and eternal home of all,² and Eros [Desire], the most beautiful of the immortal gods, who in every man and every god softens the sinews and overpowers the prudent purpose of the mind. Out of the Void came Darkness and black Night, and out of Night came Light and day, her children conceived after union in love with Darkness. Earth first produced starry Sky, equal in size with herself.

¹The Greek word is *Chaos;* but this has a misleading connotation in English. ²Omitting lines 118–19: "the immortals who live on the peaks of snowy Olympus, and gloomy Tartarus in a hole underneath the highways of the earth."

Behavior of the Gods

Of particular interest here—as in Homer's Iliad—is that the gods are as susceptible to Eros [er-oss], or Desire, as is humankind. In fact, the Greek gods are sometimes more human than humans—susceptible to every human foible. Like many a family on Earth, the father, Zeus, is an allpowerful philanderer, whose wife, Hera [HAIR-uh], is watchful, jealous, and capable of inflicting great pain upon rivals for her husband's affections. Their children are scheming and self-serving in their competition for their parents' attention. The gods think like humans, act like humans, and speak like humans. They sometimes seem to differ from humans only in the fact that they are immortal. Unlike the Hebrew God, who is sometimes portrayed as arbitrary, the Greek gods present humans with no clear principles of behavior, and the priests and priestesses who oversaw the rituals dedicated to them produced no scriptures or doctrines. The gods were capricious, capable of changing their minds, susceptible to argument and persuasion, alternately obstinate and malleable. If these qualities created a kind of cosmic uncertainty, they also embodied the intellectual freedom and the spirit of philosophical inquiry that would come to define the Greek state.

THE POLIS

Although Greece was an agricultural society, the **polis**, or city-state—not the farm—was the focal point of cultural life.

It consisted of an urban center, small by modern standards, often surrounding some form of natural citadel, which could serve as a fortification, but which usually functioned as the city-state's religious center. The Greeks called this citadel an **acropolis** [uh-KROP-uh-liss]—literally, the "top of the city." On lower ground, at the foot of the acropolis, was the **agora** [AG-uh-ruh], a large open area that served as public meeting place, marketplace, and civic center.

Athens led the way, perhaps because it had become something of a safe haven during the Dark Ages, even flourishing as a result, and it thus maintained something of a civic identity. However, by 800 BCE, several hundred similar poleis [POL-ays] (plural of polis [POL-us]) were scattered throughout Greece. Gradually, the polis came to describe less a place and more a cultural and communal identity. The citizens of the polis, including the rural population of the region—the polis of Sparta, for instance, comprised some 3,000 square miles of the Peloponnese, while Athens controlled the 1,000 square miles of the region known as Attica—owed allegiance and loyalty to it. They depended upon and served in its military. They worshipped and trusted in its gods. And they asserted their identity, first of all, by participating in the affairs of the city-state, next by their family (genos) [jee-nus] involvement, and, probably least of all, by any sense of being Greek.

In fact, the Greek poleis are distinguished by their isolation from one another and their fierce independence. For the most part, Greece is a very rugged country of mountains separating small areas of arable plains. The Greek historian Thucydides [thoo-SID-ih-deez] attributed the independence of the poleis to the historical competition in earlier times for these fertile regions of the country. His History of the Peloponnesian Wars, written in the last decades of the fifth century and begun during the wars (he served as a general in the Athenian army), opens with an account of these earlier times, tracing the conflict in his own time to that historical situation (Reading 4.5):

READING 4.5

Thucydides, History of the Peloponnesian Wars

[I]t is evident that the country now called Hellas had in ancient times no settled population; on the contrary, migrations were of frequent occurrence, the several tribes readily abandoning their homes under the pressure of superior numbers. Without commerce, without freedom of communication either by land or sea, cultivating no more of their territory than the exigencies of life required, destitute of capital, never planting their land (for they could not tell when an invader might not come and take it all away, and when he did come they had no walls to stop him), thinking that the necessities of daily sustenance could be

supplied at one place as well as another, they cared little for shifting their habitation, and consequently neither built large cities nor attained to any other form of greatness. The richest soils were always most subject to this change of masters; such as the district now called Thessaly [THES-uh-lee], Boeotia, most of the Peloponnese, Arcadia excepted, and the most fertile parts of the rest of Hellas. The goodness of the land favored the aggrandizement of particular individuals, and thus created faction which proved a fertile source of ruin. It also invited invasion.

While Greek poleis might form temporary alliances, almost always in league against other poleis, few of the invasions Thucydides speaks of resulted in the domination of one polis over another, at least not for long. Rather, each polis maintained its own identity and resisted domination.

But inevitably, certain city-states became more powerful than others. During the Dark Ages, many Athenians had migrated to Ionia [eye-OH-nee-uh] in southwestern Anatolia [an-uh-TOE-lee-uh] (modern Turkey), and relations with the Near East helped Athens to flourish. Corinth, situated on the isthmus between the Greek mainland and the Peloponnese, controlled north—south trade routes from early times, but after it built a towpath to drag ships over the isthmus on rollers, it soon controlled the sea routes east and west as well.

Life in Sparta

Of all the early city-states, Sparta was perhaps the most powerful. The Spartans traced their ancestry back to the legendary Dorians, whose legacy was military might. The rule of the city-state fell to the *homoioi*, [hoh-moh-YOY] or "equals," who comprised roughly 10 percent of the population. The population consisted largely of farm laborers, or *helots* [HEE-luts], essentially slaves who worked the land held by the *homoioi*. (A third class of people, those who had inhabited the area before the arrival of the Spartans, enjoyed limited freedom but were subject to Spartan rule.)

Political power resided with five overseers who were elected annually by all homoioi—excluding women—over the age of 30. At age 7, males were taken from their parents to live under military discipline in barracks until age 30 (though they could marry at age 20). Men ate in the military mess until age 60. Women were given strenuous physical training so that they might bear strong sons. Weak-looking babies were left to die. The city-state, in short, controlled every aspect of the Spartans' lives. If the other Greek poleis were less militaristic, they nevertheless exercised the same authority in some fashion. They exercised power more often through political rather than militaristic means, though most could be as militaristic as Sparta when the need arose.

CONTEXT

The Greek Gods

The religion of the Greeks informed almost every aspect of daily life. The gods watched over the individual at birth, nurtured the family, and protected the city-state. They controlled the weather, the seasons, health, marriage, longevity, and the future, which they could foresee. Each polis traced its origins to a particular founding god—Athena for Athens, Zeus for Sparta. Sacred sanctuaries were dedicated to others.

The Greeks believed that the 12 major gods lived on Mount Olympus, in northeastern Greece. There they ruled over the Greeks in a completely human fashion—they quarreled and meddled, loved and lost, exercised justice or not—and they were depicted by the Greeks in human form. There was nothing special about them except their power, which was enormous, sometimes frighteningly so. But the Greeks believed that as long as they did not overstep their bounds and try to compete with the gods—the sin of **hubris**, or pride—that the gods would protect them.

Among the major gods (with their later Roman names in parentheses) are:

Zeus (Jupiter): King of the gods, usually bearded, and associated with the eagle and thunderbolt.

Hera (Juno [J00-no]): Wife and sister to Zeus, the goddess of marriage and maternity.

Athena (Minerva): Goddess of war, but also, through her association with Athens, of civilization; the daughter of Zeus, born from his head; often helmeted, shield and spear in hand, the owl (wisdom) and the olive tree (peace) are sacred to her.

Ares (Mars): God of war, and son of Zeus and Hera, usually armored.

Aphrodite [af-ra-DIE-tee] (Venus): Goddess of love and beauty; Hesiod says she was born when the severed genitals of Uranus, the Greek personification of the sky, were cast into the sea and his sperm mingled with sea foam to create her. Eros is her son.

Apollo (Phoebus [FEE-bus]): God of the sun, light, truth, prophecy, music, and medicine; he carries a bow and arrow, sometimes a lyre; often depicted riding a chariot across the sky.

Artemis [AR-tuh-mis] (Diana): Goddess of the hunt and the moon; Apollo's sister, she carries bow and arrow, and is accompanied by hunting dogs.

Demeter [dem-EE-ter] (Ceres [SIR-eez]): Goddess of agriculture and grain.

Dionysus [dy-uh-NY-sus] (Bacchus [BAK-us]): God of wine and inspiration, closely aligned to myths of fertility and sexuality

Hermes [HER-meez] (Mercury): Messenger of the gods, but also god of fertility, theft, dreams, commerce, and the market-place; usually adorned with winged sandals and a winged hat, he carries a wand with two snakes entwined around it.

Hades [HAY-deez] (Pluto): God of the underworld, accompanied by his monstrous dog, Cerberus.

Hephaestus [hif-ES-tus] (Vulcan): God of the forge and fire; son of Zeus and Hera and husband of Aphrodite; wears a blacksmith's apron and carries a hammer.

Hestia [HES-te-uh] (Vesta): Goddess of the hearth and sister of Zeus.

Poseidon [po-SI-don] (Neptune): Brother of Zeus and god of the sea; carries a trident (a three-pronged spear); the horse is sacred to him.

Persephone [per-SEF-uh-nee] (Proserpina [pro-SUR-puhnuh]): Goddess of fertility, Demeter's daughter, carted off each winter to the underworld by her husband Hades, but released each spring to restore the world to plenty.

THE SACRED SANCTUARIES

Although rival city-states were often at war with one another, they also increasingly came to understand their common heritage. As early as the eighth century BCE, they created sanctuaries where they could come together to share music, religion, poetry, and athletics. The sanctuary was a large-scale reflection of another Greek invention, the **symposium**, literally "drinking together" by men (originally of the same military unit) meeting to share poetry, food, and wine. At the sanctuaries, people from different city-states came together to honor their gods and, by extension, to celebrate, in the presence of their rivals, their own accomplishments.

Delphi The sanctuaries were sacred religious sites. They inspired the city-states, which were always trying to outdo one another, to create the first monumental architecture

since Mycenaean times. At Delphi [DEL-fie], high in the mountains above the Gulf of Corinth, and home to the Sanctuary of Apollo [uh-POLL-oh], the city-states, in their usual competitive spirit, built monuments and statues dedicated to the god, and elaborate treasuries to store offerings. Here, the Greeks believed, Earth was attached to the sky by its navel. Here, too, through a deep crack in the ground, Apollo spoke, through the medium of a woman called the Pythia [PITH-ee-uh]. Priests interpreted the cryptic omens and messages she delivered. The Greek author Plutarch [PLOO-tark], writing in the first century CE, said that the Pythia entered a small chamber beneath the temple, smelled sweet-smelling fumes, and went into a trance. Modern scholars dismissed the story as fiction until recently, when geologists discovered that two faults intersect directly below the Delphic temple, allowing hallucinogenic gases to rise through the fissures, specifically ethylene,

Fig. 4.17 The Athenian Treasury, Delphi, and plan. ca. 510 BCE. The sculptural program around the Treasury, just below the roof line, depicts the adventures of two great Greek mythological heroes, Theseus and Herakles.

which has a sweet smell and produces a narcotic effect described as a floating or disembodied euphoria.

The facade of the Athenian Treasury at Delphi consisted of two columns standing *in antis* (that is, between two squared stone pilasters, called **antae** [an-tie]). Behind them is the **pronaos** [pro-NAY-os], or enclosed vestibule, at the front of the building, with its doorway leading into the **cella** [SEL-uh] (or *naos* [NAY-os]), the principal interior space of the building (see the floor plan, Fig. **4.17**).

We can see the antecedents of this building type in a small ceramic model of an early Greek temple dating from the eighth century BCE and found at the Sanctuary of Hera near Argos [AR-gus] (Fig. 4.18). Its projecting porch supported by two columns anticipates the *in antis* columns and pronaos of the Athenian Treasury. The triangular area over the porch created by the pitch of the roof, called the pediment, is not as steep in the Treasury.

The Temples of Hera at Paestum From this basic form, surviving in the small treasuries at Delphi, the larger temples of the Greeks would develop. Two distinctive **orders**—systems of proportion that include the building's plan, its **elevation** (the arrangement and appearance of the temple's foundation, columns, and lintels), and decorative scheme—developed before 500 BCE, the **Doric order** and the **Ionic order** (see *Closer Look*, pages 114–115). Later, a

Fig. 4.18 Model of a temple, found in the Sanctuary of Hera, Argos, mid-eighth century BCE. Terra cotta, length $4\frac{1}{2}$ ". National Archaeological Museum, Athens. We do not know if later temples were painted like the model here.

CLOSER LOOK

lassical Greek architecture is composed of three vertical elements—the platform, the column, and the entablature—which comprise its elevation. The relationship of these three units is referred to as the elevation's order. There are three orders: Doric, Ionic, and Corinthian, each distinguished by its specific design.

The classical Greek orders became the basic design elements for architecture from ancient Greek times to the present day. A major source of their power is the sense of order, predictability, and proportion that they embody. Notice how the upper elements of each order—the elements comprising the entablature—change as the column supporting them becomes narrower and taller. In the Doric order, the architrave (the bottom layer of the entablature), and the frieze (the flat band just above the architrave decorated with sculpture, painting, or moldings), are comparatively massive. The Doric is the heaviest of the columns. The Ionic is lighter and noticeably smaller. The Corinthian is smaller yet, seemingly supported by mere leaves.

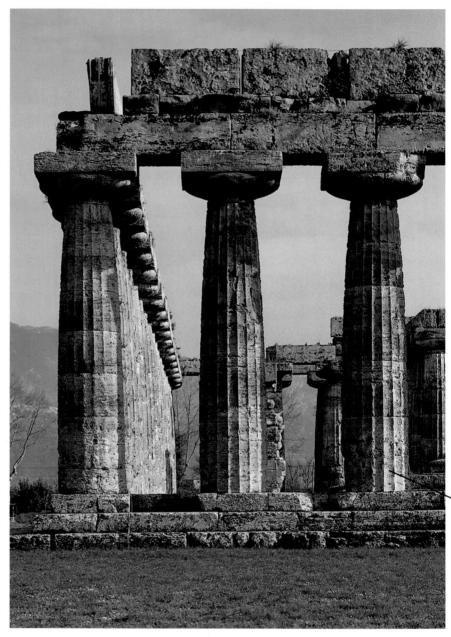

Doric columns at the Temple of Hera I, and plan. Paestum, Italy. ca. 540. The floor plan of all three orders is essentially the same, although in the Doric order, the last two columns were set slightly closer together—corner contraction, as it is known—resulting in the corner gaining a subtle visual strength and allowing for regular spacing of sculptural elements in the entablature above.

Something to Think About . . .

The base, shaft, and capital of a Greek column have often been compared to the feet, body, and head of the human figure. How would you compare the Doric, Ionic, and Corinthian orders to Figures 4.20, 4.21, and 4.30?

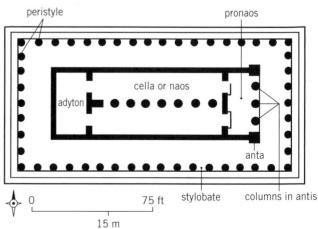

The Classical Orders

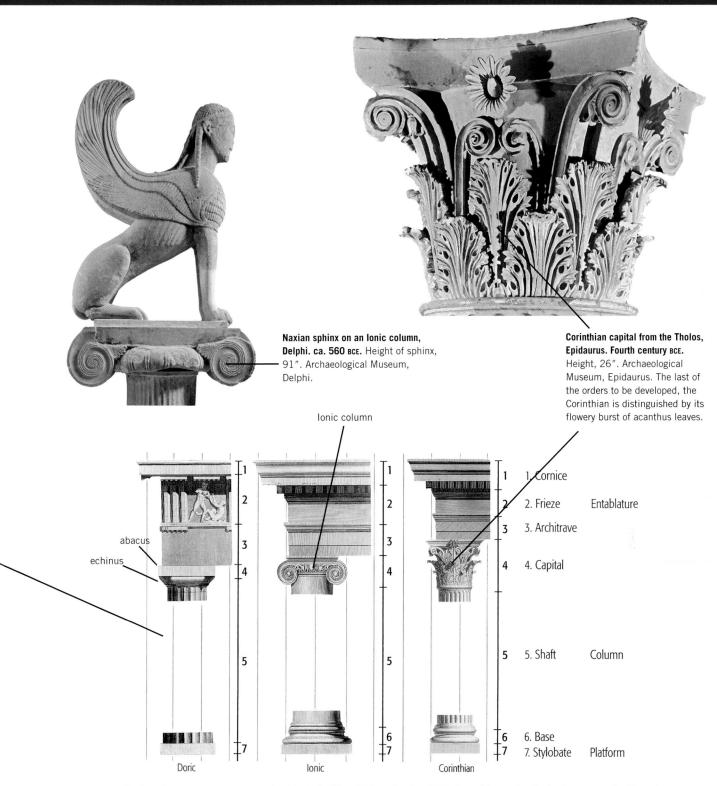

The Classical Orders, from James Stuart, *The Antiquities of Athens*, London. 1794. An architectural order lends a sense of unity and structural integrity to a building as a whole. By the sixth century BCE, the Greeks had developed the Doric and the Ionic orders. The former is sturdy and simple. The latter is lighter in proportion and more elegant in detail, its capital characterized by a scroll-like motif called a **volute**. The Corinthian order, which originated in the last half of the fifth century BCE, is the most elaborate of all. It would become a favorite of the Romans.

LEARN MORE View an architectural simulation of the classical orders at **www.myartslab.com**

third Corinthian order would emerge. Among earliest surviving examples of a Greek temple of the Doric order are the Temples of Hera I and II in the Sanctuary of Hera at Paestum [PES-tum], a Greek colony established in the seventh century BCE in Italy, about 50 miles south of modern Naples (see Fig. 4.16). As the plan of the Temple of Hera I makes clear (see Closer Look, 114), the earlier of the two temples was a large, rectangular structure, with a pronaos containing three (as opposed to two) columns and an elongated cella, behind which is an advton [AD-eetun, the innermost sanctuary housing the place where, in a temple with an oracle, the oracle's message was delivered. Surrounding this inner structure was the peristyle [PER-uh-style], a row of columns that stands on the stylobate [STY-luh-bate], the top step of the platform on which the temple rests. The columns swell about one-third of the way up and contract again at the top, a characteristic known as entasis [EN-tuh-sis], and are topped by the twopart capital of the Doric order with its rounded echinus [EH-ki-nus] and tabletlike abacus [AB-uh-kus].

Olympia and the Olympic Games The Greeks date the beginning of their history to the first formal Panhellenic ("all-Greece") athletic competition, held in 776 BCE. These first Olympic Games were held at Olympia. There, a sanctuary dedicated to Hera and Zeus also housed an elaborate athletic facility. The first contest of the first games was a 200-yard dash the length of the Olympia stadium, a race called the *stadion* (Fig. **4.19**). Over time, other events of solo performance were added, including chariot-racing, boxing, and the *pentathlon* (from Greek *penta*, "five," and *athlon*, "contest"), consisting of discus, javelin, long jump, sprinting, and wrestling. There were no second or third prizes. Winning was all. The contests were

conducted every four years during the summer months and were open only to men (married women were forbidden to attend, and unmarried women probably did not attend). The Olympic Games were held for more than 1,000 years, until the Christian Byzantine Emperor Theodosius [the-uh-DOH-she-us] banned them in 394 CE. The Games were revived in 1896 to promote international understanding and friendship.

The Olympic Games were only one of numerous athletic festivals held in various locations. These games comprised a defining characteristic of the developing Greek national identity. As a people, the Greeks believed in *agonizesthai*, [ah-gon-ee-zus-TYE] a verb meaning "to contend for the prize." They were driven by competition. Potters bragged that their work was better than any other's. Playwrights competed for best play, poets for best recitation, athletes for best performance. As the city-states themselves competed for supremacy, they began to understand the spirit of competition as a trait shared by all.

Male Sculpture and the Cult of the Body

Greek athletes performed nude, so it is not surprising that athletic contests gave rise to what may be called a "cult of the body." The physically fit male not only won accolades in athletic contests, he also represented the conditioning and strength of the military forces of a particular polis. The male body was also celebrated in a widespread genre of sculpture known as the *kouros* [KOOR-os], meaning "young man" (Figs. **4.20** and **4.21**). This celebration of the body was uniquely Greek. No other Mediterranean culture so emphasized depiction of the male nude.

Several thousand *kouroi* [KOOR-oy] (plural of *kouros*) appear to have been carved in the sixth century BCE alone.

Fig. 4.19 Euphiletos Painter. Detail of a blackfigure amphora showing a foot-race at the Panathenaic Games in Athens. ca. 530 BCE. Terra cotta, height 24 $\frac{1}{2}$ ". The Metropolitan Museum of Art, Rogers Fund, 1914 (14.130.12). Image copyright © The Metropolitan Museum of Art/Art Resource, NY. Greek athletes competed nude. In fact, our word gymnasium derives from the Greek word for "naked," gymnos.

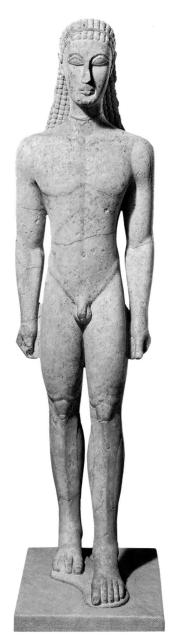

Fig. 4.20 *New York Kouros*. ca. 600 BCE. Height 6' 4". The Metropolitan Museum of Art, New York. Fletcher Fund, 1932 (32.11.1). Image copyright © The Metropolitan Museum of Art/Art Resource, NY.

They could be found in sanctuaries and cemeteries, most often serving as votive offerings to the gods or as commemorative grave markers, embodying the best characteristics of the aristocracy.

Egyptian Influences Although we would never mistake the earlier figure for the work of an Egyptian sculptor—its nudity and much more fully realized anatomical features are clear differences—still, its Egyptian influences are obvious. In fact, as early as 650 BCE, the Greeks were in Egypt, and by the early sixth century BCE, 12 cooperating city-states had established a trading outpost in the Nile Delta. The Greek sculpture serves the same funerary function as its Egyptian ancestors. The young man's arms drop stiffly to his side. His

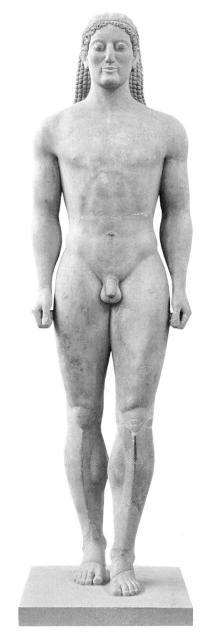

Fig. 4.21 *Anavysos Kouros*, from Anavysos cemetery, near Athens. **ca. 525** BCE. Marble with remnants of paint, height 6' 4". National Archaeological Museum, Athens. The sculpture on the left is one of the earliest known life-size standing sculptures of a male in Greek art. The one on the right represents 75 years of Greek experimentation with the form. Note its closed-lip "Archaic smile," a symbol of liveliness and vitality.

fists are clenched in the Egyptian manner. His left foot strides forward, though both heels remain unnaturally cemented to the ground, altogether like the Old Kingdom

Egyptian *ka* statue of Menkaure with his queen (see Fig. 3.10), which is nearly 2,000 years older. The facial features of the kouros, with its wide, oval eyes, sharply delineated brow, and carefully knotted hair, are also reminiscent of third-millennium BCE Sumerian votive statues (see Fig. 2.4).

Increasing Naturalism During the course of the sixth century, kouroi became distinguished by **naturalism**. That is, they increasingly reflect the artist's desire to represent the human body as it appears in nature. This in turn probably reflects the growing role of the individual in Greek political life.

We see more stylistic change between the first kouros and the second, a span of just 60 years, than between the first kouros and its Egyptian and Sumerian ancestors, created over 2,000 years earlier. The musculature of the later figure, with its highly developed thighs and calves, the naturalistic curve delineating the waist and hips, the collarbone and tendons in the neck, the muscles of the ribcage and belly, the precisely rendered feet and toes, all suggest that this is a representation of a real person. In fact, an inscription on the base of the sculpture reads, "Stop and grieve at the dead Kroisos [kroy-sos], slain by wild Ares [AR-eez] [the god of war] in the front rank of battle." This is a monument to a fallen hero, killed in the prime of youth.

Both sculptures are examples of the developing Archaic style, the name given to art produced from 600 to 480 BCE. We do not know why sculptors wanted to realize the human form more naturalistically, but we can surmise that the reason must be related to agonizesthai, the spirit of competition so dominant in Greek society. Sculptors must have competed against one another in their attempts to realize the human form. Furthermore, since it was believed that the god Apollo manifested himself as a well-endowed athlete, the more lifelike and natural the sculpture, the more nearly it could be understood to resemble the god himself.

THE ATHENS OF PEISISTRATUS

The growing naturalism of sixth-century BCE sculpture coincides with the rise of democratic institutions in Athens and reflects this important development. Both bear witness to a growing Greek spirit of innovation and accomplishment. And both testify to a growing belief in the dignity and worth of the individual.

Toward Democracy

By the time Peisistratus [pie-SIS-truh-tus] assumed rule of Athens in 560 BCE, the city was well on the way toward establishing itself as a **democracy**—from the Greek *demokratia* [dem-oh-KRAY-te-uh], the rule (*kratia*) of the people (*demos*). Early in the sixth century BCE, a reformer statesman named Solon [SO-lun] (ca. 630–ca.560 BCE) overturned a severe code of law that had been instituted about one century earlier by an official named Draco [DRAY-koh]. Draco's law was especially hard on debtors, and from his name comes our use of the term "Draconian" [dray-KOH-nee-un] to describe particularly harsh punishments or laws. A bankrupt member of the polis could not sell or mortgage his land, but was required to mortgage the produce of the land to his creditor, effectively enslaving

himself and his family to the creditor forever. Similarly, a bankrupt merchant was obliged to become the slave of his creditor

Solon addressed the most painful of these provisions. He canceled all current debts, freed both landholders and merchants, and published a new code of law. He deemphasized the agricultural basis of the polis and encouraged trade and commerce, granting citizenship to anyone who would come and work in Athens. He also formed the Council of Four Hundred, which was comprised of landowners selected by Solon himself. This group recommended policy, which a general assembly of all citizens voted on. Only the council could formulate policy, but the citizens could veto it.

A division between the urban and the rural was a defining characteristic of the city-state. The aristocratic landowners from the plains thought that Solon had overstepped his authority. The much poorer hill people living on the mountainsides thought he had not gone far enough, and the coastal people felt satisfied with his reforms. Peisistratus (r. 560–527 BCE) moderated the conflict among the three factions, establishing a period of lasting peace in the polis. The hill people in particular supported him, because he advanced money to help them sustain themselves and thereby agricultural production in the polis. Two centuries later, the philosopher Aristotle [ar-uh-STOT-ul] would tell a story that reflects Peisistratus's rule (Reading 4.6):

READING 4.6

from Aristotle's Athenian Constitution

His revenues were increased by the thorough cultivation of the country, since he imposed a tax of one tenth on all the produce. For the same reasons he instituted the local justices, and often made expeditions in person into the country to inspect it and to settle disputes between individuals, that they might not come into the city and neglect their farms. It was in one of these progresses that, as the story goes, Peisistratus had his adventure with the man of Hymettus [hy-MET-us], who was cultivating the spot afterwards known as "Tax-free Farm." He saw a man digging and working at a very stony piece of ground, and being surprised he sent his attendant to ask what he got out of this plot of land. "Aches and pains," said the man; "and that's what Peisistratus ought to have his tenth of." The man spoke without knowing who his questioner was; but Peisistratus was so pleased with his frank speech and his industry that he granted him exemption from all taxes. And so in matters in general he burdened the people as little as possible with government, but always cultivated peace and kept them in all quietness.

Peisistratus was a tyrant; he ruled as a dictator, without consulting the people. But he was, by and large, a benevolent tyrant. He recognized the wisdom of Solon's economic policies and encouraged the development of trade. Perhaps most important of all, he initiated a lavish program of public works in order to provide jobs for the entire populace. He built roads and drainage systems and provided running water to most of the city. He was also a patron of the arts. Evidence suggests that in the Agora he built the first Athenian space for dramatic performances. On the Acropolis, he built several temples, though only fragmentary evidence remains.

Female Sculpture and the Worship of Athena

We know that Peisistratus emphasized the worship of Athena [uh-THEE-nuh] on the Acropolis. She was the city's protector, and from the mid-sixth century BCE on, the sculptural production of *korai* [KOR-eye], or "maidens," flourished under Peisistratus's rule. Just as the

kouros statue seems related to Apollo, the **kore** [KOR-ee] (singular of korai.) statue appears to have been a votive offering to Athena and was apparently a gift to the goddess. Male citizens dedicated korai to her as a gesture of both piety and evident pleasure.

As with the kouroi statues, the *korai* also became more naturalistic during the century. This trend is especially obvious in their dress. In the sculpture known as the *Peplos Kore* (Fig. **4.22**), anatomical realism is suppressed by the straight lines of the sturdy garment known as a peplos [PEPlus]. Usually made of wool, the peplos is essentially a rectangle of cloth folded down at the neck, pinned at the shoulders, and belted. Another kore, also remarkable for the amount of original paint on it, is the *Kore* dating from 520 BCE found on Athenian Acropolis (Fig. **4.23**). This one

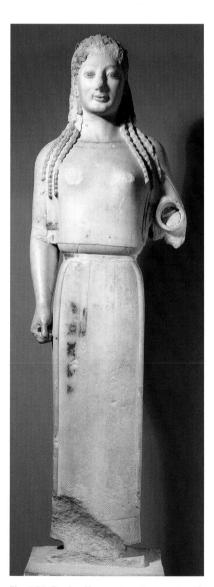

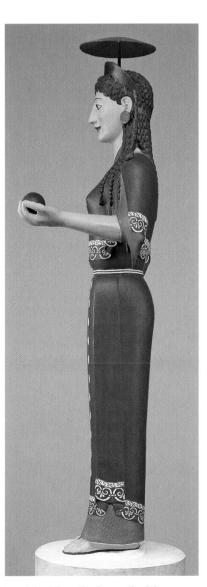

Fig. 4.22 *Peplos Kore* and cast reconstruction of the original, from the Acropolis, Athens. **Dedicated 530** BCE. Polychromed marble, height $47^{1/2}$ ". Acropolis Museum, Athens (original) and Museum of Classical Archaeology, Cambridge, England (cast). The extended arm, probably bearing a gift, was originally a separate piece, inserted in the round socket at her elbow. Note the small size of this sculpture, more than two feet shorter than the male *kouros* sculptures (Figs. 4.20, 4.21).

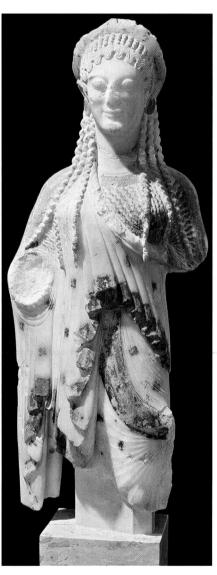

Fig. 4.23 *Kore*, from the Acropolis, Athens. ca. 520 BCE. Polychromed marble, height 21". Acropolis Museum, Athens. Although missing half its height, the sculpture gives us a clear example of the elaborate dress of the last years of the sixth century BCE.

wears a chiton [KY-ton], a garment that by the last decades of the century had become much more popular than the peplos. Made of linen, the chiton clings more closely to the body and is gathered to create pleats and folds that allow the artist to show off his virtuosity. On top of it, a gathered mantle called a himation [hi-MAT-ee-on] is draped diagonally from one shoulder. These sculptures, dedicated to Athena, give us some idea of the richness of decoration that adorned Peisistratus's Athens.

Athenian Pottery

As early as the tenth century BCE, elaborate ceramic manufactories had been established in Athens at the Kerameikos [ker-AM-ay-kos] cemetery (the origin of the word ceramics) on the outskirts of the city. Athenian artisans invented a new, much faster potter's wheel that allowed them to control more reliably the shapes of their vases. They also created new kilns, with far greater capacity to control heat, resulting in richer, more lustrous glazes. Because the human figure is largely absent from the pots produced, which favor abstract geometric patterns, some see this work as unsophisticated, especially when compared to the great figurative tradition of later Greek art. But when we consider the Greek genius for mathematics, the abstract design and patterning of these ceramics begin to seem complex and sophisticated. Concentric circles, made with a new tool—a compass with multiple brushes—decorate even the earliest pots (Fig. 4.24).

drinking cup.

Fig. 4.25 "Dipylon Vase," large sepulchral amphora from the Kerameikos cemetery, with prothesis (ritual mourning) scene.
ca. 760 BCE. Height 5'1". National Archeological Museum, Athens. This monumental vase was placed above a grave as a memorial.

By the middle of the ninth century BCE, an elaborate geometric style dominates the pottery's surface (Fig. 4.25), characterized by circles, rectangles, and triangles in parallel bands around the vase. This represents an extremely elaborate and highly stylized approach to decoration, one that echoes the Homeric epic in the submission of its detail to the unity of the whole. Layered band upon band, these geometric designs hint at what the Greeks believed to be the structure of the cosmos as a whole, a structure they tirelessly sought to understand. Soon, the physical philosopher Pythagoras [pie-THAG-uh-rus] (ca. 580–500 BCE), who studied the mathematical differences in the lengths of strings needed to produce various notes on the lyre, would develop his famous theorem. The Pythagorean theorem states that in a right triangle, the square of the hypotenuse is

equal to the sum of the squares of the other two sides. And by 300 BCE, Euclid [YOU-klid], a Greek philosopher (ca. 325–250 BCE) working in Alexandria, Egypt, would formulate his definitive geometry of two- and three-dimensional space.

Athenian potters were helped along by the extremely high quality of the clay available in Athens, which turned a deep orange color when fired. As with Athenian sculpture, the decorations on Athenian vases grew increasingly naturalistic and detailed until, generally, only one scene filled each side of the vase. They soon developed two types of vases characterized by the relationship of figure to ground: black- and red-figure vases. The figures on black-figure vases are painted with slip, a mixture of clay and water, so that after firing they remain black against an

unslipped red background. Women at a Fountain House (Fig. 4.26) is an example. Here the artist, whom scholars have dubbed the Priam [PRY-um] painter, has added touches of white by mixing white pigment into the slip. By the second half of the sixth century, new motifs, showing scenes of everyday life, became increasingly popular. This hydria [HY-dree-uh], or water jug, shows women carrying similar jugs as they chat at a fountain house of the kind built by Peisistratus at the ends of the aqueducts that brought water into the city. Such fountain houses were extremely popular spots, offering women, who were for the most part confined to their homes, a rare opportunity to gather socially. Water flows from animal-head spigots at both the sides and across the back of the scene. The composition's strong vertical and horizontal framework, with its Doric columns, is softened by the rounded contours of

the women's bodies and the vases they carry. This vase underscores the growing Greek taste for realistic scenes and naturalistic representation.

Many pots depict gods and heroes, including representations inspired by the Iliad and Odyssey (see Figs. 4.14 and 4.15). An example of this tendency is a krater [KRAYtur, or vessel in which wine and water are mixed, that shows the Death of Sarpedon [sar-PE-dun], painted by Euphronius [you-FRO-ne-us] and made by the potter Euxitheos [you-ZI-thee-us (soft th as in think)] by 515 BCE Fig. 4.27). Euphronius was praised especially for his ability to render human anatomy accurately. Here, Sarpedon has just been killed by Patroclus (see Reading 4.1). Blood pours from his leg, shoulder, and carefully drawn abdomen. The winged figures of Hypnos [HIP-nos] (Sleep) and Thanatos [THAN-uh-tohs] (Death) are about to carry off his body as Hermes [HER-meez], messenger of the gods who guides the dead to the underworld, looks on. But the naturalism of the scene is not the source of its appeal. Rather, its perfectly balanced composition trans-

forms the tragedy into a rare depiction of death as an instance of dignity and order. The spears of the two warriors left and right mirror the edge of the vase, the design formed by Sarpedon's stomach muscles is echoed in the decorative bands both top and bottom, and the handles of the vase mirror the arching backs of Hypnos and Thanatos.

The *Death of Sarpedon* is an example of a red-figure vase. The process is the reverse of the black-figure process, and more complicated. Here, the slip is used to paint the background, outlining the figures. Using the same slip, Euphronius also drew details on the figure (such as Sarpedon's abdomen) with a brush. The vase was then fired in three stages, each one varying the amount of oxygen allowed into the kiln. In the first stage, oxygen was allowed into the kiln, which "fixed" the whole vase in one overall shade of red. Then,

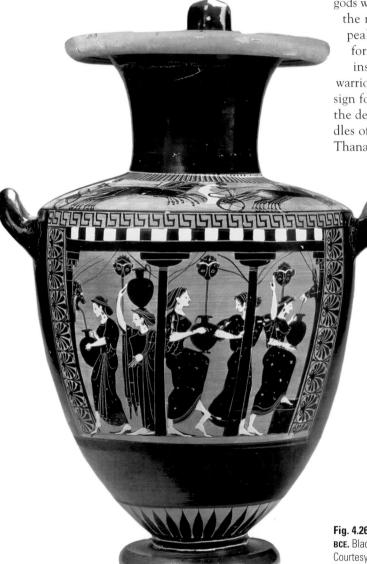

Fig. 4.26 The Priam Painter, *Women at a Fountain House.* **ca. 520–510 BCE.** Black-figure decoration on a hydria vase, height of hydria $20^{7}/8''$. Courtesy Museum of Fine Arts, Boston. Reproduced with permission. © 2005 Museum of Fine Arts, Boston. All rights reserved. The convention of depicting women's skin as white is also found in Egyptian and Minoan art.

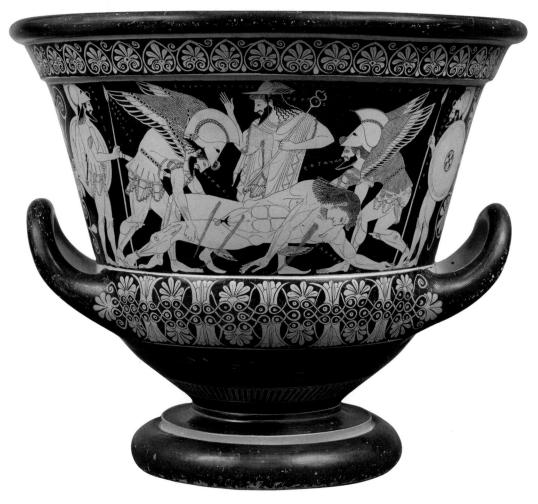

Fig. 4.27 Euphronius (painter) and Euxitheos (potter), *Death of Sarpedon.* **ca. 515 BCE.**Red-figure decoration on a calyx krater. Ceramic, height of krater 18". Museum of Villa Giulia, Rome. This type of krater is called a *calyx krater* because its handles curve up like the calyx of a flower. The krater was housed in the collection of the Metropolitan Museum of Art in New York until it became clear that it was illegally excavated in Italy in the early 1970s. The Museum returned the piece to Italy in 2008.

SEE MORE For a Closer Look at the Euphronois Krater, go to www.myartslab.com

oxygen in the kiln was reduced to the absolute minimum, turning the vessel black. At this point, as the temperature rose, the slip became vitrified, or glassy. Finally, oxygen entered the kiln again, turning the unslipped areas—in this case, the red figures—back into a shade of red. The areas painted with the vitrified slip were not exposed to oxygen, so that they remained black.

The Poetry of Sappho

The poet Sappho (ca. 610–ca. 580 BCE) was hailed throughout antiquity as "the tenth Muse" and her poetry celebrated as a shining example of female creativity. We know little of Sappho's somewhat extraordinary life. She was born on the

island of Lesbos, and probably married. She mentions both a brother and a daughter, Cleis, in her poetry. As an adult poet, she surrounded herself with a group of young women who together engaged in the celebration of Aphrodite (love), the Graces (beauty), and the Muses (poetry). Her own poetry gives rise to the suggestion that her relation to these women was erotic. It seems clear that most of her circle shared their lives with one another only for a brief period before marriage. As we will see later, Plato's Symposium suggests that homoeroticism was institutionalized for young men at this stage of life; it may have been institutionalized for young women as well.

Sappho produced nine books of lyric poems—poems to be sung to the accompaniment of a lyre—on themes of

love and personal relationships, often with other women. Sappho's poetry was revered throughout the Classical world, but only fragments have survived. It is impossible to convey the subtlety and beauty of her poems in translation, but their astonishing economy of feeling does come across. In the following poem (**Reading 4.7a**) one of the longest surviving fragments, she expresses her love for a married woman:

READING 4.7a

Sappho, lyric poetry

He is more than a hero He is a god in my eyes the man who is allowed to sit beside vou-he who listens intimately to the sweet murmur of your voice, the enticina laughter that makes my own heart beat fast. If I meet you suddenly, I can't speak—my tongue is broken; a thin flame runs under my skin; seeing nothing hearing only my ears drumming, I drip with sweat; trembling shakes my body and I turn paler than dry grass. At such times death isn't far from me.

Sappho's talent is the ability to condense the intensity of her feelings into a single breath, a breath that, as the following poem suggests, lives on (**Reading 4.7b**). Even in so short a poem, Sappho realizes concretely the Greek belief that we can achieve immortality through our words and deeds:

READING 4.7b

Sappho, lyric poetry

Although they are only breath, words which I command are immortal

THE FIRST ATHENIAN DEMOCRACY

Peisistratus's son Hippias [HIP-ee-us] became the ruler of Athens in 527 BCE. Peisistratus had been a tyrant, exiling aristocrats who did not support him, and often keeping a son of a noble family as a personal hostage to guarantee the family's loyalty. Hippias was harsher still, exiling more nobles and executing many others. In 510, the exiled nobles led a revolt, with aid from Sparta, and Hippias escaped to Persia.

In 508 BCE, Kleisthenes [KLEYE-sthuh-neez] instituted the first Athenian democracy, an innovation in self-government that might not have been possible until the Athenians had experienced the tyranny of Hippias. Kleisthenes reorganized the Athenian political system into demes [deemz], small local areas comparable to precincts or wards in a modern city. Because all citizens—remember, only males were citizens—registered in their given deme, landowners and merchants had equal political rights. Kleisthenes then grouped the demes into ten political "tribes," whose membership cut across all family, class, and regional lines, thus effectively diminishing the power and influence of the noble families. Each tribe appointed 50 of its members to a Council of Five Hundred, which served for 36 days. There were thus 10 separate councils per year, and no citizen could serve on the council more than twice in his lifetime. With so many citizens serving on the council for such short times, it is likely that nearly every Athenian citizen participated in the government at some point during his lifetime.

The new Greek democracy was immediately threatened by the rise of the Persian Empire in the east. These were the same Persians who had defeated the Babylonians and freed the Jews in 520 BCE (see Chapter 2). In 499 BCE, probably aware of the newfound political freedoms in Athens and certainly chafing at the tyrannical rule of the Persians, Persian-controlled cities in Ionia rebelled, burning down the city of Sardis, the Persian headquarters in Asia Minor. In 495 BCE, Darius struck back. He burned down the most important Ionian city, Miletus [my-LEET-us], slaughtering the men and taking its women and children into slavery. Then, probably influenced by Hippias, who lived in exile in his court, Darius turned his sights on Athens, which had sent a force to Ionia to aid the rebellion. But if the Greek democracy was threatened—and it was, to the point of destruction—it would respond by creating a new Golden Age.

Egyptian and Greek Sculpture

reestanding Greek sculpture of the Archaic period—that is, sculpture dating from about 600 to 480 BCE—is notable for its stylistic connections to 2,000 years of Egyptian tradition. The Late Period statue of Mentuemhet [men-too-em-het] (Fig. 4.28), from Thebes, dating from around 2500 BCE, differs hardly at all from Old Kingdom sculpture at Giza (see Figs. 3.8 and 3.9), and even though the Anavysos [ah-NAH-vee-sus] Kouros (Fig. 4.29), from a cemetery near Athens, represents a significant advance in relative naturalism over the Greek sculpture of just a few years before, it still resembles its Egyptian ancestors. Remarkably, since it follows upon the Anavysos Kouros by only 75 years, the Doryphoros [dor-IF-uh-ros] (Spear Bearer) (Fig. 4.30) is significantly more naturalistic. Although this

is a Roman copy of a lost fifth-century BCE bronze Greek statue, we can assume it reflects the original's naturalism, since the original's sculptor, Polyclitus [pol-ih-KLY-tus], was renowned for his ability to render the human body realistically. But this advance, characteristic of Golden Age Athens, represents more than just a cultural taste for naturalism. As we will see in the next chapter, it also represents a heightened cultural sensitivity to the worth of the individual, a belief that as much as we value what we have in common with one another—the bond that creates the city-state—our *individual* contributions are at least of equal value. By the fifth century BCE, the Greeks clearly understood that individual genius and achievement could be a matter of civic pride. •

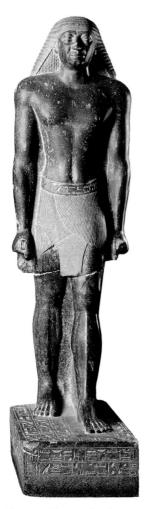

Fig. 4.28 *Montuemhet*, from Karnak, Thebes. ca. 660 BCE. Granite, height 54". Egyptian Museum, Cairo.

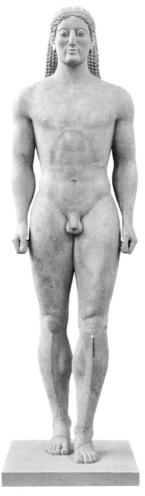

Fig. 4.29 Anavysos Kouros, from a cemetery at Anavysos, near Athens. ca. 525 BCE. Marble with remnants of paint, height 6' 4". National Archaeological Museum, Athens.

Fig. 4.30 Doryphoros (Spear Bearer), Roman copy after the original bronze by Polyclitus of ca. 450–440 всв. Marble, height 6' 6". Museo Archeològico Nazionale, Naples.

What were the Cycladic, Minoan, and Mycenaean cultures?

The later Greeks traced their ancestry to the cultures that arose in the islands of the Aegean Sea. The art of the Cyclades consisted of highly simplified Neolithic figurines and, later, probably under the influence of Minoan culture to the south, elaborate wall frescoes depicting everyday events. Unique to Minoan culture is an emphasis on the bull, associated with the legend of King Minos and the Minotaur, and the double axe, symbol of the palace of Minos at Knossos, the complex layout that gives rise to the word labyrinth. Mycenaean warriors from the Greek mainland invaded Crete in about 1450 BCE. There is abundant archeological evidence that they had valued Minoan artistry long before and had traded with the Minoans. But from all appearances their two cultures could not have been more different. In what ways did Minoan and Mycenaean cultures differ?

Who was Homer and what did he write?

Around 800 BCE, Homer's great epics, the *Iliad* and the *Odyssey*, were transcribed. The stories had been passed down orally for generations. The *Iliad* tells of the anger of the Greek hero Achilles and its consequences during a war between Mycenae and Troy, which occurred sometime between 1800 and 1300 BCE. The Odyssey follows the Greek commander Odysseus on his adventure-laden journey home to his faithful wife, Penelope. These stories, and legends such as the myth of the Minotaur, comprised for the Greeks their *archaiologia*, their way of knowing their past. How do the *Iliad* and the *Odyssey* differ from each other in their depictions of Greek culture and values?

What is a polis and how did poleis shape Greek culture?

Each of the rural areas of Greece, separated from one another by mountainous geography, gradually began to form into a community—the polis, or city- state—that exercised authority over its region. Inevitably, certain of these poleis became more powerful than the others. Corinth's central location allowed it to control sea traffic, and trade with the Near East inspired its thriving pottery industry. Sparta was the most powerful of the early Greek city-states, and it exercised extreme authoritarian rule over its people. At Delos, Delphi, Olympia, and even in colonies such as Paestum on the Italian peninsula, the city-states came together to honor their gods at sanctuaries. What role did these sanctuaries play in the development of Greek culture?

What does kouros mean?

The Greeks were unique among Mediterranean cultures in portraying the male nude, especially in the widespread genre of kouros sculpture, ideal male nude statues found in sanctuaries and cemeteries, most often serving as votive offerings to the gods or as commemorative grave markers. How would you describe the evolution of the kouros in the sixth century BCE?

Who or what inspired the rise of democracy in Athens?

The rise of democratic institutions in Athens was inspired in no small part in reaction to the tyranny of Peisistratus and his successor, his son Hippias. Peisistratus was by and large a benevolent tyrant who championed the arts, while Hippias was almost his opposite. After Hippias was overthrown, Kleisthenes instituted the first Athenian democracy in 508 BCE. The power and influence of noble families was diminished under the rule of the Council of Five Hundred, the membership of which changed every 36 days. How is this movement toward democracy reflected in Greek art?

PRACTICE MORE Get flashcards for images and terms and review chapter material with quizzes at www.myartslab.com

GLOSSARY

abacus The tabletlike slab that forms the uppermost part of a *capital*.

acropolis Literally, "top of the city"; the natural citadel of a Greek city that served as a fortification or religious center.

adyton The innermost sanctuary of a building housing the place where, in a temple with an oracle, the oracle's message was delivered.

agora A large open area in ancient Greek cities that served as public meeting place, marketplace, and civic center.

amphora A Greek jar with an egg-shaped body and two curved handles that was used for storing oil or wine.

antae Pilasters of slight projection terminating the walls of a *cella*.

Archaic style A style in early Greek art (ca. 600–480 BCE) marked by increased *naturalism*, seen especially in the period's two predominant sculptural types, *kouros* and *kore*.

architrave The bottom layer of an *entablature*.

bard A singer of songs about the deeds of heroes and the ways of the gods.

black-figure A style in Greek pottery decoration composed of black figures against a red background.

buon fresco The technique of applying pigment mixed with water onto wet plaster so that the paint is absorbed by the plaster and becomes part of the wall when dry.

capital A sculpted block that forms the uppermost part of a *column*.

cella The principal interior space of a Greek building, especially a temple; also called a *naos*.

column A vertical element that serves as an architectural support, usually consisting of a *capital*, shaft, and base.

Corinthian order The most elaborate of the Greek architectural orders distinguished by a capital decorated with acanthus leaves.

cyclopean masonry Walls made of huge blocks of rough-hewn stone; so called because of myth that a race of monsters known as the Cyclopes built them.

dactyl An element of meter in poetry consisting of one long syllable followed by two short syllables.

deme A division of the Athenian political system composed of small local areas comparable to modern-day precincts or wards.

democracy Rule by the people.

Doric order The oldest and simplest of the Greek architectural orders characterized by a heavy *column* that stands directly on a temple's *stylobate*.

echinus The rounded part of a *capital*.

elevation The arrangement, proportions, and appearance of a temple foundation, columns, and lintels.

engaged column A half-column that projects from a wall but serves no structural purpose.

entablature The uppermost horizontal elements of an order composed of the cornice, frieze, and architrave.

entasis A swelling of the shaft of a column.

epic conventions Standard ways of composing an epic.

faience A type of earthenware ceramic decorated with glazes.

feudal A system of political organization based on ties of allegiance between a lord and those who owed their welfare to him.

formulaic epithet A descriptive phrase applied to a person or thing, serving as an aid to memory in oral recitation.

geometric style A style of early Greek ceramics characterized by circles, rectangles, and triangles arranged in parallel bands.

hexameter A poetic form composed of six metrical units per line.

hubris Exaggerated pride and self-confidence.

lonic order One of the Greek architectural orders characterized by columns either of caryatids or with scrolled capitals.

kore (pl. korai) A freestanding sculpture of a standing maiden.

kouros (pl. kouroi) A freestanding sculpture of a nude male youth.

lyric poem Poetry generally written to be accompanied by a lyre.

naturalism A style in art that seeks to represent forms, including the human body, as they appear in nature.

order In Classical Greek architecture, the relationship of an elevation's three vertical elements: *platform*, *column*, and *entablature*; see *Doric*, *Ionic*, and *Corinthian*.

pantheon All the gods as a group.

pediment The triangular area over a porch.

peristyle A row of columns.

platform A raised horizontal surface.

polis The Greek city-state that formed the center of cultural life.

pronaos The enclosed vestibule at the front of a Greek building, especially a temple.

red-figure A style in Greek pottery decoration composed of red figures against a black background.

relieving triangle A triangular-shaped opening above a lintel that relieves some of the weight the lintel bears.

repoussé A metalworking technique of creating a design in relief by hammering or pressing on the reverse side.

shaft grave A deep vertical pit enclosed in a circle of stone slabs.

spondee An element of meter in poetry consisting of two long syllables.

stylobate The top step of the raised *platform* of a temple.

symposium In ancient Greece, a gathering of men initially for the purpose of sharing poetry, food, and wine.

tholos A round building.

volute A scroll-like motif on a column's capital.

READING 4.1

from Homer, Iliad, Book 16 (ca. 750 BCE)

Homer's epic poem the Iliad begins after the Trojan War has begun. It narrates, in 24 books, what it describes in the first line as "the rage of Achilles," the Greeks' greatest warrior. Achilles has withdrawn from combat in anger at the Greek leader Agamemnon for taking the beautiful Briseis from him. Finally, in Book 16, with the Greeks in desperate straits, Achilles partially relents and allows his close friend Patroclus to don his armor and lead the Greeks into combat. The following excerpts from Book 16 describe scenes from the battle in which Patroclus defeats the Trojan warrior Sarpedon. It is a stunning portrayal of the horrible realities of war.

10

20

30

. . . And Hector? Hector's speeding horses swept him away armor and all, leaving his men to face their fate, Trojans trapped but struggling on in the deep trench. Hundreds of plunging war-teams dragging chariots down, snapping the yoke-poles, ditched their masters' cars and Patroclus charged them, heart afire for the kill, shouting his Argives forward—"Slaughter Trojans!" Cries of terror breaking as Trojans choked all roads, their lines ripped to pieces, up from under the hoofs a dust storm swirling into the clouds as rearing horses broke into stride again and galloped back to Troy, leaving ships and shelters in their wake. Patrocluswherever he saw the biggest masses dashing before him, there he steered, plowing ahead with savage cries and fighters tumbled out of their chariots headfirst, crushed under their axles, war-cars crashing over, yes, but straight across the trench went his own careering team at a superhuman bound. Magnificent racing stallions, gifts of the gods to Peleus, shining immortal gifts, straining breakneck on as Patroclus' high courage urged him against Prince Hector, keen for the kill but Hector's veering horses swept him clear. And all in an onrush dark as autumn days when the whole earth flattens black beneath a gale, when Zeus flings down his pelting, punishing rainsup in arms, furious, storming against those men who brawl in the courts and render crooked judgments, men who throw all rights to the winds with no regard for the vengeful eyes of the gods-so all their rivers crest into flood spate, ravines overflowing cut the hilltops off into lonely islands, the roaring flood tide rolling down to the storm-torn sea, headlong down from the foothills washes away the good plowed work of men-

Rampaging so, the gasping Trojan war-teams hurtled on.

Patroclus—soon as the fighter cut their front battalions off he swerved back to pin them against the warships, never letting the Trojans stream back up to Troy as they struggled madly on—but there mid-field between the ships, the river and beetling wall Patroclus kept on sweeping in, hacking them down, making them pay the price for Argives slaughtered. There, Pronous first to fall—a glint of the spear and Patroclus tore his chest left bare by the shield-rim, loosed his knees and the man went crashing down.

And next he went for Thestor the son of Enops cowering, crouched in his fine polished chariot, crazed with fear, and the reins flew from his grip-Patroclus rising beside him stabbed his right jawbone, ramming the spearhead over the chariot-rail, hoisted, dragged the Trojan out as an angler perched on a jutting rock ledge drags some fish from the sea, some noble catch, with line and glittering bronze hook. So with the spear Patroclus gaffed him off his car, his mouth gaping round the glittering point and flipped him down facefirst, dead as he fell, his life breath blown away. And next he caught Erylaus closing, lunging inhe flung a rock and it struck between the eyes and the man's whole skull split in his heavy helmet, down the Trojan slammed on the ground, head-down and courage-shattering Death engulfed his corpse. Then in a blur of kills, Amphoterus, Erymas, Epaltes, Tiepolemus son of Damastor, and Echius and Pyris, Ipheus and Euippus and Polymelus the son of Argeashe crowded corpse on corpse on the earth that rears us all.

But now Sarpedon watching his comrades drop and die, wars-shirts billowing free as Patroclus killed them, dressed is godlike Lycians down with a harsh shout: "Lycians, where's your pride? Where are you running? Now be fast to attack! I'll take him on myself, see who he is who routs us, wreaking havoc against us—cutting the legs from under squads of good brave men."

With that he leapt up from his chariot fully armed and hit the ground and Patroclus straight across, as soon as he saw him, leapt from his car too. As a pair of crook-clawed, hook-beaked vultures swoop to fight, screaming above some jagged rock so with their battle cries they rushed each other there. And Zeus the son of Cronus with Cronus' twisting ways, filling with pity now to see the two great fighters, said to Hera, his sister and his wife, "My cruel fate . . . my Sarpedon, the man I love the most, my own sondoomed to die at the hands of Menoetius' son Patroclus. My heart is torn in two as I try to weigh all this. Shall I pluck him up, now, while he's still alive and set him down in the rich green land of Lycia, far from the war at Troy and all its tears? Or beat him down at Patroclus' hands at last?"

90

But Queen Hera, her eyes wide, protested strongly: "Dread majesty, son of Cronus—what are you saying? A man, a mere mortal, his doom sealed long ago? You'd set him free from all the pains of death? Do as you please, Zeus . . . but none of the deathless gods will ever praise you. And I tell you this—take it to heart, I urge you—if you send Sarpedon home, living still, beware! Then surely some other god will want to sweep his own son clear of the heavy fighting too. Look down. Many who battle round King Priam's mighty walls are sons of the deathless gods—you will inspire lethal anger in them all.

No,

110

120

140

dear as he is to you, and your head grieves for him, leave Sarpedon there to die in the brutal onslaught, beaten down at the hands of Menoetius' son Patroclus. But once his soul and the life force have left him, send Death to carry him home, send soothing Sleep, all the way till they reach the broad land of Lycia. There his brothers and countrymen will bury the prince with full royal rites, with mounded tomb and pillar. These are the solemn honors owed the dead.

So she pressed and Zeus the father of men and gods complied at once. But he showered tears of blood that drenched the earth, showers in praise of him, his own dear son, the man Patroclus was just about to kill

on Troy's fertile soil, far from his fatherland.

Now as the two came closing on each other Patroclus suddenly picked off Thrasymelus the famous driver, the aide who flanked Sarpedonhe speared him down the guts and loosed his limbs. But Sarpedon hurled next with a flashing lance and missed his man but he hit the horse Bold Dancer, stabbing his right shoulder and down the stallion went, screaming his life out, shrieking down in the dust as his life breath winged away. And the paired horses reared apart—a raspy creak of the yoke, the reins flying, fouled as the trace horse thrashed the dust in death-throes. But the fine spearman Automedon found a cure for that drawing his long sharp sword from his sturdy thigh he leapt with a stroke to cut the trace horse freeit worked. The team righted, pulled at the reins and again both fighters closed with savage frenzy, dueling now to the death.

Again Sarpedon missed over Patroclus' left shoulder his spearhead streaked, it never touched his body. Patroclus hurled next, the bronze launched from his hand—no miss, a mortal hit. He struck him right where the midriff packs the pounding

and down Sarpedon fell as an oak or white poplar falls or towering pine that shipwrights up on a mountain hew down with whetted axes for sturdy ship timber—so he stretched in front of his team and chariot, sprawled and roaring, clawing the bloody dust. As the bull a marauding lion cuts from the herd, tawny and greathearted among the shambling cattle, dies bellowing under the lion's killing jaws—

so now Sarpedon, captain of Lycia's shieldsmen, died at Patroclus' hands and died raging still, crying out his beloved comrade's name: "Glaucus—oh dear friend, dear fighter, soldier's soldier!

Now is the time to prove yourself a spearman, a daring man of war—now, if you are brave, make grueling battle your one consuming passion.

First find Lycia's captains, range the ranks, spur them to fight and shield Sarpedon's body.

Then you, Glaucus, you fight for me with bronze!

You'll hang your head in shame—every day of your life—if the Argives strip my armor here at the anchored ships where I have gone down fighting. Hold on, full force—spur all our men to battle!"

Death cut him short.

The end closed in around him, swirling down his eyes, choking off his breath. Patroclus planted a heel against his chest, wrenched the spear from his wound and the midriff came out with it—so he dragged out both the man's life breath and the weapon's point together.

. . . .

So veteran troops kept swarming round that corpse, never pausing—nor did mighty Zeus for a moment turn his shining eyes from the clash of battle. He kept them fixed on the struggling mass forever, the Father's spirit churning, thrashing out the ways the numberless ways to cause Patroclus' slaughter . . . To kill him too in this present bloody rampage over Sarpedon's splendid body? Hector in glory cutting Patroclus down with hacking bronze then tearing the handsome war-gear off his back? Or let him take still more, piling up his kills? And storming Zeus was stirring up Apollo: "On with it nowsweep Sarpedon clear of the weapons, Phoebus, my friend, and once you wipe the dark blood from his body, bear him far from the fighting, off and away, and bathe him well in a river's running tides and anoint him with deathless oils . . . dress his body in deathless, ambrosial robes. Then send him on his way with the wind-swift escorts, twin brother Sleep and Death, who with all good speed will set him down in the broad green land of Lycia, There his brothers and countrymen will bury the prince with full royal rites, with mounded tomb and pillar. These are the solemn honors owed the dead."

So he decreed

and Phoebus did not neglect the Father's strong desires. Down from Ida's slopes he dove to the bloody field and lifting Prince Sarpedon clear of the weapons, bore him far from the fighting, off and away

READING CRITICALLY

The scene described is full of Homeric similes. Two of the most effective follow each other in short order directly after Patroclus hurls his spear into Sarpedon's midriff. How do these similes contribute to the power of the poem? How might they either contribute to or diminish our sense of the warriors' areté?

160

170

180

190

200

from Homer, Odyssey, Book 9 (ca 725 BCE)

The sequel to Homer's Iliad, the Odyssey is a second epic poem by Homer that narrates the adventures of the Greek warrior Odysseus on his 20-year journey home from the Trojan War. The following passage from Book 9, recounts Odysseus's confrontation with the Cyclops Polyphemus. In this confrontation Odysseus displays the cunning and skill that make him a great leader.

In the next land we found were Kyklopês.1 giants, louts, without a law to bless them. In ignorance leaving the fruitage of the earth in mystery to the immortal gods, they neither plow nor sow by hand, nor till the ground, though grainwild wheat and barley—grows untended, and wine-grapes, in clusters, ripen in heaven's rain. Kyklopês have no muster and no meeting, no consultation or old tribal ways, but each one dwells in his own mountain cave dealing out rough justice to wife and child, indifferent to what the others do. . . . [Camped on a desert island across from the mainland home of the Kyklopes, Odysseus announces his intention to explore the mainland itself.] 'Old shipmates, friends, the rest of you stand by; I'll make the crossing in my own ship, with my own company, and find out what the mainland natives arefor they may be wild savages, and lawless, or hospitable and god fearing men.' At this I went aboard, and gave the word to cast off by the stern. My oarsmen followed, filing in to their benches by the rowlocks, and all in line dipped oars in the grey sea. As we rowed on, and nearer to the mainland, at one end of the bay, we saw a cavern yawning above the water, screened with laurel, and many rams and goats about the place inside a sheepfold—made from slabs of stone earthfast between tall trunks of pine and rugged towering oak trees. A prodigious man slept in this cave alone, and took his flocks to graze afield—remote from all companions, knowing none but savage ways, a brute so huge, he seemed no man at all of those who eat good wheaten bread; but he seemed rather a shaggy mountain reared in solitude. We beached there, and I told the crew to stand by and keep watch over the ship; as for myself I took my twelve best fighters and went ahead. I had a goatskin full of that sweet liquor that Euanthês' son, Maron, had given me. . . . No man turned away

A wineskin full I brought along, and victuals in a bag, for in my bones I knew some towering brute would be upon us soon—all outward power, a wild man, ignorant of civility. We climbed, then, briskly to the cave. But Kyklops had gone afield, to pasture his fat sheep. so we looked round at everything inside. . . . My men came pressing round me, pleading: 'Why not take these cheeses, get them stowed, come back. throw open all the pens, and make a run for it? We'll drive the kids and lambs aboard. We say put out again on good salt water!' Ah, how sound that was! Yet I refused. I wished to see the caveman, what he had to offerno pretty sight, it turned out, for my friends. We lit a fire, burnt an offering, and took some cheese to eat; then sat in silence around the embers, waiting. When he came he had a load of dry boughs on his shoulder to stoke his fire at suppertime. He dumped it with a great crash into that hollow cave. and we all scattered fast to the far wall. . . . 'Strangers,' he said, 'who are you? And where from? What brings you here by sea ways—a fair traffic? Or are you wandering rogues, who cast your lives like dice, and ravage other folk by sea?' We felt a pressure on our hearts, in dread of that deep rumble and that mighty man. But all the same I spoke up in reply: 'We are from Troy, Akhaians, blown off course by shifting gales on the Great South Sea; homeward bound, but taking routes and ways uncommon; so the will of Zeus would have it. . . . It was our luck to come here; here we stand, beholden for your help, or any gifts you give—as custom is to honor strangers. We would entreat you, great Sir, have a care for the gods' courtesy; Zeus will avenge the unoffending guest.'2 He answered this from his brute chest, unmoved: 'You are a ninny, or else you come from the other end of nowhere, telling me, mind the gods! We Kyklopês care not a whistle for your thundering Zeus

when cups of this came round.

²Zeus was the protector and guarantor of the laws of hospitality.

or all the gods in bliss; we have more force by far.

¹One-eyed giants, inhabitants of Sicily. Also spelled Cyclops.

I would not let you go for fear of Zeusyou or your friends—unless I had a whim to. Tell me, where was it, now, you left your shiparound the point, or down the shore, I wonder?' He thought he'd find out, but I saw through this, and answered with a ready lie: 'My ship? Poseidon Lord, who sets the earth a-tremble, broke it up on the rocks at your land's end. A wind from seaward served him, drove us there. We are survivors, these good men and I.' Neither reply nor pity came from him, but in one stride he clutched at my companions and caught two in his hands like squirming puppies to beat their brains out, spattering the floor. Then he dismembered them and made his meal, gaping and crunching like a mountain lioneverything: innards, flesh, and marrow bones. We cried aloud, lifting our hands to Zeus, powerless, looking on at this, appalled; but Kyklops³ went on filling up his belly with manflesh and great gulps of whey, then lay down like a mast among his sheep. My heart beat high now at the chance of action, and drawing the sharp sword from my hip I went along his flank to stab him where the midriff holds the liver. I had touched the spot when sudden fear stayed me: if I killed him we perished there as well, for we could never move his ponderous doorway slab aside. So we were left to groan and wait for morning. When the young Dawn with finger tips of rose lit up the world, the Kyklops built a fire and milked his handsome ewes, all in due order, putting the sucklings to the mothers. Then, his chores being all dispatched, he caught another brace of men to make his breakfast, and whisked away his great door slab to let his sheep go through—but he, behind, reset the stone as one would cap a quiver. There was a din of whistling as the Kyklops rounded his flock to higher ground, then stillness. And now I pondered how to hurt him worst, if but Athena granted what I prayed for. Here are the means I thought would serve my turn: a club, or staff, lay there along the foldan olive tree, felled green and left to season for Kyklops' hand. And it was like a mast a lugger of twenty oars, broad in the beama deep-sea-going craft—might carry: so long, so big around, it seemed. Now I chopped out a six foot section of this pole and set it down before my men, who scraped it; and when they had it smooth, I hewed again to make a stake with pointed end. I held this in the fire's heart and turned it, toughening it, then hid it, well back in the cavern, under

110

120

140

one of the dung piles in profusion there. Now came the time to toss for it: who ventured along with me? whose hand could bear to thrust and grind that spike in Kyklops' eye, when mild sleep had mastered him? As luck would have it, the men I would have chosen won the tossfour strong men, and I made five as captain. At evening came the shepherd with his flock, his woolly flock. The rams as well, this time, entered the cave: by some sheep-herding whimor a god's bidding—none were left outside. He hefted his great boulder into place and sat him down to milk the bleating ewes in proper order, put the lambs to suck, and swiftly ran through all his evening chores. Then he caught two more men and feasted on them. My moment was at hand, and I went forward 170 holding an ivy bowl of my dark drink, looking up, saying: 'Kyklops, try some wine. Here's liquor to wash down your scraps of men. Taste it, and see the kind of drink we carried under our planks. I meant it for an offering if you would help us home. But you are mad, unbearable, a bloody monster! After this, will any other traveller come to see you?' He seized and drained the bowl, and it went down 180 so fiery and smooth he called for more: 'Give me another, thank you kindly. Tell me, how are you called? I'll make a gift will please you." I saw the fuddle and flush come over him, then I sang out in cordial tones: 'Kyklops, you ask my honorable name? My name is Nohbdy: mother, father, and friends, everyone calls me Nohbdy.' And he said: 'Nohbdy's my meat, then, after I eat his friends. Others come first. There's a noble gift, now.' Even as he spoke, he reeled and tumbled backward, his great head lolling to one side; and sleep took him like any creature. Drunk, hiccuping, he dribbled streams of liquor and bits of men. Now, by the gods, I drove my big hand spike deep in the embers, charring it again, and cheered my men along with battle talk to keep their courage up: no quitting now. 200 The pike of olive, green though it had been, reddened and glowed as if about to catch. I drew it from the coals and my four fellows gave me a hand, lugging it near the Kyklops as more than natural force nerved them; straight forward they sprinted, lifted it, and rammed it deep in his crater eye, and I leaned on it turning it as a shipwright turns a drill in planking, having men below to swing the two-handled strap that spins it in the groove. 210 So with our brand we bored that great eye socket while blood ran out around the red hot bar. Eyelid and lash were seared; the pierced ball

hissed broiling, and the roots popped.

³Here used as a singular; his name, we learn later, is Polyphêmos.

In a smithy Last of them all my ram, the leader, came, one sees a white-hot axehead or an adze weighted by wool and me with my meditations. plunged and wrung in a cold tub, screeching steam-The Kyklops patted him, and then he said: the way they make soft iron hale and hard-: 'Sweet cousin ram, why lag behind the rest just so that eyeball hissed around the spike. in the night cave? You never linger so, The Kyklops bellowed and the rock roared round him, but graze before them all, and go afar 220 and we fell back in fear. Clawing his face to crop sweet grass, and take your stately way he tugged the bloody spike out of his eye, leading along the streams, until at evening threw it away, and his wild hands went groping; you run to be the first one in the fold. then he set up a howl for Kyklopês Why, now, so far behind? Can you be grieving who lived in caves on windy peaks nearby. over your Master's eye? That carrion roque Some heard him; and they came by divers ways and his accurst companions burnt it out to clump around outside and call: when he had conquered all my wits with wine. 'What ails you, Nohbdy will not get out alive, I swear. Polyphêmos? Why do you cry so sore Oh, had you brain and voice to tell in the starry night? You will not let us sleep. where he may be now, dodging all my fury! Sure no man's driving off your flock? No man Bashed by this hand and bashed on this rock wall has tricked you, ruined you?' his brains would strew the floor, and I should have Out of the cave rest from the outrage Nohbdy worked upon me.' the mammoth Polyphêmos roared in answer: He sent us into the open, then. Close by, 'Nohbdy, Nohbdy's tricked me, Nohbdy's ruined me!' I dropped and rolled clear of the ram's belly, To this rough shout they made a sage reply: going this way and that to untie the men. 'Ah well, if nobody has played you foul With many glances back, we rounded up there in your lonely bed, we are no use in pain his fat, stiff-legged sheep to take aboard, given by great Zeus. Let it be your father, and drove them down to where the good ship lay. Poseidon Lord, to whom you pray.' We saw, as we came near, our fellows' faces So saying shining; then we saw them turn to grief they trailed away. And I was filled with laughter tallying those who had not fled from death. to see how like a charm the name deceived them. I hushed them, jerking head and eyebrows up, Now Kyklops, wheezing as the pain came on him, and in a low voice told them: 'Load this herd; fumbled to wrench away the great doorstone move fast, and put the ship's head toward the breakers.' and squatted in the breach with arms thrown wide They all pitched in at loading, then embarked for any silly beast or man who boltedand struck their oars into the sea. Far out, hoping somehow I might be such a fool. as far off shore as shouted words would carry, But I kept thinking how to win the game: I sent a few back to the adversary: death sat there huge; how could we slip away? 'O Kyklops! Would you feast on my companions? I drew on all my wits, and ran through tactics, Puny, am I, in a Caveman's hands? reasoning as a man will for dear life, How do you like the beating that we gave you, until a trick came—and it pleased me well. you damned cannibal? Eater of guests The Kyklops' rams were handsome, fat, with heavy under your roof! Zeus and the gods have paid you!' fleeces, a dark violet. The blind thing in his doubled fury broke Three abreast a hilltop in his hands and heaved it after us. I tied them silently together, twining Ahead of our black prow it struck and sank cords of willow from the ogre's bed; whelmed in a spuming geyser, a giant wave then slung a man under each middle one that washed the ship stern foremost back to shore. to ride there safely, shielded left and right. I got the longest boathook out and stood So three sheep could convey each man. I took fending us off, with furious nods to all the woolliest ram, the choicest of the flock, to put their backs into a racing strokeand hung myself under his kinky belly, row, row, or perish. So the long oars bent pulled up tight, with fingers twisted deep kicking the foam sternward, making head in sheepskin ringlets for an iron grip. until we drew away, and twice as far. So, breathing hard, we waited until morning. Now when I cupped my hands I heard the crew When Dawn spread out her finger tips of rose in low voices protesting: the rams began to stir, moving for pasture, 'Godsake, Captain! and peals of bleating echoed round the pens Why bait the beast again? Let him alone!' where dams with udders full called for a milking. 'That tidal wave he made on the first throw Blinded, and sick with pain from his head wound, all but beached us." the master stroked each ram, then let it pass, 'All but stove us in!' but my men riding on the pectoral fleece 'Give him our bearing with your trumpeting, the giant's blind hands blundering never found.

he'll get the range and lob a boulder.'

280

300

310

320

330

'Aye
He'll smash our timbers and our heads together!'
I would not heed them in my glorying spirit,
but let my anger flare and yelled:
'Kyklops,
if ever mortal man inquire
how you were put to shame and blinded, tell him
Odysseus, raider of cities, took your eye:
Laërtês' son, whose home's on Ithaka!' . . .
Now he laid hands upon a bigger stone
and wheeled around, titanic for the cast,
to let it fly in the black-prowed vessel's track.

But it fell short, just aft the steering oar, and whelming seas rose giant above the stone to bear us onward toward the island. . . .

READING CRITICALLY

340

One of the features that distinguishes this particular tale in the *Odyssey* from Homer's narration in the *Iliad* is that Odysseus tells it himself, in his own voice. How does this first-person narrative technique help us to understand Homer's hero better than we might if Homer narrated the events himself?

which begins with the rise to power of Alexander the Great (356–323 BCE) and extends to the Roman defeat of Cleopatra in Egypt in 30 BCE. (*Hellenes* is what the Greeks called, and still call, themselves, and Alexander was understood to have made the world over in the image of Greece.) In the Hellenistic age, as Alexander conquered region after region, cities were built on the model of the Athenian polis, many of which became great centers of culture and learning in their own right. Soon, the accomplishments of Greek culture had spread throughout the Mediterranean, across North Africa and the Middle East, even into the Indian subcontinent.

THE GOOD LIFE AND THE POLITICS OF ATHENS

When the Athenians returned to a devastated Athens after their victory at Salamis, they turned their attention first to the **agora**, an open place used for congregating or as a market (Map **5.1**). The principal architectural feature of the agora was the **stoa** (Fig. **5.2**), a long, open arcade supported by **colonnades**, rows of columns. While Athenians could shop for grapes, figs, flowers, and lambs in the agora, it was far more than just a shopping center. It was the place where citizens congregated, debated the issues of the day, argued points of law, settled disputes, and presented philosophical discourse. In short, it was the place where they practiced their politics.

In his *Politics*, the Greek philosopher Aristotle (384–322 BCE) described the politics and the Athenian polis like

this: "The partnership finally composed of several villages is the polis; it has at last attained the limit of virtually complete self-sufficiency, and thus while it comes into existence for the sake of mere life, it exists for the sake of the good life." For Aristotle, the essential purpose of the polis was to

Fig. 5.2 The Stoa of Attalus, Athens, Greece. 150 BCE. This stoa, reconstructed at the eastern edge of the modern agora, retains traditional form. The broad causeway on the right was the Panathenaic Way, the route of the ritual processions to the Acropolis in the distance. The original agora buildings lie farther to the right and overlook the Panathenaic Way.

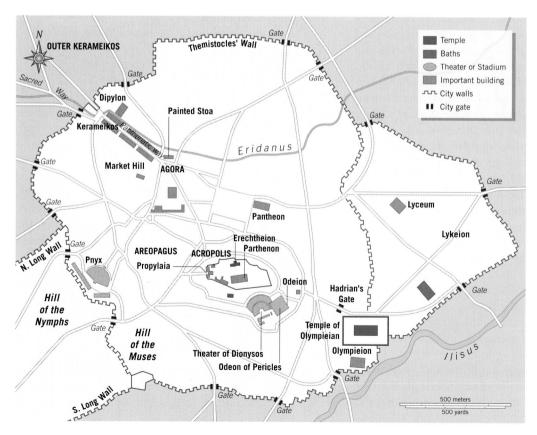

Map 5.1 Athens as it appeared in the late fifth century BCE. The map shows a modern artist's rendering of the city.

guarantee, barring catastrophe, that each of its citizens might flourish. Writing in the fourth century BCE, Aristotle is thinking back to the Athens of the fifth century BCE, the so-called Golden Age. During these years, the pursuit of what Aristotle called *eudaimonia* [yoo-day-MOE-nee-uh], "the good or flourishing life," resulted in a culture of astonishing sophistication and diversity. For *eudaimonia* is not simply a happy or pleasurable existence; rather, the polis provides the conditions in which each individual may pursue an "activity of soul in accordance with complete excellence." For Aristotle, this striving to "complete excellence" defines Athens in the Golden Age.

A politics such as Aristotle describes depends upon at least a limited democracy. In a tyranny, there can be no politics because there can be no debate. Whatever their diverging views, the citizens of the polis were free to debate the issues, to speak their minds. They spoke as individuals, and they cherished the freedom to think as they pleased. But they spoke out of a concern for the common good, for the good of the polis, which, after all, gave them the freedom to speak in the first place. When Aristotle says, in his *Politics*, that "man is a political animal," he means that man is a creature of the polis, bound to it, dedicated to it, determined by it, and, somewhat paradoxically, liberated by it as well.

The City Council of Athens, consisting of 500 citizens, elected annually, met in the Bouleuterion [boo-loo-TER-ee-un] in the agora, and its executive committee dined, at public expense, in the nearby Tholos, a round building with six columns supporting a conical roof. In the Metroon [MET-rohown], the polis housed its weights and measures as well as its official archives. A special place honored the laws of Solon. Carved into the hill in the southwestern part of the city was a giant bowl, the Pnyx, where as many as 10,000 citizens could gather. Here the polis convened four times each month (the Greek calendar consisted of ten months), to vote on the resolutions of its governing council.

The chief occupation of Athenian citizens was to gather in the agora to exercise their political duties. This purpose explains several seemingly contradictory aspects of the Athenian polis. Most citizens lived, by modern standards, in relatively humble circumstances. Homes were tiny and hygiene practically nonexistent. Furniture was basic and minimal. Bread was the staple of life, eaten with olives or relish made from fish (though wine, at least, was plentiful). Wood for fire and heat was scarce, and the water supply was inadequate. This is not to say that the Athenians had no wealth. They were richer than most. And they acquired leisure, the free time necessary to perform the responsibilities of citizenship.

Slaves and Metics

The limited Athenian democracy was based on its citizens' ability to have others do its manual work. This marks a radical departure from the culture of Hesiod's *Works and Days*, in which one advanced oneself by "work with work

upon work." To the Athenian citizen, work was something to be avoided. Typically, working fell to slaves or to *metics* [MET-iks], free men who were not citizens because they came from some other polis in Greece or from a Greek colony.

By the middle of the Golden Age, the population of Athens was approximately 275,000, of which only 40,000 were citizens. Between 80,000 and 100,000 residents of Athens were slaves. The rest were metics and women. The practice of slavery came naturally to the Greeks, since most slaves were "barbarians" (the word *Greeks* used to describe non-Greek-speaking people) and hence by definition inferior. Almost every citizen had at least one slave attendant and a female domestic servant. As for the metics, one contemporary reported that "They do everything. . . . [They] do the removal of rubbish, mason's work, and plastering, they capture the wood trade, timber construction, and rough carpentry, metal work and all subsidiary occupations are in their hands, and they hold the clothing industries, the sale of colors and varnishes, and in short every small trade."

Metics were equally central to the development of the arts and philosophy in the Golden Age. Most of the sculptors, potters, and painters came from abroad and thus were metics. Almost all of the city's philosophers—except, most notably, Socrates and Plato—were also metics. By the fourth century, so were all the leading comic playwrights, with the important exception of Aristophanes.

The Women of Athens

Like the metics, the women of Athens were not citizens and did not enjoy any of the privileges of citizenship. In 431 BCE, the playwright Euripides put these words into the mouth of Medea, a woman believed to be of divine origin who punished the mortal Jason for abandoning her. Medea kills Jason's new bride as well as her own children (Reading 5.1):

READING 5.1

from Euripides, Medea (431 BCE)

Of all things which are living and can form a judgment We women are the most unfortunate creatures. Firstly, with an excess of wealth it is required For us to buy a husband and take for our bodies A master; for not to take one is even worse. . . . A man, when he's tired of the company in his home, Goes out of the house and puts an end to his boredom And turns to a friend or companion of his own age. But we are forced to keep our eyes on one alone [i.e., the husband].

What they say of us is that we have a peaceful time Living at home, while they do the fighting in war. How wrong they are! I would very much rather stand Three times in front of battle than bear one child.

As Medea suggests, women in Athens were excluded from most aspects of social life. In general, they married before they were 15 years old, at an age when they were considered to be still educable by husbands who averaged about 30 years of age. Athenian women were not educated. Near the beginning of the third century BCE, the comic playwright Menander explained the reason this way: "Teach a woman to read and write? What a terrible thing to do! Like feeding a vile snake on more poison." Neither were women expected to participate in conversation, which was the male's prerogative. Their role was largely domestic, even though their household obligations were sometimes minimal given the number of slaves and maids. Above all, the wife's primary duty was to produce male offspring for her husband's household.

Women did, in fact, serve another important role in Athenian social life—they took part in religious rituals and public festivals. They were also, as Euripides's *Medea* suggests, central figures in much of Greek culture, from its mythology, to its painting and sculpture, and, perhaps above all, its theater. Plays such as Euripides's *Medea* and Sophocles's *Antigone*, and especially Aristophanes's comedy *Lysistrata*, in which the women of Athens and Sparta unite to withhold sexual favors from their husbands until they agree to make peace, suggest that Athenian society was deeply torn by the tension between the reality of female power and the insistence on male authority.

Nevertheless, we know that some women exerted real power in Greek culture. A particularly powerful woman was Aspasia (ca. 469–ca. 406 BCE), mistress of the statesman and leader Pericles (whose rule is discussed later in the chapter). Aspasia was a hetaira [heh-TYE-ruh], one of a class of Greek courtesans distinguished by their beauty and, as opposed to most women in Athenian society, their often high level of education. After Pericles divorced his wife around 445 BCE. Aspasia lived with him openly as if they were married. (Since she was both foreign-born and a hetaira, actual marriage was forbidden by Athenian law.) She is said to have taught rhetoric with such skill that some scholars believe it was actually she who invented the "dialectic method" (see page 149). And she evidently exerted enough political influence on Pericles that their relationship was the target of attacks and jokes in Greek comedy.

Some Hellenic city-states treated their women better than the Athenians. Spartan women were taught to read and write, and they were encouraged to develop the same physical prowess as Spartan men, participating in athletic events such as javelin, discus, and foot races, as well as fighting in staged battles. Spartan women met with their husbands only for procreative purposes and had little to do with their children, who were raised by the community. A woman's property was her own to keep and manage, and if her husband was away too long at war, she was free to remarry.

Pericles and the School of Hellas

No person dominated Athenian political life during the Golden Age more than the statesman Pericles (ca. 495–429 BCE), who served on the Board of Ten Generals for nearly

30 years. An aristocrat by birth, he was nonetheless democracy's strongest advocate. Late in his career, in 431 BCE, he delivered a speech honoring soldiers who had fallen in early battles of the Peloponnesian War, a struggle for power between Sparta and Athens that would eventually result in Athens's defeat in 404 BCE, long after Pericles's own death. Although Athens and Sparta had united to form the Delian League in the face of the Persian threat in 478 BCE, by 450 BCE, Persia was no longer a threat, and Sparta sought to foment a large-scale revolt against Athenian control of the Delian League. Sparta formed its own Peloponnesian League, motivated at least partly by Athens's use of Delian League funds to rebuild its acropolis. Pericles resisted the rebellion vigorously, as Athenian preeminence among the Greeks was at stake. The Greek historian Thucydides recorded Pericles's speech in honor of his soldiers in its entirety in his History of the Peloponnesian Wars (Readings 5.2a, 5.2b, and 5.2c). Although Thucydides, considered the greatest historian of antiquity, tried to achieve objectivity—to the point that he claimed, rather too humbly, that he was so true to the facts that the reader might find him boring—he did admit that he had substituted his own phrasings when he could not remember the exact words of his subjects. Thus, Pericles's speech may be more Thucydides than Pericles. Furthermore, gossip at the time suggests that the speech was in large part the work of Aspasia, Pericles's mistress and partner. So the speech may, in fact, be more Aspasia than Pericles, and more Thucydides than Aspasia. Nevertheless, it reflects what the Athenians thought of themselves.

Pericles begins his speech by saying that, in order to properly honor the dead, he would like "to point out by what principles of action we rose to power, and under what institutions and through what manner of life our empire became great." First and foremost in his mind is Athenian democracy:

READING 5.2a

Thucydides, History of the Peloponnesian Wars, Pericles's Funeral Speech (ca. 410 BCE)

Our form of government does not enter into rivalry with the institutions of others. We do not copy our neighbors, but are an example to them. It is true that we are called a democracy, for the administration is in the hands of the many not the few. But while the law secures equal justice to all alike in their private disputes, the claim of excellence is also recognized; and when a citizen is in any way distinguished, he is preferred to the public service, not as a matter of privilege, but as the reward of merit. Neither is poverty a bar, but a man may benefit his country whatever be the obscurity of his condition. There is no exclusiveness in our public life, and in our private intercourse we are not suspicious of one another, nor angry with our neighbor if he does what he likes, we do not put on sour looks at him which, though harmless, are not pleasant. We are thus unconstrained in our private intercourse, a spirit of reverence pervades our public acts; we are prevented from doing wrong by respect for authority and for the laws. . . .

This "claim of excellence" defines Athenians' political, social, and cultural life. It is the hallmark not only of their political system but also of their military might. It explains their spirited competitions in the arts and in their athletic contests, which the citizens regularly enjoyed. All true Athenians, Pericles suggests, seek excellence through the conscientious pursuit of the beautiful and the good:

READING 5.2b

Pericles's Funeral Speech

For we are lovers of the beautiful, yet with economy, and we cultivate the mind without loss of manliness. Wealth we employ, not for talk and ostentation, but when there is a real use for it. To avow poverty with us is no disgrace; the true disgrace is in doing nothing to avoid it. An Athenian citizen does not neglect the state because he takes care of his own household; and even those who are engaged in business have a very fair idea of politics. We alone regard a man who takes no interest in public affairs, not as a harmless, but as a useless character; and if few of us are originators, we are all sound judges of policy. The great impediment to action is, in our opinion, not discussion, but the want of that knowledge which is gained by discussion preparatory to action. For we have a peculiar power of thinking before we act and of acting too, whereas other men are courageous from ignorance but hesitate upon reflection.

Pericles is not concerned with politics alone. He praises the Athenians' "many relaxations from toil." He acknowledges that life in Athens is as good as it is because "the fruits of the whole earth flow in upon us." And, he insists, Athenians are "lovers of the beautiful" who seek to "cultivate the mind." "To sum up," he concludes:

READING 5.2c

Pericles's Funeral Speech

I say that Athens is the school of Hellas, and that the individual Athenian in his own person seems to have the power of adapting himself to the most varied forms of action with the utmost versatility and grace. This is no passing and idle word, but truth and fact; and the assertion is verified by the position to which these qualities have raised the state. . . . I have dwelt upon the greatness of Athens because I want to show you that we are contending for a higher prize than those who enjoy none of these privileges, and to establish by manifest proof the merit of these men whom I am now commemorating. Their loftiest praise has been already spoken. For in magnifying the city, I magnify them, and men like them whose virtues made her glorious.

When Pericles says that Athens is "the school of Hellas," he means that it teaches all of Greece by its example. He insists that the greatness of the state is a function of the greatness of its individuals. The quality of Athenian life depends upon this link between individual freedom and civic responsibility—which most of us in the Western world recognize as the foundation of our own political idealism (if, too often, not our political reality).

Beautiful Mind, Beautiful Body

One of the most interesting aspects of Pericles's oration is his sense that the greatness of the Athenians is expressed in both the love of beauty and the cultivation of intellectual inquiry. We find this particularly in the development of scientific inquiry. In fact, one of the more remarkable features of fifth-century Greek culture is that it spawned a way of thinking that transformed the way human beings see themselves in relation to the natural world. Most people in the ancient world saw themselves at the mercy of flood and sun, subject to the wiles of gods beyond their control. They faced the unknown through the agency of priests, shamans, kings, mythologies, and rituals.

In contrast, the Greeks argued that the forces that governed the natural world were knowable. The causes of natural disasters—flood, earthquake, drought—could be understood as something other than the punishment of an angry god. As early as 600 BCE, for instance, Thales of Miletus (ca. 625–547 BCE) accurately described the causes of a solar eclipse—an event that had periodically terrorized ancient peoples. His conclusions came from objective observation and rigorous analysis of the facts. Observing that water could change from solid to liquid to gas, Thales also argued that water was the primary substance of the universe. Many disagreed, opting for air or fire as the fundamental substance. Nevertheless, the debate inaugurated a tradition of dialogue that fostered increasingly sophisticated thinking. Intellectuals challenged one another to ever more demonstrable and reasonable explanations of natural phenomena.

In this light, the cult of the human body developed in the Golden Age. The writings attributed to Hippocrates (ca. 470–390 BCE), the so-called "father of medicine," insist on the relationship between cause and effect in physical illness, the mind's ability to influence the physical body for good or ill, and the influence of diet and environment on physical health. In fact, in the Golden Age, the beautiful body comes to reflect not only physical but also mental superiority.

In a pile of debris on the Acropolis, pushed aside by Athenians cleaning up after the Persian sack of Athens in 479 BCE, a sculpture of a nude young man, markedly more naturalistic than its kouros predecessors, was uncovered in 1865 (its head was discovered 23 years later, in a separate location). Attributed by those who found it to the sculptor Kritios, the so-called *Kritios Boy*

(Fig. 5.3) demonstrates the increasing naturalism of Greek sculpture during the first 20 years of the fifth century BCE.

Compare the Kritios Boy with the earlier stiff-looking kouros figures (see Figs. 4.20 and 4.21). The boy's head is turned slightly to the side. His weight rests on the left leg. and the right leg extends forward, bent slightly at the knee. The figure seems to twist around its axis, or imaginary central line, the natural result of balancing the body over one supporting leg. The term for this stance, coined during the Italian Renaissance, is contrapposto ("counterpoise"), or weight-shift. The inspiration for this development seems to have been a growing desire by Greek

sculptors to dramatize the stories narrated in the decorative programs of temples and sanctuaries. Liveliness of posture and gesture and a sense of capturing the body in action became their primary sculptural aim and the very definition of classical beauty.

An even more developed version of the *contrapposto* pose can be seen in the Doryphoros, or Spear Bearer (Fig. 5.4), whose weight falls on the forward right leg. An idealized portrait of a warrior, originally done in bronze, the Doryphoros is a Roman copy of the work of Polyclitus, one of the great artists of the Golden Age. The sculpture was famous throughout the ancient world as a demonstration of Polyclitus's treatise on proportion known as The Canon (from the Greek kanon, meaning "measure" or "rule"). In Polyclitus's system, the ideal human form was determined by the height of the head from the crown to the chin. The head was one-eighth the total height, the width of the shoulders was one-quarter the total height, and so on, each measurement reflecting these ideal proportions. For Polyclitus, these relations resulted in the work's symmetria, the origin of our word symmetry, but meaning, in Polyclitus's usage, "commensurability," or "having a common measure." Thus, the figure, beautifully realized in great detail, right down to the veins on the back of the hand, reflects a higher mathematical order and embodies the ideal harmony between the natural world and the intellectual or spiritual realm.

REBUILDING THE ACROPOLIS

After the Persian invasion in 480 BCE, the Athenians had initially vowed to keep the Acropolis in a state of ruin as a reminder of the horrible price of war; however, Pericles

Fig. 5.3 Kritios Boy, from Acropolis, Athens. ca. 480 BCE. Marble, height 46". Acropolis Museum, Athens. The growing naturalism of Greek sculpture is clear when one compares the Kritios Boy to the earlier kouros figures discussed in Chapter 4. Although more naturalistic, this figure still served a votive function.

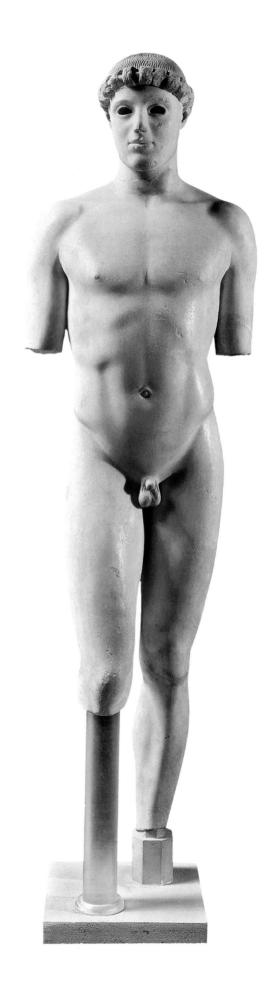

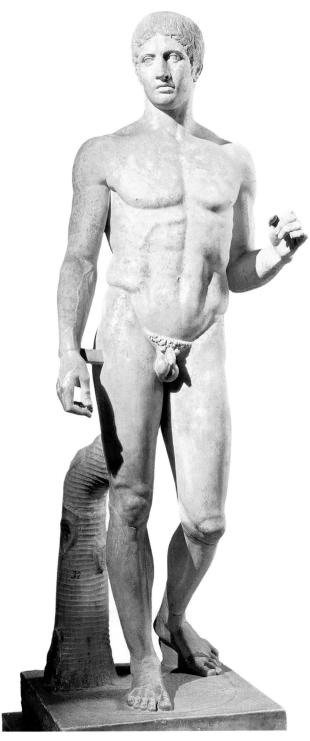

Fig. 5.4 Doryphoros (Spear Bearer), Roman copy after the original bronze by Polyclitus of ca. 450–440 BCE. Marble, height 6' 6". Museo Archeològico Nazionale, Naples. There is some debate about just what "measure" Polyclitus employed to achieve his ideal figure. Some argue that his system of proportions is based on the length of the figure's index finger or the width of the figure's hand across the knuckles. The idea that it is based on the distance between the chin and hairline derives from a much later discussion of proportion by the Roman writer Vitruvius, who lived in the first century CE. It is possible that Vitruvius had firsthand knowledge of Polyclitus's Canon, which was lost long ago.

convinced them to rebuild it. Richly decorated with elaborate architecture and sculpture, it would become, Pericles argued, a fitting memorial not only to the war but especially to Athena's role in protecting the Athenian people. Furthermore, at Persepolis, the defeated Xerxes and then his son and successor Artaxerxes [ar-tuh-ZERK-seez] I (r. 465–424 BCE), were busy expanding their palace, and Athens was not about to be outdone.

Pericles placed the sculptor Phidias in charge of the sculptural program for the new buildings on the Acropolis, and Phidias may have been responsible for the architectural project as well. The centerpiece of the project was the Parthenon, a temple to honor Athena, which was completed in 432 BCE after 15 years of construction. The monumental entryway to the complex, the Propylaia, was completed the same year. Two other temples, completed later, the Erechtheion (430s–406 BCE) and the Temple of Athena Nike (420s BCE), also may have been part of the original scheme. The chief architects of the Acropolis project were Ictinus, Callicrates, and Mnesicles.

The Architectural Program at the Acropolis

The cost of rebuilding the Acropolis was enormous, but despite the reservations expressed by many over such an extravagant expenditure—financed mostly by tributes that Athens assessed upon its allies in the Delian League—the project had the virtue of employing thousands of Athenians—citizens, metics, and slaves alike—thus guaranteeing its general popularity. Writing a *Life of Pericles* five centuries later, the Greekborn biographer Plutarch (ca. 46–after 119 CE) gives us some idea of the scope of the rebuilding project and its effects (Reading 5.3):

READING 5.3

Plutarch, Life of Pericles (75 CE)

The raw materials were stone, bronze, ivory, gold, ebony, and cypress wood. To fashion them were a host of craftsmen: carpenters, moulders, coppersmiths, stonemasons, goldsmiths, ivory-specialists, painters, textile-designers, and sculptors in relief. Then there were the men detailed for transport and haulage: merchants, sailors, and helmsmen at sea; on land, cartwrights, drovers, and keepers of traction animals. There were also the rope-makers, the flax-workers, cobblers, roadmakers, and miners. Each craft, like a commander with his own army, had its own attachments of hired labourers and individual specialists organized like a machine for the service required. So it was that the various commissions spread a ripple of prosperity throughout the citizen body.

The Parthenon (see *Closer Look*, pages 142–143), was of course the centerpiece of the project, but there were other important structures built on the Acropolis as well (Fig. 5.5).

CLOSER LOOK

he Parthenon is famous both for its architectural perfection and for the sculptural decoration that is so carefully integrated into the structure. The decorative sculptures were in three main areas—in the pediments at each end of the building, on the metopes, or the square panels between the beam ends under the roof, and on the frieze that runs across the top of the outer wall of the cella. Brightly painted, these sculptures must have appeared strikingly lifelike. In the clarity of its parts, the harmony among them, and its overall sense of proportion and balance, it represents the epitome of classical architecture. Built to give thanks to Athena for the salvation of Athens and Greece in the Persian Wars, it was a tangible sign of the power and might of the Athenian state, designed to impress all who visited the city. It was built on the foundations and platform of an earlier structure, but the architects Ictinus and Callicrates clearly intended it to represent the Doric order in its most perfect form. It has eight columns at the ends and seventeen on the sides. Each column swells out about one-third of the way up, a device called entasis, to counter the eye's tendency to see the uninterrupted parallel columns as narrowing as they rise and to give a sense of "breath" or liveliness to the stone. The columns also slant slightly inward, so that they appear to the eye to rise straight up. And since horizontal lines appear to sink in the middle, the platform beneath them rises nearly five inches from each corner to the middle. There are no true verticals or horizontals in the building, a fact that lends its apparently rigid geometry a sense of liveliness and animation.

The building's classical sense of beauty manifests itself in the architects' use of a system of proportionality in order to coordinate the construction process in a way that resulted in a harmonious design. The ratio controlling the Parthenon's design can be expressed in the algebraic formula x = 2y + 1. The temple's columns, for instance, reflect this formula: there are 8 columns on the short ends and 17 on the sides, because $17 = (2 \times 8) + 1$. The ratio of the stylobate's length to width is 9:4, because $9 = (2 \times 4) + 1$. This mathematical regularity is central to the overall harmony of the building.

The interior decoration of the Parthenon ceiling, as

reconstructed and published by Gottfried Semper, 1878. Paint traces provided clues to the original decorative design that once adorned the ceiling of the temple.

Something to Think About . . .

Athena, to whom the Parthenon is dedicated, is not only goddess of war, but also goddess of wisdom. How does the Parthenon reflect both of her roles?

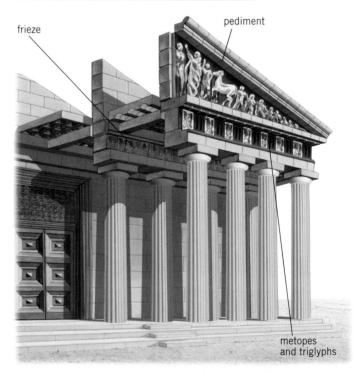

Cutaway drawing of the Parthenon porch showing friezes, metopes, and pediment. Evident here is the architect Ictinus's juxtaposition of the Doric order, used for the columns with their capitals and the entablature on the outside, with the lighter Ionic order of its continuous frieze, used for the entablature inside the colonnade.

SEE MORE For a Closer Look at the Parthenon, go to www.myartslab.com

The Parthenon

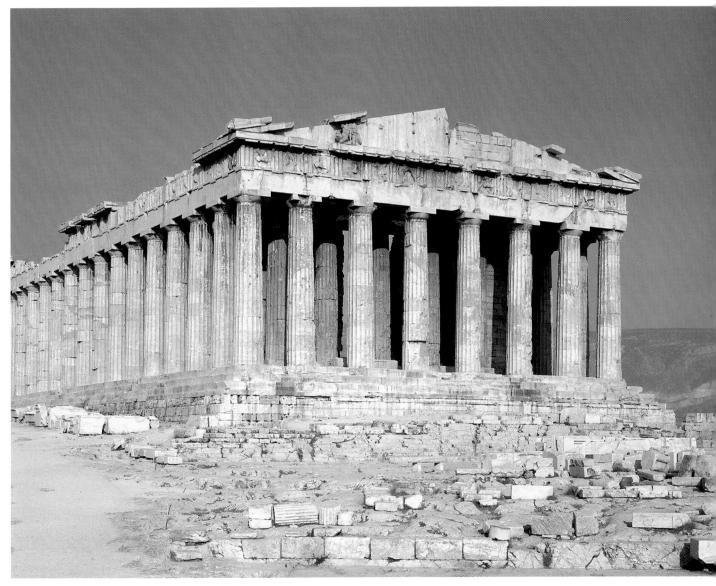

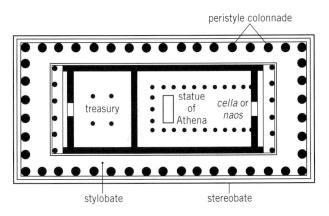

Ictinus, with contributions by Callicrates, the Parthenon and its plan, Acropolis, Athens. 447–438 scs. Sculptural program completed 432 scs. The temple measures about $228^{\prime} \times 101^{\prime}$ on the top step. The temple remained almost wholly intact (though it served variously as a church and then a mosque) until 1687, when the attacking Venetians exploded a Turkish powder magazine housed in it.

The giant, 40-foot-high sculpture of Athena Parthenos was located in the Parthenon's *cella* or *naos*, the central interior room of a temple in which the cult statue was traditionally housed.

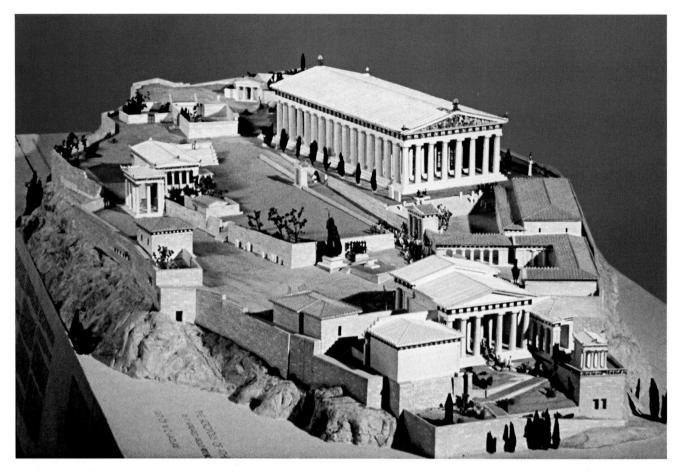

Fig. 5.5 Model of the Acropolis. ca. 400 BCE. American School of Classical Studies, Athens.

One of the architects employed in the project, Mnesicles [NES-ih-kleez], was charged with designing the **propylon**, or large entryway, where the Panathenaic Way approached the Acropolis from below. Instead of a single gate, he created five, an architectural tour de force named the Propylaia [prop-uh-LAY-uh] (the plural of propylon), flanked with porches and colonnades of Doric columns. The north wing eventually included a picture gallery featuring paintings of Greek history and myth, none of which survive. Contrasting with the towering mass of the Propylaia was the far more delicate Temple of Athena Nike (Fig. 5.6), situated on the promontory just to the west and overlooking the entrance way. Graced by slender Ionic columns, the diminutive structure (it measures a mere 27 by 19 feet) was built in 425 BCE, not long after the death of Pericles. It was probably meant to celebrate what the Athenians hoped would be their victory in the Peloponnesian Wars, as nike is Greek for "victory." Before the end of the wars, between 410 and 407 BCE, it was surrounded by a parapet, or low wall, faced with panels depicting Athena together with her winged companions, the Victories.

After passing through the Propylaia into the sacred precinct at the top of the Acropolis, the visitor would

confront not only the massive spectacle of the Parthenon, but also an imposing statue of Athena Promachus [PROMuh-kus], Athena the Defender, executed by Phidias between 465 and 455 BCE. Twenty feet high, it was tall enough that sailors landing at the port of Piraeus several miles away could see the sun reflected off Athena's helmet. And just to the left of the statue they would have seen the Erechtheion (Fig. 5.7). Its asymmetrical and multileveled structure is unique, resulting from the rocky site on which it is situated. Flatter areas were available on the Acropolis, so its demanding position is clearly intentional. The building surrounds a sacred spring dedicated to Erechtheus, the first legendary king of Athens, after whom the building is named. Work on the building began after the completion of the Parthenon, in the 430s BCE, and took 25 years. Among its unique characteristics is the famous Porch of the Maidens, facing the Parthenon. It is supported by six caryatids, female figures serving as columns. These figures illustrate the idea of the temple column as a kind of human figure, and the idea that the stability of the polis depends upon the conduct of its womenfolk. All assume a classic contrapposto pose, the three on the left with their weight over the right leg, the three on the right with their weight over the left. Although each figure is unique—the folds on

Fig. 5.6 Temple of Athena Nike, Acropolis, Athens. ca. **425** BCE. Overlooking the approach to the Propylaia, the lighter lonic columns of the temple contrast dramatically with the heavier, more robust Doric columns of the gateway.

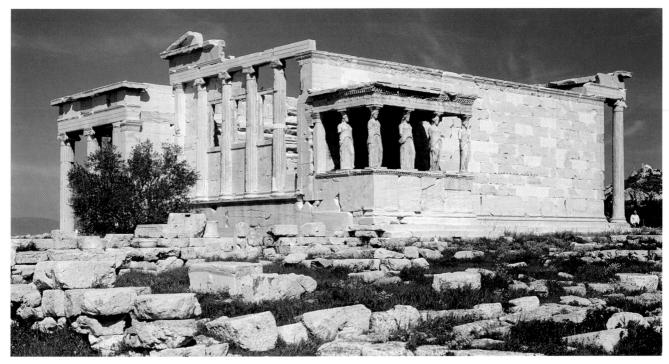

Fig. 5.7 Erechtheion, Acropolis, Athens. 430s-405 BCE. The Erechtheion, with its irregular and asymmetrical design, slender Ionic columns, and delicate Porch of the Maidens, contrasts dramatically and purposefully with the more orthodox and highly regular Parthenon across the Acropolis to the south.

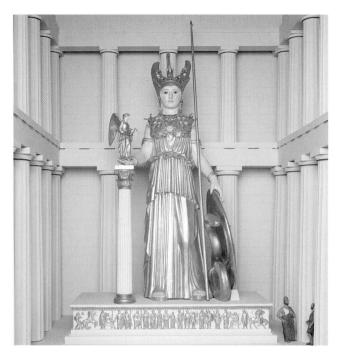

Fig. 5.8 Model of the *Athena Parthenos*, by Phidias, original ca. 440 BCE. Royal Ontario Museum, Toronto. Surviving "souvenir" copies of Phidias's original give us some idea of how it must have originally appeared, and this model is based on those.

their chitons fall differently, and their breasts are different sizes and shapes—together they create a sense of balance and harmony.

The Sculpture Program at the Parthenon

If Phidias's hand was not directly involved in carving the sculpture decorating the Parthenon, most of the decoration is probably his design. We know for certain that he designed the giant statue of Athena Parthenos housed in the Parthenon (Fig. 5.8). Though long since destroyed, we know its general characteristics through literary descriptions and miniature copies. It stood 40 feet high and was supported by a ship's mast. Its skin was made of ivory and its dress and armor of gold. Its spectacular presence was meant to celebrate not only the goddess's religious power but also the political power of the city she protected. She is at once a warrior, with spear and shield, and the model of Greek womanhood, the *parthenos*, or maiden, dressed in the standard Doric peplos. And since the gold that formed the surface of the statue was removable, she was, in essence, an actual treasury.

The three-foot-high frieze that originally ran at a height of nearly 27 feet around the central block of the building depicts a ceremonial procession (Fig. **5.9**). Traditionally, the frieze has been interpreted as a depiction of the Panathenaic procession, a civic festival occurring every four years in honor of Athena. Some 525 feet long, the frieze consists of horsemen, musicians, water carriers, maidens, and sacrificial beasts. All the human figures have the ideal proportions of the *Doryphoros* (see Fig. 5.4).

The sculptural program in the west pediment depicts Athena battling with Poseidon to determine who was to be patron of Athens. Scholars debate the identity of the figures in the east pediment, but it seems certain that overall it portrays the birth of Athena with gods and goddesses in attendance (Fig. 5.10). The 92 metopes on the four sides of the temple, each separated from the next by **triglyphs**, square blocks divided by grooves into three sections, narrate battles between the Greeks and four enemies—the Trojans on one side, and on the other three, giants, Amazons (perhaps symbolizing the recently defeated Persians), and centaurs, mythological beasts with the legs and bodies of horses and the trunks and heads of humans. Executed in high relief (Fig. 5.11), these metopes represent the clash between the forces of civilization—the Greeks—and their barbarian, even

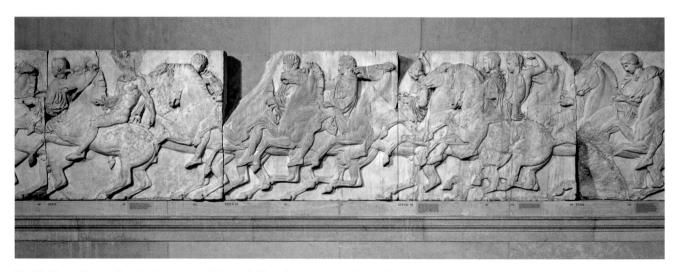

Fig. 5.9 Young Men on Horseback, segment of the north frieze, Parthenon. ca. 440 BCE. Marble, height 41".

© The Trustees of The British Museum/Art Resource, NY. This is just a small section of the entire procession, which extends completely around the Parthenon.

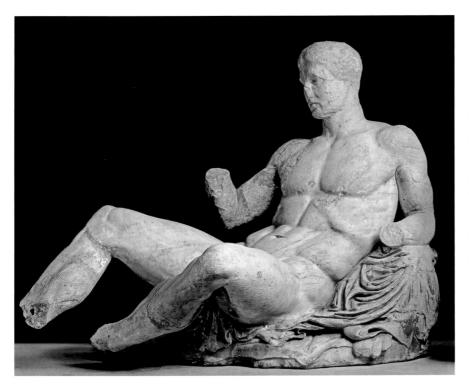

Fig. 5.10 A recumbent god (Dionysus or Heracles), east pediment of the Parthenon. ca. 435 BCE. © The Trustees of The British Museum/Art Resource, NY. In 1801, Thomas Bruce, Earl of Elgin and British ambassador to Constantinople, brought the marbles from the east pediment, as well as some from the west pediment and the south metopes, and a large part of the frieze, back to England—the source of their name, the Elgin Marbles. The identities of the figures are much disputed, but the greatness of their execution is not. Now exhibited in the round, in their original position on the pediment, they were carved in high relief. As the sun passed over the three-dimensional relief on the east and west pediments, the sculptures would have appeared almost animated by the changing light and the movement of their cast shadows.

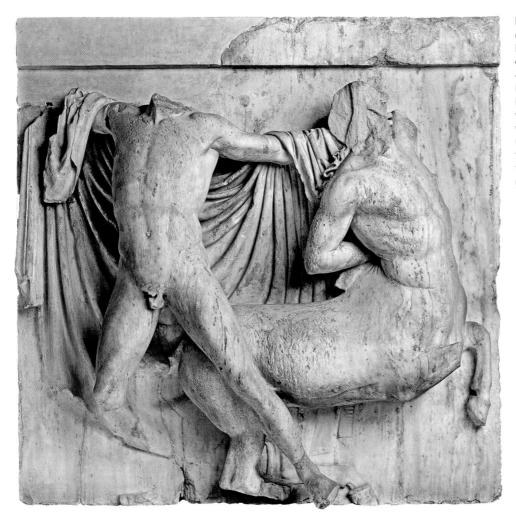

Fig. 5.11 Lapith overcoming a centaur, south metope 27, Parthenon, Athens.

447–438 BCE. Marble relief, height 4′ 5″. © The Trustees of The British Museum/Art Resource, NY. The Lapiths are a people in Greek myth who defeated drunken centaurs at the wedding of their king, Pirtihous. The Greeks identified centaurs with the Persians, whom they considered the embodiment of chaos, possessing centaur-like forces of irrationality.

bestial opponents. The male nude reflects not only physical but mental superiority, a theme particularly appropriate for a temple to Athena, goddess of both war and wisdom.

PHILOSOPHY AND THE POLIS

The extraordinary architectural achievement of the Acropolis is matched by the philosophical achievement of the great Athenian philosopher Socrates, born in 469 BCE, a decade after the Greek defeat of the Persians. His death in 399 BCE arguably marks the end of Athens's Golden Age. Socrates' death was not a natural one. His execution was ordered by a polis in turmoil after its defeat by the Spartans in 404 BCE. The city had submitted to the rule of the oligarchic government installed by the victorious Spartans, the socalled Thirty Tyrants, whose power was ensured by a gang of "whip-bearers." They deprived the courts of their power and initiated a set of trials against rich men, especially metics, and democrats who opposed their tyranny. Over 1,500 Athenians were subsequently executed. Socrates was brought to trial, accused of subversive behavior, corrupting young men, and introducing new gods, though these charges may have been politically motivated. He antagonized his jury of citizens by insisting that his life had been as good as anyone's and that far from committing any wrongs, he had greatly benefited Athens. He was convicted by a narrow majority and condemned to death by drinking poisonous hemlock. His refusal to flee and his willingness to submit to the will of the polis and drink the potion testify to his belief in the very polis that condemned him. His eloquent defense of his decision to submit is recorded in the Crito [KRIH-toh] (see Reading 5.4 on pages 168–169), a dialogue between Socrates and his friend Crito, actually written by Plato, Socrates' student and fellow philosopher. Although the Athenians would continue to enjoy relative freedom for many years to come, the death of Socrates marks the end of their great experiment with democracy. Although Socrates was no defender of democracy—he did not believe that most people were really capable of exercising good governmenthe became the model of good citizenship and right thinking for centuries to come.

The Philosophical Context

To understand Socrates' position, it is important to recognize that the crisis confronting Athens in 404 BCE was not merely political, but deeply philosophical. And furthermore, a deep division existed between the philosophers and the polis. Plato, Socrates' student, through whose writings we know Socrates' teachings, believed good government was unattainable "unless either philosophers become kings in our cities or those whom we now call kings and rulers take to the pursuit of philosophy." He well understood that neither was likely to happen, and good government was, therefore, something of a dream. To further complicate matters, there were two distinct

traditions of Greek *philosophia*—literally, "love of wisdom"—pre-Socratic and Sophist.

The Pre-Socratic Tradition The oldest philosophical tradition, that of the pre-Socratics, referring to Greek philosophers who preceded Socrates, was chiefly concerned with describing the natural universe—the tradition inaugurated by Thales of Miletus. "What," the pre-Socratics asked, "lies behind the world of appearance? What is everything made of? How does it work? Is there an essential truth or core at the heart of the physical universe?" In some sense, then, they were scientists who investigated the nature of things, and they arrived at some extraordinary insights. Pythagoras (ca. 570– 490 BCE) was one such pre-Socratic thinker. He conceived of the notion that the heavenly bodies appear to move in accordance with the mathematical ratios and that these ratios also govern musical intervals producing what was later called "the harmony of the spheres." Leucippus (fifth century BCE) was another. He conceived of an atomic theory in which everything is made up of small, indivisible particles and the empty space, or void, between them (the Greek word for "indivisible" is atom). Democritus of Thrace (ca. 460-ca. 370 BCE) furthered the theory by applying it to the mind. Democritus taught that everything from feelings and ideas to the physical sensations of taste, sight, and smell could be explained by the movements of atoms in the brain. Heraclitus of Ephesus (ca. 540–ca. 480 BCE) argued for the impermanence of all things. Change, or flux, he said, is the basis of reality, although an underlying Form or Guiding Force (logos) guides the process, a concept that later informs the Gospel of John in the Christian Bible, where logos is often mistranslated as "word."

The Sophist Tradition Socrates was heir to the second tradition of Greek philosophy, that of the Sophists, literally "wise men." The Sophists no longer asked, "What do we know!" but, instead, "How do we know what we think we know!" and, crucially, "How can we trust what we think we know!" In other words, the Sophists concentrated not on the natural world but on the human mind, fully acknowledging the mind's many weaknesses. The Sophists were committed to what we have come to call humanism—that is, a focus on the actions of human beings, political action being one of the most important.

Protagoras (ca. 485–410 BCE), a leading Sophist, was responsible for one of the most famous of all Greek dictums: "Man is the measure of all things." By this he meant that each individual human, not the gods, not some divine or all-encompassing force, defines reality. All sensory appearances and all beliefs are true for the person whose appearances or beliefs they are. The Sophists believed that there were two sides to every argument. Protagoras's attitude about the gods is typical: "I do not know that they exist or that they do not exist."

The Sophists were teachers who traveled about, imparting their wisdom for pay. Pericles championed them,

EXPLORE MORE To see a studio video about carving, go to **www.myartslab.com**

encouraging the best to come to Athens, where they enjoyed considerable prestige despite their status as metics. Their ultimate aim was to teach political virtue—areté [ahray-TAY]—emphasizing skills useful in political life, especially rhetorical persuasion, the art of speaking eloquently and persuasively. Their emphasis on rhetoric—their apparent willingness to assume either side of any argument merely for the sake of debate—as well as their critical examination of myths, traditions, and conventions, gave them a reputation for cynicism. Thus, their brand of argumentation came to be known as sophistry—subtle, tricky, superficially plausible, but ultimately false and deceitful reasoning.

Socrates and the Sophists Socrates despised everything the Sophists stood for, except their penchant for rhetorical debate, which was his chief occupation. He roamed the streets of Athens, engaging his fellow citizens in dialogue, wittily and often bitingly attacking them for the illogic of their positions. He employed the dialectic method—a process of inquiry and instruction characterized by continuous question-and-answer dialogue intent on disclosing the unexamined premises held implicitly by all reasonable beings. Unlike the Sophists, he refused to demand payment for his teaching, but like them, he urged his fellow men not to mistake their personal opinions for truth. Our beliefs, he knew, are built mostly on a foundation of prejudice and historical conditioning. He differed from the Sophists most crucially in his emphasis on virtuous behavior. For the Sophists, the true, the good, and the just were relative things. Depending on the situation or one's point of view, anything might be true, good, or just—the point, as will become evident in the next section, of many a Greek tragedy.

For Socrates, understanding the true meaning of the good, the true, and the just was prerequisite for acting virtuously, and the meaning of these things was not relative. Rather, true meaning resided in the psyche, the seat of both intelligence and character. Through inductive reasoning—moving from specific instances to general principles, and from particular to universal truths—it was possible, he believed, to understand the ideals to which human endeavor should aspire. Neither Socrates nor the Sophists could have existed without the democracy of the polis and the freedom of speech that accompanied it. Even during the reign of Pericles, Athenian conservatives had charged the Sophists with the crime of impiety. In questioning everything, from the authority of the gods to the rule of law, they challenged the stability of the very democracy that protected them. It is thus easy to understand how, when democracy ended, Athens condemned Socrates. He was democracy's greatest defender, and if he believed that the polis had forsaken its greatest invention, he himself could never betray it. Thus, he chose to die.

Plato's Republic and Idealism

So far as we know, Socrates himself never wrote a single word. We know his thinking only through the writings of his greatest student, Plato (ca. 428–347 BCE). Thus, it may be true that the Socrates we know is the one Plato wanted us to have, and that when we read Socrates' words, we are encountering Plato's thought more than Socrates'.

As Plato presents Socrates to us, the two philosophers, master and pupil, have much in common. They share the premise that the psyche is immortal and immutable. They also share the notion that we are all capable of remembering the psyche's pure state. But Plato advances Socrates' thought in several important ways. Plato's philosophy is a brand of idealism—it seeks the eternal perfection of pure ideas, untainted by material reality. He believes that there is an invisible world of eternal Forms, or Ideas, beyond everyday experience, and that the psyche, trapped in the material world and the physical body, can only catch glimpses of this higher order. Through a series of mental exercises, beginning with the study of mathematics and then moving on to the contemplation of the Forms of Justice, Beauty, and Love, the student can arrive at a level of understanding that amounts to superior knowledge.

Socrates' death deeply troubled Plato—not because he disagreed with Socrates' decision, but because of the injustice of his condemnation. The result of Plato's thinking is The Republic. In this treatise, Plato outlines his model of the ideal state. Only an elite cadre of the most highly educated men were to rule—those who had glimpsed Plato's ultimate Form, or Idea—the Good. In The Republic, in a section known as the "Allegory of the Cave" (Fig. 5.12), Socrates addresses Plato's older brother, Glaucon [GLAW-kon], in an attempt to describe the difficulties the psyche encounters in its attempt to understand the higher Forms (see Reading 5.5 on pages 169–171). The Form of Goodness, Socrates says, is "the universal author of all things beautiful and right, parent of light and of the lord of light in this visible world, and the immediate source of reason and truth in the intellectual; and . . . this is the power upon which he who would act rationally, either in public or private life must have his eye fixed." The Form of Goodness, then, is something akin to God (though not God, from whom imperfect objects such as human beings descended, but more like an aspect of the Ideal, of which, one supposes, God must have some superior knowledge). The difficulty is that, once having attained an understanding of the Good, the wise individual will appear foolish to the people, who understand not at all. And yet, as Plato argues, it is precisely these individuals, blessed with wisdom, who must rule the commonwealth.

In many ways, Plato's ideal state is reactionary—it certainly opposes the individualistic and self-aggrandizing world of the Sophists. Plato is indifferent to the fact that his wise souls will find themselves ruling what amounts to a totalitarian regime. He believes their own sense of Goodness will prevail over their potentially despotic position. Moreover, rule by an intellectual philosopher king is superior to rule by any person whose chief desire is to satisfy his own material appetites.

To live in Plato's *Republic* would have been dreary indeed. Sex was to be permitted only for purposes of procreation.

Fig. 5.12 "Allegory of the Cave," from *The Great Dialogues of Plato*, trans. W.H.D. Rouse.
Translation © 1956, renewed 1984 by J.C.G. Rouse. Used by permission of Dutton Signet, a division of Penguin Books USA Inc. The scene

imaged here is fully described by

Plato in Reading 5.5, page 169.

Everyone would undergo physical and mental training reminiscent of Sparta in the sixth century BCE. Although he believed in the intellectual pursuit of the Form or Idea of Beauty, Plato did not champion the arts. He condemned certain kinds of lively music because they affected not the reasonable mind of their audience but the emotional and sensory tendencies of the body. (But even for Plato, a man who did not know how to dance was uneducated—Plato simply preferred more restrained forms of music.) He also condemned sculptors and painters, whose works, he believed, were mere representations of representations—for if an actual bed is once removed from the Idea of Bed, a painting of a bed is twice removed, the faintest shadow. Furthermore, the images created by painters and sculptors appealed only to the senses. Thus he banished them from his ideal republic. Because they gave voice to tensions within the state, poets were banned as well.

Plato's Symposium

If Plato banned sex in his *Republic*, he did not ban it in his life. Indeed, one of the most remarkable of his dialogues is *The Symposium*. A symposium is literally a drinking party, exclusively for men, except for a few slaves and a nude female flute player or two. Dinner was served first, followed by ritualized drinking. Wine was poured to honor the "good spirit," hymns were sung, a member of the group was elected to decide the strength of the wine, which was mixed with water (usually five parts water to two of wine), and then host and guests, seated usually two to a couch around a square room, took turns in song or speech, one after another around the room.

Plato's *Symposium* recounts just such an evening. At the outset, the female flute player provided by the host is sent away, indicating the special nature of the event, which turns

out to be a series of speeches on the nature of love, homoerotic love in particular. To the Greeks, it was considered normal for males to direct their sexual appetites toward both males and females, generally without particular preference for one or the other. Since the symposium was an all-male environment (Fig. 5.13), it is hardly surprising that homoerotic behavior was commonplace, or at least commonly discussed.

In *The Symposium*, each member of the party makes a speech about the nature of Love—or more precisely Eros, the god of love *and* desire—culminating with Socrates, whose presentation is by far the most sophisticated. Phaedrus makes clear, and all agree, that the loved one becomes virtuous by being loved. Pausanius [paw-ZAY-nee-us] contributes an important distinction between Common Love, which is simply physical, and Heavenly Love, which is also physical but is generated only in those who are capable of rational and ethical development. Thus, he suggests, an older man contributes to the ethical education of a youth through his love for him. No one disagrees, though the question remains whether *physical* love is necessary to the relationship.

Since Plato was himself a bachelor who led an essentially monastic existence, it is hardly surprising that by the time Socrates contributes to this discussion, Eros comes to be defined as more than just interpersonal love; it is also desire, desire for something it *lacks*. What Eros lacks and needs is beauty. The purpose of love, then, according to Socrates, and by extension Plato, is to give birth to beauty "in both body and mind," and, finally, to attain insight into the ultimate Form of Beauty. These are lessons, Socrates claims, that he learned from a woman named Diotima [dye-oh-TEE-ma], who "was wise about this and many other things," a character many believe to be modeled on Aspasia, Pericles's mistress and partner. In our

Fig. 5.13 Banqueting Scene, panel from the Tomb of the Diver, Paestum, Italy. Early fifth century BCE. Fresco, Museo Archeològico Nazionale, Paestum. Scala, Florence. Part of a painted tomb, this is a rare surviving example of Greek painting.

excerpt, Socrates quotes Diotima at length (see **Reading 5.6** on page 171).

The high philosophical tone of Socrates' speech comes to an abrupt end when the drunken politician Alcibiades crashes the party, regaling all with a speech in praise of Socrates, including an account of his own physical attraction to the older philosopher, his desire for an erotic-educational relationship with him, and the surprising denouement, a description of a time when he succeeded in getting into bed with him (Reading 5.6a).

READING 5.6a

Plato, The Symposium

I threw my arms round this really god-like and amazing man, and lay there with him all night long. And you can't say this is a lie, Socrates. After I'd done all this he completely triumphed over my good looks—and despised, scorned and insulted them—although I placed a very high value on these looks, gentlemen of the jury. . . . I swear to you by the gods, and by the goddesses, that when I got up the next morning I had no more slept with Socrates than if I'd been sleeping with my father or elder brother.

Socrates, Plato finally shows us, knows a higher form of Love than the physical and is an example to all present at the symposium.

THE THEATER OF THE PEOPLE

The Dionysian aspects of the symposium—the drinking, the philosophical dialogue, and sexual license—tell us something about the origins of Greek drama. The drama

was originally a participatory ritual, tied to the cult of Dionysus. A chorus of people participating in the ritual would address and respond to another chorus or to a leader, such as a priest, perhaps representing (thus "acting the part" of) Dionysus. These dialogues usually occurred in the context of riotous dance and song—befitting revels dedicated to the god of wine. By the sixth century BCE, groups of men regularly celebrated Dionysus, coming together for the enjoyment of dance, music, and wine. Sexual license was the rule of the day. On a mid-sixth-century amphora used as a wine container (Fig. 5.14) we see five satyrs,

Fig. 5.14 Amasis Painter (?) Satyrs Making Wine, detail of Athenian black-figure amphora. ca. 540–530 BCE. Martin von Wagner Museum, University of Würzburg, Germany. The entire ritual of wine production is depicted here, from harvesting the grapes, to stomping them to render their juice, to pouring the juice into large vats for fermentation. All lead to the state of ecstasy (ekstasis) painted across the top band.

minor deities with characteristics of goats or horses, making wine, including one playing pipes. Depicted in the band across the top is Dionysus himself, sitting in the midst of a rollicking band of satyrs and maenads—the frenzied women with whom he cavorted.

This kind of behavior gave rise to one of the three major forms of Greek drama, the **satyr play**. Always the last event of the daylong performances, the satyr play was **farce**, that

is, broadly satirical comedy, in which actors disguised themselves as satyrs, replete with

extravagant genitalia, and generally honored the "lord of misrule," Dionysus, by misbehaving themselves. One whole satyr play survives, the Cyclops of Euripides, and half of another, Sophocles's Trackers. The spirit of these plays can perhaps be summed up best by Odysseus's first words in the Cyclops as he comes ashore on the island of Polyphemus (recall Reading 4.2, page 130, and Fig. 4.15): "What? Do I see right? We must have come to the city of Bacchus. These are satyrs I see around the cave." The play, in other words, spoofs or lampoons traditional Greek legend by setting it in a world turned topsy-turvy, a world in which Polyphemus is stronger than Zeus because

Comedy

Closely related to the satyr plays was **comedy**, an amusing or lighthearted play designed to make its audience laugh. The word itself is derived from the *komos* [KOmus], a phallic dance, and nothing is sacred to comedy. It freely slandered, buffooned, and ridiculed politicians, generals, public figures, and especially the gods. Foreigners, as always in Greek culture, are subject to

his farts are louder than Zeus's thunder.

particular abuse, as are women; in fact, by our standards, the plays are racist and sexist. Most of what we know about Greek comedies comes from two sources: vase painting and the plays of the playwright Aristophanes.

Comedic action was a favorite subject of vase painters working at Paestum in Italy in the fourth century BCE. They depict actors wearing masks and grotesque costumes distinguished by padded bellies, buttocks, and enlarged genitalia. These vases show a theater of burlesque and slapstick that relied heavily on visual gags (Fig. 5.15).

The works of Aristophanes (ca. 445–388 BCE) are the only comedies to have survived, and only 11 of his 44 plays have come down to us. *Lysistrata* is the most famous. Sexually explicit to a degree that can still shock a modern audience, it takes place during the Peloponnesian Wars and tells the story of an Athenian matron who convinces the women of Athens and Sparta to withhold sex from their husbands until they sign a peace treaty. First performed in 411 BCE, seven years

before Sparta's victory over Athens, it has its serious side, begging both Atheni-

ans and Spartans to remember their common traditions and put down their arms. Against this dark background, the play's ac-

tion must have seemed absurd and hilarious to its Athenian audience, ignorant of what the future would hold for them.

Tragedy

It was at **tragedy** that the Greek playwrights truly excelled. As with comedy, the basis for tragedy is conflict, but

the tensions at work in tragedy—

murder and revenge, crime and retribution, pride and humility, courage and cowardice—have far more serious consequences. Tragedies often explore the physical and moral depths to which human life can

descend. The form also has its origins in the Dionysian rites—the name itself derives from tragoidos [trah-GOY-dus], the "goat song" of the half-goat, half-man satyrs, and tragedy's seriousness of purpose is not at odds with its origins. Dionysus was also the god of immortality, and an important aspect of his cult's influence is that he promised his followers life after death, just as the grapevine regenerates itself year after year. If tragedy can be said to have a subject, it

is death—and the lessons the living can learn from the dead.

The original chorus structure of the Dionysian rites survives as an important element in tragedy. Thespis, a playwright from whom we derive the word *thespian*, "actor," first assumed the conscious role of an actor in the mid-sixth century BCE and apparently redefined the role of the **chorus**. At first, the actor asked questions of the chorus, perhaps of the "tell me what happened next" variety, but when two, three, and sometimes four actors were introduced to the stage, the

in cov quenc an

Fig. 5.15 Assteas. Red-figure krater depicting a comedy, from Paestum, Italy. ca. 350 Bcs. Staatliche Museen, Berlin. On a stage supported by columns, with a scenic backdrop to the left, robbers try to separate a man from his strongbox.

chorus began to comment on their interaction. In this way, the chorus assumed its classic function as an intermediary between actors and audience. Although the chorus's role diminished noticeably in the fourth century BCE, it remained the symbolic voice of the people, asserting the importance of the action to the community as a whole.

Greek tragedy often focused on the friction between the individual and his or her community, and, at a higher level, between the community and the will of the gods. This conflict manifests itself in the weakness or "tragic flaw" of the play's **protagonist**, or leading character, which brings the character into conflict with the community, the gods, or some **antagonist** who represents an opposing will. The action occurs in a single day, the result of a single incident that precipitates the unfolding crisis. Thus the audience feels that it is experiencing the action in real time, that it is directly involved in and affected by the play's action.

During the reign of the tyrant Peisistratus, the performance of all plays was regularized. An annual competitive festival for the performance of tragedies called the City Dionysia was celebrated for a week every March as the vines came back to life, and a separate festival for comedies occurred in January. At the City Dionysia, plays were performed in sets of four—tetralogies—all by the same author, three of which were tragedies, performed during the day, and the fourth a satyr play, performed in the evening. The audiences were as large as 14,000, and audience response determined which plays were awarded prizes. Slaves, metics, and women judged the performances alongside citizens.

Aeschylus Although many Greek playwrights composed tragedies, only those of Aeschylus, Sophocles, and Euripides have come down to us. Aeschylus (ca. 525–ca. 456 BCE), the oldest of the three, is reputed to have served in the Athenian armies during the Persian Wars and fought in the battles at Marathon and Salamis. He won the City Dionysia 13 times. It was Aeschylus who introduced a third actor to the tragic stage, and his chorus plays a substantial role in drawing attention to the underlying moral principles that define or determine the action. He also was a master of the visual presentation of his drama, taking full advantage of stage design and costume. Three of his plays, known as the *Oresteia* [oh-ray-STYE-ee-uh], form the only complete set of tragedies from a tetralogy that we have.

The plays narrate the story of the Mycenaean king Agamemnon, murdered by his adulterous wife Clytemnestra and mourned and revenged by their children, Orestes and Electra. In the first play, Agamemnon, Clytemnestra murders her husband, partly in revenge for his having sacrificed their daughter Iphigenia to ensure good weather for the invasion of Troy, and partly to marry her lover, Aegisthus. In the second play, The Libation Bearers, Orestes murders Aegisthus and Clytemnestra, his mother, to avenge his father's death. Orestes is subsequently pursued by the Furies, a band of chthonian gods (literally "gods of the earth," a branch of the Greek pantheon that is distinguished from the Olympian,

or "heavenly" gods), whose function is to seek retribution for wrongs and blood-guilt among family members. The Furies form the Chorus of the last play in the cycle, the *Eumenides*, in which the seemingly endless cycle of murder comes to an end. In this play, Athens institutes a court to hear Orestes' case. The court absolves him of the crime of matricide, with Athena herself casting the deciding vote.

None of the violence in the plays occurs on stage—either the chorus or a messenger describes it. And in fact, the ethical dimension of Aeschylus's trilogy is underscored by the triumph of civilization and law, mirrored by the transformation of the Furies—the blind forces of revenge—into the Eumenides, or "Kindly Ones," whose dark powers have been neutralized.

Sophocles Playwright, treasurer for the Athenian polis, a general under Pericles, and advisor to Athens on financial matters during the Peloponnesian Wars, Sophocles (ca. 496–406 BCE) was an almost legendary figure in fifthcentury BCE Athens. He wrote over 125 plays, of which only 7 survive, and he won the City Dionysia 18 times. In Oedibus the King, Sophocles dramatizes how the king of Thebes, a polis in east central Greece, mistakenly kills his father and marries his mother, then finally blinds himself to atone for his crimes of patricide and incest. In Antigone, he dramatizes the struggle of Oedipus's daughter, Antigone, with her uncle, Creon, the tyrannical king who inherited Oedipus's throne. Antigone struggles for what amounts to her democratic rights as an individual to fulfill her familial duties, even when this opposes what Creon argues is the interest of the polis. Her predicament is doubly complicated by her status as a woman.

As the play opens, Antigone's brothers, Polynices and Eteocles, have killed each other in a dispute over their father's throne. Creon, Oedipus's brother-in-law, who has inherited the throne, has forbidden the burial of Polynices, believing Eteocles to have been the rightful heir. Antigone, in the opening scene, defends her right to bury her brother, and this willful act, which she then performs in defiance of Creon's authority, leads to the tragedy that follows. She considers the burial her duty, since no unburied body can enjoy an afterlife. The play begins as Antigone explains her action to her sister, Ismene, who thoroughly disapproves of what she has done (Reading 5.7a).

READING 5.7a

Sophocles, Antigone

ISMENE Oh my sister, think—
think how our own father died, hated,
his reputation in ruins, driven on
by the crimes he brought to light himself
to gouge out his eyes with his own hands—
then mother . . . his mother and wife, both in one,
mutilating her life in the twisted noose—
and last, our two brothers dead in a single day,

both shedding their own blood, poor suffering boys, battling out their common destiny hand-to-hand. Now look at the two of us, left so alone. . . . think what a death we'll die, the worst of all if we violate the laws and override the fixed decree of the throne, its power—we must be sensible. Remember we are women, we're not born to contend with men. Then too, we're underlings, ruled by much stronger hands, so we must submit in this, and things still worse. I, for one, I'll beg the dead to forgive me—I'm forced, I have no choice—I must obey the ones who stand in power. Why rush to extremes? It's madness, madness.

The conflict between Antigone and Creon is exacerbated by their gender difference. The Greek male would expect a female to submit to his will. But it is, in the end, Antigone's "rush to extremes" that forces the play's action—that, and Creon's refusal to give in. Creon's "fatal flaw"—his pride (hubris)—leads to the destruction of all whom he loves, and Antigone herself is blindly dedicated to her duty to honor her family. Her actions in the play have been the subject of endless debate. Some readers feel that she is far too hard on Ismene, and certainly a Greek audience would have found her defiance of male authority shocking. Nevertheless, her strength of conviction seems to many—especially modern audiences—wholly admirable.

But beyond the complexities of Antigone's personality, one of Sophocles's greatest achievements, the play really pits two forms of idealism against one another: Antigone's uncompromising belief in herself plays off Creon's equally uncompromising infatuation with his own power and his dedication to his political duty, which he puts above devotion even to family.

The philosophical basis of the play is clearly evident in the essentially Sophist debate between Creon and his son Haemon [HEE-mun], as Haemon attempts to point out the wrong in his father's action (Reading 5.7b):

READING 5.7b

Sophocles, Antigone

HAEMON Father, the gods implant reason in men, the highest of all things that we call our own. Not mine the skill—far from me be the quest!—to say wherein thou speakest not aright; and yet another man, too, might have some useful thought. . . . No, though a man be wise, 'tis no shame for him to learn many things, and to bend in season. Seest thou, beside the wintry torrent's course, how the trees that yield to it save every twig, while the stiff-necked perish root and branch? And even thus he who keeps the sheet of his sail taut, and never slackens it, upsets his boat, and finishes his voyage with keel uppermost.

Nay, forego thy wrath; permit thyself to change. For if I, a younger man, may offer my thought, it were far best, I ween, that men should be all-wise by nature; but, otherwise—and oft the scale inclines not so—'tis good also to learn from those who speak aright. . . .

CREON Men of my age are we indeed to be schooled, then, by men of his?

HAEMON In nothing that is not right; but if I am young, thou shouldest look to my merits, not to my years.

CREON Is it a merit to honour the unruly?

HAEMON I could wish no one to show respect for evildoers.

CREON Then is not she tainted with that malady?

HAEMON Our Theban folk, with one voice, denies it. . . .

CREON Am I to rule this land by other judgment than mine own?

HAEMON That is no city which belongs to one man.

CREON Is not the city held to be the ruler's?

HAEMON Thou wouldst make a good monarch of a desert.

CREON This boy, it seems, is the woman's champion.

HAEMON If thou art a woman; indeed, my care is for thee.

CREON Shameless, at open feud with thy father!

HAEMON Nay, I see thee offending against justice.

CREON Do I offend, when I respect mine own prerogatives?

HAEMON Thou dost not respect them, when thou tramplest on the gods' honours

CREON Thou shalt rue thy witless teaching of wisdom.

HAEMON Wert thou not my father, I would have called thee unwise.

CREON Thou woman's slave, use not wheedling speech with me.

HAEMON Thou wouldest speak, and then hear no reply?

CREON Sayest thou so? Now, by the heaven above us—be sure of it—thou shalt smart for taunting me in this opprobrious strain. Bring forth that hated thing, that she may die forthwith in his presence—before his eyes—at her bridegroom's side!

Finally, the play demonstrates the extreme difficulty of reconciling the private and public spheres—one of Greek philosophy's most troubling and troubled themes—even as it cries out for the rational action and sound judgment that might have spared its characters their tragedy.

Euripides The youngest of the three playwrights, Euripides (ca. 480–406 BCE), writing during the Peloponnesian Wars,

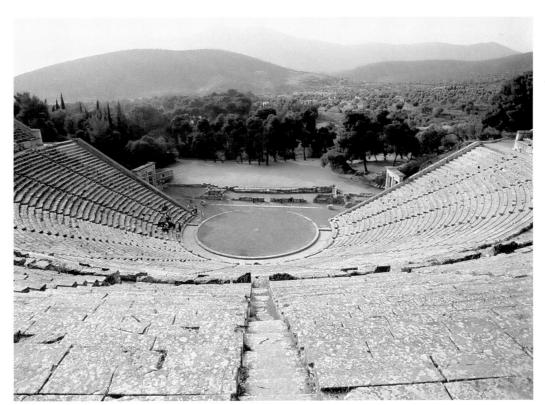

Fig. 5.16 Theater,
Epidaurus. Early third
century BCE. This theater is
renowned for its democratic
design—not only is every
viewer equally well situated,
but the acoustics of the
space are unparalleled.
A person sitting in the very
top row can hear a pin drop
on the orchestra floor.

brought a level of measured skepticism to the stage. Eighteen of his 90 works survive, but Euripides won the City Dionysia only 4 times. His plays probably angered more conservative Athenians, which may be why he moved from Athens to Macedonia in 408 BCE. In *The Trojan Women*, for instance, performed in 415 BCE, he describes, disapprovingly, the Greek enslavement of the women of Troy, drawing an unmistakable analogy to the contemporary Athenian victory at Melos, where women were subjected to Athenian abuse.

His darkest play, and his masterpiece, is The Bacchae, which describes the introduction to Thebes of the worship of Dionysus by the god himself, disguised as a mortal. Pentheus, the young king of the city, opposes the Dionysian rites both because all the city's women have given themselves up to Dionysian ecstasy and because the new religion disturbs the larger social order. Performed at a festival honoring Dionysus, the play warns of the dangers of Dionysian excess as the frenzied celebrants, including Pentheus's own mother, mistake their king for a wild animal and murder him. Euripides's play underscores the fact that the rational mind is unable to comprehend, let alone control, all human impulses. Greek theater itself, particularly the tragedies of Aeschylus, Sophocles, and Euripides, would become the object of study in the fourth century BCE, when the philosopher Aristotle, Plato's student, attempted to account for tragedy's power in his Poetics. And despite the fact that the tragedies were largely forgotten in the Western world until the sixteenth century, they have had a lasting impact upon Western literature, deeply influencing writers from William Shakespeare to the modern American novelist William Faulkner.

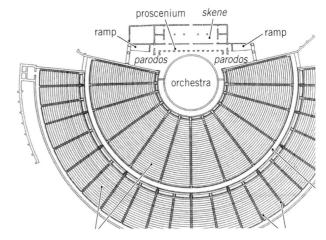

Fig. 5.17 Plan of the theater at Epidaurus. Early third century BCE.

The Performance Space

During the tyranny of Peisistratus, plays were performed in an open area of the agora called the *orchestra*, or "dancing space." Spectators sat on wooden planks laid on portable scaffolding. Sometime in the fifth century BCE, the scaffolding collapsed, and many people were injured. The Athenians built a new theater (*theatron*, meaning "viewing space"), dedicated to Dionysus, into the hillside on the side of the Acropolis away from the agora and below the Parthenon. Architecturally, it was very similar to the best preserved of all Greek theaters, the one at Epidaurus (Figs. 5.16 and 5.17), built in the early third century BCE. The *orchestra* has

been transformed into a circular performance space, approached on each side by an entryway called a *parodos*, through which the chorus would enter the *orchestra* area. Behind this was an elevated platform, the *proscenium*, the stage on which the actors performed and where painted backdrops could be hung. Behind the proscenium was the *skene*, literally a "tent," and originally a changing room for the actors. Over time, it was transformed into a building, often two stories tall. Actors on the roof could portray the gods, looking down on the action below. By the time of Euripides, it housed a rolling or rotating platform that could suddenly reveal an interior space.

Artists were regularly employed to paint stage sets, and evidence suggests that they had at least a basic knowledge of perspective (although the geometry necessary for a fully realized perspectival space would not be developed until around 300 BCE, in Euclid's *Optics*). Their aim was, as in sculpture, to approximate reality as closely as possible. We know from literary sources that the painter Zeuxis "invented" ways to shade or model the figure in the fifth century BCE. Legend also had it that he once painted grapes so realistically that birds tried to eat them. The theatrical sets would have at least aimed at this degree of naturalism.

THE HELLENISTIC WORLD

Both the emotional drama of Greek theater and the sensory appeal of its music reveal a growing tendency in the culture to value emotional expression at least as much, and sometimes more, than the balanced harmonies of classical art. During the Hellenistic age in the fourth and third centuries BCE, the truths that the culture increasingly sought to understand were less idealistic and universal, and more and more empirical and personal. This shift is especially evident in the new empirical philosophy of Aristotle (384–322 BCE), whose investigation into the workings of the real world supplanted, or at least challenged, Plato's idealism. In many ways, however, the ascendancy of this new aesthetic standard can be attributed to the daring, the audacity, and the sheer awe-inspiring power of a single figure, Alexander of Macedonia, known as Alexander the Great (356-323 BCE). Alexander aroused the emotions and captured the imagination of not just a theatrical audience, but an entire people—perhaps even the entire Western world—and created a legacy that established Hellenic Greece as the model against which all cultures in the West had to measure themselves.

The Empire of Alexander the Great

Alexander was the son of Philip II (382–336 BCE) of Macedonia, a relatively undeveloped state to the north whose inhabitants spoke a Greek dialect unintelligible to Athenians. Macedonia was ruled loosely by a king whose power was checked by a council of nobles. Philip had been a hostage in the polis of Thebes early in his life, and while there he had learned to love Greek civilization, but he also recognized

that, after the Peloponnesian Wars, the Greek poleis were in disarray. In 338 BCE, at the battle of Chaeronea, on the plains near Delphi, he defeated the combined forces of southern Greece, led by Athens and Thebes, and unified all of Greece, with the exception of Sparta, in the League of Corinth.

In the process of mounting a military campaign to subdue the Persians, Philip was assassinated in 336 BCE, possibly ordered by Alexander himself. (Philip had just divorced the 19-year-old's mother and removed him from any role in the government.) Although the Thebans immediately revolted, Alexander quickly took control, burning Thebes to the ground and selling its entire population into slavery. He then turned his sights on the rest of the world, and henceforth representations of him would proliferate. Even during his lifetime, but especially after his death, sculptures celebrating the youthful hero abounded, almost all of them modeled on originals sculpted by Lysippus (flourished fourth century BCE) whom Alexander hired to do all his portraits. Alexander is easily recognizable—his disheveled hair long and flowing, his gaze intense and melting, his mouth slightly open, his head alertly turned on a slightly tilted neck (Fig. 5.18). Lysippus dramatized his hero. That is, he did not merely represent Alexander as naturalistically as possible, he also animated

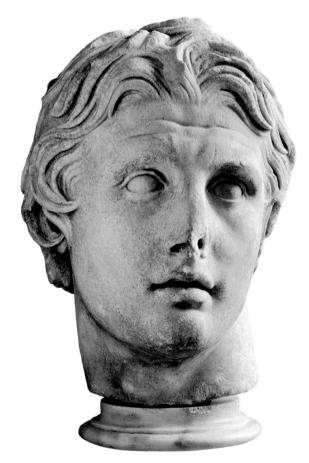

Fig. 5.18 Alexander the Great, head from a Pergamene copy (ca. 200 BCE) of a statue, possibly after a fourth-century BCE original by Lysippus. Marble, height $16 \frac{1}{8}$ ". Archaeological Museum, Istanbul, Turkey. Alexander is traditionally portrayed as if looking beyond his present circumstances to greater things.

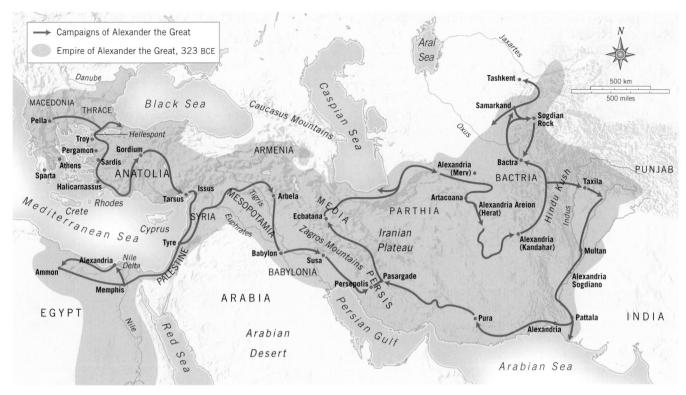

Map 5.2 Alexander's empire as of his death in 323 BCE and the route of his conquests. Alexander founded over 70 cities throughout his empire, naming many after himself.

him, showing him in the midst of action. In all likelihood, he idealized him as well. The creation of Alexander's likeness was a conscious act of propaganda. Early in his conquests, the young hero referred to himself as "Alexander the Great," and Lysippus's job was to embody that greatness.

Within two years of conquering Thebes, Alexander had crossed the Hellespont into Asia and defeated Darius III of Persia at the battle of Issus (just north of modern Iskenderon, Turkey). The victory continued Philip's plan to repay the Persians for their role in the Peloponnesian Wars and to conquer Asia as well. By 332 BCE, Alexander had conquered Egypt, founding the great city of Alexandria (named, of course, after himself) in the Nile Delta (Map 5.2). Then he marched back into Mesopotamia, where he again defeated Darius III and then marched into both Babylon and Susa without resistance. After making the proper sacrifices to the Akkadian god Marduk (see Chapter 2)—and thus gaining the admiration of the locals—he advanced on Persepolis, the Persian capital, which he burned after seizing its royal treasures. Then he entered present-day Pakistan.

Alexander's object was India, which he believed was relatively small. He thought if he crossed it, he would find what he called Ocean, and an easy sea route home. Finally, in 326 BCE, his army reached the Indian Punjab. Under Alexander's leadership, it had marched over 11,000 miles without a defeat. It had destroyed ancient empires, founded many cities (in the 320s BCE, Alexandrias proliferated across the world), and created the largest empire the world had ever known.

When Alexander and his army reached the banks of the Indus River in 326 BCE, he encountered a culture that had

long fascinated him. His teacher Aristotle had described it, wholly on hearsay, as had Herodotus before him, as the farthest land mass to the east, beyond which lay an Endless Ocean that encircled the world. Alexander stopped first at Taxila (20 miles north of modern Islamabad, Pakistan; see Map 5.2), where King Omphis [OHM-fis] greeted him with a gift of 200 silver talents, 3,000 oxen, 10,000 sheep, and 30 elephants, and bolstered Alexander's army by giving him 700 Indian cavalry and 5,000 infantry.

While Alexander was in Taxila, he became acquainted with the Hindu philosopher Calanus [kuh-LAY-nus]. Alexander recognized in Calanus and his fellow Hindu philosophers a level of wisdom and learning that he valued highly, one clearly reminiscent of Greek philosophy, and his encounters with them represent the first steps in a long history of the cross-fertilization of Eastern and Western cultures.

But in India the army encountered elephants, whose formidable size proved problematic. East of Taxila, Alexander's troops managed to defeat King Porus [PAW-rus], whose army was equipped with 200 elephants. Rumor had it that farther to the east, the kingdom of the Ganges, their next logical opponent, had a force of 5,000 elephants. Alexander pleaded with his troops: "Dionysus, divine from birth, faced terrible tasks—and we have outstripped him! . . . Onward, then: let us add to our empire the rest of Asia!" The army refused to budge. His conquests thus concluded, Alexander himself sailed down the Indus River, founding the city that would later become Karachi. As he returned home, he contracted fever in Babylon and died in 323 BCE. Alexander's life was brief, but his influence on the arts was long-lasting.

Toward Hellenistic Art: Sculpture in the Late Classical Period

During Alexander's time, sculpture flourished. Ever since the fall of Athens to Sparta in 404 BCE, Greek artists had continued to develop the Classical style of Phidias and Polyclitus, but they modified it in subtle yet innovative ways. Especially notable was a growing taste for images of men and women in quiet, sometimes dreamy and contemplative moods, which increasingly replaced the sense of nobility and detachment characteristic of fifth-century Classicism and found its way even into depictions of the gods. The most admired sculptors of the day were Lysippus, Praxiteles, and Skopas. Very little of the latter's work has survived, though he was noted for high-relief sculpture featuring highly energized and emotional scenes. The work of the first two is far better known.

The Heroic Sculpture of Lysippus In sculpting a full-length standing figure of Alexander, which we know only from descriptions, Lysippus also challenged the Classical kanon of proportion created by Polyclitus—smaller heads and slenderer bodies lent his heroic sculptures a sense of greater height. In fact, he transformed the Classical tradition in sculpture and began to explore new possibilities that, eventually, would define Hellenistic art, with its sense of animation, drama, and psychological complexity. In a Roman copy of a lost original by Lysippus known as the Apoxyomenos [uhpox-ee-oh-MAY-nus] (Fig. 5.19), or The Scraper, an athlete removes oil and dirt from his body with an instrument called a strigil. Compared to the Doryphoros (Spear Bearer) of Polyclitus (see Fig. 5.4), the Scraper is much slenderer, his legs much longer, his torso shorter. The Scraper seems much taller, though, in fact, the sculptures are very nearly the same height. The arms of The Scraper break free of his frontal form and invite the viewer to look at the sculpture from the sides as well as the front. He seems detached from his circumstances, as if recalling his athletic performance. All in all, he seems both physically and mentally uncontained by the space in which he stands.

The Sensuous Sculpture of Praxiteles Competing with Lysippus for the title of greatest sculptor of the fourth century BCE was the Athenian Praxiteles (flourished 370–330 BCE). Praxiteles was one of the 300 wealthiest men in Athens, thanks to his skill, but he also had a reputation as a womanizer. The people of the port city of Knidos [ku-NEE-dus], a Spartan colony in Asia Minor, asked him to provide them with an image of their patron goddess, Aphrodite, in her role as the protectress of sailors and merchants. Praxiteles responded with a sculpture of Aphrodite as the goddess of love, here reproduced in a later Roman copy (Fig. 5.20). She stands at her bath, holding her cloak in her left hand. The sculpture is a frank celebration of the body—reflecting in the female form the humanistic appreciation for the dignity of the human body in its own right. (Images of it on local coins suggest that her original pose was far less modest than that of the Roman copy, her right hand not shielding her genitals.) The statue made Knidos famous, and

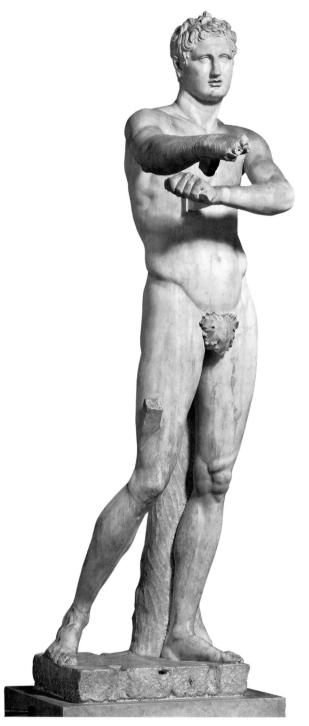

Fig. 5.19 Lysippus, *Apoxyomenos (The Scraper)*, Roman copy of an original Greek bronze of ca. 350–325 BCE. Museo Pio Clementino, Vatican Museums, Vatican State. Marble, height 6' 8". According to the Roman Pliny the Elder, writing in his *Natural History* in the first century CE, Lysippus "made the heads of his figures smaller than the old sculptors used to do." In fact, the ratio of the head size to the body in Lysippus's sculpture is 1:9, as compared to Polyclitus's Classical proportions of 1:8.

many people traveled there to see it. She was enshrined in a circular temple, easily viewed from every angle, the Roman scholar Pliny the Elder (23–79 CE) tells us, and she quickly became an object of religious attention—and openly sexual

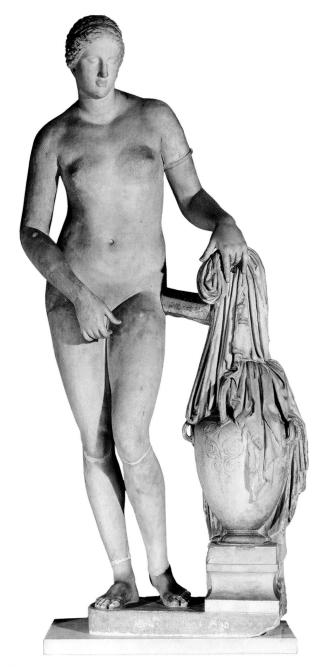

Fig. 5.20 Praxiteles, Aphrodite of Knidos, Roman copy of an original of ca. 350 BCE. P. Zigrossi/Vatican Museums, Vatican State. Marble, height 6' 8" The head of this figure is from one Roman copy, the body from another. The right forearm and hand, the left arm, and the lower legs of the Aphrodite are all seventeenth- and eighteenth-century restorations. There is reason to believe that her hand was not so modestly positioned in the original.

adoration. The reason for this is difficult to assess in the rather mechanical Roman copies of the lost original.

Praxiteles' Aphrodite of Knidos may be the first fully nude depiction of a woman in Greek sculpture, which may be why it caused such a sensation. Its fame elevated female nudity from a sign of low moral character to the embodiment of beauty, even truth itself. Paradoxically, it is also one of the earliest examples of artwork designed to appeal to what some art historians describe as the male gaze that regards woman

as its sexual object. Praxiteles' canon for depicting the female nude—wide hips, small breasts, oval face, and centrally parted hair—remained the standard throughout antiquity.

Aristotle: Observing the Natural World

We can only guess what motivated Lysippus and Praxiteles to so dramatize and humanize their sculptures, but it is likely that the aesthetic philosophy of Aristotle (384–322 BCE) played a role. Aristotle was a student of Plato's. Recall that, for Plato, all reality is a mere reflection of a higher, spiritual truth, a higher dimension of Ideal Forms that we glimpse only through philosophical contemplation (see Fig. 5.12).

Aristotle disagreed. Reality was not a reflection of an ideal form, but existed in the material world itself, and by observing the material world, one could come to know universal truths. So Aristotle observed and described all aspects of the world in order to arrive at the essence of things. His methods of observation came to be known as empirical investigation. And though he did not create a formal scientific method, he and other early empiricists did create procedures for testing their theories about the nature of the world that, over time, would lead to the great scientific discoveries of Bacon, Galileo, and Newton. Aristotle studied biology, zoology, physics, astronomy, politics, logic, ethics, and the various genres of literary expression. Based on his observations of lunar eclipses, he concluded as early as 350 BCE that the Earth was spherical, an observation that may have motivated Alexander to cross India in order to sail back to Greece. He described over 500 animals in his Historia Animalium, including many that he dissected himself. In fact, Aristotle's observations of marine life were unequaled until the seventeenth century and were still much admired by Charles Darwin in the nineteenth.

He also understood the importance of formulating a reasonable hypothesis to explain phenomena. His Physics is an attempt to define the first principles governing the behavior of matter—the nature of weight, motion, physical existence, and variety in nature. At the heart of Aristotle's philosophy is a question about the relation of identity and change (not far removed, incidentally, from one of the governing principles of this text, the idea of continuity and change in the humanities). To discuss the world coherently, we must be able to say what it is about a thing that makes it the thing it is, that separates it from all the other things in the world. In other words, what is the attribute that we would call its material identity or essence? What it means to be human, for instance, does not depend on whether one's hair turns gray. Such "accidental" changes matter not at all. At the same time, our experience of the natural world suggests that any coherent account requires us to acknowledge process and change—the change of seasons, the changes in our understanding associated with gaining knowledge in the process of aging, and so on. For Aristotle, any account of a thing must accommodate both aspects: We must be able to say what changes a thing undergoes while still retaining its essential nature, and Aristotle thus approached all manner of things—from politics to the human condition—with an eye toward determining what constituted its essence.

Aristotle's Poetics What constitutes the essential nature of literary art, and the theater in particular, especially fascinated him. Like all Greeks, Aristotle was well acquainted with the theater of Aeschylus, Euripides, and Sophocles, and in his *Poetics* he defined their literary art as "the imitation of an action that is complete and whole." Including a whole action, or a series of events that ends with a crisis, gives the play a sense of unity. Furthermore, he argued (against Plato, who regarded imitation as inevitably degrading and diminishing) that such imitation elevates the mind ever closer to the universal.

One of the most important ideas that Aristotle expressed in the *Poetics* is catharsis, the cleansing, purification, or purgation of the soul (see Reading 5.8 on pages 172–173). As applied to drama, it is not the tragic hero who undergoes catharsis, but the audience. The audience's experience of catharsis is an experience of change, just as change always accompanies understanding. In the theater, what moves the audience to change is its experience of the universality of the human condition—what it is that makes us human, our weaknesses as well as our strengths. At the sight of the action onstage, they are struck with "fear and pity." Plato believed that both of these emotions were pernicious. But Aristotle argued that the audience's emotional response to the plight of the characters on stage clarified for them the fragility and mutability of human life. What happens in tragedy is universal—the audience understands that the action could happen to anyone at any time.

The Golden Mean In Aristotle's philosophy, such Classical aesthetic elements as unity of action and time, orderly arrangement of the parts, and proper proportion all have ethical ramifications. He argued for them by means of a philosophical method based on the **syllogism**, two premises from which a conclusion can be drawn. The most famous of all syllogisms is this:

All men are mortal; Socrates is a man; Therefore, Socrates is mortal.

In the *Nicomachean Ethics*, written for and edited by his son Nicomachus [nee-koh-MAH-kus], Aristotle attempts to define, once and for all, what Greek society had striven for since the beginning of the polis—the good life. The operative syllogism goes something like this:

The way to happiness is through the pursuit of moral virtue;

The pursuit of the good life is the way to happiness; Therefore, the good life consists in the pursuit of moral virtue.

The good life, Aristotle argued, is attainable only through balanced action. Tradition has come to call this the **Golden Mean**—not Aristotle's phrase but that of the Roman poet Horace—the middle ground between any two extremes of behavior. Thus, in a formulation that was particularly applicable to his student Alexander the Great, the Golden Mean between cowardice and recklessness is courage. Like the arts, which imitate an action, human beings are defined by their actions: "As with a flute-player, a statuary, or any artisan, or in fact anybody who has a definite function, so it would seem to be with humans. . . . The function of humans is an *activity* of soul in accordance with reason." This activity of soul seeks out the moral mean, just as "good artists . . . have an eye to the mean in their works"

Despite the measure and moderation of Aristotle's thinking, Greek culture did not necessarily reflect the balanced approach of its leading philosopher. In his emphasis on catharsis—the value of experiencing "fear and pity," the emotions that move us to change—Aristotle introduced the values that would define the age of Hellenism, the period lasting from 323 to 31 BCE, that is, from the death of Alexander to the Battle of Actium, the event that marks in the minds of many the beginning of the Roman Empire.

Pergamon: Hellenist Capital

Upon his death, Alexander left no designated successor, and his three chief generals divided his empire into three successor states: the kingdom of Macedonia (including all of Greece), the kingdom of the Ptolemies (Egypt), and the kingdom of the Seleucids (Syria and what is now Iraq). But a fourth, smaller kingdom in western Anatolia, Pergamon (modern-day Bergama, Turkey), soon rose to prominence and became a center of Hellenistic culture. Ruled by the Attalids [ATT-uh-lidz]—descendants of a Macedonian general named Attalus [ATT-uh-lus]—Pergamon was founded as a sort of treasury for the huge fortunes Alexander had accumulated in his conquests. It was technically under the control of the Seleucid kingdom. However, under the leadership of Eumenes [YOU-mee-neez] I (r. 263–241 BCE), Pergamon achieved virtual independence.

The Library at Pergamon The Attalids created a huge library filled with over 200,000 Classical Athenian texts. These were copied onto parchment, a word that derives from the Greek *pergamene*, meaning "from Pergamon," and refers to sheets of tanned leather. Pergamon's vast treasury allowed the Attalids the luxury of investing enormous sums of money in decorating their acropolis with art and architecture. Especially under the rule of Eumenes II (r. 197–160 BCE), the building program flourished. It was Eumenes II who built the library, as well as the theater and a gymnasium. And he was probably responsible for the Altar of Zeus (Fig. **5.21**), which is today housed in Berlin.

A New Sculptural Style The altar is decorated with the most ambitious sculptural program since the Parthenon, but unlike the Parthenon, its frieze is at eye level and is $7^{1}/_{2}$ feet high. Its subject is the mythical battle of the gods and the giants for control of the world. The giants are depicted with snakelike bodies that coil beneath the feet of the triumphant gods (Fig. 5.22). These figures represent one of the greatest examples of the Hellenized style of sculpture that depends for

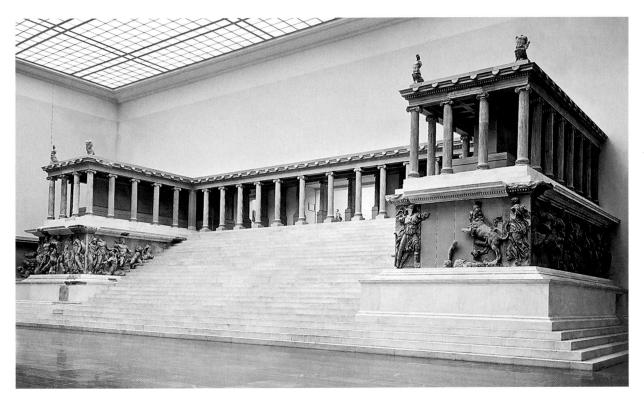

Fig. 5.21 Reconstructed west front of the Altar of Zeus, from Pergamon. ca. 165 BCE. Marble, Staatliche Museen zu Berlin, Antikensammlung, Pergamonmuseum. The staircase entrance to the altar is 68 feet wide and nearly 30 feet deep. It rises to an Ionic colonnade. As opposed to the Parthenon, where the frieze is elevated above the colonnade, the first thing the viewer confronts at the Altar of Zeus is the frieze itself, a placement that draws attention to its interlace of nearly 200 separate twisted, turning, and animated figures. Notice how, as the frieze narrows and rises up the stairs, the figures seem to break free of the architectural space that confines them and crawl out onto the steps of the altar. As the figures come to occupy real space, they simultaneously gain a theatrical reality, as if they were live stage presences in the visitor's space.

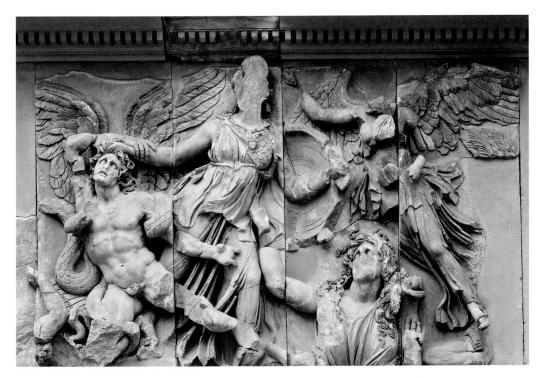

Fig. 5.22 Detail of the east frieze of the Altar of Zeus, from Pergamon. ca. 165 BCE. In this image, Athena grabs the hair of a winged, serpent-tailed monster, who is identified on the base of the monument as Alkyoneos, son of the earth goddess Ge. Ge herself rises up from the ground on the right to avenge her son. Behind Ge, a winged Nike flies to Athena's rescue.

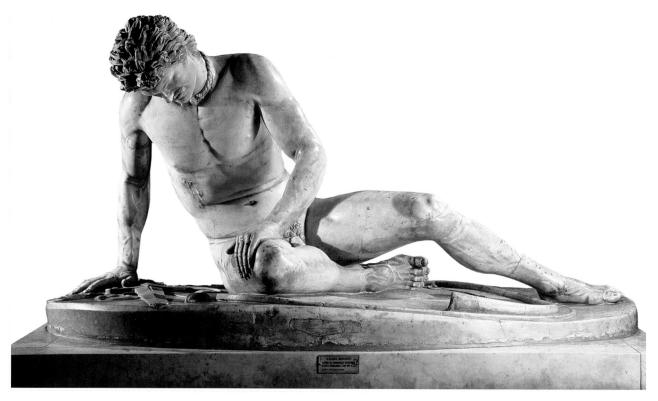

Fig. 5.23 Epigonos (?). *Dying Gaul*, **Roman copy of an original bronze of ca. 220 BCE.** Marble, height 37" Museo Capitolino, Rome. The Gaul seems both resigned to his fate—pressing against the ground to support himself as if pushing futilely against death—and also determined to show his valor and strength to the end—holding himself up as long as he can. Such emotional ambiguity is an integral aspect of Hellenistic art.

its effects on its **expressionism**, that is, the attempt to elicit an emotional response in the viewer. The theatrical effects of Lysippus are magnified into a heightened sense of drama. Where Classical artists sought balance, order, and proportion, this frieze, with its figures twisting, thrusting, and striding in motion, stresses diagonal forces that seem to pull each other apart. Swirling bodies and draperies weave in and out of the sculpture's space, and the relief is so three-dimensional that contrasts of light and shade add to the dramatic effects. Above all, the frieze is an attempt to evoke the emotions of fear and pity that Aristotle argued led to catharsis in his *Poetics* (see page 172), not the intellectual order of Classical tradition.

The relief was designed to celebrate Pergamon's role as the new center of Hellenism, its stature as the "new Athens." To that end, most authorities agree that the relief depicts the Attalid victory over the Gauls, a group of non-Greekspeaking and therefore "barbarian" central European Celts who had begun to migrate south through Macedonia as early as 300 BCE, and who had eventually settled in Galatia, just east of Pergamon. Sometime around 240–230 BCE, Attalus I (r. 241–197 BCE) defeated the Gauls in battle. Just as the Athenians had alluded to the battle between the forces of civilization and inhuman, barbarian aggressors in the metopes of the Parthenon (see Fig. 5.10), so too the Pergamenes [PUR-guh-meen] suggested the nonhumanity of the Gauls by depicting the giants as snakelike and legless, unable to even begin to rise to the level of the Attalid victors.

When Attalus I defeated the Gauls, he commissioned a group of three life-size figures to decorate the sanctuary of Athena Nikephoros [nee-KAY-for-us] (the "Victorybringer") on the acropolis of Pergamon. The original bronze versions of these sculptures, which represent the vanguished Gauls, no longer exist, and how they related to each other is not clear. Nevertheless, the drama of their presentation and their appeal to the emotions of the viewer is unmistakable. One of the three figures, which depicts a wounded Gallic trumpeter (Fig. 5.23), is possibly by the sculptor Epigonos. The Gaul's identity is established by his tousled hair and moustache (uncharacteristic of Greeks) and by his golden Celtic torque, or choker, the only item of clothing the Gauls wore in combat. He is dying from a chest wound that bleeds profusely below his right breast. The brutal realism together with the nobility and heroism of the defeated Gaul places this work among the earliest examples of Hellenistic expressionism.

Other Hellenistic sculptures deserve particular attention: the *Nike of Samothrace* and the *Aphrodite of Melos*. Convincing arguments date the *Nike of Samothrace* (Fig. **5.24**) anywhere from 300 BCE to as late as 31 BCE, though most agree that it was probably commissioned to celebrate a naval victory. It originally stood (with head and arms that have not survived, except for a single hand) upon the sculpted prow of a ship that was dramatically set in a pool of water at the top of a cliff on the island of Samothrace in the north Aegean. The dynamic forward movement of the striding figure is balanced dramatically by the open gesture of her

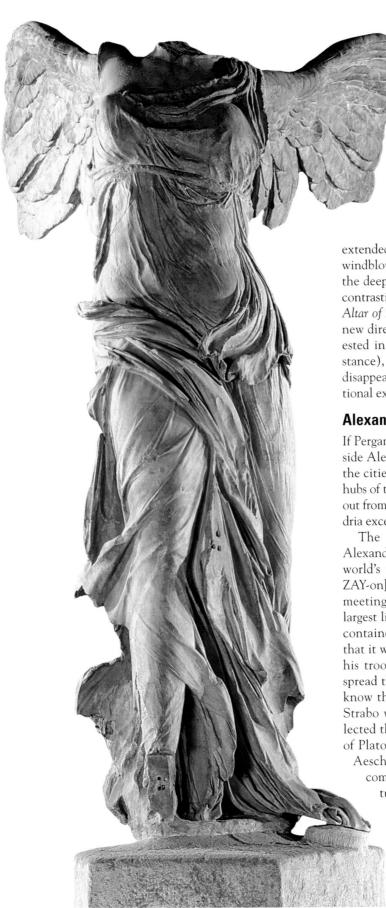

Fig. 5.24 Nike (Victory) of Samothrace, from the Sanctuary of the Great Gods, Samothrace, ca. 300-190 BCE. Musée du Louvre, Paris. Marble, height 8' 1". Discovered by French explorers in 1863, the Nike appears so immediate and alive that the viewer can almost feel the gust of wind that blows across her body.

extended wings and the powerful directional lines of her windblown gown across her body. When light rakes across the deeply sculpted forms of this figure, it emphasizes the contrasting textures of feathers, fabric, and flesh. With the Altar of Zeus and the Dying Gaul, this sculpture reflects a new direction in art. Not only is this new art more interested in non-Greek subjects (Gauls and Trojans, for instance), but the calm and restraint of Classical art have disappeared, replaced by the freedom to explore the emotional extremes of the human experience.

Alexandria

If Pergamon was a spectacular Hellenistic city, it paled beside Alexandria in Egypt. Alexander had conceived of all the cities he founded as centers of culture. They would be hubs of trade and learning, and Greek culture would radiate out from them to the surrounding countryside. But Alexandria exceeded even Alexander's expectations.

The city's ruling family, the Ptolemies (heirs of Alexander's close friend and general, Ptolemy I), built the world's first museum-from the Greek mouseion [moo-ZAY-onl, literally, "temple to the muses"—conceived as a meeting place for scholars and students. Nearby was the largest library in the world, exceeding even Pergamon's. It contained over 700,000 volumes. Plutarch later claimed that it was destroyed in 47 BCE, after Julius Caesar ordered his troops to set fire to the Ptolemaic fleet and winds spread the flames to warehouses and dockyards. We now know that the library survived—the Roman geographer Strabo worked there in the 20s BCE. But here were collected the great works of Greek civilization, the writings of Plato and Aristotle, the plays of the great tragedians Aeschylus, Sophocles, and Euripides, as well as the

comedies of Aristophanes. Stimulated by the intellectual activity in the city, the great mathematician

> Euclid formulated the theorems of plane and solid geometry here. And, when Ptolemy I (r. 323–285 BCE) diverted the funeral train of Alexander the Great from its Macedonian destination to Egypt, burying him either in Memphis or Alexandria (his tomb has never been found), the city was inevitably associated with the cult of Alexander himself.

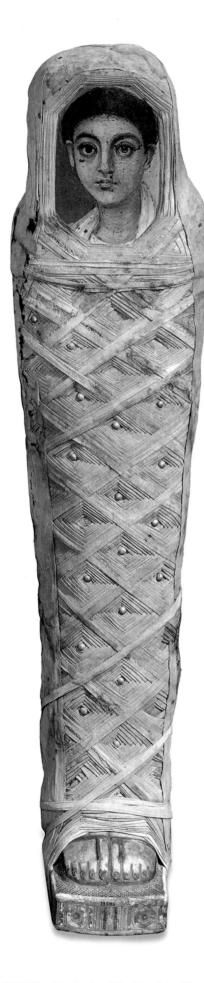

Tomb decorations at Luxor depict Alexander in the traditional role and style of an Egyptian pharaoh.

The city was designed by Alexander's personal architect, Dinocrates [dye-NOK-rah-teez] of Rhodes (flourished fourth century BCE), laid out in a grid, enclosed by a wall, and accessible by four gates at the ends of its major avenues. It was blessed by three extraordinary harbors. One was connected to the Nile, allowing for the transfer of the Nile's enormous agricultural wealth. Two others opened onto the Mediterranean, the Western Port and the Great Port, both protected by the island of Pharos, upon which was erected a giant lighthouse. Atop its 440-foot structure, a beam of light from a lantern was magnified by a system of reflectors so that approaching sailors could see the harbor from far off at sea. With the Hanging Gardens of Babylon and the Pyramids at Giza, the lighthouse at Pharos was considered one of the Seven Wonders of the World. (Its remains have been discovered in the harbor.)

Alexandria was a cosmopolitan city, exceeding even Golden Age Athens in the diversity of its inhabitants. As its population approached 1 million at the end of the first century BCE, commerce was its primary activity. Banks did transactions. Markets bustled. Inhabitants traded with others from all parts of the known world. Peoples of different ethnic backgrounds—Jews, black Africans, Greeks, Egyptians, various races and tribes from Asia Minor—all came together with the single purpose of making money. Gradually, Hellenistic and Egyptian cultures merged. The most striking evidence of this are the large number of mummy coffins decorated with startlingly realistic portraits of the deceased (Fig. 5.25). These give us some idea of Hellenistic portrait painting, almost none of which otherwise survives. They are encaustic, done with pigment mixed with heated wax, and the artists, in keeping with the Hellenistic style, were evidently intent on conveying something of the deceased's personality and emotional makeup. No more dramatic or moving approach to coffin decoration could be conceived, nor one more traditional in terms of preserving the tradition of the Egyptian ka.

Fig. 5.25 Youth from Hawarra, from Egypt. ca. 100 BCE. Encaustic on wood, height of entire coffin, 52". © The Trustees of The British Museum/Art Resource, NY. Mummy portraits were executed in encaustic, a medium composed of beeswax and pigment. Applied in molten form, it fuses to the surface to create a lustrous enamel effect of intense color. It is the most durable of all artists' paints, since wax is impervious to moisture. As the Egyptian mummy portraits attest, over time, encaustic retains all the freshness of a newly finished work.

Rome and Its Hellenistic Heritage

ome traced its origins back to the Trojan warrior Aeneas, who at the end of the Trojan War sailed off to found a new homeland for his people. The Roman poet Virgil (70–19 BCE) would celebrate Aeneas's journey in his epic poem, the *Aeneid*, written in the last decade of his life. There, he describes how the gods who supported the Greeks punished the Trojan priest Laocoön for warning his countrymen not to accept the "gift" of a wooden horse from the Greeks:

I shudder even now, Recalling it—there came a pair of serpents With monstrous coils, abreast the sea, and aiming Together for the shore. . . . Straight toward Laocoön, and first each serpent Seized in its coils his two young sons, and fastened The fangs in those poor bodies. And the priest Struggled to help them, weapons in his hand. They seized him, bound him with the mighty coils, Twice round his waist, twice round his neck, they squeezed With scaly pressure, and still towered above him Straining his hands to tear the knots apart, His chaplets¹ stained with blood and the black poison, He uttered horrible cries, not even human, More like the bellowing of a bull when, wounded, It flees the altar, shaking from the shoulder The ill-aimed axe.

1 chaplets: Garlands for the head.

It is likely that as he wrote the *Aeneid*, Virgil had seen the sculpture of *Laocoön and His Sons* (Fig. 5.26), carved in about 150 BCE. (Some argue that the sculpture, discovered in 1506 in the ruins of a palace belonging to the emperor Titus [r. 79–81 CE] in Rome, is a copy of the now-lost original.) Whatever the case, the drama and expressionism of the sculpture are purely Hellenic. So too are its complex interweaving of elements and diagonal movements reminiscent of Athena's struggle with the giants on the frieze of the Altar of Zeus at Pergamon (see Fig. 5.22).

In fact, even though Rome conquered Greece in 146 BCE (at about the time that the *Laocoön* was carved), Greece could be said to have "ruled" Rome, at least culturally. Rome was a fully Hellenized culture—it fashioned itself in the image of Greece almost from its beginnings. Indeed, many of the works of Greek art reproduced in this book are not Greek at all but later Roman copies of Greek originals. The emperor Augustus (r. 27 BCE–14 CE) sought to transform Rome into the image of Pericles's Athens. A sculpture by Lysippus was a favorite of the emperor Tiberius (r. 14–57 CE), who had it removed from public display and placed in his bedroom. So outraged was the public, who considered

the sculpture theirs and not the emperor's, that he was forced to return it to its public place. Later Roman emperors, notably Caligula and Nero, raided Delphi and Olympia for works of art.

It was not, in the end, its art in which Rome most prided itself. "Others," Virgil would write in his poem, "no doubt, will better mold the bronze." He concludes:

. . . remember, Roman,
To rule the people under law, to
establish
The way of peace, to battle down
the haughty,

To spare the meek. Our fine arts, these, forever. ■

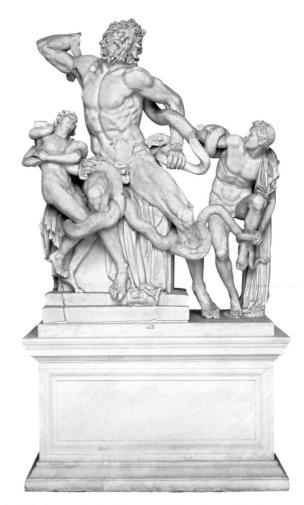

Fig. 5.26 Hagesandros, Polydoros, and Athanadoros of Rhodes. Laocoön and His Sons, Hellenistic, Second–first century BCE, or marble copy of an original, Rome, first century CE. Marble, height 8 $^1/_2$ " Museo Pio Clementino, Vatican Museums, Vatican State. Pliny the Elder attributes the sculpture to the three artists from Rhodes. If this is a copy of a lost original (and scholars debate the issue), it was probably inspired by Virgil's poem.

What is eudaimonia, and how did Athenians pursue it?

In their politics, the Athenians sought to strike a balance between the rights of the individual and the needs of the state. They collectively pursued what Aristotle called *eudaimonia*, "the good or flourishing life" in the agora, the secular center of the city. Slaves and metics, as well as women, were excluded from governance. Women were, however, given greater privileges in other city-states, particularly in Sparta. The place of women in Greek society is dramatized in Sophocles's play *Antigone*. How does that play depict the predicament of the Greek woman's place in society?

How did Pericles shape Athens?

In the fifth century, the statesman Pericles dominated Athenian political life. In his funeral speech honoring the dead, delivered early in the Peloponnesian Wars, he claimed "excellence" for Athenians in all aspects of endeavor, leading Greece by its example.

The Athenians realized the excellence of their sculpture, which became increasingly naturalistic even as they embodied an increasingly perfect sense of proportion. They realized it even more dramatically on the Acropolis, where Pericles instituted a massive architectural program that included what is perhaps the highest expression of the Doric order, the Parthenon. How would you explain the Idea of Beauty as reflected in Greek sculpture? How is it exemplified by the Parthenon? Why have we come to call this work "Classical"?

Who is Socrates?

Pericles also championed the practice of philosophy in Athens. His Athens inherited two distinct philosophical traditions, that of the Pre-Socratics, who were chiefly concerned with describing the natural universe, and that of the Sophists, who were primarily concerned with understanding the nature of human "knowing" itself. Pericles was particularly interested in the Sophists. Why? The Sophist philosophy was, however, questioned by Socrates. A stonemason by training, he practiced philosophy by engaging all comers in conversation in the agora. Socrates never wrote a word himself, but his student Plato recorded his thoughts. How does Plato extend Socratic thought in the *Republic* and the *Symposium*?

How did Greek theater originate?

Greek theatrical practice arose out of rites connected with Dionysus, god of wine. In what ways do both Greek comedy and Greek tragedy reflect this common origin? How would you describe the chief characteristics of Greek comedy and Greek tragedy?

When we speak of the Hellenistic World, to what are we referring?

The influence of Alexander the Great extended across North Africa and Egypt, the Middle East, as far as the Indian subcontinent, creating the largest empire the world had ever known. During his reign, sculpture flourished as a medium, the two masters of the period being Lyssipos and his chief competitor, Praxiteles. What new direction in sculpture do they introduce and how do later Hellenistic sculptors exploit that direction?

Alexander's tutor, the philosopher Aristotle, emphasized the importance of empirical observation in understanding the world, distinguishing between a thing's identity, its essence, and the changes that inevitably occur to it over time. How would you compare Aristotle's philosophy to Plato's? How does Aristotle's *Poetics* inform later Hellenistic sculpture?

PRACTICE MORE Get flashcards for images and terms and review chapter material with quizzes at www.myartslab.com

GLOSSARY

agora An open place used for gathering or as a market.

antagonist One who represents an opposing will; an adversary or opponent.

axis An imaginary central line.

caryatid A female figure that serves as a column.

catharsis Cleansing, purification, or purgation of the soul.

chorus The company of actors who comment on the action of some Greek dramas, both tragedies and comedies.

Classical Refers specifically to the art of the Greeks in the fifth century BCE; also commonly used to refer to anything of the first or highest class, when it is lower case.

colonnade A row of columns.

comedy An amusing or lighthearted play designed to evoke laughter in an audience.

contrapposto Italian for "counterpoise"; a term used to describe the weight-shift stance developed by the ancient Greeks in which the sculpted figure seems to twist around its axis as a result of balancing the body over one supporting leg.

dialectic method A process of inquiry and instruction characterized by continuous question-and-answer dialogue designed to elicit a clear statement of knowledge supposed to be held implicitly by all reasonable beings.

encaustic A paint medium composed of beeswax and pigment. **entasis** A swelling of the shaft of a column.

expressionism The attempt to elicit an emotional response in a viewer.

farce A broadly satirical comedy.

Golden Mean Philosophically, the middle ground between any two extremes of behavior.

Hellenistic A period of Greek history that begins with the death of Alexander the Great (356–323 BCE) and extends to the Roman defeat of Cleopatra in Egypt in 30 BCE.

humanism A focus on the actions of human beings, especially political action.

idealism The eternal perfection of pure ideas untainted by material reality.

inductive reasoning A type of reasoning that moves from specific instances to general principles and from particular truths to universal ones.

maenad In ancient Greek literature, the frenzied women inspired to ecstatic dance by Dionysus.

male gaze A term used especially in art to describe the chauvinistic glance that regards woman as its sexual object.

metope A square panel between *triglyphs* on a Doric frieze.

muse One of the nine sister goddesses in Greek mythology who presided over song, poetry, and the arts and sciences.

orchestra The "dancing space" on which ancient Greek plays were performed.

parodos An entranceway through which the chorus entered the *orchestra* area.

parapet A low wall.

pre-Socratic Greek philosophy that preceded Socrates, chiefly concerned with describing the natural world.

propylon A large entryway.

proscenium The stage on which actors perform and where painted backdrops can be hung.

protagonist The leading character in a play or literary work.

psyche The seat of both intelligence and character.

satyr A woodland deity part human and part goat, and noted for its lasciviousness.

satyr play A comic play that was one of the three major forms of Greek drama; see *farce*.

scientific method The effort to construct an accurate (that is, reliable, consistent, and nonarbitrary) representation of the world.

skene Literally, "tent"; originally a changing room for Greek actors that, over time, was transformed into a building, often two stories tall.

Sophist Literally, "wise man"; an ancient Greek teacher or philosopher who was committed to humanism and primarily concerned with understanding the nature of human "knowing" itself.

stoa A long hall, enclosed on the ends and back with a *colonnade* on the open side, used as a meeting hall or market building.

syllogism A type of deductive reasoning consisting of two premises from which a conclusion can be drawn.

tetralogy A set of four related plays.

tragedy A type of drama whose basis is conflict; it often explores the physical and moral depths to which human life can descend.

triglyph The element of a Doric frieze separating two consecutive *metopes* and divided by grooves into three sections.

READING 5.4

from Plato, Crito

The Crito is a dialogue between Socrates and his friend, the rich Athenian citizen Crito, about the source and nature of political obligation. Crito tries to persuade Socrates to escape his imprisonment and go into exile after he is sentenced to death on the charges of impiety and corrupting the youth of Athens. But Socrates counters each of Crito's arguments.

SOCRATES Why have you come at this hour, Crito? Is it not still early?

CRITO. Yes, very early.

SOCR. About what time is it?

CRITO. It is just daybreak.

SOCR. I wonder that the jailer was willing to let you in.

CRITO. He knows me now, Socrates; I come here so often, and besides, I have given him a tip.

SOCR. Have you been here long?

CRITO. Yes, some time.

SOCR. Then why did you sit down without speaking? Why did you not wake me at once?

CRITO. Indeed, Socrates, I wish that I myself were not so sleepless and sorrowful. But I have been wondering to see how soundly you sleep. And I purposely did not wake you, for I was anxious not to disturb your repose. Often before, all through your life, I have thought that your temperament was a happy one; and I think so more than ever now when I see how easily and calmly you bear the calamity that has come to you. . . . But, O my good Socrates, I beg you for the last time to listen to me 20 and save yourself. For to me your death will be more than a single disaster; not only shall I lose a friend the like of whom I shall never find again, but many persons who do not know you and me well will think that I might have saved you if I had been willing to spend money, but that I neglected to do so. And what reputation could be more disgraceful than the reputation of caring more for money than for one's friends? The public will never believe that we were anxious to save you, but that you yourself refused to escape.

SOCR. But, my dear Crito, why should we care so much about 30 public opinion? Reasonable men, of whose opinion it is worth our while to think, will believe that we acted as we really did.

CRITO. But you see, Socrates, that it is necessary to care about public opinion, too. This very thing that has happened to you proves that the multitude can do a man not the least, but almost the greatest harm, if he is falsely accused to them.

SOCR. I wish that the multitude were able to do a man the greatest harm, Crito, for then they would be able to do him the greatest good, too. That would have been fine. But, as it is, they can do neither. They cannot make a man either wise or foolish: 40 they act wholly at random. . . . Consider it in this way. Suppose the laws and the commonwealth were to come and appear to me as I was preparing to run away (if that is the right phrase to

describe my escape) and were to ask, "Tell us, Socrates, what have you in your mind to do? What do you mean by trying to escape but to destroy us, the laws and the whole state, so far as you are able? Do you think that a state can exist and not be overthrown, in which the decisions of law are of no force, and are disregarded and undermined by private individuals?" How shall we answer questions like that, Crito? Much might be said, 50 especially by an orator, in defense of the law which makes judicial decisions supreme. Shall I reply, "But the state has injured me by judging my case unjustly?" Shall we say that?

CRITO. Certainly we will, Socrates.

SOCR. And suppose the laws were to reply, "Was that our agreement? Or was it that you would abide by whatever judgments the state should pronounce?" And if we were surprised by their words, perhaps they would say, "Socrates, don't be surprised by our words, but answer us; you yourself are accustomed to ask questions and to answer them. What complaint 60 have you against us and the state, that you are trying to destroy us? Are we not, first of all, your parents? Through us your father took your mother and brought you into the world. Tell us, have you any fault to find with those of us that are the laws of marriage?" "I have none," I should reply. . . . "Well, then, since you were brought into the world and raised and educated by us, how, in the first place, can you deny that you are our child and our slave, as your fathers were before you? And if this be so, do you think that your rights are on a level with ours? Do you think that you have a right to retaliate if we should try to do anything 70 to you? . . . And do you think that you may retaliate in the case of your country and its laws? If we try to destroy you, because we think it just, will you in return do all that you can to destroy us, the laws, and your country, and say that in so doing you are acting justly-you, the man who really thinks so much of excellence? Or are you too wise to see that your country is worthier, more to be revered, more sacred, and held in higher honor both by the gods and by all men of understanding, than your father and your mother and all your other ancestors; and that you ought to reverence it, and to submit to it, and to approach it 80 more humbly when it is angry with you than you would approach your father; and either to do whatever it tells you to do or to persuade it to excuse you; and to obey in silence if it orders you to endure flogging or imprisonment, or if it sends you to battle to be wounded or to die? . . . But it is impious to use violence against your father or your mother; and much more impious to use violence against your country." What answer shall we make, Crito? Shall we say that the laws speak the truth, or not?

CRITO. I think that they do.

SOCR. "Then consider, Socrates," perhaps they would say, "if we are right in saying that by attempting to escape you are attempting an injustice. We brought you into the world, we raised you, we educated you, we gave you and every other citizen a share of all the good things we could. Yet we proclaim that if any man of the Athenians is dissatisfied with us, he may take his goods and go away wherever he pleases; we give that privilege to every man who chooses to avail himself of it, so soon as he has reached manhood, and sees us, the laws, and the administration of our state. No one of us stands in his way or forbids him to take his 100 goods and go wherever he likes, whether it be to an Athenian colony or to any foreign country, if he is dissatisfied with us and with the state. But we say that every man of you who remains here, seeing how we administer justice, and how we govern the state in other matters, has agreed, by the very fact of remaining here, to do whatsoever we tell him. And, we say, he who disobeys us acts unjustly on three counts: he disobeys us who are his parents, and he disobeys us who reared him, and he disobeys us after he has agreed to obey us, without persuading us that we are wrong. Yet we did not tell him sternly to do what- 110 ever we told him. We offered him an alternative; we gave him his choice either to obey us or to convince us that we were wrong; but he does neither. . . .

They would say, "Socrates, we have very strong evidence that you were satisfied with us and with the state. You would not have been content to stay at home in it more than other Athenians unless you had been satisfied with it more than they.

You never went away from Athens to the festivals, nor elsewhere except on military service; you never made other journeys like other men; you had no desire to see other states or 120 other laws; you were contented with us and our state; so strongly did you prefer us, and agree to be governed by us. And what is more, you had children in this city, you found it so satisfactory. Besides, if you had wished, you might at your trial have offered to go into exile. At that time you could have done with the state's consent what you are trying now to do without it. But then you gloried in being willing to die. You said that you preferred death to exile. And now you do not honor those words: you do not respect us, the laws, for you are trying to destroy us; and you are acting just as a miserable slave would act, 130 trying to run away, and breaking the contracts and agreement which you made to live as our citizen. First, therefore, answer this question. Are we right, or are we wrong, in saying that you have agreed not in mere words, but in your actions, to live under our government?" What are we to say, Crito? Must we not admit that it is true?

CRITO. We must, Socrates.

READING CRITICALLY

What is the "implicit contract" Socrates speaks about, and why does it follow that, having entered this contract, Socrates must accept his punishment?

READING 5.5

Plato, "Allegory of the Cave," from The Republic

The Republic is an inquiry into the nature of justice, which in turn leads logically to a discussion about the nature of the ideal state (where justice would, naturally, be meted out to perfection). The work takes the form of a dialogue between Socrates and six other speakers. The passage here is from Book 7, the famous "Allegory of the Cave," in which Socrates addresses an older brother of Plato named Glaucon. Socrates distinguishes between unenlightened people and enlightened philosophers such as himself, even as he demonstrates how difficult it is for the enlightened to reenter the sphere of everyday affairs—which they must, of course, since it is their duty to rule.

And now, I [Socrates] said, let me show in a figure how far our nature is enlightened or unenlightened:—Behold! human beings living in an underground den, which has a mouth open towards the light and reaching all along the den; here they have been from their childhood, and have their legs and necks chained so that they cannot move, and can only see before them, being prevented by the chains from turning round their heads. Above and behind them a fire is blazing at a distance, and between the fire and the prisoners there is a raised way; and you will see, if you look, a low wall built along the way, like the screen which marionette players have 10 in front of them, over which they show the puppets.

I see [replied Glaucon].

And do you see, I said, men passing along the wall carrying all sorts of vessels, and statues and figures of animals made of wood and stone and various materials, which appear over the wall? Some of them are talking, others silent.

You have shown me a strange image, and they are strange prisoners.

Like ourselves, I replied; and they see only their own shadows, or the shadows of one another, which the fire throws on the op- 20 posite wall of the cave?

True, he said; how could they see anything but the shadows if they were never allowed to move their heads?

And of the objects which are being carried in like manner they would only see the shadows?

Yes, he said.

And if they were able to converse with one another, would they not suppose that they were naming what was actually before them?

Very true.

30

And suppose further that the prison had an echo which came from the other side, would they not be sure to fancy when one of the passers-by spoke that the voice which they heard came from the passing shadow?

No question, he replied

To them, I said, the truth would be literally nothing but the shadows of the images.

That is certain.

And now look again, and see what will naturally follow it: the prisoners are released and disabused of their error. At first, when any 40 of them is liberated and compelled suddenly to stand up and turn his neck round and walk and look towards the light, he will suffer sharp pains; the glare will distress him, and he will be unable to see the realities of which in his former state he had seen the shadows; and then conceive some one saying to him, that what he saw before was an illusion, but that now, when he is approaching nearer to being and his eye is turned towards more real existence, he has a clearer vision—what will be his reply? And you may further imagine that his instructor is pointing to the objects as they pass and requiring him to name them-will he not be perplexed? 50 Will he not fancy that the shadows which he formerly saw are truer than the objects which are now shown to him?

Far truer.

And if he is compelled to look straight at the light, will he not have a pain in his eyes which will make him turn away to take and take in the objects of vision which he can see, and which he will conceive to be in reality clearer than the things which are now being shown to him?

True.

And suppose once more, that he is reluctantly dragged up a 60 steep and rugged ascent, and held fast until he's forced into the presence of the sun himself, is he not likely to be pained and irritated? When he approaches the light his eyes will be dazzled, and he will not be able to see anything at all of what are now called realities.

Not all in a moment, he said.

He will require to grow accustomed to the sight of the upper world. And first he will see the shadows best, next the reflections of men and other objects in the water, and then the objects themselves; then he will gaze upon the light of the moon 70 and the stars and the spangled heaven; and he will see the sky and the stars by night better than the sun or the light of the sun by day?

Certainly.

Last of all he will be able to see the sun, and not mere reflections of him in the water, but he will see him in his own proper place, and not in another; and he will contemplate him as he is. . . . And when he remembered his old habitation, and the wisdom of the den and his fellow-prisoners, do you not suppose that he would felicitate himself on the change, and pity them? 80

Certainly, he would. . . .

Would he not say with Homer, Better to be the poor servant of a poor master, and to endure anything, rather than think as they do and live after their manner?

Yes, he said, I think that he would rather suffer anything than entertain these false notions and live in this miserable manner.

Imagine once more, I said, such an one coming suddenly out of the sun to be replaced in his old situation; would he not be certain to have his eyes full of darkness?

To be sure, he said. . . .

This entire allegory, I said, you may now append, dear Glaucon, to the previous argument; the prison-house is the world of sight, the light of the fire is the sun, and you will not misapprehend me if you interpret the journey upwards to be the ascent of the soul into the intellectual world according to my poor belief, which, at your desire, I have expressed whether rightly or wrongly God knows. But, whether true or false, my opinion is that in the world of knowledge the idea of good appears last of all, and is seen only with an effort; and, when seen, is also inferred to be the universal author of all things beautiful and right, 100 parent of light and of the lord of light in this visible world, and the immediate source of reason and truth in the intellectual; and that this is the power upon which he who would act rationally, either in public or private life must have his eye fixed.

I agree, he said, as far as I am able to understand you.

Moreover, I said, you must not wonder that those who attain to this beatific vision are unwilling to descend to human affairs; for their souls are ever hastening into the upper world where they desire to dwell; which desire of theirs is very natural, if our allegory may be trusted. . . .

[A]nd there is another thing which is likely, or rather a necessary inference from what has preceded, that neither the uneducated and uninformed of the truth, nor yet those who never make an end of their education, will be able ministers of State; not the former, because they have no single aim of duty which is the rule of all their actions, private as well as public; nor the latter, because they will not act at all except upon compulsion, fancying that they are already dwelling apart in the islands of the blest.

Very true, he replied.

Then, I said, the business of us who are the founders of the 120 State will be to compel the best minds to attain that knowledge which we have already shown to be the greatest of all—they must continue to ascend until they arrive at the good; but when they have ascended and seen enough we must not allow them to do as they do now.

What do you mean?

I mean that they remain in the upper world: but this must not be allowed; they must be made to descend again among the prisoners in the den, and partake of their labours and honours, whether they are worth having or not.

But is not this unjust? he said; ought we to give them a worse life, when they might have a better? . . .

Observe, Glaucon, that there will be no injustice in compelling our philosophers to have a care and providence of others; we shall explain to them that in other States, men of their class are not obliged to share in the toils of politics: and this is reasonable, for they grow up at their own sweet will, and the government would rather not have them. Being self-taught, they cannot be expected to show any gratitude for a culture which they have

never received. But we have brought you into the world to be 140 rulers of the hive, kings of yourselves and of the other citizens, and have educated you far better and more perfectly than they have been educated, and you are better able to share in the double duty. Wherefore each of you, when his turn comes, must go down to the general underground abode, and get the habit of seeing in the dark. When you have acquired the habit, you will see ten thousand times better than the inhabitants of the den, and you will know what the several images are, and what they represent, because you have seen the beautiful and just and good in their truth. And thus our State which is also yours will be a reality, and not a dream only, and will be administered in a spirit

unlike that of other States, in which men fight with one another about shadows only and are distracted in the struggle for power, which in their eyes is a great good. Whereas the truth is that the State in which the rulers are most reluctant to govern is always the best and most quietly governed, and the State in which they are most eager, the worst. . . .

READING CRITICALLY

In what way does Glaucon's experience, as Socrates' student, mirror Socrates' allegory?

READING 5.6

Plato, from The Symposium

The Symposium recounts a discussion about the nature of Love among members of a drinking party in Athens at which Plato and Socrates were in attendance. Their homosexual love for young boys, commonplace in Athens, is the starting point, but the essay quickly moves beyond discussion of mere physical love. In the excerpt below, Socrates quotes a woman named Diotima who has taught him, he says, that the purpose of love is to give birth to beauty, which in turn allows the philosopher to attain insight into the ultimate Form of Beauty. His speech is addressed to one Phaedrus, who has already made an important distinction between common physical love and a higher heavenly love.

"Even you, Socrates, could perhaps be initiated in the rites of love I've described so far. But the purpose of these rites, if they are performed correctly, is to reach the final vision of the mysteries; and I'm not sure you could manage this. But I'll tell you about them," she said, "and make every effort in doing so; try to follow, as far as you can."

"The correct way," she said, "for someone to approach this business is to begin when he's young by being drawn towards beautiful bodies. At first, if his guide leads him correctly, he should love just one body and in that relationship produce 10 beautiful discourses. Next he should realize that the beauty of any one body is closely related to that of another, and that, if he is to pursue beauty of form, it's very foolish not to regard the beauty of all bodies as one and the same. Once he's seen this, he'll become a lover of all beautiful bodies, and will relax his intense passion for just one body, despising this passion and regarding it as petty. After this, he should regard the beauty of minds as more valuable than that of the body, so that, if someone has goodness of mind even if he has little of the bloom of beauty, he will be content with him, and will love 20 and care for him, and give birth to the kinds of discourse that help young men to become better. As a result, he will be forced to observe the beauty in practices and laws and to see that every type of beauty is closely related to every other, so that he will regard beauty of body as something petty. After practices, the guide must lead him towards forms of knowledge, so that he sees their beauty too. Looking now at beauty in general and not just at individual instances, he will no longer be slavishly attached to the beauty of a boy, or of any particular person at all, or of a specific practice. Instead of this low and 30 small-minded slavery, he will be turned towards the great sea

of beauty and gazing on it he'll give birth, through a boundless love of knowledge, to many beautiful and magnificent discourses and ideas. At last, when he has been developed and strengthened in this way, he catches sight of one special type of knowledge, whose object is the kind of beauty I shall now describe.

"Now try," she said, "to concentrate as hard as you can. Anyone who has been educated this far in the ways of love, viewing beautiful things in the right order and way, will now reach the goal 40 of love's ways. He will suddenly catch sight of something amazingly beautiful in its nature; this, Socrates, is the ultimate objective of all the previous efforts. First, this beauty always is, and doesn't come into being or cease; it doesn't increase or diminish. Second, it's not beautiful in one respect but ugly in another, or beautiful at one time but not at another, or beautiful in relation to this but ugly in relation to that; nor beautiful here and ugly there because it is beautiful for some people but ugly for others. Nor will beauty appear to him in the form of a face or hands or any part of the body; or as a specific account or piece of knowledge; 50 or as being anywhere in something else, for instance in a living creature or earth or heaven or anything else. It will appear as in itself and by itself, always single in form; all other beautiful things share its character, but do so in such a way that, when other things come to be or cease, it is not increased or decreased in any way nor does it undergo any change. . . . "

READING CRITICALLY

How does the process of coming to a higher understanding of the nature of love compare to Socrates' description of arriving at enlightenment in "Allegory of the Cave"?

of these cities, with their amphitheaters, temples, arches, roads, fortresses, aqueducts, bridges, and monuments of every description. From Scotland in the north to the oases of the Sahara Desert in the south, from the Iberian peninsula in the west to Asia Minor as far as the Tigris River in the east, local aristocrats took up Roman customs (Map 6.1). Roman law governed each region. Rome remained the center of culture all others at the periphery imitated.

Rome admired Greece for its cultural achievements, from its philosophy to its sculpture, and, as we have seen, its own art developed from Greek-Hellenic models. But Rome admired its own achievements as well, and its art differed from that of its Hellenic predecessors in certain key respects. Instead of depicting mythological events and heroes, Roman artists depicted current events and real

people, from generals and their military exploits to portraits of their leaders and recently deceased citizens. They celebrated the achievements of a state that was their chief patron so that all the world might stand in awe of the state's accomplishments.

Nowhere was this identity more fully expressed than in Roman architecture. Though the structural principles of the arch had long been known, the Romans mastered the form. They also invented concrete, the structural strength of which, when combined with the arch, made possible the vault, and the vault in turn made possible the soaring and expansive interior spaces for which Roman architecture is known. The Romans were great engineers, and public works were fundamental to the Roman sense of identity, propagandistic tools that symbolized Roman power.

Map 6.1 The Roman Empire at its greatest extent. ca. 180 ce. By 180 ce, the Roman Empire extended from the Atlantic Ocean in the west to Asia Minor, Syria, and Palestine in the east, and from Scotland in the north to the Sahara Desert in North Africa.

This chapter traces the rise of Roman civilization from its Greek and Etruscan origins in the sixth century BCE to about 313 CE, when the empire was Christianized. Based on values developed in Republican Rome and extended to the Imperial state, the Roman citizen owed the state dutiful respect. As the rhetorician and orator Marcus Tullius Cicero put it in his firstcentury BCE essay, On Duty, "It is our duty, then, to be more ready to endanger our own than the public welfare." This sense of duty was mirrored in family life, where reverence for one's ancestors was reflected in the profusion of portrait busts that decorated Roman households. One was obliged to honor one's father as one honored Rome itself. The family became one of the focuses of the first Roman emperor, Augustus, and his dedication to it was reflected in his public works and statuary, and in the work of the artists and writers he supported. But the lasting legacy of Augustus was his transformation of Rome into what he called "a city of marble." Subsequent emperors in the first two centuries CE would continue to transform Rome until it was arguably the most magnificent center of culture ever built.

ORIGINS OF ROMAN CULTURE

The origins of Roman culture are twofold. On the one hand, there were the Greeks, who as early as the eighth century BCE colonized the southern coastal regions of the Italian peninsula and Sicily and whose Hellenic culture the Romans adopted for their own. On the other hand, there were the Etruscans.

The Etruscan Roots

The Etruscan homeland, Etruria, occupied the part of the Italian peninsula that is roughly the same as modern-day Tuscany. It was bordered by the Arno River to the north (which runs through Florence) and the Tiber River to the south (which runs through Rome). No Etruscan literature survives, although around 9,000 short texts do, enough to make clear that even though the alphabet was related to Greek, the lan-

guage itself was unrelated to any other in Europe. Scholars know how to pronounce most of its words, although only several hundred words have been translated with any certainty. By the seventh and sixth centuries, they were major exporters of fine painted pottery, a black ceramic ware known

as bucchero, bronze-work, jewelry, oil, and wine. By the fifth century BCE, they were known throughout the Mediterranean for their skill as sculptors in both bronze and terra-cotta.

Tombs: Clues to Etruscan Life The Etruscans buried their dead in cemeteries removed from their cities. The tombs were arranged like a town with a network of streets winding through them. They used a type of tomb called a tumulus, a round structure partially belowground and partially aboveground, covered with earth. Inside, the burial chambers are rectangular and resemble domestic architecture. In fact, they may resemble actual Etruscan homes—only the foundations of their homes survive, so we cannot be sure—since entire families were buried together. Plaster reliefs on the walls include kitchen implements, tools, and, in general, the necessities for everyday life, suggesting that the Etruscan sense of the afterlife was in some ways similar to that of the Egyptians, with whom, incidentally, they traded.

Most of what we know about the Etruscans comes from the sculptures and paintings that have survived in tombs. Women evidently played a far more important role in Etruscan culture than in Greece, and Roman culture would later reflect the Etruscan sense of women's equality. On Etruscan sarcophagi, or coffins, many of which are made of terra-cotta, there are many examples of husbands and wives reclining together. One of the most famous examples comes from Cerveteri, on the coast north of Rome (Fig. 6.3). Husband and wife are depicted reclining on a dining couch, and they are given equal status. Their hands are animated, their smiles full, and they seem engaged in a lively dinner conversation. Their smiles, in fact, are reminiscent of the Greek Archaic smiles found on sculptures such as the nearly contemporary Anavysos Kouros (see Fig. 4.21), suggesting that the Etruscans were acquainted with Greek art.

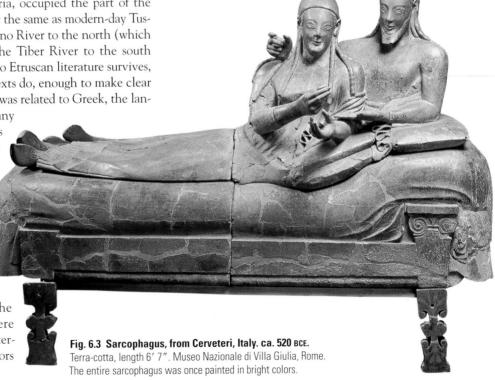

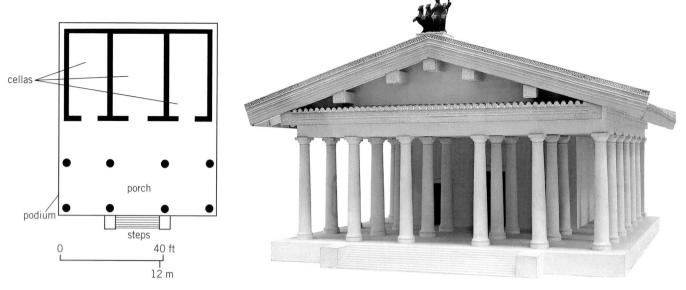

Figs. 6.4 and 6.5 Plan and reconstruction model of an Etruscan temple. Instituto di Etruscologia e Antichità Italiche, University of Rome. Note the sculptures adorning the roof, an innovation in Etruscan architecture very different from the relief sculptures decorating the pediments and entablatures of the Greek temple.

Architectural Influences Because of their mud-brick wall and wooden column construction, only the foundations of Etruscan temples survive, but we know something of what they looked like from surviving votive terra-cotta models and from written descriptions. The first-century BCE Roman architect Vitruvius described Etruscan temples in writings that date from between 46 and 39 BCE, 700 years after the Etruscans built them. Vitruvius describes temples constructed on a platform, or podium, with a single set of steps up to a porch or portico in front of three interior cellas (modern archeological evidence demonstrates that there were many other arrangements as well, including one- and two-cella temples). The ground plan was almost square, and the space was divided about equally between the porch and three interior cellas which probably housed cult statues (Figs. **6.4** and **6.5**).

The Etruscans also adapted the Greek Doric order to their own ends, creating what Vitruvius called the **Tuscan order** (Fig. **6.6**). The Tuscan order used an unfluted, or smooth, shaft and a pedestal base. Overall, the Tuscan order shares with the Doric a sense of geometric simplicity. But the Etruscan temples were also heavily decorated with brightly colored paintings, probably similar to those that survive in the tombs, and their roofs were decorated with sculptural groups. Both of these features must have lent them an air of visual richness and complexity.

The later Romans modified the Tuscan order by adding a much more elaborate pedestal, but their debt to Etruscan temples is especially evident if we compare the Etruscan model and its plan to a Roman temple from the late second century BCE (Figs. 6.7 and 6.8), the Temple of Portunus [por-TOO-nus] (also known as the Temple of Fortuna Virilis [for-TOO-nuh vee-RIL-is]). Dedicated to Portunus, the god of harbors and ports, the temple stands beside the Tiber

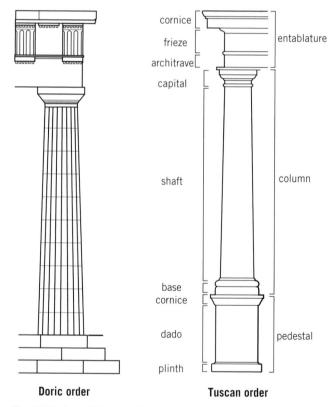

Fig. 6.6 Doric and Tuscan orders. The Tuscan order illustrated here is a later Roman version of the early Tuscan order. The simple base of the column, evident in the temple model in Figure 6.7 but never found in the Doric order, was elaborated by the Romans into a pedestal composed of a plinth, a dado, and a base cornice.

River and represents a mixture of Etruscan and Greek influences. Like the Etruscan temple, it is elevated on a podium and approached by a set of stairs at the front. Although more rectangular than its Etruscan ancestor, its floor plan is

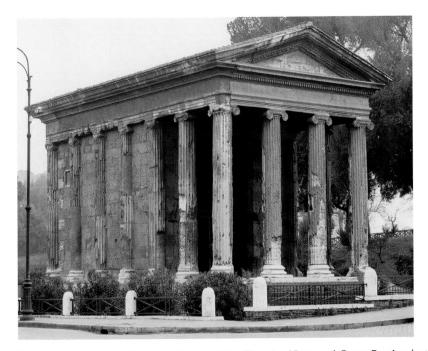

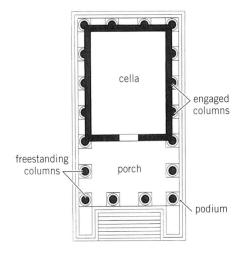

Figs. 6.7 and 6.8 Plan and Temple of Fortuna Virilis (Temple of Portunus), Forum Boarium (cattle market), Rome. Late second century BCE. This temple stood next to the Bridge of Aemilius, remnants of which still survive. The bridge crossed the Tiber River just below Tiber Island.

similarly divided between exterior porch and interior space. But it uses the Greek Ionic order, and its Ionic columns represent a new direction in exterior design. Though free-standing on the porch, they are *engaged* around the cella. That is, they serve no real support function, but rather are decorative additions that give the effect of a continuous colonnade surrounding the entire structure.

The double ancestry of the Temple of Portunus, both Etruscan and Greek, is reflected in almost every aspect of early Roman culture. Even geographically, Rome lies between the two cultures, with the Greek colonies to the south and the Etruscan settlements to the north. Its situation, in fact, is geographically improbable.

Rome was built on a hilly site (seven hills to be precise) on the east bank of the Tiber. Its low-lying areas were swampy and subject to flooding, while the higher elevations of the hillsides did not easily lend themselves to building. The river Tiber itself provides a sensible explanation for the city's original siting, since it gave the city a trade route to the north and access to the sea at its port of Ostia to the south. And so does Tiber Island, next to the Temple of Portunus, which was one of the river's primary crossings

Fig. 6.9 *She-Wolf.* **ca. 500–480 BCE.** Bronze, with glass-paste eyes, height 33". Museo Capitolino, Rome. The two suckling figures representing Romulus and Remus are Renaissance additions. This Etruscan bronze, which became a symbol of Rome, combines a ferocious realism with the stylized portrayal of, for instance, the wolf's geometrically regular mane.

from the earliest times. Thus, Rome was physically and literally the crossing place of Etruscan and Greek cultures.

The Etruscan Founding Myth The city also had competing foundation myths. One was Etruscan. Legend had it that twin infants named Romulus and Remus were left to die on the banks of the Tiber but were rescued by a she-wolf who suckled them (Fig. 6.9). Raised by a shepherd, the twins decided to build a city on the Palatine Hill above the spot where they had been saved (accounting, in the manner of

foundation myths, for the unlikely location of the city). Soon, the two boys feuded over who would rule the new city. In his *History of Rome*, the Roman historian Livy (59 BCE–17 CE) briefly describes the ensuing conflict:

Then followed an angry altercation; heated passions led to bloodshed; in the tumult Remus was killed. The more common report is that Remus contemptuously jumped over the newly raised walls and was forthwith killed by the enraged Romulus, who exclaimed, "So shall it be henceforth with every one who leaps over my walls." Romulus thus became sole ruler, and the city was called after him, its founder.

The date, legend has it, was 753 BCE.

It has long been known that the figures of Romulus and Remus in the she-wolf sculpture are Renaissance additions, but scholars who were responsible for its restoration a decade ago now believe the wolf itself is of medieval origin, dating from the sixth or seventh century CE. Results of radiocarbon dating of its bronze conducted by the Capitoline Museum in Rome, where it is housed, have not been released as of this writing. Whatever the outcome of the investigation, the centrality of the she-wolf to Roman legend is indisputable.

Fig. 6.10 *Thorn-Puller.* Late first century BCE. Bronze, height 33". Museo Capitolino, Rome. The statue is one of the few large-scale bronze sculptures to survive from antiquity.

The Greek Roots

The second founding myth, as told by the poet Virgil (70–19 BCE) in his epic poem the Aeneid, was Greek in its inspiration. By the second and first centuries BCE, Rome had achieved political control of the entire Mediterranean. But even after Rome conquered Greece in 146 BCE, Greece could be said to "rule" Rome, at least culturally. Rome was a fully Hellenized culture—it fashioned itself in the image of Greece almost from its beginnings. Indeed, many of the works of Greek art reproduced in this book are not Greek at all but later Roman copies of Greek originals. The Romans loved Greek

art. Julius Caesar would set up the Pergamene *Dying Gaul* (see Fig. 5.23) as a symbol of his own triumph over the Gauls of France from 58 to 51 BCE. Augustus (r. 27 BCE–14 CE) sought to transform Rome into the image of Pericles's Athens. Lysippus's *Scraper*

(see Fig. 5.19) was a favorite of the emperor Tiberius (r. 14–37 CE), who had it removed from public display and placed in his bedroom. So outraged was the public, who considered the sculpture theirs and not the emperor's, that he was forced to return it to its public place. Later Roman emperors, notably Caligula and Nero, raided Delphi and Olympia for works of art.

Even works of art that may be original to Rome, like the first-century CE bronze *Thorn-Puller* (Fig. 6.10) reveal strong Hellenistic influence. Depicting a young boy pulling a thorn from his foot, it is derived from Hellenistic models of the third century BCE for the body, with a head derived from Greek works of the fifth century BCE. The boy is probably a slave—masters rarely provided shoes for their slaves—or, given the rock he is sitting on, he might be a boy from the countryside. The realistic portrayal of his self-absorbed and intense concentration combined with the beauty of his physique both suggest the Roman attraction to Hellenistic precedents.

Rome's sense of its Greek origins is nowhere more forcefully stated than in the story of its founding by the Trojan warrior Aeneas, who at the end of the Trojan War sailed off to found a new homeland for his people. Aeneas's story is recounted by the poet Virgil (70–19 BCE) in the Aeneid, an epic poem written around 30–19 BCE. In Book 2, Virgil recounts Laocoön's warning to his countrymen not to accept the "gift" of a wooden horse from the Greeks (Reading 6.1a):

READING 6.1a

Virgil, Aeneid, Book II

"Are you crazy wretched people?

Do you think they have gone, the foe? Do you think that any Gifts of the Greeks lack treachery? Ulysses,1—

What was his reputation? Let me tell you,

Either the Greeks are hiding in this monster,

Or it's some trick of war, a spy, or engine,

To come down on the city. Tricky business Is hiding in it. Do not trust it, Trojans, Do not believe this horse. Whatever it may be, I fear the Greeks even when bringing presents." With that, he hurled the great spear at the side With all the strength he had. I hastened, trembling, And the struck womb rang hollow, a moaning sound.

¹Ulysses: The Roman name for Odysseus.

As we have seen in Chapter 5's Continuity & Change, Laocoön's warning is ignored, and a few pages later, Aeneas describes how the gods (probably Athena) who supported the Greeks punished Laocoön, entangling him in the coiled snakes, which crush him together with his sons—the subject of the famous sculpture that belonged to the Roman emperor Titus (r. 79–81 CE) in Rome (see Fig. 5.26).

And yet Virgil's poem romanizes the story. Virgil incorporates Greek culture as part and parcel of Roman tradition even as he rejects it, a fact that becomes apparent in comparing Virgil's version to Homer's description of the same scene in the *Odyssey*. At the end of Book 8, Odysseus asks a minstrel to sing the story of the wooden horse:

READING 6.1b

Homer, Odyssey, Book VIII

The minstrel stirred, murmuring to the god, and soon clear words and notes came one by one, a vision of the Akhaians in their graceful ships drawing away from shore: the torches flung and shelters flaring: Argive soldiers crouched in the close dark around Odysseus: and the horse, tall on the assembly ground of Troy. For when the Trojans pulled it in, themselves, up to the citadel, they say nearby with long-drawn-out and hapless argumentfavoring, in the end, one course of three: either to stave the vault with brazen axes, or to haul it to a cliff and pitch it down, or else to save it for the gods, a votive glorythe plan that could not but prevail. For Troy must perish, as ordained, that day. . . .

Though Laocoön's position on the wooden horse is articulated, no mention is made of him—nor in the entire Odyssey—let alone his terrible fate. Virgil's debt to Homer is clear. In fact, the first six books of the Aeneid, in which Aeneas's wanderings through the Mediterranean are narrated, could be said to mirror the Odyssey, while the last six books are a war story similar to the Iliad. But Laocoön is not an Homeric character (Virgil probably knew him through a Greek epic cycle dating from the seventh and sixth centuries BCE of which only a few fragments survive). He is, by and large, a Roman invention.

If the Romans trace their origins to the Trojans, Laocoön functions in Virgil's poem as almost the sole embodiment of

wisdom among their ancestors and as Rome's first martyr, sacrificed together with his children to the gods. Virgil's poem celebrate this martyrdom. But Laocoön's warning against Greeks bearing gifts had clear cultural implications for Virgil. In Book 6, the ghost of Aeneas's father Anchises tells his son (see also Continuity & Change, Chapter 5):

READING 6.1c

Virgil, Aeneid, Book VI

Others, no doubt, will better mould the bronze
To the semblance of soft breathing, draw, from marble,
The living countenance; and other plead
With greater eloquence, or learn to measure,
Better than we, the pathways of the heaven,
The risings of the stars: remember, Roman,
To rule the people under law, to establish
The way of peace, to battle down the haughty,
To spare the meek. Our fine arts, these, forever.

If the Greeks brought to Rome the gifts of art, rhetoric, and scientific knowledge, it remained for Rome to rule wisely—this was the art it practiced best. Good governance would become, Virgil's *Aeneid* argued, Rome's historical destiny.

REPUBLICAN ROME

By the time of Virgil, the Greek and Etruscan myths had merged. Accordingly, Aeneas's son founded the city of Alba Longa, just to the south of Rome, which was ruled by a succession of kings until Romulus brought it under Roman control.

According to legend, Romulus inaugurated the traditional Roman distinction between **patricians**, the land-owning aristocrats who served as priests, magistrates, lawyers, and judges, and **plebians**, the poorer class who were craftspeople, merchants, and laborers. When, in 510 BCE, the Romans expelled the last of the Etruscan kings and decided to rule themselves without a monarch, the patrician/plebian distinction became very similar to the situation in fifth-century BCE Athens. There, a small aristocracy who owned the good land and large estates shared citizenship with a much larger working class (see Chapter 5).

In Rome, as in the Greek model, every free male was a citizen, but in the Etruscan manner, not every citizen enjoyed equal privileges. The Senate, the political assembly in charge of creating law, was exclusively patrician. In reaction, the plebians formed their own legislative assembly, the Consilium Plebis (Council of Plebians), to protect themselves from the patricians, but the patricians were immune from any laws the plebians passed, known as *plebiscites*. Finally, in 287 BCE, the plebiscite became binding law on all citizens, and something resembling equality of citizenship was assured.

The expulsion of the Etruscan kings and the dedication of the Temple of Jupiter on the Capitoline Hill in 509 BCE mark the beginning of actual historical records documenting the development of Rome. They also mark the beginning of the Roman Republic, a state whose political organization rested on the principle that the citizens were the ultimate source of legitimacy and sovereignty. Many people believe that the Etruscan bronze head of a man (Fig. 6.11) is a portrait of Lucius Junius Brutus, the founder and first consul of the Roman Republic. However, it dates from approximately 100 to

200 years after Brutus's life, and it more likely represents a noble "type," an imaginary portrait of a Roman founding father, or *pater*, the root of the word *patrician*. This role is conveyed through the figure's strong character and strength of purpose.

In Republican Rome, every plebian chose a patrician as his patron—and, indeed, most patricians were themselves clients of some other patrician of higher status—whose duty it was to represent the plebian in any matter of law and provide an assortment of assistance matters, primarily economic. This paternalistic relationship—which we call patronage—reflected the family's central role in Roman culture. The pater, "father," protected not only his wife and family but also his clients, who submitted to his patronage. In return for the pater's protection, family and client equally owed the pater their total obediencewhich the Romans referred to as pietas, "dutifulness." So embedded was this attitude that when toward the end of the first century BCE the Republic declared itself an empire, the emperor was called pater patriae, "father of the

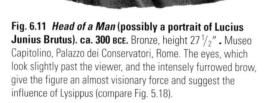

Roman Rule

fatherland."

By the middle of the third century BCE, the Republic had embarked on a series of military exploits known as the Punic Wars that recall Alexander's imperial adventuring of the century before. For over 100 years, beginning in 264 BCE, the Republic advanced against Carthage, the Phoenician state in present-day Tunisia (see Map 6.1). Carthage controlled most of the wealth of the western Mediterranean, including the vast agricultural and commercial resources of Sicily, Sardinia, Corsica, and the eastern portion of the Iberian peninsula.

In his *History of Rome*, Livy immortalized the Carthaginian general Hannibal's march, from what is now Spain, over the Pyrenees, across the Rhône River, and through the Alps with his army of nearly 100,000 men—including a contingent of elephants. (Perhaps this was meant to imitate the armies of India that had terrorized Alexander's troops.) Hannibal laid waste to most of northern Italy, defeating an army of 80,000 men in 216 BCE, the worst defeat in Roman

history. But Rome eventually defeated him by adopting a policy "always to fight him where he is not," cutting off supplies from the Iberian peninsula, and counterattacking back home in Carthage. When Hannibal returned to defend his homeland, in 202 BCE, without ever having lost a battle to the Romans in Italy, he was defeated by the general

Scipio [SEE-pee-oh] Africanus (236—ca. 184 BCE) in northern Africa. Despite the fact that Hannibal had occupied Italy for 15 years, marching to the very gates of Rome in 211, his eventual defeat led the Romans (and their potential adversaries) to believe Rome was invincible.

Meanwhile, in the eastern Mediterranean, Philip V of Macedonia (r. 221–179 BCE), Alexander's heir, had made an alliance with Hannibal and threatened to overrun the Greek peninsula. With

the northern Greek region of Thessaly in 197 BCE, then pressed on into

Asia Minor, which they controlled

Greek help, the Romans defeated him in

by 189 BCE. (Just over 50 years later, in 133 BCE, Attalus III of Pergamon would deed his city and all its wealth to Rome.) Finally, in the Third Punic War (149-146 BCE), the Romans took advantage of a weakened Carthage and destroyed the city, plowing it under and sprinkling salt in the furrows to symbolize the city's permanent demise. Its citizens were sold into slavery. When all was said and done, Rome controlled almost the entire Mediterranean world (see Map 6.1).

The Aftermath of Conquest Whenever Rome conquered a region, it established permanent colonies of

veteran soldiers who received allotments of land, virtually guaranteeing them a certain level of wealth and status. These soldiers were citizens. If the conquered people proved loyal to Rome, they could gain full Roman citizenship. Furthermore, when not involved in combat, the local Roman soldiery transformed themselves into engineers, building roads, bridges, and civic projects of all types, significantly improving the region. In this way, the Republic diminished the adversarial status of its colonies and gained their loyalty.

The prosperity brought about by Roman expansion soon created a new kind of citizen in Rome. They called themselves *equites* ("equestrians") to connect them to the cavalry, the elite part of the military, since only the wealthy could afford the necessary horses. The *equites* were wealthy businessmen, but not often landowners and therefore not patricians. The patricians considered the commercial

exploits of the *equites* crass and their wealth ill-gotten. Soon the two groups were in open conflict, the *equites* joining ranks with the plebians.

The Senate was the patrician stronghold, and it feared any loss of power and authority. When the general Pompey the Great (106–48 BCE), returned from a victorious campaign against rebels in Asia Minor in 62 BCE, the Senate refused to ratify the treaties he had made in the region and refused to grant the land allotments he had given his soldiers. Outraged, Pompey joined forces with two other successful military leaders. One had put down the slave revolt of Spartacus in 71 BCE. The other was Gaius Julius Caesar (100–44 BCE), a military leader from a prestigious patrician family that claimed descent from Aeneas and Venus. The union of the three leaders became known as the First Triumvirate.

A Divided Empire Wielding the threat of civil war, the First Triumvirate soon dominated the Republic's political life, but theirs was a fragile relationship. Caesar accepted a fiveyear appointment as governor of Gaul, present-day France. By 49 BCE, he had brought all of Gaul under his control. He summed up this conquest in his Commentaries in the famous phrase "Veni, vidi, vici"—"I came, I saw, I conquered"—a statement that captures, perhaps better than any other, the militaristic nature of the Roman state as a whole. He was preparing to return home when Pompey joined forces with the Senate. They reminded Caesar of a long-standing tradition that required a returning commander to leave his army behind, in this case on the Gallic side of the Rubicon River, but Caesar refused. Pompey fled to Greece, where Caesar defeated him a year later. Again Pompey fled, this time to Egypt, where he was murdered. The third member of the Triumvirate had been captured and executed several years

Now unimpeded, Caesar assumed dictatorial control over Rome. Caesar treated the Senate with disdain, and most of its membership counted themselves as his enemies. On March 15, 44 BCE, the Ides of March, he was stabbed 23 times by a group of 60 senators at the foot of a sculpture honoring Pompey on the floor of the Senate. This scene was memorialized in English by Shakespeare's great play *Julius Caesar* and Caesar's famous line, as he sees his ally Marcus Junius Brutus (85–42 BCE) among the assassins, "Et tu, Brute?"—"You also, Brutus?" Brutus and the others believed they had freed Rome of a tyrant, but the people were outraged, the Senate disgraced, and Caesar martyred.

Caesar had recognized that his position was precarious, and he had prepared a member of his own family to assume power in his place, his grandnephew, Gaius Octavius, known as Octavian (63 BCE–14 CE), whom he adopted as son and heir. Although only 18 years old when Caesar died, Octavian quickly defeated his main rival, Marcus Antonius (ca. 82–30 BCE), known to most English speakers as Mark Antony. He then adroitly formed an alliance with the defeated Marcus Antonius and Marcus Emilius Lepidus

(died ca. 12 BCE), another of Caesar's officers, known as the Second Triumvirate. Octavian and Antony pursued Cassius and Brutus into Macedonia and defeated them at the battle of Philippi. Octavian, Antonius, and Lepidus then divided up the empire, which was larger than any one person could control and govern: Lepidus got Africa, Antonius the eastern provinces including Egypt, and Octavian the west, including Rome. Lepidus soon plotted against Octavian, but Octavian persuaded Lepidus's troops to desert him. Antonius, meanwhile, had formed an alliance with Cleopatra VII, the queen of Egypt (r. 51–31 BCE). When Octavian defeated Antonius at the battle of Actium in 31 BCE, Antonius and Cleopatra committed suicide. Octavian was left the sole ruler of the empire. He assumed power as a monarch in everything but actual title.

Cicero and the Politics of Rhetoric

In times of such political upheaval, it is not surprising that one of the most powerful figures of the day would be someone who specialized in the art of political persuasion. In pre-Augustan Rome, that person was the rhetorician (writer and public speaker, or orator) Marcus Tullius Cicero (106–43 BCE). First and foremost, Cicero recognized the power of the Latin language to communicate with the people. Although originally used almost exclusively as the language of commerce, Latin, by the first century CE, was understood to be potentially a more powerful tool of persuasion than Greek, still the literary language of the upper classes. The clarity and eloquence of Cicero's style can be quickly discerned, even in translation, as an excerpt (Reading 6.2) from his essay On Duty demonstrates.

READING 6.2

Cicero, On Duty

That moral goodness which we look for in a lofty, highminded spirit is secured, of course, by moral, not physical strength. And yet the body must be trained and so disciplined that it can obey the dictates of judgment and reason in attending to business and in enduring toil. But that moral goodness which is our theme depends wholly upon the thought and attention given to it by the mind. And, in this way, the men who in a civil capacity direct the affairs of the nation render no less important service than they who conduct its wars: by their statesmanship oftentimes wars are either averted or terminated; sometimes also they are declared. . . . And so diplomacy in the friendly settlement of controversies is more desirable than courage in settling them on the battlefield; but we must be careful not to take that course merely for the sake of avoiding war rather than for the sake of public expediency. War, however, should be undertaken in such a way as to make it evident that it has no other object than to secure peace.

But it takes a brave and resolute spirit not to be disconcerted in times of difficulty or ruffled and thrown off one's feet, as the saying is, but to keep one's presence of mind and one's self-possession and not to swerve from the path of reason.

Now all this requires great personal courage; but it also calls for great intellectual ability by reflection to anticipate the future, to discover some time in advance what may happen whether for good or for ill, and what must be done in any possible event, and never to be reduced to having to say "I had not thought of that."

The dangers attending great affairs of state fall sometimes on those who undertake them, sometimes upon the state. In carrying out such enterprises, some run the risk of losing their lives, others their reputation and the good-will of their fellow-citizens. It is our duty, then, to be more ready to endanger our own than the public welfare and to hazard honor and glory more readily than other advantages. . . .

Philosophically, Cicero's argument extends back to Plato and Aristotle, but rhetorically—that is, in the structure of its argument—it is purely Roman. It is purposefully deliberative in tone—that is, its chief concern is to give sage advice rather than to engage in a Socratic dialogue to evolve that advice.

In his speeches and his letters, Cicero was particularly effective. His speeches were notoriously powerful. He understood, as he wrote in De Oratore (Concerning Oratory), that "Nature has assigned to each emotion a particular look and tone of voice and bearing of its own; and the whole of a person's frame and every look on his face and utterance of his voice are like strings of a harp, and sound according as they are struck by each successive emotion." In his letters, he could be disarmingly frank. After having invited Julius Caesar to dinner—in the struggle between Pompey and Caesar, Cicero had backed Pompey, and he hardly trusted the new dictator—he described the great man in a letter to his friend Atticus (Reading 6.3):

READING 6.3

Cicero, Letters to Atticus

Quite a guest, although I have no regrets and everything went very well indeed. . . . He was taking medicine for his digestion, so he ate and drank without worrying and seemed perfectly at ease. It was a lavish dinner, excellently served and in addition well prepared and seasoned with good conversation, very agreeable, you know. What can I say? We were human beings together. But he's not the kind of guest to whom you'd say "it's been fun, come again on the way back." Once is enough! We talked about nothing serious, a lot about literature: he seemed to enjoy it and have a good time. So now you know about how I entertained him-or rather had him billeted on me. It was a nuisance, as I said, but not unpleasant.

His ambivalence about Caesar notwithstanding, the "dangers attending great affairs of state" that concerned Cicero in his On Duty would come back to haunt him. Fearing Cicero's power, and angry that he had called Antonius a tyrant in his speeches, the Second Triumvirate sent troops to hunt him down at his country estate in 43 BCE. Laena, their leader, severed Cicero's head, then presented it, in Rome, to Antonius himself.

Portrait Busts, Pietas, and Politics

This historical context helps us understand a major Roman art form of the second and first centuries BCE, the portrait bust. These are generally portraits of patricians (and upper-middleclass citizens wishing to emulate them) rather than equites. Roman portrait busts share with their Greek ancestors an affinity for naturalistic representation, but they are even more realistic, revealing their subjects' every wrinkle and wart (Fig. 6.12). This form of realism is known as verism (from the Latin veritas, "truth"). Indeed, the high level of naturalism may have resulted from their original form, wax ancestral

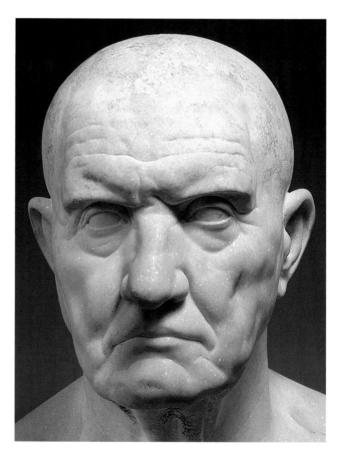

Fig. 6.12 A Roman Man. ca. 80 BCE. Marble, life-size. The Metropolitan Museum of Art, Rogers Fund, 1912 (12.233). © The Metropolitan Museum of Art/Art Resource, NY. His face creased by the wrinkles of age, this man is the very image of the pater, the man of gravitas (literally "weight," but also. "presence" or "influence"), dignitas ("dignity," "worth," and "character"), and fides ("honesty" and "conscientiousness").

LEARN MORE Gain insight from a primary source document from Cicero at www.myartslab.com

masks, usually made at the peak of the subject's power, called *imagines*, which were then transferred to stone.

Compared to the Greek Hellenistic portrait bust—recall Lysippus's portrait of Alexander

(see Fig. 5.18), copies of which proliferated throughout the Mediterranean in the third century BCE—the Roman portrait differs particularly in the age of the sitter. Both the Greek and Roman busts are essentially propagandis-

tic in intent, designed to extol the virtues of the sitter, but where Alexander is portrayed as a young man at the height of his powers, the usual Roman portrait bust depicts its subject at or near the end of life. The Greek portrait bust, in other words, signifies youthful possibility and ambition, while the Roman version claims for its subject the wisdom and experience of age. These images celebrate *pietas*, the deep-seated Roman virtue of dutiful respect toward the gods, fatherland, and parents. To respect one's parents was tantamount, for the Romans, to respecting one's moral obligations to the gods. The respect one owed one's parents was, in effect, a religious obligation.

If the connection to Alexander—especially the emphasis in both on the power of the gaze—is worth considering, the Roman portrait busts depict a class under attack, a class whose virtues and leadership were being threatened by upstart generals and *equites*. They are, in other words, the very picture of conservative politics. Their furrowed brows represent their wisdom, their wrinkles their experience, their extraordinarily naturalistic representation their character. They represent the Senate itself, which should be honored, not disdained.

IMPERIAL ROME

On January 13, 27 BCE, Octavian came before the Senate and gave up all his powers and provinces. It was a rehearsed event. The Senate begged him to reconsider and take Syria, Gaul, and the Iberian Peninsula for his own (these provinces just happened to contain 20 of the 26 Roman legions, guaranteeing him military support). They also asked him to retain his title as consul of Rome, with the supreme authority of imperium, the power to give orders and exact obedience, over all of Italy and subsequently all Roman-controlled territory. He agreed "reluctantly" to these terms, and the Senate, in gratitude, granted him the semidivine title Augustus, "the revered one." Augustus (r. 27 BCE-14 CE) thereafter portrayed himself as a near-deity. The Augustus of Primaporta (Fig. 6.13) is the slightly larger-than-life-size sculpture named for its location at the home of Augustus's wife, Livia, at Primaporta, on the outskirts of Rome. Augustus is represented as the embodiment of the famous admonition given to Aeneas by his dead father (Aeneid, Book 6), "To rule the people under law, to establish / The way of peace."

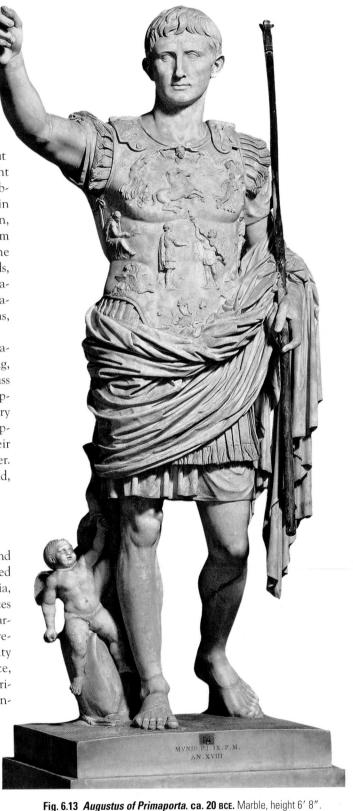

Fig. 6.13 Augustus of Primaporta. ca. 20 BCE. Marble, height 6' 8". Vatican Museums, Rome. On the breastplate, a bearded Parthian from Asia Minor hands over Roman standards that had been lost in a battle of 53 BCE. In 20 BCE, when the original version of this statue was carved—most scholars believe this is actually a later copy—Augustus had won them back.

Augustus, like Aeneas, is duty-bound to exhibit *pietas*, the obligation to his ancestor "to rule earth's peoples."

The sculpture, though recognizably Augustus, is nevertheless idealized. It adopts the pose and ideal proportions of Polyclitus's *Doryphoros* (see Fig. 5.4). The gaze, reminis-

cent of the look of Alexander the Great, purposefully recalls the visionary hero of Greece who died 300 years earlier. The right arm is extended in the gesture of *ad locutio*—he is giving a (military) address. The military garb announces his role as commander-in-chief.

Riding a dolphin at his feet is a small Cupid, son of the goddess Venus, laying claim to the Julian family's divine descent from Venus and Aeneas. Though Augustus was over 70 years old when he died, he was always depicted as young and vigorous, choosing to portray himself, apparently, as the ideal leader rather than the wise, older pater.

Augustus was careful to maintain at least the trappings of the Republic. The Senate stayed in place, but Augustus soon eliminated the distinction between patricians and *equites* and fostered the careers of all capable individuals, whatever their origin. Some he made provincial governors, others administrators in the city, and he encouraged still others to enter political life. Soon the Senate was populated with many men who had never dreamed of political power. All of them—governors, administrators, and politicians—owed everything to Augustus. Their loyalty further solidified his power.

Family Life

Augustus also quickly addressed what he considered to be another crisis in Roman society—the demise of family life. Adultery and divorce were commonplace. There were more slaves and freed slaves in the city than citizens, let alone aristocrats. And family size, given the cost of living in the city, was diminishing. He reacted by criminalizing adultery and passed several other laws to promote family life. Men between the ages of 20 and 60 and women between the ages of 20 and 50 were required to marry. A divorced woman was required to remarry within six months, a widow within a year. Childless adults were punished with high taxes or deprived of inheritance. The larger an aristocrat's family, the greater his political advantage. It is no coincidence that when Augustus commissioned a large monument to commemorate his triumphal return after establishing Roman rule in Gaul and restoring peace to Rome, the Ara Pacis Augustae (Altar of Augustan Peace), he had its exterior walls on the south decorated with a retinue of his own large family, a model for all Roman citizens, in a procession of lictors, priests, magistrates, senators, and other representatives of the Roman people (Figs. 6.14 and 6.15).

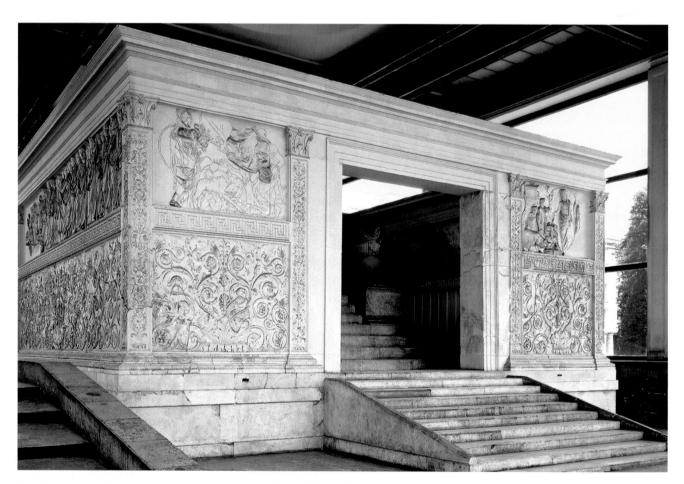

Fig. 6.14 Ara Pacis Augustae, west side. Rome. 13–9 BCE. Marble, $34'5'' \times 38'$

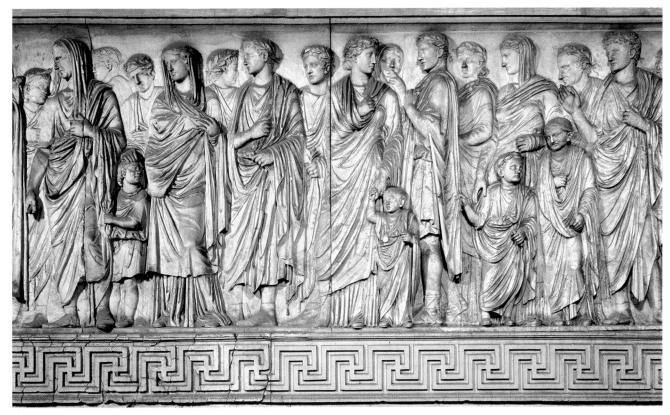

Fig. 6.15 *Ara Pacis Augustae*, **detail of Imperial Procession, south frieze, Rome. 13–9 BCE.** Marble, width approx. 35'. At the left is Marcus Agrippa, Augustus's son-in-law, married to his daughter Julia. The identities of the other figures are not secure, but scholars speculate that clinging to Agrippa's robe is either a foreign child belonging to Agrippa's household or Augustus's grandson, Gaius Caesar, who with his brother Lucius often traveled with their grandfather and whom Augustus taught to imitate his own handwriting. The child looks backward and up at Augustus's wife, Livia, one of the most powerful people in Rome. Behind Livia is her son by an earlier marriage, Tiberius, who would succeed Augustus as emperor.

Art historians believe that the *Ara Pacis Augustae* represents a real event, perhaps a public rejoicing for Augustus's reign (it was begun in 13 BCE when he was 50), or the dedication of the altar itself, which occurred on Livia's fiftieth birthday in 9 BCE. The realism of the scene is typically Roman. A sense of spatial depth is created by depicting figures farther away from us in low relief and those closest to us in high relief, so high in fact that the feet of the nearest figures project over the architectural frame into our space (visible in the detail, Fig. 6.15). This technique would have encouraged viewers—the Roman public—to feel that they were part of the same space as the figures in the sculpture itself. The Augustan peace is the peace enjoyed by the average Roman citizen, the Augustan family a metaphor for the larger family of Roman citizens.

The Ara Pacis Augustae is preeminently a celebration of family. Three generations of Augustus's family are depicted in the relief. It also demonstrates the growing prominence of women in Roman society. Augustus's wife, Livia, is depicted holding Augustus's family together, standing between her stepson-in-law, Marcus Agrippa, and her own sons, Tiberius and Drusus.

Livia became a figure of idealized womanhood in Rome. She was the "female leader" of Augustus's programs of reform, a sponsor of architectural projects and a trusted advisor to both her husband and son. While Livia enjoyed greater power and influence than most, Roman women possessed the rights of citizenship, although they could not vote or hold public office. Still, married women retained their legal identity. They controlled their own property and managed their own legal affairs. Elite women modeled themselves after Livia, wielding power through their husbands and sons.

Education of the Sexes

The Romans educated their girls like their boys. Patricians probably hired tutors for their daughters, but the middle classes sent both their boys and girls to school until they were 12 years old, where they learned to read, write, and calculate. Education as a whole was left largely to Greeks, who came to Rome in Republican times to teach language, literature, and philosophy, as well as what the Romans called *humanitas*. *Humanitas* was considered the equivalent of the Greek *paideia* [pie-DAY-uh], the process of educating a person into his or her true and genuine form. It developed from Plato's insistence on the four sciences—arithmetic, geometry, astronomy, and music—as well as grammar and

rhetoric. Both formed the core of the curriculum from Roman times through the Middle Ages. Through the study of Classical Greek literature, a student possessing true humanitas should be able to find beauty in the equilibrium and harmony of a work of art, which should in turn inspire the student to search for such beauty in his or her own way of life.

Most Romans learned Greek from a teacher called a grammaticus, who taught not only rhetoric and grammar but also Greek literature, especially Homer. As a result, most Romans were bilingual. As Latin began to establish a literature of its own—it was initially the language of politics, law, and commerce—translation became a course of study, and the great Greek classics were soon available in Latin.

In a wall painting from Pompeii (Fig. 6.16), a young woman bites on her stylus, as if contemplating her next words. Perhaps she is a poet. There were notable women poets in Roman times, including Julia Balbilla [bal-BIL-uh] and Sulpicia [sul-PEE-see-uh], an elegist who was accepted into male literary circles. Women were, at any rate, sufficiently well educated that the satirist Juvenal would complain about it in his *Satires*, written in the early second century CE (Reading 6.4).

READING 6.4

Juvenal, Satires

Exasperating is the woman who begs as soon as she sits down to dinner to discourse on poets and poetry. . . . She rattles on at such a pitch that you'd think that all the pots and pans in the kitchen were crashing to the floor and that every bell in town was clanging. . . . She should learn the philosopher's lesson: "moderation is necessary even for intellectuals." And if she still wants to appear educated and eloquent, let her dress as a man, sacrifice to men's gods, and bathe in men's baths. Wives shouldn't try to be public speakers; they shouldn't use rhetorical devices; they shouldn't read the classics—there should be some things women don't understand. I myself cannot understand a woman who can quote the rules of grammar and never make a mistake and cite obscure, long-forgotten poets—as if men cared for such things.

For all the misogyny in Juvenal's diatribe, one thing is clear: women understand most everything that men do—and maybe better. His is a world in which women have attained an education at least comparable to that of men.

The Philosophy of the City: Chance and Reason

Many wealthier Romans hired Greek philosophers to teach their children in their own homes, and as a result Roman philosophy is almost wholly borrowed from the Greeks. Two of the most attractive philosophical systems to the Romans were Epicureanism and Stoicism.

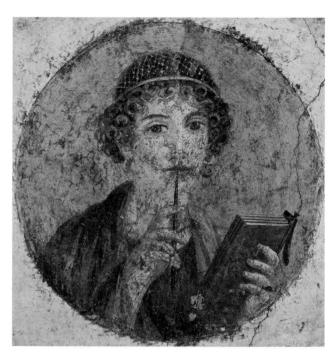

Fig. 6.16 Young Woman Writing, detail of a wall painting from Pompeii. Late first century ce. Diameter $14^5/8$ ". Museo Archeològico Nazionale, Naples. Women at all levels of society, except the very poorest, apparently learned to read and write.

Epicureanism Epicurus (341–270 BCE) was a Greek philosopher who taught in Athens. His ideas were promoted in Rome, particularly by the poet Lucretius (ca. 99-ca. 55 BCE) in his treatise On the Nature of Things. Epicureanism is based on the theory of Epicurus, who believed that fear, particularly fear of death, was responsible for all human misery, and that the gods played no part in human affairs. All things, he argued, are driven by the random movement of atoms swirling through space. There are no first causes or final explanations, only chance. Thus, life can be enjoyed with complete serenity, and pleasure is the object of human life. At death, he concluded, our atoms simply disperse. Epicurus's philosophy might seem hedonistic, but, in fact, he argued that pleasure of the soul, attained through the quiet contemplation of philosophy, was far preferable to bodily pleasure. He stressed clarity and simplicity of thought, and "sober reasoning." In Lucretius's version of the philosophy, love is but a mental delusion.

Stoicism Most Romans rejected Epicureanism because they associated it with self-indulgence and debauchery, despite Lucretius's efforts to emphasize its more moderate and intellectual aspects. **Stoicism**, a hardheaded, practical philosophy that had developed in the Athenian *stoa* during the late fourth and early third centuries BCE, was far more popular. In the first century CE, as the population of Rome approached one million and the empire expanded almost unimaginably, the rational detachment and practical commonsense principles of Stoicism appealed to a citizenry confronting a host of problems related to the sheer size of city and empire. By submitting one's emotions to the practice of reason, one could achieve what the playwright and

essayist Lucius Annaeus Seneca (ca. 8 BCE–65 CE) called "tranquility of mind." In his most famous essay, *Tranquility of Mind*, Seneca argues that the best way to achieve peace of mind is to avoid responsibilities, especially those associated with excessive wealth (**Reading 6.5**):

READING 6.5

Seneca, Tranquility of Mind

Our question, then, is how the mind can maintain a consistent and advantageous course, be kind to itself and take pleasure in its attributes, never interrupt this satisfaction but abide in its serenity, without excitement or depression. This amounts to tranquility. We shall inquire how it may be attained. . . .

A correct estimate of self is prerequisite, for we are generally inclined to overrate our capacities. One man is tripped by confidence in his eloquence, another makes greater demands upon his estate than it can stand, another burdens a frail body with an exhausting office. Some are too bashful for politics, which require aggressiveness; some are too headstrong for court; some do not control their temper and break into unguarded language at the slightest provocation; some cannot restrain their wit or resist making risky jokes. For all such people retirement is better than a career; an assertive and intolerant temperament should avoid incitements to outspokenness that will prove harmful. . . .

We pass now to property, the greatest source of affliction to humanity. If you balance all our other troubles—deaths, diseases, fears, longings, subjection to labor and pain—with the miseries in which our money involves us, the latter will far weigh the former. Reflect, then, how much less a grief it is not to have money than to lose it, and then you will realize that poverty has less to torment us with in the degree that it has less to lose. If you suppose that rich men take their losses with greater equanimity you are mistaken; a wound hurts a big man as much as it does a little. . . .

All life is bondage. Man must therefore habituate himself to his condition, complain of it as little as possible, and grasp whatever good lies with his reach. No situation is so harsh that a dispassionate mind cannot find some consolation in it. If a man lays even a very small area out skillfully it will provide ample space for many uses, and even a foothold can be made livable by deft arrangement. Apply good sense to your problems; the hard can be softened, the narrow widened, and the heavy made lighter by the skillful bearer. . . .

Seneca's message was especially appealing to many Romans who were struggling for survival in the city. If we are all slaves to our situation, he seemed to argue, then like slaves, we must make of life the best we can. Tragically, Seneca would not get the opportunity to practice what he preached. When his student, the emperor Nero, ordered him to commit suicide, a practice sanctioned by his Stoic philosophy, Seneca obliged.

Literary Rome: Catullus, Virgil, Horace, and Ovid

Perhaps the most influential poet in Rome before the Augustan age was Gaius Valerius Catullus (ca. 84-54 BCE). In his short life, Catullus wrote only 114 poems, many of them very short, but in their insistence on revealing the details of his personal emotional life, they reflect the Roman taste for the kind of verism we see in the ancestral masks and sculptures that dominate Roman portraiture (see Fig. 6.12). Particularly popular were a series of poems written to a woman many believe to be one Clodia, sister of a Roman patrician and senator, and wife of another, with whom he had a passionate if short-lived affair. In the poems, he addresses her as Lesbia, a clear reference to the poems of Sappho (see Readings 4.7a and 4.7b), and a testament to the Greek poet's lasting influence on Roman literature. Catullus's poems to Lesbia move from the passion of his early infatuation to a growing sense of despair that their love will not last (see Reading 6.6 on page 209).

Catullus's work influenced virtually all subsequent Roman poets, but where Catullus worked independently, after Augustus took control of Rome, all artistic patronage passed through his office. During the civil wars, the two major poets of the day, Virgil and Horace, had lost all their property, but Augustus's patronage allowed them to keep on with their writings. Because the themes they pursued were subject to Augustus's approval, they tended to glorify both the emperor and his causes. He was far less supportive of the poet Ovid, whom he permanently banished from Rome.

Virgil and the *Aeneid* After Augustus's triumph over Antony and Cleopatra at the battle of Actium in 31 BCE, Virgil retired to Naples, where he began work on an epic poem designed to rival Homer's *Iliad* and to provide the Roman state—and Augustus in particular—with a suitably grand founding myth. Previously he had been engaged with two series of pastoral idylls, the *Eclogues* (or *Bucolics*) and the *Georgics*. The latter poems (**Reading 6.7**) are modeled after Hesiod's *Works and Days* (see Chapter 4). They extol the importance of hard work, the necessity of forging order in the

CONTINUITY CHANGE

Works and Days, p. 110

face of a hostile natural world, and, perhaps above all, the virtues of agrarian life.

READING 6.7

from Virgil, Georgics

In early spring-tide, when the icy drip
Melts from the mountains hoar, and Zephyr's breath
Unbinds the crumbling clod, even then 'tis time;
Press deep your plough behind the groaning ox,
And teach the furrow-burnished share to shine.
That land the craving farmer's prayer fulfils,
Which twice the sunshine, twice the frost has felt;
Ay, that's the land whose boundless harvest-crops
Burst, see! the barns.

The political point of the *Georgics* was to celebrate Augustus's gift of farmlands to veterans of the civil wars, but in its exaltation of the myths and traditions of Italy, it served as a precursor to the *Aeneid*. It was written in **dactylic hexameter**, the verse form that Homer had used in the *Iliad* and *Odyssey* (the metrical form of the translation above, however, is iambic pentameter—five rhythmic units, each short long, as in *dee-dum*—a meter much more natural to English than the Latin dactylic hexameter). In dactylic hexameter, each line consists of six rhythmic units, or **feet**, and each foot is either a **dactyl** (long, short, short, as in *dum-diddy*) or a **spondee** (long, long, as in *dum-dum*). Virgil reportedly wrote the *Georgics* at a pace of less than one line a day, perfecting his understanding of the metrical scheme in preparation for the longer poem.

The Aeneid opens in Carthage, where, after the Trojan War, Aeneas and his men have been driven by a storm, and where they are hosted by the Phoenician queen Dido. During a rainstorm, Aeneas and Dido take refuge in a cave, where the queen, having fallen in love with the Trojan hero, gives herself willingly to him. She now assumes that she is married, but Aeneas, reminded by his father's ghost of his duty to accomplish what the gods have predetermined a classic instance of pietas—knows he must resume his destined journey (see Reading 6.8 on pages 209–210). An angry and accusing Dido begs him to stay. When Aeneas rejects her pleas, Dido vows to haunt him after her death and to bring enmity between Carthage and his descendants forever (a direct reference on Virgil's part to the Punic Wars). As his boat sails away, she commits suicide by climbing a funeral pyre and falling upon a sword. The goddesses of the underworld are surprised to see her. Her death, in their eyes, is neither deserved nor destined, but simply tragic. Virgil's point is almost coldly hard-hearted: All personal feelings and desires must be sacrificed to one's responsibilities to the state. Civic duty takes precedence over private life.

The poem is, on one level, an account of Rome's founding by Aeneas, but it is also a profoundly moving essay on human destiny and the great cost involved in achieving and sustaining the values and principles upon which culture—Roman culture in particular, but all cultures by extension—must be based. Augustus, as Virgil well knew, claimed direct descent from Aeneas, and it is particularly important that the poem presents war, at which Augustus excelled, as a moral tragedy, however necessary.

In Book 7, Venus gives Aeneas a shield made by the god Vulcan. The shield displays the important events in the future history of Rome, including Augustus at the Battle of Actium. Aeneas is, Virgil writes, "without understanding... proud and happy... [at] the fame and glory of his children's children." But in the senseless slaughter that ends the poem, as Aeneas and the Trojans battle Turnus and the Italians, Virgil demonstrates that the only thing worse than not avenging the death of one's friends and family is, perhaps, avenging them. In this sense the poem is a profound plea for peace, a peace that Augustus would dedicate himself to pursuing.

The Horatian *Odes* Quintus Horatius Flaccus [KWIN-tus hor-AY-she-us FLAK-us], known as Horace (65–8 BCE), was a close friend of Virgil. Impressed by Augustus's reforms, and probably moved by his patronage, Horace was won over to the emperor's cause, which he celebrated directly in two of his many **odes**, lyric poems of elaborate and irregular meter. Horace's odes imitated Greek precedents. The following lines open the fifth ode of Book 3 of the collected poems, known simply as the *Odes*:

Jove [the Roman Zeus, also called Jupiter] rules in heaven, his thunder shows; Henceforth Augustus earth shall own Her present god, now Briton foes And Persians bow before his throne.

The subject matter of the Odes ranges from these patriotic pronouncements to private incidents in the poet's own life, the joys of the countryside (Fig. 6.17), the pleasures of wine, and so on. His villa offered him an escape from the trials of daily life in Rome itself. In Ode 13 of Book 2, for instance, Horace addresses a tree that had unexpectedly crashed down, nearly killing him (see Reading 6.9 on page 211). He begins by cursing the man who planted the tree but then concludes that we all fail to pay attention to the real dangers in life. Apparently lost in thought, he begins to imagine the underworld, the abode of departed souls, where he sees the love poet Sappho (see Chapter 4) and the political poet Alcaeus both writing poetry. Their lyrics give comfort to the dead, just as Horace's own poem has comforted him and allowed him to forget his near-death experience. No Roman poet more gracefully harmonized the Greek reverence for beauty with the Roman concern with duty and obligation.

Ovid's Art of Love and Metamorphoses Augustus's support for poets did not extend to Publius Ovidius Naso [POO-bleus ov-ID-ee-us NAY-sol, known as Ovid (43 BCE-17 CE). Ovid's talent was for love songs designed to satisfy the notoriously loose sexual mores of the Roman aristocrats, who lived in somewhat open disregard of Augustus and Livia's family-centered lifestyle. His Ars Amatoria [ahrs ah-mah-TOR-ee-uh] (Art of Love) angered Augustus, as did some undisclosed indiscretion by Ovid. As punishment—probably more for the indiscretion than the poem—Augustus permanently exiled him to the town of Tomis [TOE-mus] on the Black Sea, the remotest part of the empire, famous for its wretched weather. The Metamorphoses, composed in the years just before his exile, is a collection of stories describing or revolving around one sort of supernatural change of shape or another, from the divine to the human, the animate to the inanimate, the human to the vegetal.

In the Ars Amatoria, the poet describes his desire for the fictional Corinna. Ovid outlines the kinds of places in Rome where one can meet women, from porticoes to gaming houses, from horse races to parties, and especially anywhere wine, that great banisher of inhibition, can be had.

Women, he says, love clandestine affairs as much as men; they simply do not chase after men, "as a mousetrap does not chase after mice." Become friends with the husband of a woman you desire, he advises. Lie to her—tell her that you only want to be her friend. Nevertheless, he says, "If you want a woman to love you, be a lovable man."

Ovid probably aspired to Virgil's fame, though he could admit, "My life is respectable, but my Muse is full of jesting." His earliest major work, the Amores [ah-MOHR-ee2] (Loves), begins with many self-deprecating references to Virgil's epic, which begins with the famous phrase, "Arms and the man I sing":

Arms, warfare, violence—I was winding up to produce

A regular enic, with verse form to match.

A regular epic, with verse-form to match— Hexameters, naturally. But Cupid (they say) with a snicker

Lopped off one foot from each alternate line. "Nasty young brat," I told him, "who made you Inspector of Metres?"

Nevertheless, Ovid uses dactylic hexameter for the *Metamorphoses* and stakes out an epic scope for the poem in its opening lines:

My intention is to tell of bodies changed
To different forms; the gods, who made the changes,
Will help me—or I hope so—with a poem
That runs from the world's beginning to our
own days!

If the *Metamorphoses* is superficially more a collection of stories than an epic, few poems in any language have contributed so importantly to later literature. It is so complete in its survey of the best-known classical myths, plus stories from Egypt, Persia, and Italy, that it remains a standard reference work. At the same time, it tells its stories in an utterly moving and memorable way. The story of Actaeon, for instance, is a cautionary tale about the power of the gods. Actaeon happens to see the virgin goddess Diana bathing one day when he is out hunting with his dogs. She turns him into a stag to prevent him from ever telling what he has seen. As his own dogs turn on him and savagely tear him apart, his friends call out for him, lamenting his absence from the kill. But he is all too present:

Well might he wish not to be there, but he was there, and well might he wish to see And not to feel the cruel deeds of his dogs.

In the story of Narcissus, Echo falls in love with the beautiful youth Narcissus, but when Narcissus spurns her, she fades away. He in turn is doomed to fall in love with his own image reflected in a pool, according to Ovid, the spring at Clitumnus [clye-TOOM-nus]. So consumed, he finally dies beside the pool, his body transformed into the narcissus flower. In such stories, the duality of identity and

Fig. 6.17 *Idyllic Landscape*, wall painting from a villa at Boscotrecase, near Pompeii. First century BCE. Museo Nazionale, Naples. This landscape depicts the love of country life and the idealizing of nature that is characteristic of the Horatian *Odes*. It contrasts dramatically with urban life in Rome.

change, Aristotle's definition of the essence of a thing, becomes deeply problematic. Ovid seems to deny that any human characteristic is essential, asserting that all is susceptible to change. To subsequent generations of readers, from Shakespeare to Freud, Ovid's versions of myths would raise the fundamental questions that lie at the heart of human identity and psychology.

Augustus and the City of Marble

Of all the problems facing Augustus when he assumed power, the most overwhelming was the infrastructure of Rome. The city was, quite simply, a mess. Seneca reacted by preaching Stoicism. He argued that it was what it was, and one should move on as best one can. Augustus reacted by calling for a series of public works, which would serve the people of Rome and, he well understood, himself. The grand civic improvements Augustus planned would be a kind of imperial propaganda, underscoring not only his power but also his care for the people in his role as *pater patriae*. Public works could—and indeed did—elicit the public's loyalty.

Rome had developed haphazardly, without any central plan, spilling down the seven hills it originally occupied into the valleys along the Tiber. By contrast, all of the empire's provincial capitals were conceived on a strict grid plan, with colonnaded main roads leading to an administrative center, and adorned with public works like baths, theaters, and triumphal arches. In comparison, Rome was pitiable. Housing conditions were dreadful, water was scarce, food was in short supply. Because the city was confined by geography to a small area, space was at a premium.

Urban Housing: The Apartment At least as early as the third century BCE, the ancient Romans created a new type of living space in response to overcrowding—the multistoried apartment block, or *insula* [IN-soo-luh]. In Augustus's time, the city was increasingly composed of such *insulae* [IN-soo-lye], in which 90 percent of the population of Rome lived.

The typical apartment consisted of two private rooms—a bedroom and a living room—that opened onto a shared central space. The poor lived in kitchenless apartments, cooking and eating in the shared space.

The *insulae* were essentially tenements, with shops on the ground floor and living quarters above. They rose to a height of 60 or 70 feet (five or six stories), were built with inadequate wood frames, and often collapsed. Fire was an even greater danger. Richer apartment dwellers—and there were many, buildable land being scarce—often employed slaves as their own private fire brigades. In 6 CE, Augustus

introduced *vigils* [VI-juls] to the city, professional firefighters (and policemen) who patrolled the city at night.

In the *insulae*, noise was a constant problem, and hygiene an even worse issue. Occupants of the upper stories typically dumped the contents of their chamber pots into the streets rather than carry them down to the cesspool. As the satirist Juvenal described the situation: "You can suffer as many deaths as there are open windows to pass under. So offer up a prayer that people will be content with just emptying out their slop bowls."

Augustus could not do much about the housing situation, although he did build aqueducts to bring more water into the city. He created a far larger administrative bureaucracy than before and oversaw it closely, guaranteeing its efficiency. But most of all he implemented an ambitious building program designed to provide elegant public spaces where city dwellers could escape from their cramped apartments. He once claimed that he had restored 82 temples in one year. But if he could boast, "I found a city of brick, and left it a city of marble," that was largely because he had put a lot of marble veneer over brick wall. By the second century CE, the city would be one of the most beautiful in the world, but the beauty was only skin-deep. The housing situation that Augustus inherited had barely improved.

Fig. 6.18 Aerial view of Colosseum, Rome. 72–80 cs. The opening performance at the Colosseum in 80 cs. lasted 100 days. During that time, 9,000 wild animals—lions, bears, snakes, boars, even elephants, imported from all over the empire—were killed, and so were 2,000 gladiators.

Public Works and Monuments Augustus inaugurated what amounted to an ongoing competition among the emperors to outdo their predecessors in the construction of public works and monuments. His ambitions are reflected in the work of the architect Vitruvius (flourished late first century BCE to early first century CE). A military engineer for Julius Caesar, under Augustus's patronage, Vitruvius wrote the 10-volume On Architecture. The only work of its kind to have survived from antiquity, it would become extremely influential over 1,000 years later, when Renaissance artists became interested in classical design. In its large scale, the work matches its patron's architectural ambitions, dealing with town planning, building materials and construction methods, the construction of temples, the classical orders, and the rules of proportion. Vitruvius also wrote extensively about one of Rome's most pressing problems—how to satisfy the city's needs for water. In fact, one of the most significant contributions of the Julio-Claudian dynasty, which extends from Augustus through Nero (r. 54-68 CE), was an enormous aqueduct, the Aqua Claudia. These aqueducts depended on Roman ingenuity in perfecting the arch and vault so that river gorges could be successfully spanned to carry the pipes bringing water to a city miles away. The Aqua Claudia delivered water from 40 miles away into the very heart of the city, not so much for private use as for the fountains, pools, and public baths. (See Materials & Techniques, page 196.)

The Colosseum Although Nero had overseen the completion of the Aqua Claudia, the end of his rule was tumultuous. First, fire destroyed a large portion of the insulae in 64 CE, but when Nero revealed that, in taking the opportunity to institute a new code of building safety to protect against future fires, he would also confiscate a large piece of land previously in private occupation for an enormous new house (the Golden House, as it became known) and spacious parks in the center of the city, rumors quickly circulated that he had set the fire himself and recited his own poems as the city burned. Taxes levied to support the new construction met with the disfavor of the upper classes, assassination attempts followed, Nero was declared a public enemy, and he subsequently committed suicide. He was succeeded by one of his own generals, Vespasian (r. 69–79 CE), the former commander in Palestine. Across from Nero's Golden House, Vespasian built the Colosseum (Fig. 6.18) so named in the Middle Ages after the Colossus, a 120-foot high statue of Nero as sun god that stood in front of it. A giant oval, 615 feet long, 510 feet wide, and 159 feet high, audiences of as many as 50,000 could enter or exit through its 76 vaulted arcades in a matter of minutes.

These vaults were made possible by the invention of concrete, which the Romans had increasingly used in their buildings since the second century BCE. Mixed with volcanic aggregate from nearby Naples and

Fig. 6.19 Detail of outer wall of Colosseum, Rome. 72–80 cs. The opening performance at the Colosseum in 80 cs lasted 100 days. Behind the archways entering the facade at ground level, barrel vaults ringed the oval arena, providing entrance into the arena. See *Materials & Techniques*, page 196.

Pompeii, it set more quickly and was stronger than any building material yet known. The Colosseum's wooden floor, the arena (Latin for "sand," which covered the floor), lay over a maze of rooms and tunnels that housed gladiators, athletes, and wild animals that entertained the masses. The top story of the building housed an awning system that could be extended on a system of pulleys and ropes to shield part of the audience from the hot Roman sun. Each level employed a different architectural order: the Tuscan order on the ground floor, the Ionic on the second, and the Corinthian, the Romans' favorite, on the third (Fig. 6.19). All of the columns are engaged and purely decorative, serving no structural purpose. The facade thus moves from the heaviest and sturdiest elements at the base to the lightest, most decorative at the top, a logic that seems both structurally and visually satisfying.

The Imperial Roman Forum The Colosseum stands at the eastern end of the Imperial Roman Forum. This vast building project was among the most ambitious undertaken in Rome by the Five Good Emperors. (See *Closer Look*, pages 194–195.)

CLOSER LOOK

he Forum Romanum, or Roman Forum, was the chief public square of Rome, the center of Roman religious, ceremonial, political, and commercial life. Originally, a Roman forum was comparable to a Greek agora, a meeting place in the heart of the city. Gradually, the forum took on a symbolic function as well, becoming a symbol of imperial power that testified to the prosperity—and peace—that the emperor bestowed upon Rome's citizenry. Julius Caesar was the first to build a forum of his own in 46 BCE, just to the north of the Forum Romanum. Augustus subsequently paved it over, restored its Temple of Venus, and proceeded to build his own forum with its Temple of Mars the Avenger. Thus began what amounted to a competition among successive emperors to outdo their predecessors by creating their own more spectacular forums. These imperial forums lined up north of and parallel to the great Roman Forum, which over the years was itself subjected to new construction. Stretched out along the Via dei Fori Imperiali (Street of Imperial Forums) were Vespasian's Forum of Peace (laid out after the Jewish War in 70 CE), the Forum of Nerva (completed in 97 CE), the Forum of Augustus, the Forum of Caesar, and the Forum of Trajan (completed by Hadrian, ca. 117 CE). The result was an extremely densely built city center. Trajan's was the last, largest, and most splendid forum. It sheltered the Column of Trajan, Trajan's Market, and the Basilica Ulpia—the largest basilica in the empire (see the discussion of the basilica in Chapter 8, page 260).

SEE MORE For a Closer Look at the *Forum Romanum* and Imperial Forums, go to **www.myartslab.com**

Something to Think About . . .

The shopping center at Caesar's Palace Hotel and Casino in Las Vegas, Nevada, is called The Forum. In what ways is a modern shopping mall comparable to the Roman Forum? In what important ways do they differ?

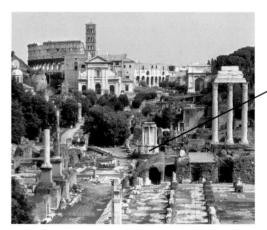

Contemporary view of the Forum Romanum. Little remains of the Forum Romanum but a field of ruins in the heart of the city. The rounded white columns are the ruins of the Temple of Vesta, one of the earliest buildings erected there.

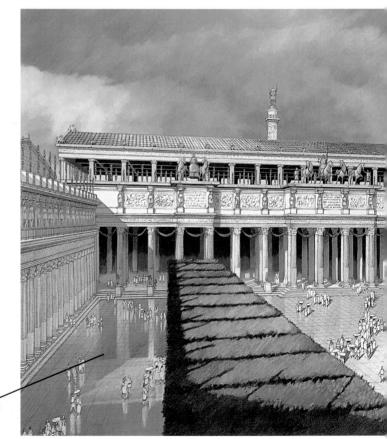

Forum of Trajan, Rome. 110–112 cs. Restored view by Gilbert Gorski. To make up for the destruction of a major commercial district that was required to construct his forum, Trajan commissioned a large marketplace. Like a contemporary mall, the market had 150 different shops on several levels.

The Forum Romanum and Imperial Forums

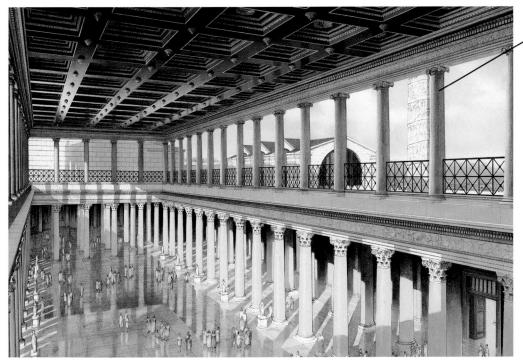

Reconstruction drawing of the central hall, Basilica Ulpia, Forum of Trajan, Rome. 113 cs. A basilica is a large, rectangular building with a rounded extension, called an apse, at one or both ends, and easy access in and out. It was a general-purpose building that could be adapted to many uses. Designed by Trajan's favorite architect, the Greek Apollodorus of Damascus, the Basilica Ulpia was 200 feet wide and 400 feet long. In a courtyard outside a door in the middle of the colonnade to the right stood the Column of Trajan. Relatively plain and massive on the outside, the basilica is distinguished by its vast interior space, which would later serve as the model for some Christian churches.

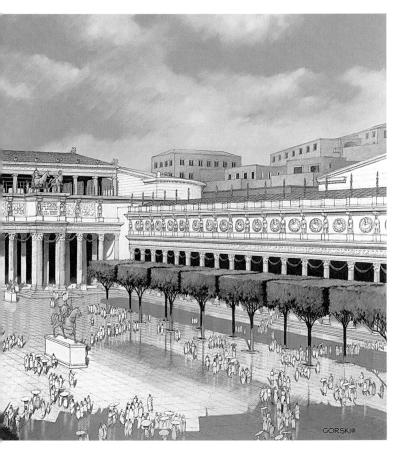

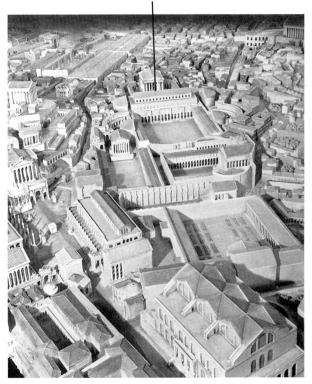

Materials & Techniques

Arches and Vaults

While the arch was known to cultures such as the Mesopotamians, the Egyptians, and the Greeks, it was the Romans who perfected it, evidently learning its principles from the Etruscans but developing those principles further. The Pont du Gard, a beautiful Roman aqueduct in southern France near the city of Nîmes, is a good example.

The Romans understood that much wider spans than the Etruscans had bridged could be achieved with the **round arch** than with post-and-lintel construction. The weight of the masonry above the arch is displaced to the supporting upright elements (**piers** or **jambs**). The arch is constructed on a temporary supporting scaffolding and is formed with wedge-shaped blocks, called **voussoirs**

[voo-swarrs], capped by a large, wedge-shaped stone, called the **keystone**, the last element put in place. The space inside the arch is called a **bay**. And the wall areas between the arches of an **arcade** (a succession of arches, such as seen on the Pont du Gard) are called **spandrels**.

When a round arch is extended, it forms a **barrel vault**. To ensure that the downward pressure from the arches does not collapse the walls, a **buttress** support is often added. When two barrel vaults meet one another at a right angle, they form a **groin** vault. The interior corridors of the Colosseum in Rome use both barrel and groin vaulting. Since all the stones in a vault must be in place to support the arched structure, the vault cannot be penetrated by windows.

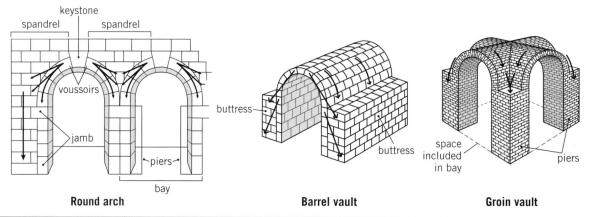

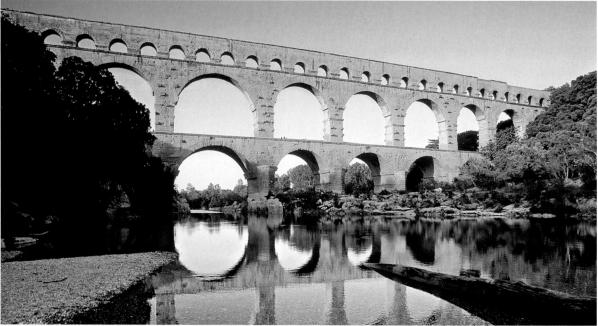

Pont du Gard, near Nîmes, France, late first century BCE—early first century CE. Height 180'. The Roman city of Nîmes received 8,000 to 12,000 gallons of water a day from this aqueduct.

LEARN MORE View an architectural simulation of the round arch at www.myartslab.com

Rome thrived under the rule of the Five Good Emperors: Nerva (r. 96–98 CE), Trajan (r. 98–117 CE), Hadrian (r. 117–138 CE), Antonius Pius (r. 138–161 CE), and Marcus Aurelius (r. 161–180 CE). The stability and prosperity of the city was due, at least in part, to the fact that none of these men except Marcus Aurelius had a son to whom he could pass on the empire. Thus, each was handpicked by his predecessor from among the ablest men in the Senate. When, in 180 CE, Marcus Aurelius's decadent and probably insane son, Commodus (r. 180–192 CE), took control, the empire quickly learned that the transfer of power from father to son was not necessarily a good thing.

Triumphal Arches and Columns During Vespasian's reign, his son Titus (r. 79–81 CE) defeated the Jews in Palestine, who were rebelling against Roman interference with their religious practices. Titus's army sacked the Second Temple of Jerusalem in 70 CE. To honor this victory and the death of Titus 11 years later, a memorial arch was constructed on the Sacred Way. Originally, the Arch of Titus was topped by a statue of a four-horse chariot and driver. Such arches, known as *triumphal arches* because triumphant armies marched through them, were composed of a simple barrel vault enclosed within a rectangle, and enlivened with sculpture and decorative engaged columns (Fig. **6.20**). They would deeply influence later

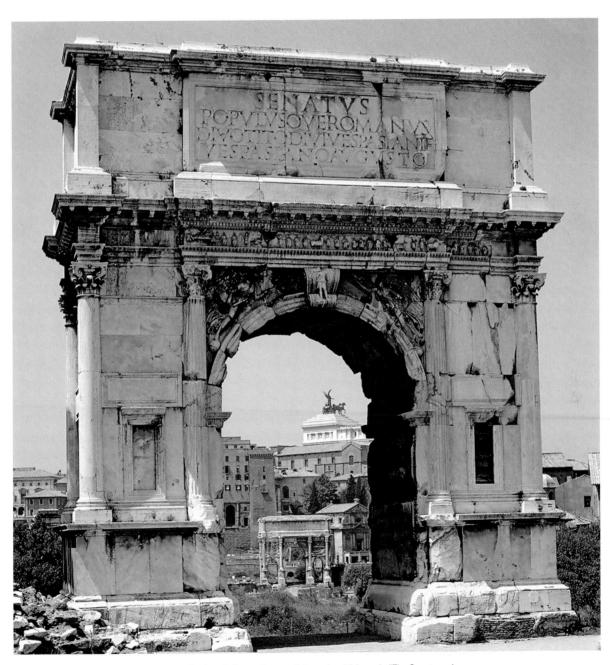

Fig. 6.20 Arch of Titus, Rome. ca. 81 cs. The inscription at the top of the arch, which reads "The Senate and the Roman people to the Deified Titus Vespasian Augustus, son of the the Deified Vespasian," was chiseled deeply into the stone, so that it might catch the light, allowing it to be read from a great distance.

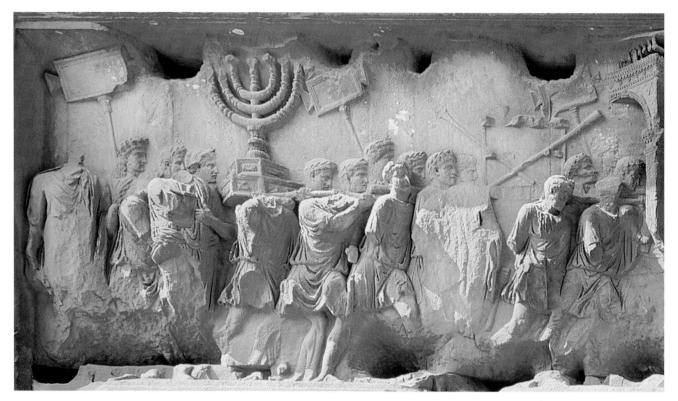

Fig 6.21 *Spoils from the Temple in Jerusalem,* a detail of the interior relief of the Arch of Titus. **ca. 81 ce.** Height of relief, approx. 7′ 10″. The figures in the relief are nearly life-size. The relief has been badly damaged, largely because in the Middle Ages, a Roman family used the arch as a fortress, constructing a second story in the vault. Holes for the floor beams appear at the top of the relief.

architecture, especially the facades of Renaissance cathedrals. Hundreds of arches of similar form were built throughout the Roman Empire. Most were not technically triumphal, but like all Roman monumental architecture, they were intended to symbolize Rome's political power and military might.

The Arch of Titus was constructed of concrete and faced with marble, its inside walls decorated with narrative reliefs. One of them shows Titus's soldiers marching with the treasures of the Second Temple in Jerusalem (Fig. 6.21). In the foreground, the soldiers carry what some speculate might be the golden Ark of the Covenant, and behind that a menorah, the sacred Jewish candelabrum, also made of gold. They bend under the weight of the gold and stride forward convincingly. The carving is extremely deep, with nearer figures and elements rendered with undercutting and in higher relief than more distant ones. This creates a sense of real space and, when light and shadow play over the sculptural relief, even a sense of real movement.

Another type of monument favored by the Romans and with similar symbolic meaning—suggestive not only of power but also of male virility—is the ceremonial column. Like the triumphal arch, it was a masonry and concrete platform for narrative reliefs. Two of the so-called Five Good Emperors who ruled Rome after the Flavian dynasty—Trajan and Marcus Aurelius—built columns to celebrate their military victories. Trajan's Column, perhaps the most complete

artistic statement of Rome's militaristic character, consists of a spiral of 150 separate scenes from his military campaign in Dacia, across the Danube River in what is now Hungary and Romania. If laid out end to end, the complete narrative would be 625 feet long (Fig. 6.22). At the bottom of the column, the band is 36 inches wide, at the top 50 inches, so that the higher elements might be more readily visible. In order to eliminate shadow and increase the legibility of the whole, the carving is very low relief. At the bottom of the column, the story begins with Roman troops crossing the Danube on a pontoon bridge (Fig. 6.23). A river god looks on with some interest. Battle scenes constitute less than a quarter of the entire narrative. Instead, we witness the Romans building fortifications, harvesting crops, participating in religious rituals. All in all, the column's 2,500 figures are carrying out what Romans believed to be their destiny—they are bringing the fruits of civilization to the world.

The Pantheon Hadrian's Pantheon ranks with the Forum of Trajan as one of the most ambitious building projects undertaken by the Good Emperors. The Pantheon (from the Greek pan, "all," and theoi, "gods") is a temple to "all the gods," and sculptures representing all the Roman gods were set in recesses around its interior. The facade is a Roman temple, originally set on a high podium, with its eight massive Corinthian columns and deep portico, behind which

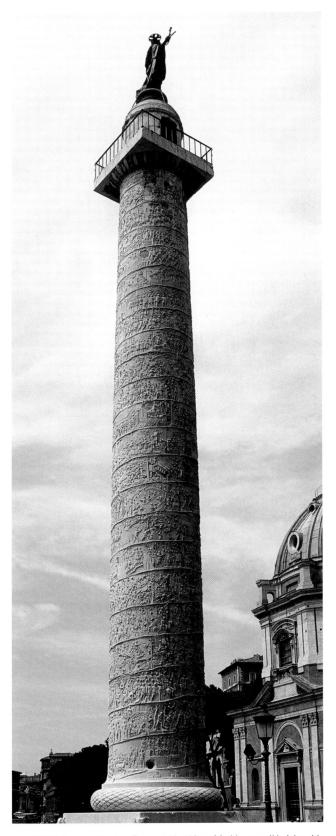

Fig. 6.22 Column of Trajan, Rome. 106–113 cs. Marble, overall height with base, 125'. Winding through the interior of the shaft is a staircase leading to a viewing platform on the top.

SEE MORE For a Closer Look at the Column of Trajan, go to www.myartslab.com

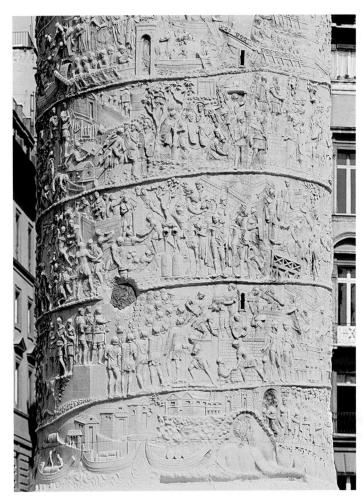

Fig. 6.23 Lower portion of the column of Trajan, Forum of Trajan, Rome. 106–113 cc. To the left of the second band, Trajan addresses his troops. To the right of that scene, his troops build a fortification.

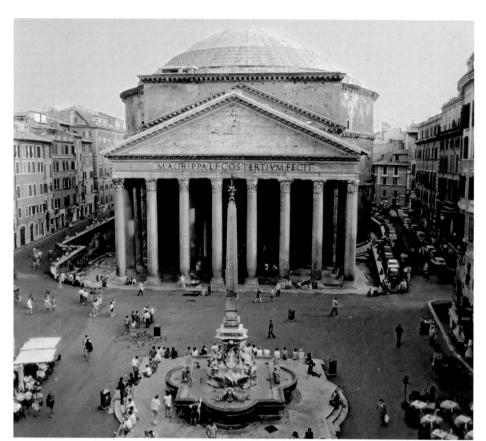

Fig. 6.24 The Pantheon, Rome. 118–125 ce.

The Pantheon is an impressive feat of architectural engineering, and it would inspire architects for centuries to come. However, Hadrian humbly (and politically) refused to accept credit for it. He passed off the building as a "restoration" of a temple constructed on the same site by Augustus's closest friend, colleague, and son-in-law, Marcus Agrippa, in 27 to 25 BCE. Across the architrave (the bottom element in an entablature above the columns) of the facade is an inscription that serves both propagandistic and decorative purposes: "Marcus Agrippa, son of Lucius, three times consul. made this."

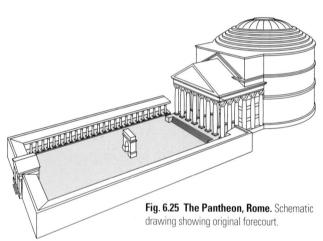

are massive bronze doors (Fig. 6.24). Photography presents little evidence of its monumental presence, elevated above its long forecourt (Fig. 6.25). Today, both the forecourt and the elevation have disappeared beneath the streets of modern Rome. Figure 6.24 shows the Pantheon as it looks today.

The facade gives no hint of what lies beyond the doors. The interior of the Pantheon consists of a cylindrical space topped by a dome, the largest built in Europe before the twentieth century (Fig. 6.26). The whole is a perfect hemisphere—the diameter of the rotunda is 144 feet, as is the height from floor to ceiling. The weight of the dome rests on eight massive supports, each more than 20 feet thick. The dome itself is 20 feet thick at the bottom but narrows to only 6 feet thick at the *oculus*, the circular opening at

the top. The *oculus* is 30 feet in diameter. Recessed panels, called **coffers**, further lighten the weight of the roof. The *oculus*, or "eye," admits light, which forms a round spotlight that moves around the building during the course of a day (it admits rain as well, which is drained out by small openings in the floor). For the Romans, this light may well have symbolized Jupiter's ever-watchful eye cast over the affairs of state, illuminating the way.

In the vast openness of its interior, the Pantheon mirrors the cosmos, the vault of the heavens. Mesopotamian and Egyptian architecture had created monuments with exterior mass. Greek architecture was a kind of sculptural event, built up of parts that harmonized. But the Romans concentrated on sheer size, including the vastness of interior space. Like the Basilica Ulpia (see *Closer Look*, pages 194–195) in the Forum of Trajan, the Pantheon is concerned primarily with realizing a single, whole, uninterrupted interior space.

In this sense, the Pantheon mirrors the empire. It, too, was a single, uninterrupted space, stretching from Hadrian's Wall in the north of England to the Rocks of Gibraltar in the south, across north Africa and Asia Minor, and encompassing all of Europe except what is now northern Germany and Scandinavia (see Map 6.1). Like Roman architecture, the empire was built up of parts that were meant to harmonize in a unified whole, governed by rules of proportion and order. And if the monuments the empire built to celebrate itself were grand, the empire was grander still.

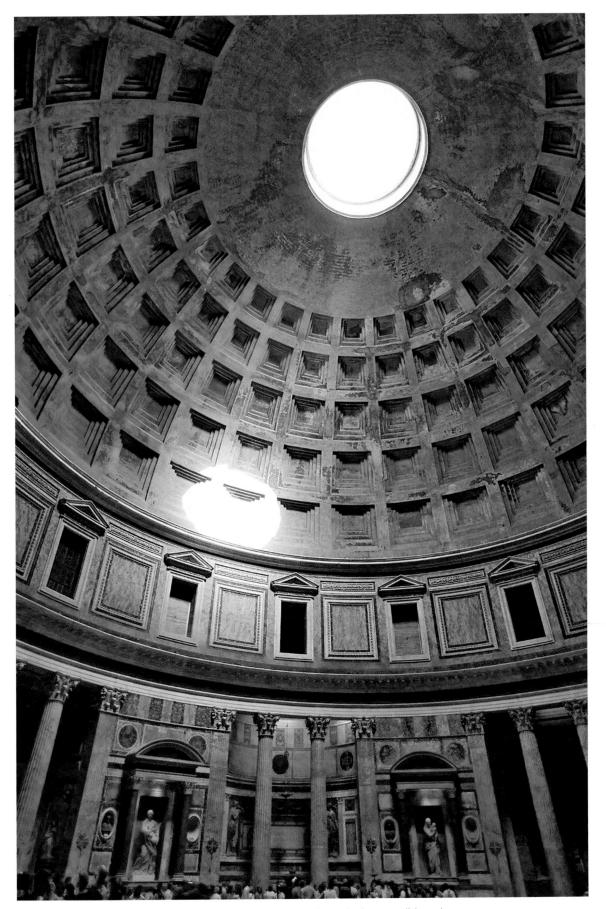

Fig. 6.26 The Pantheon, Rome. Interior. The sun's rays entering through the *oculus* form a spotlight on the Pantheon's interior, moving and changing intensity with the time of day.

Pompeii

In 79 CE, during the rule of the Emperor Titus, the volcano Vesuvius erupted southeast of Naples, burying the seaside town of Pompeii in 13 feet of volcanic ash and rock. Its neighbor city Herculaneum was covered in 75 feet of a ground-hugging avalanche of hot ash that later solidified. Living in retirement nearby was Pliny the Elder, a commander in the Roman navy and the author of *The Natural History*, an encyclopedia of all contemporary knowledge. At the time of the eruption, his nephew, Pliny the Younger (ca. 61–ca. 113 CE), was staying with him. This is his eyewitness account (**Reading 6.10**):

READING 6.10

from Letters of Pliny the Younger

On 24 August, in the early afternoon, my mother drew his attention to a cloud of unusual size and appearance. He had been out in the sun, had taken a cold bath, and lunched while lying down, and was then working at his books. He called for his shoes and climbed up to a place which would give him the best view of the phenomenon. It was not clear at that distance from which mountain the cloud was rising (it was afterwards known to be Vesuvius); its general appearance can best be expressed as being like an umbrella pine, for it rose to a great height on a sort of trunk and then split off into branches, I imagine because it was thrust upwards by the first blast and then left unsupported as the pressure subsided, or else it was borne down by its own weight so that it spread out and gradually dispersed. . . .

They debated whether to stay indoors or take their chance in the open, for the buildings were now shaking with violent shocks, and seemed to be swaying to and fro as if they were torn from their foundations. Outside on the other hand, there was the danger of falling pumice-stones, even though these were light and porous; however, after comparing the risks they chose the latter. In my uncle's case one reason outweighed the other, but for the others it was a choice of fears. As a protection against falling objects they put pillows on their heads tied down with cloths. . . .

We also saw the sea sucked away and apparently forced back by the earthquake: at any rate it receded from the shore so that quantities of sea creatures were left stranded on dry sand. On the landward side a fearful black cloud was rent by forked and quivering bursts of flame, and parted to reveal great tongues of fire, like flashes of lightning magnified in size. . . .

You could hear the shrieks of women, the wailing of infants, and the shouting of men; some were calling their parents, others their children or their wives, trying to recognize them by their voices. People bewailed their own fate or that of their relatives, and there were some who prayed for death in their terror of dying. Many besought the aid of the gods, but still more imagined there were no gods left, and that the universe was plunged into eternal darkness for evermore. . . .

Pliny's uncle, Pliny the Elder, interested in what was happening, made his way toward Vesuvius, where he died, suffocated by the poisonous fumes. Pliny the Younger, together with his mother, survived. Of the 20,000 inhabitants of Pompeii, 2,000 died, mostly slaves and the poor left behind by the rich who escaped the city after early warning shocks.

Much of what we know today about everyday Roman life is the direct result of the Vesuvius eruption. Those who survived left their homes in a hurry, and were unable to recover anything they left behind. Buried under the ashes were not only homes and buildings but also food and paintings, furniture and garden statuary, even pornography and graffiti. The latter include the expected—"Successus was here," "Marcus loves Spendusa"—but also the unexpected and perceptive—"I am amazed, O wall, that you have not collapsed and fallen, since you must bear the tedious stupidities of so many scrawlers." When Pompeii was excavated, beginning in the eighteenth century, many of the homes and artifacts were found to be relatively well preserved. The hardened lava and ash had protected them from the ravages of time. But eighteenth-century excavators also discovered something unexpected. By filling the hollows where the bodies of those caught in the eruption had decomposed, they captured images of horrific death.

Domestic Architecture: The Domus Although by no means the most prosperous town in Roman Italy, Pompeii was something of a resort, and, together with villas from other nearby towns, the surviving architecture gives us a good sense of the Roman domus—the townhouse of the wealthier class of citizen. The domus was oriented to the street along a central axis that extended from the front entrance to the rear of the house. The House of the Silver Wedding at Pompeii is typical in its design (Figs. 6.27 and 6.28). An atrium, a large space with a shallow pool for catching rainwater below its open roof, extends directly behind the vestibule. The atrium was the symbolic heart of the house: the location for the imagines (see Fig. 6.12) and the main reception area. Imagines were also housed in the reception rooms just off the main one, which in turn opens onto a central peristyle courtyard, surrounded by a colonnaded walkway. The dining room faces into the courtyard, as do a number of cubicula, small general-purpose rooms often used for sleeping quarters. At the back of the house, facing into the courtyard, is a hall furnished with seats for discussion. Servants probably lived upstairs at the rear of the house.

The domus was a measure of a Roman's social standing, as the vast majority lived in an apartment block or *insulae*. The house itself was designed to underscore the owner's reputation. Each morning, the front door was opened and left open. Gradually, the atrium would fill with clients—remember, the head of a Roman household was patron to many—who came to show their respect in a ritual known as the *salutatio* [sah-loo-TAH-tee-oh]. Passersby could look in to see the crowded atrium, and the patron himself was generally seated in the in the open area between the

Fig. 6.27 Atrium, House of the Silver Wedding,
Pompeii. First century BCE. This view looks through the
atrium to the main reception area and the peristyle court.
The house gets its name from the silver wedding
anniversary of Italy's King Humbert and his queen,
Margaret of Savoy, in 1893, the year it was excavated.
They actively supported archeological fieldwork at
Pompeii, which began in the mid-eighteenth century.

cubicula cubicula vestibule atrium

Fig. 6.28 Plan of the House of the Silver Wedding, Pompeii. First century BCE.

atrium and the peristyle courtyard, silhouetted by the light from the peristyle court behind. Surrounded by the busts of his ancestors, the symbol of his social position

and prestige, he watched over all who entrusted themselves to his patronage.

At the center of the Roman domus was the garden of the peristyle courtyard, with a fountain or pond in the middle. Thanks to the long-term research of the archeologist Wilhelmina Jashemski, we know a great deal about these courtyard gardens. At the House of G. Polybius [poe-LEE-bee-us] in Pompeii, excavators carefully removed ash down to the level of the soil on the summer day of the eruption in 79 CE, when the garden would have been in full bloom. They were able to collect pollen, seeds, and other evidence, including root systems (obtained by pouring plaster into the surviving cavities) and thus determine what plants and trees were cultivated in it. Polybius's garden was lined, at one end, with lemon trees in pots, which were apparently trained and pruned to cover the wall in an espalier—a geometric trellis. Cherry, pear, and fig trees filled the rest of the space. Gardens at other homes suggest that most were planted with nut- and fruit-bearing trees, including olive, which would provide the family with a summer harvest. Vegetable

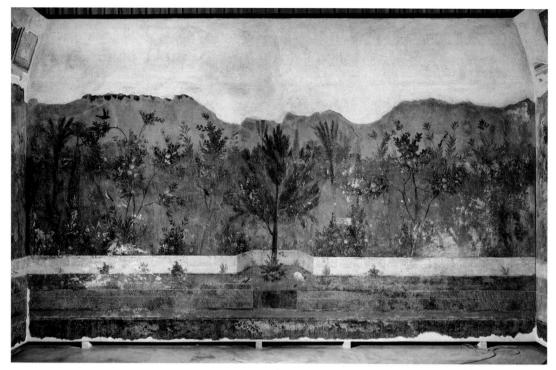

Fig. 6.29 *Garden Scene*, detail of a wall painting from the Villa of Livia at Primaporta, near Rome. Late first century BCE. Museo Nazionale Romano, Rome. The artist created a sense of depth by setting a wall behind a fence with its open gate.

gardens are sometimes found at the rear of the *domus*, a source of more fresh produce.

The garden also provided visual pleasure for the family. In the relatively temperate South Italian seaside climate, the garden was in bloom for almost three-quarters of the year. It was the focus of many rooms in the *domus*, which opened onto the garden. And it was evidently a symbol for the fertility, fecundity, and plenty of the household itself, for many a Roman garden was decorated with statuary referencing the cult of Dionysus.

Wall Painting Mosaics decorated many floors of the *domus*, and paintings adorned the walls of the atrium, the hall, the dining room, and other reception rooms throughout the villa. Artists worked with pigments in a solution of lime and soap, sometimes mixed with a little wax, polished with a special metal or glass, and then buffed with a cloth. Even the *cubicula* bedrooms were richly painted.

Writing in the second century CE, the satirist and rhetorician Lucian (ca. 120–after 180 CE) describes what he takes to be the perfect house—"lavish, but only in such degree as would suffice a modest and beautiful woman to set off her beauty." He continues, describing the wall paintings:

The . . . decoration—the frescoes on the walls, the beauty of their colors, and the beauty, exactitude and truth of each detail—might well be compared with the face of spring and with a flowery field, except that those things fade and wither and change and cast their beauty, while this is spring eternal, field unfading, bloom undying.

Just outside Rome, at the villa of Livia at Primaporta, a wall painting depicting a garden full of fresh fruit, songbirds, and flowers reflects this sensibility (Fig. 6.29). It is rendered as if it were an extension of the room itself, as if Livia and Augustus and their visitors could, at any time, step through the wall into their "undying" garden. Thus, although naturalistically rendered, it is an idealistic representation.

THE LATE ROMAN EMPIRE: MORAL DECLINE

Most of the late emperors were themselves "romanized" provincials. Both Trajan and Hadrian were born on the Iberian peninsula, near present-day Seville, and during his reign, Hadrian had the city redesigned with colonnaded streets and an amphitheater. Septimius Severus [sep-TIM-ee-us suh-VIR-us] (r. 193–211 CE) was African, and two of his successors were Syrian. Septimius Severus lavished an elaborate public works project on his hometown of Leptis Magna, on the coast just east of Tripoli in present-day Libya, giving the city a new harbor, a colonnaded forum, and an aisled basilica, the Roman meeting hall that would develop into the earliest architectural form of the Christian church.

In the third century CE, during the Severan [suh-VIR-un] Dynasty (193–235 CE), Rome's every amenity was imitated at its outposts, especially its baths. Septimius Severus began construction of enormous baths, dedicated in 217 by his son and successor, Caracalla [kar-uh-KAL-uh] (Fig. 6.30). The baths were set within a 50-acre walled park on the south side of the

Fig. 6.30 Baths of Caracalla, Rome. 211–217 cE. Rome's baths and public waterworks required enormous amounts of water. The city's 14 aqueducts brought 220 million gallons of pure spring water per day from the Apennines, the mountain chain that extends the length of the Italian peninsula. This water supplied 11 public baths, 856 private smaller baths, and 1,352 fountains and cisterns.

city and were fed by an aqueduct dedicated exclusively to this purpose. Although no ceilings survive, the vaulted central hall appears to have been 140 feet high. There were three bathing halls with a combined capacity of 1,600 bathers: the frigidarium [free-gee-DAR-ee-um] (cold bath), the tepidarium [te-pee-DAR-ee-um] (lukewarm bath), and the caldarium [cal-DAR-ee-um] (hot bath). There were two gymnasia (exercise rooms) on either side of the pools, as well a barbershop and a hair salon, sauna-like moist- and dry-heat chambers, and outdoor areas for sunbathing or exercising in the nude. Other amenities of the baths included libraries, a painting gallery, auditoriums, and, possibly, a stadium. Early in the fourth century, the emperor Diocletian [dy-uh-KLEE-shun] would build even more enormous and sumptuous baths at the northern end of the city. Although dedicated to public health and hygiene, the baths came to signal a general decline in the values that had defined Rome. Writing as early as the mid-first century CE, in his Moral Letters, Seneca complained that no one in his day could bathe in the simple ways of the great Republican general Scipio Africanus [SIP-ee-oh af-ruh-CAN-us], who had defeated Hannibal in 202 BCE (Reading 6.11):

READING 6.11

Seneca, Moral Epistles, Epistle 86

Who today could bear to bathe in such a fashion? We think ourselves poor and mean if our walls are not

resplendent with large and costly mirrors; if our marbles from Alexandria are not set off by mosaics of Numidian [noo-MID-ee-un] stone, if their borders are not faced over on all sides with difficult patterns, arranged in many colors like paintings; if our vaulted ceilings are not buried in glass; if our swimming pools are not lined with Thasian [THAY-zhun] marble, once a rare and wonderful sight in any temple. . . . What a vast number of statues, of columns that support nothing, but are built for decoration, merely in order to spend money! And what masses of water that fall crashing from level to level! We have become so luxurious that we will have nothing but precious stones to walk upon.

To many citizens at the time, such material excess signaled an atmosphere of moral depravity, inevitably associated with the public nudity practiced at the baths. In Carthage, the Christian writer Tertullian [tur-TUL-yun] (ca. 160–ca. 240 CE) had argued against the worldly pleasures of secular culture, as early as 197 CE, going so far as to propose the "rule of faith" over the rule of Roman law. By the early fourth century CE, Christians across the Empire forbade visitation to the baths, arguing that bathing might be practiced for cleanliness but not for pleasure. Thus would the Empire find itself defined in moral opposition to a growing religious community throughout its territories. With its moral authority challenged, its political power would inevitably be threatened as well.

264 BCE and lasted for over 100 years. Subsequently, whenever Rome conquered a region, it established permanent colonies and gave land to the victorious citizen-soldiers. During the first century, the powerfully eloquent and persuasive writing of the rhetorician Cicero helped to make Latin the chief language of the empire. His essay *On Duty* helped to define *pietas* as a Roman value. How is this value evidenced in the portrait busts of the era? How does Cicero's essay argue against the political state of affairs in Rome itself?

What was Imperial Rome?

In 27 BCE, the Senate granted Octavian the imperial name Augustus and the authority of *imperium* over all the *empire*. Why was Augustus idealized in the monumental statues dedicated to him? How did he present his wife Livia and his family to the public, and what values did he wish his family to embody?

Two Greek philosophical systems gained considerable Roman following—Epicureanism and, especially, Stoicism.

How would you describe these philosophies? Under Augustus Roman literature also thrived. Although the poetry of Catullus, Virgil, Horace, and Ovid are very different in character, their work could all be described as exploring the nature of Roman identity. Using their work as examples, can you describe that Roman identity?

But Augustus's greatest achievement, and that of the emperors to follow him, was the transformation of Rome into, in Augustus's words, "a city of marble." Why did the Roman emperors build so many public works? What did they symbolize or represent? In the private sphere, how does the architecture of the *domus* reflect Roman values?

Why did Rome decline?

By the third century, the Empire's material excess produced an atmosphere of decadence and depravity. Romans were no longer willing to make the sacrifices necessary to maintain their Empire. What was the appeal of Christianity as it came to supplant the rule of Roman law?

PRACTICE MORE Get flashcards for images and terms and review chapter material with quizzes at www.myartslab.com

GLOSSARY

apse A rounded extension at the end of a basilica.

arcade A succession of arches.

atrium An unroofed interior, or walled-in courtyard.

barrel vault A rounded vault formed when a round arch is extended.

basilica A large, rectangular building with an *apse* at one or both ends.

bay The space inside an arch.

buttress An architectural support usually formed by a projecting masonry structure.

coffer A recessed panel in a ceiling or dome.

dactyl An element of meter in poetry consisting of one long syllable followed by two short syllables.

dactylic hexameter A poetic verse consisting of six rhythmic units, or feet, each foot being either a dactyl or a spondee.

domus A traditional Roman house or villa.

Epicureanism A philosophy founded by Epicurus (341-270 BCE), who stressed clarity and simplicity of thought and believed that fear was responsible for all human misery.

foot A rhythmic unit in poetry.

groin The projecting line formed when two *barrel vaults* meet one another at a right angle.

jamb An upright structural support.

keystone A wedge-shaped stone at the top of an arch.

nave The central space of a *basilica*, usually flanked by aisles.

oculus A circular opening at the top of a dome.

ode A lyric poem of elaborate and irregular meter.

patrician A land-owning aristocrat.

peristyle courtyard A courtyard surrounded by a colonnaded walkway.

pier An upright structural support.

plebian A member of the poorer classes of ancient Rome.

podium An elevated platform.

rhetorician A writer or orator.

round arch A curved architectural support element that spans an opening.

sarcophagus (pl. sarcophagi) A coffin, usually of stone.

spandrel The areas between the arches of an arcade.

spondee An element of meter in poetry consisting of two long syllables.

Stoicism A practical philosophy that developed in the Athenian *stoa* and stressed rational detachment and practical, commonsense principles.

tumulus A round structure, partially excavated and partly aboveground, covered with earth.

Tuscan order A Classical architectural order composed of columns with unfluted shafts and a pedestal base.

verism A form of realism in art or literature.

voussoir A wedge-shaped block used to form an arch or vault.

READING 6.6

Catullus, Poems 5 and 43

Born in Verona, Catullus apparently arrived in Rome as a very young man. His poems were inspired directly by Greek Hellenistic models, as well as more classical Greek writers such as Sappho. The most famous of his works are the socalled Lesbia poems, written to a lover whom many believe to be Clodia, sister of a Roman patrician and senator, and notoriously adulterous wife of yet another Roman patrician. Poem 5 is the most famous of the Lesbia series, and Poem 43 is a good example of Catullus's wit, as he compares a prostitute to his beloved.

POEM 5

Lesbia.

live with me & love me so we'll laugh at all the sour-faced strictures of the wise. This sun once set will rise again, when our sun sets, follows night & an endless sleep. Kiss me now a thousand times & now a hundred more & then a hundred & a thousand more again till with so many hundred thousand kisses you & I shall both lose count nor any can from envy of so much kissing put his finger

of sweet kisses you of me & I of you darling, have had.

POEM 43

O elegant whore! with remarkably long nose unshapely feet lack lustre eyes

fat fingers

wet mouth and language not the choicest, you are I believe the mistress of the hell-rake Formianus.

And the Province calls you beautiful; they set you up beside my Lesbia. O generation witless and uncouth!

READING CRITICALLY

How does Catullus's Poem 43 compare to Roman statuary portraiture? What do his poems share with the poetry of Sappho? If the poems are addressed to other people, what do they reveal about Catullus himself? In other words, are they in some sense confessional?

READING 6.8

on the number

Virgil, from the Aeneid, Book IV

Modeled on the epics of Homer, Virgil's Aeneid opens in Carthage, where Aeneas and his men have been the guests of the Phoenician queen Dido. She has fallen in love with Aeneas, but he must, he knows, forge ahead to meet his destiny. The following passage opens as Dido begins to realize that he is preparing to desert her.

10

He is more than eager To flee that pleasant land, awed by the warning Of the divine command. But how to do it? How get around that passionate queen? What opening Try first? His mind runs out in all directions, Shifting and veering. Finally, he has it, Or thinks he has: he calls his comrades to him, The leaders, bids them quietly prepare The fleet for voyage, meanwhile saying nothing About the new activity; since Dido Is unaware, has no idea that passion As strong as theirs is on the verge of breaking,

He will see what he can do, find the right moment To let her know, all in good time. Rejoicing, The captains move to carry out the orders. Who can deceive a woman in love? The queen Anticipates each move, is fearful even While everything is safe, foresees this cunning, And the same trouble-making goddess, Rumor, Tells her the fleet is being armed, made ready For voyaging. She rages through the city Like a woman mad. . . . She waits no explanation from Aeneas; She is the first to speak: "And so, betrayer,

You hoped to hide your wickedness, go sneaking Out of my land without a word? Our love Means nothing to you, our exchange of vows, And even the death of Dido could not hold you. The season is dead of winter, and you labor Over the fleet; the northern gales are nothing-You must be cruel, must you not? Why, even, If ancient Troy remained, and you were seeking Not unknown homes and lands, but Troy again, Would you be venturing Troyward in this weather? I am the one you flee from: true? I beg you By my own tears, and your right hand—(I have nothing Else left my wretchedness)—by the beginnings Of marriage, wedlock, what we had, if ever I served you well, if anything of mine Was ever sweet to you, I beg you, pity A falling house; if there is room for pleading As late as this, I plead, put off that purpose. . . . There was nothing he could say. Jove bade him keep Affection from his eyes, and grief in his heart With never a sign. At last, he managed something:— "Never, O Queen, will I deny you merit Whatever you have strength to claim; I will not Regret remembering Dido, while I have Breath in my body, or consciousness of spirit. I have a point or two to make. I did not, Believe me, hope to hide my flight by cunning; I did not, ever, claim to be a husband, Made no such vows. If I had fate's permission To live my life my way, to settle my troubles At my own will, I would be watching over The city of Troy, and caring for my people, Those whom the Greeks had spared, and Priam's palace Would still be standing; for the vanguished people I would have built the town again. But now It is Italy I must seek, great Italy, Apollo orders, and his oracles Call me to Italy. There is my love, There is my country. . . . " Out of the corner of her eye she watched him During the first of this, and her gaze was turning Now here, now there; and then, in bitter silence, She looked him up and down; then blazed out at him:— "You treacherous liar! No goddess was your mother, No Dardanus the founder of your tribe, Son of the stony mountain-crags, begotten On cruel rocks, with a tigress for a wet-nurse! Why fool myself, why make pretense? What is there To save myself for now? When I was weeping Did he so much as sigh? Did he turn his eyes. Ever so little, toward me? Did he break at all, Or weep, or give his lover a word of pity? What first, what next? Neither Jupiter nor Juno Looks at these things with any sense of fairness. Faith has no haven anywhere in the world. He was an outcast on my shore, a beggar, I took him in, and, like a fool, I gave him Part of my kingdom; his fleet was lost, I found it, His comrades dying, I brought them back to life. I am maddened, burning, burning: now Apollo The prophesying god, the oracles Of Lycia, and Jove's herald, sent from heaven,

Come flying through the air with fearful orders,— Fine business for the gods, the kind of trouble That keeps them from their sleep. I do not hold you, I do not argue, either. Go. And follow Italy on the wind, and seek the kingdom Across the water. But if any gods Who care for decency have any power, They will land you on the rocks; I hope for vengeance, I hope to hear you calling the name of Dido Over and over, in vain. Oh, I will follow In blackest fire, and when cold death has taken Spirit from body, I will be there to haunt you, A shade, all over the world. I will have vengeance, And hear about it; the news will be my comfort 100 In the deep world below." She broke it off, Leaving the words unfinished; even light Was unendurable; sick at heart, she turned And left him, stammering, afraid, attempting To make some kind of answer. And her servants Support her to her room, that bower of marble, A marriage-chamber once; here they attend her, Help her lie down. And good Aeneas, longing To ease her grief with comfort, to say something 110 To turn her pain and hurt away, sighs often, His heart being moved by this great love, most deeply, And still—the gods give orders, he obeys them: He goes back to the fleet. And then the Trojans Bend, really, to their work, launching the vessels All down the shore. The tarred keel swims in the water, The green wood comes from the forest, the poles are lopped For oars, with leaves still on them. All are eager For flight; all over the city you see them streaming, Bustling about their business, a black line moving 120 The way ants do when they remember winter And raid a hill of grain, to haul and store it At home, across the plain, the column moving In thin black line through grass, part of them shoving Great seeds on little shoulders, and part bossing The job, rebuking laggards, and all the pathway Hot with the stream of work. And Dido saw them With who knows what emotion: there she stood On the high citadel, and saw, below her. 130 The whole beach boiling, and the water littered With one ship after another, and men yelling, Excited over their work, and there was nothing For her to do but sob or choke with anguish. There is nothing to which the hearts of men and women Cannot be driven by love. Break into tears, Try prayers again, humble the pride, leave nothing Untried, and die in vain. . . .

READING CRITICALLY

40

60

70

The tragedy here lies in the conflict between personal desire and civic duty. What metaphor does Virgil use to underscore the power of civic duty and responsibility to overcome the demands of human love? What does Dido do that demonstrates the opposite? How, for Virgil, do these alternatives seem to be driven by gender?

READING 6.9

Horace, Ode 13 from the Odes

Horace's Odes are lyric poems of elaborate and complex meter. Although they often extol the virtues of life on his rural estate outside Rome, in the following example Horace curses a tree that has unexpectedly crashed down, nearly killing him. It is an instance, among many others that he mentions, of the unanticipated but nevertheless real dangers of life. In the last half of the poem, he imagines that he has been killed, finding himself in the underworld with other lyric poets who give comfort to the dead with their verses.

The man who first planted thee did it upon an evil day and reared thee with a sacrilegious hand, O tree, for the destruction of posterity and the countryside's disgrace. I could believe that he actually strangled his own father and spattered his hearthstone with a guest's blood at dead of night; he too has dabbled in Colchic poisons and whatever crime is anywhere conceived—the man that set thee out on my estate, thou miserable stump, to fall upon the head of thy unoffending master. Man never heeds enough from hour to hour what he should shun. The Punic sailor dreads the Bosphorus, 1 but fears not the unseen fates beyond that threaten from other quarters. The soldier dreads the arrows of the Parthians and their swift retreat; the Parthian fears the chains and rugged strength of Italy; but the fatal violence that has snatched away, and again will snatch away, the tribes of men, is something unforeseen. 20 How narrowly did I escape beholding the realms of dusky Proserpine² and Aeacus³ on his judgment-seat, and the abodes set apart

and Sappho complaining on Aeolian lyre of her countrywomen, and thee, Aleaeus, rehearsing in fuller strain with golden plectrum⁴ the woes of a seaman's life, the cruel woes of exile, and the woes of war. The shades⁵ marvel at both as they utter words worthy of reverent silence; but the dense throng, shoulder to shoulder packed, drinks in more eagerly with

of reverent silence; but the dense throng, shoulder to shoulder packed, drinks in more eagerly with listening ear stories of battles and of tyrants banished. What wonder, when lulled by such strains, the hundred-headed monster lowers his black ears, and the serpents writhing in the locks of the Furies stop for rest!

Yea, even Prometheus and Pelops' sire⁶ are bequiled of their sufferings by the soothing

READING CRITICALLY

or the wary lynxes.

for the righteous,

Why do you suppose this poem has been described as "a defense of poetry"?

sound, nor does Orion⁷ care to chase the lions

¹Punic sailor dreads the Bosphorus, etc. (lines 14–19): each person fears the danger near at hand.

²Proserpine: wife of Pluto and queen of the underworld.

⁴**plectrum:** a device for plucking a stringed instrument, such as a lyre.

shades: souls of the dead in the underworld.

⁶Prometheus and Pelops' sire: Prometheus and Tantalus, both of whom received especially terrible punishments.

⁷Orion: a mighty hunter.

 $^{{}^3\}text{Aeacus:}$ A righteous king who, after his death, judges the souls who arrive in the underworld.

7

Other Empires

Urban Life and Imperial Majesty in China and India

THINKING AHEAD

What were early China's lasting contributions to Chinese civilization?

How was China unified as an empire?

How did religious outlooks shape ancient India?

he North China plain lies in the large, fertile valley of the Yellow River (Map 7.1). Around 7000 BCE, when the valley's climate was much milder and the land more forested than it is today, the peoples inhabiting this fertile region began to cultivate the soil, growing primarily millet. Archeologists recognize at least three separate cultural groups in this region during this period, distinguished by their different pottery styles and works in jade. As Neolithic tribal people, they used stone tools, and although they domesticated animals very early on, they maintained the shamanistic practices of their huntergatherer heritage. Later inhabitants of this region would call this area the "Central Plain" because they believed it was the center of their country. During the ensuing millennia, Chinese culture in the Central Plain coalesced in ways that parallel developments in the Middle East and Greece during the same period, as China transformed itself from an agricultural society into a more urban-centered state.

By the third century BCE, at about the same time that Rome began establishing its imperial authority over the Mediterranean world, the government of China was sufficiently unified that it could build a Great Wall (Fig. 7.1) across the hills north of the Central Plain to protect the realm from the intruding Central Asians who lived beyond its

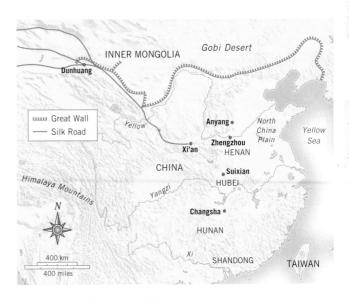

Map 7.1 Map of China. 1000-200 BCE.

northern borders. Some sections of the wall were already in place, built in previous centuries to protect local areas. These were rebuilt and connected to define a frontier stretching some 1,500 miles from northeast to northwest China. New roads and canal systems were built linking the entire nation, a

▼ Fig. 7.1 The Great Wall, near Beijing, China. Begun late third century BCE. Length approx. 4,100 miles, average height 25′. In the third century BCE, the Chinese Emperor Shihuangdi ordered his army to reconstruct, link, and augment walls on the northern frontier of China in order to form a continuous barrier protecting his young country from northern Mongol "barbarians."

HEAR MORE Listen to an audio file of your chapter at www.myartslab.com

large salaried bureaucracy was established, and a new imperial government headed by an emperor collected taxes, codified the law, and exerted control over a domain of formerly rival territories. Unification—first achieved here by the Qin dynasty—has remained a preeminent problem throughout China's long history.

This ritual jade disc, or *bi* [bee], made sometime in the fourth or third century BCE (Fig. 7.2), is emblematic of the continuity of Chinese historical traditions and ethnic identity. The earliest *bi* disks are found in burials dating from around 4000 BCE, and are thought to be part of the archaic paraphernalia of the shaman. While their original significance is unknown, by the time this one was made they were said to symbolize heaven. This example is deco-

rated with a dragon and two tigers, auspicious symbols likewise emerging from China's prehistoric past. The first part of this chapter surveys the rise of the Chinese culture into a unified state capable of such an enormous undertaking as the Great Wall as well as the artistic refinement of the jade *bi* disk seen here.

At the same time, another culture was developing in the river valleys of the Asian subcontinent of India. In both China and Innational literatures arose, as did religious and philosophical practices that continue to this day and are influential worldwide. But in the ancient world, East and West had not yet met. The peoples of the Mediterranean world and those living in the Yellow and Indus River valleys were isolated from one another. As trade routes stretched across the

Asian continent, these cultures would eventually cross paths. Gradually, Indian thought, especially Buddhism, would find its way into China, and Chinese goods would find their way to the West. Even more gradually, intellectual developments in ancient China and India, from Daoism to the teachings of Confucius [kun-FYOO-shus] and Buddha [BOO-duh], would come to influence cultural practice in the Western world. But throughout the period studied in this chapter, up until roughly 200 CE, the cultures of China and India developed independently of those in the West.

EARLY CHINESE CULTURE

Very few of the built edifices of ancient Chinese civilization have been found. We know that by the middle of the second millennium BCE, Chinese leaders ruled from large capitals, rivaling those in the West in their size and splendor. Beneath present-day Zhengzhou [juhng-joe], for instance, lies an early metropolitan center with massive earthen walls. Stone was scarce in this area, but abundant forests made wood plentiful, so it was used to build cities. As impressive as they were, cities built of wood were vulnerable to fire and military attack, and no sign of them remains. Nevertheless, we know a

fair amount about early Chinese culture from the remains of its written language and the tombs of its rulers. Even the most ancient Chinese writing—found on oracle bones and ceremonial bronze vessels—is closely related to modern Chinese.

And archeologists discovered that royal Chinese tombs, like Egyptian burial sites, contain furnishings, implements, luxury goods, and clothing that—together with the written record—give us a remarkably vivid picture of ancient China.

Chinese Calligraphy

Sometime during the Bronze Age, the Chinese developed a writing system that used individual pictographic characters to stand for distinct ideas and specific spoken words. According to Chinese legend, this writing system was invented by the culture-hero Fu Xi [foo shee] (who also taught the clans to hunt and fish), inspired by both the constellations and bird and animal footprints. Abundant surviving

examples of writing from around 1400 to 1200 BCE—engraved with a sharp point on oracle bones made of turtle plastrons and ox scapula—record answers received from the spirit world during rituals asking about the future. We

know as much as we do about the day-to-day concerns of the early Chinese rulers from these oracular fragments, on which a special order of priests, or diviners, posed questions of importance and concern (Fig. 7.3). They might ask about the harvest, the outcome of a war, the threat of flood, the course of an illness, or the wisdom of an administrative decision. To find answers, bones were heated with hot pokers, causing fissures to form with a loud crack. The patterns of these fissures were interpreted, and the bones were then inscribed. The first Chinese signs were pictograms, which, as in

dynasty, Warring States period, fourth—third century BCE. Jade, diameter 6 $\frac{1}{4}$ ". The Nelson-Atkins Museum of Art, Kansas City, Missouri. Purchase: Nelson Trust 33-81. This disc was discovered in a tomb, probably placed there because the Chinese believed that jade preserved the body from decay.

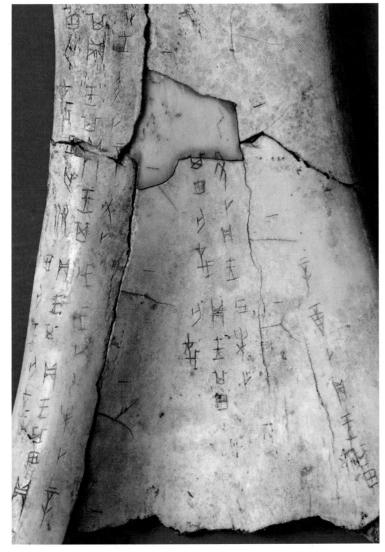

Fig. 7.3 Inscribed oracle bone. Shang period, ca. 1765-1122 BCE. The priests inscribed the characters representing the question from top to bottom in columns.

"middle," "field," "frontier," and "door.'

Fig. 7.4 Chinese characters. Shown are ancient characters (left) and modern ones (right). From top to bottom, they mean "sun," "mountain," "tree."

Mesopotamia, soon became stylized, particularly after the brush became the principal writing instrument (see Chapter 2, Closer Look, pages 38-39 for comparison.) The essence of Chinese written language is that a single written character has a fairly fixed significance, no matter how its pronunciation might vary over time or from place to place. This stability of meaning has allowed the Chinese language to remain remarkably constant through the ages. In the figure above right, 3,000 years separate the characters on the right from those on the left (Fig. 7.4).

The Shang Dynasty (ca. 1700–105 BCE)

Chinese records say that King Tang established the Shang dynasty. The Shang state was a linked collection of villages, stretching across the plains of the lower Yellow River valley. But it was not a contiguous state with distinct borders; other villages separated some of the Shang villages from

one another, and were frequently at war with the Shang. The royal family surrounded itself with shamans, who soon developed into a kind of nobility and, in turn, walled urban centers formed around the nobles' palaces or temples. The proliferation of bronze vessels, finely carved jades, and luxury goods produced for the Shang elite suggests that wellorganized centers of craft production were located nearby. The Shang nobility organized itself into armies—surviving inscriptions describe forces as large as 13,000 men—that controlled the countryside and protected the king.

The Book of Changes: The First Classic Chinese Text The Shang priests were avid interpreters of oracle bones. From a modern Western perspective, cracks in burnt bones are a matter of pure chance, but to the Shang, no event was merely random. The belief that the cosmos is pervaded by a greater logic and order lies at the heart of Chinese culture. In other words, there is no such thing as chance, and no transformation is without significance, not even a crack in a bone. The challenge lies in conducting one's affairs in accordance with the transformations of the cosmos.

The first classic of Chinese literature, *The Book of Changes*, or *Yi Jing*, compiled later from ideas that developed in the Shang era, is a guide to interpreting the workings of the universe. A person seeking to understand some aspect of his or her life or situation poses a question and tosses a set of straws or coins. The arrangement they make when they fall leads to one of 64 readings (or hexagrams) in the *Yi Jing*. (Fu Xi, the culture-hero who invented writing, is also said to have invented the eight trigrams that combine in pairs to form the 64 hexagrams.) Each hexagram describes the circumstances of the specific moment, which is, as the title suggests, always a moment of transition, a movement from one set of circumstances to the next. The *Yi Jing* prescribes certain behaviors appropriate to the moment. Thus, it is a book of wisdom.

This wisdom is based on a simple principle—that order derives from balance, a concept that the Chinese share with the ancient Egyptians. The Chinese believe that over time, through a series of changes, all things work toward a condition of balance. Thus, when things are out of balance, diviners might reliably predict the future by understanding that the universe tends to right itself. For example the eleventh hexagram, entitled *T'ai* [tie], or "Peace," indicated the unification of heaven and earth. The image reads:

Heaven and earth unite: the image of PEACE.

Thus the ruler

Fig. 7.5 Yin-yang

symbol.

Divides and completes the course of heaven and earth.

And so aids the people.

In fact, according to the Shang rulers, "the foundation of the universe" is based on the marriage of *Qian*

[chee-an] (at once heaven and the creative male principle) and *Kun* (the earth, or receptive female princi-

ple), symbolized by the Chinese symbol of yin-yang (Fig. 7.5). Yin is soft, dark, moist, and cool; yang is hard, bright, dry, and warm. The two combine to create the endless cycles of change, from night o day, across the four seasons of the

to day, across the four seasons of the year. They balance the five elements

(wood, fire, earth, metal, and water) and the five powers of creation (cold, heat, dryness, moisture, and wind). The yinyang sign, then, is a symbol of harmonious integration, the perpetual interplay and mutual relation among all things. And note that each side contains a circle of the same values as its opposite—neither side can exist without the other.

Shang Bronze The interlocking of opposites illustrated by the yin-yang motif is also present in the greatest artistic achievement of the Shang, their bronze casting. In order to cast bronze, a negative shape must be perfected first, into which the molten metal is then poured to make a positive

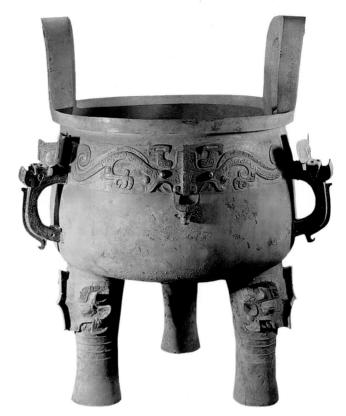

Fig. 7.6 Five-eared *ding* with dragon pattern. ca. 1200 BCE. Bronze, height 48", diameter at mouth, $32 \frac{1}{4}$ ". Chinhua County Cultural Museum. One of the key features of Shang bronze decoration is the bilateral symmetry of the animal motifs, suggesting the importance of balance and order in ancient Chinese culture.

shape. Through the manufacture of ritual vessels, the Shang developed an extremely sophisticated bronze-casting technology, as advanced as any ever used. Made for offerings of food, water, and wine during ceremonies of ancestor worship, these bronze vessels were kept in the ancestral hall and brought out for banquets. Like formal dinnerware, each type of vessel had a specific shape and purpose; the *ding* (Fig. 7.6), for example, was used for cooked food.

The conduct of the ancestral rites was the most solemn duty of a family head, with explicit religious and political significance. While the vessel shapes derived from the shapes of Neolithic pottery, in bronze they gradually became decorated with fantastic, supernatural creatures, especially dragons. For the Shang, the bronzes came to symbolize political power and authority. Leaders made gifts of bronze as tokens of political patronage, and strict rules governed the number of bronzes a family might possess according to rank. Like the oracle bones, many of these bronzes are inscribed with written characters.

At the last Shang capital and royal burial center, Yinxu [yin-shoo] (modern Anyang [ahn-yahng]), archeologists have unearthed the undisturbed royal tomb of Lady Fu Hao [foo how] (died ca. 1250 BCE), consort to the king Wu Ding. Consisting of a deep pit over which walled buildings were constructed as ritual sites to honor the dead, Lady Fu Hao's grave contained the skeletons of horses and dogs; about 440 cast and decorated bronzes,

which probably originally held food and drink; 600 jade objects; chariots; lacquered items; weapons; gold and silver ornaments; and about 7,000 cowrie shells, which the Shang used as money. One of the most remarkable objects found in her grave is an ivory goblet inlaid with turquoise (Fig. 7.7). Ivory was a local product, harvested from elephants that ranged, in the warmer Chinese climate of 3,000 years ago, much farther north than today. But the turquoise had to have come from far away. The goblet has a handle in the shape of a bird with a hooked beak, and a similar bird has been found far to the south in Sichuan province at a site roughly contemporary with Fu Hao's tomb, suggesting the jade's source. In addition, the turquoise inlay forms horned monsters with two bodies reminiscent of those seen on Shang bronze. As in Sumerian royal burials, Lady Fu Hao was not buried alone. The bodies of 16 people, apparently slaves, were found in the grave. Whether they submitted voluntarily to their deaths is a matter of pure conjecture.

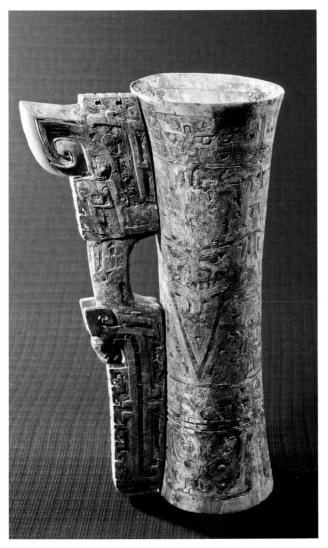

Fig. 7.7 Ivory goblet inlaid with turquoise. ca. 1200 BCE. Height 8". From Tomb 5, Xiaotun Locus North, at Yinxu, Anyang, Henan Province. Excavated in 1976. The Institute of Archaeology, Chinese Academy of Social Sciences, Beijing. Both the ivory and the turquoise inlay have been heavily restored.

Though geographically separate, the Bronze Age tombs of the Sumerians, Egyptians, Mycenaeans, and Shang demonstrate the widespread belief in life after death. They also testify to the enormous wealth that Bronze Age rulers were capable of accumulating.

The Zhou Dynasty (1027–256 BCE)

The Shang believed that their leaders were the sole conduit to the heavenly ancestors. However, in 1027 BCE, a rebel tribe known as the Zhou [joe] overthrew the Shang dynasty, claiming that the Shang had lost the Mandate of Heaven by not ruling virtuously. The Zhou asserted that the legitimacy of a ruler derived from divine approval, and that the Shang had lost this favor because of their decadent extravagances. Even so, the Zhou took measures to intermarry with the elite whom they had overthrown and took pains to conserve and restore what they admired of Shang culture. In fact, both the *Book of Changes* and the yin-yang symbol were originated by the Shang but codified and written down by the Zhou.

The Zhou ushered in an era of cultural refinement and philosophical accomplishment. One example is the oldest collection of Chinese poetry, the Book of Songs (Shi jing [she jee-ung]), still taught in Chinese schools today. According to tradition, government officials were sent into the countryside to record the lyrics of songs that expressed the feelings of the people. The collection that survives, first compiled by the Zhou, consists of 305 poems from between the eleventh and seventh centuries BCE. The poems address almost every aspect of life. There are love poems, songs celebrating the king's rule, sacrificial hymns, and folk songs. Descriptions of nature abound—over 100 kinds of plants are mentioned, as well as 90 kinds of animals and insects. Marriage practices, family life, clothing, and food are all subjects of poems. One of the oldest celebrates the harvest as an expression of the family's harmony with nature, the symbol that the family's ancestors are part of the same natural cycle of life and death, planting and harvest, as the universe as a whole (Reading 7.1a; for more selections from the Book of Songs, see Reading 7.1, page 237):

READING 7.1a

from the Book of Songs

Abundant is the year, with much millet, much rice; But we have tall granaries, To hold myriads, many myriads and millions of grain. We make wine, make sweet liquor, We offer it to ancestor, to ancestress, We use it to fulfill all the rites, To bring down blessings upon each and all.

Zhou Music The *Book of Songs* lists 29 different types of percussion, wind, and stringed instruments. The Chinese classified their instruments according to from which of

eight different materials they were made: bronze (bells), bamboo (flutes), bone (flutes), clay (simple wind instruments), animal skin (drums), calabash (mouth-organs), and wood (zithers and lutes with silk strings). Like the Shang, the Zhou were masterful bronze artisans, and they carried this mastery into crafting their bells. A magnificent set of bronze bells (Fig. 7.8), found in the tomb of Marquis Yi [MAR-kee yee] of Zeng [dzung], brother of the Zhou ruler, gives us some feeling for the accomplishment of the Zhou in both bronze and music. The carillon consists of 65 bells, each capable of producing two distinct tones when hit either at the center or the rim. Thus, musicians playing the carillon had 130 different pitches or notes (compared to 88 on a modern piano) available in octaves of up to 10 notes. Seven zithers, two pipes, three flutes, and three drums were also found in the tomb (together with the bodies of eight young women and a dog). It is reasonable to suppose that these bells and instruments were designed for ceremonial and ritual use, as well as the simple pleasure of Marquis Yi.

Spiritual Beliefs: Daoism and Confucianism The songs in the *Shi jing* are contemporary with the poems that make up the *Dao de jing* [dow duh jee-ung] (*The Way and Its Power*), the primary philosophical treatise, written in verse, of Daoism, the Chinese mystical school of thought. The *Dao* ("the way") is deeply embedded in nature, and to attain it, the individual must accord by it, by "not-doing." (It is said that those who speak about the Dao do not know of it, and those who know about the Dao, do not speak of it.) The book, probably composed in the third century BCE, is traditionally ascribed to Lao Zi [lou zuh] ("the Old One") who lived during the sixth

century BCE. In essence, it argues for a unifying principle in all nature, the interchangeability of energy and matter, a principle the Chinese call *qi* [chee]. The *qi* can be understood only by those who live in total simplicity, and to this end the Daoist engages in strict dietary practices, breathing exercises, and meditation. In considering such images as the one expressed in the following poem, the first in the volume, the Daoist finds his or her way to enlightenment (**Reading 7.2**):

READING 7.2

from the Dao de jing

There are ways but the Way is uncharted; There are names but not nature in words: Nameless indeed is the source of creation But things have a mother and she has a name.

The secret waits for the insight Of eyes unclouded by longing; Those who are bound by desire See only the outward container.

These two come paired but distinct By their names. Of all things profound, Say that their pairing is deepest, The gate to the root of the world.

The final stanza seems to be a direct reference to the principle of yin-yang, itself a symbol of the *qi*. But the chief argument here, and the outlook of Daoism as a whole, is that enlightenment lies neither in the visible world nor in

Fig. 7.8 Set of 65 bronze bells, from the tomb of Marquis Yi of Zeng, Suixian, Hubei. 433 BCE. Bronze, frame, frame height 9', length 25'. Hubei Provincial Museum, Wuhan. Each of these bells is inscribed with the names of its two notes and with a *taotie*, a masklike image combining animal and human features that is found on many ritual bronze objects. Similar half-animal half-human figures are painted on Marquis Yi's coffin, suggesting that the ancient Chinese connected the afterlife with these supernatural figures.

Fig. 7.9 Admonitions of the Imperial Instructress to Court Ladies (detail), attributed to Gu Kaizhi. Six Dynasties period, ca. 344–464 cE. Handscroll, ink, and colors on silk, $9\sqrt[3]{4} \times 11'6$ ". © The Trustees of the British Museum/Art Resource, NY. This handscroll, painted nearly 900 years after the death of Confucius, shows his impact on Chinese culture.

language, although to find the "way" one must, paradoxically, pass through or use both. Daoism thus represents a spiritual desire to transcend the material world.

If Daoism sought to leave the world behind, another great canon of teachings developed during the Zhou dynasty sought to define the proper way to behave *in* the world. For 550 years, from about 771 BCE to the final collapse of the Zhou in 221 BCE, China was subjected to ever greater political turmoil as warring political factions struggled for power. Reacting to this state of affairs was the man many consider China's greatest philosopher and teacher, Kong Fuzi [kung-fu-zuh], or, as he is known in the West, Confucius.

Confucius was born to aristocratic parents in the province of Shandong in 551 BCE, the year before Peisistratus [pie-SIS-trah-tus] came to power in Athens. By his early twenties, Confucius had begun to teach a way of life, now referred to as Confucianism, based on self-discipline and proper relations among people. If each individual led a virtuous life, then the family would live in harmony. If the family lived in harmony, then the village would follow its moral leadership. If the village exercised proper behavior toward its neighbor villages, then the country would live in peace and thrive.

Traditional Chinese values—values that Confucius believed had once guided the Zhou, such as self-control, propriety, reverence for one's elders, and virtuous behavior—lie at the core of this system. Tradition has it that Confucius compiled and edited *The Book of Changes*, *The Book of Songs* (which he edited down to 305 verses), and four other "classic" Chinese texts: *The Book of History*, containing speeches and pronouncements of historical rulers; *The Book of Rites*, which is essentially a code of conduct; *The Spring and Autumn Annals*, a history of China up to the fifth century BCE; and a lost treatise on music.

Confucius particularly valued *The Book of Songs*. "My little ones," he told his followers, "why don't you study the

Songs? Poetry will exalt you, make you observant, enable you to mix with others, provide an outlet for your vexations; you learn from it immediately to serve your parents and ultimately to serve your prince. It also provides wide acquaintance with the names of birds, beasts, and plants."

After his death, in 479 BCE, Confucius's followers transcribed their conversations with him in a book known in English as the Analects. (For a selection, see Reading 7.3 on page 238.) Where the Dao de jing is a spiritual work, the Analects is a practical one. At the heart of Confucius's teaching is the principle of li [lee]—propriety in the conduct of the rites of ancestor worship. The courtesy and dignity required when performing the rites lead to the second principle, ren, or benevolent compassion and fellow feeling, the ideal relationship that should exist among all people. Based on respect for oneself, ren extends this respect to all others, manifesting itself as charity, courtesy, and above all, justice. De [duh], or virtue, is the power of moral example that an individual, especially a ruler, can exert through a life dedicated to the exercise of *li* and *ren*. Finally, wen, or culture, will result. Poetry, music, painting, and the other arts will all reveal an inherent order and harmony reflecting the inherent order and harmony of the state. Like an excellent leader, brilliance in the arts illuminates virtue. The Chinese moral order depended not upon divine decree or authority, but instead upon the people's own right actions. A scene from a painted handscroll of a later period, known as Admonitions of the Imperial Instructress to Court Ladies (Fig. 7.9), illustrates a Confucian story of wifely virtue and proper behavior. As the viewer unrolled the scroll (handscrolls were not meant to be viewed all at once, as displayed in modern museums, but unrolled right to left a foot or two at a time, as a tabletop might allow), he or she would observe a bear, who having escaped from his cage threatens the Emperor, seated at the right. Until two guards arrive to try to keep the bear at bay, Lady Feng [fung] has stepped forward, courageously placing herself between the bear and her lord. She illustrates the fifth rule of Confucian philosophy—yi [yee], or duty, the obligation of the wife to her husband and of the subject to her ruler.

Its emphasis on respect for age, authority, and morality made Confucianism extremely popular among Chinese leaders and the artists they patronized. It embraced the emperor, the state, and the family in a single ethical system with a hierarchy that was believed to mirror the structure of the cosmos. As a result, the Han [hahn] dynasty (206 BCE-220 CE) adopted Confucianism as the Chinese state religion, and a thorough knowledge of the Confucian classics was subsequently required of any politically ambitious person. Despite the later ascendancy among intellectuals of Daoism and Buddhism (which would begin to flourish in China after the collapse of the Han dynasty, Confucianism continued to be the core of civil service training in China until 1911, when the Chinese Republic ended the dynastic system. Even though Mao Zedong [mao zuh-dong], chairman of the Chinese Communist Party from 1945 until his death in 1976, conducted a virulent campaign against Confucian thought, many in China now believe that Confucianism offers the most viable alternative to the nation's political status quo. In fact, the noncommunist "Little Dragons" of East Asia—Hong Kong, Singapore, Taiwan, and South Korea—would all attribute their economic success in the 1980s to their Confucian heritage.

IMPERIAL CHINA

At the same time that Rome rose to dominance in the West (see Chapter 6), a similar empire arose in China. But whereas Rome's empire derived from outward expansion, China's empire arose from consolidation at the center. From about the time of Confucius onward, seven states vied for control. They mobilized armies to battle one another; iron weapons replaced bronze; they organized bureaucracies and established legal systems; merchants gained political power; and a "hundred schools of thought" flowered.

The Qin Dynasty (221–206 BCE): Organization and Control

This period of warring states culminated when the western state Qin [chin] (the origin of our name for China) conquered the other states and unified them under the Qin empire in 221 BCE. Under the leadership of Qin Shihuangdi [chin shuh-hwang-dee] (r. 221–210 BCE), who declared himself "First Emperor," the Qin worked very quickly to achieve a stable society. To discourage nomadic invaders from the north, they built a wall from the Yellow Sea east of modern Beijing far into Inner Mongolia, known today as the Great Wall of China (see Fig. 7.1).

The wall was constructed by soldiers, augmented by accused criminals, civil servants who found themselves in

disfavor, and conscripts from across the countryside. Each family was required to provide one able-bodied adult male to work on the wall each year. It was made of rammed earth, reinforced by continuous, horizontal courses of brushwood, and faced with stone. Watchtowers were built at high points, and military barracks were built in the valleys below. At the same time, the Chinese constructed nearly 4,350 miles of roads, linking even the furthest reaches of the country to the Central Plain. By the end of the second century CE, China had some 22,000 miles of roads serving a country of nearly 1.5 million square miles.

Such massive undertakings could only have been accomplished by an administrative bureaucracy of extraordinary organizational skill. Indeed, in the 15 years that the Qin ruled China, the written language was standardized, a uniform coinage was introduced, all wagon axles were required to be the same width so that they would uniformly fit in the existing ruts on the Chinese roads (thus accommodating trade and travel), a system of weights and measures was introduced, and the country was divided into the administrative and bureaucratic provinces much as they exist to the present day.

Perhaps nothing tells us more about Qin organization and control than the tomb of its first emperor, Qin Shihuangdi (see *Closer Look*, pages 222–223). When he died, battalions of life-size earthenware guards in military formation were buried in pits beside his tomb. (More than 8,000 have been excavated so far.) Like the Great Wall, this monumental undertaking required an enormous workforce, and we know that the Qin enlisted huge numbers of workers in this and its other projects.

The Philosophy of Han Feizi To maintain control, in fact, the Qin suppressed free speech, persecuted scholars, burned classical texts, and otherwise exerted absolute power. They based their thinking on the writings of Han Feizi [hahn-faydzuh], who had died in 233 BCE, just before the Qin took power. Orthodox Confucianism had been codified by Meng-zi [mung-dzuh], known as Mencius [men-shus] (ca. 370–300 BCE), an itinerant philosopher and sage who argued for the innate goodness of the individual. He believed that bad character was a result of society's inability to provide a positive, cultivating atmosphere in which individuals might realize their capacity for goodness. Han Feizi, on the other hand, argued that human beings were inherently evil and innately selfish (exactly the opposite of Mencius's point of view). Legalism, as Han Feizi's philosophy came to be called, required that the state exercise its power over the individual, because no agency other than the state could instill enough fear in the individual to elicit proper conduct. The Qin Legalist bureaucracy, coupled with an oppressive tax structure imposed to pay for their massive civil projects, soon led to rebellion, and after only 15 years in power, the Qin collapsed.

The Han Dynasty (206 BCE-220 CE): The Flowering of Culture

In place of the Qin, the Han dynasty came to power, inaugurating over 400 years of intellectual and cultural growth. The Han emperors installed Confucianism as the official state philosophy and established an academy to train civil servants. Where the Qin had disenfranchised scholars, the Han honored them, even going so far as to give them an essential role in governing the country.

Han prosperity was constantly threatened by incursions of nomadic peoples to the north, chiefly the Huns, whom the Chinese called Xiongnu [she-ong-noo], and whose impact would later be felt as far away as Rome. In 138 BCE, Emperor Wu (r. 141–87 BCE) attempted to forge military alliances with Huns, sending General Zhang Qian [jahng chee-an] with 100 of his best fighting men into the northern territories. The Huns held General Zhang captive for ten years. When he returned, he spoke of horses that were far stronger and faster than those in China. Any army using them, he believed, would be unbeatable. In fact, horses could not be bred successfully in China owing to a lack of calcium in the region's water and vegetation, and until General Zhang's report, the Chinese had known horses only as small, shaggy creatures of Mongolian origin. To meet the Huns on their own terms, with cavalry instead of infantry, China needed horses from the steppes of western Asia.

"The Heavenly Horses" A small bronze horse found in the tomb of General Zhang at Wuwei [woo-way] in Gansu [gahnsoo] represents the kind of horse to which the Chinese aspired (Fig. 7.10). Its power is captured in the energetic lines of its composition, its flaring nostrils and barreled chest. But it is, simultaneously, perfectly, almost impossibly, balanced on one leg, as if defying gravity, having stolen the ability to fly from the bird beneath its hoof. In 101 BCE, the Emperor Wu, awaiting delivery of 30 such horses in the Chinese capital of Chang'an [chahng-ahn], composed a hymn in their honor (Reading 7.4):

READING 7.4

from Emperor Wu's "Heavenly Horses"

The Heavenly Horses are coming, Coming from the Far West...
The Heavenly Horses are coming Across the pastureless wilds
A thousand leagues at a stretch,
Following the eastern road...
Should they choose to soar aloft,
Who could keep pace with them?
The Heavenly Horses are coming...

Fig. 7.10 Flying Horse Poised on One Leg on a Swallow, from the tomb of Governor-General Zhang at Wuwei, Gansu. Late Han dynasty, second century cE. Bronze, $13^{1/2}$ " \times 17 $^{3/4}$ ". Gansu Provincial Museum. According to Chinese tradition, these horses sweated blood, perhaps the result of a parasitic infection. The Chinese, incidentally, also imported grass seed to feed these horses.

CLOSER LOOK

ne day in 1974, peasants digging a well on the flat plain 1,300 yards east of the huge Qin dynasty burial mound of the Emperor Qin Shihuangdi in the northern Chinese province of Shaanxi [shahn-shee] unearthed parts of a life-size clay soldier—a head, hands, and body. Archeologists soon discovered an enormous subterranean pit beneath the fields containing an estimated 6,000 infantrymen, most standing four abreast in eleven parallel trenches paved with bricks. In 1976 and 1977, two smaller

but equally spectacular sites were discovered north of the first one, containing another 1,400 individual warriors and horses, complete with metal weaponry.

Qin Shihuangdi's actual tomb has never been excavated. It rises 140 feet above the plain. Historical records indicated that below the mound is a subterranean palace estimated to be about 400 feet by 525 feet. According to the *Shi Ji* [shr jee] (*Historical Records*) of Sima Qian [shee-mah chee-an], a scholar from the Han dynasty, the emperor was buried there

The Tomb of Qin Shihuangdi

in a bronze casket surrounded by a river of mercury. Scientific tests conducted by Chinese archeologists confirm the presence of large quantities of mercury in the soil of the burial mound. Magnetic scans of the tomb have also revealed large numbers of coins, suggesting the emperor was buried with his treasury.

Something to Think About . . .

Why do you suppose this ceramic army was deployed outside the tomb of Qin Shihuangdi and not in it?

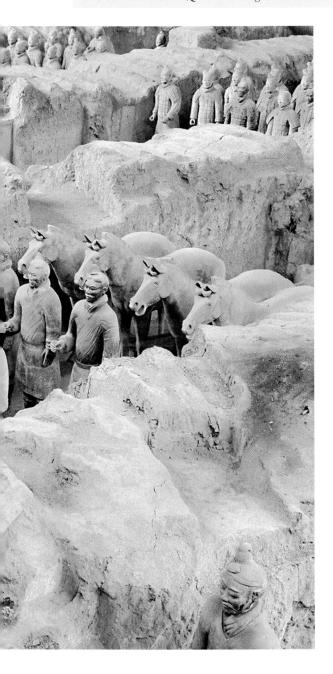

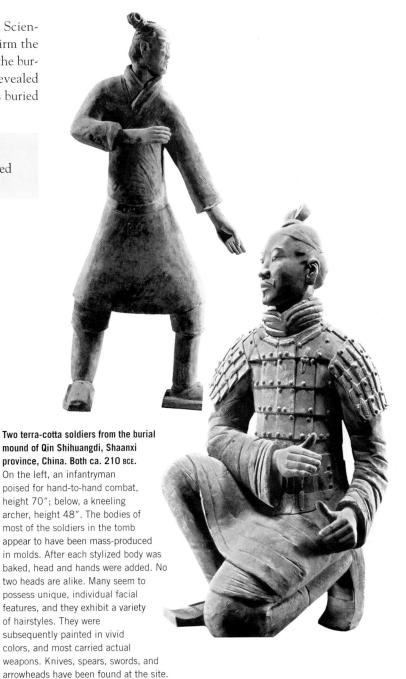

Soldiers and horses, from the pits near the tomb of Emperor Qin Shihuangdi, Lintong, Shaanxi, China. Qin dynasty, ca. 210 BCE.
Terra-cotta, life-size. The practice of fashioning clay replicas of humans for burial at mausoleum sites replaced an earlier practice of actual human sacrifice. Over 700,000 people were employed in preparing the tomb.

SEE MORE For a Closer Look at the Tomb of Shihuangdi, go to www.myartslab.com

Han Poetry Under Emperor Wu, Chinese literary arts flourished. In 120 BCE, he established the Yue fu [yoo-eh foo], the so-called Music Bureau, which would come to employ some 829 people charged with collecting the songs of the common people. The folk style of the *yuefu* songs was widely imitated, both by court poets during the Han and throughout the history of Chinese poetry. The lines are of uneven length, although often of five characters, and emphasize the joys and vicissitudes of daily life. A case in point is a poem by Liu Xijun [lee-ooh shee-june], a Chinese princess who, around 110 BCE, was married for political reasons to the chief of the Wusun, a band of nomads who lived in the steppes of northwest China. Her husband, as it turned out when she arrived, was old and decrepit, spoke almost no Chinese, and by and large had nothing to do with her, seeing her every six months or so. This is her "Lament" (Reading 7.5):

READING 7.5

Liu Xijun, "Lament"

My family married me off to the King of the Wusun. and I live in an alien land a million miles from nowhere. My house is a tent, My walls are of felt. Raw flesh is all I eat, with horse milk to drink. I always think of home and my heart strings, O to be a yellow snow-goose floating home again!

The poem's last two lines—what might be called the flight of Liu Xijun's imagination—are typical of Chinese poetry, where time and again the tragic circumstances of life are overcome through an image of almost transcendent natural beauty.

As Liu Xijun's poem suggests, women poets and scholars were common—and respected—during the Han dynasty. But as the circumstances surrounding Liu Xijun's poem also suggest, women did not enjoy great power in society. The traditional Chinese family was organized around basic Confucian principles: Elder family members were wiser, and therefore superior to the younger, and males were superior to females. Thus, while a grandmother might hold sway over her grandson, a wife owed unquestioning obedience to her husband. The unenviable plight of women is the subject of a poem by Fu Xuan [foo schwan], a male poet of the late Han dynasty who apparently was one of the most prolific poets of his day, although only 63 of his poems survive (Reading 7.6):

READING 7.6

Fu Xuan, "To Be a Woman"

It is bitter to be a woman, the cheapest thing on earth.

A boy stands commanding in the doorway like a god descended from the sky. His heart hazards the four seas, thousands of miles of wind and dust. but no one laughs when a girl is born. The family doesn't cherish her. When she's a woman she hides in back rooms, scared to look a man in the face. They cry when she leaves to marry a brief rain, then mere clouds. Head bowed she tries to compose her face. her white teeth stabbing red lips. She bows and kneels endlessly, even before concubines and servants. If their love is strong as two stars she is like a sunflower in the sun. but when their hearts are water and fire a hundred evils descend on her. The years change her jade face and her lord will find new lovers. Who were close like body and shadow will be remote as Chinese and Mongols. Sometimes even Chinese and Mongols meet but they'll be far as polar stars.

The poem is notable for the acuity and intensity of its imagery—her "white teeth stabbing red lips," the description of a close relationships as "like body and shadow," and, in the last lines, the estrangement of their relationship to a point as far apart as "polar stars," farther apart even than the Chinese and Mongols. (And who, one must ask, is more like the barbarian hordes, the male or the female?)

Han Architecture What we know about the domestic setting of Han dynasty society we can gather mostly from surviving poetic images describing everyday life in the home, but our understanding of domestic architecture derives from ceramic models. A model of a house found in a tomb, presumably provided for the use of the departed in the afterlife, is four stories high and topped by a watchtower (Fig. 7.11). The family lived in the middle two stories, while livestock, probably pigs and oxen, were kept in the gated lower level with its courtyard extending in front of the house.

Architecturally, the basic form of the house is commonly found across the world—rectangular halls with columns supporting the roof or the floor above. The walls serve no weight-bearing function. Rather, they serve as screens separating the inside from the outside, or one interior room from another. Distinctive to Chinese architecture are the broad eaves of the roof, which would become a standard feature of East Asian construction. Adding playful charm is the elaborate decoration of the facade, including painted trees flanking the courtyard.

Han Silk Aside from their military value, horses advanced the growth of trade along the Silk Road. Nearly 5,000 miles long, this trade route led from the Yellow River valley to the Mediterranean, and along it, the

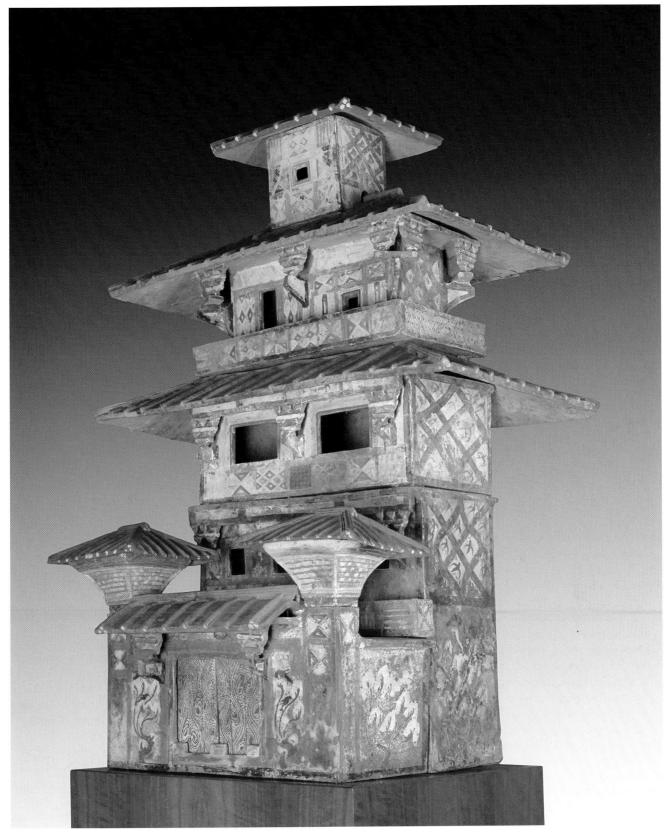

Fig. 7.11 Model of a House, Eastern Han Dynasty (25-200 c.e.), 1st century c.e. Painted earthenware with unfired coloring, $52 \times 33 \frac{1}{2} \times 27$ " (132.1 \times 85.1 \times 68.6 cm) The Nelson-Atkins Museum of Art, Kansas City, Missouri. This is one of the largest and most complete models of a Han house known.

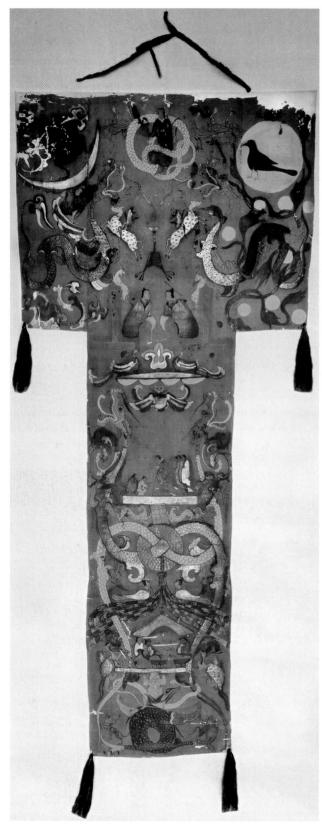

Fig. 7.12 Painted banner from the tomb of the wife of the Marquis of Dai, Mawangdui, Changsha, Hunan. Han dynasty, ca. 160 BCE. Colors on silk, height $6'8^{1}/2''$. Hunan Provincial Museum. The banner was found in the innermost of the nested coffins opened in 1972.

Chinese traded their most exclusive commodity, silk. (See Continuity & Change, page 235.) The quality of Han silk is evident in a silk banner from the tomb of the wife of the Marquis of Dai, discovered on the outskirts of present-day Changsha [chahng-shah] in Hunan [hoonahn] (Fig. 7.12). Painted with scenes representing the underworld, the earthly realm, and the heavens, it represents the Han conception of the cosmos. Long, sinuous lines representing dragons' tails, coiling serpents, longtailed birds, and flowing draperies unify the three realms. In the right corner of the heavenly realm, above the crossbar of the T, is an image of the sun containing a crow, and in the other corner is a crescent moon supporting a toad. Between them is a deity entwined within his own long, red serpent tail. The deceased noblewoman herself stands on the white platform in the middle region of the banner. Three attendants stand behind her and two figures kneel before her, bearing gifts. On a white platform in the lower realm, bronze vessels contain food and wine for the deceased.

Papermaking and Other Han Technologies One of the important characteristics of Han poetry is that, as opposed to the poems in the Book of Songs, many poems did not emerge out of oral traditions but originated as written works. In the West, the limitations of papyrus as a writing medium had led to the invention of parchment at Pergamon (see Chapter 5), but the Chinese invention of cellulose-based paper in 105 CE by Cai Lun [tsai lwun], a eunuch and attendant to the Imperial Court who held a post responsible for manufacturing instruments and weapons, enabled China to develop widespread literacy much more rapidly than the West. Paper made of hemp had already been produced by the Han for over 200 years, but Cai Lun improved both the techniques used and its quality while using a variety of materials, such as tree bark, hemp, and rags. Although modern technologies have simplified the process, his method remains basically unchanged—the suspension in water of softened plant fibers that are formed in moulds into thin sheets, couched (pressed), drained, and then dried.

The Han were especially inventive. Motivated by trade, the Han began to make maps, becoming the world's first cartographers. They invented important agricultural technologies such as the wheelbarrow and horse collar. They learned to measure the magnitude of earthquakes with a crude but functional seismograph. But persistent warring with the Huns required money to support military and bureaucratic initiatives. Unable to keep up with increased taxes, many peasants were forced off the land and popular rebellion ensued. By the third century CE, the Han dynasty had collapsed. China reentered a period of political chaos lasting from 220 until 589 CE, when imperial rule finally regained its strength.

ANCIENT INDIA

Indian civilization was born along the Indus [IN-duhs] River in the northwest corner of the Indian subcontinent in present-day Pakistan somewhere around 2700 BCE in an area

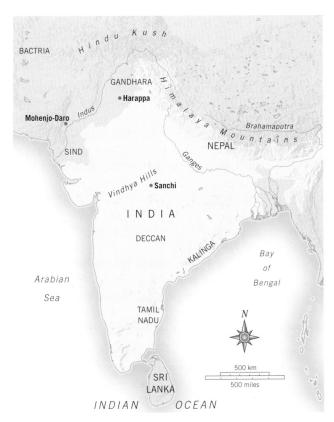

Map 7.2 India around 1500 BCE. Cut off from the rest of Asia by high mountains to the north, India was nevertheless a center of trade by virtue of its prominent maritime presence.

known as Sind—from which the words *India* and *Hindu* originate (see Map 7.2). The earliest Indian peoples lived in at least two great cities in the Indus valley, Mohenjo-Daro [moh-HEN-joh-DAR-oh], on the banks of the Indus, and Harappa [huh-RAH-puh], on the river Ravi [RAH-vee], downstream from modern Lahore [luh-HORE]. These great cities thrived until around 1900 BCE and were roughly contemporaneous with Sumerian Ur, the Old Kingdom of Egypt, and Minoan civilization in the Aegean.

The cities were discovered by chance in the early 1920s, and excavations have continued since. The best preserved of the sites is Mohenjo-Daro. Built atop a citadel is a complex of buildings, presumably a governmental or religious center, surrounded by a wall 50 feet high. Set among the buildings on the citadel is a giant pool (Fig. 7.13). Perhaps a public bath or a ritual space, its finely fitted bricks, laid on edge and bound together with gypsum plaster, made it watertight. The bricks on the side walls of the tank were covered with a thick layer of bitumen (natural tar) to keep water from seeping through the walls and up into the superstructure. The pool was open to the air and surrounded by a brick colonnade.

Outside the wall and below the citadel, a city of approximately 6 to 7 square miles, with broad avenues and narrow side streets, was laid out in a rough grid. It appears to have been home to a population of between 20,000 and 50,000. Most of the houses were two stories tall and built around a central courtyard. A network of covered drainage systems

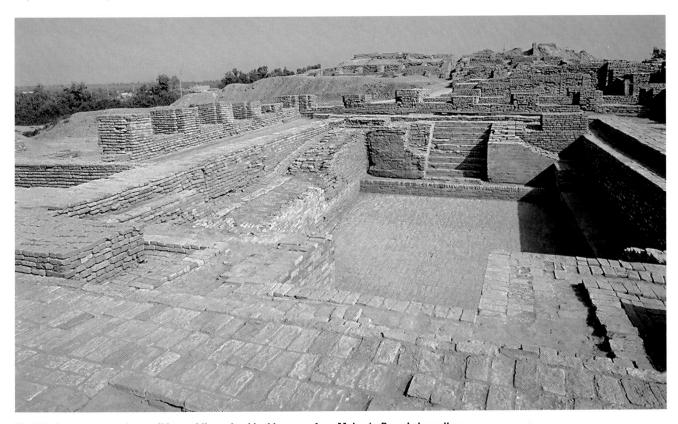

Fig. 7.13 Large water tank, possibly a public or ritual bathing area, from Mohenjo-Daro, Indus valley civilization. ca. 2600–1900 BCE. It measures approximately $39\frac{1}{2}$ feet north-south and 23 feet wide, with a maximum depth of almost 8 feet.

ran through the streets, channeling waste and rainwater into the river. The houses were built with standard sizes of baked brick, each measuring $2\frac{1}{4} \times 5\frac{1}{2} \times 11$ inches, a ratio of 1:2:4. A brick of identical ratio but larger— $4 \times 8 \times 16$ inches—was used in the building of platforms and city walls. Unlike the sun-dried bricks used in other cultures at the time, Mohenjo-Daro's bricks were fired, which made them much more durable. All of this suggests a civilization of considerable technological know-how and sophistication.

The arts of the Indus civilizations include human figurines and animal figurines made of stone, terra-cotta,

bronze, and other materialsincluding the so-called "priest-king" found at Mohenjo-Daro (Fig. 7.14)—terra-cotta pottery, and various styles of decorative ornaments for human wear including beads and stoneware bangles. Over 2,000 small seals have been unearthed. Carved from steatite stone. coated with alkali. and then fired to produce a luminous white surface, many depict animals with an extraordinary naturalism, especially considering that they are rendered in such miniature detail (Fig. 7.15). Depictions of warfare or conquered enemies are strikingly absent in representational art. As the top of this seal shows, the peoples of the valley had a written language, although it re-

mains undeciphered.

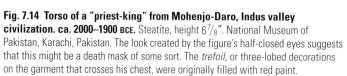

Sometime around 1500 BCE the Aryans [AIR-ee-uhnz], nomads from the north, invaded the Indus River Valley and conquered its inhabitants, making them slaves. Thus began the longest-lasting set of rigid, class-based societal divisions in world history, the Indian caste system. By the beginning of the first millennium BCE, these castes consisted of five principal groups, based on occupation: At the bottom of the ladder

was a group considered "untouchable," people so scorned by society that they were not even considered a caste. Next in line were the Shudras [SHOO-druhz], unskilled workers. Then came the Vaishyas [VYSH-yuhz], artisans and merchants. They were followed by the Kshatriyas [kuh-SHAHT-ree-uhz], rulers and warriors. At the highest level were the Brahmins [BRAH-minz], priests and scholars.

Hinduism and the Vedic Tradition

The social castes were sanctioned by the religion the Aryans brought with them, a religion based on a set of sacred hymns to the Aryan gods.

> These hymns, called Vedas [VAY-duhz], were written in the Arvan language, Sanskrit, and they gave their name to an entire period of Indian civilization, the Vedic [VAY-dik] period (ca. 1500-322 BCE). From the Vedas in turn came the Upanishads [00-PAHN-ih-shadz], a book of mystical and philosophical texts that date from sometime after 800 BCE. Taken together, the Vedas and the Upanishads form the basis of the Hindu religion, with Brahman, the universal soul, at its center. The religion has no single body of doctrine, nor any standard set of practices. It is defined above all by the diversity of its beliefs and deities. Indeed, several images of mother goddesses, stones in the phallic form, as well as a seal with an image that resem-

bles the Hindu god Shiva, have been excavated at various Indus sites, leading scholars to believe that certain aspects and concepts of Hinduism survived from the Indus civilizations and were incorporated into the Vedic religion.

The *Upanishads* argue that all existence is a fabric of false appearances. What appears to the senses is entirely illusory. Only Brahman is real. Thus, in a famous story illustrating the point, a tiger, orphaned as a cub, is raised by

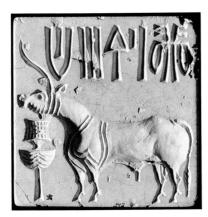

Fig. 7.15 Seal depicting a horned animal, Indus valley civilization. ca. 2500–1900 BCE. Steatite, approx. $1^{1/4} \times 1^{1/4}$ ". National Museum of Pakistan, Karachi, Pakistan. The function of these seals remains unknown.

goats. It learns, as a matter of course, to eat grass and make goat sounds. But one day it meets another tiger, who takes it to a pool to look at itself. There, in its reflection in the water, it discovers its true nature. The individual soul needs to discover the same truth, a truth that will free it from the endless cycle of birth, death, and rebirth and unite it with the Brahman in nirvana [nir-VAH-nuh], a place or state free from worry, pain, and the external world.

Brahman, Vishnu, and Shiva As Hinduism [HIN-doo-izuml developed, the functions of Brahman, the divine source of all being, were split among three gods: Brahma, the creator; Vishnu [VISH-noo], the preserver; and Shiva [SHEE-vuh], the destroyer. Vishnu was one of the most popular of the Hindu deities. In his role as preserver, he is the god of benevolence, forgiveness, and love, and like the other two main Hindu gods, he was believed capable of assuming human form, which he did more often than the other gods due to his great love for humankind. Among Vishnu's most famous incarnations is his appearance as Rama [rah-mah] in the oldest of the Hindu epics, the Ramayana [rah-mah-yuh-nuh] (Way of Rama), written by Valmiki [vahl-MIH-kee] in about 550 BCE. Like Homer in ancient Greece, Valmiki gathered together many existing legends and myths into a single story, in this case narrating the lives of Prince Rama and his queen, Sita [SEE-tuh]. The two serve as models of Hindu life. Rama is the ideal son, brother, husband, warrior, and king, and Sita loves, honors, and serves her husband with absolute and unquestioning fidelity. These characters face moral dilemmas to which they must react according to dharma [DAHR-muh], good and righteous conduct reflecting the cosmic moral order that underlies all existence. For Hindus, correct actions can lead to cosmic harmony; bad actions, violating dharma, can trigger cosmic tragedies such as floods and earthquakes.

An equally important incarnation of Vishnu is as the charioteer Krishna [KRISH-nuh] in the later Indian epic the Mahahbarata [muh-ha-BAHR-uh-tuh], composed between 400 BCE and 400 CE. In the sixth book of the Mahahbarata, titled the Bhagavad Gita [BUH-guh-vud GHEE-tuh]

(see Reading 7.7, pages 238–240), Krishna comes to the aid of Arjuna [ahr-JOO-nuh], a warrior who is tormented by the conflict between his duty to fight and kill his kinsmen in battle and the Hindu prohibition against killing. Krishna explains to Arjuna that as a member of the Kshatriya caste—that is, as a warrior—he is freed from the Hindu sanction against killing. In fact, by fighting well and doing his duty, he can free himself from the endless cycle of birth, death, and reincarnation, and move toward spiritual union with the Brahman.

But Vishnu's popularity is probably most attributable to his celebration of erotic love, which to Hindus symbolizes the mingling of the self and the absolute spirit of Brahman. In the Vishnu Puranas [poor-AH-nuhz] (the "old stories" of Vishnu), collected about 500 CE, Vishnu, in his incarnation as Krishna, is depicted as seducing one after another of his devotees. In one story of the Vishnu Puranas, he seduces an entire band of milkmaids: "They considered every instant without him a myriad of years; and prohibited (in vain) by husbands, fathers, brothers, they went forth at night to sport with Krishna, the object of their affection." Allowing themselves to be seduced does not suggest that the milkmaids were immoral, but shows an almost inevitable manifestation of their souls' quest for union with divinity.

If Brahma is the creator of the world, Shiva takes what Brahma has made and embodies the world's cyclic rhythms. Since in Hinduism the destruction of the old world is followed by the creation of a new world, Shiva's role as destroyer is required and a positive one. In this sense, he possesses reproductive powers, and in this part of his being, he is represented as a *linga* [LING-uh] (phallus), often carved in stone on temple grounds or at shrines.

The Goddess Devi Goddess worship is fundamental to Hindu religion. Villages usually recognize goddesses as their protectors, and the goddess Devi is worshipped in many forms throughout India. She is the female aspect without whom the male aspect, which represents consciousness or discrimination, remains impotent and void. For instance, in the Devi Mahatmayam, another of the Puranas, composed like the Vishnu Puranas around 500 CE, Vishnu was asleep on the great cosmic ocean, and due to his slumber, Brahma was unable to create. Devi intervenes, kills the demons responsible for Vishnu's slumber, and helps wake up Vishnu. Thus continues the cycle of life.

Devi is synonymous with Shakti, the primordial cosmic energy, and represents the dynamic forces that move through the entire universe. Shaktism, a particular brand of Hindu faith that regards Devi as the Supreme Brahman itself, believes that all other forms of divinity, female or male, are themselves simply forms of Devi's diverse manifestations. But she has a number of particular manifestations. In an extraordinary miniature carving from the

LEARN MORE Gain insight from a primary source document from the sermon of the Buddha at **www.myartslab.com**

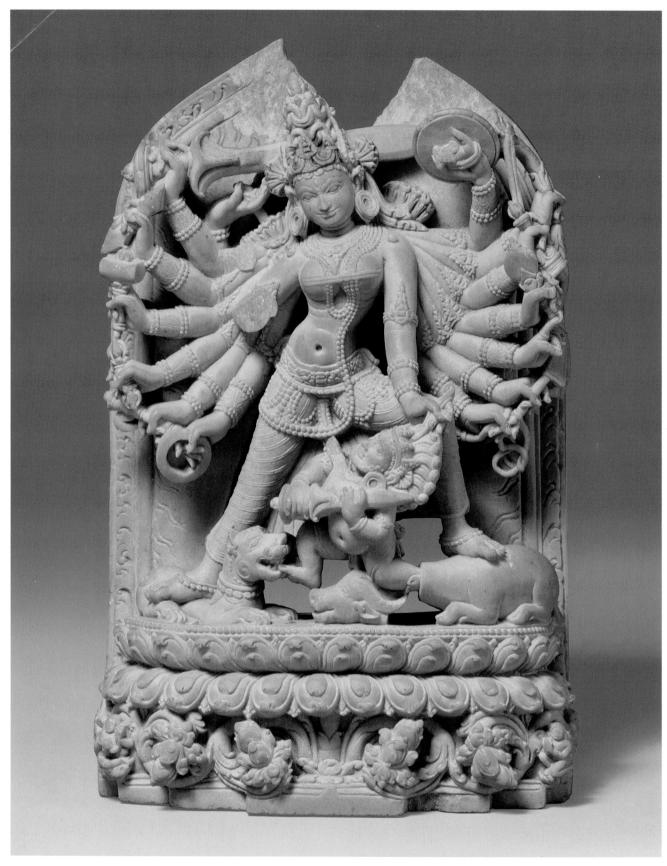

Fig. 7.16 The Goddess Durga Killing the Buffalo Demon, Mahisha (Mahishasuramardini). Bangladesh or India, Pala period, twelfth century. Argillite, height. $5^5/_{16}$ ". Image copyright © The Metropolitan Museum of Art/Art Resource, NY. Durga represents the warrior aspect of Devi.

twelfth century, Devi is seen in her manifestation as Durga (Fig. 7.16), portrayed as the sixteen-armed slayer of a buffalo inhabited by the fierce demon Mahisha. Considered invincible, Mahisha threatens to destroy the world, but Durga comes to the rescue. In this image, she has just severed the buffalo's head and Mahisha, in the form of a tiny, chubby man, his hair composed of snake heads, emerges from the buffalo's decapitated body and looks up admiringly at Durga even as his toes are being bitten by her lion. Durga smiles serenely as she hoists Mahisha by his hair and treads gracefully on the buffalo's body.

Buddhism: "The Path of Truth"

Because free thought and practice mark the Hindu religion, it is hardly surprising that other religious movements drew on it and developed from it. Buddhism is one of those. Its founder, Shakyamuni [SHAHK-yuh-moo-nee] Buddha, lived from about 563 to 483 BCE. He was born Prince Siddhartha Gautama [sid-DAR-thuh gau-tah-muh], child of a ruler of the Shakya [SHAK-yuh] clan—Shakyamuni means "sage of the Shakyas"—and was raised to be a ruler himself. Troubled by what he perceived to be the suffering of all human beings, he abandoned the luxurious lifestyle of his father's palace to live in the wilderness. For six years he meditated, finally attaining complete enlightenment while sitting under a banyan tree at Bodh Gaya [bod GUY-ah]. Shortly thereafter he gave his first teaching, at the Deer Park at Sarnath, expounding the Four Noble Truths:

- 1. Life is suffering.
- 2. This suffering has a cause, which is ignorance.
- 3. Ignorance can be overcome and eliminated.
- 4. The way to overcome this ignorance is by following the Eightfold Path of right view, right resolve, right speech, right action, right livelihood, right effort, right mindfulness, and right concentration.

Living with these truths in mind, one might overcome what Buddha believed to be the source of all human suffering the desire for material things, which is the primary form of ignorance. In doing so, one would find release from the illusions of the world, from the cycle of birth, death, and rebirth, and ultimately reach nirvana. These principles are summed up in the Dhammapada [dah-muh-PAH-duh], the most popular canonical text of Buddhism, which consists of 423 aphorisms, or savings, attributed to Buddha and arranged by subject into 26 chapters (see Reading 7.8, pages 240-241). Its name is a compound consisting of dhamma, the vernacular form of the formal Sanskrit word dharma, mortal truth, and pada, meaning "foot" or "step" hence it is "the path of truth." The aphorisms are widely admired for their wisdom and their sometimes stunning beauty of expression.

The Buddha (which means "Enlightened One") taught for 40 years until his death at age 80. His followers preached that anyone could achieve buddhahood, the ability to see the ultimate nature of the world. Persons of very near total enlightenment, but who have vowed to help others achieve buddhahood before crossing over to nirvana, came to be known as **bodhisattvas** [boh-dih-SUT-vuhz], meaning "those whose essence is wisdom." In art, bodhisattvas wear the princely garb of India, while Buddhas wear a monk's robe.

The Maurya Empire Buddhism would become the official state religion of the Maurya Empire, which ruled India from 321 to 185 BCE. The Empire was founded by Chandragupta Maurya [chan-druh-GOOP-tuh MA-ur-ya] (r. ca. 321–297 BCE) in eastern India. Its capital was Pataliputra (modern Patna) on the Ganges River, but Chandragupta rapidly expanded the empire westward, taking advantage of the vacuum of power in the Indus Valley that followed in the wake of Alexander the Great's invasion of 326 BCE (see Chapter 5). In 305 BCE, the Hellenistic Greek ruler Suleucus I, ruler of the one of the three states that succeeded Alexander's empire, the kingdom of the Suleucids, tried to reconquer India once again. He and Chandragupta eventually signed a peace treaty, and diplomatic relations between Suleucid Greece and the Maurya Empire were established. Several Greeks ambassadors were soon residing in the Mauryan court, the beginning of substantial relations between East and West. Chandragupta was succeeded by his son Bindusara [BIN-doo-sah-rah] (r. ca. 297-273 BCE), who also had a Greek ambassador at his court, and who extended the empire southward, conquering almost all the Indian peninsula and establishing the Maurya Empire as the largest empire of its time. He was in turn succeeded by his son Ashoka [uh-SHOH-kuh] (r. ca. 273-232 BCE).

It was Ashoka who established Buddhism as the official state religion. On a battlefield in 261 BCE, Ashoka was appalled by the carnage he had inflicted in his role as a warrior king. As he watched a monk walking slowly among the dead, Ashoka was moved to decry violence and force of arms and to spread the teachings of Buddha. From that point, Ashoka, who had been described as "the cruel Ashoka," began to be known as "the pious Ashoka." At a time when Rome was engaged in the Punic Wars, Ashoka pursued an official policy of nonviolence. The unnecessary slaughter or mutilation of animals was forbidden. Sport hunting was banned, and although the limited hunting of game for the purpose of consumption was tolerated, Ashoka promoted vegetarianism. He built hospitals for people and animals alike, preached the humane treatment of all living things, and regarded all his subjects as equals, regardless of politics, religion, or caste. He also embarked on a massive Buddhist architectural campaign, erecting as many as 8,400 shrines and monuments to Buddha throughout the empire. Soon, Buddhism would spread beyond India, and Buddhist monks from China traveled to India to observe Buddhist practices.

Buddhist Monuments: The Great Stupa Among the most famous of the Buddhist monuments that Ashoka erected is

231

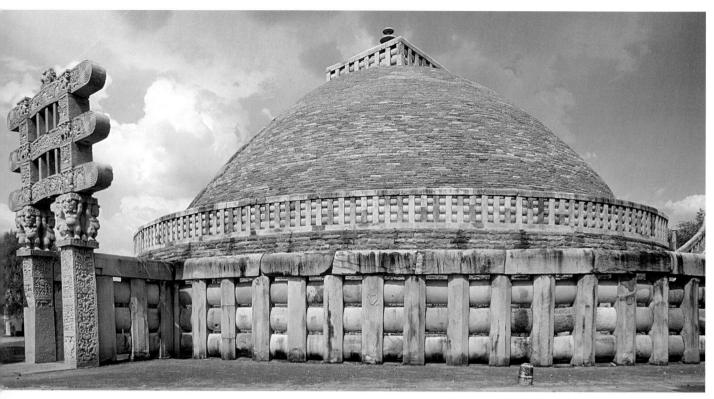

Fig. 7.17 The Great Stupa, Sanchi, Madhya Pradesh, India, view of the West Gateway. Founded third century BCE, enlarged ca. 150–50 BCE. Shrine height 50', diameter 105'. In India, the stupa is the principal monument to Buddha. The stupa symbolizes, at once, the World Mountain, the Dome of Heaven, and the Womb of the Universe.

SEE MORE For a Closer Look at the Great Stupa at Sanchi, go to www.myartslab.com

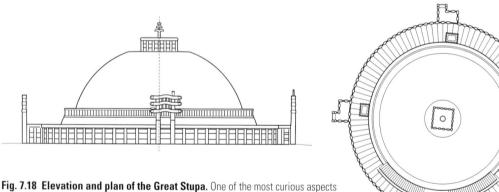

Fig. 7.18 Elevation and plan of the Great Stupa. One of the most curious aspects of the Great Stupa is that its four gates are not aligned on an axis with the four openings in the railing. Some scholars believe that this arrangement is derived from gates on farms, which were designed to keep cattle out of the fields.

the Great Stupa [STOO-puh] at Sanchi [SAHN-chee] (Fig. 7.17), which was enlarged in the second century BCE. A **stupa** is a kind of burial mound. The earliest eight of them were built around 483 BCE as reliquaries for Buddha's remains, which were themselves divided into eight parts. In the third century, Ashoka opened the original eight stupas and further divided Buddha's relics, scattering them among a great many other stupas, probably including Sanchi.

The stupa as a form is deeply symbolic, consisting first and foremost of a hemispheric dome, built of rubble and dirt and faced with stone, evoking the Dome of Heaven (see the plan, Fig. 7.18). Perched on top of the dome is a small square platform, in the center of which is a mast supporting three circular discs or "umbrellas," called *chatras* [CHAH-truz]. These signify both the banyan tree beneath which Buddha achieved enlightenment and the three levels of Buddhist consciousness—desire, form,

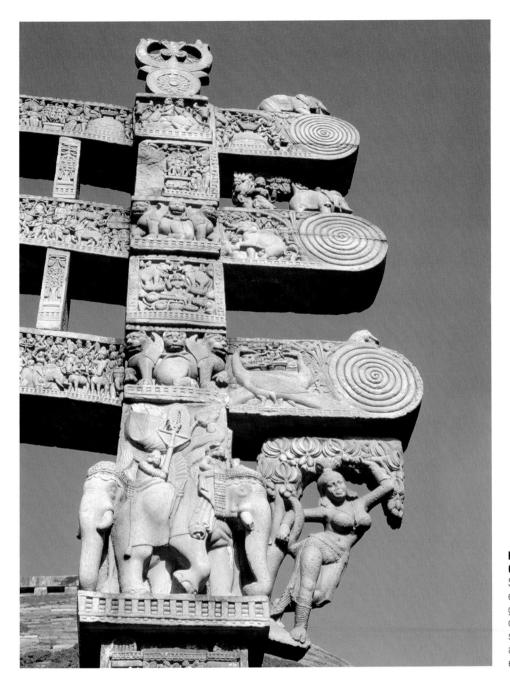

Fig. 7.19 Column capital on the East Gate of the Great Stupa, Sanchi.
Stone, height of gate, 32'. The carved elephants that serve as the capital to the gateway column are traditional symbols of Buddha, signs of his authority and spiritual strength. A yakshi figure serves as a bracket at the right front of the elephant.

formlessness—through which the soul ascends to enlightenment. The dome is set on a raised base, around the top of which is a circumambulatory walkway. As pilgrims to the stupa circle the walkway, they symbolically follow Buddha's path, awakening to enlightenment. The whole is a mandala [MUN-duh-luh] (literally "circle"), the Buddhist diagram of the cosmos.

Leading out from the circular center of the stupa are four gates, positioned at the cardinal points, that create directional "rays," or beams of teaching, emanating from the "light" of the central mandala. They are 32 feet high and decorated with stories from the life of Buddha, as well as other sculptural elements including vines, lotuses, peacocks, and elephants (Fig. 7.19). Extending as a sort

of bracket from the sides of the gateways were *yakshis* [YAK-shees]—some 24 in all—female spirit figures that probably derives from Vedic tradition. The *yakshi* symbolizes the productive forces of nature. As in Hinduism, sexuality and spirituality are visually represented here as forms of an identical cosmic energy, and the sensuous curves of the *yakshi* emphasize her deep connection to the creative force. In fact, here she seems to cause the fruit in the tree above her head to ripen, as if she is the source of its nourishment.

The *yakshi* and the gate she decorates embody the distinctive sense of beauty that is characteristic of Indian art. Both are images of abundance that reflect a belief in the generosity of spirit that both Buddha and the

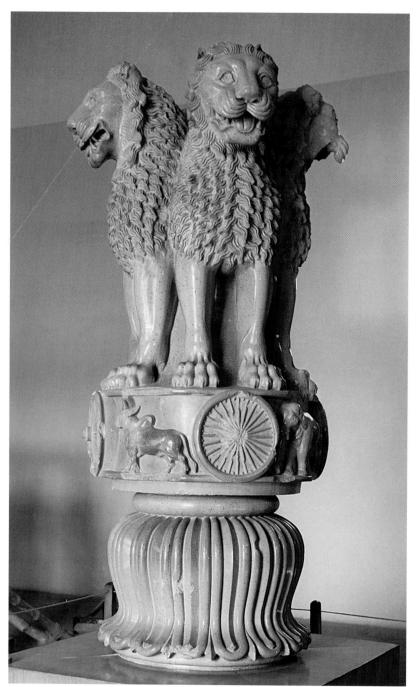

Fig. 7.20 Lion capital, Ashokan pillar at Sarnath, Uttar Pradesh, India. Maurya period, ca. 250 BCE. Polished sandstone, height, 7'. Archeological Museum, Sarnath. Some scholars speculate that the pillars upon which such capitals rested represent the axis mundi, or "axis of the world," joining the earth with the heavens.

Hindu gods share. Sensuous form, vibrant color, and a profusion of ornament dominate Indian art as a whole, and the rich textures of this art are meant to capture the very essence of the divine. Originally, all four gates at Sanchi were flanked with a total of 24 such female figures.

Buddhist Monuments: The Pillar Ashoka also erected a series of pillars across the empire, primarily at sites related to Buddha's life. These pillars, made of sandstone, usually rested on a stone foundation sunk more than 10 feet into the ground. They rose to a height of about 50 feet. They

were inscribed with inscriptions relating to dharma, the rules of good conduct that Vedic kings such as Rama were required to uphold in the *Ramayana*. But Buddhists quickly interpreted the writings as referring to Buddhist teachings. At the top of each pillar was a capital carved in the shape of an animal.

The pillar at Sarnath, the site of Buddha's first sermon, was crowned with a sculpture of four lions facing in the cardinal directions and standing back-to-back on a slab decorated with four low-relief sculptures of wheels and, between each wheel, four different animals—lion, horse, bull, and elephant (Fig. 7.20). Beneath these features are the turned-down petals of a lotus flower, which, since the lotus emerges from dirty water without blemish, traditionally symbolized the presence of divine purity (which is to say, Buddha and his teachings) in an imperfect world. All of the other elements on the capital have similar symbolic significance. The lions probably refer to Buddha himself,

who was known "the lion of the Shakya," the clan into which he was born as prince, and whose teachings spread in all directions like the roar of the lions. The wheels, too, are a universal symbol of Buddha's teachings at Sarnath, where, it is said, "he set the wheel of the law [dharma] in motion." In fact, the lions originally supported a large copper wheel, now lost.

Ashoka's missionary ambition matched his father's and grandfather's military zeal, and he sent Buddhist emissaries as far as west as Syria, Egypt, and Greece. No Western historical record of these missions survives, and their impact on Western thought remains a matter of speculation.

The Silk Road

nder the Han, (206 BCE-220 CE), Chinese trade flourished. Western linen, wool, glass, and gold, Persian pistachios, and mustard originating in the Mediterranean, were imported in exchange for the silk, ceramics, fur, lacquered goods, and spices that made their way west along the "Silk Road" that stretched from the Yellow River across Asia to the Mediterranean (see Map 7.3). The road followed the westernmost spur of the Great Wall to the oasis town of Dunhuang [doon-hwahng], where it split into northern and southern routes, passing through smaller oasis towns until converging again at Kashgar [KAHSHgahr] on the western edge of the western Chinese deserts. From there, traders could proceed into present-day Afghanistan, south into India, or westward through presentday Uzbekistan, Iran, and Iraq into Syria and the port city of Antioch [AN-tee-awk]. Goods passed through many hands, trader to trader, before reaching the Mediterranean, and according to an official history of the Han dynasty compiled in the fifth century CE, it was not until 97 CE that one Gan Ying went "all the way to the Western sea and back." According to Gan Ying, there he encountered an empire with "over four hundred walled cities" to which "tens of small states are subject"—some of them probably outposts of the Roman Empire, but others, like the city of Bam, with its towering citadle first constructed in about 55 BCE (Fig. 7.21), Persian strongholds.

Goods and ideas spread along the Silk Road, as trade spurred the cultural interchange between East and West, India and China. As early as the first century BCE, silk from China reached Rome, where it captured the Western imagination, but the secret of its manufacture remained a mystery in the West until the sixth century CE. Between the first and third centuries CE, Buddhist missionaries from

India carried their religion over the Silk Road into Southeast Asia and north into China and Korea, where it quickly became the dominant religion. By the last half of the first millennium, the Chinese capital of Chang'an, at the eastern terminus of the Silk Road, hosted Korean, Japanese, Jewish, and Christian communities, and Chinese emperors maintained diplomatic relations with Persia. Finally, the Venetian merchant Marco Polo (ca. 1254–1324), bearing a letter of introduction from Pope Gregory X, crossed the Asian continent on the Silk Road in 1275. He arrived at the new Chinese capital of Beijing, and served in the imperial court for nearly two decades. His *Travels*, written after his return to Italy in 1292, constitute the first eyewitness account of China available in Europe.

Fig. 7.21 The Arg-é Bam ("Bam Citadel"), Iran.
© Isabelle Vayron/Sygma/
Corbis. All Rights Reserved.
The citadel was largest adobe structure in the world until approximately 80% of it was destroyed in a massive earthquake in 2003. The Iranian government has undertaken its reconstruction.

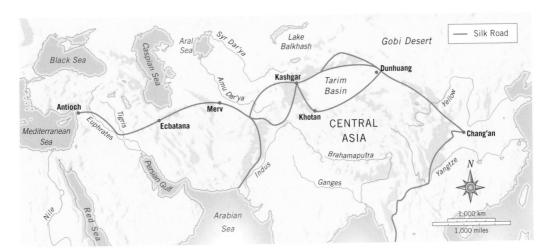

Map 7.3 The Silk Road, the trading route between the east and west and between southeast Asia and China.

What were early China's lasting contributions to Chinese civilization?

As inscribed on oracle bones and bronze vessels, the earliest Chinese written language is so closely related to modern Chinese written language that it remains legible. During the Shang (ca. 1700-1045 BCE) and Chou (1045–221 BCE) dynasties, with the production of the Book of Changes, or I Jing, and the collection of a national poetry in the Book of Songs, or Shi Jing, a lasting national literature began to arise. The two great strains of Chinese philosophy—Daoism, a mystical quietism based on harmony with Nature, and Confucianism, a pragmatic political philosophy based on personal cultivation—came into full flower at this time as well. The philosophical symbol of the yin-yang was devised during this early period too. Can you detect the workings of the yin-yang philosophy in the poetry of the Book of Songs? in the Dao de jing? in Confucianism? How did Confucianism contribute to the workings of the Chinese state? Why is Daoism less suited as a political philosophy?

How was China unified as an empire?

Under the leadership of the Emperor Qin Shihuangdi, the Qin dynasty (221–206 BCE) unified China and undertook massive building projects, including the 4,000-mile-long Great Wall, enormous networks of roads, and the emperor's own tomb, guarded by nearly 8,000 life-size ceramic soldiers, projects that required the almost complete reorganization of Chinese society. This reorganization was made possible by placing totalitarian authority in the hands of a ruthless dictator.

What philosophy supported the emperor's approach? How does Imperial China compare to the Roman Empire in the West?

During the Han dynasty (206 BCE–220 CE), the scholars and writers disenfranchised by the Qin were restored to respectability, but women remained disenfranchised. How does *yuefu* poetry reflect women's lot? How does it compare to the poetry of the *Book of Songs?* Paper was invented during the Han dynasty. What effect did this invention have on Chinese culture?

How did religious outlooks shape ancient India?

Before 2000 BCE, in the Indus Valley, sophisticated cultures arose at cities such as Mohenjo-Daro and Harappa. What archeological evidence gives credence to the idea that these were indeed sophisticated cultures?

After the invasion of the Aryans in about 1500 BCE, the Hindu religion took hold in India. The *Vedas* and *Upanishads* were its two basic texts. Its three major gods were Brahma, the creator; Vishnu, the preserver, and god of benevolence, forgiveness, and love; and Shiva, the destroyer, who is also a great dancer, embodying the sacred rhythms of creation and destruction, birth, death, and rebirth. Vishnu was an especially popular god, who appeared in human form as Rama in the epic *Ramayana* and as Krishna in the epic *Mahahbarata*. What place do female divinities hold in Hindu religion? What does this religion share with the official Indian state religion adopted by the Maurya emperor Ashoka, Buddhism? In what ways did Ashoka seek to spread Buddhism as the dominant Indian faith?

PRACTICE MORE Get flashcards for images and terms and review chapter material quizzes at www.myartslab.com

GLOSSARY

bodhisattva In Buddhism, a person who refrains from achieving total enlightenment in order to help others achieve buddhahood.

dharma In Hinduism, good and righteous conduct that reflects the cosmic moral order underlying all existence.

legalism A philosophy that requires the state to exercise power over the individual to elicit proper conduct.

mandala The Buddhist diagram of the cosmos.

nirvana A place or state free from worry, pain, and the external world.

stupa A type of Buddhist burial mound.

READING 7.1

From the Book of Songs

The Book of Songs is the earliest collection of Chinese poetry. Like all subsequent Chinese poetry, for which these poems, not coincidentally, provide the tradition, the poems provide a telling glimpse into everyday Chinese life. But they also demonstrate the centrality of the natural world and its rhythms and cycles to Chinese thought and feeling.

IN THE WILDS IS A DEAD RIVER-DEER

In the wilds is a dead river-deer wrapped in white rushes. A lady yearned for spring and a fine man seduced her.

In the woods are clusters of bushes and in the wilds a dead river-deer wrapped in white rushes. There was a lady fine as jade.

Oh! Slow down, don't be so rough, let go of my girdle sash. Shhh! You'll make the dog bark.

READING CRITICALLY

The poem contrasts the dead deer to the lady's desire. What is the point? How does time, the sense of human urgency versus the natural rhythm of nature, play into this theme?

WHEN THE GOURD HAS DRIED LEAVES

When the gourd has dried leaves you can wade the deep river. Keep your clothes on if the water's deep; hitch up your dress when it's shallow.

The river is rising, pheasants are chirping.
The water is just half a wheel deep, and the hen is chirping for the cock.

Wild geese are trilling, the rising sun starts dawn. If you want to marry me, come before the river is frozen. The ferryman is gesturing, other people are going, but not me, other people are going, but not me, I'm waiting for you.

READING CRITICALLY

Who is the speaker? How does the cycle of the seasons play into the poem's argument? Are there any double entendres at work in this argument?

ALL THE GRASSLANDS ARE YELLOW

All the grasslands are yellow and all the days we march and all the men are conscripts sent off in four directions.

All the grasslands are black and all the men like widowers. So much grief! Are soldiers not men like other men?

We aren't bison! We aren't tigers crossing the wilderness, but our sorrows roam from dawn till dusk.

Hairy tailed foxes slink through the dark grass as we ride tall chariots along the wide rutted roads.

READING CRITICALLY

Clearly, the speaker of this poem is very different from the speakers of the first two. But in what ways are the themes of the first two poems reiterated here?

READING 7.3

Confucius, from the Analects

The Analects of Confucius are a collection of his dialogues and utterances, probably recorded by his disciples after his death. They reflect Confucius's dream of an ideal society of hardworking, loyal people governed by wise, benevolent, and morally upright officials—a government based on moral principles that would be reflected in the behavior of its populace.

- 2-1 The Master said, "He who exercises government by means of his virtue may be compared to the north polar star. which keeps its place and all the stars turn towards it.'
- 2-2 The Master said, "In the Book of Poetry are three hundred pieces, but the design of them all may be embraced in one sentence 'Having no depraved thoughts.'"
- 2-3 The Master said, "If the people be led by laws, and uniformity sought to be given them by punishments, they will try to avoid the punishment, but have no sense of shame."

"If they be led by virtue, and uniformity sought to be given 10 them by the rules of propriety, they will have the sense of shame, and moreover will become good." . . .

- 4-3 The Master said, "It is only the truly virtuous man, who can love, or who can hate, others."
- 4-4 The Master said, "If the will be set on virtue, there will be no practice of wickedness."
- 4-5 The Master said, "Riches and honors are what men desire. If they cannot be obtained in the proper way, they should not be held. Poverty and meanness are what men dislike. If they cannot be avoided in the proper way, they should not be 20 avoided." . . .
- 4-6 The Master said, "I have not seen a person who loved virtue, or one who hated what was not virtuous. He who loved virtue, would esteem nothing above it. He who hated what is not virtuous, would practice virtue in such a way that he would not allow anything that is not virtuous to approach his person." . . .
- 4-9 The Master said, "A scholar, whose mind is set on truth. and who is ashamed of bad clothes and bad food, is not fit to be discoursed with."

- 4-10 The Master said, "The superior man, in the world, does not set his mind either for anything, or against anything; what is right he will follow."
- 4-11 The Master said, "The superior man thinks of virtue: the small man thinks of comfort. The superior man thinks of the sanctions of law; the small man thinks of favors which he may receive."
- 4-12 The Master said, "He who acts with a constant view to his own advantage will be much murmured against." . . .
- 4-17 The Master said, "When we see men of worth, we 40 should think of equaling them; when we see men of a contrary character, we should turn inwards and examine ourselves."
- 4-18 The Master said, "In serving his parents, a son may remonstrate with them, but gently; when he sees that they do not incline to follow his advice, he shows an increased degree of reverence, but does not abandon his purpose; and should they punish him, he does not allow himself to murmur." . . .
- 4-22 The Master said, "The reason why the ancients did not readily give utterance to their words, was that they feared lest their actions should not come up to them."
- 4-23 The Master said, "The cautious seldom err."
- 4-24 The Master said, "The superior man wishes to be slow in his speech and earnest in his conduct." . . .

READING CRITICALLY

Give two or three examples, from the previous passages, of the principle of li at work, and explain how li leads to jen (these terms are defined in the chapter).

READING 7.7

from "The Second Teaching" in the Bhagavad Gita: Krishna's Counsel in Time of War

The Bhagavad Gita constitutes the sixth book of the first-century CE epic Sanskrit poem, the Mahahbarata. It represents, in many ways, a summation of Hindu thought and philosophy. The bulk of the poem consists of the reply of Krishna, an avatar, or incarnation, of Vishnu, to Arjuna, leader of the Pandavas, who on the battlefield has decided to lay down his arms. In the following passage, Arjuna declares his unwillingness to fight. The charioteer Sanjaya, the narrator of the entire Mahahbarata, then introduces Krishna, who replies to Arjuna's decision and goes on to describe, at Arjuna's request, the characteristics of a man of "firm concentration and pure insight."

FROM THE SECOND TEACHING

SANJAYA:

Arjuna sat dejected, filled with pity, his sad eyes blurred by tears. Krishna gave him counsel.

LORD KRISHNA:

Why this cowardice in time of crisis, Arjuna? The coward is ignoble, shameful, foreign to the ways of heaven. Don't yield to impotence!

It is unnatural in you! Banish this petty weakness from your heart. Rise to the fight, Arjuna!

Krishna, how can I fight against Bhishma and Drona with arrows when they deserve my worship? It is better in this world to beg for scraps of food than to eat meals smeared with the blood of elders I killed

at the height of their power while their goals were still desires. We don't know which weight is worse to bearour conquering them or their conquering us. We will not want to live if we kill the sons of Dhritarashtra assembled before us. The flaw of pity blights my very being conflicting sacred duties confound my reason. I ask you to tell me decisively—Which is better? I am your pupil. Teach me what I seek! I see nothing that could drive away the grief that withers my senses; even if I won kingdoms of unrivaled wealth on earth and sovereignty over gods.

SANJAYA:

Arjuna told this To Krishna—then saying, "I shall not fight," he fell silent. Mocking him gently, Krishna gave this counsel as Arjuna sat dejected, between the two armies.

LORD KRISHNA:

You grieve for those beyond grief, and you speak words of insight; but learned men do not grieve for the dead or the living. Never have I not existed, nor you, nor these kings; and never in the future shall we cease to exist. Just as the embodied self enters childhood, youth, and old age, so does it enter another body: this does not confound a steadfast man. Contacts with matter make us feel heat and cold, pleasure and pain. Arjuna, you must learn to endure fleeting things—they come and go! When these cannot torment a man, when suffering and joy are equal for him and he has courage, he is fit for immortality. Nothing of nonbeing comes to be, nor does being cease to exist;

the boundary between these two is seen by men who see reality. Indestructible is the presence that pervades all this; no one can destroy this unchanging reality. Our bodies are known to end, but the embodied self is enduring, indestructible, and immeasurable; therefore, Arjuna, fight the battle! He who thinks this self a killer and he who thinks it killed, both fail to understand; it does not kill, nor is it killed. . . .

ARJUNA:

40

50

60

Krishna, what defines a man deep in contemplation whose insight and thought are sure? How would he speak? How would he sit? How would he move?

LORD KRISHNA:

When he gives up desires in his mind, is content with the self within himself, then he is said to be a man whose insight is sure, Arjuna.

When suffering does not disturb his mind, when his craving for pleasures has vanished, when attraction, fear, and anger are gone, he is called a sage whose thought is sure.

When he shows no preference in fortune or misfortune and neither exults nor hates, his insight is sure. When, like a tortoise retracting its limbs he withdraws his senses completely from sensuous objects, his insight is sure.

So, Great Warrior, when withdrawal of the senses from sense objects is complete, discernment is firm.

When it is night for all creatures, a master of restraint is awake; when they are awake, it is night for the sage who sees reality.

As the mountainous depths of the ocean are unmoved when waters rush into it. so the man unmoved when desires enter him attains a peace that eludes the man of many desires.

When he renounces all desires and acts without craving, possessiveness, or individuality, he finds peace.

120

This is the place of the infinite spirit; achieving it, one is freed from delusion; abiding in it even at the time of death, one finds the pure calm of infinity.

READING CRITICALLY

What does Krishna mean when he says, "Nothing of nonbeing comes to be / nor does being cease to exist; / the boundary between these two / is seen by men who see reality"?

READING 7.8

from the Dhammapada

The Dhammapada, or "path of truth," consists of 423 sayings, or aphorisms, of Buddha divided by subject into 26 books. They are commonly thought to be the answers to questions put to Buddha on various occasions, and as such they constitute a summation of Buddhist thought. The following passages, consisting of different aphorisms from five different books, emphasize the Buddhist doctrine of self-denial and the wisdom inherent in pursuing the "path."

10

from 5. The Fool

. . . Should a traveler fail to find a companion

Equal or better,

Rather than suffer the company of a fool.

He should resolutely walk alone.

"I have children; I have wealth."

These are the empty claims of an unwise man.

If he cannot call himself his own,

How can he then claim children and wealth as his own?

To the extent that a fool knows his foolishness,

He may be deemed wise.

A fool who considers himself wise

Is indeed a fool. . . .

from 6. The Wise

Irrigators contain the flowing waters.

Arrowsmiths fashion arrows.

Carpenters shape wood to their design.

Wise men mold their characters. . . .

from 11. Old Age

Can there be joy and laughter

When always the world is ablaze?

Enshrouded in darkness

Should you not seek a light?

Look at the body adorned,

A mass of wounds, draped upon a heap of bones,

A sickly thing, this subject of sensual thoughts!

Neither permanent, nor enduring!

The body wears out,

A nest of disease,

Fragile, disintegrating,

Ending in death.

What delight is there in seeing the bleached bones,

Like gourds thrown away,

Dried and scattered in the autumn sun?

A citadel is this structure of bones,

Blood and flesh, within which dwell

Decay, death, conceit, and malice.
The royal chariots surely come to decay

Just as the body, too, comes to decay.

But the shining truth and loving kindness live on.

So speak the virtuous to the virtuous.

from 18. Blemishes

. . . The wise man, carefully, moment by moment,

One by one,

Eliminates the stains of his mind.

As a silversmith separates the dross from the silver.

Just as rust produced by iron

Corrodes the iron,

So is the violator of moral law

Destroyed by his own wrong action.

Disconnection from scripture is learning's taint,

Neglect is the taint of houses,

Uncared-for beauty withers,

Negligence is the taint of one who keeps watch.

A woman behaving badly loses her femininity.

A giver sharing grudgingly loses his generosity.

Deeds done from bad motives remain everlastingly tainted.

50

60

70

But there is nothing more tainted than ignorance.

Eliminate ignorance, O disciples,

And purity follows. . . .

Be aware, everyone, that those flawed in their nature

Have no control of themselves.

Do not let greed and anger cause you suffering

By holding you in their grasp.

Men give for different reasons,

Such as devotion or appreciation.

Whoever finds fault with the food or drink given by others

Will have no peace, day or night.

However, whoever gives up this habit of finding fault

With others' offerings

Will know peace, day and night.

There is no fire like lust,

No vise like hatred,

No trap like delusion,

And no galloping river like craving.

from 24. Craving

. . . Unchecked craving strangles the careless man,

Like a creeper growing in the jungle.

He leaps from lifetime to lifetime,

Like a monkey seeking fruit.

This craving, this clinging,

Overpowers the man caught in it,

And his sorrows multiply,

Like prairie grass fed by rain.

Although it is hard to gain this freedom, Sorrow leaves the man who overcomes this toxic craving, This clinaina to the world, Just as drops of water fall from a lotus leaf. Therefore, I admonish you all who are here assembled. You have my blessings. Eradicate craving at the root, as you would weeds. Find the sweet root. Do not succumb to temptation over and over again. The tree may be cut down but the roots remain, Uninjured and strong, 90 And it springs up again. Likewise, suffering returns, again and again, If the dormant craving is not completely eradicated. . . . Craving grows in the man aroused by worldly thoughts. Tied to his senses, he makes his fetters strong. Taking delight in calming sensual thoughts, Ever mindful, meditating on the impurities of the body and so on, One will certainly get rid of craving. Such a one will cut off Mara's bond. The diligent monk Has reached the summit, Fearless, free of passion. This is the final birth of such a man.

Free of craving and grasping,
Skilled in the knowledge of the meanings within meanings,
The significance of terms, the order of things.
This great man, greatly wise,
Need return no more.
I have conquered all, I know all,
I am detached from all, I have renounced all,
I am freed through destruction of craving.
Having myself realized all,
Whom shall I call my teacher?
The gift of truth is the highest gift.
The taste of truth is the sweetest taste.
The joy of truth is the greatest joy.
The extinction of craving is the end of suffering.

READING CRITICALLY

The *Dhammapada* is rich in metaphors, figures of speech that draw direct comparison between two seemingly unrelated things (from "Cravings," for instance, the comparison of a craving to the entangling creeper called *birana* [bir-AH-nuh]). How does Buddha's use of metaphor reflect his status as the "Enlightened One"?

INDFX

Boldface names refer to artists. Pages in italics refer to illustrations.
Abraham of Ur, 50 Achilles, 105 Acropolis, 134–135 architectural program, 141–146 definition, 111

Erechtheion, 141, 144, 145 Kritios Boy, 139–140, 140 model of, 144 rebuilding, 140-148

sculpture program at the Parthenon, 146–148 Temple of Athena Nike, 141, 144, 145 worship of Athena, 112, 119–120 Actaeon, 191

Admonitions of the Imperial Instructress to Court Ladies, 219, 219 Adyton, 116 Aegean, 95–133 See also Greece

Cyclades, 96, 96 Homeric epics, 103–108, 189–190 introduction to, 95

Minoan culture, 96–100 Mycenaean culture, 100–103

sculpture, 96, 96 Aeneas, 180 Aeneid (Virgil), 165, 180–181, 189–190, 209–210 Aeschylus, 153

Africa head, Nok, 13 Nok people, 12–13 San people wall painting, 18, 19 Agamemnon, 105

Agamemnon (Aeschylus), 153

Agency, 4–5 Agonizesthai, 116, 118 Agora, 111, 119, 136–137, 155, 194, *194* Agriculture

in Greek city-states, 110 in Greek city-states, 110 in Mesopotamia, 32 rise of in Neolithic era, 8–15 Agrippa, Marcus, 187, 200 Ain Gharal, 20 Akhenaten and His Family, Egypt, 87 Akhenaten and His Family, Egypt, 87 Akhenaten's Hymn to the Stan, 85–86 Akkad, 37–40

Head of an Akkadian Man, Nineveh, Iraq, 37, 37 sculpture, 37, 40 Seal of Adda, Akkadian, 34

Akrotiri, 96 Alexander the Great, 90, 136, 156–157, 157

Alexander the Great, (Lysippus), 156, 185 Alexandria, 163–164

"Allegory of the Cave" (Plato), 149, 150, 169–171

169–171 Altamira, Spain, 12 Altar of Zeus, Pergamon, 160–162, 161, 163, 165 Altar Stone, 17 Amarna style, Egyptian, 86–87 Amasis Painter, 151 Amenhotep III, 85 Amenhotep IV, 85–86 Ameniose

Anasazi, 19–21, 20, 25

Mound Builders, 24–26, 25, 26 Olmecs, 24–25, 24–25 sacred sites, 24–26 Amphora, 105, 105, 116, 121, 151

Amun, 81 Analects (Confucius), 219, 237–238

Anasazi, 19–21, 20, 25 Anavysos Kouros, Athens, Greece, 117, 125, 125,

Animal world, representations of power in, 27

Ashimals in art
Ashokan pillar at Sarnath, India, 234
Ashumasirpal II Killing Lions, Kalhu, Iraq, 43, 43, 108

Beaker with ibex, dogs, and long-necked birds, from Susa, southwest Iran, 12 Buffalo Kachina, Zuni, 22

Bull Leaping (Toreador Fresco), from the palace complex at Knossos, Crete, 97 Chauvet cave painting, 2–3, 4–5, 27, 27 Etruscan She-Wolf, 179

Five-eared ding with dragon pattern, 216 Flying Horse Poised on One Leg on a Swallow, from the tomb of Governor-General Zhan,

Lascaux cave painting, 4, 4–5 Lion capital, column capital on the East Gate of the Great Stupa, Sanchi, 233

Lyre from Tomb 789, cemetery at Ur, Iraq, 35 Nebamun Hunting Birds, Thebes, Egypt, 67, 84 Palette of Narmer, Egypt, 69, 70–71, 70–71, 72 Persian art, 58

Persian art, 58
Rhyton, Achaemenid, Iran, 57
Royal Standard of Ur, 36–37, 69
Seal depicting a horned animal, Indus valley civilization, 229
Seal of Adda, Akkadian, 34
Soundbox panel front of the lyre form Tomb 789, cemetery at Ur, Iraq, 35
The Trojan Horse, detail from a storage jar

from Chora, Mykonos, 106, 107
Vessel in the shape of an ostrich egg, Royal
Cemetery of Ur, 31
Wall painting with giraffes, zebra, eland, and

abstract shapes, San people, 19
Young Men on Horseback, Parthenon, 146
Animism, 22 Ankh. 81

Antae, 113 Antagonist, 153
Anthropomorphism, 22, 45
Antigone (Sophocles), 138, 153–154
Antonius, Marcus (Mark Antony), 183
Anubis, 82, 89
Aphrodite, 112

Aphrodite, 112
Aphrodite of Knidos, 159, 159
Aphrodite of Melos, 162
Apollo, 112
Apollodorus of Damascus, 195

Apoxyomenos (The Scraper), 158, 158 Apse, 195, 207

Aqua Claudia, 193 Aqueducts, 193, 196, 205 Arcade, 196 Arch of Titus, Rome, 197, 198

Archaic period, 125 Archaic style, 118 Archaiologia, 95, 100, 103 archeological sites of Anasazi and mound

builders, 25 Arches, 196, 197–198 Architectural elements agora, 136 apse, 195, 207 aqueducts, 193, 196, 205

arcade, 196 arches, 196, 197, 197–198 atrium, 202–203, 203 barrel vault, 196, 196

bay, 196 buttress, 196

buttress, 196 columns, 103, 114, 197–198 cubicula, 202, 204 espaller, 203 groin vault, 196, 196 jambs, 196 keystone, 196 liprels, 14

lintels, 14 metopes, 142, 142, 146 nave, 207 oculus, 200, 201

parapet, 144 parodos, 156 pediment, 142 piers, 196

platform, 114 podium, 178

proscenium, 156 round arch, 196, 196 skene, 156 spandrels, 196

stoa, 136 triglyphs, 146 vaults, 196 voussoirs, 196

Architecture reintecture
See also Housing; Pyramids
Christian, 206–207, 206–207
classical, 114–115
domestic in Imperial Rome, 202–203

domestic in Imperial Rome, 202–203
Egypt, New Kingdom, 81–85
Egypt, Old Kingdom, 73–76
Egyptian, 81–85
Etruscan, 178, 178–179
Greek, 109, 111, 113, 114–115, 119, 119–120, 134–135, 139–148, 140, 144–145
Greek sanctuaries, 112–118, 113
Han Dynasty, China, 224, 225
Hellenistic, 134–135, 136, 140–148, 142–145, 155, 155, 161, 161
Imperial Rome, 174–175, 175–176, 186–187, 186–187, 191–204, 192, 197, 199–201
India, 227, 227–228, 231–233, 232
Minoan, 98–100

Mycenaean culture, 100–101, 101–102 Persian, 56, 56

Architrave, 114 Arena, 193 Ares, 112 Areté, 105, 106, 108, 149

Areté, 105, 106, 108, 149
Aristophanes, Lysistrata, 138, 152
Aristotle, 155, 156, 159–160, 162
Athenian Constitution, 118
Golden Mean, 160

Historia Animalium, 159 Nicomachean Ethics, 160

Physics, 159
Poetics, 155, 160, 162, 172–173
Politics, 136–137

Ark of the Covenant, 54, 198
Ark of the Covenant, mosaic floor decorations, Israel, 51

See also Literature; Paintings; Pottery; Sculpture Art, Assyrian Empire, 43 Art of Love (Ovid), 190–191 Artemis, 112 Ashoka, 231

Ashumasirpal II, 43 Ashumasirpal II Killing Lions, Kalhu, 43 Ashumasirpal II Killing Lions, Kalhu, Iraq, 43, 43,

Aspasia, 138

Aspasia, 138
Assteas, red-figure krater depicting a comedy,
Paestum, Italy, 152
Assyrian Empire, 43–46, 44–45, 90
Athanadoros, 165
Athena, 112, 119–120
Athena Nikephoros, Pergamon, 162
Athena Parthenos, Parthenon, 146, 146
Athena Parthenos sculpture, Parthenon, 143
Athena Promachus (Athena the Defender), 144
Atheniam Constitution (Aristotle), 118
Atheniam Treasury, Delphi, Greece, 113, 113

Athenian Constitution (Aristotle), 118
Athenian Treasury, Delphi, Greece, 113, 113
Athens, 118–124, 135–173
See also Acropolis; Greece; Hellenistic world cult of the body, 116–118, 139–140
democracy, 118–119, 124
female sculpture, 119–120
life and exhibits in 136, 140

life and politics in, 136-140

life and politics in, 136–140 map, 136
Pericles, 138–139, 140–141, 148–149 philosophy, 148–151 poetry of Sappho, 123–124 polis, 110–112, 148–151 pottery, 119–123, 119–123 School of Hellas, 138–139 slaves and metics, 137 theater, 151–156 women of, 137–138 byteus, 102–103

Atreus, 102–103 Atrium, 202–203, 203

Atrium, 202–205, 205 Atralus I, 162 Augustus, 165, 177, 186–187, 191–201 Augustus of Primaporta, 185, 185 Auping, Michael, 27 Aurelius, Marcus, 197

Avenue, 17 Axis, 140

Ba, 73, 88 Babylon, 40–43 The Bacchae (Euripides), 155 Bacchus, 112

Balance, concept of, 216
Balbilla, Julia, 188
Bam Citadel, Iran, 235, 235
Banqueting Scene, Paestum, Italy, 151 Bard, 103

Barrel vault, 196, 196 Bas relief, 7 Basilica, 195

Basilica Nova, Rome, 206–207
Basilica of Maxentius and Constantine, Rome, 206–207 Basilica Ulpia, 195

Baths of Caracalla, Rome, 205, 207 Bay, 196 Beehive tombs, 102 Bhagavad Gita, 229, 238–240 Bi, 214, 214

Bible

See also Hebrew Bible See also Horocons and See also Horocons and See also Horocons and See also Horocons and See also (Theogony) (Hesiod), 110 Black-figure vases, 121–122, 122, 151 The Blessing of Inanna, 44–45 The Blinding of Polyphemus, Sparta, Greece, 108, 108

Bluestone Circle, 17

Bodhisattvas, 231 Bodhisattvas, 231
The Book of Changes, 215–216, 217, 219
The Book of History, 219
Book of Knowledge (Zend-Avesta), 58
The Book of Rites, 219
The Book of Songs, 217, 219, 237
Books of Going Forth by Day, 88–89, 89, 108
Books of the Dead, 88–89
Botkin Class Amphora, Greece, 105, 105
Berdenon, 278, 279

Brahman, 228–229 Bronze age, 32, 103 Bronze bells, from tomb of Marquis Yi, 218 Bronze work

Bronze work
Shang Dynasty, China, 216, 216–217
Zhou Dynasty, China, 218
Bruce, Thomas, 147
Brutus, Lucius Junius, 182, 182, 183
Buddhism, in India, 231–234
Buddhist monuments, 231–234

Buddhist monuments, 231–234 Buffalo Kachina, Zuni, 22 Bull Leaping (Toreador Fresco), Crete, 97, 97 Bulls in Minoan culture, 97 Burial mounds, 231–233 Buttress, 196

Caesar, Julius, Commentaries, 183 Cahokia mound, Mississippian culture, Illinois,

26, 26 Cai Lun, 226 Cairn, 14 Calanus, 157 Caldarium, 205 Callicrates, 141, 142, 143

Calligraphy, in China, 214–215 The Canon (Polyclitus), 140, 141 Canopic chest, 88 Capitals, 98 Caracalla, 204 Carter, Howard, 65, 87 Cartharsis, 160 Cartouche, 75 Carving, 7

Carving, 7
Caryatids, 144
Catullus, Poems 5 and 43, 209
Catullus, Valerius, 189
Cave art, 3–5

Chauvet cave painting, 2-3, 4-5, 27, 27 Cosquer cave painting, 4 Lascaux cave painting, 4, 4–5 Cella, 113

Cemetery at Ur, 35–37 Ceramic figures, Neolithic era, 12–13 Ceres, 112

Champollion, Jean-François, 75 Chandragupta Maurya, 231 Charles the Great. See Charlemagne Chauvet, Jean-Marie, 3

Chauvet cave painting, 2–3, 4–5, 27, 27

China architecture, 224 bronze work, 216, 216–217, 218 calligraphy, 214–215 early culture, 214–220 Han Dynasty, 220–226, 235 "Heavenly Horses," 221 Imperial period, 220–226 introduction to, 213–214 literature, 215–216, 217, 218, 219, 221, 224, 237–238 map of, 213

map of, 213 music, 217-218 music, 217–218
painting, 219, 219
papermaking, 226
philosophy of Han Feizi, 220
poetry, 217, 224, 237
pottery, Neolithic, 11, 11–12
Qin Dynasty, 220
religion in, 218–220
sculpture, 221

sculpture, 221 Shang Dynasty, 215–217 silk, 224–226, 226, 235 soldiers and horses, Emperor Shihuangdi tomb, 222–223, 222–223 Zhou Dynasty, 217–220

Chinese characters, 215 Chiton, 120 Chorus, 152–153 Chorus structure, 152 Christianity architecture, 206-207, 206-207

in Rome, 206
"Chronicles of Japan," 22
Cicero, Marcus Tullius, 177, 183–184
City-states, 32, 108–109, 109

Civilization, 8 Classical style of art, 158 Clay soldiers, 222-223, 222-223

Chapter 1

PO Werner Forman/Art Resource, NY; 1-1 Ministere de la Culture et de la Communication. Direction Regionale des affaires Culturelles de Rhone-Alpes. Service Regional de l'Archeologie;1-2 © Yvonne Vertut; 1-3 Erich Lessing/Art Resource, NY; 1-4 Dr. Semenov Yu, 2004. Courtesy Palaeontological Museum, National Museum of Natural History of NAS of Ukraine, Kiev, Ukraine.; 1-5 © Photo Atlante/Folco Quilici; 1-6 The Nicholson Museum, University of Sydney. NM57.03; 1-7 © David Lyons/Alamy; 1-9 Réunion des Musées Nationaux/Art Resource, NY; 1-10 © Judith Miller/Wallis and Wallis/Dorling Kindersley; 1-11 Réunion des Musées Nationaux/Art Resource, NY; 1-12 © Werner Forman/Art Resource, NY; 1-13 Yan Arthus-Bertrand/Altitude/ Photo Researchers, Inc.; 1-14 © Joe Cornish/Dorling Kindersley; 1-15 © English Heritage.NMR Aerofilms Collection; 1-16 © Christopher and Sally Gable/ Dorling Kindersley; 1-17 John Deeks/Photo Researchers, Inc.; 1-19 Zuni, "Buffalo Kachina". c. 1875. Wood, cloth, hide, fur, shell, feathers, horse hair, and tin cones. © Millicent Rogers Museum; 1-20 © Kenneth Hamm/Photo Japan; 1-21 Suzanne Larronde Murphy; 1-22 © Tony Linck/ SuperStock; 1-23 William Iseminger, "Reconstruction of Central Cahokia Mounds". c. 1150 CE. Courtesy of Cahokia Mounds State Historic Site;1-24 © Ministere de la Culture et des Communication; 1-25 Susan Rothenberg, "Untitled". 1978. Acrylic, Flashe, Pencil on Paper. 20" × 20". Collection Walker ARt Center, Minneapolis. Art Center Acquisition Fund, 1979. © 2008 Susan Rothenberg/ Artist's Rights Society (ARS), NY; page 7, Musee des Antiquites Nationales, St. Germain-en-Laye, France/Giraudon/The Bridgeman Art Library.

Chapter 2

2-1 © Nik Wheeler/CORBIS; 2-2 Courtesy of the Penn Museum, film # 152071 Gold vessel in the shape of an ostrich egg; 2-3 The Oriental Institute Museum, Courtesy of the Oriental Institute of the University of Chicago; 2-4 Courtesy of the Oriental Institute of the University of Chicago; 2-5 © The Trustees of The British Museum/Art Resource, NY; 2-6 © The Trustees of the British Museum/Art Resource, NY; 2-7 Courtesy of the Penn Museum object # B17694, image #150848.Mythological figures, Detail of the sound box of "Sound Box of the Bull Lyre"; 2-8 © The Trustees of The British Museum/Art Resource, NY; 2-9 Scala/Art Resource, NY; 2-10 Réunion des Musées Nationaux/Art Resource, NY; 2-11 Réunion des Musées Nationaux/Art Resource, NY; 2-12 © The Trustees of The British Museum/Art Resource, NY; 2-13 SCALA/Art Resource, NY; 2-14 © The Trustees of the British Museum/Art Resource, NY; 2-15 Z. Radovan/www.BibleLandPictures.com; 2-16 Erich Lessing/Art Resource, NY; 2-17 Courtesy of the Oriental Institute of the University of Chicago; 2-18 Bildarchiv Preussischer Kulturbesitz/Art Resource, NY; 2-19 © Gérard Degeorge/CORBIS; 2-20 © Livius.Org; 2-21 Scala/Art Resource, NY; 2-22 © Joel Wintermantle /Alamy; page 39, SCALA/Art Resource, NY.

Chapter 3

3-1 Scala/Art Resource, NY; 3-2 Werner Forman/Art Resource, NY; 3-3 © Dorling Kindersley; 3-6 © Staffan Widstrand/naturepl.com; 3-8 Vanni/Art Resource, NY; 3-9 Araldo de Luca/The Egyptian Museum, Cairo/Index Ricerca Icongrafica; 3-10 King Menkaure (Mycerinus) and Queen. Egyptian, Old Kingdom, Dynasty 4, reign of Menkaure. About 2490-2472 BC. Findspot: Egypt, Giza, Menkaure Valley Temple. Greywacke. 142.2 × 57.1 × 55.2 cm (56 × 22 1/2 × 21 3/4 in.) Museum of Fine Arts, Boston. Harvard University-Boston Museum of Fine Arts, 11.1738. Photograph © 2008 Museum of Fine Arts, Boston; 3-11 Réunion des Musées Nationaux/Art Resource, NY; 3-12 The Art Archive/Egyptian Museum Cairo/Gianni Dagli Orti; 3-13 The Art Archive/Egyptian Museum Cairo/Alfredo Dagli Orti; 3-14 Scala/Art Resource, NY; 3-16 © The Metropolitan Museum of Art/Art Resource,

NY. 3-17 © Peter A. Clayton; 3-18 © Yvonne Vertut; 3-20 akg-images/Andrea Jemolo; 3-21 © The Trustees of The British Museum/Art Resource, NY; 3-22 Bildarchiv Preussischer Kulturbesitz/Art Resource, NY; 3-23 Bildarchiv Preussischer Kulturbesitz/Art Resource, NY; 3-24 Scala/Art Resource, NY 3-25 © The Trustees of the British Museum/Art Resource, NY; 3-26 Scala/Art Resource, NY 3-27 © Erich Lessing/Art Resource, NY; 3-28 Scala/Art Resource, NY; 3-29 Courtesy of The Bodrum Museum of Underwater Archeology, Bodrum, Turkey; pages 70-71, Werner Forman/Art Resource, NY; page 75, © The Trustees of the British Museum/Art Museum, NY; page 84, © The Trustees of the British Museum.

Chapter 4

4-1 Nimatallah/Art Resource, NY; 4-2 Figure, Cyclades, ca. 2500 BCE, Marble, height: 15-3/4" (40 cm). Museum of Cycladic Art. Nicholas P. Goulandris Foundation, no. 206; 4-3 Archeological Museum, Iraklion, Crete/Studio Kontos Photostock; 4-4 Erich Lessing/Art Resource, NY; 4-5 © Mauzy photo; 4-6 © Roger Wood/CORBIS; 4-7 National Archaeological Museum, © Hellenic Ministry of Culture, Archaeological Receipts Fund; 4-8 Studio Kontos Photostock; 4-9 National Archaeological Museum, Athens/Hirmer Fotoarchiv, Munich, Germany; 4-10 © Vanni Archive/CORBIS; 4-11 © Maltings Partnership/Dorling Kindersley; 4-12 Studio Kontos Photostock; 4-13 Museum of Fine Arts, Boston, Henry Lillie Pierce Fund. Photograph © 2008 Museum of Fine Arts, Boston; 4-14 Erich Lessing/Art Resource, NY; 4-15 Erich Lessing/Art Resource, NY; 4-16 © Marco Cristofori/Corbis; 4-17 © Marie Mauzy; 4-18 Nimatallah/Art Resource, NY; 4-19 Image copyright © The Metropolitan Museum of Art/Art Resource, NY; 4-20 Image copyright © The Metropolitan Museum of Art/Art Resource, NY; 4-21 Scala/Art Resource, NY; 4-22 Akropolis Museum, Athens/Studio Kontos Photostock; 4-23 The Art Archive/ Acropolis Museum Athens/Gianni Dagli Orti; 4-24 © The Trustees of The British Museum/Art Resource, NY; 4-25 The Dipylon Amphora, funerary urn in the geometric style from the Kerameikos Necropolis, Athens, c.750 BC (terracotta); 4-26 A. D. Painter, "Hydria (water jug)". Greek, Archaic Period, about 520 BCE. Greece, Attica, Athens. Ceramic, Black Figure. H: 53 cm (20 7/8") D: 37 cm (14 9/16"). Courtesy, Museum of Fine Arts, Boston. Reproduced with permission. © 2005 Museum of Fine Arts, Boston. All Rights Reserved; 4-27 Scala/Ministero per i Beni e le Attività culturali/Art Resource, NY; 4-28 Scala/Art Resource, NY; 4-29 Scala/Art Resource, NY; 4-30 The Art Archive/Musée Archéologique Naples/Alfredo Dagli Orti; page 95, Nimatallah/Art Resource, NY; page 114, Canali Photobank, Milan, Italy; page 115 (top left), Nimatallah/Art Resource, NY; page 115 (top right), John Decopoulos; page 115 (bottom), Courtesy of the Library of Congress.

Chapter 5

5-1 © Marie Mauzy; 5-2 © Marie Mauzy; 5-3 Nimatallah/Art Resource, NY; 5-4 The Art Archive/ Musée Archéologique Naples/Alfredo Dagli Orti;5-5 With permission of the Royal Ontario Museum © ROM; 5-6 Studio Kontos Photostock; 5-7 © Marie Mauzy; 5-8 With permission of the Royal Ontario Museum © ROM; 5-9 © The Trustees of The British Museum/Art Resource, NY; 5-10 © The Trustees of The British Museum/Art Resource, NY; 5-11 ©The Trustees of the British Museum/Art Resource, NY; 5-12 "Book VII of The Republic: The Allegory of the Cave", from THE GREAT DIA-LOGUES OF PLATO by Plato, translated by W.H.D. Rouse, copyright ©1956, renewed ©1984 by J.C.G. Rouse. Used by Permission of Dutton Signet, a division of Penguin Group (USA) Inc.; 5-13 Scala/Art Resource, NY; 5-14 Martin von Wagner Museum, University of Wurzburg, Wurzburg, Germany; 5-15 Bildarchiv Preussischer Kulturbesitz/Art Resource, NY; 5-16 © Ruggero Vanni/CORBIS; 5-18 Erich Lessing/Art Resource, NY; 5-19 Scala/Art Resource, NY; 5-20 P. Zigrossi/Vatican Museums, Rome, Italy; 5-21 Tourist Organization of

Chapter 5

Reading 5.6, page 171: From THE SYMPOSIUM by Plato, trans. with an introduction and notes by Christopher Gill (Penguin Classics, 1999). Copyright © 1999 Christopher Gill. Reproduced by permission of Penguin Books Ltd. Reading 5.7a, page 153: From "Antigone" by Sophocles, from THREE THEBAN PLAYS by Sophocles, trans. by Robert Fagles, copyright © 1982 by Robert Fagles. Used by permission of Viking Penguin, a division of Penguin Group (USA) Inc.

Chapter 6

Reading 6.1a, page 180: From THE AENEID OF VIRGIL, trans. by Rolfe Humphries, copyright © 1984. Reprinted by permission of Pearson Education. Reading 6.1b, page 181: Excerpts from THE ODYSSEY by Homer, trans. by Robert Fitzgerald. Copyright © 1961, 1963 by Robert Fitzgerald. Copyright renewed 1989 by Benedict R.C. Fitzgerald, on behalf of the Fitzgerald children. Reprinted by permission of Farrar, Straus and Giroux, LLC and the Estate of Robert Fitzgerald. Reading 6.1c, page 181: From THE AENEID OF VIRGIL, trans. by Rolfe Humphries, copyright © 1984. Reprinted by permission of Pearson Education. Reading 6.6, page 209: From THE POEMS OF CATULLUS, trans. with an introduction by Peter Whigham (Penguin Classics 1966). Copyright © 1966 Penguin Books Ltd. Reproduced by permission of Penguin Books Ltd. Reading 6.8, page 209: From THE AENEID OF VIRGIL, trans. by Rolfe Humphries, copyright © 1984. Reprinted by permission of Pearson Education. Reading 6.9, page 211: Reprinted by permission of the publishers and the Trustees of the Loeb Classical Library from HORACE: ODES AND EPODES, Loeb Classical Library, vol. 33, tr. C.E. Bennett 1914; revised 1927, 1968. Copyright © 1927, 1968 by the President and Fellows of Harvard College. Loeb Classical $\mbox{Library} \mbox{\ensuremath{\mathbb{B}}}$ is a registered trademark of the President and Fellows of Harvard College.

Chapter 7

Reading 7.1, page 237: Poems from "The Book of Songs" trans. by Tony Barnstone and Chou Ping from LITERATURES OF ASIA ed. by Tony Barnstone (Pearson Education 2003). Reprinted by permission of Tony Barnstone. Reading 7.1a, page 217: From THE BOOK OF SONGS translated by Arthur Waley (Allen & Unwin, 1937). Copyright © by permission of The Arthur Waley Estate. Reading 7.2, page 218:From THE WAY OF LIFE b Lao Tzu, trans. by Raymond B. Blakney, copyright © 1955 by Raymond B. Blakney, renewed © 1983 by Charles Philip Blakney. Used by permission of Dutton Signet, a division of Penguin Group (USA) Inc. Reading 7.4, page 221: Lines from Emperor Wu's "Heavenly Horses," tr. by Arthur Waley Source: "Heavenly Horses of Ferghana" by Arthur Waley,p. 96, History Today, v. 5 # 2 (1955) 96-193. Copyright © 1955 by History Today. Reprinted by permission of the publisher. Reading 7.5, page 224: "Lament" by Liu Xijun, trans. by Tony Barnstone and Chou Ping, From LITERATURES OF ASIA, ed. by Tony Barnstone (Pearson Education 2003). Reprinted by permission of Tony Barnstone. Reading 7.6, page 224: "To Be a Woman" by Fu Xuan, trans. by Tony Barnstone and Willis Barnstone from LITERATURES OF ASIA, ed. by Tony Barnstone (Pearson Education 2003). Reprinted by permission of the translators. Reading 7.7, page 238: From BHAGAVAD-GITA, trans. by Barbara Stoler Miller, trans. copyright © 1986 by Barbara Stoler Miller. Used by permission of Bantam Books, a division of Random House, Inc. Reading 7.8, page 240: Reprinted from THE DHAMMAPADA (1995) trans. by Ven. Ananda Maitreya, revised by Rose Kramer, with the permission of Parallax Press, Berkeley, CA, www.parallax.org.

Greece; 5-22 Vanni/Art Resource, NY; 5-23 Scala/Art Resource, NY; 5-24 Réunion des Musées Nationaux/Art Resource, NY; 5-25 © The Trustees of The British Museum /Art Resource, NY; 5-26 Scala/Art Resource, NY; page 143, Studio Kontos Photostock.

Chapter 6

6-1 Henri Stierlin; 6-2 © 1996 Harry N. Abrams, Inc.; 6-3 Ministero per i Beni e le Attivita Culturali/Roma; 6-5 Penelope Davies; 6-07 Canali Photobank, Milan, Italy; 6-9 Erich Lessing/Art Resource, NY; 6-10 Timothy McCarthy/Art Resource, NY; 6-11 © Araldo de Luca/CORBIS; 6-12 © The Metropolitan Museum of Art/Art Resource, NY; 6-13 Vatican Museums & Galleries, Vatican City/Superstock; 6-14 Foto Vasari/Index Ricerca Icongrafica; 6-15 Scala/Art Resource, NY: 6-16 Gemeinnutzige Stiftung Leonard von Matt, Buochs, Switzerland; 6-17 The Art Archive/Musée Archéologique Naples/Gianni Dagli Orti; 6-18 Pubbli Aer Foto; 6-19 Canali Photobank, Milan, Italy; 6-20 Canali Photobank, Milan, Italy; 6-21 Werner Forman/Art Resource, NY; 6-22 Robert Frerck/Woodfin Camp & Associates, Inc.; 6-23 Scala/Art Resource, NY; 6-24 Canali Photobank, Milan, Italy; 6-26 Hemera Technolgies/Alamy; 6-27 Henri Stierlin; 6-28 Cambridge University Press. Reprinted with the permission of Cambridge University Press; 6-29 Canali Photobank, Milan, Italy; 6-30 © Alinari Archives/CORBIS; 6-31 Scala/Art Resource, NY; page 194 (top), Vanni/Art Resource, NY; page 194 (bottom), Gilbert Gorski; page 195 (top), Dr. James E. Packer; page 195 (bottom), Fototeca Unione, American Academy in Rome; page 196, © Jon Arnold Images/DanitaDelimont.com.

Chapter 7

7-1 D. E. Cox/Stone/Getty Images; 7-2 Chinese, "Ritual Disc with Dragon Motiff (Pi)," Eastern Zhou Dynasty, Warring States period. Jade (nephrite); 6 1/2 in. (16.5 cm.) The Nelson-Atkins Museum of Art, Kansas City, Missouri. (Purchase: Nelson Trust) 33-81; 7-3 © Lowell Georgia/CORBIS; 7-6 Five-eared "ding" with dragon pattern, c. 1200 BCE. Bronze: height 48 in.; diameter at mouth, 32 3/4 in. Chunhua County Cultural Museum.; 7-7 © Wang Lu/ChinaStock; 7-8 Liu Liqun/ChinaStock Photo Library; 7-9 ©The Trustees of the British Museum/Art Resource, NY; 7-10 The Art Archive/Genius of China Exhibition; 7-11 The Nelson-Atkins Museum of Art, Kansas City, Missouri. Model of a House, Chinese, 1st century C.E., Eastern Han Dynasty (25-220 C.E.). Earthenware with unfired coloring, $52 \times$ 33 12; 27 inches $(132.1 \times 85.1 \times 68.6 \text{ cm})$; 7-12 Hunan Provincial Museum; 7-13 J M Kenover/Harappa; 7-14 Scala/Art Resource, NY; 7-15 Two seals depicting mythological animals, from Mohenjo-Daro, c.2300 BC (stone), Harappan/National Museum of Karachi, Karachi, Pakistan/Giraudon/The Bridgeman Art Library; 7-16 Image copyright © The Metropolitan Museum of Art/Art Resource, NY; 7-17 © Atlantide Phototravel/Corbis; 7-19 © Adam Woolfitt/CORBIS; 7-20 Jean-Louis Nou/Archaeological Museum, Sarnath/akg-images; 7-21 © Isabelle Vayron/Sygma/Corbis All Rights Reserved; pages 222-223, O. LOUIS MAZZATENTA/National Geographic Stock; page 223 (top), Wang Lu/China Stock Photo Library; page 223 (bottom), Terracotta Army, Qin Dynasty, 210 BC (terracotta), Chinese School, (3rd century BC)/Tomb of Qin shi Huang Di, Xianyang, China /The Bridgeman Art Library.

TEXT CREDITS

Chapter 2

Reading 2.1, page 42: From "The Law Code of Hammurabi" from LAW COLLECTIONS FROM MESOPOTAMIA AND ASIA MINOR, 2/e, 1997 by Martha T. Roth is reprinted by permission of the Society of Biblical Literature. Reading 2.2, page 45: "The Blessing of Inanna" from MESOPOTAMIA: WRITING, REASONING, AND THE GODS by Jean Bottero, trans. by Zainab Bahrani and Marc Van De Mieroop. Copyright © 1992 by the University of Chicago. Reprinted by permission of The University of Chicago Press. Reading 2.3, page 61: From THE EPIC OF GILGAMESH, with an Introduction and Notes, trans. by Maureen Gallery Kovacs. Copyright © 1989 by the Board of Trustees of the Leland Stanford Jr. University. All rights reserved. Used with the permission of Stanford University Press. www.sup.org. Reading 2.3a-e, pages 46-48: From THE EPIC OF GIL-GAMESH, with an Introduction and Notes, trans. by Maureen Gallery Kovacs. Copyright © 1989 by the Board of Trustees of the Leland Stanford Jr. University. All rights reserved. Used with the permission of Stanford University Press. www.sup.org. Reading 2.4, pages 61-63: From The Hebrew Bible Genesis 2-3, 6-7 from the NEW REVISED STANDARD VERSION OF THE BIBLE, copyright © 1989 by the National Council of the Churches of Christ in the U.S.A. Used by permission. All rights reserved. Reading 2.4a, page 51: From The Holy Bible Deuteronomy 6:6-9 from the NEW REVISED STANDARD VERSION OF THE BIBLE, copyright © 1989 by the National Council of the Churches of Christ in the U.S.A. Used by permission. All rights reserved. Reading 2.4b, page 52: From The Hebrew Bible Song of Solomon 4:1-6, 7:13-14 from THE SONG OF SONGS: A NEW TRANSLATION AND COMMENTARY by Ariel Bloch and Chana Bloch. Copyright © 1995 by Ariel Bloch and Chana Bloch. Reprinted by permission of Georges Borchardt, Inc., on behalf of Ariel Bloch and Chana Bloch. Reading 2.5, page 54: From the Hymn to Marduk From MESOPOTAMIA: WRITING, REASONING, AND THE GODS by Jean Bottero, trans. by Zainab Bahrani and Marc Van De Mieroop. Copyright © 1992 by the University of Chicago. Reprinted by permission of The University of Chicago Press.

Chapter 3

Reading 3.1, page 69: "This It Is said of Ptah" from ANCIENT EGYPTIAN LITERATURE: A BOOK OF READINGS, vol. 1, THE OLD AND MIDDLE KINGDOMS by Miriam Lichtheim. Copyright © 1973 by University of California Press. Reproduced with permission of University of California Press. Reading 3.3, page 86: From Akhenaten's Hymn to the Sun from ANCIENT EGYPTIAN LITERATURE: AN ANTHOLOGY, trans. by John L. Foster. Copyright © 2001. Used by permission of the University of Texas Press.

Chapter 4

Reading 4.1, page 128: From THE ILIAD by Homer, trans. by Robert Fagles, copyright © 1990 by Robert Fagles. Used by permission of Viking Penguin a division of Penguin Group (USA) Inc. Reading 4.1a, page 106: From THE ILIAD by Homer, trans. by Robert Fagles, copyright © 1990 by Robert Fagles. Used by permission of Viking Penguin a division of Penguin Group (USA) Inc. Reading 4.2, page 130: Excerpts from THE ODYSSEY by Homer, trans. by Robert Fitzgerald. Copyright © 1961, 1963 by Robert Fitzgerald. Copyright renewed 1989 by Benedict R.C. Fitzgerald, on behalf of the Fitzgerald children. Reprinted by permission of Farrar, Straus and Giroux, LLC and the Estate of Robert Fitzgerald. Reading 4.2 a-b, pages 106-107: Excerpts from THE ODYSSEY by Homer, trans. by Robert Fitzgerald. Copyright © 1961, 1963 by Robert Fitzgerald. Copyright renewed 1989 by Benedict R.C. Fitzgerald, on behalf of the Fitzgerald children. Reprinted by permission of Farrar, Straus and Giroux, LLC and the Estate of Robert Fitzgerald. Reading 4.3, page 110: From WORKS AND DAYS AND THEOGONY by Hesiod, trans. by Stanley Lombardo. Copyright © 1993. Reprinted by permission of Hackett Publishing Company, Inc. All rights reserved. Reading 4.7 a-b, page 124: From Sappho: A New Translation by Mary Barnard. Copyright © 1958 by University of California Press. Reproduced with permission of University of California Press via Copyright Clearance Center.

Classic Fairy Tales

Featuring Cinderella, Snow White, Belle, and all your favorite fairy tale characters!

Illustrated by The Disney Storybook Artists

© 2017 Disney Enterprises, Inc. All rights reserved.

Illustrated by The Disney Storybook Artists

No license is herein granted for the use of any drawing of a Disney character for any commercial purpose, including, but not limited to, the placing of any such drawing on an article of merchandise or the reproduction, public display, or sale of any such drawing. Any other use than home use by the reader of any such drawing is prohibited.

Learn to Draw Disney Villains © 2012 Disney Enterprises, Inc. All rights reserved. Illustrated by The Disney Storybook Artists.

Learn to Draw Disney's The Little Mermaid © 2013 Disney Enterprises, Inc. All rights reserved. Illustrated by The Disney Storybook Artists.

Learn to Draw Disney's Enchanted Princesses © 2012 Disney Enterprises, Inc. All rights reserved. Illustrated by The Disney Storybook Artists.

Published by Walter Foster Jr., an imprint of Quarto Publishing Group USA Inc. 6 Orchard Road, Suite 100, Lake Forest, CA 92630

Printed in China
3 5 7 9 10 8 6 4 2

Table of Contents

Tools & Materials	4
How to Use This Book	5
Cinderella	6
The Fairy Godmother	10
Gus & Jaq	
Lucifer	14
Lady Tremaine	16
Anastasia & Drizella	18
Belle	20
The Beast	24
Lumière & Cogsworth	26
Mrs. Potts & Chip	28
Gaston	30
Ariel	32
Prince Eric	36
Sebastian	38
Flounder	40
Snow White	42
The Seven Dwarfs	46
The Queen	50
The Witch	52
Sleeping Beauty	54
Flora, Fauna & Merryweather	58
Maleficent	
Dragon Maleficent	62
The End	64

ools & Materials

You need to gather a few simple art supplies before you begin. Start with a drawing pencil and an eraser. Make sure you also have a pencil sharpener and a ruler. To add color to your drawings,

How to Use This Book

You can draw any of the characters in this book by following these simple steps.

First draw the basic shapes, using light lines that will be easy to erase.

Each new step is shown in blue, so you'll always know what to draw next.

Take your time and copy the blue lines, adding detail.

Darken the lines you want to keep, and erase the rest.

Add color to your drawing with colored pencils, markers, paints, or crayons!

Ginderella

Though Cinderella lives a life of servitude, she greets each day full of hope that her destiny will change. She imagines how wonderful it would be to fall in love with a handsome prince who would treat her with kindness. Thanks to her Fairy Godmother, that day may come sooner than she thinks. Meanwhile, Cinderella never stops believing in her dreams.

The Fairy Godmother

With a wave of her wondrous wand and a bouncy "Bibbidi-bobbidi-boo," the Fairy Godmother transforms a simple pumpkin into a magical coach—and Cinderella's rags into a gorgeous gown.

Gus & Fag

Quick-thinking Jaq and clumsy Gus are good friends and make a great team, especially when it comes to protecting Cinderella and helping her achieve a happily ever after.

Luciper

Lucifer, the devilish pet cat of Lady Tremaine, has black fur, sharp claws, and a toothy grin. He is a sneaky feline who loves nothing more than tormenting Cinderella and catching mice.

Lady Tremaine

Cold, ruthless, and calculating, Lady Tremaine's primary role is simple: to oppress Cinderella and shatter her dream of a happily ever after. A wicked stepmother indeed!

Anastasia & Drizella

United in their jealousy of Cinderella, these wicked stepsisters have harsh, cold hearts (and enormous feet!) underneath their frightful frocks.

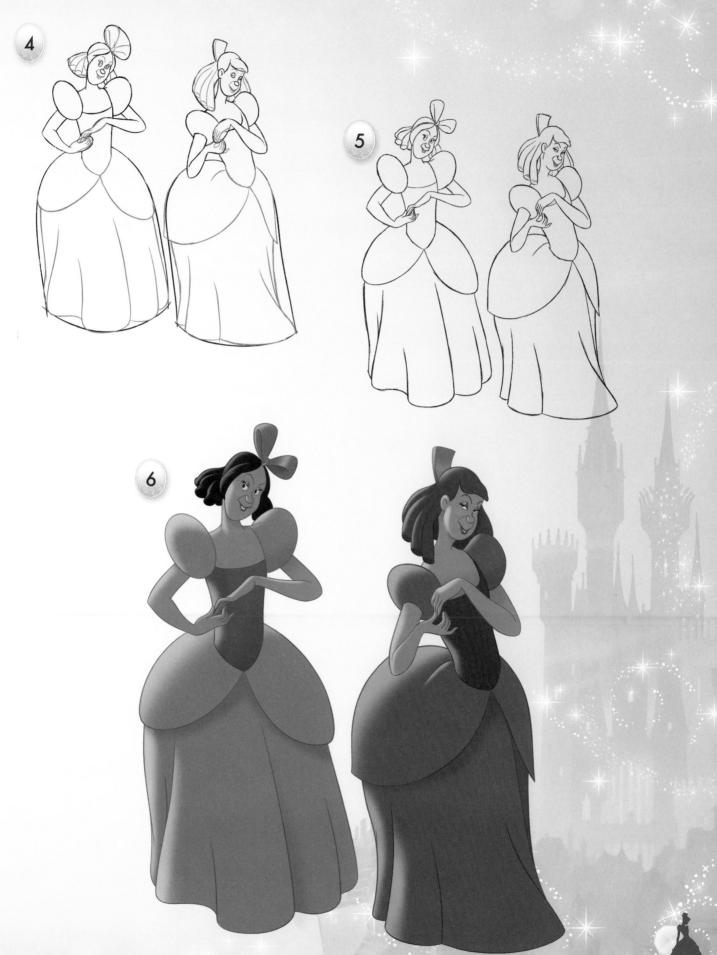

Belle

Belle is a simple country girl with a natural beauty that is due as much to her inner goodness as it is to her appearance. When drawing her, notice how soft curves create her simple beauty.

The Beast

His temper may often get the better of him, but the Beast has a softer side that only Belle can bring out. Those claws along with his horns and angry eyebrows scare most people away.

Lunière & Cogsworth

Voila! Best friends and also rivals of sorts, Lumière and Cogsworth keep the household running and on course—and they try to do the same for the Beast!

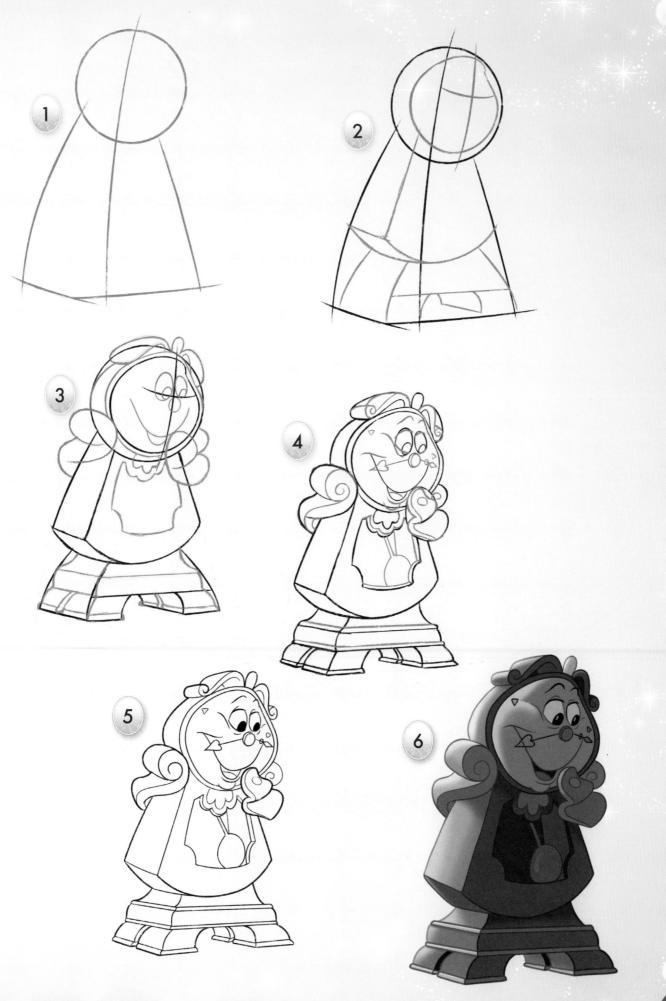

Mrs. Potts & Chip

With a spot of tea, Mrs. Potts can make any situation better. And her inquisitive son Chip keeps everyone's spirits up by shooting water through his front teeth.

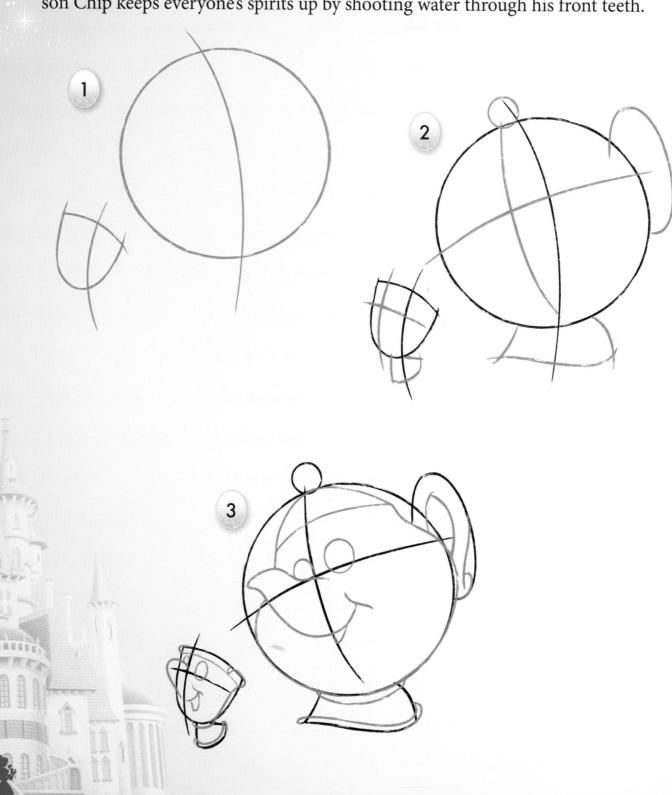

Ruffle usually has five peaks along front

5

Thin delicate trim rim

Gaston

Gaston, a handsome but arrogant hunter, is considered to be the town hero. He is only interested in physical appearances, and often makes fun of Belle for reading books.

Ariel's cheerful enthusiasm, engaging mannerisms, and unmatched charm all come to life in this pose. A strong line of action will help give the feeling that Ariel's body flows naturally into her graceful tail!

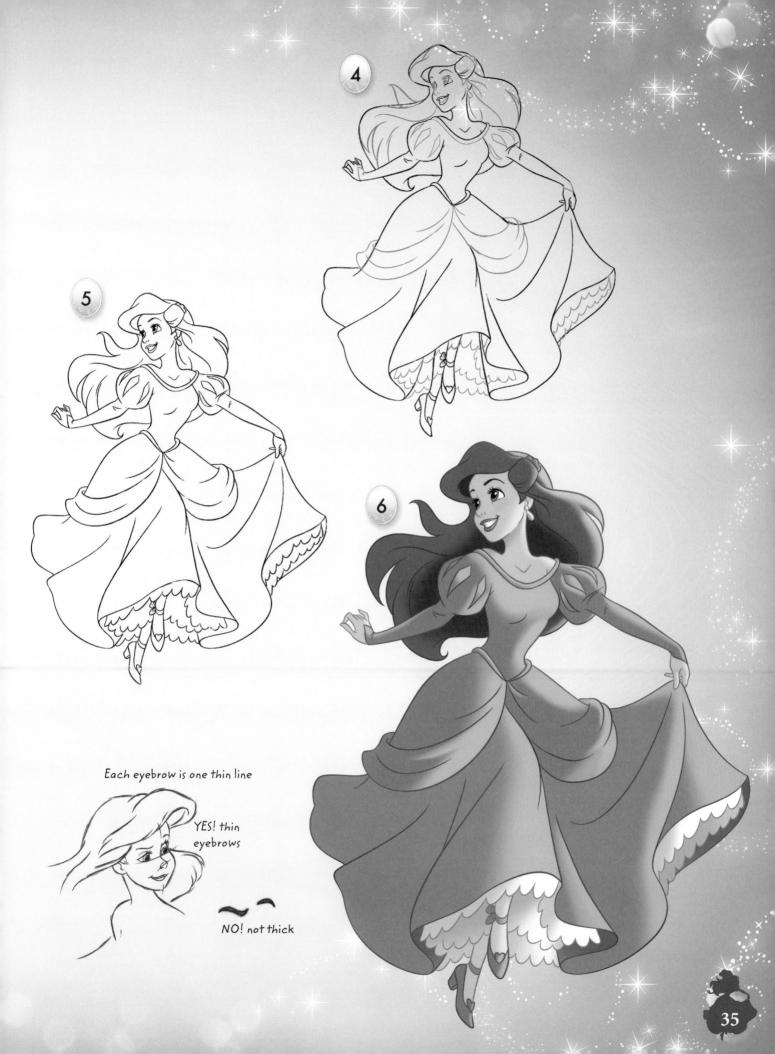

Prince Eric

Eric is a brave, athletic prince who loves the high seas, and his handsome looks capture Ariel's heart. Make sure to show his love for adventure when drawing him in an action pose.

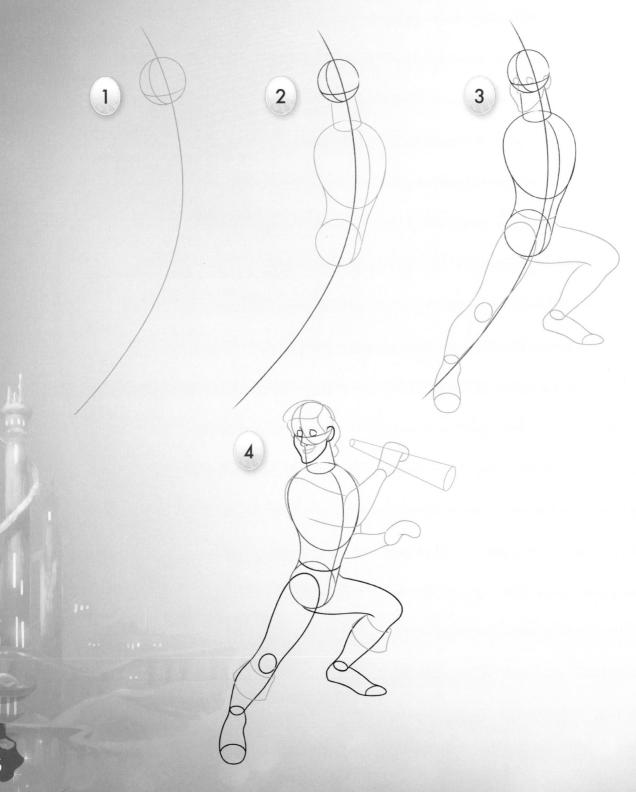

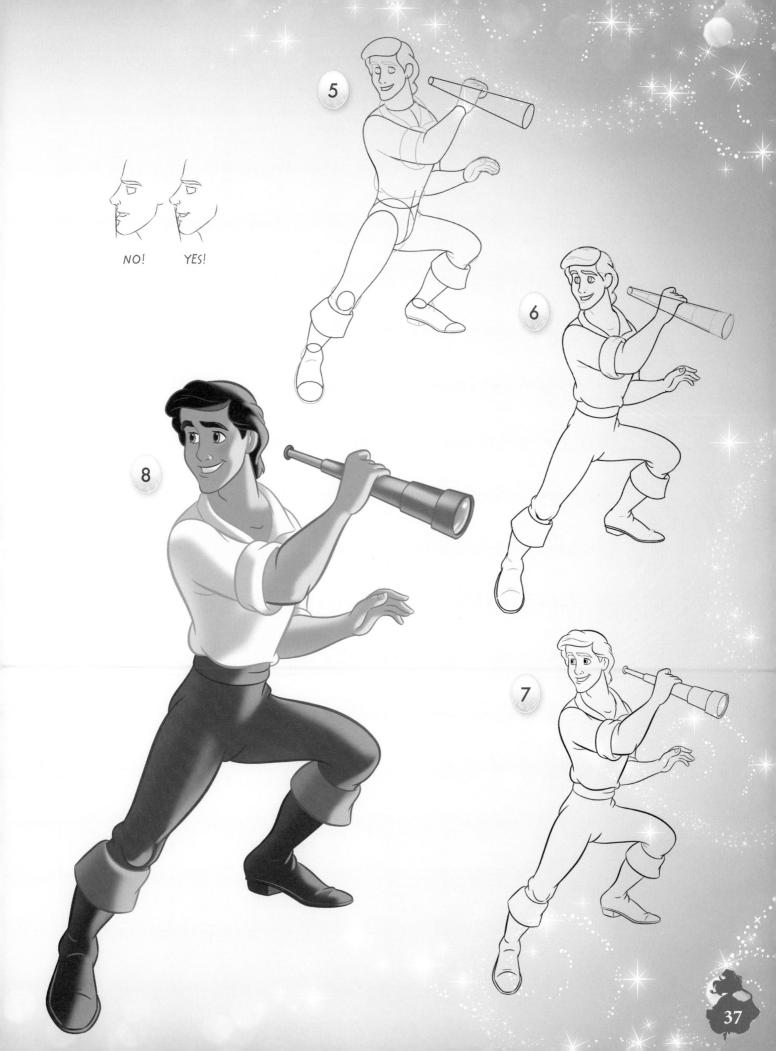

Sebastian

Sebastian is a little crab with a big heart—and an even bigger voice. He is tasked by King Triton with keeping an eye on Ariel, but "tagging along with some headstrong teenager" isn't an easy job. Good thing Sebastian has a good sense of humor, along with a great set of pipes.

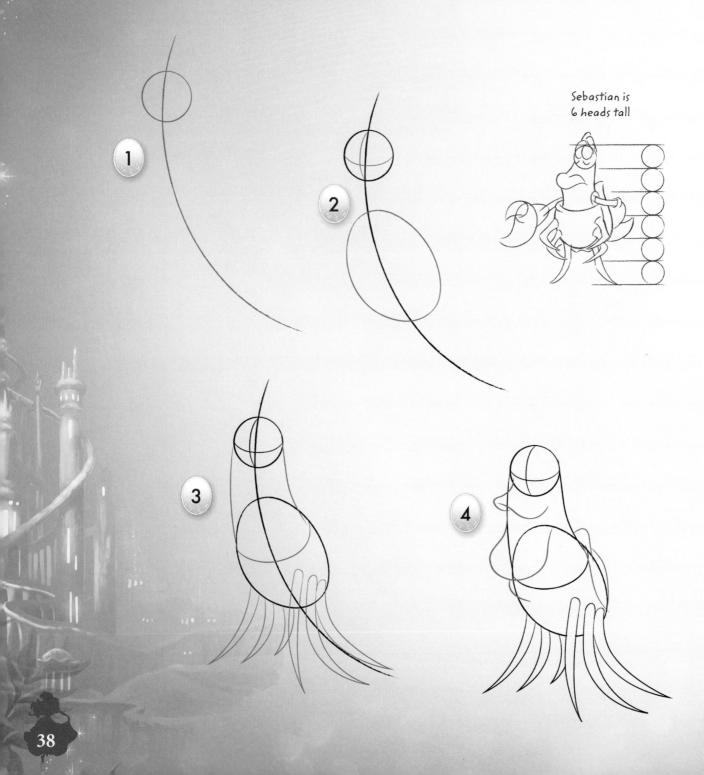

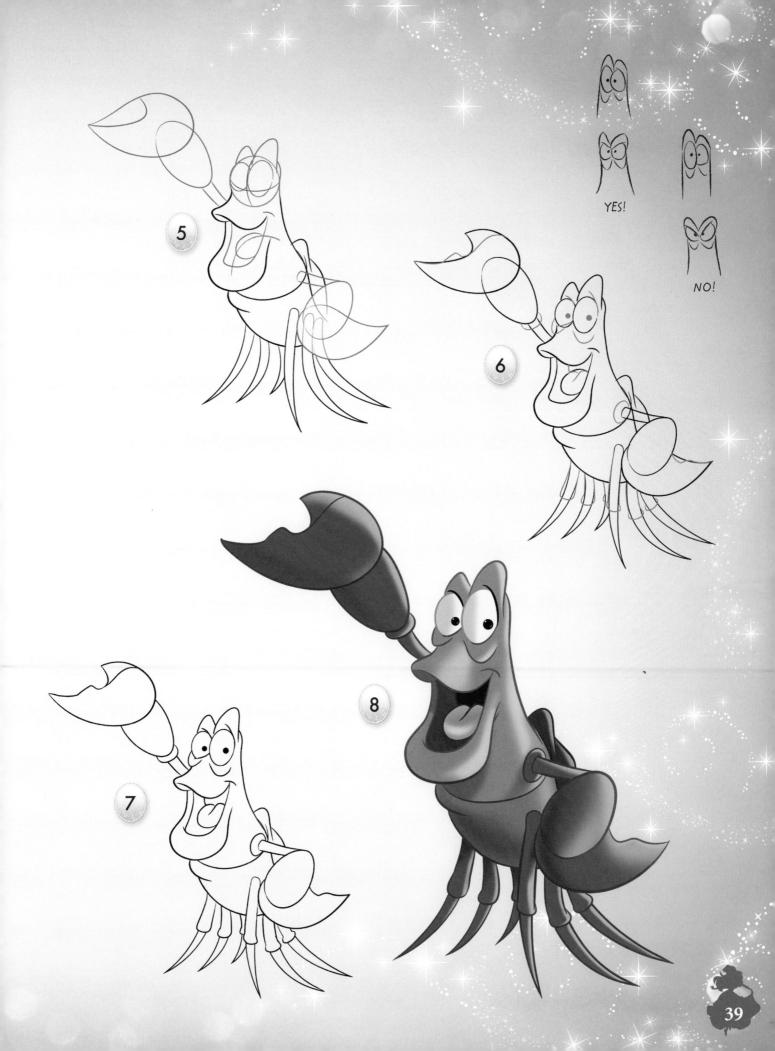

Flounder

Ariel's loyal best friend, Flounder is full of spunk. He has an innocence and vulnerability, so he can scare easily, but when it comes to his little mermaid, Flounder never lets her down!

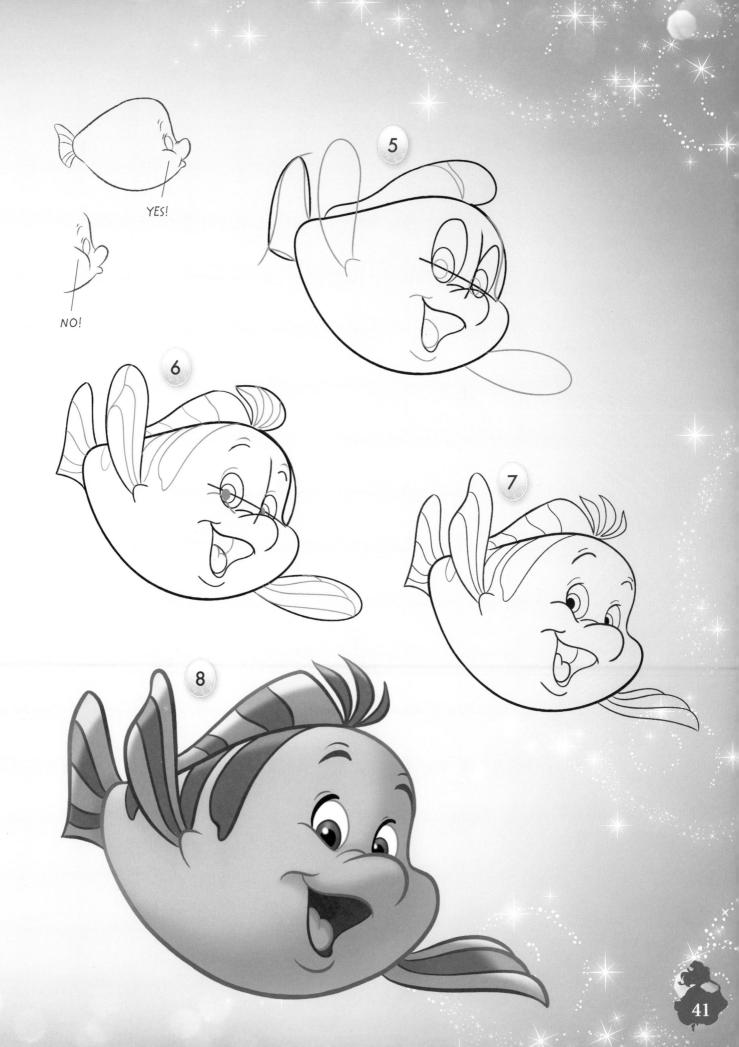

Snow White

Snow White is the fairest one in the land. She is full of innocence, charm, and sweetness. When you draw Snow White, be sure to show the soft, sweeping lines in her dress and the gentle arm movements that emphasize her cheerful, sweet disposition and her joy for life.

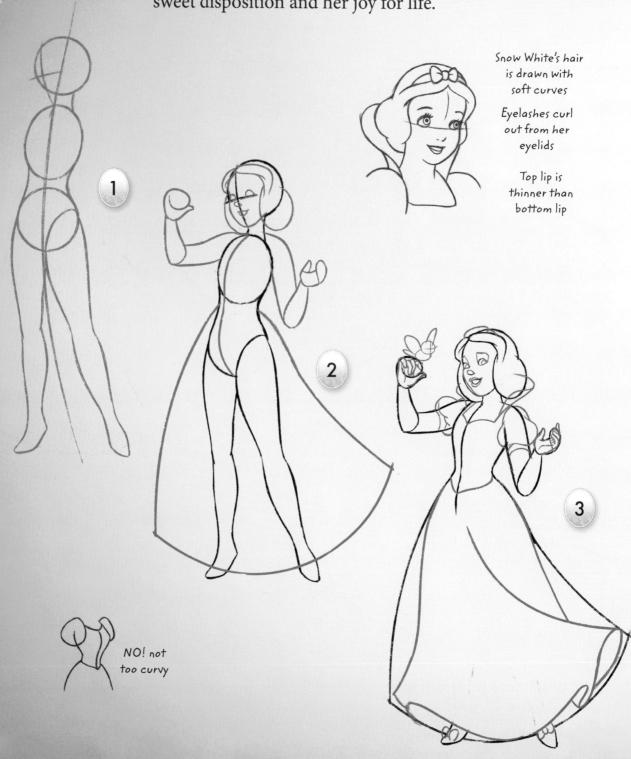

The Seven Dwarfs

Snow White's fate is forever changed when she meets Doc, Grumpy, Happy, Sleepy, Bashful, Sneezy, and Dopey in their cottage in the woods.

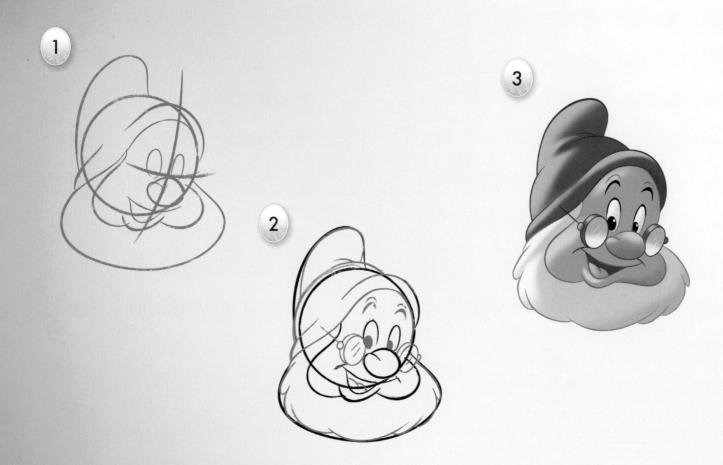

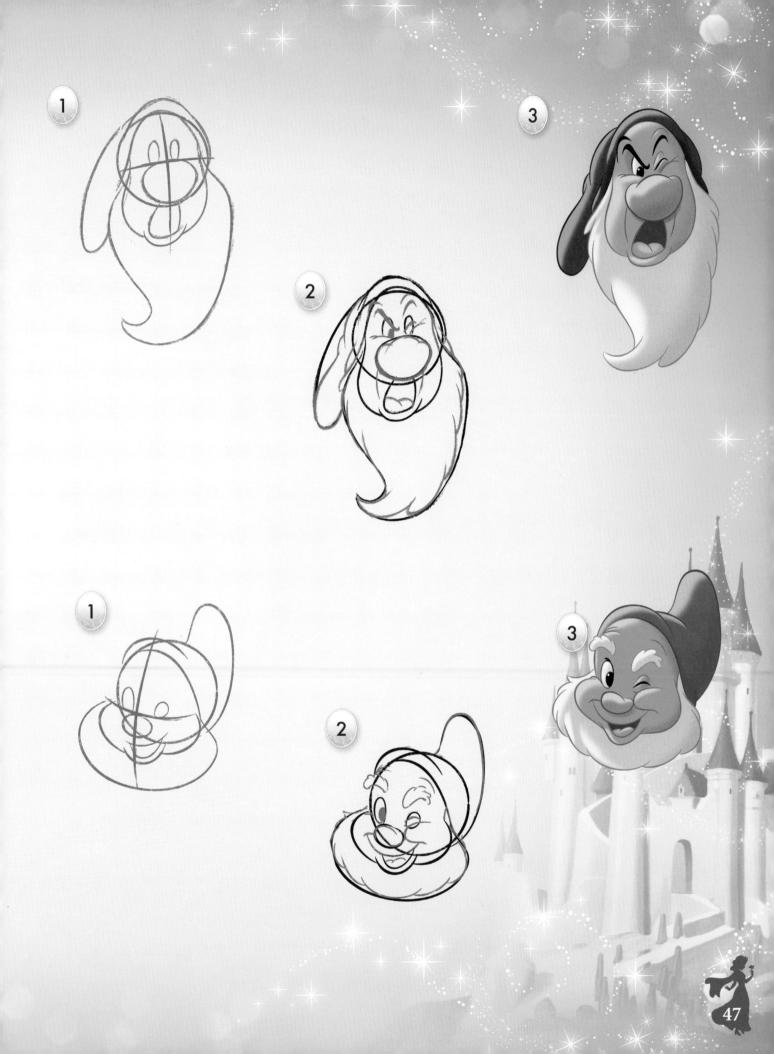

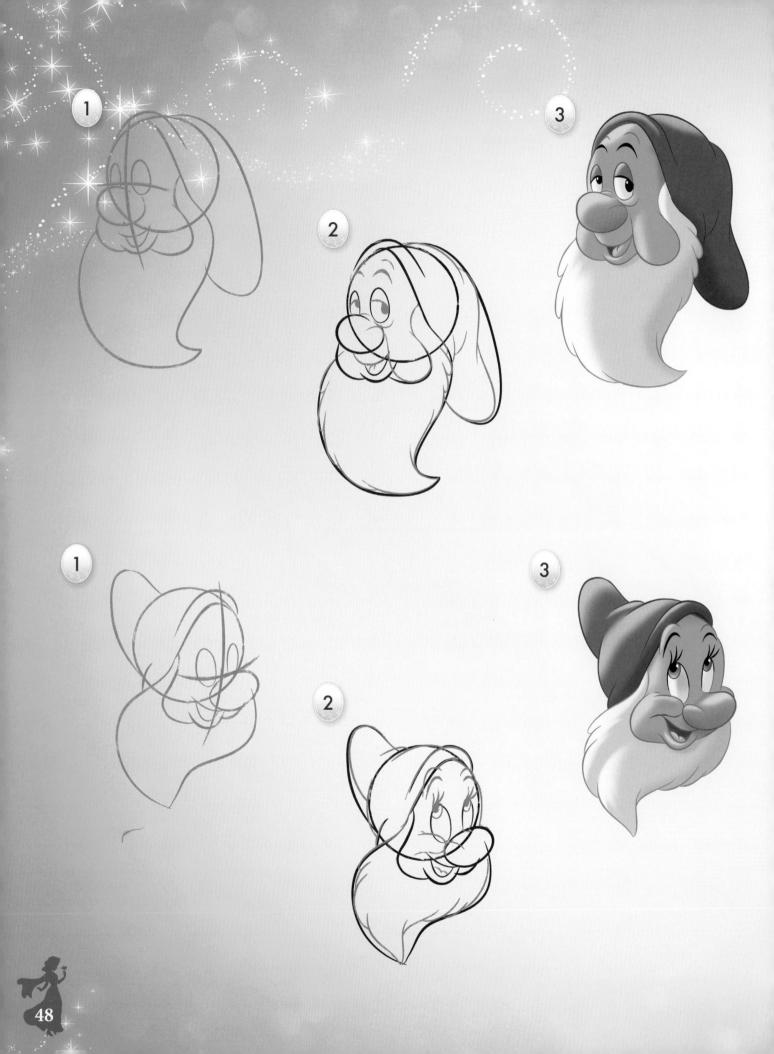

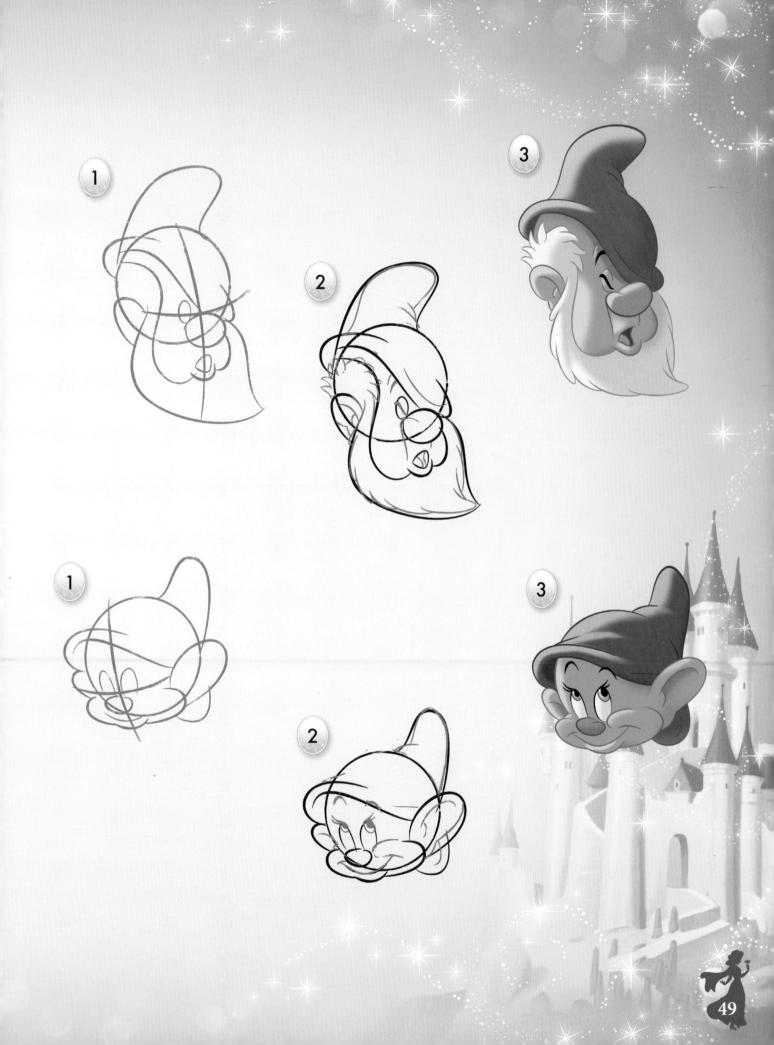

The Queen

The Queen, ruled by jealousy, anger, and vanity, tries to thwart Snow White at every turn. She truly is not the fairest one of all.

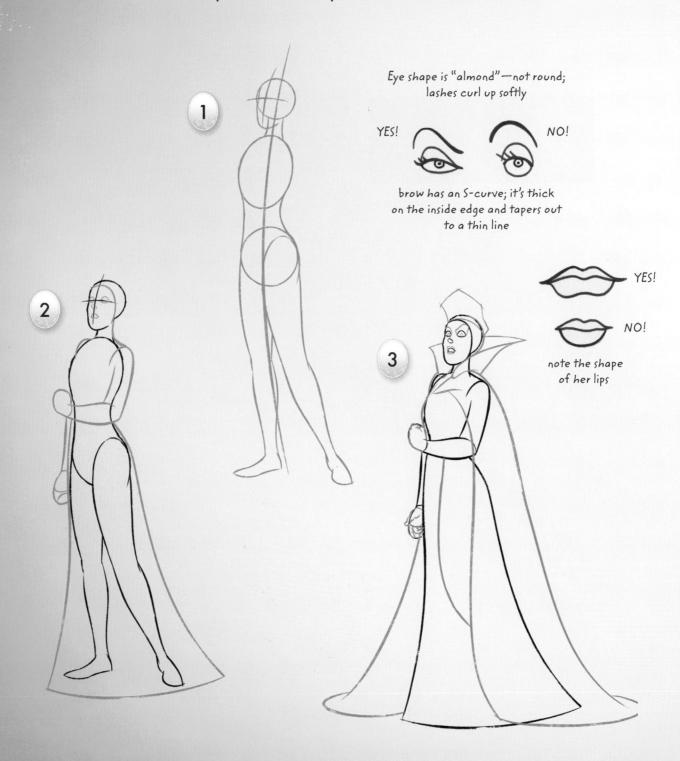

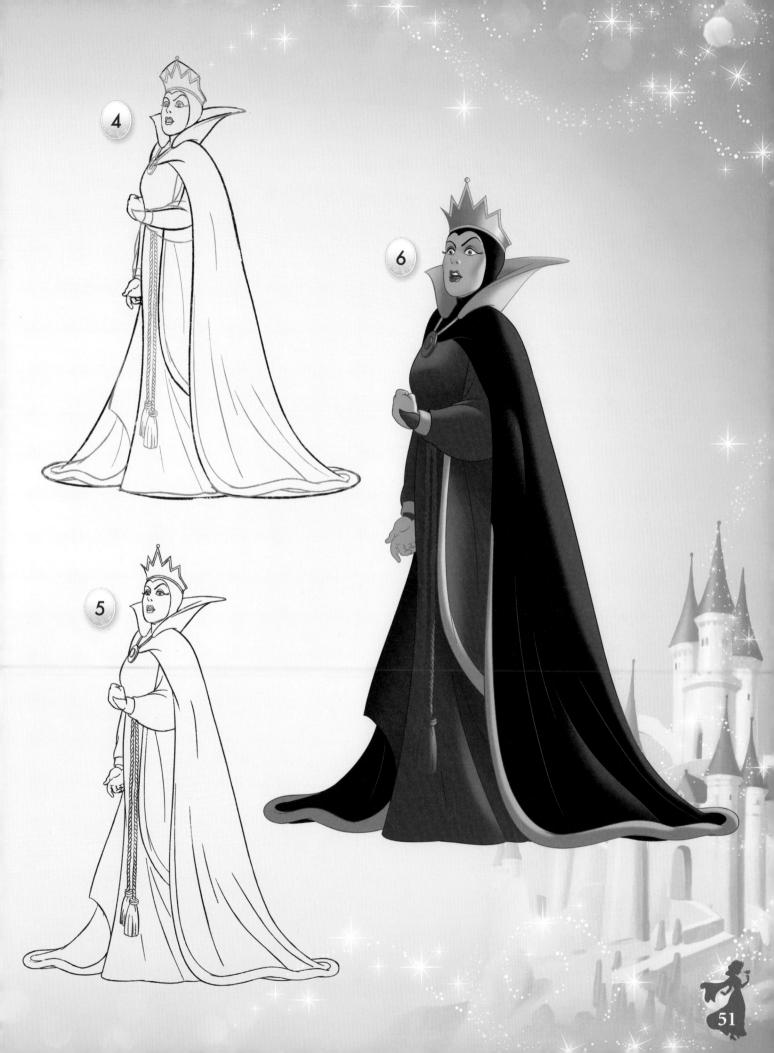

The Witch

The evil Queen uses dark magic to transform herself into an old witch in a final attempt to do away with Snow White—by giving her a poison apple.

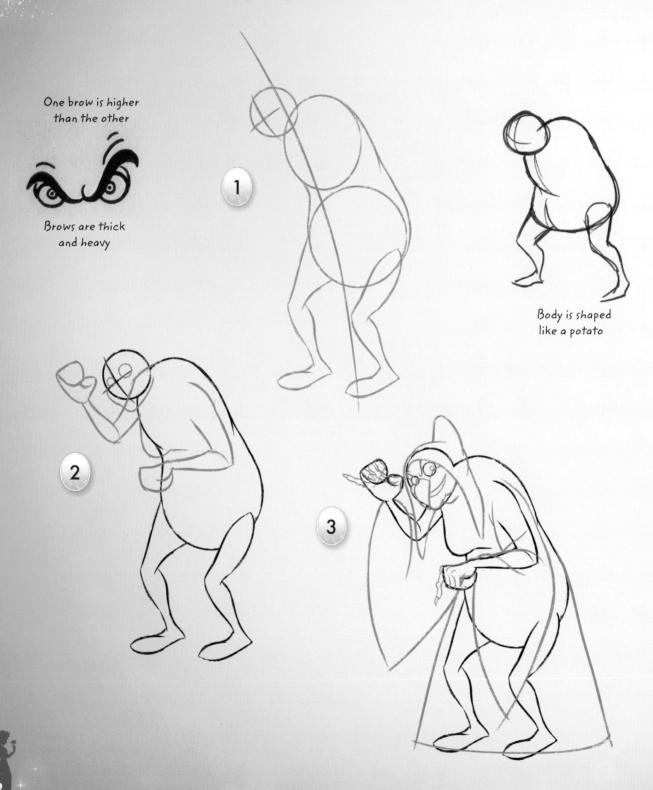

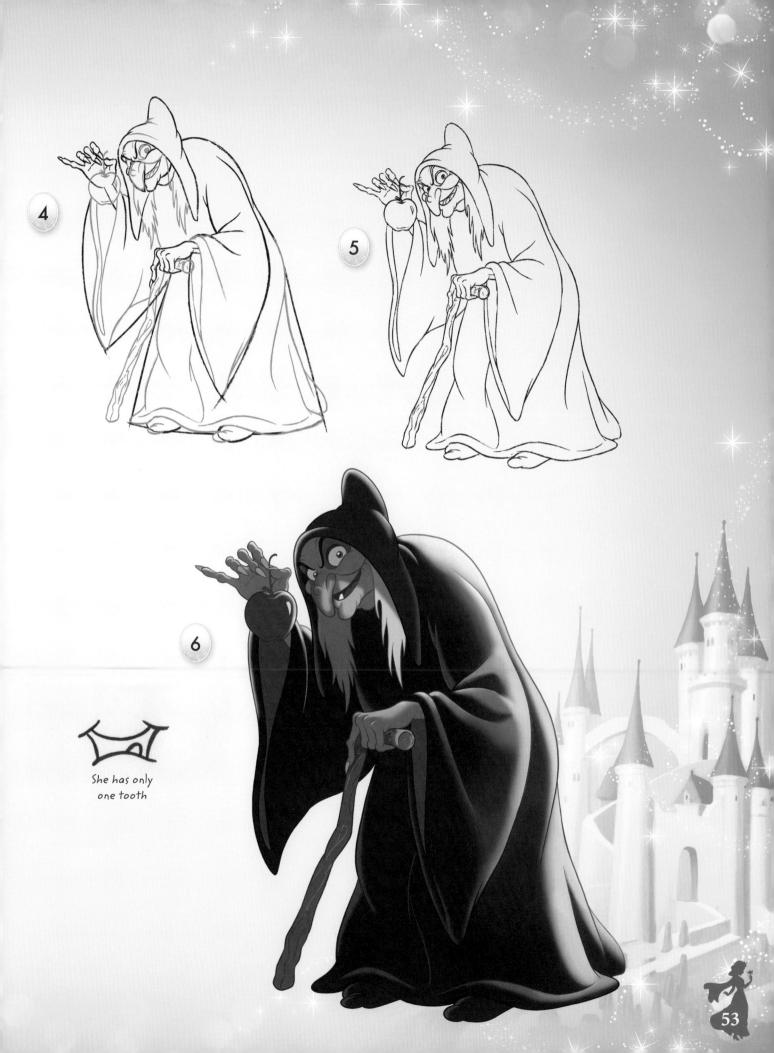

Sleeping Beauty

Born into royalty, Princess Aurora is beautiful, graceful, and sweet young woman. She is innocent and beloved by all who know her, bringing sunshine to everyone's life (contrasting with the darkness of Maleficent). She has "hair of sunshine gold and lips red as the rose."

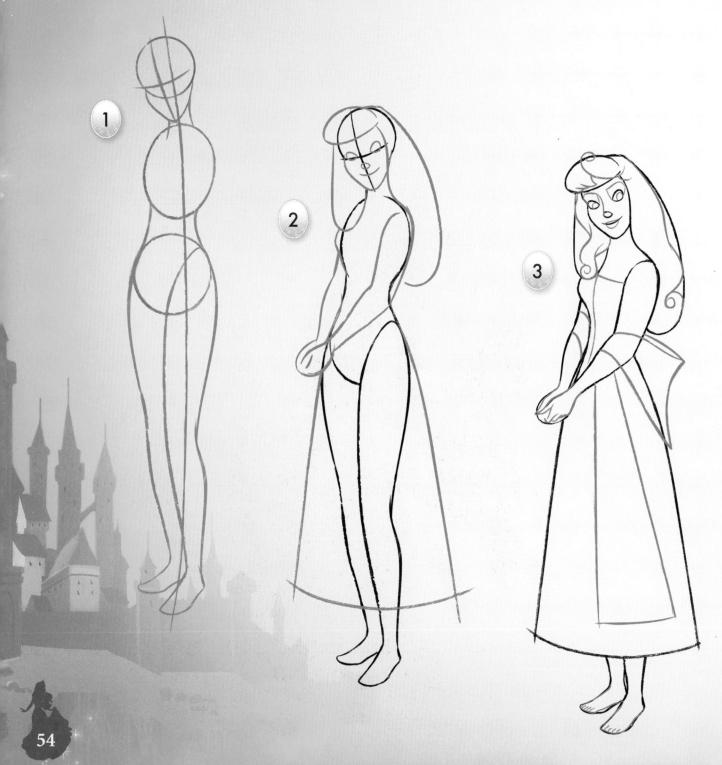

The top of her head is fairly flat

Sleeping Beauty's features are more angular than Snow White's or Cinderella's

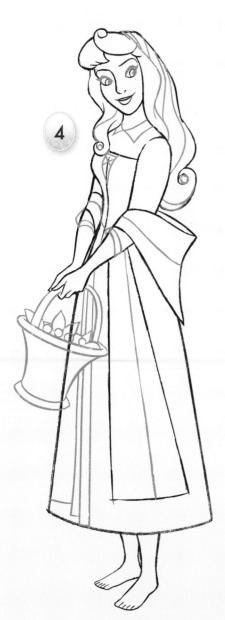

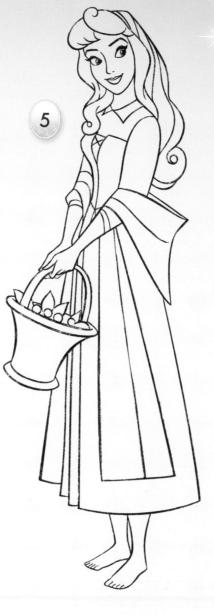

Flora, Fauna & Morryweather

These three good fairies—Flora (in red), Fauna (in green), and Merryweather (in blue)—protect Princess Aurora against the evil Maleficent and help Prince Phillip break the curse and awaken Sleeping Beauty.

Maleficent

Filled with jealousy, the malevolent witch Maleficent curses Princess Aurora, and no evil deed will stop her from seeing out her plan to the end.

Dragon Maleficent

In a last, mighty attempt to stop Prince Phillip from reaching Sleeping Beauty, Maleficent transforms into a huge, dark dragon in order to drive him away.

The End